RED LINES

**Information Policy Series**
Edited by Sandra Braman

The Information Policy Series publishes research on and analysis of significant problems in the field of information policy, including decisions and practices that enable or constrain information, communication, and culture irrespective of the legal siloes in which they have traditionally been located as well as state-law-society interactions. Defining information policy as all laws, regulations, and decision-making principles that affect any form of information creation, processing, flows, and use, the series includes attention to the formal decisions, decision-making processes, and entities of government; the formal and informal decisions, decision-making processes, and entities of private and public sector agents capable of constitutive effects on the nature of society; and the cultural habits and predispositions of governmentality that support and sustain government and governance. The parametric functions of information policy at the boundaries of social, informational, and technological systems are of global importance because they provide the context for all communications, interactions, and social processes.

A complete list of the books in the Information Policy series appears at the back of this book.

© 2021 Massachusetts Institute of Technology

Printed and bound in the United States of America.

Library of Congress Cataloging-in-Publication Data

Names: George, Cherian, author. | Liew, Sonny, 1974– artist.
Title: Red lines : political cartoons and the struggle against censorship / Cherian George, Sonny Liew.
Description: Cambridge : The MIT Press, [2021] | Series: Information policy | Includes bibliographical references and index.
Identifiers: LCCN 2020047262 | ISBN 9780262543019 (Paperback)
Subjects: LCSH: Political cartoons–Censorship–History–21st century. | Political cartoons–Censorship–Comic books, strips, etc.
Classification: LCC NC1763.P66 G46 2021 | DDC 320.02/07–dc23 LC record available at https://lccn.loc.gov/2020047262

10  9  8  7  6  5  4  3  2  1

# RED LINES
## Political Cartoons and the Struggle against Censorship

CHERIAN GEORGE

SONNY LIEW

The MIT Press
Cambridge, Massachusetts
London, England

# HOW TO READ THIS BOOK

## Organization

Chapter 1
introduces the purpose
and scope of the book.

It includes the working
definitions of censorship and
other key concepts, as well
as a primer on freedom of
expression in international
human rights law, which
provides the normative
framework for this project.

Chapters 2 to 6
deal with censorship in
different types of regime, from
the more politically repressive
to the more open.

Chapter 7
is a transitional chapter,
containing a gallery of
censored cartoons
in democratic societies.

Chapters 8 to 14
take thematic looks
at key controversies
around identity-based
censorship.

Chapter 15
concludes with
some more theoretical
musings on 21st century
censorship.

## Style

The approach taken in this
book is a mélange of
different traditions and
sensibilities, which we hope
will enrich and not confuse
your reading experience.

In substance, it follows
the academic convention
of evidence-based,
theoretically grounded
research.

In writing style, the book
borrows from long-form
journalism, with an emphasis
on giving voice to its subjects.
All our text is factual; nothing
is made up or "dramatized."

Sonny Liew's visual
treatment, meanwhile, evokes
the scrappy, cut-and-paste
aesthetics of self-published
zines and draws from his
background as an artist
specializing in comics.

## Sources

All sources,
primary and secondary,
are referenced — though
you may not realize this
at first.

To avoid visual clutter,
references are not indicated
within the text, so don't look
for those conventional
numbered notes inserted as
superscripts like [5] and [32].

Instead, if you want to
check sources, flip to the
Notes at the back of the
book, where you will see
them organized by page
number.

The same goes for
image credits.

## Taste

A visual book about the
boundaries of free speech
necessarily includes
material that crosses
those lines.

Many readers will find a
few of the cartoons
distasteful or offensive.

That, of course, is not the
point of the exercise but
an inevitable by-product
for which we apologize in
advance.

We have tried to avoid
being gratuitously hurtful,
and in some cases may
have erred on the side of
caution.

Regardless of whether we
have made the right visual
choices in your eyes, we
hope you will be able to
engage with the ideas in
this book.

# INSIDE

# Series Editor's Introduction

The first reason Cherian George and Sonny Liew give for choosing cartoons as a lens onto censorship is that they both love and have worked with them — Sonny as an international award-winning comic book artist, Cherian as the former art editor of a newspaper who approaches them here as a researcher, scholar, and thinker. Given the ubiquity and political importance of cartoons, that would be enough, but they go further. Cartoons are everywhere, essential for a global survey of 21st century restrictions on free speech. They are a very basic form of political speech, available to everyone. Cartoons can be produced cheaply, without either complex technologies or large teams. Nor does their success depend upon particular forms of literacy; it is a feature of cartoons as a genre that they are easily understood by all.

Terry Anderson, head of an international rights organization for cartoonists cited in this book, notes that what happens to political cartoonists is a useful indicator of a society's state of democratic freedom. Where there are lots of people publishing work regularly, it is a sign that those in power are perceived as sufficiently legitimate that they don't feel threatened by critical speech and that the population isn't so polarized that individuals can't appreciate the humor in a cartoon irrespective of whether or not they agree with its political position.

Defining political cartoons as "drawn commentary on current affairs," the creators of *Red Lines* spoke with over 50 artists from 6 continents and drew upon the stories of many others. This breadth was necessary because there are so many variations on censorship in the contemporary environment. It is happening in developed and developing countries, those perceived as democratic and those that are not, in economies that are capitalist and those that are socialist, and in countries both with and without long histories of protecting human rights.

George and Liew highlight the difference between classical forms of censorship that rely upon physical restraint and violence (instrumental power) and more contemporary approaches that may not be visible or that appear to be less oppressive but are, nonetheless, highly effective (structural and symbolic, or persuasive, forms of power). Censorship can be undertaken by the government, the self, or proxies such as social media companies. Tools of censorship include violence, laws and regulations restrictive of speech, social ostracism, or worse — mob action, and money.

Most of the existing literature on censorship looks at classical examples, but money matters. When myriad independent newspapers made money from cartoons because they attracted readers, cartoonists made money too because they had jobs. When social

media companies make money from cartoons because they trigger the extended online conversations that draw advertisers, cartoonists do not receive financial support.

George and Liew also remind us that cartoonists have tools, too. To protect themselves they may choose to stay silent, drawing cartoons in their minds only. They may water down what they are saying. They may choose to inspire and lead by continuing to publish in the face of censorship, despite the consequences. And, occasionally, they succeed in the sense that a political figure threatening a cartoonist with jail may instead be the one to wind up in jail. The stories told in this book are powerful, moving, and valuable both politically and analytically.

Whether or not a particular cartoon generates a censorious response may have nothing to do with either content or intention. As George so powerfully demonstrates in *Hate Spin* (MIT Press, 2016), an original theorization and analysis of extreme speech developments in several large democracies, furor over a cartoon may, instead, be the product of deliberate efforts by political entrepreneurs who manufacture a sense of offense in order to mobilize groups in pursuit of other goals. This danger is particularly difficult to protect against when the political valence of specific images and linguistic memes rapidly churns — when what may have been neutral or seen as positively benign one day may be treated as extreme hate speech the next (think Pepe the Frog). Under such conditions, even an Aesopian approach, expressing thoughts that appear on their face to be innocent but that convey additional meanings to insiders — or even silence — can be fraught. Completely spurious charges can be brought under such conditions.

WHAT HAPPENS TO CARTOONISTS HAPPENS TO ALL OF US.

The long history of constitutional protections for freedom of speech began with Sweden's constitution of 1766. It was the U.S. that introduced the legal innovation of truth as an absolute defense in libel law. At the time of writing, the number of governments criminalizing critique of all kinds — whether or not based in truth — is growing, with strong and repeated pressure in this direction even in the United States under the Administration in office in 2020. Such laws, and the practices they justify, apply across genres, across media and platforms, and across types of creators. Thus this book is critically important for our times.

SANDRA BRAMAN

THIS IS PROBABLY WHERE
WE SHOULD START.

Rue Nicolas Appert,
Paris, France.

1

HERE, ON 7 JANUARY 2015, TWO ASSASSINS VISITED THE OFFICES OF THE SATIRICAL MAGAZINE *CHARLIE HEBDO* ...

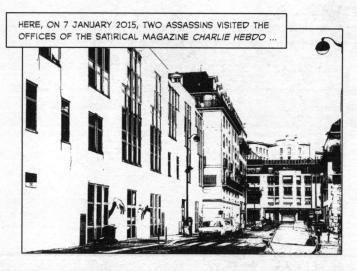

... AND LAUNCHED THE DEADLIEST ASSAULT ON MEDIA WORKERS SINCE THE 2009 AMPATUAN MASSACRE IN THE PHILIPPINES.

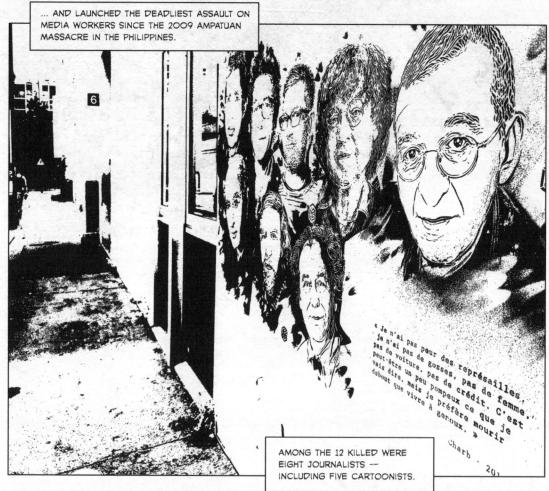

AMONG THE 12 KILLED WERE EIGHT JOURNALISTS -- INCLUDING FIVE CARTOONISTS.

THE PARIS ATTACK WAS THE CLIMAX OF THE ORGY OF OUTRAGE THAT BEGAN WITH THE PUBLICATION OF CARTOONS OF THE PROPHET MOHAMMED IN DENMARK ALMOST TEN YEARS EARLIER.

WHATEVER OTHER MEANINGS PEOPLE ATTACHED TO THE EVENT ...

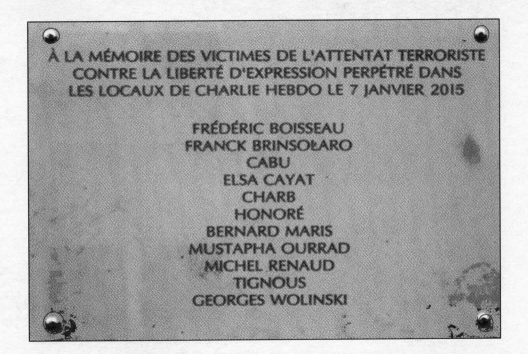

À LA MÉMOIRE DES VICTIMES DE L'ATTENTAT TERRORISTE CONTRE LA LIBERTÉ D'EXPRESSION PERPÉTRÉ DANS LES LOCAUX DE CHARLIE HEBDO LE 7 JANVIER 2015

FRÉDÉRIC BOISSEAU
FRANCK BRINSOLARO
CABU
ELSA CAYAT
CHARB
HONORÉ
BERNARD MARIS
MUSTAPHA OURRAD
MICHEL RENAUD
TIGNOUS
GEORGES WOLINSKI

... IT ESTABLISHED ONCE AND FOR ALL THAT CARTOONS ARE SERIOUS BUSINESS.

# 1. Introduction

## The Power and
## Precarity of the Pencil

# ABOUT THIS BOOK

THIS IS A BOOK ABOUT *CARTOON CENSORSHIP* AND ITS MANY *MODALITIES* AND *MOTIVATIONS*.

ENCROACHMENTS ON CARTOONISTS' FREEDOM CAN FLOW FROM THE BARREL OF A GUN, THE TAP OF A JUDGE'S GAVEL, THE RAUCOUS CHANTS OF AN OUTRAGED MOB, OR THE INVISIBLE HAND OF THE CAPITALIST FREE MARKET.

CENSORS AIM TO EVADE POLITICAL ACCOUNTABILITY, ENFORCE RELIGIOUS TABOOS, PRESERVE THE MYTHS OF GROUP IDENTITIES, AND PROTECT ECONOMIC SELF-INTERESTS.

THIS BOOK WILL SHOW THAT "CLASSIC" CENSORSHIP STILL OCCURS: THERE ARE STILL AUTOCRATS WHO CRUSH DISSENT VIOLENTLY.

BUT, A FULL HEALTH EXAMINATION OF FREE SPEECH REQUIRES PAYING ATTENTION TO LESS OBVIOUS SYMPTOMS.

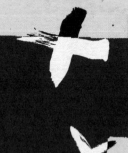

AUTHORITARIAN REGIMES USE A WIDE REPERTOIRE OF LESS COERCIVE CENSORSHIP TACTICS, OFTEN WORKING WITH THE MARKETS, TECHNOLOGIES, AND PUBLICS THAT WERE ONCE THOUGHT OF AS LIBERATING FORCES.

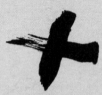

IN DEMOCRACIES, COMMERCIAL IMPERATIVES HAVE DECIMATED THE RANKS OF POLITICAL CARTOONISTS, WHILE ENVELOPING THOSE WHO REMAIN IN A CULTURE OF CAUTION.

THE POLITICS OF IDENTITY -- OF NATION, GENDER, RACE, RELIGION -- BLUR THE LINE BETWEEN HARMLESS PROVOCATION AND ILLEGITIMATE INSULT; CARTOONS ARE CAUGHT OUT BOTH BY COMMUNITIES' REASONABLE DEMANDS FOR DIGNITY AND THE POLITICALLY OPPORTUNISTIC MANUFACTURE OF OUTRAGE.

THIS BOOK FOCUSES MAINLY ON *POLITICAL CARTOONING* -- DRAWN COMMENTARY ON CURRENT AFFAIRS -- DIPPING OCCASIONALLY INTO THE ASSOCIATED ARTS OF CARICATURE, COMIC STRIPS, MEMES, AND GRAPHIC NOVELS.

LIKE THEIR WORD-BASED COUSINS -- THE OPINION COLUMNS THAT APPEAR IN NEWS MEDIA AND BLOGS -- POLITICAL CARTOONS CAN BE ENLIGHTENING OR CONFOUNDING, EMPOWERING OR ABUSIVE, UNIFYING OR POLARIZING.

AT THEIR BEST, POLITICAL CARTOONS ARE CELEBRATED FOR THEIR ABILITY TO BRING THE POWERFUL DOWN TO EARTH, STRIPPING THEM OF THE ACCOUTREMENTS OF RANK AND STATUS AND EXPOSING THEM TO THE RIDICULE MANY OF THEM DESERVE.

THE BEST CARTOONS ALSO EXPOSE THE CONTRADICTIONS AND THE HYPOCRISY THAT INFUSES MUCH OF SOCIAL LIFE WHEN IT'S RIVEN BY INEQUALITIES OF POWER AND WEALTH.

THEY BOOST VOICELESS COMMUNITIES AND WORTHY CAUSES.

BOOKS ABOUT POLITICAL CARTOONS HAVE DIFFERENT GOALS.

What are you looking for?

A. A tribute to satire from Aristophanes to John Oliver, and how caricature and cartoons fit in that history.

B. A Great (white) Man cartooning hall of fame, from Hogarth, Daumier, Gillray, and Nast, to Herblock, Crumb, and Spiegelman.

C. A formal analysis of the literary and artistic properties of cartoons as visual rhetoric.

D. A survey of 21st century restrictions on freedom of expression, as experienced by political cartoonists around the world.

If you answered A, B, or C, there are other good books to turn to. If you picked D, you've come to the right place.

WE INTERVIEWED MORE THAN 60 ARTISTS FROM 6 CONTINENTS ...

... AND COLLECTED THE STORIES OF SEVERAL OTHERS WE COULDN'T MEET.

WE PICKED THEM NOT BECAUSE THEY ARE STARS (THOUGH SOME HAPPEN TO BE), BUT BECAUSE THEIR STORIES ADD PIECES TO A COMPLICATED PUZZLE, HELPING US SEE THE GLOBAL LANDSCAPE OF MODERN CENSORSHIP IN ALL ITS HUES.

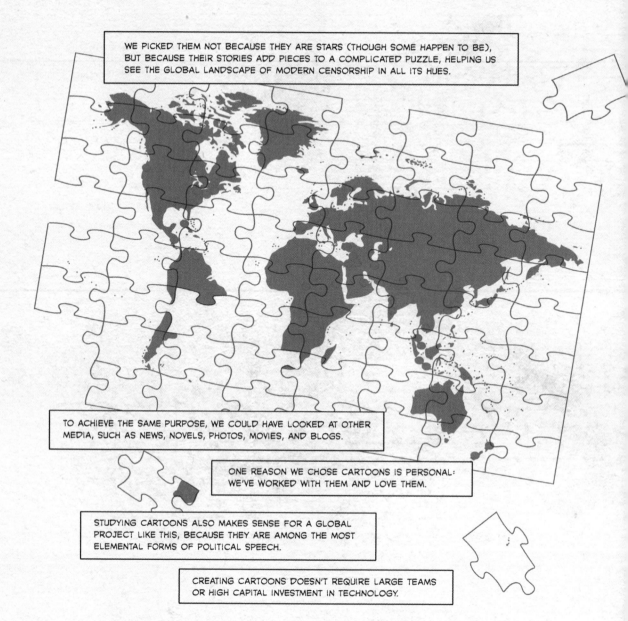

TO ACHIEVE THE SAME PURPOSE, WE COULD HAVE LOOKED AT OTHER MEDIA, SUCH AS NEWS, NOVELS, PHOTOS, MOVIES, AND BLOGS.

ONE REASON WE CHOSE CARTOONS IS PERSONAL: WE'VE WORKED WITH THEM AND LOVE THEM.

STUDYING CARTOONS ALSO MAKES SENSE FOR A GLOBAL PROJECT LIKE THIS, BECAUSE THEY ARE AMONG THE MOST ELEMENTAL FORMS OF POLITICAL SPEECH.

CREATING CARTOONS DOESN'T REQUIRE LARGE TEAMS OR HIGH CAPITAL INVESTMENT IN TECHNOLOGY.

THIS MEANS POLITICAL CARTOONS ARE MADE IN A WIDE RANGE OF POLITICAL AND ECONOMIC CONTEXTS. CARTOONISTS MAKE THEM ON BIG-SCREEN COMPUTERS FOR MAJOR MEDIA COMPANIES, BUT ALSO IN SECRET ON STYROFOAM CUPS IN PRISON CELLS.

TODAY, THE URGE TO CREATE SUCH CARTOONS IS FOUND ALL OVER THE WORLD, REFLECTING THE DIFFUSION OF DEMOCRATIC VALUES SUCH AS THE RIGHT TO HOLD ONE'S OWN OPINIONS AND TO BE FREE FROM TYRANNY.

IN SOME CONTEXTS, CARTOONS STAY CONCEALED WITHIN THEIR MAKERS' IMAGINATION, WAITING MONTHS OR YEARS FOR THE FREEDOM TO BE INKED ON PAPER.

IN MOST OTHERS, CARTOONISTS' UNADULTERATED VIEWS ARE WATERED DOWN BEFORE PUBLICATION, BY SOCIAL CONVENTION OR FEAR OF PUNISHMENT.

TO VARYING DEGREES, WHAT'S PUBLISHED REFLECTS A COMPROMISE BETWEEN THE ARTIST AND THOSE WHO OWN AND MANAGE THE MEANS OF DISSEMINATION.

THE STATUS OF POLITICAL CARTOONS IS THUS A FAIRLY UNIVERSAL MEASURE OF THE STATE OF DEMOCRACY AND FREEDOM.

IF YOU LOOK AT A COUNTRY AND CAN FIND A GOOD NUMBER OF CARTOONISTS FREELY LAMPOONING THE GOVERNMENT ON A REGULAR BASIS ...

... THAT'S A GOOD INDICATOR THAT WHOEVER IS IN CHARGE FEELS SUFFICIENTLY LEGITIMATE IN THEIR POWER.

... SO THEY DON'T FEEL THE NEED TO MISTAKE SOMETHING DISRESPECTFUL FOR SOMETHING CRIMINAL.

IT ALSO MEANS THAT THE POPULATION IS NOT TOO RADICALIZED OR DIVIDED. THEY ARE CAPABLE OF SAYING ...

... OK, THAT CARTOONIST IS NOT MY FAVORITE ...

... BUT THAT'S A GOOD ONE.

Terry Anderson, cartoonist and executive director of Cartoonists Rights Network International

# CENSORSHIP: THE GRAND TOUR

FOR A QUICK TOUR OF THE REALITIES FACED BY CARTOONISTS AROUND THE WORLD, ASK *JOHN LENT*.

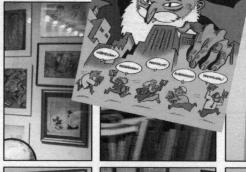

LENT HAS PROBABLY MET AND TALKED TO MORE CARTOONISTS THAN ANY OTHER SCHOLAR ON THE PLANET.

HIS HOME IN PHILADELPHIA IS A VERITABLE CARTOON MUSEUM, WITH SIGNED ORIGINALS FROM EVERY CONTINENT.

THE FOUNDER AND EDITOR OF THE *INTERNATIONAL JOURNAL OF COMIC ART*, LENT HAS INTERVIEWED AND BEFRIENDED SOME OF THE WORLD'S GREATEST EXPONENTS OF THE ART, FROM BRITAIN'S RALPH STEADMAN TO INDIA'S R. K. LAXMAN AND KENYA'S PAUL KELEMBA.

HE'S HEARD FIRSTHAND HOW CARTOONISTS GET CRUSHED, CAUTIONED, AND CO-OPTED.

THERE HAVE BEEN CARTOONISTS KILLED.

THEY GET DEATH THREATS, RAPE THREATS.

THERE HAVE BEEN CARTOONISTS BEATEN. THEIR OFFICES AND STUDIOS GET RANSACKED. OTHERS GET ARRESTED, JAILED.

John Lent

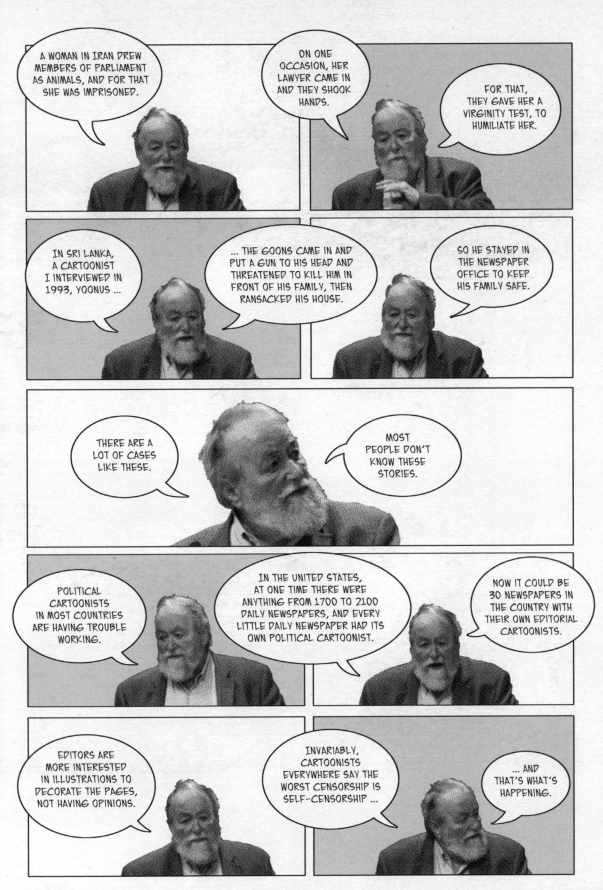

A WOMAN IN IRAN DREW MEMBERS OF PARLIAMENT AS ANIMALS, AND FOR THAT SHE WAS IMPRISONED.

ON ONE OCCASION, HER LAWYER CAME IN AND THEY SHOOK HANDS.

FOR THAT, THEY GAVE HER A VIRGINITY TEST, TO HUMILIATE HER.

IN SRI LANKA, A CARTOONIST I INTERVIEWED IN 1993, YOONUS ...

... THE GOONS CAME IN AND PUT A GUN TO HIS HEAD AND THREATENED TO KILL HIM IN FRONT OF HIS FAMILY, THEN RANSACKED HIS HOUSE.

SO HE STAYED IN THE NEWSPAPER OFFICE TO KEEP HIS FAMILY SAFE.

THERE ARE A LOT OF CASES LIKE THESE.

MOST PEOPLE DON'T KNOW THESE STORIES.

POLITICAL CARTOONISTS IN MOST COUNTRIES ARE HAVING TROUBLE WORKING.

IN THE UNITED STATES, AT ONE TIME THERE WERE ANYTHING FROM 1700 TO 2100 DAILY NEWSPAPERS, AND EVERY LITTLE DAILY NEWSPAPER HAD ITS OWN POLITICAL CARTOONIST.

NOW IT COULD BE 30 NEWSPAPERS IN THE COUNTRY WITH THEIR OWN EDITORIAL CARTOONISTS.

EDITORS ARE MORE INTERESTED IN ILLUSTRATIONS TO DECORATE THE PAGES, NOT HAVING OPINIONS.

INVARIABLY, CARTOONISTS EVERYWHERE SAY THE WORST CENSORSHIP IS SELF-CENSORSHIP ...

... AND THAT'S WHAT'S HAPPENING.

# Assassinated

NAJI AL-ALI, A PALESTINIAN CARTOONIST WHO CREATED THE ICONIC CHARACTER HANDALA, WAS SHOT IN THE HEAD IN LONDON IN 1987.

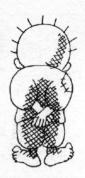

Above
**Handala**
Palestinian defiance symbol

HIS MURDER IS UNSOLVED.

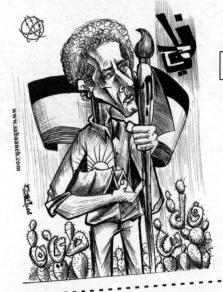

HIS CARTOONS CRITICIZED DIFFERENT SIDES OF THE ISRAELI-PALESTINIAN CONFLICT, AND IT IS NOT KNOWN WHICH GROUP KILLED HIM.

Left
**Naji Al-Ali**
Mohammed Sabaaneh

# Abducted, presumed killed

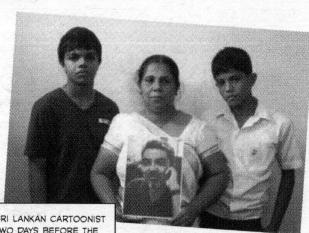

Right
The family of Prageeth Eknaligoda, still waiting for answers.

PRAGEETH EKNALIGODA, A SRI LANKAN CARTOONIST AND WRITER, DISAPPEARED TWO DAYS BEFORE THE PRESIDENTIAL ELECTIONS OF JANUARY 2010.

HE WAS AN OPPONENT OF THE THEN PRESIDENT, MAHINDA RAJAPAKSA.

# Died in custody

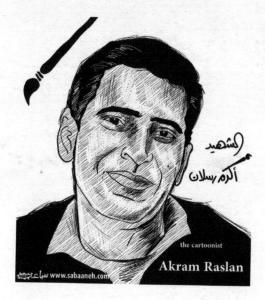

FROM THE START OF THE SYRIAN UPRISING IN 2011, AKRAM RASLAN WAS A FIERCE CRITIC OF THE BASHAR AL-ASSAD REGIME.

the cartoonist
**Akram Raslan**
www.sabaaneh.com

*Left*
Portrait of Akram Raslan
by Mohammed Sabaaneh

RASLAN WAS SEIZED FROM HIS NEWSPAPER OFFICE IN OCTOBER 2012 BY GOVERNMENT AGENTS.

HE DIED IN A PRISON HOSPITAL IN THE SPRING OF 2013, PRESUMABLY AFTER BEING TORTURED.

*Below*
A cartoon by Akram Raslan.

# Assaulted

ALI FERZAT, ANOTHER SYRIAN CARTOONIST AND PUBLISHER WHO CHALLENGED THE REGIME, WAS BEATEN BY GUNMEN IN 2011.

THEY BROKE BOTH HIS HANDS.

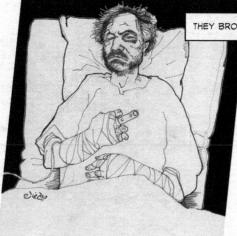

*Left & above*
Ali Ferzat shows the finger to his attackers in a self-portrait drawn after he recovered from his injuries.

# Jailed

ATENA FARGHADANI, AN IRANIAN ACTIVIST AND ARTIST, SPENT ALMOST TWO YEARS IN PRISON FOR A CARTOON INSULTING LEGISLATORS. READ HER STORY IN CHAPTER 10.

# Threatened

KANIKA MISHRA, A CARTOONIST IN INDIA, RECEIVED RAPE AND DEATH THREATS THROUGH SOCIAL MEDIA AND TELEPHONE AFTER SHE CRITICIZED A RELIGIOUS LEADER WHO EXPRESSED SUPPORT FOR THE SUSPECTS IN THE NOTORIOUS DELHI BUS RAPE OF 2012 (CHAPTER 10).

*Right*
Kanika Mishra's cartoon avatar Karnika Kahen confronts the mob.

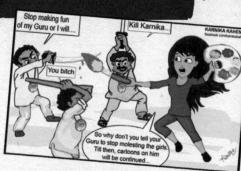

# Sued

JONATHAN SHAPIRO ("ZAPIRO") WAS SUED TWICE BY SENIOR SOUTH AFRICAN POLITICIAN JACOB ZUMA (CHAPTER 12).

# Deleted

KUANG BIAO, A CARTOONIST IN CHINA, HAS BEEN BLOCKED SEVERAL TIMES BY SOCIAL MEDIA PLATFORMS IN HIS COUNTRY. HIS ACCOUNTS HAVE ALSO BEEN DELETED (CHAPTER 4).

*Left*
Kuang Biao on China's internet censorship.

# Fired

ROB ROGERS, AN AMERICAN EDITORIAL CARTOONIST, WAS FIRED BY THE NEWSPAPER AFTER 25 YEARS OF SERVICE WHEN HE REFUSED TO TONE DOWN HIS CRITICISM OF PRESIDENT DONALD TRUMP. READ HIS STORY IN CHAPTER 6.

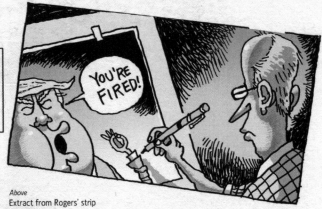

*Above*
Extract from Rogers' strip about his dismissal.

# FREE SPEECH

THE *SATIRICAL IMPULSE* SEEMS TO BE UNIVERSAL.

HUMAN CULTURE HAS DEVELOPED, AT THE MARGINS AT LEAST, THE CAPACITY TO MOCK AUTHORITY AND CHALLENGE CONVENTION, AS A DEFENSE MECHANISM AGAINST THE TOTALIZING TENDENCIES OF POWER AND TRADITION.

SOME OF THE COUNTRIES WHERE CARTOONISTS ARE UNDER GREATEST THREAT TODAY -- SUCH AS IRAN AND TURKEY -- HAVE LONG TRADITIONS OF ANTIESTABLISHMENT CARICATURE.

SO DO SOCIETIES SEEMINGLY TOO POLITE TO COUNTENANCE INSOLENT ART, SUCH AS JAPAN.

BUT, IT WAS IN EUROPE AND AMERICA WHERE CARTOONS WERE ABLE TO ENTER THE PUBLIC SPHERE AND POPULAR CULTURE WITH GREATEST EASE.

THESE SOCIETIES RADICALLY RECONSTITUTED THEIR LAWS AND POLITICAL SYSTEMS AROUND LIBERAL PRINCIPLES.

THE LIBERAL TRADITION VALUES FREE SPEECH, FIRST, BECAUSE SELF-EXPRESSION IS ESSENTIAL FOR PEOPLE TO DEVELOP THEIR INDIVIDUAL HUMANITY. MOST CARTOONISTS' ARTISTIC IMPULSE STEMS FROM THIS DEEP HUMAN NEED.

POLITICAL CARTOONING IS ALSO DRIVEN BY A JOURNALISTIC ETHOS TO CONTRIBUTE TO PUBLIC DISCOURSE. THIS RELATES TO ANOTHER KEY LIBERAL ARGUMENT FOR FREE SPEECH: THAT IT'S A PUBLIC GOOD REQUIRED FOR COLLECTIVE SELF-DETERMINATION.

SOCIETIES CAN PROGRESS ONLY IF THEY TOLERATE DIFFERENT VIEWS AND PROTECT DIVERSE VOICES FROM SUPPRESSION BY DOMINANT GROUPS.

ALL THINGS MUST BE EXAMINED, DEBATED, INVESTIGATED WITHOUT EXCEPTION AND WITHOUT REGARD FOR ANYONE'S FEELINGS ...

WE MUST RUN ROUGHSHOD OVER ALL THESE ANCIENT PUERILITIES, OVERTURN THE BARRIERS THAT REASON NEVER ERECTED ...

... GIVE BACK TO THE ARTS AND SCIENCES THE LIBERTY THAT IS SO PRECIOUS TO THEM.

*Right*
**Denis Diderot**
French Enlightenment philosopher
(1713-1784)

FROM THE LATE 18TH CENTURY, WESTERN DEMOCRACIES BEGAN WEAVING THESE ENLIGHTENMENT IDEALS INTO FORMALLY RECOGNIZED RIGHTS, LIMITING THE STATE'S ABILITY TO RESTRICT OR PUNISH PROVOCATIVE OR INSULTING EXPRESSION.

*Left*
Sweden's Press Freedom Act of 1766, the world's first.

IN THE MID-20TH CENTURY, THE RIGHT TO FREEDOM OF EXPRESSION WAS ENSHRINED IN INTERNATIONAL HUMAN RIGHTS LAW.

THIS IS PART OF A MAJOR, HISTORIC SHIFT IN GLOBAL NORMS. WHATEVER THEIR POLITICAL SYSTEM, MOST PEOPLE TODAY DON'T BELIEVE THEIR RULERS HAVE SOME NATURAL, GOD-GIVEN AUTHORITY TO SPEAK FOR THEM ALL THE TIME.

AMARTYA SEN WRITES THAT EVEN WHERE THEY LACK THE LEGAL RIGHT TO ELECT THEIR RULERS, PEOPLE CONSIDER 'GOVERNMENT BY DISCUSSION' AS MORALLY LEGITIMATE ...

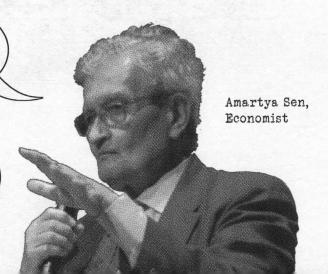

IN THE GENERAL CLIMATE OF WORLD OPINION, DEMOCRATIC GOVERNANCE HAS NOW ACHIEVED THE STATUS OF BEING TAKEN TO BE GENERALLY RIGHT.

Amartya Sen, Economist

THE BALL IS VERY MUCH IN THE COURT OF THOSE WHO WANT TO RUBBISH DEMOCRACY TO PROVIDE JUSTIFICATION FOR THAT REJECTION.

# FREEDOM OF EXPRESSION
# IN INTERNATIONAL HUMAN RIGHTS LAW

**Article 19.2:** "Everyone shall have the right to freedom of expression; this right shall include freedom to seek, receive and impart information and ideas of all kinds, regardless of frontiers, either orally, in writing or in print, in the form of art, or through any other media of his choice."

– International Covenant on Civil & Political Rights

## A HUMAN RIGHT

Although different countries have their own ways to define (or ignore) this right, Article 19 of the International Covenant on Civil and Political Rights (ICCPR) is the closest thing the world has to a universal agreement to protect freedom of expression as a fundamental human right.

The ICCPR has the legal status of a treaty, and more than 170 countries have agreed to be bound by it. It evolved from the Universal Declaration of Human Rights (UDHR), which the United Nations General Assembly proclaimed in 1948. While political and religious documents had made similar stantements in the past, the UDHR marked the first time that governments collectively agreed that their citizens, as individual human beings and no matter where they live, have rights that transcend the interests of states.

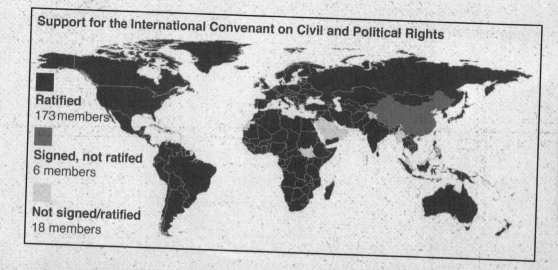

**Support for the International Convenant on Civil and Political Rights**

**Ratified**
173 members

**Signed, not ratifed**
6 members

**Not signed/ratified**
18 members

## BUT NOT ABSOLUTE – THE 3-PART TEST

Under the ICCPR, freedom of expression is not an absolute or limitless right (unlike, say, freedom from slavery or freedom from torture). Speech can threaten other fundamental human rights and societal interests. The ICCPR therefore says that states may restrict freedom of expression.

International law does not, however, give governments total licence to determine how and when to impose restrictions. Embedded in Article 19.3 (below) are the conditions that any proposed restriction must meet. These conditions are known as the "three-part test." Fail any of them, and a government can be said to have violated Article 19.

**Article 19.3:** "The exercise of [these] rights... carries with it special duties and responsibilities. It may therefore be subject to certain restrictions, but these shall only be such as are provided by law and are necessary:

(a) For respect of the rights or reputations of others;

(b) For the protection of national security or of public order (ordre public), or of public health or morals."

– International Covenant on Civil & Political Rights

### TEST 1: BY LAW?
ANY RESTRICTION MUST BE WRITTEN IN UNAMBIGUOUS AND NARROWLY WORDED LAW.

ONLY THEN CAN PEOPLE KNOW WHETHER THEIR INTENDED SPEECH MIGHT BREAK THE LAW.

IF THEY DON'T KNOW, AND IF POSSIBLE PENALTIES ARE HARSH, THE LAW WILL HAVE A CHILLING EFFECT ON SPEECH.

### TEST 2: LEGITIMATE AIM?
RESTRICTIONS ARE PERMISSIBLE ONLY FOR ONE OF THE REASONS SPELLED OUT IN THE ARTICLE. NO OTHER JUSTIFICATION, INCLUDING ANY OF THE FOLLOWING, ARE LEGITIMATE: SHIELDING THE GOVERNMENT FROM CRITICISM; PROTECTING RELIGIONS FROM INSULT; AND MAINTAINING SOCIAL HARMONY.

### TEST 3: NECESSARY?
RESTRICTIONS MUST BE NECESSARY AND PROPORTIONATE, USING THE LEAST INVASIVE MEASURE AVAILABLE.

IMPRISONMENT IS NEVER APPROPRIATE FOR DEFAMATION.

PENALTIES MUST TAKE INTO ACCOUNT THE NEED FOR ROBUST PUBLIC DEBATE ABOUT THE POLITICAL DOMAIN.

**KEY CHALLENGES:** *While most countries have ratified the ICCPR, freedom of expression faces key challenges, say international monitors.*

1. Government control over the media continues to be a serious problem. Concerns include: ownership of the media by politicians, and politically motivated legal cases brought against media.

2. Many countries have laws making it a crime to defame or insult, and antiquated laws such as sedition, which penalize criticism of government.

3. National security and concerns about terrorism are abused to impose unduly broad limitations on freedom of expression.

4. Violence against journalists, and impunity for such crimes, remains a very serious threat.

5. Commercial pressures pose a threat to the ability of the media to disseminate public interest content. Concentration of ownership of the media reduces content diversity.

6. The internet's potential as a tool to promote the free flow of information and ideas has not been fully realized due to efforts by some governments to control or limit this medium.

# APPLYING THE 3-PART TEST

MOST STATE ACTIONS AGAINST CARTOONING ARE PROBLEMATIC, NOT BECAUSE CARTOONING IS AN ABSOLUTE AND INVIOLABLE RIGHT, BUT BECAUSE STATES DON'T MEET THE *THREE-PART TEST* FOR RESTRICTING EXPRESSION.

## 1. By law?

WHEN CARTOONIST NIKAHANG KOWSAR GOT UNDER THE SKIN OF THE IRANIAN REGIME, ITS MOST INTIMIDATING RESPONSES WERE *NOT BY LAW*.

HE RECEIVED DEATH THREATS, AND WAS CHASED BY BASIJI, THE VOLUNTEER MILITIA THAT THE REGIME DEPLOYS TO TERRORIZE PROTESTERS AND ACTIVISTS. KOWSAR FLED THE COUNTRY AND NOW LIVES IN THE UNITED STATES. READ HIS STORY IN CHAPTER 3.

*Left*
Basiji in Tehran.

## 2. For a legitimate purpose?

IN INDIA, WHEN SWATHI VADLAMUDI DREW A CARTOON CRITICAL OF THE HINDU RIGHT, POLICE SUMMONED HER.

THEY CITED WRITTEN LAW, SECTION 295A OF THE INDIAN PENAL CODE. BUT THIS COLONIAL-ERA LAW BANS RELIGIOUS INSULT, TO PROTECT PEOPLE'S RELIGIOUS FEELINGS -- A PURPOSE THAT'S *NOT LEGITIMATE* UNDER THE ICCPR. SEE CHAPTER 10.

Swathi Vadlamudi

### NOTICE
### U/s.91/160 Cr.PC

You are hereby informed that on 13.04.2018 on complaint of Sri. Kashimshetty Karuna Sagar S/o Krishnaiah occ: Advocate a case has been registered in Cr.No.132/2018 U/s 295(A) IPC at Police Station Saidabad and the case has been transferred to CCS and re-registered in Cr.No.81/2018 dated 10-05-2018 and entrusted to me for further investigation.

In this complaint stated that you are sketching the derogatory cartoon on Hindu gods hurting the sentiments of Hindus and posted on twitter, a separate complaint was given on 14.04.2018 by the complainant against you.

## 3. Necessary and proportionate?

SOUTH AFRICAN POLITICIAN JACOB ZUMA'S DEFAMATION THREAT AGAINST ZAPIRO WAS *NOT PROPORTIONATE*.

IN TWO LAWSUITS, ZUMA INITIALLY DEMANDED DAMAGES TOTALING 20 MILLION RAND (MORE THAN 1.3 MILLION US DOLLARS). THESE ONLY SUCCEEDED IN TARNISHING HIS OWN IMAGE, SO ZUMA WITHDREW THE SUITS AFTER A FEW YEARS. (READ ZAPIRO'S STORY IN CHAPTER 12.)

Jacob Zuma

# STUDYING CENSORSHIP

INTERNATIONAL HUMAN RIGHTS LAW OBVIOUSLY HASN'T ERADICATED EGREGIOUS CENSORSHIP.

THE ICCPR'S ENFORCEMENT MECHANISMS LACK TEETH.

BUT, A STATE THAT STIFLES DISSENT TOO BRUTALLY COULD ATTRACT SANCTIONS AND BOYCOTTS.

THE REGIME COULD ALSO BE SHAMED IN THE COURT OF INTERNATIONAL OPINION. THIS COULD PLAY INTO THE HANDS OF ITS DOMESTIC OPPONENTS.

TO MINIMIZE NATIONAL AND INTERNATIONAL BLOWBACK, MANY GOVERNMENTS THAT WANT TO REMAIN ILLIBERAL HAVE MODIFIED THEIR CENSORSHIP METHODS.

THEY *CALIBRATE* THE VIOLENCE, VISIBILITY, AND EXTENT OF CENSORSHIP.

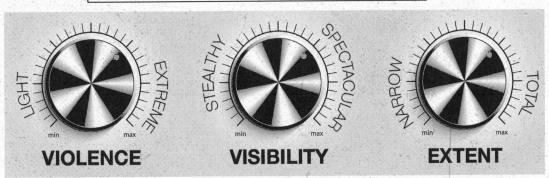

LIGHT / EXTREME — min / max

**VIOLENCE**

STEALTHY / SPECTACULAR — min / max

**VISIBILITY**

NARROW / TOTAL — min / max

**EXTENT**

To the autocrat, physical violence may be attractive as a final solution against a troublesome cartoonist. But subtler means – like economic pressure – can be as effective, and less messy.

Very public interventions send a strong threat to the whole society, but can alienate public opinion. Stealthy methods, including algorithmic filtering of online content, are politically less costly.

Trying to control all of the people all of the time is the totalitarian dream, but today's resilient authoritarian regimes understand that it's more sustainable to intervene narrowly, targeting those who mobilize dissent.

SMART CENSORS ADJUST THESE LEVELS TO ACHIEVE THEIR DESIRED RESULTS. CENSORSHIP DETECTION NEEDS TO BE SIMILARLY CALIBRATED TO CAPTURE CENSORS' FULL SPECTRUM OF METHODS.

*Left*
Chile, 1973: Soldiers burning subversive materials under orders from the new military junta led by Augusto Pinochet.

FOR A LONG TIME, CENSORSHIP WAS REGARDED AS SOMETHING DONE BY THE CHURCH OR THE STATE, IN A DIRECT AND COERCIVE MANNER ...

IN WESTERN DEMOCRACIES, LIBERALISM SUCCESSFULLY PUSHED BACK SUCH CENSORSHIP.

COURTS GREW SYMPATHETIC TO FREEDOM OF EXPRESSION AS A FUNDAMENTAL VALUE.

JUDGES WERE INCREASINGLY LIKELY TO BLOCK GOVERNMENTS AND DOMINANT RELIGIOUS INSTITUTIONS THAT WERE STILL KEEN ON SUPPRESSING DISSENT.

LIBERALISM'S VICTORY SEEMED SO FINAL THAT CENSORSHIP DROPPED OFF THE RADAR OF MOST MEDIA SCHOLARS AND POLITICAL SCIENTISTS IN THE WEST.

SOME SCHOLARS WENT THE OTHER EXTREME. INSPIRED ESPECIALLY BY MICHEL FOUCAULT, THEY ARGUED THAT CENSORSHIP IS ALL-PERVASIVE; EVEN THAT FORECLOSING EXPRESSION IS A NECESSARY PART OF COMMUNICATION.

THE PROBLEM WITH BOTH PERSPECTIVES -- CENSORSHIP HAS DISAPPEARED, OR CENSORSHIP IS EVERYWHERE -- IS THAT THEY ARE INSENSITIVE TO MANY RESTRICTIONS ON SPEECH THAT NEED TO CONCERN US AS CITIZENS IN EXISTING AND WOULD-BE DEMOCRACIES.

TO DETECT 21ST CENTURY CENSORSHIP, WE NEED A MORE REFINED VIEW OF BOTH THE *WHO* AND THE *HOW* OF CENSORSHIP.

# WHO
⬇

Liberalism emerged in the West in opposition to the twin tyrannies of the church and the state, so it's not surprising that censorship came to be defined as tools of these two dominant institutions.

But political and religious institutions are not the only groups with the power to restrict people's freedoms.

Economically powerful interests such as commercial organizations exercise corporate censorship.

Intolerant grassroots movements and lobby groups can punish expression they find offensive.

Though they lack the coercive might of the state, their power is hardly trivial: they can deprive artists of their livelihood, and even threaten violence.

The defining feature of censorship is not state or church, but **power** in all its forms.

# HOW
⬇

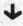

The most obvious kind of censorship is direct and coercive – killings, beatings, jailings, bannings. It's what makes headlines and draws condemnation from human rights defenders.

Precisely for that reason, though, many autocrats have shifted to less violent, more indirect, and stealthier means of information control.

Indeed, inducing **self-censorship** to to pre-empt troublesome speech may be the smart censor's preferred mode of information control.

Direct censorship – stopping the distribution of unauthorized content or punishing creators after the fact – need not be the state's first choice.

It's Plan B when self-censorship fails.

# CENSORSHIP: A SIMPLE MODEL

IF FREE EXPRESSION IS THE CONSENSUAL COMMUNICATION OF INFORMATION AND IDEAS ...

Censor

... THEN CENSORSHIP IS A THIRD PARTY'S USE OF *POWER* TO BLOCK OR DISTORT THAT EXCHANGE.

Willing Sender

Message

Willing Receiver

This model recognizes people's agency and free will, which includes their right not to send or receive a piece of communication. If a cartoon doesn't make fun of a minority group, that needn't be the result of censorship (or self-censorship); the cartoonist could be exercising self-restraint based on professional ethics and respect for the dignity of others.

The censor doesn't have to be the state; it doesn't matter who the actor is. It's the use of power that characterizes censorship. It's about coercion – actual or implied, physical, economic, or technological. But it's not censorship if someone in authority uses only moral influence and the power of argument to urge cartoonists to act responsibly.

# SELF-CENSORSHIP

SELF-CENSORSHIP IS THE RESULT WHEN OTHERWISE WILLING SENDERS BECOMING UNWILLING...

Censor

...DUE TO ANTICIPATED INTERFERENCE BY A THIRD PARTY WHO HAS THE POWER TO REWARD OR PUNISH SPEECH.

Willing Sender

Message

Willing Receiver

Self-censorship is a pre-emptive move by a sender who predicts a powerful actor's response. The prediction could be based on fresh warning signs, including direct threats. Or, the sender may be extrapolating from the censor's past conduct. A censor's track record of repression can thus have a deterrent "chilling effect" on speech.

Self-censorship is often hard to prove. Editors who surrender to fear may not admit it, preferring to defend their decisions as independent judgment. The actors who pressure editors to self-censor often expect these dealings to be kept confidential – a kind of "meta-censorship." (Note: Fear can also turn willing receivers into unwilling ones.)

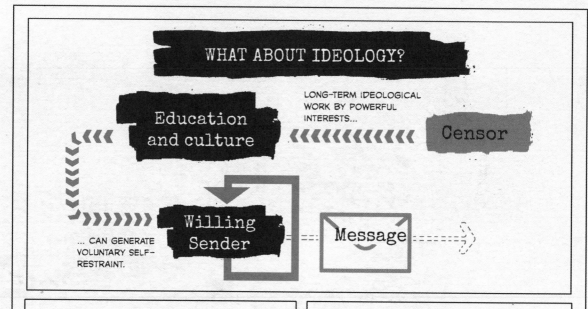

# WHAT ABOUT IDEOLOGY?

Education and culture

LONG-TERM IDEOLOGICAL WORK BY POWERFUL INTERESTS...

Censor

Willing Sender

Message

... CAN GENERATE VOLUNTARY SELF-RESTRAINT.

This is the realm of "**hegemony,**" where the preferred worldviews of the powerful few become the convention and common sense of the many.

But distinguishing the free exercise of individual values from the effects of political and religious brainwashing is a highly subjective judgment call.

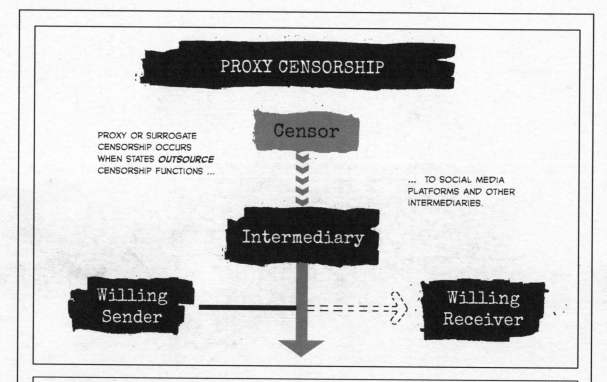

# PROXY CENSORSHIP

Censor

PROXY OR SURROGATE CENSORSHIP OCCURS WHEN STATES *OUTSOURCE* CENSORSHIP FUNCTIONS ...

... TO SOCIAL MEDIA PLATFORMS AND OTHER INTERMEDIARIES.

Intermediary

Willing Sender

Willing Receiver

Proxy censorship is usually less visible than traditional state censorship. Carried out by private firms, it is not subject to the levels of public accountability that democracy demands of state actions. Increasingly, proxy censorship rides on the algorithms that internet services are built on: the agents of censorship are robots that users are struggling to understand.

# MARKET CENSORSHIP

Most media work happens in a commercial environment that financially rewards some kinds of communication and penalizes others.

MARKET CENSORSHIP RESULTS FROM DIVERTING MEDIA SPACE, TIME, MONEY, AND TALENT TOWARD CONTENT AND GENRES THAT ARE FINANCIALLY MORE PROFITABLE AND LESS RISKY. WITHIN MEDIA ORGANIZATIONS, THE LOGIC OF THE MARKET IS USUALLY IMPOSED BY OWNERS AND MANAGERS. IT CAN BECOME ROUTINE, APPEARING RATIONAL AND INEVITABLE.

THIRD PARTIES EXERT COMMERCIAL PRESSURES THAT OFTEN PUSH MEDIA AWAY FROM THEIR PUBLIC SERVICE MISSION.

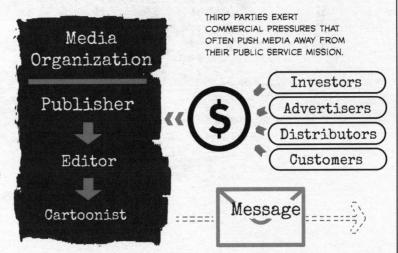

Media Organization

Publisher

Editor

Cartoonist

$

Investors
Advertisers
Distributors
Customers

Message

Market censorship can be direct: killing cartoons that may upset a big advertiser, for example. But it is mostly indirect: media allocate resources towards market-friendly, consumer-oriented content and away from the needs of democratic life. States can ride on market forces, amplifying economic pressure on corporate decision makers.

A 21ST CENTURY DEFINITION OF "CENSORSHIP" WOULD COVER NOT ONLY THE CONDUCT OF AUTOCRATIC GOVERNMENTS, BUT ALSO MANY ACTIONS COMMON IN LIBERAL DEMOCRACIES -- LIKE A PRIVATE NEWSPAPER'S DECISION TO KILL A POTENTIALLY CONTROVERSIAL CARTOON TO AVOID UPSETTING A VOCAL LOBBY GROUP.

THAT IS *NOT* TO SAY THAT THESE DIVERSE FORMS OF CENSORSHIP ARE ALL MORALLY EQUIVALENT.

Cherian George

A STATE THAT THROWS A DISSIDENT ARTIST INTO SOLITARY CONFINEMENT (WITH OR WITHOUT A VIRGINITY TEST) VIOLATES HER MORE PROFOUNDLY THAN A NEWSPAPER THAT CHOOSES NOT TO PUBLISH HER CARTOON.

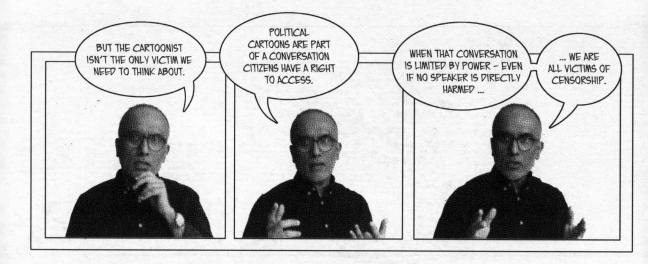

FROM THIS PERSPECTIVE, THE QUESTION TO ASK ISN'T WHAT TYPES OF CENSORSHIP CAUSE GREATEST SUFFERING TO THE ARTIST, BUT:

**WHAT FORCES RESTRAIN POLITICAL CARTOONS' CONTRIBUTION TO A ROBUST PUBLIC DISCOURSE?**

IN MANY COUNTRIES, THE FEAR OF NEGATIVE REACTIONS FROM EMPLOYERS, ADVERTISERS, AND AUDIENCES IS MORE INHIBITIVE THAN THE THREAT OF VIOLENT GOVERNMENTAL ACTION.

IN OTHERS, EVEN GOVERNMENT CENSORSHIP LEAVES NO FINGERPRINTS, BECAUSE IT'S DONE *INDIRECTLY* THROUGH CRONIES IN THE PRIVATE SECTOR.

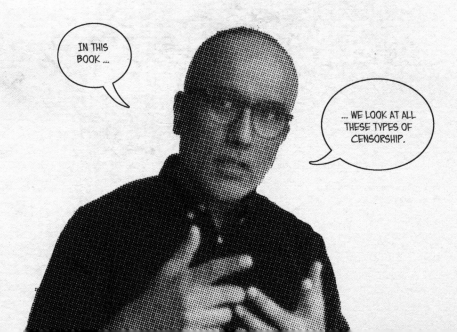

# THE STRUGGLE

POLITICAL CARTOONS ARE A SITE OF STRUGGLE.

THIS IS A PARADOX THAT CONTINUES TO MYSTIFY:
WHY SOMETHING AS SIMPLE AS DRAWINGS ON A
PAGE CAN EXCITE SUCH ANGER IN THE POWERFUL.

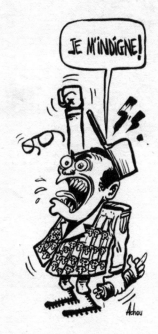

*Right*
Chad President Idriss Déby
expressing indignation, by
Adjim Danngar

THE IMPULSE TO CENSOR MAY BE PARTLY IRRATIONAL.

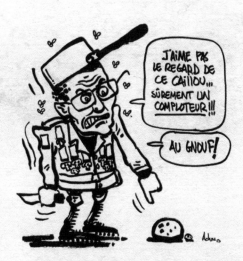

*Left*
"I don't like the look of this pebble.
Must be a conspirator!"
By Adjim Danngar

BUT EXTREME REACTIONS ARE ALSO AN ACKNOWLEDGMENT OF THE MEDIUM'S POWER.

A GOOD CARTOON COMBINES THE INSTANT IMPACT OF IMAGES WITH THE DISARMING POWER OF HUMOR.

IT INVOLVES "CONDENSATION OF A COMPLEX IDEA IN ONE STRIKING AND MEMORABLE IMAGE," SAYS ART HISTORIAN ERNST GOMBRICH.

*Left*
The Catholic church and its child sex victims, by Vilma Vargas

CARTOONISTS METAPHORICALLY BRING THE POWERFUL DOWN TO EARTH, PLACING THEM IN MORE FAMILIAR CONTEXTS.

*Above and Right*
Syrian President Bashar Hafez al-Assad, by Ali Ferzat. Ferzat drew these cartoons in August 2011. Later the same month, the cartoonist's hands were broken.

YET, IT'S UNCLEAR WHETHER CARTOONS ACTUALLY DO HAVE A SUBVERSIVE EFFECT. SKEPTICS SAY SAY A GOOD LAUGH GIVES THE WEAK A PSYCHOLOGICAL RELEASE ...

... AFTER WHICH THE POWERFUL ARE ABLE TO RESTORE EXISTING HIERARCHIES.

OTHERS ARGUE THAT CARTOONS THAT MOCK THE POWERFUL AND HIGHLIGHT CONTRADICTIONS IN SOCIETY CAN HAVE A LASTING IMPACT ON CITIZENS' PERCEPTIONS AND ATTITUDES.

THIS IS WHAT MANY CENSORS BELIEVE, REGARDLESS OF HOW SOCIAL SCIENCE SETTLES THE THEORETICAL DEBATE.

ANOTHER REASON WHY PEOPLE IN POWER FIND SATIRICAL CARTOONS INSUFFERABLE IS THAT IT'S DIFFICULT TO RESPOND IN KIND (UNLESS THEY HAPPEN TO BE TALENTED CARTOONISTS THEMSELVES).

IT'S HARD TO ARGUE WITH A CARTOON.

HUMOR AND RIDICULE IS NOT PART OF THE MEANS THE POLICE, PRISONS, AND COURTS ARE USED TO RESPONDING TO.

BUT IF THE OPPRESSOR USES FORCE AGAINST SOMEONE WHO IS 'JUST MAKING FUN,' HE MAKES HIMSELF LOOK RIDICULOUS AND GIVES THE MOVEMENT NEW MATERIAL FOR FURTHER DEVELOPMENT OF THE FUN ...

THEY KNOW HOW TO REACT TO VIOLENCE, AND HOW TO ACT IN RESPONSE TO 'ORDINARY' PROTEST SUCH AS DEMONSTRATIONS.

THIS DOES NOT MEAN THAT AN OPPRESSIVE SYSTEM DOES NOT RESPOND WITH VIOLENCE, JUST THAT IT IS MUCH HARDER TO JUSTIFY IT.

Majken Jul Sørensen,
sociologist, writing on resistance and humor

IT WOULD SEEM THAT THE SMARTEST RESPONSE IS TO DO NOTHING, LIKE MOST POLITICIANS IN MOST LIBERAL DEMOCRACIES HAVE LEARNT TO DO.

PERHAPS, THOUGH, WE SHOULDN'T BE SURPRISED CARTOONS ARE TAKEN SO SERIOUSLY BY THE MOST POWERFUL PEOPLE IN SOCIETY. IT FEELS LIKE A PARADOX ONLY BECAUSE WE ASSUME THAT "REAL" POWER, UNLIKE THE SYMBOLIC TOOLS USED IN CARTOONS, IS SOLID AND TANGIBLE.

SURE, THE MEANS OF VIOLENCE THAT UNDERWRITE STATE POWER POSSESS AN OBJECTIVE REALITY.

Mao Zedong

POLITICAL POWER GROWS OUT OF THE BARREL OF A GUN.

THAT'S A FAMOUS MAO ZEDONG QUOTE. BUT, WHAT'S LESS WELL KNOWN IS WHAT HE WENT ON TO SAY...

YET, HAVING GUNS, WE CAN CREATE PARTY ORGANIZATIONS.... WE CAN ALSO CREATE CADRES, CREATE SCHOOLS, CREATE CULTURE, CREATE MASS MOVEMENTS.

NATIONAL, RELIGIOUS, AND MOVEMENT LEADERS KNOW THAT TO STAY IN POWER, ICONS AND SYMBOLS ARE AS IMPORTANT AS IRON AND STEEL.

ART HISTORIAN ERNST GOMBRICH HAS POINTED OUT THAT POLITICAL THOUGHT AND RHETORIC IS FULL OF *IMAGERY*. LEADERS HAVE ALWAYS NEEDED IMAGES TO EXPLAIN THEMSELVES, EVEN IF PURELY VERBALLY.

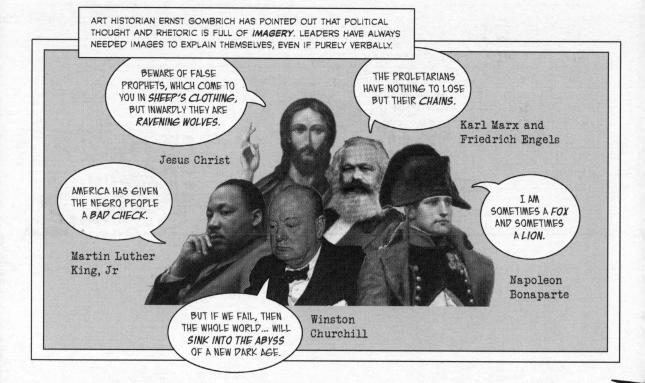

BEWARE OF FALSE PROPHETS, WHICH COME TO YOU IN *SHEEP'S CLOTHING*, BUT INWARDLY THEY ARE *RAVENING WOLVES*.

Jesus Christ

THE PROLETARIANS HAVE NOTHING TO LOSE BUT THEIR *CHAINS*.

Karl Marx and Friedrich Engels

AMERICA HAS GIVEN THE NEGRO PEOPLE A *BAD CHECK*.

Martin Luther King, Jr

I AM SOMETIMES A *FOX* AND SOMETIMES A *LION*.

Napoleon Bonaparte

BUT IF WE FAIL, THEN THE WHOLE WORLD... WILL *SINK INTO THE ABYSS* OF A NEW DARK AGE.

Winston Churchill

ANCIENT GREEKS LIKED TO "PERSONIFY ABSTRACT CONCEPTS IN TERMS OF LIVING PRESENCES" AND TO ELEVATE THESE "PERSONIFIED WORDS" TO THE PANTHEON OF "IMMORTAL GODS," GOMBRICH NOTED.

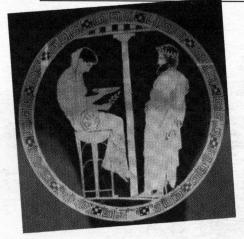

Left
**Law, worshipped:**
Themis, the Goddess of Law, being consulted by King Aegeus, on a piece of pottery from around 430BC.

*Right*
**Law, violated:** Lady Justice, having been raped by the South African government, warns Free Speech to defend herself. This 2011 Zapiro cartoon was a sequel to his controversial 2008 "Lady Justice" cartoon (Chapter 12).

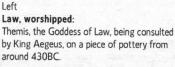

IT IS THE STRENGTH AND THE DANGER OF THE CARTOONIST THAT HE APPEALS TO THIS TENDENCY AND MAKES IT EASIER FOR US TO TREAT ABSTRACTIONS AS IF THEY WERE TANGIBLE REALITIES.

IT IS THIS FREEDOM TO TRANSLATE THE CONCEPTS AND SHORTHAND SYMBOLS OF OUR POLITICAL SPEECH INTO... METAPHORICAL SITUATIONS THAT CONSTITUTES THE NOVELTY OF THE CARTOON.

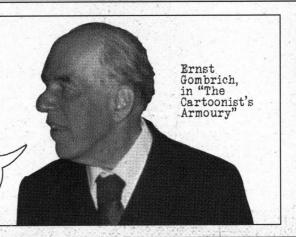

Ernst Gombrich, in "The Cartoonist's Armoury"

THERE IS ANOTHER REASON WHY OBJECTIVE POWER IS VULNERABLE TO WORKS OF THE IMAGINATION, SAYS HISTORIAN YUVAL NOAH HARARI.

THE GLUE THAT BINDS THOUSANDS OF ARMED MEN INTO A FUNCTIONING ARMY IS ITSELF A WORK OF FICTION, HE SAYS.

THE SAME IS TRUE OF THE VALUE OF MONEY, THE LEGITIMACY OF LAW, AND THE BONDS OF RELIGION, ETHNICITY AND NATIONALITY.

ALL ARE "IMAGINED REALITIES" -- STORIES LARGE SOCIETIES TELL THEMSELVES TO ENABLE COHESION AND COORDINATION, HARARI WRITES ...

LARGE NUMBERS OF STRANGERS CAN COOPERATE SUCCESSFULLY BY BELIEVING IN COMMON MYTHS ...

... ANY LARGE-SCALE HUMAN COOPERATION – WHETHER A MODERN STATE, A MEDIEVAL CHURCH, AN ANCIENT CITY OR AN ARCHAIC TRIBE ...

... IS ROOTED IN COMMON MYTHS THAT EXIST ONLY IN PEOPLE'S COLLECTIVE IMAGINATION.

Yuval Noah Harari

MUCH OF HISTORY REVOLVES AROUND THIS QUESTION ...

HOW DOES ONE CONVINCE MILLIONS OF PEOPLE TO BELIEVE PARTICULAR STORIES ABOUT GODS, OR NATIONS, OR LIMITED LIABILITY COMPANIES?

YET WHEN IT SUCCEEDS, IT GIVES SAPIENS IMMENSE POWER, BECAUSE IT ENABLES MILLIONS OF STRANGERS TO COOPERATE AND WORK TOWARDS COMMON GOALS.

TO THE EXTENT THAT POWER RESTS ON COLLECTIVE IMAGINATION, IT IS ALWAYS VULNERABLE TO ALTERNATIVE WAYS OF IMAGINING.

NO WONDER THE POWERFUL FEEL THREATENED BY POLITICAL CARTOONS -- ONE OF HUMANKIND'S MOST EFFECTIVE SYMBOLIC WEAPONS.

THEN, THERE IS THE INDIVIDUAL WHO MASTERS THE USE OF THAT WEAPON.

THE POWER OF CARTOONS IS ABOUT NOT JUST THE MEDIUM BUT ALSO THE MESSENGER.

IN MOST OF THE CASES STUDIED IN THIS BOOK, THE X-FACTOR IS THE INDIVIDUAL CARTOONIST, WHO DISPLAYS AN UNCOMMON, SOMETIMES IRRATIONAL, WILL TO RESIST POWER AND DEFY CENSORSHIP.

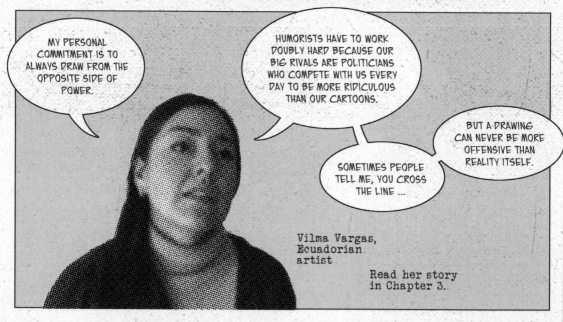

OUR COUNTRY IS NOT A SHOP FOR YOU TO HELP YOURSELF TO WHATEVER YOU WANT.

CARTOONING LIFTS A LOAD OFF ME. IT TRANSFORMS MY ANGER INTO SOMETHING POSITIVE AND CREATIVE.

IF I JUST STAYED SILENT, MY FRUSTRATION COULD HAVE TURNED INTO SOMETHING HORRIBLE AND VIOLENT.

Adjim Danngar ("Achou")

He fled Chad for France after being accosted by paramilitaries.

MY PERSONAL COMMITMENT IS TO ALWAYS DRAW FROM THE OPPOSITE SIDE OF POWER.

HUMORISTS HAVE TO WORK DOUBLY HARD BECAUSE OUR BIG RIVALS ARE POLITICIANS WHO COMPETE WITH US EVERY DAY TO BE MORE RIDICULOUS THAN OUR CARTOONS.

BUT A DRAWING CAN NEVER BE MORE OFFENSIVE THAN REALITY ITSELF.

SOMETIMES PEOPLE TELL ME, YOU CROSS THE LINE ...

Vilma Vargas, Ecuadorian artist

Read her story in Chapter 3.

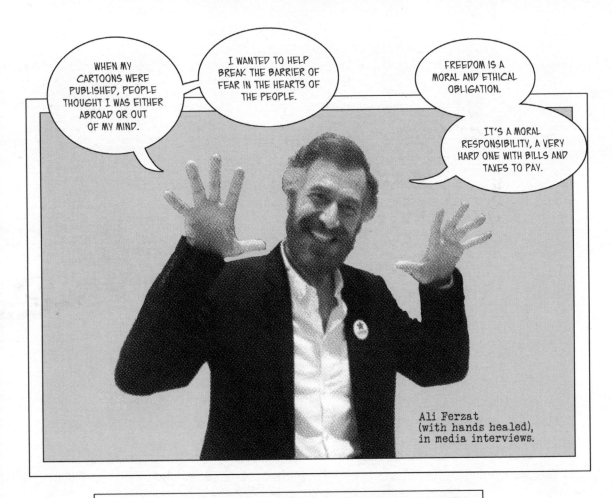

Ali Ferzat
(with hands healed),
in media interviews.

LIKE WHEN AN UNSTOPPABLE FORCE MEETS AN IMMOVABLE OBJECT, ENCOUNTERS BETWEEN THE CARTOONIST AND THE CENSOR HAVE UNPREDICTABLE OUTCOMES.

ALWAYS, THOUGH, THESE CLASHES TELL US SOMETHING ABOUT THE RED LINES BEING SHAPED BY THE FLUID FORCES OF POWER AND IDENTITY, AND WHAT THEY MEAN FOR PEOPLE'S FREEDOM OF EXPRESSION.

# 2. When Censorship Backfires

# SOMETIMES, THE GOOD GUYS WIN
# ZUNAR
## and FRIENDS

**SEPTEMBER 2018**

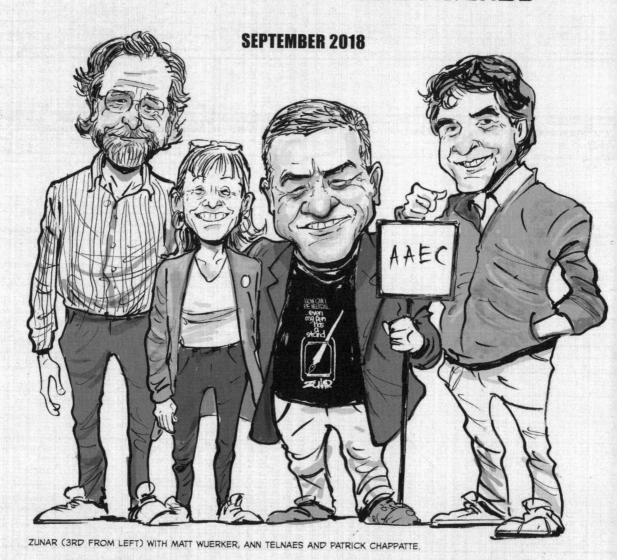

ZUNAR (3RD FROM LEFT) WITH MATT WUERKER, ANN TELNAES AND PATRICK CHAPPATTE.

**Malaysian cartoonist Zunar is enjoying a triumphant reunion with the international cartoonist community.**

# FOR MORE THAN A YEAR...

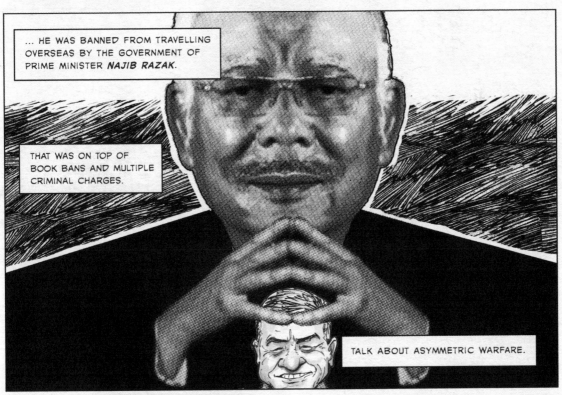

... HE WAS BANNED FROM TRAVELLING OVERSEAS BY THE GOVERNMENT OF PRIME MINISTER *NAJIB RAZAK*.

THAT WAS ON TOP OF BOOK BANS AND MULTIPLE CRIMINAL CHARGES.

TALK ABOUT ASYMMETRIC WARFARE.

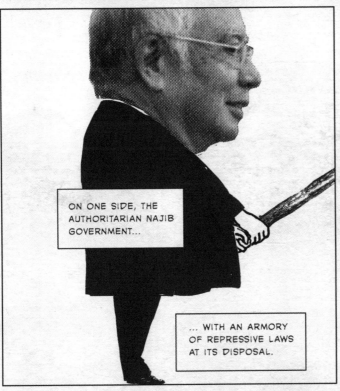

ON ONE SIDE, THE AUTHORITARIAN NAJIB GOVERNMENT...

... WITH AN ARMORY OF REPRESSIVE LAWS AT ITS DISPOSAL.

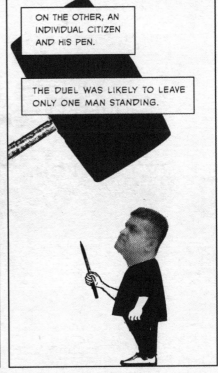

ON THE OTHER, AN INDIVIDUAL CITIZEN AND HIS PEN.

THE DUEL WAS LIKELY TO LEAVE ONLY ONE MAN STANDING.

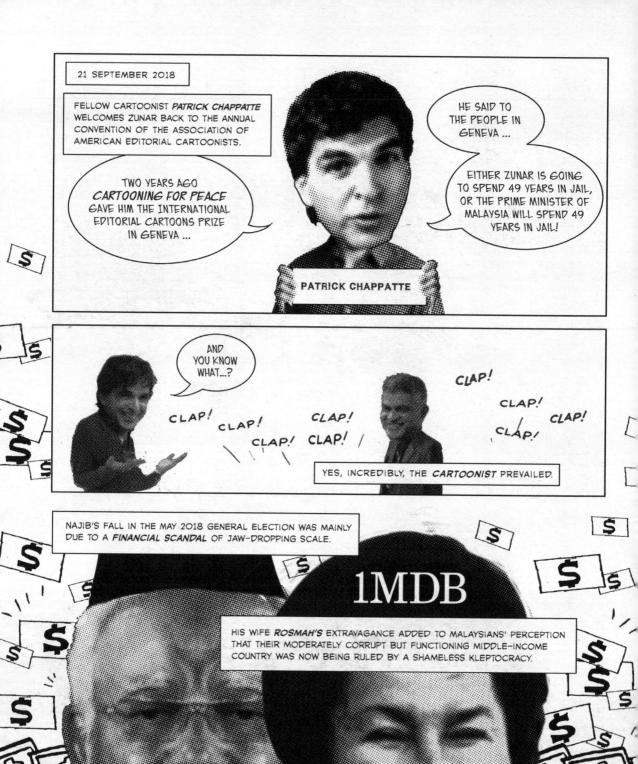

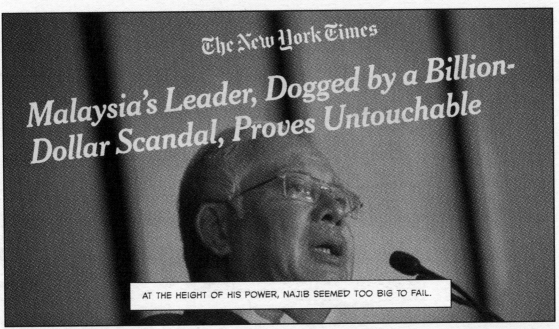

# Malaysia's Leader, Dogged by a Billion-Dollar Scandal, Proves Untouchable

AT THE HEIGHT OF HIS POWER, NAJIB SEEMED TOO BIG TO FAIL.

HE HAD A MOUNTAIN OF CASH.

AND IN POLITICS, THERE AREN'T MANY PROBLEMS THAT MONEY CAN'T SOLVE.

EVERYONE HAS A PRICE.

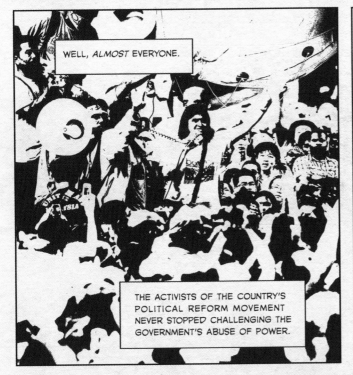

WELL, *ALMOST* EVERYONE.

THE ACTIVISTS OF THE COUNTRY'S POLITICAL REFORM MOVEMENT NEVER STOPPED CHALLENGING THE GOVERNMENT'S ABUSE OF POWER.

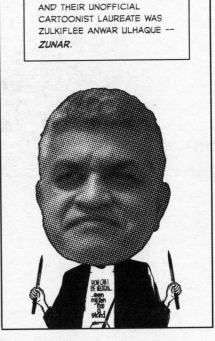

AND THEIR UNOFFICIAL CARTOONIST LAUREATE WAS ZULKIFLEE ANWAR ULHAQUE -- *ZUNAR.*

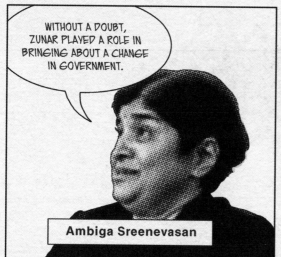

WITHOUT A DOUBT, ZUNAR PLAYED A ROLE IN BRINGING ABOUT A CHANGE IN GOVERNMENT.

Ambiga Sreenevasan

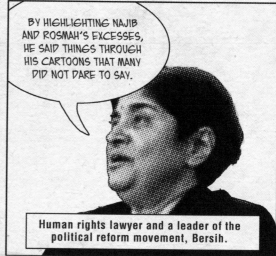

BY HIGHLIGHTING NAJIB AND ROSMAH'S EXCESSES, HE SAID THINGS THROUGH HIS CARTOONS THAT MANY DID NOT DARE TO SAY.

Human rights lawyer and a leader of the political reform movement, Bersih.

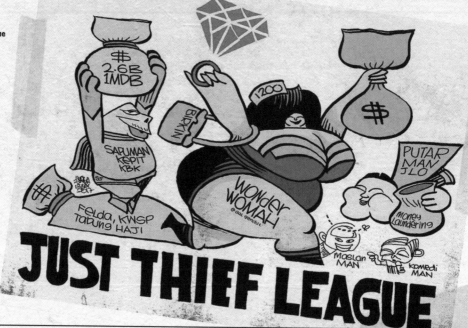

*Right*
**Just Thief League**
Nov 13, 2017
Zunar

CIRCULATED VIA SOCIAL MEDIA, INDEPENDENT NEWS OUTLETS, AND OPPOSITION SITES, ZUNAR'S MERCILESS DIGS AT NAJIB, ROSMAH, AND OTHER ELITES RECALLED A RICH LOCAL TRADITION OF UNDERGROUND HUMOR DIRECTED AGAINST THE POWERFUL.

JOKES WERE AMONG THE *"WEAPONS OF THE WEAK"* THAT JAMES SCOTT OBSERVED IN HIS ETHNOGRAPHIC STUDY OF MALAY VILLAGES.

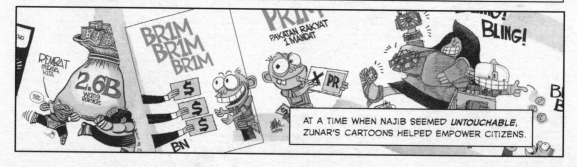

AT A TIME WHEN NAJIB SEEMED *UNTOUCHABLE*, ZUNAR'S CARTOONS HELPED EMPOWER CITIZENS.

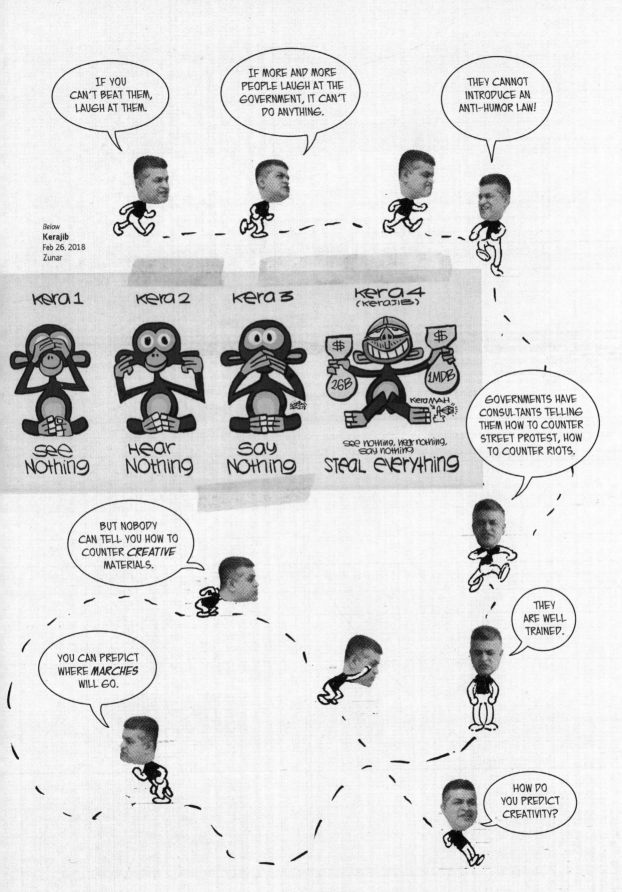

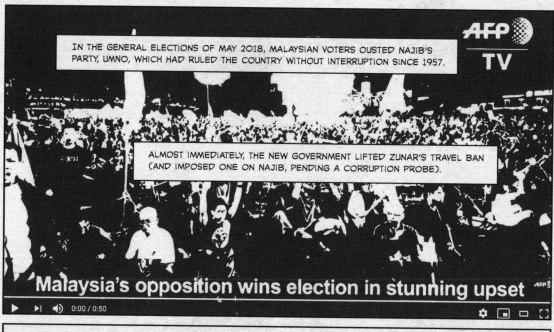

IN THE GENERAL ELECTIONS OF MAY 2018, MALAYSIAN VOTERS OUSTED NAJIB'S PARTY, UMNO, WHICH HAD RULED THE COUNTRY WITHOUT INTERRUPTION SINCE 1957.

ALMOST IMMEDIATELY, THE NEW GOVERNMENT LIFTED ZUNAR'S TRAVEL BAN (AND IMPOSED ONE ON NAJIB, PENDING A CORRUPTION PROBE).

**Malaysia's opposition wins election in stunning upset**

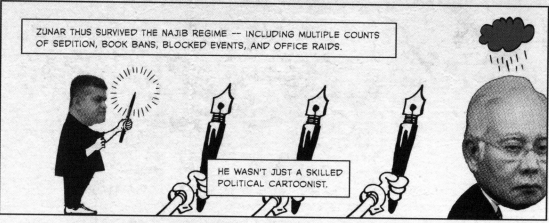

ZUNAR THUS SURVIVED THE NAJIB REGIME -- INCLUDING MULTIPLE COUNTS OF SEDITION, BOOK BANS, BLOCKED EVENTS, AND OFFICE RAIDS.

HE WASN'T JUST A SKILLED POLITICAL CARTOONIST.

HE WAS ALSO A MASTER OF THE ART OF *TURNING THE TABLES* ON HIS MORE POWERFUL TORMENTORS.

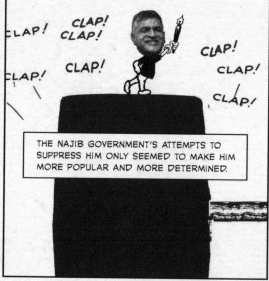

THE NAJIB GOVERNMENT'S ATTEMPTS TO SUPPRESS HIM ONLY SEEMED TO MAKE HIM MORE POPULAR AND MORE DETERMINED.

# CENSORSHIP BACKFIRES

IN 2003, SINGER BARBRA STREISAND TRIED TO SUE A PHOTOGRAPHER WHO HAD PUBLISHED THOUSANDS OF HIS AERIAL PHOTOS OF THE CALIFORNIA COAST, INCLUDING SOME SHOWING HER SEASIDE MANSION.

NOT ONLY DID SHE LOSE THE LAWSUIT, BUT THE PUBLICITY ATTRACTED MILLIONS MORE VIEWERS TO THE IMAGES. WHEN PEOPLE REALIZE SOMEONE'S TRYING TO HIDE SOMETHING, THEY ARE USUALLY MORE MOTIVATED TO FIND OUT WHAT IT IS.

THIS HAS BEEN DUBBED THE *STREISAND EFFECT*.

Don't look at my house.

Barbra Streisand

THE STREISAND EFFECT ISN'T THE ONLY WAY CENSORSHIP BACKFIRES. THE VERY ACT OF CENSORSHIP ALSO TENDS TO OPEN THE CENSOR TO CONTEMPT. WHICH IS IRONIC, BECAUSE WHEN OFFICIALS TRY TO CENSOR CARTOONS, IT'S USUALLY TO AVOID BEING MADE TO LOOK SILLY. "NOT ONLY IS IT HARD TO JUSTIFY VIOLENCE, ALMOST ALL KINDS OF REACTIONS, VIOLENT OR NOT, *MAKE THE OPPRESSOR LOOK RIDICULOUS*, "NOTES MAJKEN JUL SORENSEN, A SCHOLAR OF NONVIOLENT PROTEST AND HUMOR.

THE STATE HAS OVERWHELMING SUPERIORITY IN THE MEANS OF VIOLENCE, SO OPPONENTS CAN'T BEAT IT BY FORCE. BUT THAT VERY ASYMMETRY OF PHYSICAL POWER IS A POTENTIAL VULNERABILITY -- IF THE AUTHORITIES OVERUSE COERCION, IT CAN *PROVOKE OUTRAGE* AND LOWER THEIR MORAL STANDING. INDIAN INDEPENDENCE LEADER *MOHANDAS K. GANDHI*, THE GURU OF NONVIOLENCE AS A METHOD OF POLITICAL CONTENTION, UNDERSTOOD THIS WELL.

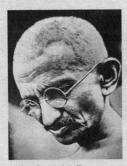 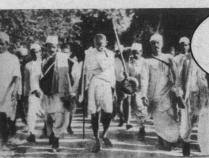

I INVITED EVEN WOMEN AND *CHILDREN*, IF THEY HAD THE COURAGE TO TAKE PART IN THE BATTLE.

IF THE POLICE LAID THEIR HANDS UPON WOMEN AND CHILDREN, I SAID THAT THE WHOLE OF INDIA WOULD BECOME INFLAMED.

Mohandas K. Gandhi

Gandhi leading the Salt March

Gandhi, to the press later

THE TACTIC OF TURNING A PHYSICAL BEATING INTO A PUBLIC RELATIONS VICTORY BECAME PART OF THE STANDARD PLAYBOOK OF SOCIAL MOVEMENTS. PIONEERING NONVIOLENCE RESEARCHER GENE SHARP CALLED IT *"POLITICAL JIU JITSU"*. LIKE THE JAPANESE MARTIAL ART, IT'S ABOUT TURNING A BIGGER OPPONENT'S FORCE AND MOMENTUM AGAINST HIM.

IT'S SUCH AN EFFECTIVE TACTIC THAT THERE IS EVEN A WHOLE HOW-TO GUIDE DEVOTED TO THE ART, BY SOCIAL SCIENTIST BRIAN MARTIN.

**Backfire Manual**
Tactics Against Injustice
Brian Martin

IRENE PUBLISHING

THE IDEA HERE IS TO TURN THE SPOTLIGHT ON THE ATTACKERS, SHOWING THEIR ULTERIOR MOTIVES, LIES, CONFLICTS OF INTEREST, CORRUPT BEHAVIOUR AND OTHER SHORTCOMINGS.

THE LOGIC OF NONVIOLENT STREET PROTEST APPLIES TO THE PRINTED PAGE AND THE ELECTRONIC SCREEN AS WELL.

IN AUTHORITARIAN SOCIETIES, DISSENTING WORDS AND IMAGES ARE A FORM OF NONVIOLENT CIVIL DISOBEDIENCE. EVEN IF THE STATE SUCCEEDS IN ITS ACT OF CENSORSHIP, IT CAN LOSE THE PUBLIC RELATIONS BATTLE.

"SOME OBSERVERS ARE *REPULSED* BY THE VERY FACT OF CENSORSHIP," SAY MARTIN AND CENSORSHIP RESEARCHER SUE CURRY JANSEN. "OTHERS ARE *INCENSED* BY THE INJUSTICE INVOLVED. STILL OTHERS RESPOND TO THE DISPROPORTION BETWEEN THE ACTS: SPEAKING, WRITING, PUBLISHING, OR CREATING WORKS OF ART -- AND THE HEAVYHANDED RESPONSES OF THOSE WHO WOULD SUPPRESS THESE ACTS."

*HUMOR* IS PARTICULARLY CONDUCIVE TO GENERATING BACKFIRE FROM CENSORSHIP.

HA! HA! HA! HA! HA! HA! HA! HA! HA! HA! HA! HA! HA! HA! HA! HA! HA! HA! HA! HA! HA!

THROUGHOUT HISTORY, WEAKER GROUPS HAVE ENGAGED IN *CARNIVAL-LIKE FORMS OF PROTEST* AGAINST OPPRESSORS WHO IN CONTRAST APPEAR "RIDICULOUS IN THEIR SERIOUSNESS," NOTES COMMUNICATION SCHOLAR M. LANE BRUNER. THE TARGETS CAN CRUSH THEIR TEASERS -- BUT IT IS HARD TO JUSTIFY RESPONDING TO TEASING WITH VIOLENCE.

HA! HA! HA!

THERE ARE, OF COURSE, *AUTOCRATS* WHO DON'T FEEL CONSTRAINED BY THE NEED TO JUSTIFY THEIR ACTIONS. "CARNIVALESQUE PROTEST IS SIMPLY NOT POSSIBLE IF THE STATE IS SO OPPRESSIVELY HUMORLESS THAT IT UTTERLY ELIMINATES *ALL* PUBLIC OPPOSITION," SAYS BRUNER.

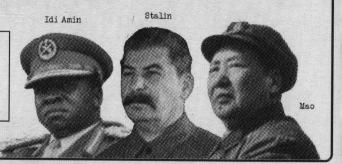

Idi Amin

Stalin

Mao

IN MOST COUNTRIES, THOUGH, AUTHORITARIAN LEADERS ARE SOMEWHAT
SENSITIVE TO PUBLIC OPINION. SO WHEN THEY ENGAGE IN REPRESSION, THEY
TRY TO MINIMIZE BLOWBACK -- EVEN AS ACTIVISTS TRY TO MAXIMIZE IT.

THE RESULT IS A *BATTLE OF WITS:*

# Government tactics

# Protestor tactics

### COVER UP

### EXPOSURE

Hide the fact of censorship, including
by intimidating the victims into
silence.

Resist attempts to silence
victims and reveal the fact
of censorship.

Explain it away as a voluntary
decision by publishers.

Show that government
coercion, not free will, was
behind it.

### DEVALUE THE TARGET

### VALIDATE THE TARGET

Say that what or who was censored
is unimportant, or even dangerous.

Show that what or who was
censored is worthy of public
support.

### USE ORDER NARRATIVE

### USE JUSTICE NARRATIVE

Frame censorship as necessary for
security, stability and harmony.

Frame censorship as an
assault on justice, fairness,
and freedom.

MOST ACTIVIST-CARTOONISTS HAVE PROBABLY NOT
STUDIED SOCIAL SCIENTISTS' PROTEST THEORIES ...

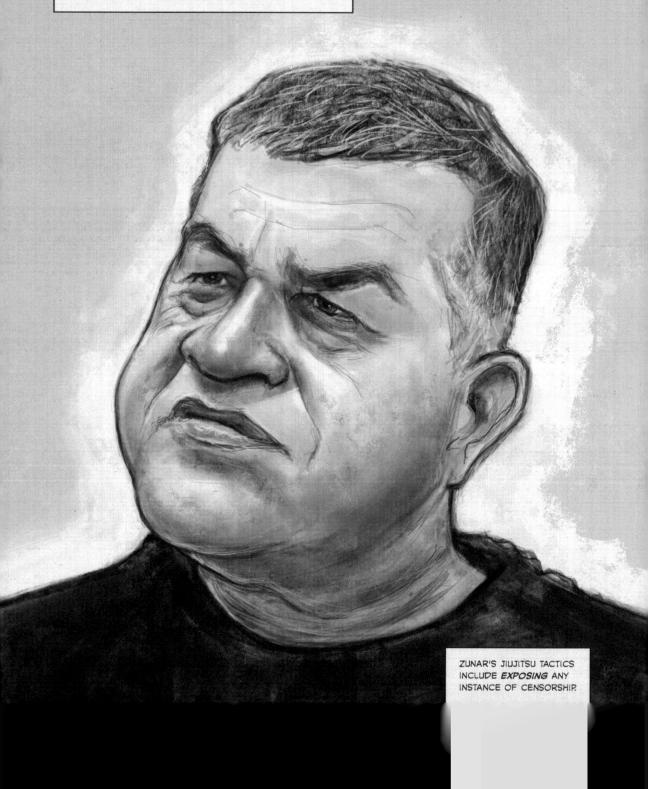

...RATHER, IT'S THE SCHOLARS WHO LEARN ABOUT PROTEST DYNAMICS BY DECONSTRUCTING THE INTUITIVE, STREETWISE METHODS OF THE LIKES OF MALAYSIA'S ZUNAR.

ZUNAR'S JIUJITSU TACTICS INCLUDE *EXPOSING* ANY INSTANCE OF CENSORSHIP.

THE COVER PHOTO OF HIS FACEBOOK PAGE IS A
CARTOON IDENTIFYING THE MANY LAWS AND
REGULATIONS THAT HAD BEEN USED AGAINST HIM.

*Leftt*
**Zunar Story**
Nov 30, 2017
Zunar

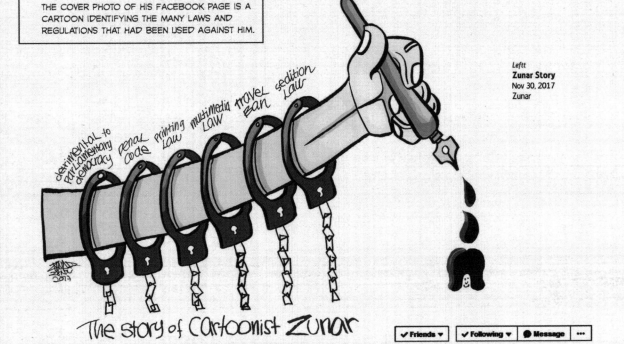

WHEN POLICE CONFISCATED HIS BOOKS,
HE WOULDN'T KEEP QUIET ABOUT IT.

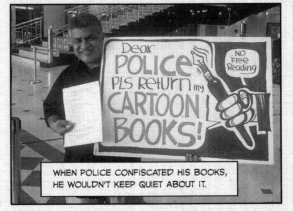

AFTER THE GOVERNMENT BEGAN HARASSING
THE PRINTERS OF HIS BOOKS, HE CONCEALED
THEIR IDENTITY -- AND MADE A SHOW OF IT,
BY BLACKING IT OUT AND ADDING A "SCRATCH
AND WIN" CAPTION.

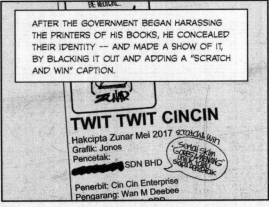

AS WITH ANY POLITICAL CONTEST, HE AND HIS SUPPORTERS
USE SOME *EXAGGERATION* TO GENERATE MORAL OUTRAGE.

# VICE News

# A Malaysian Cartoonist Told Us Why He's Risking 43 Years in Prison for Tweeting

IT WAS HIGHLY UNLIKELY THAT ZUNAR WOULD HAVE GONE TO JAIL FOR 40-PLUS YEARS. IT WAS *TECHNICALLY* POSSIBLE, IF HE WAS HANDED THE MAXIMUM SENTENCE ON EVERY COUNT OF THE CHARGES ...

BUT THERE WAS NO PRECEDENT FOR MALAYSIAN DISSIDENTS BEING LOCKED UP FOR THAT LONG.

## INDEPENDENT

# Zunar: Cartoonist arrives in Britain as he faces 43 years in Malaysian prison for 'sedition'

WHEN ACTIVISTS ARE CONVICTED, JAIL SENTENCES TEND TO BE MEASURED IN MONTHS, NOT YEARS.

BUT HIGHLIGHTING THE WORST-CASE SCENARIO HELPED TO KEEP ZUNAR ON THE WORLD'S RADAR AS A VICTIM OF INJUSTICE.

BY SPOTLIGHTING GOVERNMENT REPRESSION, ZUNAR WAS NOT TRYING TO PROVOKE PARALYZING FEAR. ON THE CONTRARY, HIS CARTOONS EMPHASIZED THAT *RESISTANCE IS POSSIBLE*.

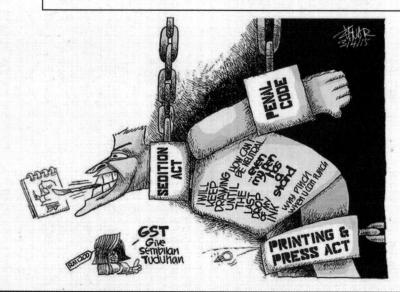

*Left*
**Cartoon Resist**
April 3, 2015
Zunar

THE HANDCUFFED HAND CAN STILL CARICATURE ROSMAH AND HER BIG HAIR.

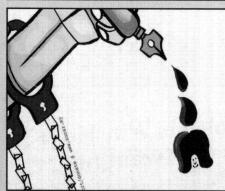

*Left*
Detail from **Zunar Story**

WHEN THE CHIEF OF MALAYSIA'S POLICE FORCE USED *TWITTER* TO ORDER ZUNAR'S ARREST, THE CARTOONIST GAVE THE TOP COP A CAMEO ROLE IN EVERY CARTOON UNTIL THE OFFICER RETIRED. .

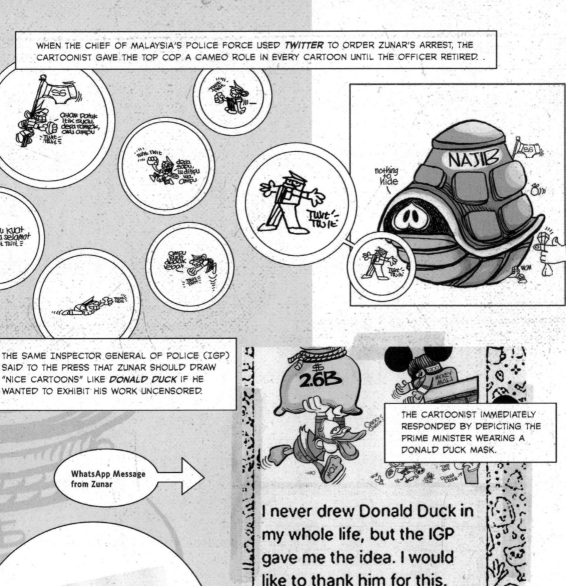

THE SAME INSPECTOR GENERAL OF POLICE (IGP) SAID TO THE PRESS THAT ZUNAR SHOULD DRAW "NICE CARTOONS" LIKE *DONALD DUCK* IF HE WANTED TO EXHIBIT HIS WORK UNCENSORED.

THE CARTOONIST IMMEDIATELY RESPONDED BY DEPICTING THE PRIME MINISTER WEARING A DONALD DUCK MASK.

WhatsApp Message from Zunar

I never drew Donald Duck in my whole life, but the IGP gave me the idea. I would like to thank him for this.

6:18 PM

EVEN THE *PRICE* OF HIS BANNED BOOKS CARRIED A PROTEST MESSAGE -- 26 MALAYSIAN RINGGIT, ECHOING THE 2.6 BILLION THAT NAJIB WAS ALLEGED TO HAVE TAKEN.

ZUNAR'S METHODS WOULD HAVE BEEN FUTILE WITHOUT THE *MORAL SUPPORT* OF MEDIA AND HUMAN RIGHTS DEFENDERS IN MALAYSIA AND AROUND THE WORLD.

WHILE THE GOVERNMENT TRIED TO PORTRAY HIM AS IRRESPONSIBLE AND DANGEROUS, HIS GLOBAL NETWORK PROVIDED *VALIDATION* ...

# HONORS

**COURAGE IN EDITORIAL CARTOONING AWARD 2011**
Cartoonists Rights Network International

**HELLMAN/HAMMETT AWARD 2011, 2015**
Human Rights Watch

**INTERNATIONAL PRESS FREEDOM AWARD 2015**
Committee to Protect Journalists

**INTERNATIONAL EDITORIAL CARTOONS PRIZE 2016**
Cartooning For Peace and the City of Geneva

EVEN WHEN HE WAS BANNED FROM TRAVELLING, ALLIES LIKE PATRICK CHAPPATTE HELPED MAINTAIN HIS GLOBAL VISIBILITY, SHOWING HIS WORK AT HIGH PROFILE VENUES LIKE THE WORLD ECONOMIC FORUM IN DAVOS, SWITZERLAND.

ZUNAR HAS BEEN RELENTLESS IN DENOUNCING THE CORRUPTION OF THE GOVERNMENT AND HE HAS BEEN HARASSED FOR YEARS.

HIS TRIAL IS NEXT WEEK IN MALAYSIA.

DOMESTICALLY, INDEPENDENT MEDIA OUTLET *MALAYSIAKINI* CONTINUED TO COVER HIM AND USE HIS WORK.

MALAYSIAN HUMAN RIGHTS LAWYERS TOOK UP THE CAUSE PRO BONO, ADOPTING HIS VARIOUS LEGAL BATTLES TO, FOR EXAMPLE, MOUNT A CONSTITUTIONAL CHALLENGE AGAINST THE SEDITION ACT.

# malaysiakini
## news and views that matter

WE CERTAINLY TOOK UP HIS CASE TO SAVE HIM ...

... OUT OF RESPECT FOR HIS *COURAGE* IN DARING TO TAKE ON NAJIB WHEN SO MANY PEOPLE WERE TOEING THE LINE.

IT WAS ALSO AN OPPORTUNITY TO DRAW ATTENTION TO THE LENGTHS THAT NAJIB AND HIS GOVERNMENT WERE WILLING TO GO TO TO SILENCE CRITICS AND TO KEEP THEIR WRONGDOINGS AWAY FROM PUBLIC SCRUTINY.

### Zunar Launches Legal Challenge to Malaysia's Sedition Act

Ambiga Sreenevasan

TO STRIKE BACK AGAINST CENSORSHIP, ZUNAR DOESN'T LIMIT HIMSELF TO THE CARTOON MEDIUM. HE IS LIKE A *PERFORMANCE ARTIST*, USING PUBLIC SPACE AND HIS OWN BODY TO RIDICULE THE AUTHORITIES.

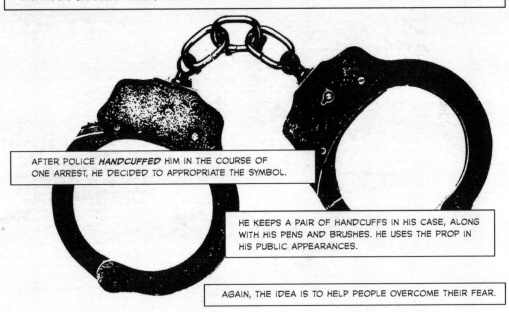

AFTER POLICE *HANDCUFFED* HIM IN THE COURSE OF ONE ARREST, HE DECIDED TO APPROPRIATE THE SYMBOL.

HE KEEPS A PAIR OF HANDCUFFS IN HIS CASE, ALONG WITH HIS PENS AND BRUSHES. HE USES THE PROP IN HIS PUBLIC APPEARANCES.

AGAIN, THE IDEA IS TO HELP PEOPLE OVERCOME THEIR FEAR.

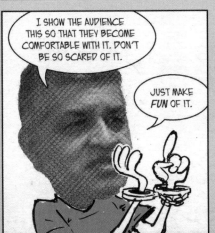

I SHOW THE AUDIENCE THIS SO THAT THEY BECOME COMFORTABLE WITH IT. DON'T BE SO SCARED OF IT.

JUST MAKE *FUN* OF IT.

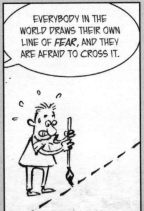

EVERYBODY IN THE WORLD DRAWS THEIR OWN LINE OF *FEAR*, AND THEY ARE AFRAID TO CROSS IT.

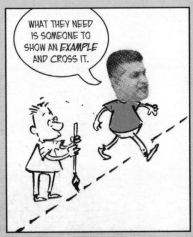

WHAT THEY NEED IS SOMEONE TO SHOW AN *EXAMPLE* AND CROSS IT.

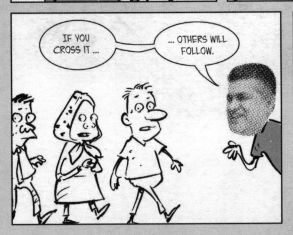

IF YOU CROSS IT ...

... OTHERS WILL FOLLOW.

I TRY TO GIVE MOTIVATION, THROUGH MY EXAMPLE.

THE PROP ALSO CATERS TO *MEDIA LOGIC* -- NEWS PHOTOGRAPHERS LOVE IT. HE IS EVEN READY TO WEAR PRISON ATTIRE FOR THE CAMERAS.

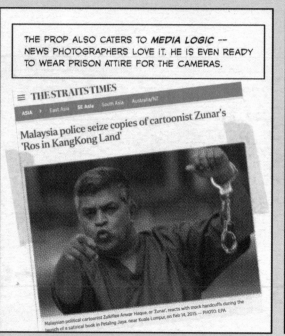

ZUNAR THUS BECAME BOTH A SYMBOL OF INJUSTICE AND AN ICON OF RESISTANCE.

HIS STORY IS A MASTERCLASS ON HOW TO MAKE CENSORSHIP BACKFIRE.

YET IT WOULD BE WRONG TO SUGGEST THAT ZUNAR SUCCEEDED WHERE OTHER CARTOONISTS FAILED ONLY BECAUSE HE WAS MORE CREATIVE, COMMITTED, OR COURAGEOUS.

ACTIVISTS' SUCCESS DOESN'T DEPEND ON THEIR OWN ABILITIES ALONE.

THERE ARE ALSO EXTERNAL FACTORS BEYOND THEIR CONTROL, WIDENING OR NARROWING THEIR POLITICAL OPPORTUNITIES.

ZUNAR SUCCEEDED PARTLY BECAUSE HE WAS PART OF A MUCH WIDER AND WELL ORGANIZED POLITICAL REFORM MOVEMENT -- SOMETHING THAT CARTOONISTS IN MORE CLOSED SOCIETIES LACK.

FURTHERMORE, THE UMNO REGIME WAS *SOFT* AUTHORITARIAN.

NAJIB AT HIS MOST REPRESSSIVE WAS A FAR CRY FROM STATES THAT PRACTICE EXTREME AND ARBITRARY VIOLENCE.

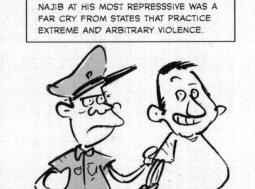

ZUNAR'S PROVOCATIVE TACTICS, CONSTANTLY BAITING THE STATE, MIGHT HAVE HAD AN UGLIER OUTCOME IN IRAN OR CHINA.

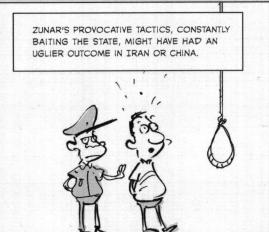

YES, IN A DIFFERENT WORLD, WE HAVE TO FIGHT DIFFERENTLY.

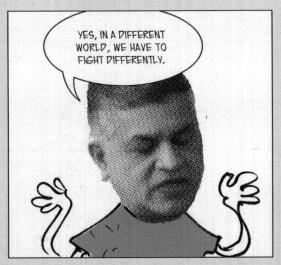

I MAY NOT BE DOING THIS IF I WAS LIVING IN CUBA ...

AS A RESULT OF IN-FIGHTING,
THE NEW MALAYSIAN GOVERNMENT
COLLAPSED SPECTACULARLY IN 2020 ...

... ALLOWING NAJIB'S SIDE TO
CREEP BACK IN FROM THE COLD.

SOMETIMES ...

... THE GOOD GUYS HAVE TO KEEP FIGHTING.

54

# 3.We Know Where You Live

## Intimate Invasions

_____

_____

_____

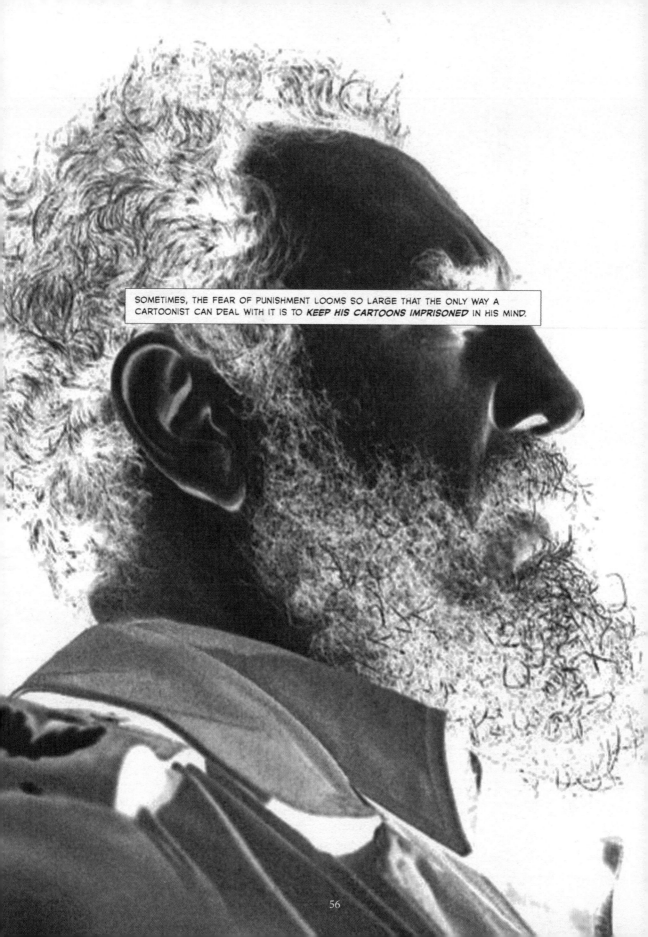

SOMETIMES, THE FEAR OF PUNISHMENT LOOMS SO LARGE THAT THE ONLY WAY A CARTOONIST CAN DEAL WITH IT IS TO *KEEP HIS CARTOONS IMPRISONED* IN HIS MIND.

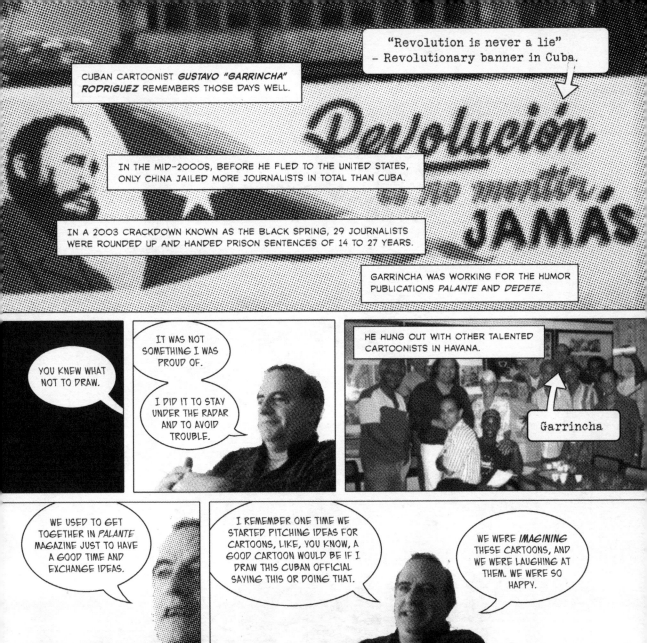

"Revolution is never a lie"
– Revolutionary banner in Cuba.

CUBAN CARTOONIST *GUSTAVO "GARRINCHA" RODRIGUEZ* REMEMBERS THOSE DAYS WELL.

IN THE MID-2000S, BEFORE HE FLED TO THE UNITED STATES, ONLY CHINA JAILED MORE JOURNALISTS IN TOTAL THAN CUBA.

IN A 2003 CRACKDOWN KNOWN AS THE BLACK SPRING, 29 JOURNALISTS WERE ROUNDED UP AND HANDED PRISON SENTENCES OF 14 TO 27 YEARS.

GARRINCHA WAS WORKING FOR THE HUMOR PUBLICATIONS *PALANTE* AND *DEDETE*.

*Revolución hasta JAMÁS*

YOU KNEW WHAT NOT TO DRAW.

IT WAS NOT SOMETHING I WAS PROUD OF.

I DID IT TO STAY UNDER THE RADAR AND TO AVOID TROUBLE.

HE HUNG OUT WITH OTHER TALENTED CARTOONISTS IN HAVANA.

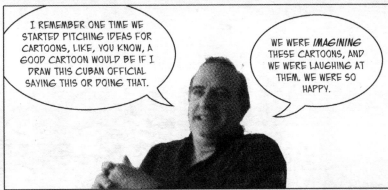

Garrincha

WE USED TO GET TOGETHER IN *PALANTE* MAGAZINE JUST TO HAVE A GOOD TIME AND EXCHANGE IDEAS.

I REMEMBER ONE TIME WE STARTED PITCHING IDEAS FOR CARTOONS, LIKE, YOU KNOW, A GOOD CARTOON WOULD BE IF I DRAW THIS CUBAN OFFICIAL SAYING THIS OR DOING THAT.

WE WERE *IMAGINING* THESE CARTOONS, AND WE WERE LAUGHING AT THEM. WE WERE SO HAPPY.

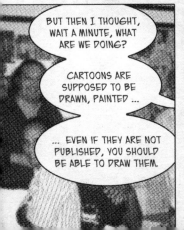

BUT THEN I THOUGHT, WAIT A MINUTE, WHAT ARE WE DOING?

CARTOONS ARE SUPPOSED TO BE DRAWN, PAINTED ...

... EVEN IF THEY ARE NOT PUBLISHED, YOU SHOULD BE ABLE TO DRAW THEM.

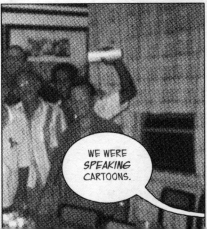

WE WERE *SPEAKING* CARTOONS.

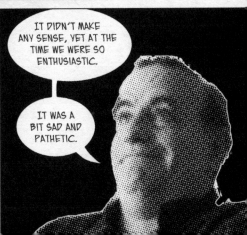

IT DIDN'T MAKE ANY SENSE, YET AT THE TIME WE WERE SO ENTHUSIASTIC.

IT WAS A BIT SAD AND PATHETIC.

IT IS A DILEMMA THAT MANY CARTOONISTS IN UNFREE SOCIETIES KNOW TOO WELL.

EITHER YOU *SUCCUMB TO FEAR*, AND KNOW THAT YOU ARE PAYING FOR YOUR SAFETY WITH A LITTLE BIT OF YOUR SOUL.

OR YOU *TAKE THE RISK*, TEST THE LIMITS, GAIN A BRIEF SENSE OF AUTONOMY, BUT LOSE PEACE OF MIND (AT THE VERY LEAST).

THUS, CLOSED SOCIETIES MAKE THE POLITICAL CARTOONIST CHOOSE BETWEEN DESPAIR AND DREAD.

THESE DECISIONS TAKE PLACE AWAY FROM THE PUBLIC EYE.

ARRESTS AND ASSASSINATIONS MAKE THE NEWS, BUT CENSORSHIP IS ALSO ABOUT MIND-GAMES PLAYED OUT IN PRIVATE.

IT IS ABOUT FEAR -- THE *ANTICIPATION* OF A HARM. IT CAN HAVE A POWERFUL EFFECT EVEN IF THAT FEAR DOES NOT MATERIALIZE. SOMETIMES IT DOES, SOMETIMES IT DOESN'T.

IN UNFREE SOCIETIES, *REPRESSIVE LAWS* ARE BROAD AND VAGUE.

THEY ARE NOT APPLIED CONSISTENTLY.

THEY ARE USED AGAINST SOME OF THE PEOPLE SOME OF THE TIME.

LEGAL ACTIONS ARE THUS *UNPREDICTABLE*.

THE PEOPLE IN POWER ALSO HAVE *EXTRALEGAL WEAPONS* AT THEIR DISPOSAL, INCLUDING HIRED GOONS AND PARAMILITARIES WHO ARE NOT BOUND BY COURT VERDICTS AND ARE OFTEN ABOVE THE LAW.

FURTHERMORE, THERE IS ALMOST NEVER A SIMPLE CAUSE-AND-EFFECT CONNECTION BETWEEN THE CARTOON AND THE PUNISHMENT.

THE REGIME'S REACTION CAN DEPEND ON VARIOUS FACTORS THAT HAVE NOTHING TO DO WITH THE CARTOON.

CONFLICT AND COMPETITION AMONG GOVERNING ELITES AFFECT THE CALCULUS OF REPRESSION.

SO DO UPS AND DOWNS IN THE AUTHORITIES' LEVEL OF CONFIDENCE.

TO SCARE THE PUBLIC, THEY MAY DECIDE TO MAKE AN EXAMPLE OF A CARTOONIST.

LEADERS MAY ATTACK A CARTOON JUST TO GAIN ATTENTION.

THEY MAY WANT TO PLAY THE VICTIM TO GET THEIR SUPPORTERS RILED UP.

OR THEY MAY JUST NEED A CONTROVERSY TO DISTRACT FROM THE COUNTRY'S REAL PROBLEMS.

THESE CHANGES ARE OFTEN DIFFICULT TO DETECT UNTIL IT'S TOO LATE.

THIS EXPLAINS WHY EVEN EXPERIENCED CARTOONISTS *CAN'T PREDICT* WHETHER AND WHEN RETALIATION MAY COME.

Lessons Drawn:

A Safety Manual
for
Political Cartoonists
in Trouble

THIS MANUAL WAS MADE POSSIBLE BY A GENEROUS
GRANT FROM THE DOEN FOUNDATION, THE NETHERLANDS

CARTOONISTS RIGHTS
NETWORK INTERNATIONAL

"During our 20-plus years of experience working with cartoonists in trouble, we have found one outstanding feature common to many of the incidents of threats, legal charges, digital attacks and illegal attempts at censorship: the cartoonist is usually completely **taken by surprise**.

"Every cartoonist understands the meaning of **crossing the red line**. It turns out, however, that in most cases of attacks against cartoonists, the cartoonist didn't even realize he or she was anywhere near that red line."

*Left*
**Safety Manual for Cartoonists**

IT OFTEN STARTS SUBTLE, WITH A FRIENDLY CONVERSATION.

SOMEONE YOU KNOW COMES UP TO YOU AND SAYS, YOU KNOW, THE BIG MAN DOESN'T LIKE YOUR CARTOON.

MAYBE YOU SHOULD TONE THINGS DOWN A BIT.

IF YOU DON'T THEN SOMEONE WILL INVITE YOU TO COFFEE.

THIS IS SOMETHING A BIT MORE OFFICIAL.

AFTER THAT ...

... YOU COULD BE TAKEN IN FOR QUESTIONING, OR THERE ARE CHARGES LEVELLED AGAINST YOU.

Robert "Bro" Russell,
Founder, Cartoonists
Rights Network
International

OFTEN, THOUGH, IT IS NOT IN OPEN COURT THAT POWER IS EXERCISED AGAINST YOU.

IT'S *IN THE SHADOWS*.

NO FORMAL CHARGES.

NO DEFENSE LAWYERS. NO PRESS.

SOMETIMES, YOU'RE NOT EVEN SURE WHAT TO MAKE OF IT.

ARE THEY REALLY AFTER YOU? OR ARE YOU BEING PARANOID?

TARGETED CARTOONISTS TEND TO WEAR A BRAVE FACE.

THEY WON'T VOLUNTEER DETAILS ABOUT THE SLEEPLESS NIGHTS, THE STRAINED RELATIONSHIPS, THE POST-TRAUMATIC STRESS.

YOU HAVE TO *ASK*.

# THE BREAK-IN

Location: Ecuador    Year: 2015    Cartoonist: Vilma Vargas

Chambo, Ecuador.

PAINTER AND CARTOONIST *VILMA VARGAS* LIVED IN THE MOUNTAINS OUTSIDE CHAMBO IN THE SCENIC PROVINCE OF CHIMBORAZO.

IT WAS A SEDATE, SAFE AREA.

BUT, WHEN VARGAS RETURNED HOME AFTER A WEEKEND AWAY, SHE FOUND HER HOUSE HAD BEEN BROKEN INTO. HER BELONGINGS WERE IN DISARRAY.

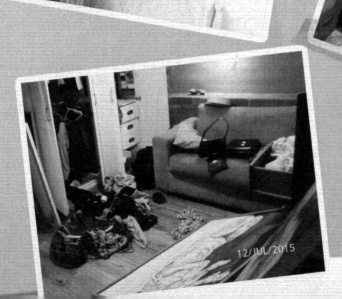

12/JUL/2015

12/JUL/2015

NOTHING WAS STOLEN, BUT HER PAINTINGS WERE DAMAGED.

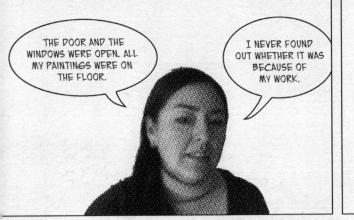

"THE DOOR AND THE WINDOWS WERE OPEN. ALL MY PAINTINGS WERE ON THE FLOOR."

"I NEVER FOUND OUT WHETHER IT WAS BECAUSE OF MY WORK."

"THEY DIDN'T LEAVE A NOTE, NOTHING."

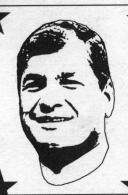

ECUADOR WAS THEN RULED BY PRESIDENT RAFAEL CORREA, WHO GREW INCREASINGLY CONTEMPTUOUS OF PRESS FREEDOM AND INTOLERANT OF DISSENT.

HIS GOVERNMENT KEPT A LID ON MEDIA FREEDOM MAINLY THROUGH *INSTITUTIONAL VIOLENCE.*

IT WAS A STYLE OF VIOLENCE THAT COULD GET *PETTY AND PERSONAL.*

TEN WEEKS BEFORE VARGAS'S HOUSE WAS BROKEN INTO, PRESIDENT CORREA, BEING DRIVEN THROUGH DOWNTOWN QUITO, SPOTTED A BOY DIRECTING A RUDE GESTURE AT HIM.

*Left*
Luis Carrera demonstrating the "yuca" gesture he showed to the president.

THE PRESIDENT ORDERED HIS MOTORCADE TO STOP.

HE BURST OUT OF HIS CAR.

ACCOMPANIED BY HIS BODYGUARDS, HE ACCOSTED THE TEENAGER AND HIS MOTHER.

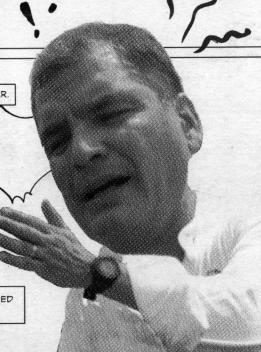

CORREA JABBED HIM REPEATEDLY IN THE CHEST AND BERATED HIM FOR SHOWING DISRESPECT, THE BOY TOLD REPORTERS LATER.

(THE PRESIDENT'S SPOKESMAN DENIED THAT HE TOUCHED THE BOY.)

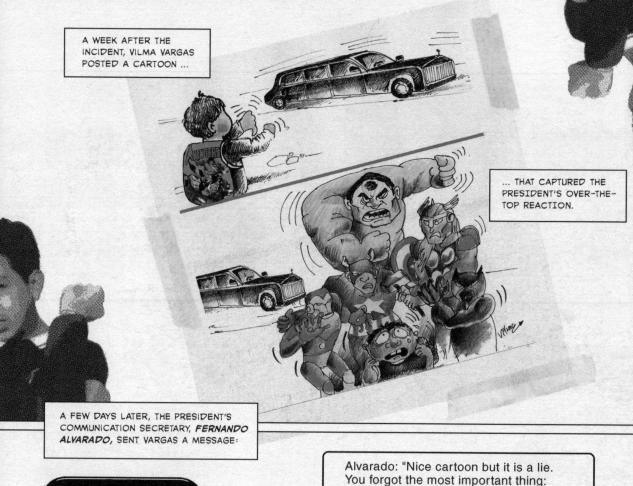

... THAT CAPTURED THE PRESIDENT'S OVER-THE-TOP REACTION.

A FEW DAYS LATER, THE PRESIDENT'S COMMUNICATION SECRETARY, **FERNANDO ALVARADO,** SENT VARGAS A MESSAGE:

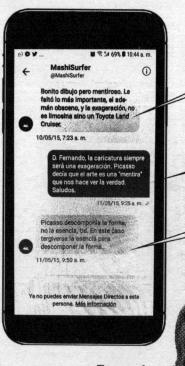

Fernando Alvarado

Alvarado: "Nice cartoon but it is a lie. You forgot the most important thing: the obscene gesture. And the drawing was an exaggeration because it was not a limousine. The car was a Toyota Land Cruiser."

Vargas: "Caricature is always an exaggeration. Picasso said that art is a 'lie' that makes us see the truth."

Alvarado: "Picasso decomposed the form, not the essence. In your case, you distort the essence by decomposing the form."

Alvarado: "It does not give the viewer the opportunity to interpret.... It is not art, it is a drawn lie."

64

CORREA HAD BEEN ELECTED ON A LEFT-WING, PRO-INDIGENOUS PLATFORM.

HE HAD PROMISED TO END ECUADOR'S "LONG NEOLIBERAL NIGHT" UNDER PREVIOUS, PRO-CAPITALIST PRESIDENTS.

BUT, EIGHT YEARS INTO HIS PRESIDENCY, HIS ACTIONS DID NOT LIVE UP TO HIS RHETORIC.

HIS POLICIES CONTINUED TO FAVOR THE POWERFUL AGRI-BUSINESS SECTOR. HE SOLD NATURAL RESOURCES TO BIG CORPORATIONS AND ARRESTED SOCIAL ACTIVISTS.

VARGAS'S JUNE 2015 CARTOON CAPTURED HIS KAFKAESQUE METAMORPHOSIS.

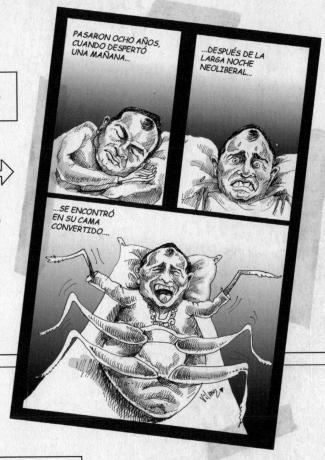

TRANSLATION: "EIGHT YEARS WENT BY, AND I WOKE UP ONE MORNING AFTER THE LONG NEOLIBERAL NIGHT AND FOUND THAT I HAD BEEN TRANSFORMED IN MY BED."

MEANWHILE, COMMUNICATIONS DIRECTOR FERNANDO ALVARADO HAD NOT GOTTEN OVER THEIR EARLIER EXCHANGE.

ALVARDO CONTACTED VARGAS AGAIN TO COMPLAIN. HE ALSO TRIED TO GET HER TO DRAW A CARTOON ATTACKING A JOURNALIST, AGUILAR, FOR CRITICIZING HIM UNFAIRLY ...

Alvarado: "Nice drawing, but lying. You should draw Aguilar like a snake spitting infamies, and me as a victim defending myself."

VARGAS IGNORED THE MESSAGE.

TWO WEEKS LATER, HER HOUSE WAS BROKEN INTO.

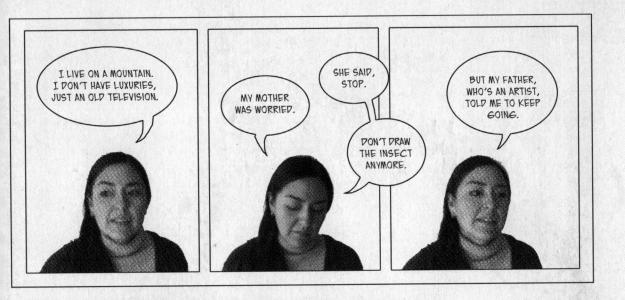

# EPILOGUE

After serving his maximum three terms as President, Rafael Correa was succeeded in May 2017 by his former vice-president, Lenin Moreno, who eased up on the media.

In 2018, Fernando Alvarado was arrested for misappropriating state funds. He fled the country after removing his electronic ankle shackle.

He is believed to be in Venezuela.

In 2016, Vilma Vargas was an Artist Protection Fund fellow in Pittsburgh, USA, under its City of Asylum program.

She returned to Ecuador in 2017 and continues to cartoon.

# THE TAG

Location: Nicaragua  Year: 2018  Cartoonist: Pedro Molina

IN APRIL 2018, A WORSENING ECONOMY PROMPTED PRESIDENT DANIEL ORTEGA TO CUT GOVERNMENT SPENDING BY SLASHING SOCIAL SECURITY BENEFITS.

PROTESTS SWEPT THE COUNTRY.

A peaceful march in 2018

Justicia y Democracia para Nicaragua

THE DEMONSTRATIONS STARTED OUT PEACEFUL, BUT THE GOVERNMENT'S RESPONSE WAS VIOLENT IN THE EXTREME.

OVER THE YEARS, ORTEGA AND HIS WIFE, VICE PRESIDENT ROSARIO MURILLO, HAD GRADUALLY CONCENTRATED POWER IN THEIR HANDS.

"house was set on fire because the owners did not allow the police and snipers to use the roof ... Six members of a family, including a three-year old and a baby perished."

"violent attacks by organized pro-Government groups, known as 'shock forces' (fuerzas de choque) or 'mobs' (turbas)"

"pro-Government armed elements (including snipers)... operating against protests"

"random and selective shootings in the streets, terrorizing local communities and causing loss of life"

THEY COULD NOW LASH OUT WITH IMPUNITY.

"a 14-month old baby died of gunshot wounds"

"police... firing live ammunition at protesters"

– **Office of the United Nations High Commissioner for Human Rights**

CARTOONIST *PEDRO MOLINA* HAD ATTENDED SOME OF THE PROTEST RALLIES AND WAS OUTRAGED AT THE GOVERNMENT'S BRUTALLY DISPROPORTIONATE REACTION. THROUGH HIS CARTOONS, HE TRIED TO ALERT THE WORLD TO WHAT WAS GOING ON.

TRANSLATION

"WE HAVE NEVER HAD A BETTER POLICE FORCE."

*Above*
Pedro Molina
Jul 17, 2018

*Right*
Pedro Molina
Dec 20, 2018

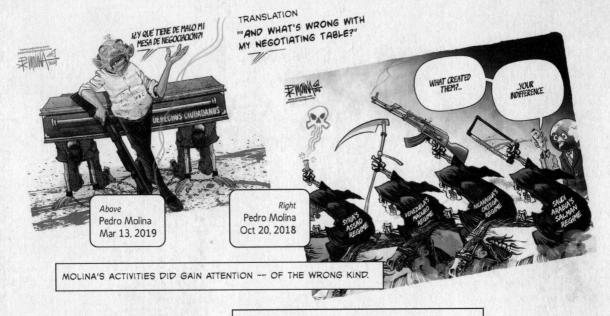

Above
Pedro Molina
Mar 13, 2019

Right
Pedro Molina
Oct 20, 2018

MOLINA'S ACTIVITIES DID GAIN ATTENTION -- OF THE WRONG KIND.

ONE MORNING, HE WOKE UP TO FIND "PLOMO" SPRAY-PAINTED ON A NEIGHBOUR'S WALL.

# Plomo

"PLOMO" MEANS LEAD (THE METAL) IN SPANISH.

IT'S A WARNING THAT YOU'VE BEEN TARGETED FOR A *BULLET*.

SPRAY-PAINTING THIS WORD IS A FORM OF "HOUSE TAGGING"--MARKING AN OPPONENT FOR HARASSMENT OR EXECUTION.

I DON'T KNOW IF IT IS BECAUSE OF MY CARTOONS OR BECAUSE I WAS SEEN IN THE MARCHES.

BUT I'M NOT IN MORE DANGER THAN ANY OTHER NICARAGUAN.

EVERYBODY IS IN DANGER RIGHT NOW.

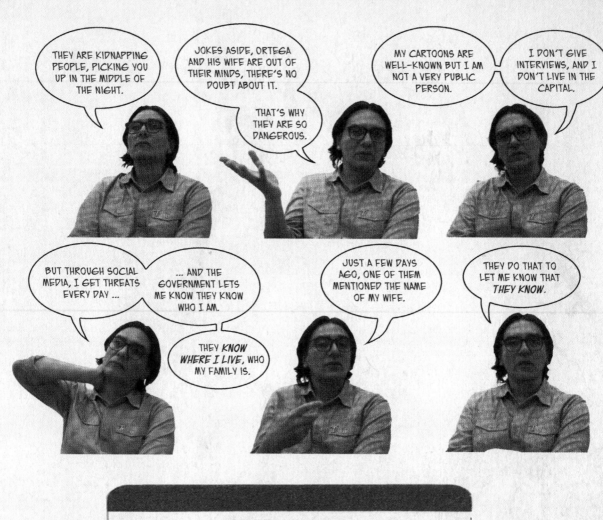

# EPILOGUE

Between April and August 2018, 200-300 Nicaraguans—perhaps more—were killed in protest-related violence.

Cartoonists Rights Network International gave Pedro Molina its 2018 Courage in Editorial Cartooning Award.

That Christmas, Molina and his family fled the country after police intensified its attacks on the press. He was the first cartoonist hosted under the Ithaca City of Asylum program.

Daniel Ortiga and Rosario Murillo still run Nicaragua.

# THE ISOLATION

Location: Occupied Palestinian Territories    Year: 2013
Cartoonist: Mohammad Sabaaneh

West Bank barrier near Ramallah

PALESTINIAN POLITICAL CARTOONIST **MOHAMMAD SABAANEH** IS A PROMINENT CRITIC OF THE ISRAELI OCCUPATION OF HIS HOMELAND.

*Left*
**Lives Interrupted**
May 19, 2006
Mohammad Sabaaneh

*Below*
**Roots**
May 19, 2006
Mohammad Sabaaneh

IN FEBRUARY 2013, HE WAS CROSSING BACK INTO THE OCCUPIED WEST BANK FROM JORDAN WHEN ISRAELI FORCES ARRESTED HIM.

HE WAS DETAINED FOR INVESTIGATION FOR TWO MONTHS, INCLUDING TWO WEEKS IN SOLITARY CONFINEMENT.

## WHITE & BLACK
Political Cartoons from Palestine

**Mohammad Sabaaneh**

*Left*
Sabaaneh's prison cartoons were later published in *White & Black: Political Cartoons from Palestine (Just World Books, 2017).*

THE STATE OF ISRAEL IS PROUD OF ITS DEMOCRATIC IMAGE AND SENSITIVE TO ACCUSATIONS OF HUMAN RIGHTS VIOLATIONS.

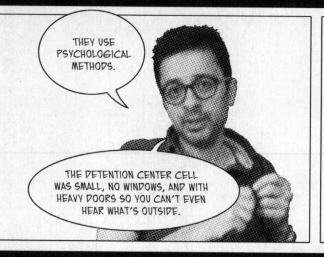

THEY USE PSYCHOLOGICAL METHODS.

THE DETENTION CENTER CELL WAS SMALL, NO WINDOWS, AND WITH HEAVY DOORS SO YOU CAN'T EVEN HEAR WHAT'S OUTSIDE.

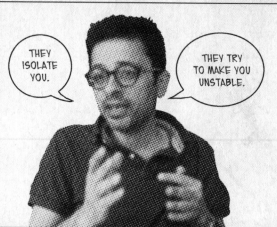

THEY ISOLATE YOU.

THEY TRY TO MAKE YOU UNSTABLE.

HE WAS INTERROGATED BY AN OFFICER OF THE ISRAELI SECURITY AGENCY (ISA, OR SHABAK).

THE QUESTIONS FOCUSED ON HIS CARTOONS.

BUT THE INTELLIGENCE AGENCY'S TUNE CHANGED AFTER HIS CASE WAS TAKEN UP BY INTERNATIONAL NGOS.

Reporters Without Borders condemns Palestinian cartoonist Mohamed Sabaaneh's arbitrary arrest ... and his continuing detention.

# REPORTERS
## WITHOUT BORDERS
### FOR PRESS FREEDOM

THE PRESS FREEDOM ORGANIZATION CALLED ON THE ISRAELI AUTHORITIES TO DECLARE PUBLICLY THE CHARGES AGAINST HIM AND TO LET HIM SEE A LAWYER.

AT THAT POINT, SHABAK ACCUSED HIM OF ASSOCIATING WITH AN ENEMY ORGANIZATION, THE ISLAMIST MILITANT MOVEMENT HAMAS.

HE HAD CONTRIBUTED CARTOONS TO A BOOK WRITTEN BY HIS BROTHER, AND THE BOOK WAS ALLEGEDLY FUNDED BY HAMAS.

*Left*
Shabak Logo

*Right*
Hamas Logo

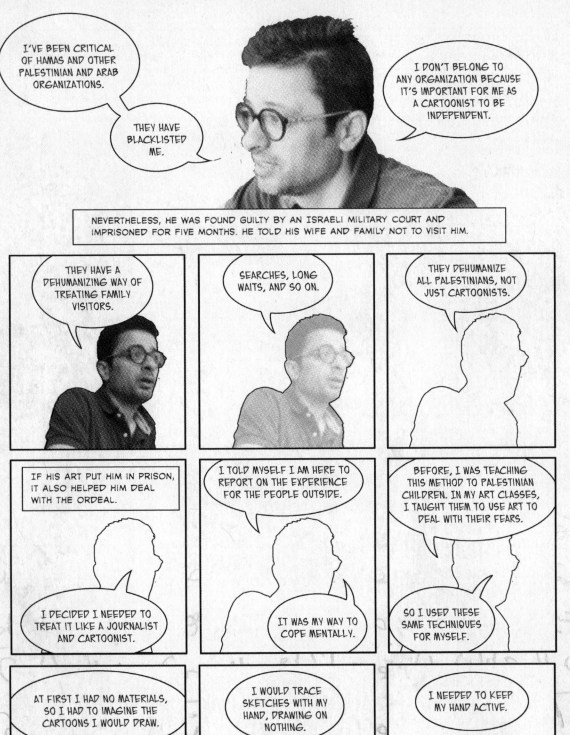

AT ONE INTERROGATION SESSION, HE MANAGED TO STEAL A SINGLE PIECE OF PAPER AND A PENCIL.

HE FILLED THE SHEET WITH IDEAS FOR CARTOONS.

HE PRODUCED THESE CARTOONS AFTER HIS DETENTION ENDED.

LONG INTERROGATIONS, SEARCHES, AND CONFISCATIONS CONTINUE TO BE ROUTINE WHEN SABAANEH TRAVELS.

AFTER I RETURNED FROM A CARTOON FESTIVAL IN BASTOGNE, BELGIUM, THEY *CONFISCATED MY ARTWORK.*

*This and Preceding Page*
Background: Sabaaneh's prison notes

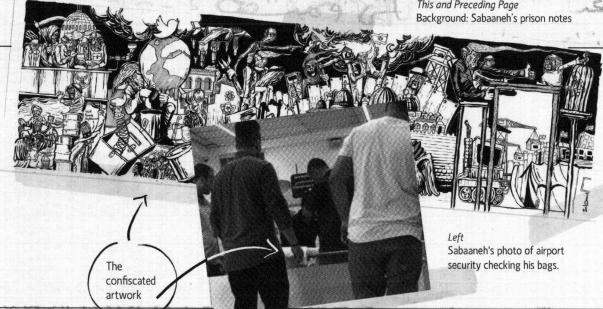

The confiscated artwork

*Left*
Sabaaneh's photo of airport security checking his bags.

FORTUNATELY IT WAS A *COPY.*

I DON'T TRAVEL WITH ORIGINALS FOR THIS VERY REASON.

WHEN I SKETCH ANYTHING IN MY NOTEBOOK WHILE I'M OVERSEAS ...

... I SCAN IT AND THEN DESTROY THE PAGE BEFORE MY RETURN TRIP.

ISRAEL IS QUICK TO ACCUSE PRO-PALESTINIAN VOICES OF ANTI-SEMITISM OR SUPPORTING TERRORISM, IN ORDER TO TURN WORLD OPINION AGAINST THEM AND FURTHER ISOLATE HIS DISPOSESSED PEOPLE, SABAANEH SAYS.

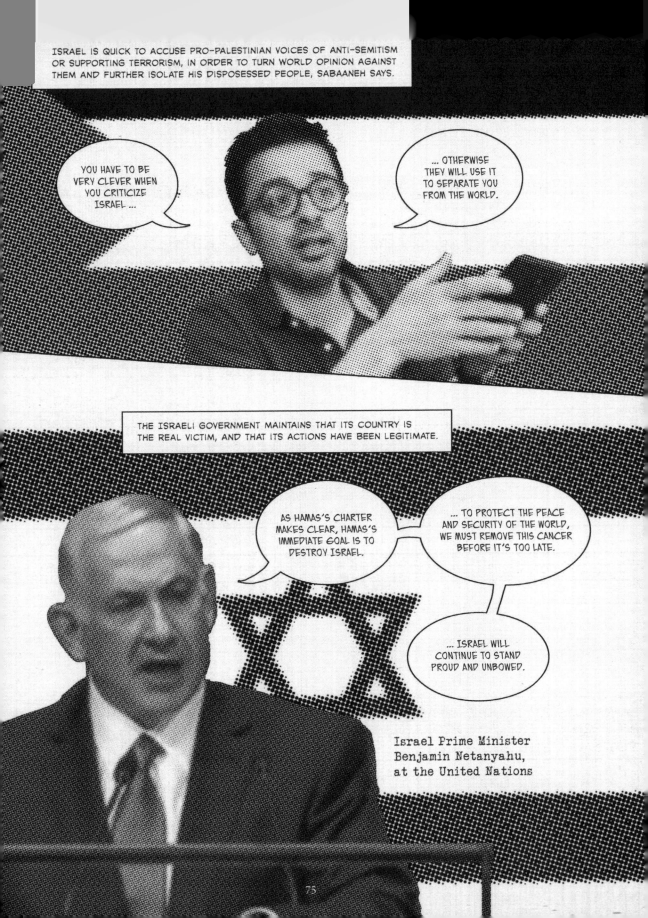

YOU HAVE TO BE VERY CLEVER WHEN YOU CRITICIZE ISRAEL ...

... OTHERWISE THEY WILL USE IT TO SEPARATE YOU FROM THE WORLD.

THE ISRAELI GOVERNMENT MAINTAINS THAT ITS COUNTRY IS THE REAL VICTIM, AND THAT ITS ACTIONS HAVE BEEN LEGITIMATE.

AS HAMAS'S CHARTER MAKES CLEAR, HAMAS'S IMMEDIATE GOAL IS TO DESTROY ISRAEL.

... TO PROTECT THE PEACE AND SECURITY OF THE WORLD, WE MUST REMOVE THIS CANCER BEFORE IT'S TOO LATE.

... ISRAEL WILL CONTINUE TO STAND PROUD AND UNBOWED.

Israel Prime Minister Benjamin Netanyahu, at the United Nations

# EPILOGUE

A 2019 Human Rights Watch report on the West Bank said Israeli authorities had denied Palestinians basic civil rights protections, arresting journalists, activists, and others for their anti-occupation speech, activism, and political ties.

"After 52 years of occupation with no end in sight, Israel should allow Palestinians a more normal public and political life, including safeguarding the rights to free speech, assembly, and association," it said.

Mohammad Sabaaneh still lives in the West Bank city of Ramallah, drawing political cartoons for the daily newspaper 'Al-Hayat al-Jadida.'

# THE HIT LIST

Location: Iran   Year: 2000   Cartoonist: Nikahang Kowsar

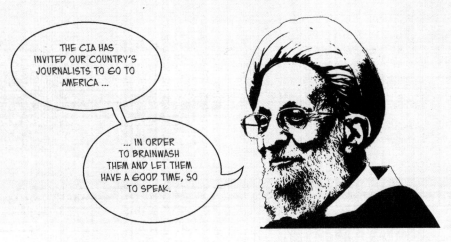

THE CIA HAS INVITED OUR COUNTRY'S JOURNALISTS TO GO TO AMERICA ...

... IN ORDER TO BRAINWASH THEM AND LET THEM HAVE A GOOD TIME, SO TO SPEAK.

Mesbah Yazdi

IN JANUARY 2000, AYATOLLAH MOHAMMAD-TAQI MESBAH-YAZDI, KNOWN AS USTAD MESBAH, LASHED OUT AT THE COUNTRY'S LIBERAL JOURNALISTS, ACCUSING THEM OF TRAITOROUS COLLUSION WITH AMERICA.

**NIKAHANG KOWSAR** RESPONDED WITH THIS CARTOON SHOWING A CROCODILE SHEDDING TEARS AS IT CHOKES A WRITER.

TRANSLATION

"Nobody's going to help me get rid of this mercenary writer?"

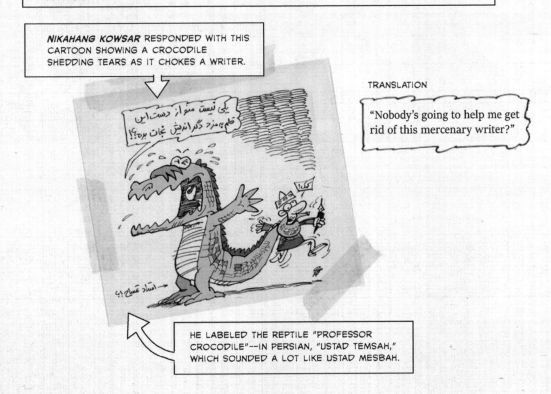

HE LABELED THE REPTILE "PROFESSOR CROCODILE"--IN PERSIAN, "USTAD TEMSAH," WHICH SOUNDED A LOT LIKE USTAD MESBAH.

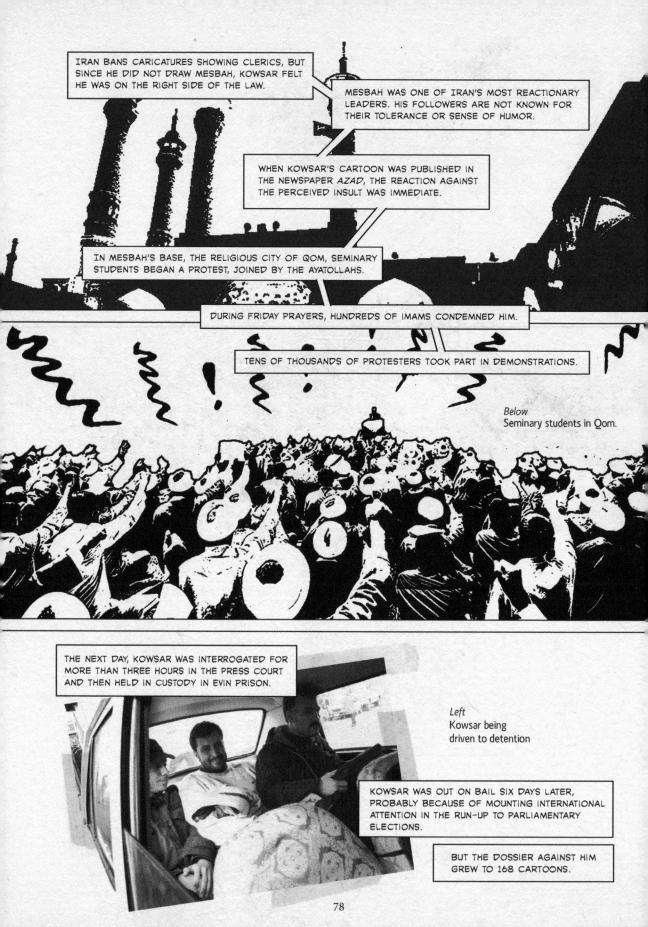

IRAN BANS CARICATURES SHOWING CLERICS, BUT SINCE HE DID NOT DRAW MESBAH, KOWSAR FELT HE WAS ON THE RIGHT SIDE OF THE LAW.

MESBAH WAS ONE OF IRAN'S MOST REACTIONARY LEADERS. HIS FOLLOWERS ARE NOT KNOWN FOR THEIR TOLERANCE OR SENSE OF HUMOR.

WHEN KOWSAR'S CARTOON WAS PUBLISHED IN THE NEWSPAPER *AZAD*, THE REACTION AGAINST THE PERCEIVED INSULT WAS IMMEDIATE.

IN MESBAH'S BASE, THE RELIGIOUS CITY OF QOM, SEMINARY STUDENTS BEGAN A PROTEST, JOINED BY THE AYATOLLAHS.

DURING FRIDAY PRAYERS, HUNDREDS OF IMAMS CONDEMNED HIM.

TENS OF THOUSANDS OF PROTESTERS TOOK PART IN DEMONSTRATIONS.

*Below*
Seminary students in Qom.

THE NEXT DAY, KOWSAR WAS INTERROGATED FOR MORE THAN THREE HOURS IN THE PRESS COURT AND THEN HELD IN CUSTODY IN EVIN PRISON.

*Left*
Kowsar being
driven to detention

KOWSAR WAS OUT ON BAIL SIX DAYS LATER, PROBABLY BECAUSE OF MOUNTING INTERNATIONAL ATTENTION IN THE RUN-UP TO PARLIAMENTARY ELECTIONS.

BUT THE DOSSIER AGAINST HIM GREW TO 168 CARTOONS.

78

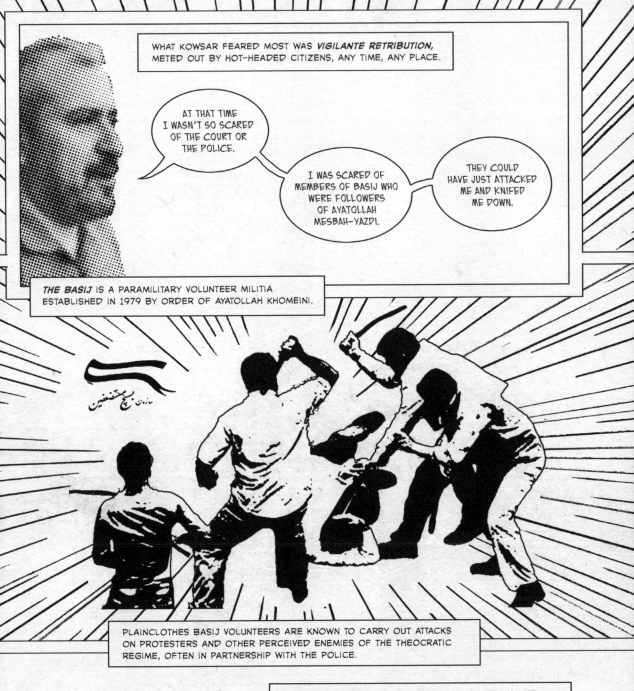

WHAT KOWSAR FEARED MOST WAS *VIGILANTE RETRIBUTION*, METED OUT BY HOT-HEADED CITIZENS, ANY TIME, ANY PLACE.

AT THAT TIME I WASN'T SO SCARED OF THE COURT OR THE POLICE.

I WAS SCARED OF MEMBERS OF BASIJ WHO WERE FOLLOWERS OF AYATOLLAH MESBAH-YAZDI.

THEY *COULD* HAVE JUST ATTACKED ME AND KNIFED ME DOWN.

*THE BASIJ* IS A PARAMILITARY VOLUNTEER MILITIA ESTABLISHED IN 1979 BY ORDER OF AYATOLLAH KHOMEINI.

PLAINCLOTHES BASIJ VOLUNTEERS ARE KNOWN TO CARRY OUT ATTACKS ON PROTESTERS AND OTHER PERCEIVED ENEMIES OF THE THEOCRATIC REGIME, OFTEN IN PARTNERSHIP WITH THE POLICE.

*Below*
A few of the victims of the 1998 "Chain Murders":
Abdul Rahman Ghassemlou, Parvaneh Forouhar,
Dariush Forouhar, Shapour Bakhtiar, Fereydoun Farrokhzad.

THEN THERE WERE THE DEVOTEES OF MOJTABA NAWAB, A GROUP OF ASSASSINS WHO HAD CLAIMED RESPONSIBILITY FOR SOME OF THE "CHAIN MURDERS" OF MORE THAN 80 INTELLECTUALS IN 1998.

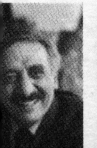

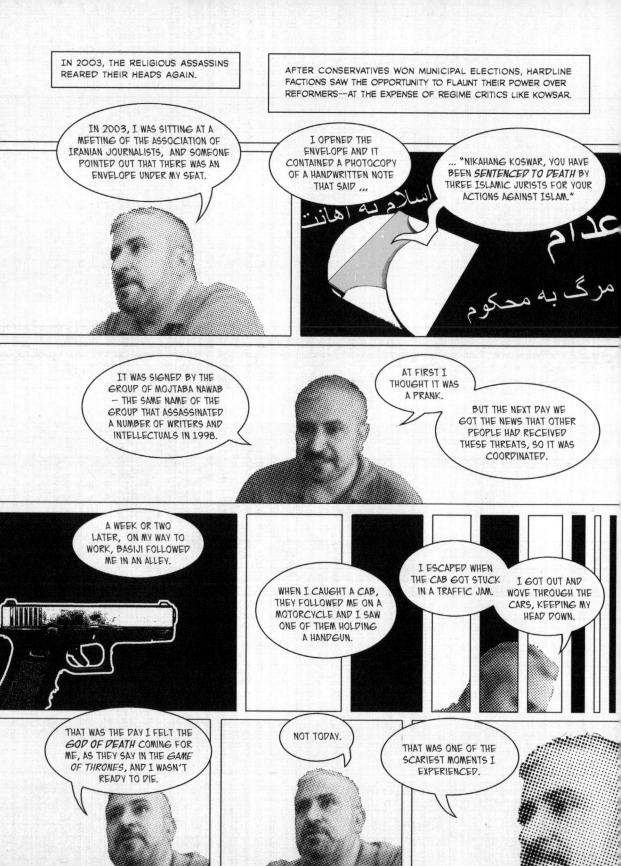

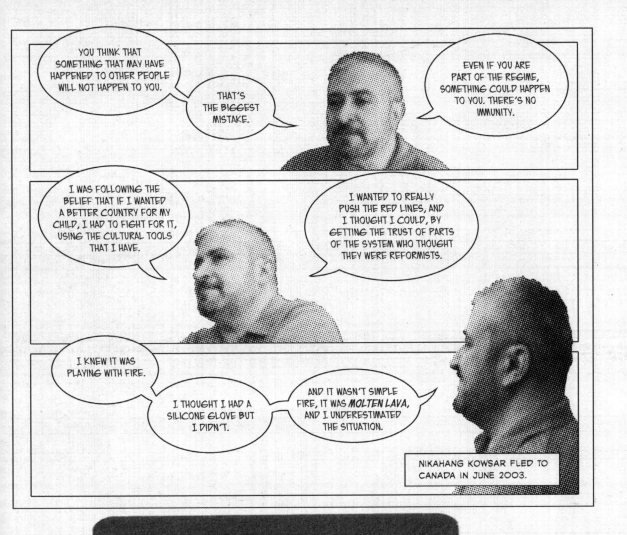

NIKAHANG KOWSAR FLED TO CANADA IN JUNE 2003.

# EPILOGUE

Ayatollah Mohammad-Taqi Mesbah-Yazdi remains an influential ultra-conservative leader in Iran's religious establishment.

Kowsar's prosecutor, Sayeed Mortazavi, was convicted and jailed in 2018 for complicity in the death of a detained protester.

The Basij continue to play an active role in domestic politics. They helped suppress pro-democracy protests in 2009 and 2018-9.

Nikahang Kowsar lives in Washington, DC, working mainly on water security issues, including in Iran.

In 2018, he was diagnosed with fibromyalgia, a debilitating auto-immune disorder linked to post-traumatic stress.

CENSORS' MIND-GAMES ARE OFTEN NOT DOCUMENTED BY THE MEDIA, ACADEMICS OR HUMAN RIGHTS WATCHDOGS.

FOR ONE, THEY CAN BE HARD TO VERIFY.

I CAN'T SAY FOR CERTAIN THE BREAK-IN WAS POLITICAL.

BESIDES, MOST POLITICAL CARTOONISTS TRY NOT TO REVEAL THEIR FEAR.

THEY FEEL THEY HAVE A RESPONSIBILITY TO DISPLAY COURAGE.

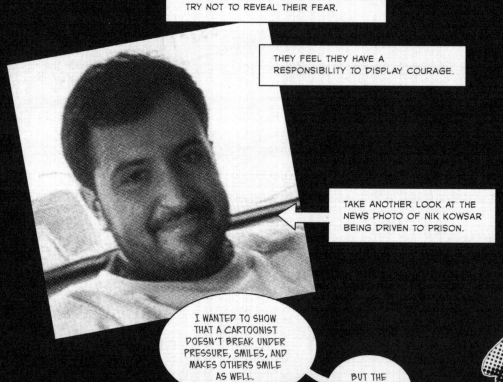

TAKE ANOTHER LOOK AT THE NEWS PHOTO OF NIK KOWSAR BEING DRIVEN TO PRISON.

I WANTED TO SHOW THAT A CARTOONIST DOESN'T BREAK UNDER PRESSURE, SMILES, AND MAKES OTHERS SMILE AS WELL.

BUT THE TRUTH IS I WAS TERRIFIED.

THUS, WE MAY UNDERESTIMATE THE TRAUMA INFLICTED ON CARTOONISTS WHO CROSS THE LINE.

IT IS EVEN HARDER TO MEASURE THE IMPACT OF SUCCESSFUL INTIMIDATION.

WE DON'T GET TO SEE THE UNDRAWN CARTOONS--THOSE PICTURED ONLY IN THE IMAGINATION, OR DESCRIBED TO ONE'S CLOSEST CONFIDANTS.

WE WERE *SPEAKING* CARTOONS.

NOR CAN WE TALLY THE *CLOSETED CARTOONISTS* ...

... INDIVIDUALS WHO HAVE THE LATENT TALENT, BUT DECIDE THE VOCATION IS NOT WORTH THE RISK WHEN THEY OBSERVE POLITICAL CARTOONISTS GETTING IN TROUBLE.

THIS CHILLING EFFECT EXACTS A *HIDDEN COST* EVEN WHEN A CARTOONIST LIKE ZUNAR SEEMS TO BEAT THE CENSOR.

WE HAVE MANY YOUNG PEOPLE WHO ARE SO CREATIVE IN USING SOCIAL MEDIA, ILLUSTRATION, AND GRAPHICS.

BUT THEY DON'T WANT TO GO BEYOND.

THEY SEE ME IN HANDCUFFS. THEY DON'T WANT TO FACE THAT KIND OF TROUBLE.

IT STOPS YOUNG ARTISTS FROM FOLLOWING MY EXAMPLE.

IT WORKS.

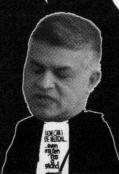

# THE FATHER FIGURE

Location: Cuba   Period: 1980s   Cartoonist: Alfredo Pong

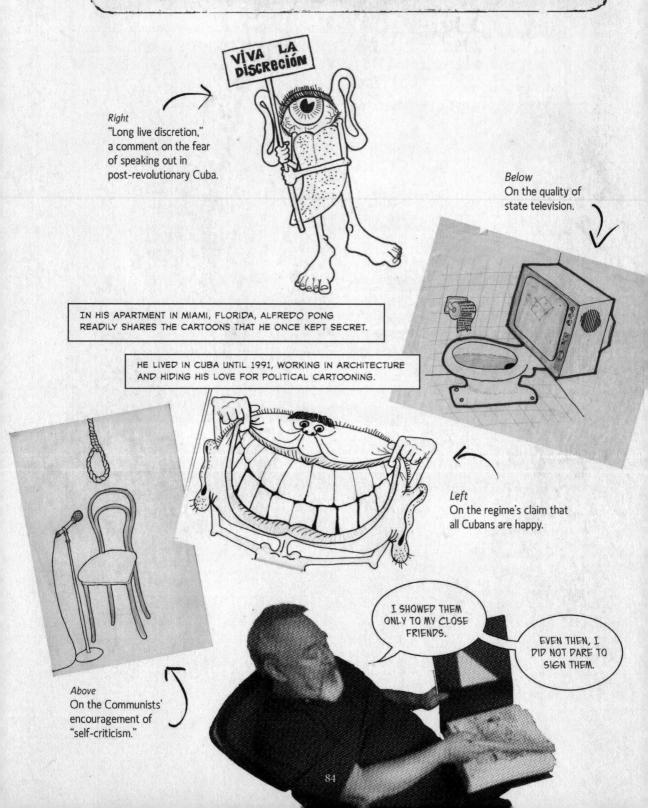

VIVA LA DISCRECIÓN

*Right*
"Long live discretion,"
a comment on the fear
of speaking out in
post-revolutionary Cuba.

*Below*
On the quality of
state television.

IN HIS APARTMENT IN MIAMI, FLORIDA, ALFREDO PONG
READILY SHARES THE CARTOONS THAT HE ONCE KEPT SECRET.

HE LIVED IN CUBA UNTIL 1991, WORKING IN ARCHITECTURE
AND HIDING HIS LOVE FOR POLITICAL CARTOONING.

*Left*
On the regime's claim that
all Cubans are happy.

I SHOWED THEM
ONLY TO MY CLOSE
FRIENDS.

EVEN THEN, I
DID NOT DARE TO
SIGN THEM.

*Above*
On the Communists'
encouragement of
"self-criticism."

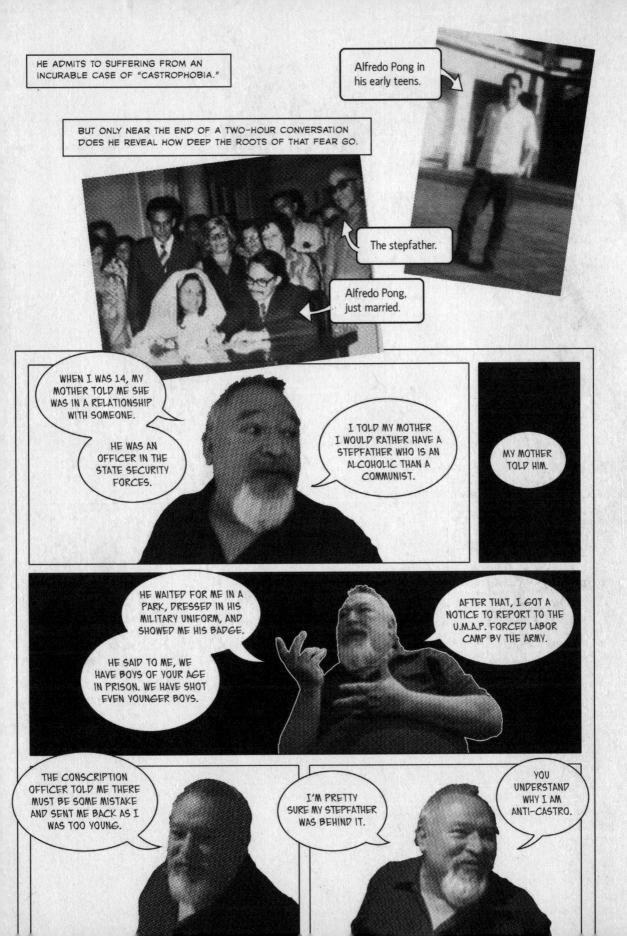

PONDERING CENSORSHIP UNDER TYRANNY, SOUTH AFRICAN AUTHOR *J. M. COETZEE* NOTES THAT THE DISSENTING WRITER SEES HIMSELF AS PART OF A BROTHERLY COMMUNITY FOR WHICH HE SPEAKS.

BUT, COETZEE WRITES, "THE STATE-AS-FATHER ALREADY ASSERTS A PRIOR RIGHT TO MAKE THE RULES, TO SPEAK THE LAW."

THE ARTIST TRIES TO NURTURE A RELATIONSHIP WITH THE LOVED OR COURTED READER--BUT THEN THE "FIGURE-OF-THE-FATHER" INTERRUPTS.

WORKING UNDER CENSORSHIP IS LIKE BEING INTIMATE WITH SOMEONE WHO DOESN'T LOVE YOU, WITH WHOM YOU WANT NO INTIMACY, BUT WHO PRESSES HIMSELF IN UPON YOU ...

BY FORCING THE WRITER TO SEE WHAT HE HAS WRITTEN THROUGH THE CENSOR'S EYES, THE CENSOR FORCES HIM TO INTERNALIZE A CONTAMINATED READING.

IT IS "THE MOST INTIMATE OF INVASIONS."

J.M. COETZEE

# 4. Post-Orwellian Censorship

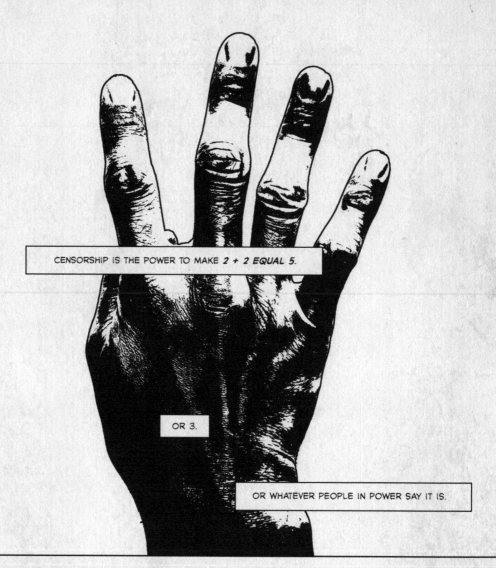

CENSORSHIP IS THE POWER TO MAKE *2 + 2 EQUAL 5.*

OR 3.

OR WHATEVER PEOPLE IN POWER SAY IT IS.

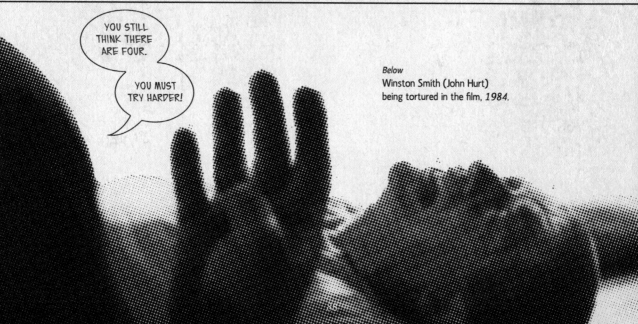

*Below*
Winston Smith (John Hurt)
being tortured in the film, *1984.*

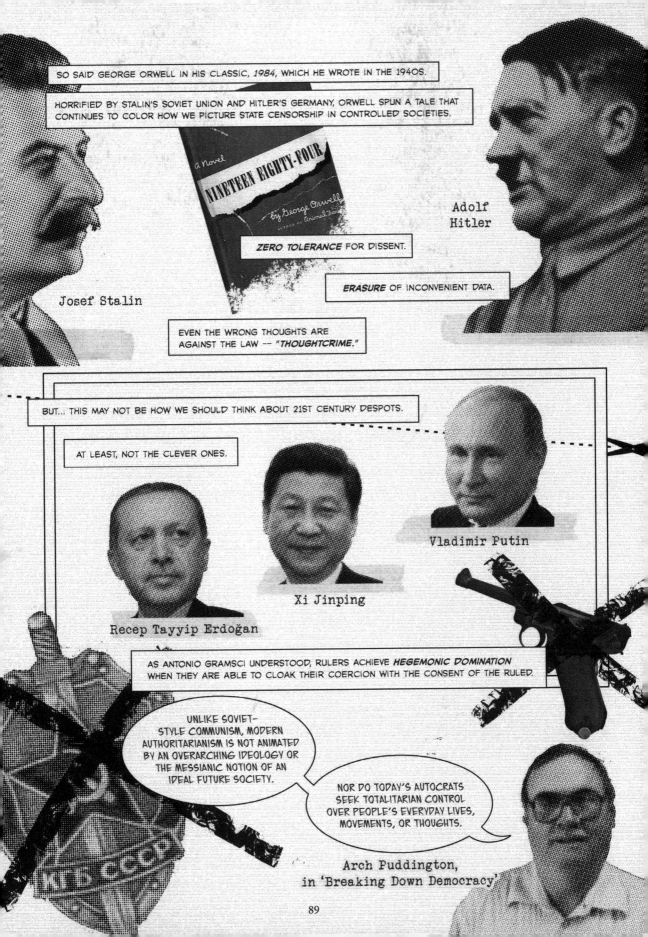

SO SAID GEORGE ORWELL IN HIS CLASSIC, *1984*, WHICH HE WROTE IN THE 1940S.

HORRIFIED BY STALIN'S SOVIET UNION AND HITLER'S GERMANY, ORWELL SPUN A TALE THAT CONTINUES TO COLOR HOW WE PICTURE STATE CENSORSHIP IN CONTROLLED SOCIETIES.

Adolf Hitler

*ZERO TOLERANCE* FOR DISSENT.

*ERASURE* OF INCONVENIENT DATA.

Josef Stalin

EVEN THE WRONG THOUGHTS ARE AGAINST THE LAW -- *"THOUGHTCRIME."*

BUT... THIS MAY NOT BE HOW WE SHOULD THINK ABOUT 21ST CENTURY DESPOTS.

AT LEAST, NOT THE CLEVER ONES.

Vladimir Putin

Xi Jinping

Recep Tayyip Erdoğan

AS ANTONIO GRAMSCI UNDERSTOOD, RULERS ACHIEVE *HEGEMONIC DOMINATION* WHEN THEY ARE ABLE TO CLOAK THEIR COERCION WITH THE CONSENT OF THE RULED.

UNLIKE SOVIET-STYLE COMMUNISM, MODERN AUTHORITARIANISM IS NOT ANIMATED BY AN OVERARCHING IDEOLOGY OR THE MESSIANIC NOTION OF AN IDEAL FUTURE SOCIETY.

NOR DO TODAY'S AUTOCRATS SEEK TOTALITARIAN *CONTROL* OVER PEOPLE'S EVERYDAY LIVES, MOVEMENTS, OR THOUGHTS.

Arch Puddington, in 'Breaking Down Democracy'

HANNAH ARENDT, A CLOSE OBSERVER OF TOTALITARIAN REGIMES, REALISED THAT *POWER NEEDS LEGITIMACY*, WHICH IS DESTROYED WHEN VIOLENCE IS OVERUSED.

Hannah Arendt ON VIOLENCE

VIOLENCE CAN BE JUSTIFIABLE, BUT IT NEVER WILL BE LEGITIMATE.

VIOLENCE... CAN BRING VICTORY, BUT THE PRICE IS VERY HIGH; FOR IT IS NOT ONLY PAID BY THE VANQUISHED, IT IS ALSO PAID BY THE VICTOR IN TERMS OF HIS OWN POWER.

IN THE 1980S, MIKLOS HARASZTI IN COMMUNIST HUNGARY OBSERVED THAT ARTS CENSORSHIP IN A MATURE ONE-PARTY STATE WAS QUITE DIFFERENT FROM THE TERROR OF STALINISM.

STALINISM WAS PARANOID, HARD AND MILITARY-LIKE.

IT REQUIRED COMPLETE CONSENSUS, AND LOUD LOYALTY.

"NEUTRALITY IS TREASON; AMBIGUITY IS BETRAYAL."

ART WAS FORCED INTO A PROPAGANDA ROLE.

POST-STALINIST REGIMES WERE MORE CONFIDENT, AND THEREFORE SOFTER. THEY *EXPANDED THE BOUNDARIES* OF THE PERMISSIBLE.

INSTEAD OF DAILY DIRECTIVES, THERE ARE GUIDELINES.

THE VELVET PRISON

ARTISTS UNDER STATE SOCIALISM

FOREWORD BY GEORGE KONRÁD

MIKLÓS HARASZTI

MAKE NO MISTAKE -- MODERN AUTHORITARIANS HAVEN'T UNDERGONE A PHILOSOPHICAL CONVERSION TO LIBERAL VALUES. THEY STILL USE BRUTAL METHODS.

BUT PARADOXICALLY, IF WE OVERESTIMATE THEIR USE OF FEAR AND FORCE, WE UNDERESTIMATE THEIR *POWER AND RESILIENCE*.

CHINA -- THE WORLD'S LONGEST-RUNNING COMMUNIST STATE -- HAS SWUNG BETWEEN HARD AND SOFT CENSORSHIP.

MAO ZEDONG'S *CULTURAL REVOLUTION* (1966-1976) WAS A PERIOD OF EXTREME, UNCOMPROMISING MIND CONTROL.

THE PARTY'S INSISTENCE ON IDEOLOGICAL PURITY IMPOVERISHED CHINA, EVEN AS OTHER LOW-INCOME COUNTRIES WERE COURTING INVESTORS AND IMPROVING LIVING STANDARDS.

AFTER MAO'S DEATH IN 1976, HIS SUCCESSORS *CHANGED COURSE* DRAMATICALLY.

THE PARTY BLAMED THE EXCESSES OF THE CULTURAL REVOLUTION ON A SMALL FACTION, LED BY THE SO-CALLED GANG OF FOUR (INCLUDING MAO'S WIDOW JIANG QING).

SUDDENLY, CARICATURES OF THE GANG OF FOUR, WHICH HAD TO BE SKETCHED IN SECRET UNDER MAO, WERE BEING CELEBRATED IN EXHIBITIONS AND THE PRESS.

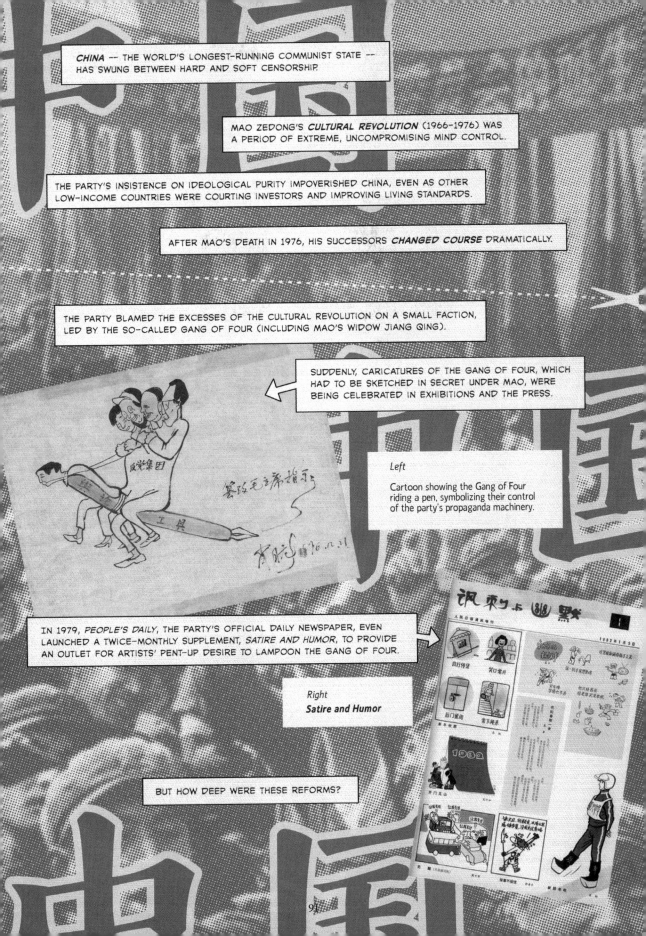

*Left*

Cartoon showing the Gang of Four riding a pen, symbolizing their control of the party's propaganda machinery.

IN 1979, *PEOPLE'S DAILY*, THE PARTY'S OFFICIAL DAILY NEWSPAPER, EVEN LAUNCHED A TWICE-MONTHLY SUPPLEMENT, *SATIRE AND HUMOR*, TO PROVIDE AN OUTLET FOR ARTISTS' PENT-UP DESIRE TO LAMPOON THE GANG OF FOUR.

*Right*
**Satire and Humor**

BUT HOW DEEP WERE THESE REFORMS?

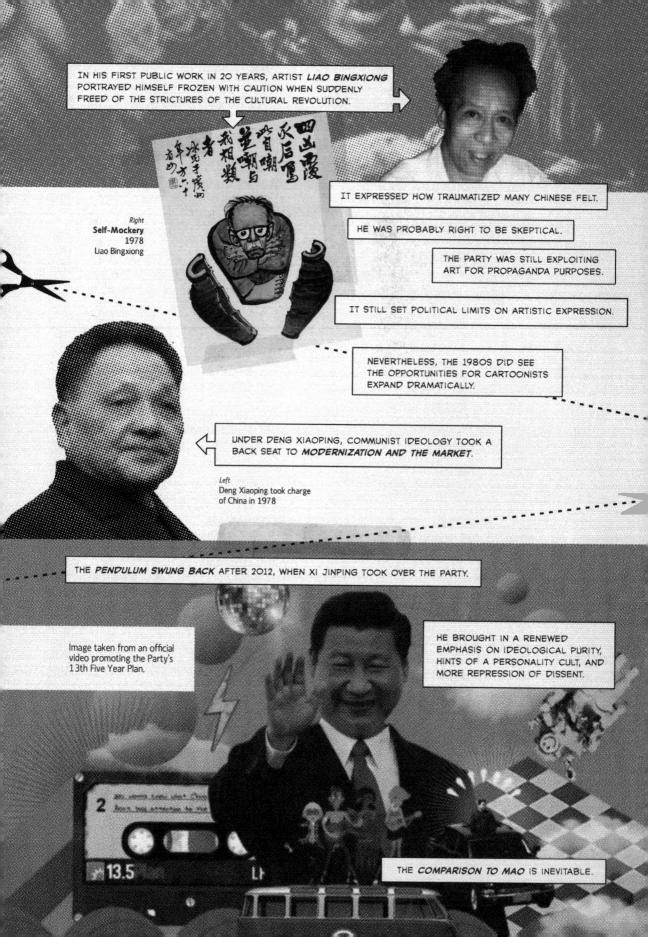

IN HIS FIRST PUBLIC WORK IN 20 YEARS, ARTIST *LIAO BINGXIONG* PORTRAYED HIMSELF FROZEN WITH CAUTION WHEN SUDDENLY FREED OF THE STRICTURES OF THE CULTURAL REVOLUTION.

*Right*
**Self-Mockery**
1978
Liao Bingxiong

IT EXPRESSED HOW TRAUMATIZED MANY CHINESE FELT.

HE WAS PROBABLY RIGHT TO BE SKEPTICAL.

THE PARTY WAS STILL EXPLOITING ART FOR PROPAGANDA PURPOSES.

IT STILL SET POLITICAL LIMITS ON ARTISTIC EXPRESSION.

NEVERTHELESS, THE 1980S DID SEE THE OPPORTUNITIES FOR CARTOONISTS EXPAND DRAMATICALLY.

UNDER DENG XIAOPING, COMMUNIST IDEOLOGY TOOK A BACK SEAT TO *MODERNIZATION AND THE MARKET*.

*Left*
Deng Xiaoping took charge of China in 1978

THE *PENDULUM SWUNG BACK* AFTER 2012, WHEN XI JINPING TOOK OVER THE PARTY.

Image taken from an official video promoting the Party's 13th Five Year Plan.

HE BROUGHT IN A RENEWED EMPHASIS ON IDEOLOGICAL PURITY, HINTS OF A PERSONALITY CULT, AND MORE REPRESSION OF DISSENT.

THE *COMPARISON TO MAO* IS INEVITABLE.

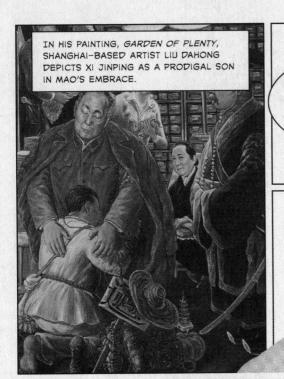

IN HIS PAINTING, *GARDEN OF PLENTY*, SHANGHAI-BASED ARTIST LIU DAHONG DEPICTS XI JINPING AS A PRODIGAL SON IN MAO'S EMBRACE.

BOTH MAO AND XI HAVE A COMMON HERITAGE — THE RED GENES OF SOVIET RUSSIA.

BOTH HAVE DOMINANT TEMPERAMENTS AND LOVE RULING THE COUNTRY LIKE A SOVEREIGN.

THE DIFFERENCE IS THAT IN MAO'S ERA, DRAWING CRITICAL CARTOONS COULD NEVER BE TOLERATED...

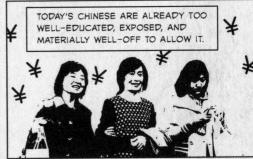

... IN XI'S ERA, THE CENSOR RAISES THE WHIP HIGH ABOVE, BUT YOU DON'T KNOW WHETHER AND WHEN HE WILL STRIKE.

Liu Dahong

XI *COULDN'T* REVERT FULLY TO CULTURAL REVOLUTION MODE EVEN IF HE WANTED TO.

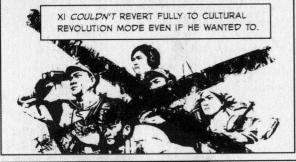

TODAY'S CHINESE ARE ALREADY TOO WELL-EDUCATED, EXPOSED, AND MATERIALLY WELL-OFF TO ALLOW IT.

THE COUNTRY IS TOO VAST AND POPULOUS; THE MEDIA ARE TOO PLENTIFUL; AND AUTHORITY IS TOO DECENTRALISED TO ALLOW MAO-STYLE TOTAL CONTROL.

BY NECESSITY AND DESIGN, CHINA'S CENSORSHIP EFFORTS ARE *POROUS*, REGULARLY BYPASSED WITHOUT PUNISHMENT, SAYS POLITICAL SCIENTIST MARGARET ROBERTS.

MODERN CHINESE CENSORSHIP USES A BLEND OF *FEAR*, *FRICTION*, AND *FLOODING*, SHE WRITES ...

恐吓　掺沙　灌水

# FEER

FEAR OF PUNISHMENT WORKS ON MOST BOSSES OF NEWS MEDIA OUTLETS AND INTERNET PLATFORMS.

IF THEY SLIP UP AND ALLOW THE WRONG CONTENT TO REACH THE PUBLIC, THEY MAY NOT BE SENT OFF TO DO HARD LABOR IN A DETENTION CAMP ...

... BUT THEY COULD BE DEMOTED AND THEIR PAY DOCKED -- A BIG SETBACK IN A HIGHLY COMPETITIVE AND UNEQUAL SOCIETY WHERE MOST PEOPLE ARE DESPERATE TO GET AHEAD.

OPINION LEADERS LIKE JOURNALISTS AND ARTISTS ARE ALSO SUBJECT TO FEAR-INDUCING THREATS.

THE FIRST TOOL IS NOT TERROR, BUT *TEA*.

IT IS LESS PUBLICLY VISIBLE THAN AN ARREST.

WANG LIMING (KNOWN AS *REBEL PEPPER*) GOT AN INVITATION TO TEA AFTER HE DREW A CARTOON SUPPORTING INDEPENDENT CANDIDATES FOR LOCAL PEOPLE'S CONGRESSES, CHALLENGING THE PARTY'S TIGHT SUPERVISION OF THESE ELECTIONS.

THE CARTOON WAS SO POPULAR, IT WAS EVEN PRINTED ON T-SHIRTS.

TWO PLAINCLOTHES OFFICIALS CAME TO MY FAMILY'S FLAT.

THEY SHOWED ME THEIR IDS, WHICH SAID MINISTRY OF STATE SECURITY. THEY SAID THEY WOULD COME BACK ON FRIDAY WITH A CAR.

ON THAT DAY, THEY TOOK ME TO THE PRIVATE ROOM OF A TEAHOUSE.

THERE WERE FIVE OFFICERS FROM THE MINISTRY OF STATE SECURITY.*

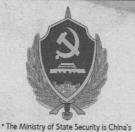

THEY ASKED WHY I DREW THIS CARTOON AND WHETHER THERE WAS SOME ORGANIZATION BEHIND ME.

* The Ministry of State Security is China's intelligence and security agency.

I WAS SCARED. SO SCARED.

A PRIVATE CONVERSATION OVER TEA CAN INTIMIDATE WITHOUT BACKFIRING THE WAY PUBLIC PUNISHMENT DOES.

BUT IT DIDN'T WORK ON WANG.

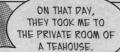

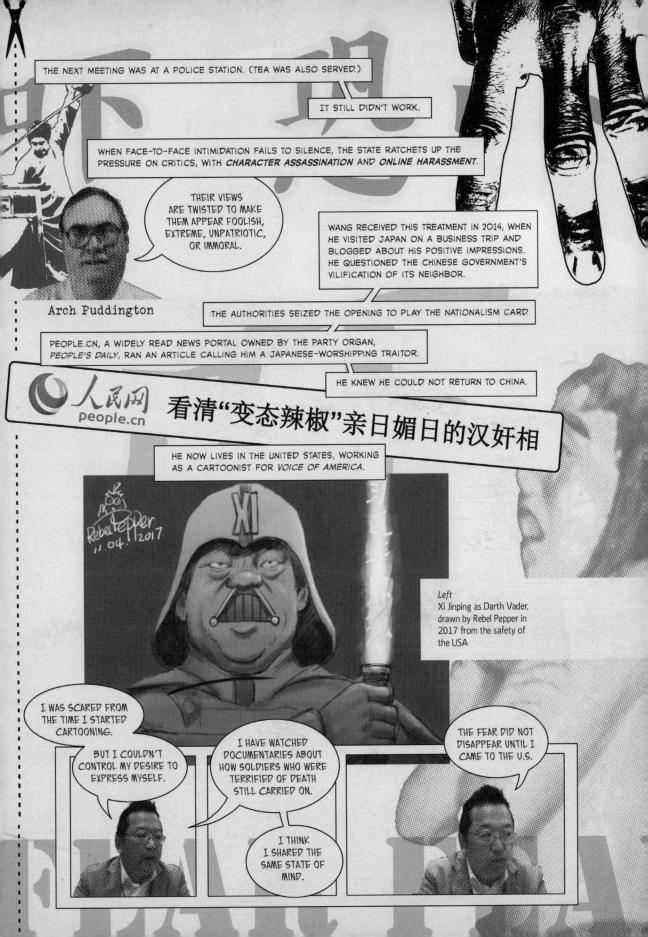

THE NEXT MEETING WAS AT A POLICE STATION. (TEA WAS ALSO SERVED.)

IT STILL DIDN'T WORK.

WHEN FACE-TO-FACE INTIMIDATION FAILS TO SILENCE, THE STATE RATCHETS UP THE PRESSURE ON CRITICS, WITH *CHARACTER ASSASSINATION* AND *ONLINE HARASSMENT*.

THEIR VIEWS ARE TWISTED TO MAKE THEM APPEAR FOOLISH, EXTREME, UNPATRIOTIC, OR IMMORAL.

WANG RECEIVED THIS TREATMENT IN 2014, WHEN HE VISITED JAPAN ON A BUSINESS TRIP AND BLOGGED ABOUT HIS POSITIVE IMPRESSIONS. HE QUESTIONED THE CHINESE GOVERNMENT'S VILIFICATION OF ITS NEIGHBOR.

Arch Puddington

THE AUTHORITIES SEIZED THE OPENING TO PLAY THE NATIONALISM CARD.

PEOPLE.CN, A WIDELY READ NEWS PORTAL OWNED BY THE PARTY ORGAN, *PEOPLE'S DAILY*, RAN AN ARTICLE CALLING HIM A JAPANESE-WORSHIPPING TRAITOR.

HE KNEW HE COULD NOT RETURN TO CHINA.

people.cn 人民网

看清"变态辣椒"亲日媚日的汉奸相

HE NOW LIVES IN THE UNITED STATES, WORKING AS A CARTOONIST FOR *VOICE OF AMERICA*.

*Left*
Xi Jinping as Darth Vader, drawn by Rebel Pepper in 2017 from the safety of the USA

I WAS SCARED FROM THE TIME I STARTED CARTOONING.

BUT I COULDN'T CONTROL MY DESIRE TO EXPRESS MYSELF.

I HAVE WATCHED DOCUMENTARIES ABOUT HOW SOLDIERS WHO WERE TERRIFIED OF DEATH STILL *CARRIED ON*.

I THINK I SHARED THE SAME STATE OF MIND.

THE FEAR DID NOT DISAPPEAR UNTIL I CAME TO THE U.S.

# FRICTION

L'EQUI

FRICTION IS ABOUT MAKING IT HARDER AND LESS CONVENIENT TO ACCESS UNAPPROVED MATERIAL.

THE CHINESE INTERNET IS A "WALLED GARDEN."

The Economist

Bloomberg

You Tube

BBC

The New York Times

**OUT**

FOREIGN SOCIAL MEDIA PLATFORMS, SEARCH ENGINES, NEWS MEDIA, HUMAN RIGHTS SITES.

AN ARMY OF HUMAN CENSORS AS WELL AS AUTOMATED PROGRAMS TRAWL THE INTERNET FOR MATERIAL THAT CROSSES THE RED LINES, FOLLOWING DIRECTIVES FROM THE PARTY.

CHINA'S *GATEWAYS* TO THE GLOBAL INTERNET ARE MAINTAINED BY NINE STATE-RUN OPERATORS.

Jingjing and Chacha, cartoon mascots of Shenzhen's internet surveillance department.

CHINESE NETIZENS CAN USE *CIRCUMVENTION TOOLS* LIKE VIRTUAL PRIVATE NETWORKS (VPNS) TO ACCESS BANNED SITES, BUT THIS IS GETTING HARDER.

CENSORSHIP BY FRICTION ON THE INTERNET OCCURS WHEN GOVERNMENTS BLOCK CONTENT, REORDER SEARCH RESULTS, OR JUST THROTTLE WEBSITES.

This image was posted on Weibo in 2013 and censored soon after.

In one of the world's most-reported cartoon bans of the era, censors made **Winnie the Pooh** taboo after a wave of Pooh-Xi diptychs struck a nerve.

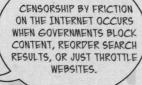
Margaret Roberts

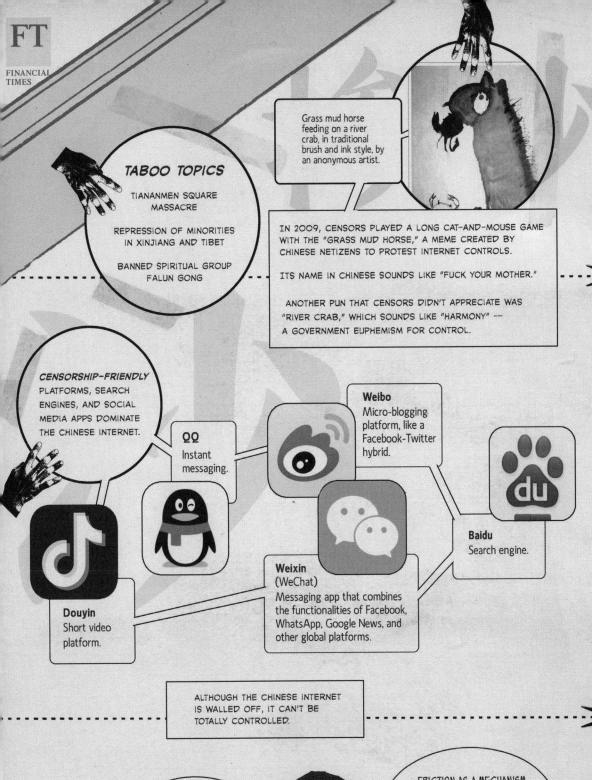

**FT** FINANCIAL TIMES

**TABOO TOPICS**

TIANANMEN SQUARE MASSACRE

REPRESSION OF MINORITIES IN XINJIANG AND TIBET

BANNED SPIRITUAL GROUP FALUN GONG

Grass mud horse feeding on a river crab, in traditional brush and ink style, by an anonymous artist.

IN 2009, CENSORS PLAYED A LONG CAT-AND-MOUSE GAME WITH THE "GRASS MUD HORSE," A MEME CREATED BY CHINESE NETIZENS TO PROTEST INTERNET CONTROLS.

ITS NAME IN CHINESE SOUNDS LIKE "FUCK YOUR MOTHER."

ANOTHER PUN THAT CENSORS DIDN'T APPRECIATE WAS "RIVER CRAB," WHICH SOUNDS LIKE "HARMONY" -- A GOVERNMENT EUPHEMISM FOR CONTROL.

**CENSORSHIP-FRIENDLY** PLATFORMS, SEARCH ENGINES, AND SOCIAL MEDIA APPS DOMINATE THE CHINESE INTERNET.

**QQ**
Instant messaging.

**Weibo**
Micro-blogging platform, like a Facebook-Twitter hybrid.

**Baidu**
Search engine.

**Weixin**
(WeChat)
Messaging app that combines the functionalities of Facebook, WhatsApp, Google News, and other global platforms.

**Douyin**
Short video platform.

ALTHOUGH THE CHINESE INTERNET IS WALLED OFF, IT CAN'T BE TOTALLY CONTROLLED.

IT IS A REALLY HUGE AND DYNAMIC SPACE.

FRICTION AS A MECHANISM OF CENSORSHIP RELIES ON THE INDIFFERENCE AND IMPATIENCE OF PEOPLE. IT NUDGES BUT DOES NOT FORCE MOST USERS AWAY FROM UNSAVORY MATERIAL.

# FLOODING

FLOODING IS ABOUT FILLING THE INTERNET AND OTHER MEDIA WITH STUFF THAT DILUTES AND DISTRACTS FROM THE PROHIBITED CONTENT.

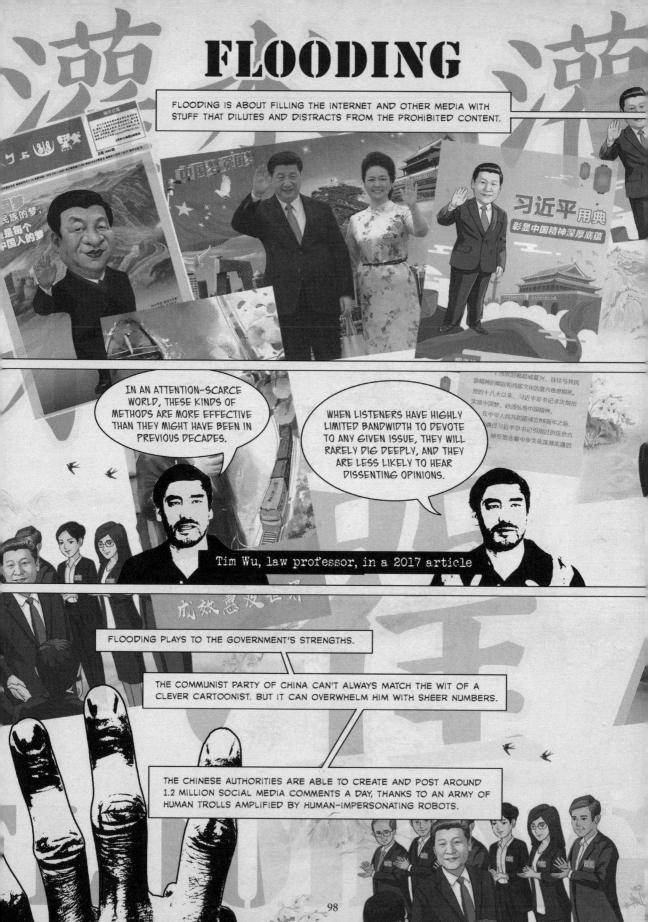

IN AN ATTENTION-SCARCE WORLD, THESE KINDS OF METHODS ARE MORE EFFECTIVE THAN THEY MIGHT HAVE BEEN IN PREVIOUS DECADES.

WHEN LISTENERS HAVE HIGHLY LIMITED BANDWIDTH TO DEVOTE TO ANY GIVEN ISSUE, THEY WILL RARELY DIG DEEPLY, AND THEY ARE LESS LIKELY TO HEAR DISSENTING OPINIONS.

Tim Wu, law professor, in a 2017 article

FLOODING PLAYS TO THE GOVERNMENT'S STRENGTHS.

THE COMMUNIST PARTY OF CHINA CAN'T ALWAYS MATCH THE WIT OF A CLEVER CARTOONIST. BUT IT CAN OVERWHELM HIM WITH SHEER NUMBERS.

THE CHINESE AUTHORITIES ARE ABLE TO CREATE AND POST AROUND 1.2 MILLION SOCIAL MEDIA COMMENTS A DAY, THANKS TO AN ARMY OF HUMAN TROLLS AMPLIFIED BY HUMAN-IMPERSONATING ROBOTS.

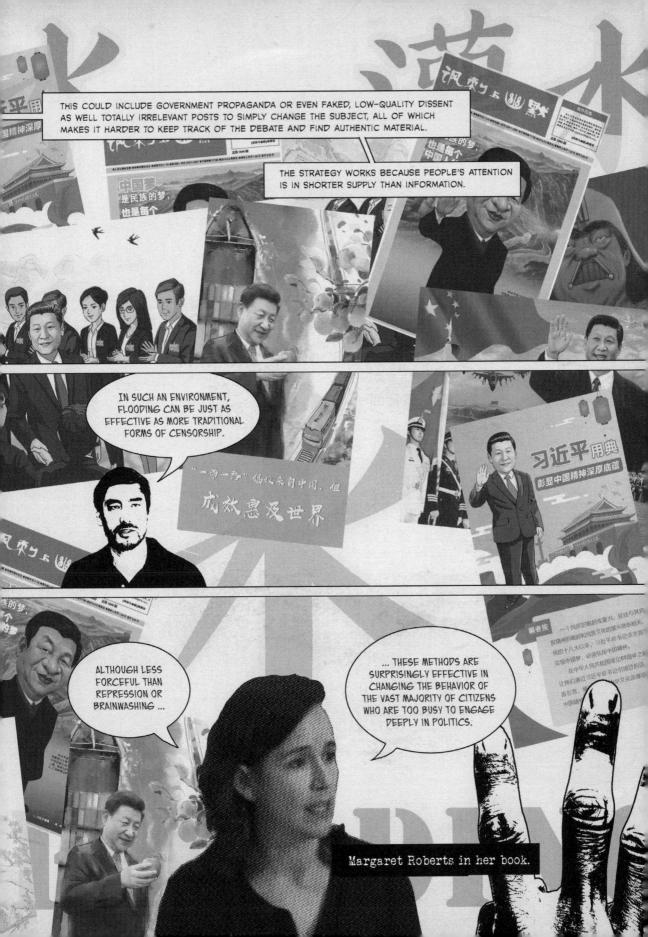

THE SHIFTING RED LINES OF CHINESE CENSORSHIP ARE REFLECTED IN THE CAREER OF *KUANG BIAO*, ONE OF CHINA'S MOST FAMOUS POLITICAL CARTOONISTS.

KUANG IS A NATIVE OF GUANGDONG PROVINCE, WHOSE COASTAL CITIES WERE AMONG THE FIRST TO BENEFIT FROM DENG'S ECONOMIC REFORMS.

THE *GUANGDONG MODEL* WAS ASSOCIATED WITH MORE FREEDOM FOR CIVIL SOCIETY, TRADE UNIONS, AND MEDIA.

KUANG'S CAREER AS A NEWSPAPER CARTOONIST BEGAN AT THE COMMERCIALLY ORIENTED *NEW EXPRESS*, WHICH HE JOINED IN 1999.

IN 2007, HE WAS RECRUITED BY ANOTHER COMMERCIAL PAPER, *SOUTHERN METROPOLIS DAILY*.

Communist party of China
Guangdong Provincial Committee

南方报业传媒集团
NANFANG MEDIA GROUP

*Southern Daily*
Official mouthpiece of the provincial Party Committee, subsidised by the Party.

*Southern Metropolis Daily* and *Southern Weekend*.
Commercially oriented newspapers.

PARTY-OWNED, *SOUTHERN METROPOLIS DAILY* AND *SOUTHERN WEEKEND* WERE NOT OBLIGED TO PARROT THE PARTY LINE.

ALTHOUGH OFFICIALLY RANKED LOWER THAN THE PARTY ORGAN, THEIR *PROFITABILITY* AND *POPULARITY* GAVE THEM PRESTIGE AND CLOUT.

THEY WERE AMONG THE MOST INDEPENDENT NEWSPAPERS IN CHINA.

THEY WERE ABLE TO PUBLISH GROUNDBREAKING INVESTIGATIVE REPORTS AND CRITICAL COMMENTARIES.

AND THEY GAVE KUANG THE CHANCE TO PUBLISH CARTOONS THAT WOULD NOT HAVE APPEARED IN A PARTY NEWSPAPER.

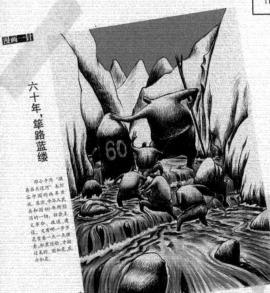

*Left*
When China celebrated the 60th anniversary of the People's Republic in 2009, the party glorified its achievements, but Kuang's artwork focused on the people's hardships, recalling Deng Xiaoping's description of China's progress as being like a person crossing a river by feeling the stones.

HE ALSO TOOK ADVANTAGE OF SOCIAL MEDIA, OPENING A WEIBO ACCOUNT IN 2009.

THIS ALLOWED HIM TO PUBLISH CARTOONS THAT HIS NEWSPAPER WOULD NOT.

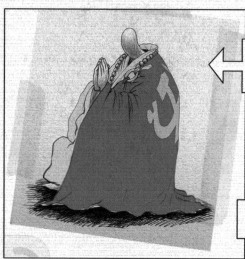

... LIKE THIS ONE, WHICH HINTS AT HOW THE RELIGIOUS FREEDOM OF BUDDHIST MONKS IS THREATENED BY THE PARTY'S INSISTENCE ON ALLEGIANCE TO THE STATE.

ONLINE, HE WAS FREE OF HIS EDITORS' RESTRAINTS.

BUT, IRONICALLY, BEING FREE TO POST HIS WORK PUBLICLY ALSO EXPOSED HIM TO MORE PERSONAL RISK.

THUS, IN 2010, HIS EMPLOYER FINED AND DEMOTED HIM AFTER HE POSTED THIS CARTOON PROTESTING THE BLACKLISTING OF CHANG PING, ONE OF CHINA'S MOST OUTSPOKEN JOURNALISTS.

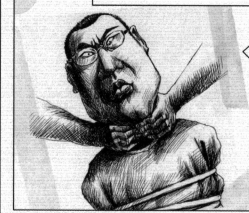

"WHEN I HEARD THE NEWS A FEW DAYS BACK, I DREW THIS PICTURE IN A COMPLETE FURY!" KUANG WROTE.

CHANG HAD BEEN A SENIOR EDITOR AT *SOUTHERN WEEKEND* BUT WAS GRADUALLY SIDELINED.

THE PROPAGANDA DEPARTMENT LATER ORDERED MEDIA TO STOP CARRYING THE WRITER'S ARTICLES.

KUANG INSISTED ON ***TESTING THE LIMITS***, MAKING HIM A REGULAR TARGET FOR CENSORSHIP.

MANY OF HIS ONLINE CARTOONS WERE SHORT-LIVED. SOCIAL MEDIA PLATFORMS WOULD REMOVE EACH ONE AS SOON AS THEY REALISED THAT THEY CROSSED A LINE.

This 2011 cartoon shows someone snipping a green sprout emerging from the Chinese characters for "democracy."

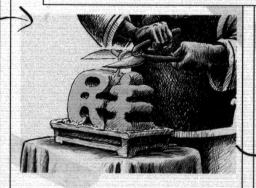

Kuang posted it on QQ after local authorities blocked the candidature of a popular Guangzhou citizen.

QQ deleted the cartoon.

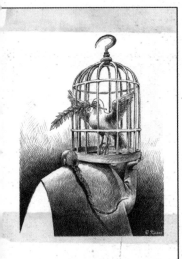

A caged dove of peace, representing dissident writer Liu Xiaobo, is carried away by a feudal jailer.

Kuang posted the cartoon to commemorate the first anniversary of Liu's Nobel Peace Prize award.

Liu, unable to attend the award ceremony in Oslo, was represented on stage by an empty chair.

An empty chair became a protest icon, which was promptly banned. In this 2013 cartoon, Kuang tried to get around the empty-chair ban by placing a tea cup on it.

This 2016 cartoon shows outspoken party critic Ren Zhiqiang getting the Cultural Revolution treatment. Weixin reacted by shutting down Kuang's public account.

Weibo, too, kept deleting his account. And Kuang kept reviving his online presence with new identities such as "Brother Kuang Cartoon 28" and "Brother Kuang Cartoon 32."

AFTER XI JINPING CAME TO POWER IN 2012, THINGS BEGAN TO CHANGE AT THE SOUTHERN MEDIA GROUP AND IN CHINESE JOURNALISM GENERALLY.

XI WASN'T THE ONLY FACTOR THAT SPELLED THE END OF WHAT, IN HINDSIGHT AT LEAST, APPEARS LIKE A GOLDEN AGE FOR POLITICAL CARTOONING AND INDEPENDENT JOURNALISM.

COMMERCIALLY ORIENTED MEDIA STARTED SUFFERING FINANCIALLY, AS ADVERTISING RAPIDLY MOVED ONLINE.

FACED WITH STAGNATING SALARIES, MANY OF THE BEST JOURNALISTS MOVED TO OTHER OCCUPATIONS.

COMMERCIAL NEWSPAPERS' DISAPPEARING PROFITS MEANT THAT THE BALANCE OF POWER IN MEDIA GROUPS SHIFTED BACK TO THE PARTY OUTLETS.

我不干了!

PARTY BOSSES WERE NO LONGER SO TOLERANT OF THEIR COMMERCIAL NEWSPAPERS' FEISTY JOURNALISM.

BY 2013, KUANG BIAO'S EDITORS WERE ROUTINELY REFUSING TO PUBLISH HIS CARTOONS.

AFTER 14 YEARS WITH THE PARTY'S COMMERCIAL NEWSPAPERS, HE QUIT.

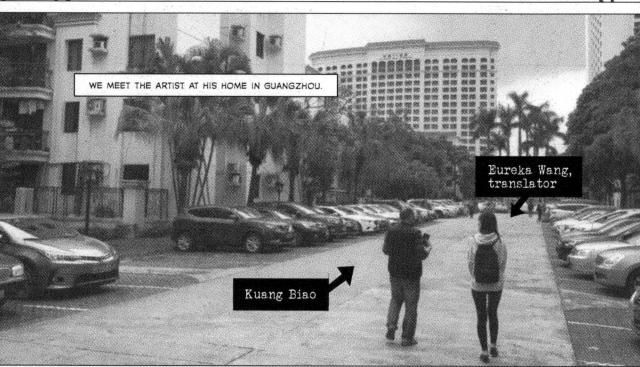

WE MEET THE ARTIST AT HIS HOME IN GUANGZHOU.

Eureka Wang, translator

Kuang Biao

A FRIEND WHO JOINS US FOR LUNCH DESCRIBES THE STATE OF AFFAIRS.

HE IS A DRAGON WHO MUST HIDE HIS TAIL.

KUANG BIAO MAKES A LIVING CONDUCTING CLASSES ON CHINESE CULTURE FOR CHILDREN IN HIS SPRAWLING UPMARKET GATED COMMUNITY.

HE ALSO GIVES FREE ONLINE CLASSES ON CARTOONING, HOPING TO INCULCATE CRITICAL THINKING IN YOUNG CHINESE.

HE REFUSES TO DO COMMISSIONED WORK.

IN COMMUNIST CHINA, CREATING ART FOR CLIENTS, WHETHER STATE OR CORPORATE, CAN ONLY COMPROMISE HIS INDEPENDENCE, HE SAYS.

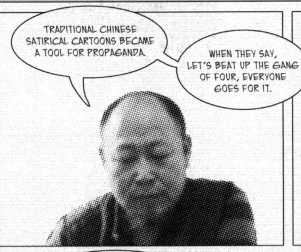

TRADITIONAL CHINESE SATIRICAL CARTOONS BECAME A TOOL FOR PROPAGANDA.

WHEN THEY SAY, LET'S BEAT UP THE GANG OF FOUR, EVERYONE GOES FOR IT.

WHEN THEY NEED TO BEAT UP AMERICAN IMPERIALISM, THERE WILL BE SUCH POSTERS ALL OVER.

MANY CARTOONISTS WHO DO NOT CARE ABOUT INDEPENDENT THINKING WILL WORK ON TOPICS PROPOSED BY THE GOVERNMENT, FOLLOWING THE GOVERNMENT'S TASTES.

I AM DIFFERENT FROM THEM.

I INSIST ON OBSERVING THE WORLD INDEPENDENTLY.

WHAT I CREATE MUST BE CONSISTENT WITH MY VALUES AND A REPRESENTATION OF MY OWN FEELINGS TOWARDS SOCIAL ISSUES.

HAVE THE SECURITY OFFICIALS MET HIM FOR "TEA"?

OF COURSE, I HAVE SERVED THEM TEA RIGHT HERE IN MY OFFICE.

THEY WERE SITTING RIGHT WHERE YOU ARE.

AND THEY PROBABLY KNOW THAT YOU HAVE COME TO MEET ME TODAY.

KUANG BIAO ANSWERS ALL OUR QUESTIONS. BUT, THERE ARE PLACES HE WILL NOT GO ...

SIMILARLY, THE POLITICAL CARTOONS HE POSTS ONLINE NOWADAYS ARE SUBTLE AND ABSTRACT.

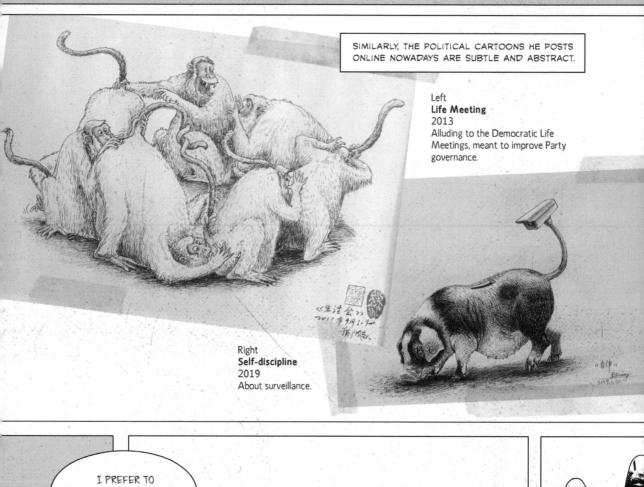

Left
**Life Meeting**
2013
Alluding to the Democratic Life Meetings, meant to improve Party governance.

Right
**Self-discipline**
2019
About surveillance.

I PREFER TO CONVEY MY THOUGHTS INDIRECTLY...

... RATHER THAN USE ART AS A KNIFE TO STAB THE OBJECT.

THE DRAGON MUST HIDE HIS TAIL.

UNLIKE CHINA, **TURKEY** IS NOT A ONE-PARTY STATE; IT HAS PLENTY OF PRIVATELY OWNED MEDIA, AND A RICH, UNINTERRUPTED HISTORY OF SATIRICAL CARTOONING.

BUT, LIKE CHINA, IT'S A SHOWCASE FOR MODERN AUTHORITARIAN CENSORSHIP.

RECEP TAYYIP ERDOĞAN'S AKP GOVERNMENT CAME TO POWER IN 2002. IN ITS FIRST TERM, IT INTRODUCED SOME LIBERALIZING REFORMS ...

... BUT AFTER 2007 IT BACKSLID DRAMATICALLY.

THERE WAS A BIG INCREASE IN INTERNET CENSORSHIP, WITH TENS OF THOUSANDS OF SITES BLOCKED.

AFTER A MILITARY FACTION ATTEMPTED A COUP IN 2016...

...THE GOVERNMENT LAUNCHED A **MASSIVE CRACKDOWN** ON PERCEIVED OPPONENTS.

IN THE FOLLOWING MONTHS, MORE THAN 150 MEDIA OUTLETS WERE CLOSED.

SINCE THE FAILED COUP, TURKEY HAS BEEN THE AMONG THE WORLD'S TOP JAILERS OF JOURNALISTS.

## Journalists in prison, 2020

| | |
|---|---|
| China | 47 |
| Turkey | 37 |
| Egypt | 27 |
| Saudi Arabia | 24 |
| Eritrea | 16 |

JAILED JOURNALISTS INCLUDE *MUSA KART,* CARTOONIST AND BOARD MEMBER OF TURKEY'S OLDEST INDEPENDENT NEWSPAPER, *CUMHURIYET.*

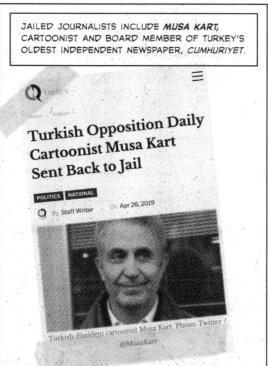

Q Turkey

Home / Politics /

## Turkish Opposition Daily Cartoonist Musa Kart Sent Back to Jail

**POLITICS** **NATIONAL**

Q By Staff Writer    On Apr 26, 2019

Turkish dissident cartoonist Musa Kart. Photo: Twitter / @MusaKart

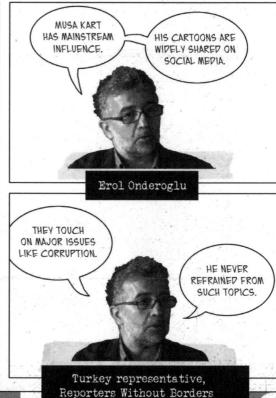

MUSA KART HAS MAINSTREAM INFLUENCE.

HIS CARTOONS ARE WIDELY SHARED ON SOCIAL MEDIA.

Erol Onderoglu

THEY TOUCH ON MAJOR ISSUES LIKE CORRUPTION.

HE NEVER REFRAINED FROM SUCH TOPICS.

Turkey representative, Reporters Without Borders

MUSA KART AND HIS COLLEAGUES WERE IMPRISONED FOR ALLEGEDLY USING *CUMHURIYET* TO SUPPORT TERRORIST ORGANIZATIONS, INCLUDING THE GULENIST MOVEMENT (FETO) BEHIND THE 2016 COUP.

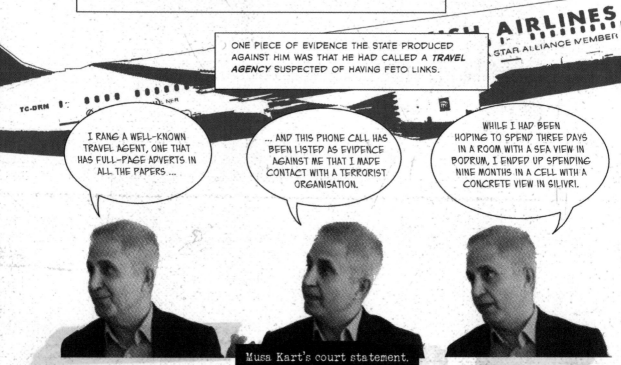

ONE PIECE OF EVIDENCE THE STATE PRODUCED AGAINST HIM WAS THAT HE HAD CALLED A *TRAVEL AGENCY* SUSPECTED OF HAVING FETO LINKS.

I RANG A WELL-KNOWN TRAVEL AGENT, ONE THAT HAS FULL-PAGE ADVERTS IN ALL THE PAPERS ...

... AND THIS PHONE CALL HAS BEEN LISTED AS EVIDENCE AGAINST ME THAT I MADE CONTACT WITH A TERRORIST ORGANISATION.

WHILE I HAD BEEN HOPING TO SPEND THREE DAYS IN A ROOM WITH A SEA VIEW IN BODRUM, I ENDED UP SPENDING NINE MONTHS IN A CELL WITH A CONCRETE VIEW IN SILIVRI.

Musa Kart's court statement.

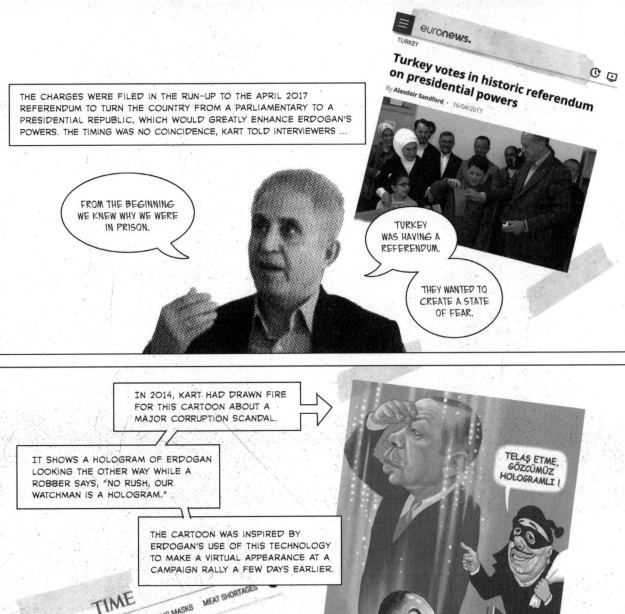

THE CHARGES WERE FILED IN THE RUN-UP TO THE APRIL 2017 REFERENDUM TO TURN THE COUNTRY FROM A PARLIAMENTARY TO A PRESIDENTIAL REPUBLIC, WHICH WOULD GREATLY ENHANCE ERDOGAN'S POWERS. THE TIMING WAS NO COINCIDENCE, KART TOLD INTERVIEWERS ...

**euronews.**

TURKEY

**Turkey votes in historic referendum on presidential powers**

By Alasdair Sandford · 16/04/2017

FROM THE BEGINNING WE KNEW WHY WE WERE IN PRISON.

TURKEY WAS HAVING A REFERENDUM.

THEY WANTED TO CREATE A STATE OF FEAR.

IN 2014, KART HAD DRAWN FIRE FOR THIS CARTOON ABOUT A MAJOR CORRUPTION SCANDAL.

IT SHOWS A HOLOGRAM OF ERDOGAN LOOKING THE OTHER WAY WHILE A ROBBER SAYS, "NO RUSH, OUR WATCHMAN IS A HOLOGRAM."

THE CARTOON WAS INSPIRED BY ERDOGAN'S USE OF THIS TECHNOLOGY TO MAKE A VIRTUAL APPEARANCE AT A CAMPAIGN RALLY A FEW DAYS EARLIER.

TELAŞ ETME, GÖZCÜMÜZ HOLOGRAMLI !

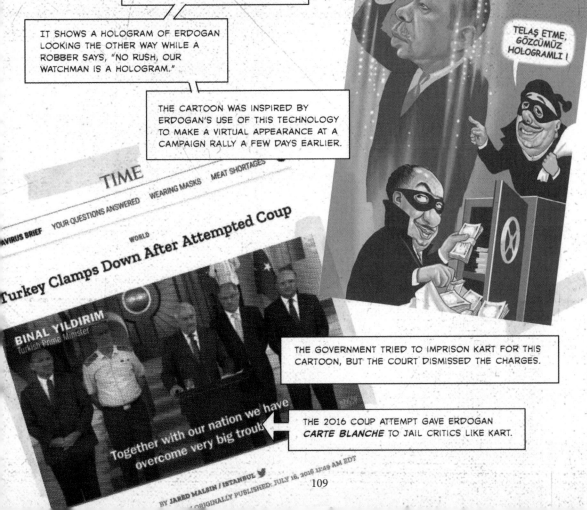

TIME

VIRUS BRIEF   YOUR QUESTIONS ANSWERED   WEARING MASKS   MEAT SHORTAGES

WORLD

**Turkey Clamps Down After Attempted Coup**

BINAL YILDIRIM
Turkish Prime Minister

Together with our nation we have overcome very big troub[le]

THE GOVERNMENT TRIED TO IMPRISON KART FOR THIS CARTOON, BUT THE COURT DISMISSED THE CHARGES.

THE 2016 COUP ATTEMPT GAVE ERDOGAN *CARTE BLANCHE* TO JAIL CRITICS LIKE KART.

BY JARED MALSIN / ISTANBUL   ORIGINALLY PUBLISHED: JULY 16, 2016 11:49 AM EDT

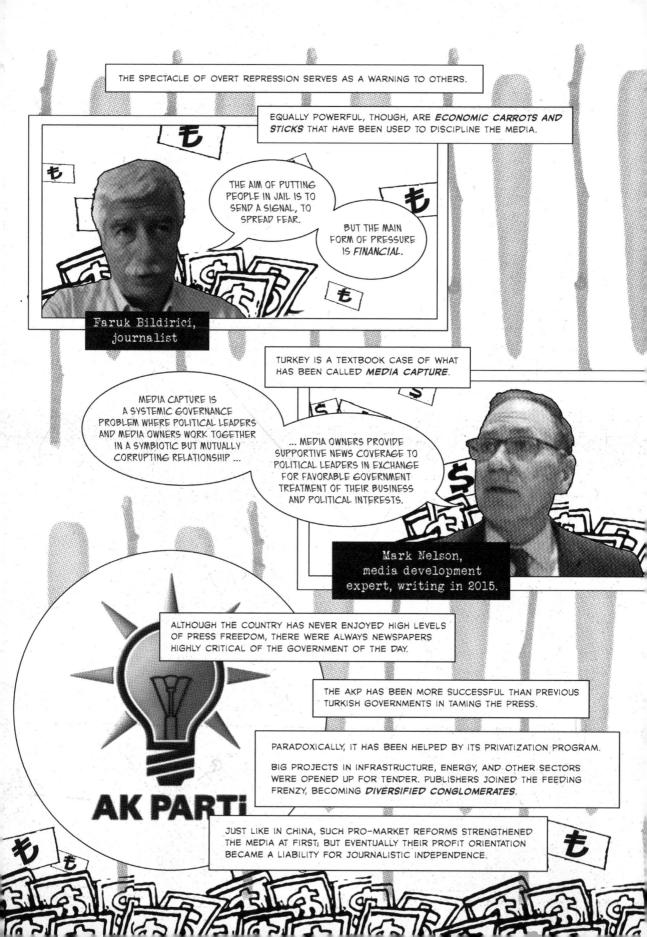

MEDIA OWNERS' INTERESTS IN SECTORS SUCH AS MINING, ENERGY, CONSTRUCTION, AND TOURISM MADE THEM RELIANT ON GOVERNMENT LICENSING, CONTRACTS, AND SUBSIDIES, THUS EXPOSING THEM TO *POLITICAL BLACKMAIL.*

TAKE, FOR EXAMPLE, THE INFLUENTIAL NEWSPAPERS *MILLIYET* AND *HÜRRIYET* ...

MILLIYET AND HÜRRIYET WERE OWNED BY THE *DOGAN GROUP.*

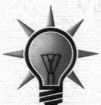

**AK PARTİ**

**Demirören Holding**

**Dogan**

**CNN TÜRK**

**KANAL D** Türkiye'nin Kanalı

INSTEAD OF ATTACKING THE NEWSPAPERS HEAD-ON, THE GOVERNMENT TARGETED THEIR OWNER AYDIN DOGAN'S FORMER INTERESTS IN FUEL RETAILER PETROL OFISI.

DOGAN GAVE UP, SELLING FIRST *MILLIYET* (IN 2009) AND THEN *HURRIYET* AND OTHER MEDIA ASSETS (IN 2011) TO DEMIRÖREN HOLDINGS, A PRO-AKP CONGLOMERATE.

DOGAN HOLDINGS WAS SLAPPED WITH A US$2.5 BILLION FINE FOR TAX EVASION.

THEY PUT PRESSURE ON THE COMPANIES OWNING INDEPENDENT NEWSPAPERS, ON THEIR ADVERTISERS, AND DISTRIBUTORS.

FINANCIAL PRESSURE IS NOT THE WORST, BUT IT IS THE MOST EFFECTIVE MEANS.

ANOTHER MAJOR PAPER THAT'S BEEN PULLED INTO AKP'S ORBIT IS *SABAH.*

ITS FORMER CARTOONIST, *SALIH MEMECAN,* DESCRIBES THE CHANGE....

IN THE PAST, EVEN WHEN WE DISAGREED WITH OUR EDITORS, THEY VALUED US AS CARTOONISTS AND COLUMNISTS.

Faruk was a former ombudsman at *Hurriyet.* He was fired in 2019.

THEY KNEW PEOPLE BOUGHT THE NEWSPAPER FOR OUR VOICES ...

BUT, WITH THE EMERGENCE OF DIGITAL MEDIA, NEWSPAPERS STARTED LOSING SALES REVENUES.

SO THEY AIMED AT GETTING GOVERNMENT CONTRACTS RATHER THAN READERS.

Memecan had a daily front page political cartoon in *Sabah*.

I FELT I DIDN'T FIT, AND I QUIT.

He left the paper in 2016, after 26 years there.

THROUGH SUCH **MARKET CENSORSHIP** AS WELL AS **REPRESSION**, AKP HAS BUILT A BLOC OF LOYALIST MEDIA.

AK PARTI

AK PARTI

ON THE MARGINS, THERE ARE STILL SOME INDEPENDENT MEDIA, INCLUDING THE SATIRICAL CARTOON MAGAZINE *LEMAN*.

TURKEY HAS A LONG TRADITION OF CARTOON-HEAVY MAGAZINES ....

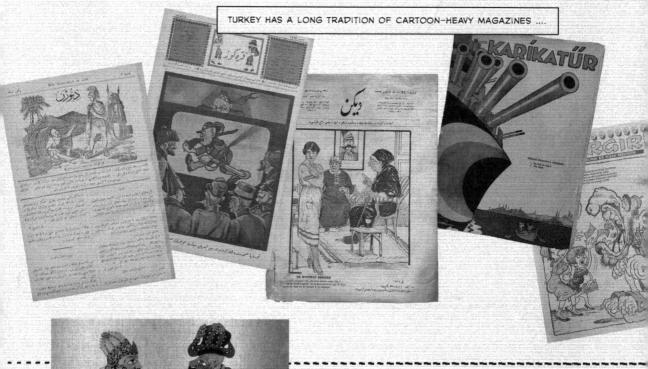

THE APPETITE FOR SATIRE DATES BACK AT LEAST TO OTTOMAN TIMES, WHEN SHADOW PUPPET THEATRE (KARAGOZ) SATIRIZED CURRENT EVENTS, TARGETING OFFICIALS AND SOMETIMES EVEN THE SULTAN.

NOT EVEN ERDOGAN HAS BEEN ABLE TO CRUSH THIS CULTURE TOTALLY.

IN 2004, MUSA KART MADE FUN OF ERDOGAN'S DIFFICULTIES ENACTING A NEW LAW, BY DRAWING HIM AS A CAT CAUGHT IN A BALL OF WOOL.

THE PRIME MINISTER TRIED (UNSUCCESSFULLY) TO SUE THE CARTOONIST.

OBSERVING ERDOGAN'S WRATH AT BEING DRAWN WITH A CAT'S BODY, THE CARTOON MAGAZINE *PENGUEN* TURNED HIM INTO VARIOUS OTHER ANIMALS.

*LEMAN* DECIDED TO GO WITH VEGETABLES.

AFTER A 15-YEAR RUN, THE LOSS-MAKING *PENGUEN* CLOSED IN 2017. *LEMAN* SURVIVES.

*TUNCAY AKGUN*, A FORMER *GIRGIR* CARTOONIST, ESTABLISHED *LEMAN* AS AN INDEPENDENT MAGAZINE IN 1991. IT WAS A REINCARNATION OF *LIMON*, WHICH DIED WHEN ITS PARENT NEWSPAPER WENT BANKRUPT.

*Above*
Tuncay Akgun and colleagues in their office, which they had turned into a mock jail as part of a protest campaign in 1997.

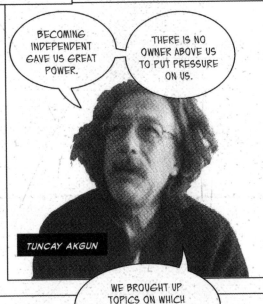

BECOMING INDEPENDENT GAVE US GREAT POWER.

THERE IS NO OWNER ABOVE US TO PUT PRESSURE ON US.

*TUNCAY AKGUN*

WE BROUGHT UP TOPICS ON WHICH MAINSTREAM PUBLISHERS REMAINED SILENT.

LEMAN CONTINUES TO TEST THE RED LINES EVERY WEEK.

*Below*
*LeMan* covers associating Erdogan with dictators Adolf Hitler and Muammar Gaddafi.

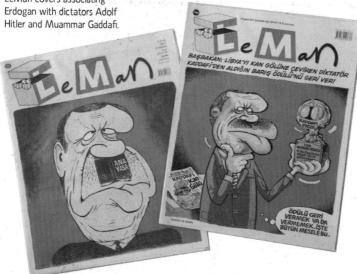

BUT IT'S GETTING HARDER.

FACING THE THREAT OF LAWSUITS AND IMPRISONMENT IS NOTHING NEW TO AKGUN.

BUT THINGS WERE MORE *PREDICTABLE* IN THE PAST, EVEN UNDER MILITARY RULE (1980–82).

NOW THERE IS A HIGHER RISK, BECAUSE YOU DON'T KNOW WHAT TO EXPECT. THERE IS A CONSTANT PRESSURE THAT GOES BEYOND THE LAW, SO WE HAVE GOT TO BE CAREFUL.

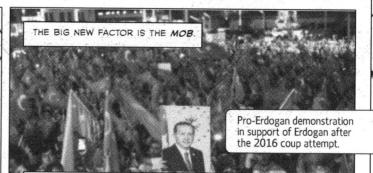

THE BIG NEW FACTOR IS THE *MOB*.

Pro-Erdogan demonstration in support of Erdogan after the 2016 coup attempt.

ERDOGAN HAS A LARGE BASE OF FOLLOWERS WHO CAN BE COUNTED ON TO GO AFTER ANYONE WHO'S NAMED AS AN ENEMY.

REAL SUPPORTERS ARE AUGMENTED BY PAID *TROLL ARMIES* AND BOTS, WHICH SWARM CRITICS AND INTIMIDATE THEM.

IF THEY JAIL EVERYONE, THEY WILL NEED TO JUSTIFY THEIR DECISION TO THE PUBLIC, BOTH LOCALLY AND OVERSEAS.

BUT WHEN TROLLS ATTACK US, WE ARE THE ONLY WITNESSES, IT IS NOT REALLY SEEN FROM THE OUTSIDE SO THAT'S WHY THESE TACTICS ARE MORE EFFECTIVE.

FOLLOWING THE ATTEMPTED COUP, *LEMAN*'S COVER DEPICTED THE COUP'S NERVOUS SOLDIERS AS WELL AS THE MOBS WHO DEFENDED THE REGIME AS PAWNS IN A LARGER GAME …

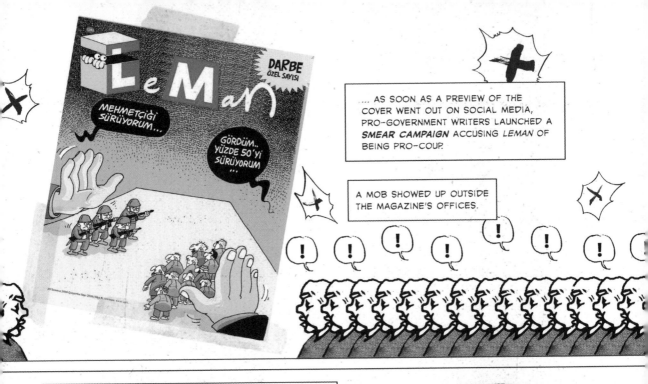

... AS SOON AS A PREVIEW OF THE COVER WENT OUT ON SOCIAL MEDIA, PRO-GOVERNMENT WRITERS LAUNCHED A *SMEAR CAMPAIGN* ACCUSING *LEMAN* OF BEING PRO-COUP.

A MOB SHOWED UP OUTSIDE THE MAGAZINE'S OFFICES.

THE GOVERNMENT GOT A COURT ORDER TO BAN THE ISSUE.

POLICE WENT TO THE MAGAZINE'S PRINTER TO HALT PRODUCTION. COPIES WEREWERE RETRIEVED FROM NEWSSTANDS.

CERTAIN WRITERS IN PARTISAN MEDIA WILL START THE PROCESS, THEY SPREAD HATE VERY OPENLY TO SCARE PEOPLE ...

... THEN THE SYSTEM SPRINGS INTO ACTION.

IT'S THE KIND OF ORCHESTRATED, *INTOLERANT POPULISM* THAT MODERN AUTHORITARIANS HAVE MASTERED—AND THAT AT LEAST ONE NOVELIST PREDICTED MANY YEARS AGO....

"A hideous ecstasy of fear and vindictiveness ... seemed to flow through the whole group of people like an electric current...." - George Orwell, 1984

'Two Minutes Hate' scene from *1984*.

"... Big Brother seemed to tower up, an invincible, fearless protector ... full of power and mysterious calm, and so vast that it almost filled up the screen. Nobody heard what Big Brother was saying.

"It was merely a few words of encouragement, the sort of words that are uttered in the din of battle, not distinguishable individually but restoring confidence by the fact of being spoken."

— George Orwell, 1984

# 5. Gilded Cages
## Censorship by Seduction

# CHERIAN'S STORY

*SINGAPORE.*

IT'S NOT CHINA. OR TURKEY, IRAN, OR NICARAGUA.

IT IS CERTAINLY ILLIBERAL, AND ARGUABLY AUTOCRATIC.

THE GOVERNMENT USES LICENSING LAWS TO KEEP NEWSPAPER OWNERSHIP IN FRIENDLY HANDS.

AND, IT DOESN'T SHY AWAY FROM WIELDING DEFAMATION, SEDITION, CONTEMPT OF COURT, AND OTHER LAWS TO KEEP JOURNALISTS, ARTISTS AND ACTIVISTS IN CHECK.

AFTER THE CHARLIE HEBDO MURDERS, A GROUP OF SINGAPORE'S DISSIDENTS SAID ...

"IT IS A SAD FACT THAT THE ATTACKS AGAINST THE FREE AND INDEPENDENT MEDIA IN PARIS COULD NOT HAVE HAPPENED IN SINGAPORE. NOT BECAUSE MURDERS NEVER HAPPEN IN SINGAPORE (THEY DO) ..."

*Below (Left to right)*
Roy Ngerng, Martyn See, Kenneth Jeyaretnam, Han Hui Hui and Alan Shadrake.

"... BUT BECAUSE THERE WOULD NOT BE ENOUGH INDEPENDENT JOURNALISTS AND CARTOONISTS TO KILL."

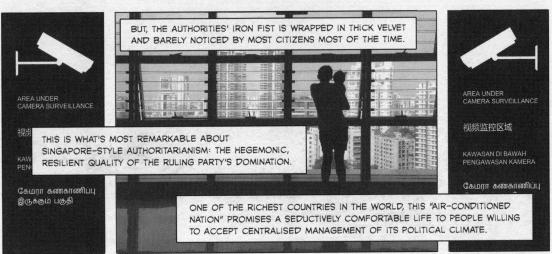

BUT, THE AUTHORITIES' IRON FIST IS WRAPPED IN THICK VELVET AND BARELY NOTICED BY MOST CITIZENS MOST OF THE TIME.

AREA UNDER CAMERA SURVEILLANCE

视频监控区域

KAWASAN DI BAWAH PENGAWASAN KAMERA

கேமரா கண்காணிப்பு இருக்கும் பகுதி

AREA UNDER CAMERA SURVEILLANCE

视频监控区域

KAWASAN DI BAWAH PENGAWASAN KAMERA

கேமரா கண்காணிப்பு இருக்கும் பகுதி

THIS IS WHAT'S MOST REMARKABLE ABOUT SINGAPORE-STYLE AUTHORITARIANISM: THE HEGEMONIC, RESILIENT QUALITY OF THE RULING PARTY'S DOMINATION.

ONE OF THE RICHEST COUNTRIES IN THE WORLD, THIS "AIR-CONDITIONED NATION" PROMISES A SEDUCTIVELY COMFORTABLE LIFE TO PEOPLE WILLING TO ACCEPT CENTRALISED MANAGEMENT OF ITS POLITICAL CLIMATE.

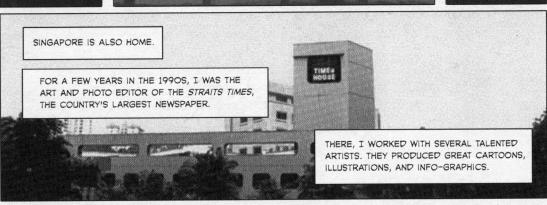

SINGAPORE IS ALSO HOME.

FOR A FEW YEARS IN THE 1990S, I WAS THE ART AND PHOTO EDITOR OF THE *STRAITS TIMES*, THE COUNTRY'S LARGEST NEWSPAPER.

THERE, I WORKED WITH SEVERAL TALENTED ARTISTS. THEY PRODUCED GREAT CARTOONS, ILLUSTRATIONS, AND INFO-GRAPHICS.

BUT, SINGAPORE'S LEADERS WERE OFF-LIMITS.

IT WAS A RED LINE WE NEVER REALLY QUESTIONED.

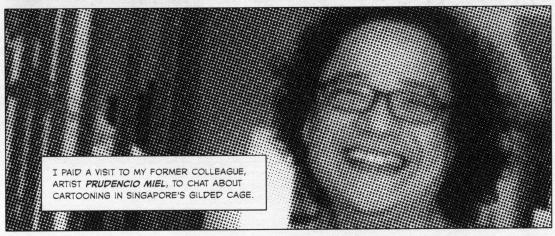

I PAID A VISIT TO MY FORMER COLLEAGUE, ARTIST *PRUDENCIO MIEL*, TO CHAT ABOUT CARTOONING IN SINGAPORE'S GILDED CAGE.

BEFORE HE EMIGRATED FROM THE PHILIPPINES, MIEL HAD BEEN ABLE TO MAKE POLITICAL CARTOONS QUITE FREELY.

THIS WAS A TALENT HE HAD TO REIN IN WHEN HE MOVED TO SINGAPORE IN 1992.

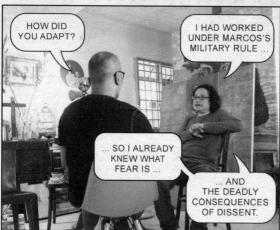

HOW DID YOU ADAPT?

I HAD WORKED UNDER MARCOS'S MILITARY RULE ...

... SO I ALREADY KNEW WHAT FEAR IS ...

... AND THE DEADLY CONSEQUENCES OF DISSENT.

AT THE *STRAITS TIMES*, MIEL DREW PAGE 1 "POCKET" CARTOONS MODELED ON BRITISH PAPERS LIKE THE *DAILY TELEGRAPH*.

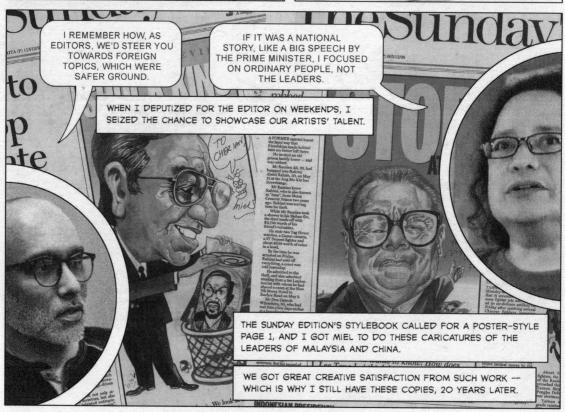

I REMEMBER HOW, AS EDITORS, WE'D STEER YOU TOWARDS FOREIGN TOPICS, WHICH WERE SAFER GROUND.

IF IT WAS A NATIONAL STORY, LIKE A BIG SPEECH BY THE PRIME MINISTER, I FOCUSED ON ORDINARY PEOPLE, NOT THE LEADERS.

WHEN I DEPUTIZED FOR THE EDITOR ON WEEKENDS, I SEIZED THE CHANCE TO SHOWCASE OUR ARTISTS' TALENT.

THE SUNDAY EDITION'S STYLEBOOK CALLED FOR A POSTER-STYLE PAGE 1, AND I GOT MIEL TO DO THESE CARICATURES OF THE LEADERS OF MALAYSIA AND CHINA.

WE GOT GREAT CREATIVE SATISFACTION FROM SUCH WORK -- WHICH IS WHY I STILL HAVE THESE COPIES, 20 YEARS LATER.

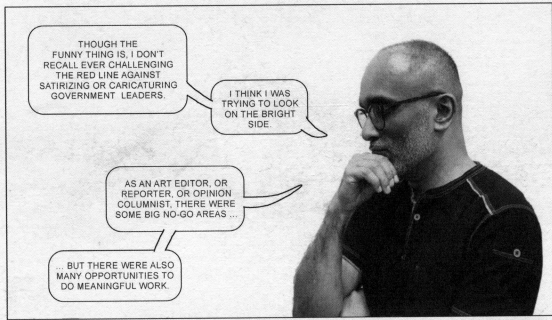

THOUGH THE FUNNY THING IS, I DON'T RECALL EVER CHALLENGING THE RED LINE AGAINST SATIRIZING OR CARICATURING GOVERNMENT LEADERS.

I THINK I WAS TRYING TO LOOK ON THE BRIGHT SIDE.

AS AN ART EDITOR, OR REPORTER, OR OPINION COLUMNIST, THERE WERE SOME BIG NO-GO AREAS ...

... BUT THERE WERE ALSO MANY OPPORTUNITIES TO DO MEANINGFUL WORK.

AND OF COURSE THE JOB PAID WELL.

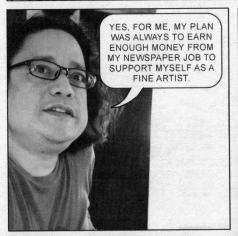

YES, FOR ME, MY PLAN WAS ALWAYS TO EARN ENOUGH MONEY FROM MY NEWSPAPER JOB TO SUPPORT MYSELF AS A FINE ARTIST.

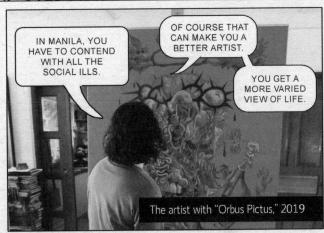

IN MANILA, YOU HAVE TO CONTEND WITH ALL THE SOCIAL ILLS.

OF COURSE THAT CAN MAKE YOU A BETTER ARTIST.

YOU GET A MORE VARIED VIEW OF LIFE.

The artist with "Orbus Pictus," 2019

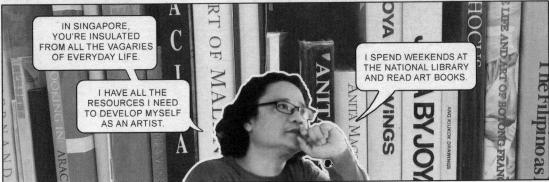

IN SINGAPORE, YOU'RE INSULATED FROM ALL THE VAGARIES OF EVERYDAY LIFE.

I HAVE ALL THE RESOURCES I NEED TO DEVELOP MYSELF AS AN ARTIST.

I SPEND WEEKENDS AT THE NATIONAL LIBRARY AND READ ART BOOKS.

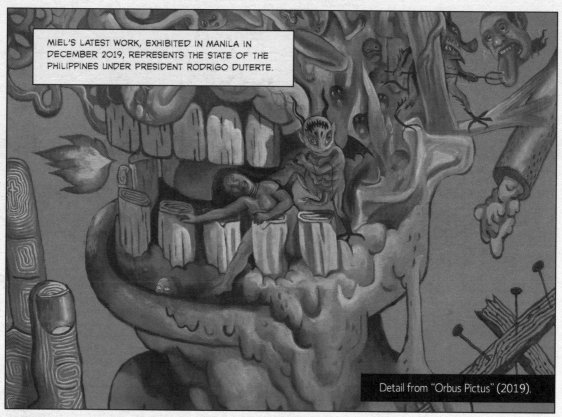

MIEL'S LATEST WORK, EXHIBITED IN MANILA IN DECEMBER 2019, REPRESENTS THE STATE OF THE PHILIPPINES UNDER PRESIDENT RODRIGO DUTERTE.

Detail from "Orbus Pictus" (2019).

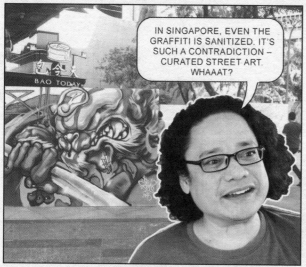

IN SINGAPORE, EVEN THE GRAFFITI IS SANITIZED. IT'S SUCH A CONTRADICTION – CURATED STREET ART. WHAAAT?

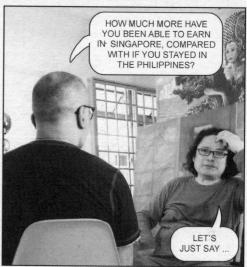

HOW MUCH MORE HAVE YOU BEEN ABLE TO EARN IN SINGAPORE, COMPARED WITH IF YOU STAYED IN THE PHILIPPINES?

LET'S JUST SAY ...

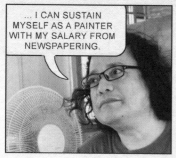

... I CAN SUSTAIN MYSELF AS A PAINTER WITH MY SALARY FROM NEWSPAPERING.

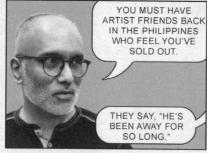

YOU MUST HAVE ARTIST FRIENDS BACK IN THE PHILIPPINES WHO FEEL YOU'VE SOLD OUT.

THEY SAY, "HE'S BEEN AWAY FOR SO LONG."

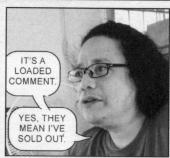

IT'S A LOADED COMMENT.

YES, THEY MEAN I'VE SOLD OUT.

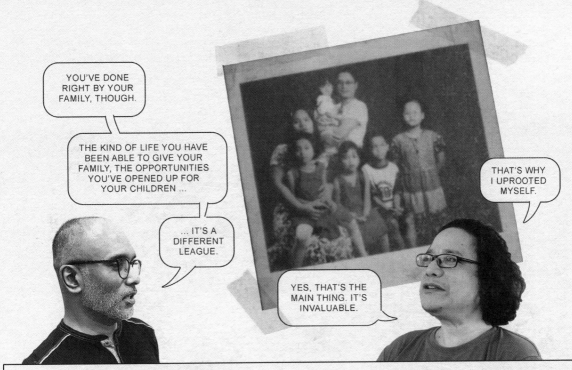
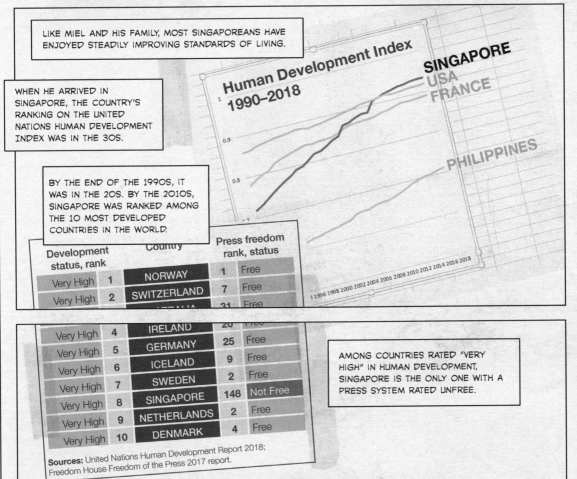

THE ARCHITECT OF SINGAPORE'S MEDIA SYSTEM, LEE KUAN YEW, WAS A "NEOLIBERAL" BEFORE THE TERM WAS COINED.

HE UNDERSTOOD THAT AUTOCRATIC CONTROL DIDN'T REQUIRE SUPPRESSING ECONOMIC MARKETS; ON THE CONTRARY, IF STATES ARE BUSINESS-FRIENDLY, BUSINESSES WILL HELP CONSOLIDATE STATE POWER.

SO, INSTEAD OF NATIONALIZING NEWSPAPER OWNERSHIP, LEE LET THE PRIVATE SECTOR CONTINUE TO MILK PROFITS FROM THE PRESS.

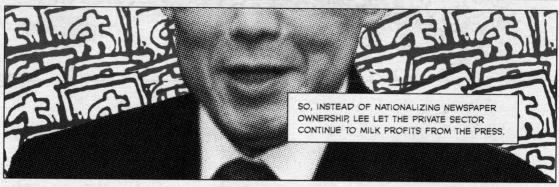

THE *STRAITS TIMES*, FOUNDED IN 1845, WAS ALREADY DOMINANT.

LEE KUAN YEW ENTRENCHED ITS MONOPOLY THROUGH A COMBINATION OF BANS AND GUIDED MERGERS THAT ENDED UP WITH THE CREATION OF A SINGLE NEWS PUBLISHING CORPORATION, SINGAPORE PRESS HOLDINGS.

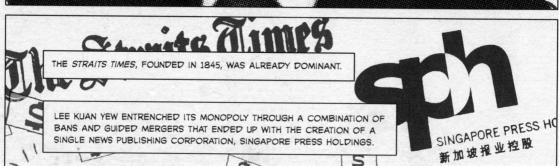

NO WONDER OUR EMPLOYERS WERE HAPPY TO TREAT THE PRESS AS THE GOVERNMENT'S PARTNER IN NATION-BUILDING.

AND SINCE JOURNALISTS, ALONG WITH SHARE-HOLDERS, BENEFITED MATERIALLY FROM THIS ARRANGEMENT, MOST OF US DIDN'T REALLY RESIST.

MIEL AND I KNEW A SINGAPOREAN CARTOONIST WHO TOOK A DIFFERENT ROUTE ...

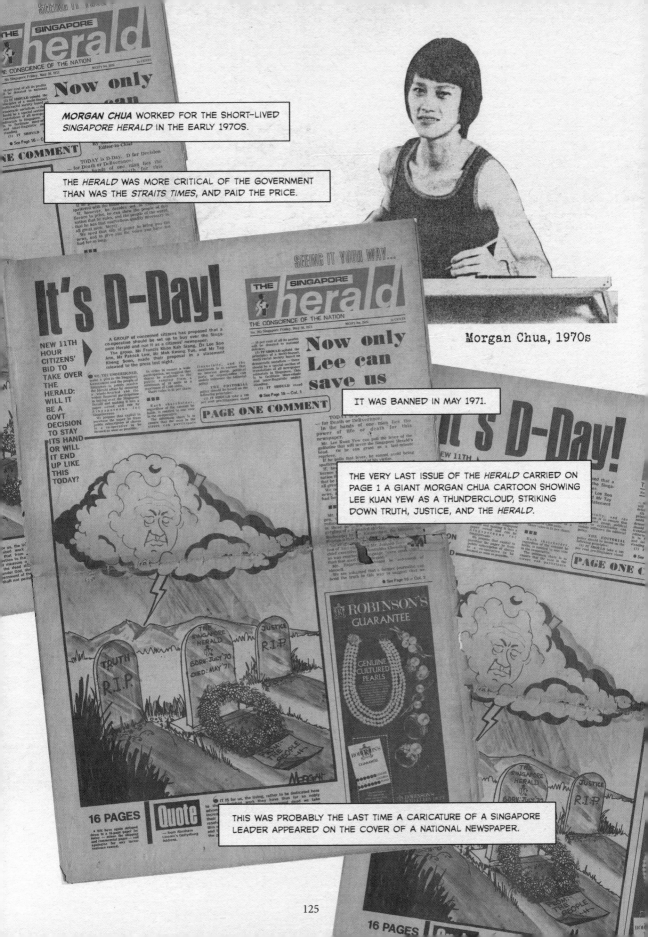

MORGAN CHUA WORKED FOR THE SHORT-LIVED *SINGAPORE HERALD* IN THE EARLY 1970S.

THE *HERALD* WAS MORE CRITICAL OF THE GOVERNMENT THAN WAS THE *STRAITS TIMES*, AND PAID THE PRICE.

Morgan Chua, 1970s

IT WAS BANNED IN MAY 1971.

THE VERY LAST ISSUE OF THE *HERALD* CARRIED ON PAGE 1 A GIANT MORGAN CHUA CARTOON SHOWING LEE KUAN YEW AS A THUNDERCLOUD, STRIKING DOWN TRUTH, JUSTICE, AND THE *HERALD*.

THIS WAS PROBABLY THE LAST TIME A CARICATURE OF A SINGAPORE LEADER APPEARED ON THE COVER OF A NATIONAL NEWSPAPER.

AFTER THE *HERALD* WAS KILLED, CHUA MOVED TO HONG KONG, WHERE HE ENJOYED A LONG AND SUCCESSFUL CAREER WITH THE FEISTY NEWSWEEKLY, *FAR EASTERN ECONOMIC REVIEW* (FEER)

THE MAGAZINE WAS LATER PURCHASED BY DOW JONES, WHOSE NEW YORK CITY EXECUTIVES WERE MORE INTERESTED IN PUMPING RESOURCES INTO THE ASIAN EDITION OF THEIR PRIZED BRAND, THE *WALL STREET JOURNAL*. THEY TERMINATED *FEER* IN 2009.

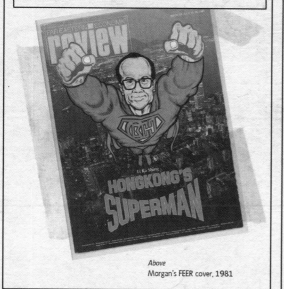

*Above*
Morgan's FEER cover, 1981

LEE KUAN YEW WAS RIGHT: GIVE PROFIT-DRIVEN MEDIA OWNERS ENOUGH ROPE, AND THEY WILL HANG INDEPENDENT JOURNALISM FOR YOU.

IT WAS DOW JONES, NOT LEE KUAN YEW, THAT TOOK AWAY THE RICE BOWL OF SINGAPORE'S TOP POLITICAL CARTOONIST.

MORGAN DIED POOR IN 2018.

## Veteran political cartoonist Morgan Chua dies at 68

HE BELONGED IN A DIFFERENT, MORE INNOCENT, ERA.

IN THE 1960S AND 70S, COMPARED WITH LATER DECADES, THERE WERE MANY MORE ARTISTS, JOURNALISTS, AND INTELLECTUALS WHO BELIEVED THEY COULD FIGHT FOR A FREER SOCIETY AND PREVAIL.

THEY UNDERESTIMATED HOW ASTUTE, UNCOMPROMISING, AND RUTHLESS LEE KUAN YEW WOULD BE IN PURSUING HIS OWN VISION FOR SINGAPORE.

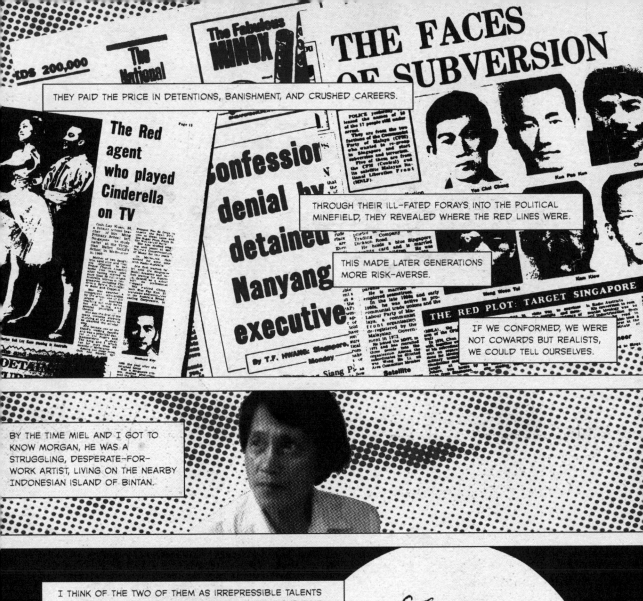

# THE FACES OF SUBVERSION

THEY PAID THE PRICE IN DETENTIONS, BANISHMENT, AND CRUSHED CAREERS.

THROUGH THEIR ILL-FATED FORAYS INTO THE POLITICAL MINEFIELD, THEY REVEALED WHERE THE RED LINES WERE.

THIS MADE LATER GENERATIONS MORE RISK-AVERSE.

IF WE CONFORMED, WE WERE NOT COWARDS BUT REALISTS, WE COULD TELL OURSELVES.

BY THE TIME MIEL AND I GOT TO KNOW MORGAN, HE WAS A STRUGGLING, DESPERATE-FOR-WORK ARTIST, LIVING ON THE NEARBY INDONESIAN ISLAND OF BINTAN.

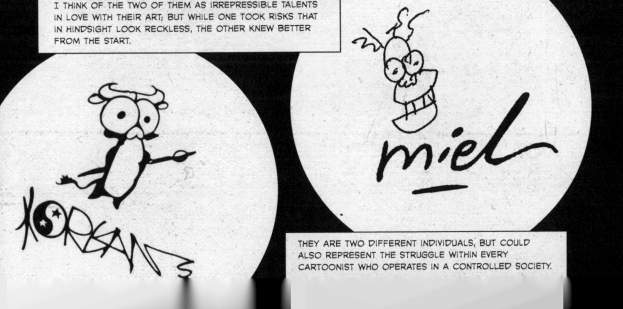

I THINK OF THE TWO OF THEM AS IRREPRESSIBLE TALENTS IN LOVE WITH THEIR ART; BUT WHILE ONE TOOK RISKS THAT IN HINDSIGHT LOOK RECKLESS, THE OTHER KNEW BETTER FROM THE START.

THEY ARE TWO DIFFERENT INDIVIDUALS, BUT COULD ALSO REPRESENT THE STRUGGLE WITHIN EVERY CARTOONIST WHO OPERATES IN A CONTROLLED SOCIETY.

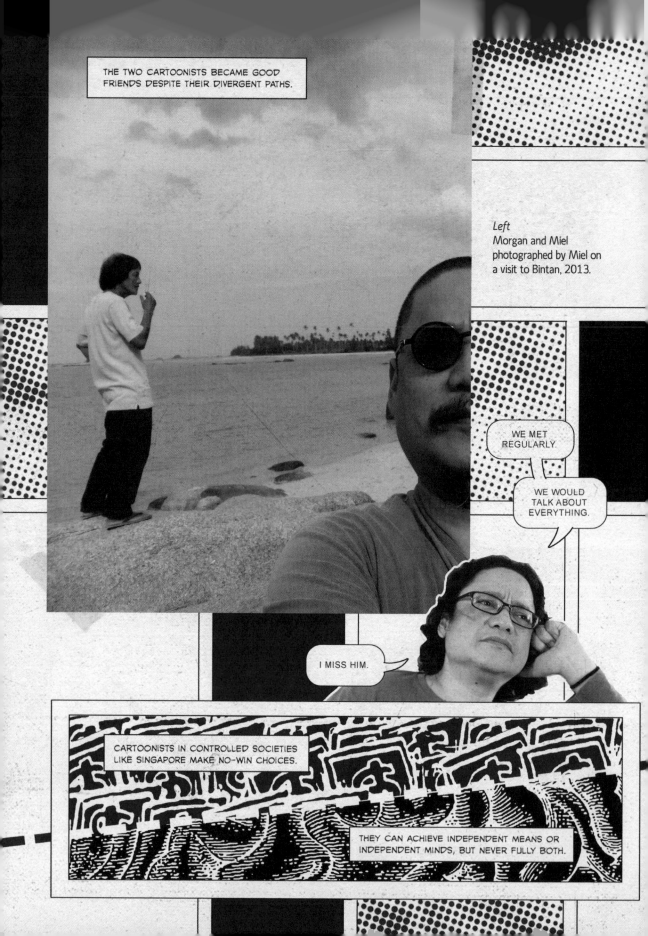

THE TWO CARTOONISTS BECAME GOOD FRIENDS DESPITE THEIR DIVERGENT PATHS.

*Left*
Morgan and Miel photographed by Miel on a visit to Bintan, 2013.

WE MET REGULARLY.

WE WOULD TALK ABOUT EVERYTHING.

I MISS HIM.

CARTOONISTS IN CONTROLLED SOCIETIES LIKE SINGAPORE MAKE NO-WIN CHOICES.

THEY CAN ACHIEVE INDEPENDENT MEANS OR INDEPENDENT MINDS, BUT NEVER FULLY BOTH.

THIS IS A DILEMMA EXPLORED IN THE STORY OF *CHARLIE CHAN HOCK CHYE* -- A TALENTED BUT TRAGIC SINGAPOREAN ARTIST WHOSE LIFE CHOICES PUT HIM ON THE LOSING SIDE OF HISTORY.

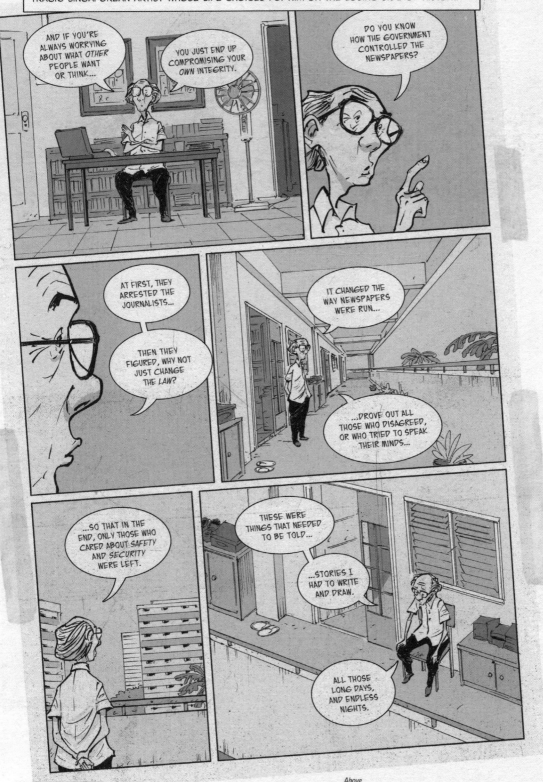

*Above*
Extract from *The Art of Charlie Chan Hock Chye*

## SONNY'S STORY

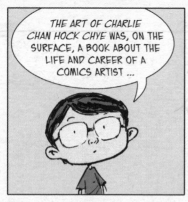

THE ART OF CHARLIE CHAN HOCK CHYE WAS, ON THE SURFACE, A BOOK ABOUT THE LIFE AND CAREER OF A COMICS ARTIST ...

... FEATURING INTERVIEWS WITH CHAN AND HIS COLLABORATORS, ALONG WITH SAMPLES OF HIS ARTWORK: PAINTINGS, SKETCHES AND COMICS PAGES.

EXCEPT OF COURSE CHAN, HIS FRIENDS, AND WORK ARE ALL FICTIONAL CREATIONS.

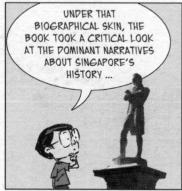

UNDER THAT BIOGRAPHICAL SKIN, THE BOOK TOOK A CRITICAL LOOK AT THE DOMINANT NARRATIVES ABOUT SINGAPORE'S HISTORY ...

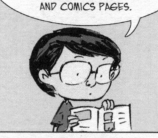

... ASKING, FOR EXAMPLE, WHETHER THERE WAS A GENUINE COMMUNIST THREAT THAT JUSTIFIED THE HARSH MEASURES TAKEN IN THE STATE'S FORMATIVE YEARS.

THE BOOK'S PUBLISHER, EPIGRAM BOOKS, HAD APPLIED FOR, AND RECEIVED, A GRANT OF $8,000 FROM THE NATIONAL ARTS COUNCIL (N.A.C.).

NATIONAL ARTS COUNCIL
SINGAPORE

BUT WHEN *THE ART OF CHARLIE CHAN* WAS RELEASED IN 2015, ITS CONTENTS WERE DEEMED BY THE AUTHORITIES TO BE OBJECTIONABLE, AND THE GRANT WAS WITHDRAWN.

NATIONAL ARTS COUNCIL
SINGAPORE

IN ITS PRESS STATEMENTS, THE N.A.C. CLAIMED THAT THE BOOK "POTENTIALLY UNDERMINE[D] THE AUTHORITY OR LEGITIMACY" OF THE GOVERNMENT.

NATIONAL ARTS COUNCIL
SINGAPORE

GIVEN THE SMALL MARKET FOR MOST LOCAL BOOKS, IT SEEMED LIKELY, AT FIRST, THAT THE GRANT WITHDRAWAL WOULD RESULT IN EPIGRAM LOSING MONEY ON THE PROJECT.

E
EPIGRAM

AS IT TURNED OUT, THE RESULTING ATTENTION WE GOT IN THE PRESS AND SOCIAL MEDIA HELPED RAISE AWARENESS OF, AND SUPPORT FOR, THE BOOK.

IT WENT ON TO BECOME A BESTSELLER, AND IS NOW IN ITS 8TH PRINT RUN HERE IN SINGAPORE.

THE "STREISAND EFFECT" ASIDE, I'D LIKE TO THINK THAT POSITIVE WORD OF MOUTH HAS ALSO HELPED.

IN ADDITION, *THE ART OF CHARLIE CHAN* HAS BEEN CRITICALLY WELL-RECEIVED, PICKING UP SEVERAL LOCAL AND INTERNATIONAL AWARDS.

INCLUDING 3 EISNERS!

CHERIAN

THE RESPONSE FROM THE AUTHORITIES TO THIS SUCCESS HAS LARGELY BEEN MUTED ...

... PERHAPS REFLECTING SOME DISQUIET OVER THE BOOK'S CRITICAL APPROACH TOWARD OFFICIAL STATE NARRATIVES.

SOME WOULD, OF COURSE, ARGUE THAT IT IS UNREASONABLE TO BE CRITICAL OF ANY INSTITUTION, AND STILL EXPECT FINANCIAL SUPPORT FROM IT.

AFTER ALL, IT'S *THEIR* MONEY, SO THEY CLEARLY HAVE THE RIGHT TO DISTRIBUTE THEIR FUNDS HOWEVER THEY SEE FIT!

DON'T BITE THE HAND THAT FEEDS YOU!

BUT ... THIS WOULD SEEM TO CONFLATE THE INTERESTS OF A PARTICULAR POLITICAL *PARTY* WITH THAT OF THE *NATION*.

I MEAN, A *NATIONAL* ARTS COUNCIL'S DISBURSEMENT OF PUBLIC FUNDS IN A DEMOCRACY SHOULD *NOT* BE POLITICISED IN FAVOUR OF ANY ONE PARTY, RIGHT?

BEYOND FUNDING ISSUES, A FAILURE TO DISTINGUISH BETWEEN PARTY AND NATION CAN ALSO RESULT IN SOME TROUBLING MINDSETS ...

... THE SORT THAT LEAD TO ASPERSIONS BEING CAST ON THOSE WHO EXPRESS CRITICISMS OF THE RULING PARTY.

ONE COULD, FOR EXAMPLE, BE BRANDED AS "ANTI-SINGAPOREAN," OR A "TRAITOR."

THOSE WHO ARE A BIT LESS CONTRARY, MIGHT FIND THEMSELVES DESCRIBED AS "LOVING CRITICS" INSTEAD.

OR, AS CHERIAN FRAMES IT ...

END UP ON A *GREY* LIST, RATHER THAN A BLACK ONE.

DOES IT MATTER WHERE A PERSON FALLS ALONG THIS SPECTRUM?

WELL ... WITH THE MAJORITY OF ARTS FUNDING *COMING* FROM STATE INSTITUTIONS, AND STATE OR STATE-LINKED PROJECTS AMONG THE BEST PAYING ...

... GETTING ON THE WRONG SIDE OF THE RULING PARTY MAY ENDANGER ONE'S CAREER PROSPECTS IN THE ARTS ...

... WHILE BEING ON THEIR *RIGHT* SIDE CAN MEAN GAINING ACCESS TO VARIOUS OPPORTUNITIES AND REWARDS.

OF COURSE, VERY LITTLE OF THIS IS EXPLICIT, OFFICIAL POLICY.

A MORE *BENIGN* REASON WILL BE OFFERED AS TO WHY CERTAIN DOORS HAVE BEEN CLOSED, COUCHED USUALLY IN MERITOCRATIC TERMS ...

... WHICH LEAVES YOU AT RISK OF SOUNDING FULL OF YOURSELF IF YOU TRY TO ARGUE THAT YOU REALLY *DID* DESERVE THIS GRANT OR THAT OPPORTUNITY.

SO... WHILE *THE ART OF CHARLIE CHAN* DID ALRIGHT, COMMERCIAL SUCCESS IN THE ARTS IS PARTLY A MATTER OF LUCK, WHICH ISN'T SOMETHING ONE CAN REALLY *PLAN* FOR.

THE FACT REMAINS THAT MANY ARTS ENDEAVOURS HERE RELY ON STATE SUPPORT FOR THEIR FINANCIAL VIABILITY ...

... AND THE GRANT WITHDRAWAL FOR THE BOOK COULD BE SEEN AS A SIGNAL TO THE WIDER ARTS COMMUNITY ...

... REAFFIRMING THE NOTION THAT DEALING WITH CERTAIN SENSITIVE TOPICS CAN MEAN THE LOSS OF FINANCIAL SUPPORT.

LET'S FACE IT: TRYING TO MAKE IT IN THE ARTS IS ALWAYS A TRICKY THING...

SO FOR SOMEONE LOOKING TO PAY THE BILLS, PROVIDE FOR THEIR FAMILIES, OR BUILD A NEST EGG FOR THEIR OLD AGE...

WELL, PERHAPS IT DOES MAKE SENSE *NOT* TO BITE THE HAND HOLDING ALL THAT MONEY!

WHENEVER I DRAW ONE OF THESE MORE POLITICAL CARTOONS, FRIENDS AND FAMILY WARN ME TO BE CAREFUL.

AND TRUTH BE TOLD ...

I ALREADY AM.

**TIME**
**Singapore swings**
Can Asia's nanny state give up its authoritarian ways?

MTV Asia's
Tune-in From
Least, if set
in the Lian City

**CRAZY RICH ASIANS**

THE PEOPLE'S ACTION PARTY (PAP) REGIME IN SINGAPORE IS *NOT* ANTI-ART.

LIKE MANY OTHER POST-INDUSTRIAL SOCIETIES, SINGAPORE HAS INVESTED HEAVILY IN BOOSTING THE CREATIVE INDUSTRIES AND BRANDING ITSELF AS A VIBRANT FIRST WORLD CITY.

(SG)
**Passion Made Possible**

**Lucasfilm boost for S'pore with state-of-the-art facility**
By TAN WEIZHEN

**VIRUS VANGUARD**

ALL THIS MEANS MORE REWARDS FOR TALENTED ARTISTS, DANGLED NOT JUST BY THE PRIVATE SECTOR BUT ALSO BY THE STATE -- THE SINGLE BIGGEST CLIENT FOR CREATIVE SERVICES.

**singapore biennale 2006**

*VARIETY*
**Lucasfilm to build Singapore facility**

We are a city fuelled by passion and pride. Around every corner, incredible experiences crafted, cooked, painted, designed, grown or built by locals who share a common trait: them, you'll be empowered to do what you love in this city of limitless possibilities—whe foodie, explorer, collector, socialiser, action seeker or culture shaper.

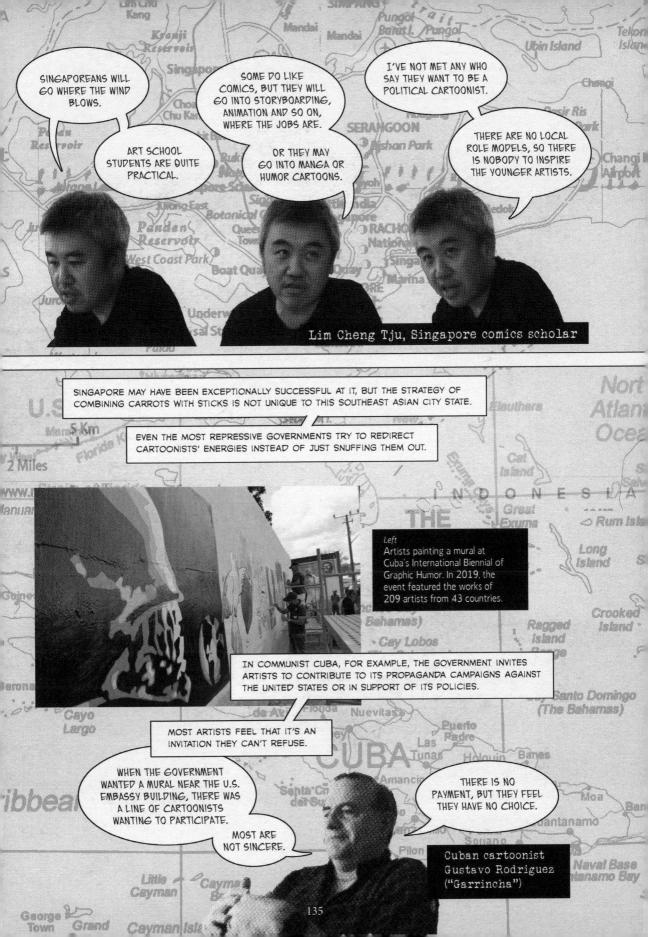

SINGAPOREANS WILL GO WHERE THE WIND BLOWS.

ART SCHOOL STUDENTS ARE QUITE PRACTICAL.

SOME DO LIKE COMICS, BUT THEY WILL GO INTO STORYBOARDING, ANIMATION AND SO ON, WHERE THE JOBS ARE.

OR THEY MAY GO INTO MANGA OR HUMOR CARTOONS.

I'VE NOT MET ANY WHO SAY THEY WANT TO BE A POLITICAL CARTOONIST.

THERE ARE NO LOCAL ROLE MODELS, SO THERE IS NOBODY TO INSPIRE THE YOUNGER ARTISTS.

Lim Cheng Tju, Singapore comics scholar

SINGAPORE MAY HAVE BEEN EXCEPTIONALLY SUCCESSFUL AT IT, BUT THE STRATEGY OF COMBINING CARROTS WITH STICKS IS NOT UNIQUE TO THIS SOUTHEAST ASIAN CITY STATE.

EVEN THE MOST REPRESSIVE GOVERNMENTS TRY TO REDIRECT CARTOONISTS' ENERGIES INSTEAD OF JUST SNUFFING THEM OUT.

*Left*
Artists painting a mural at Cuba's International Biennial of Graphic Humor. In 2019, the event featured the works of 209 artists from 43 countries.

IN COMMUNIST CUBA, FOR EXAMPLE, THE GOVERNMENT INVITES ARTISTS TO CONTRIBUTE TO ITS PROPAGANDA CAMPAIGNS AGAINST THE UNITED STATES OR IN SUPPORT OF ITS POLICIES.

MOST ARTISTS FEEL THAT IT'S AN INVITATION THEY CAN'T REFUSE.

WHEN THE GOVERNMENT WANTED A MURAL NEAR THE U.S. EMBASSY BUILDING, THERE WAS A LINE OF CARTOONISTS WANTING TO PARTICIPATE.

MOST ARE NOT SINCERE.

THERE IS NO PAYMENT, BUT THEY FEEL THEY HAVE NO CHOICE.

Cuban cartoonist Gustavo Rodriguez ("Garrincha")

135

THE MORE EFFECTIVE WAY FOR AN AUTHORITARIAN REGIME TO CO-OPT CARTOONISTS, THOUGH, IS THROUGH ECONOMIC INDUCEMENTS.

THE WORK DOES NOT NEED TO INVOLVE OBVIOUS PROPAGANDA.

IT JUST HAS TO AVOID TABOO THEMES, LIKE CRITICIZING THE GOVERNMENT.

THE MOST SUCCESSFUL VENTURE OF THIS KIND IS PROBABLY THE IRANIAN HOUSE OF CARTOON.

*Above*
Iranian House of Cartoon's Irancartoon.com website.

SUPPORTED BY THE TEHRAN MUNICIPALITY, THE IRANIAN HOUSE OF CARTOON WAS FOUNDED IN 1996 TO HOST EXHIBITIONS, RUN COMPETITIONS, AND PROVIDE TRAINING.

IT SHOT TO GLOBAL INFAMY IN 2006, WHEN IT ORGANIZED A HOLOCAUST CARTOONS COMPETITION AND EXHIBITION, AS A TASTELESS REACTION TO THE DANISH PROPHET MOHAMMED CARTOONS (CHAPTER 13).

ITS 2019 "TRUMPISM" CARTOON AND CARICATURE CONTEST ATTRACTED ENTRIES FROM 625 ARTISTS IN 79 COUNTRIES.

DOMESTICALLY, ITS IMPACT GOES FAR DEEPER.

IT HELPS CHANNEL IRAN'S STREAM OF IMMENSELY TALENTED ILLUSTRATORS AND CARTOONISTS IN APPROVED DIRECTIONS.

*Above:* Iranian cartoonists with online galleries on Irancartoon.com

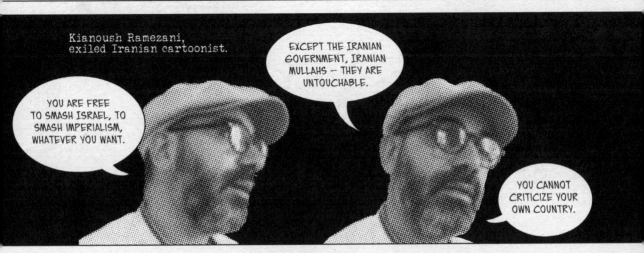

Kianoush Ramezani, exiled Iranian cartoonist.

EXCEPT THE IRANIAN GOVERNMENT, IRANIAN MULLAHS — THEY ARE UNTOUCHABLE.

YOU ARE FREE TO SMASH ISRAEL, TO SMASH IMPERIALISM, WHATEVER YOU WANT.

YOU CANNOT CRITICIZE YOUR OWN COUNTRY.

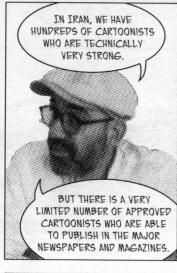

IN IRAN, WE HAVE HUNDREDS OF CARTOONISTS WHO ARE TECHNICALLY VERY STRONG.

BUT THERE IS A VERY LIMITED NUMBER OF APPROVED CARTOONISTS WHO ARE ABLE TO PUBLISH IN THE MAJOR NEWSPAPERS AND MAGAZINES.

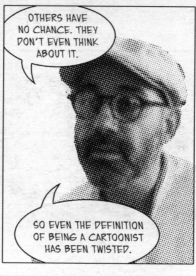

OTHERS HAVE NO CHANCE. THEY DON'T EVEN THINK ABOUT IT.

SO EVEN THE DEFINITION OF BEING A CARTOONIST HAS BEEN TWISTED.

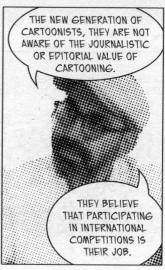

THE NEW GENERATION OF CARTOONISTS, THEY ARE NOT AWARE OF THE JOURNALISTIC OR EDITORIAL VALUE OF CARTOONING.

THEY BELIEVE THAT PARTICIPATING IN INTERNATIONAL COMPETITIONS IS THEIR JOB.

THEY BECOME PROFESSIONAL CONTEST PARTICIPANTS.

HOUSE OF CARTOON IS LED BY PRESIDENT-FOR-LIFE MASSOUD SHOJAI TABATABAI AND HIS CLOSE ASSOCIATE HOSSEIN NIROOMAND.

THE TWO EMERGED FROM *KAYHAN CARICATURE*, A PUBLICATION OF THE CONSERVATIVE KAYHAN INSTITUTE. THEY HAVE CLOSE CONNECTIONS WITH THE COUNTRY'S SECURITY, POLITICAL, AND IDEOLOGICAL APPARATUS.

CRITICS SAY SHOJAI PLAYS THE ROLE OF A BROKER IN THE STATE'S DISPENSATION OF PATRONAGE AND PUNISHMENT.

YOU CAN'T GO FAR -- OR STAY CLEAR OF TROUBLE -- IF YOU ARE NOT VALIDATED BY THE PRESIDENT OF THE HOUSE OF CARTOON.

SHOJAI TABATABAI

IN HIS 1983 BOOK, *THE VELVET PRISON*, MIKLOS HARASZTI OBSERVED HOW ARTISTS WERE CO-OPTED WITH THE HELP OF THE FIELD'S OWN LEADERS AFTER "PRIMITIVE TOTALITARIANISM" EVOLVED INTO "STATE SOCIALISM" IN EASTERN EUROPE'S COMMUNIST REGIMES.

PARTNERSHIP DISPLACES DICTATORSHIP ... STICKS ARE EXCHANGED FOR CARROTS.

WHERE THE STATE IS CHARITABLE, ARTISTS WILL TRY HARD NOT TO GIVE OFFENSE.

GENEROSITY FROM ON HIGH WILL BE MATCHED BY DOCILITY FROM BELOW.

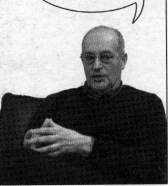

THUS, THE GILDED CAGE EXISTS NOT ONLY IN SOFT AUTHORITARIAN SOCIETIES LIKE SINGAPORE BUT ALSO IN CLOSED, REPRESSIVE COUNTRIES.

NOT SURPRISINGLY, MANY CARTOONISTS FROM AUTHORITARIAN SOCIETIES FLEE TO THE WEST.

KIANOUSH RAMEZANI, FOR EXAMPLE, FOUND FREEDOM IN FRANCE.

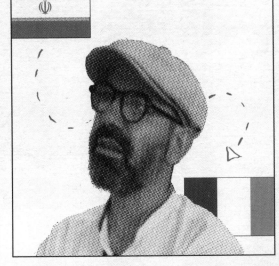

SUDANESE CARTOONIST KHALID ALBAIH, TOO, HAS SOUGHT REFUGE IN COUNTRIES MORE ACCOMMODATING TO HIS PRO-DEMOCRATIC VALUES, MOSTLY IN THE RELATIVELY FREE QATAR.

HE HAS BENEFITED FROM RESIDENCIES IN THE UNITED STATES, AND IN 2017 MOVED TO DENMARK UNDER THE INTERNATIONAL CITIES OF REFUGE NETWORK (ICORN), FOR ARTISTS AND WRITERS UNDER THREAT.

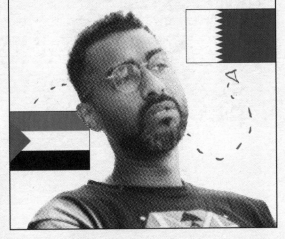

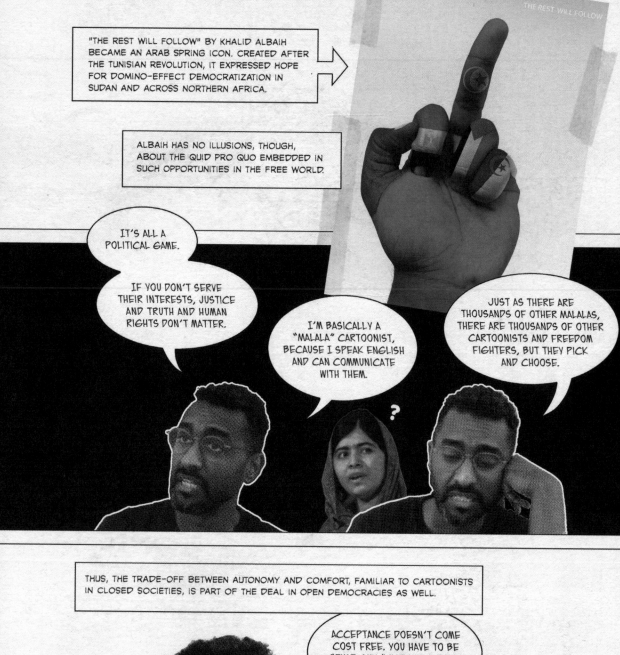

"THE REST WILL FOLLOW" BY KHALID ALBAIH BECAME AN ARAB SPRING ICON. CREATED AFTER THE TUNISIAN REVOLUTION, IT EXPRESSED HOPE FOR DOMINO-EFFECT DEMOCRATIZATION IN SUDAN AND ACROSS NORTHERN AFRICA.

ALBAIH HAS NO ILLUSIONS, THOUGH, ABOUT THE QUID PRO QUO EMBEDDED IN SUCH OPPORTUNITIES IN THE FREE WORLD.

IT'S ALL A POLITICAL GAME.

IF YOU DON'T SERVE THEIR INTERESTS, JUSTICE AND TRUTH AND HUMAN RIGHTS DON'T MATTER.

I'M BASICALLY A "MALALA" CARTOONIST, BECAUSE I SPEAK ENGLISH AND CAN COMMUNICATE WITH THEM.

JUST AS THERE ARE THOUSANDS OF OTHER MALALAS, THERE ARE THOUSANDS OF OTHER CARTOONISTS AND FREEDOM FIGHTERS, BUT THEY PICK AND CHOOSE.

THUS, THE TRADE-OFF BETWEEN AUTONOMY AND COMFORT, FAMILIAR TO CARTOONISTS IN CLOSED SOCIETIES, IS PART OF THE DEAL IN OPEN DEMOCRACIES AS WELL.

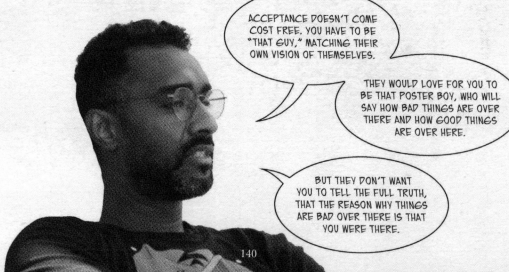

ACCEPTANCE DOESN'T COME COST FREE. YOU HAVE TO BE "THAT GUY," MATCHING THEIR OWN VISION OF THEMSELVES.

THEY WOULD LOVE FOR YOU TO BE THAT POSTER BOY, WHO WILL SAY HOW BAD THINGS ARE OVER THERE AND HOW GOOD THINGS ARE OVER HERE.

BUT THEY DON'T WANT YOU TO TELL THE FULL TRUTH, THAT THE REASON WHY THINGS ARE BAD OVER THERE IS THAT YOU WERE THERE.

AMERICANS DON'T WANT TO THINK ABOUT HOW THE UNITED STATES IS DEEPLY INVOLVED IN HOW CORRUPT SOUTH AMERICA IS.

THEY'RE COOL ABOUT TALKING ABOUT ARAB DICTATORS BUT ONCE YOU BRING UP ISRAELI COLONIALISM, THEY DON'T WANT TO TALK ABOUT IT.

SO MOST OF US END UP LIVING BETWEEN A ROCK AND A HARD PLACE.

DO WE STAY AT HOME TO BE THREATENED BY AUTHORITARIAN REGIMES AND NOT HAVE FULL INDEPENDENCE AND FREEDOM?

OR DO WE TRY TO GET TO THE WEST TO BE FREE, BUT BECOME A POSTER CHILD FOR HOW GOOD THE WEST IS ...

... EVEN THOUGH IT SUPPORTS THE VERY AUTHORITARIAN REGIMES THAT SUPPRESS US, BY SELLING WEAPONS AND MORE?

YES, YOU CAN SAY WHATEVER YOU WANT IN THE WEST ...

... BUT YOU WOULD GET LABELLED AS THE ANGRY BLACK MAN, THE LEFTIST, THE CRAZY GUY FROM DOWN THE STREET.

THEY WILL PUT YOU IN THAT BOX, AND THEN YOU LOSE ACCESS TO THE PRESS.

I PLAY THE GAME.

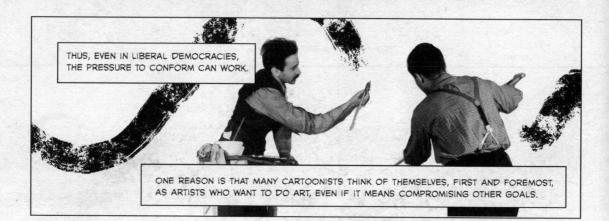

THUS, EVEN IN LIBERAL DEMOCRACIES, THE PRESSURE TO CONFORM CAN WORK.

ONE REASON IS THAT MANY CARTOONISTS THINK OF THEMSELVES, FIRST AND FOREMOST, AS ARTISTS WHO WANT TO DO ART, EVEN IF IT MEANS COMPROMISING OTHER GOALS.

POLITICAL CARTOONING IS THREE COMBINED PROFESSIONS: DRAWING, JOURNALISM, AND HUMOR.

IF YOU ASK ME WHETHER I AM MAINLY A DRAWER OR JOURNALIST OR HUMORIST, I WILL TELL YOU THAT I AM MAINLY A DRAWER.

AND IF YOU TOLD ME I HAVE TO GIVE UP DRAWING, JOURNALISM OR HUMOR ...

... I WOULD OPT TO KEEP DRAWING, AND DRAW SOMETHING ELSE INSTEAD OF POLITICAL CARTOONING.

Patrick Lamassoure (Kak), cartoonist, 'L'Opinion'

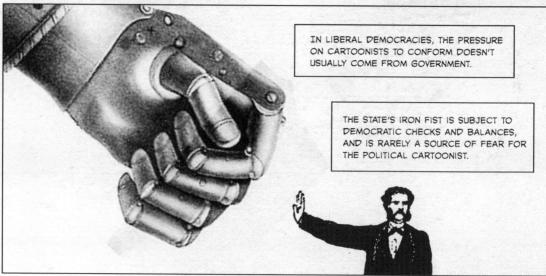

IN LIBERAL DEMOCRACIES, THE PRESSURE ON CARTOONISTS TO CONFORM DOESN'T USUALLY COME FROM GOVERNMENT.

THE STATE'S IRON FIST IS SUBJECT TO DEMOCRATIC CHECKS AND BALANCES, AND IS RARELY A SOURCE OF FEAR FOR THE POLITICAL CARTOONIST.

142

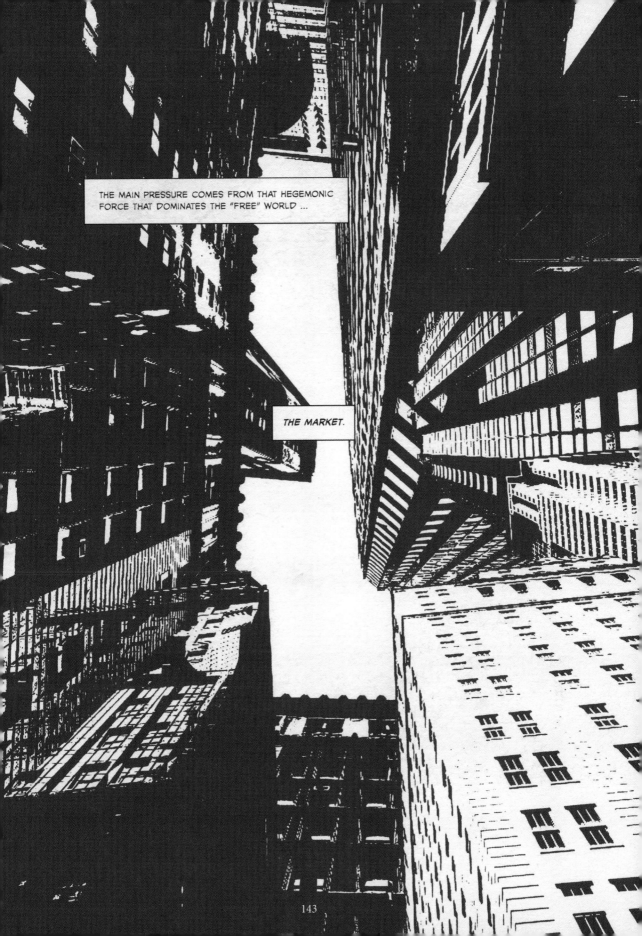

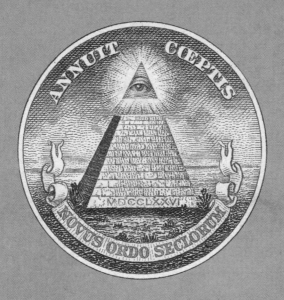

# 6. Market Censorship

### Freedom for Those
### Who Own a Press

_____

_____

_____

# THE DAILY CARTOONIST

# Endangered species found in the wild

**Newspaper cartoonists with virtually unlimited autonomy epitomize the special place that liberal democracies give to satire and ridicule of the powerful. They are now a rare breed.**

ON HIS RIGHT HAND, Canadian cartoonist Terry Mosher wears a ring his wife gave him in 2004. It is made up of 13 skulls – representing the editors he outlasted at his newspaper, *The Montreal Gazette*.

Like other cartoonists in liberal democracies, Mosher does not have to worry about government restrictions, thanks to constitutionally protected rights that are the envy of peers in other countries. He can skewer the country's leaders and its armed services without fear of arrest, or being attacked by police and paramilitaries, or getting sacked at the behest of a government official.

On top of that, he enjoys a privilege that is rare even in the freest of democracies: a fixed space in an influential media outlet, and nearly total autonomy to express his views on the news of the day with little, if any, editorial interference.

**Terry Mosher**

**13 skull ring**

Mosher is thus part of the elite band of editorial cartoonists enjoying a status close to the level of top opinion columnists.

He is not a member of the *Gazette*'s full-time staff, but the paper is contractually bound to pay him even in the rare event that editors reject a cartoon. It's been that way since 1976.

"My contract states that the newspaper will buy first rights to a given number of cartoons from me," he says. "The newspaper then has the right to publish the cartoon or not – but I am paid for it anyway. . After a short period of time, all rights to the cartoons revert to me – ownership of originals, syndication income and so on."

Ann Telnaes of the *Washington Post* and Martin Rowson of the *Guardian* in Britain have similar deals. In South Africa, Brandan Reynolds is another member of this privileged club, drawing seven cartoons a week for his newspaper group.

"SHOULDER to SHOULDER

STEPHEN HARPER SCHOOL of CABINETRY...

## RIDICULING THE POWERFUL WITH IMPUNITY

**Top:** Terry Mosher ("Aislin") on Canada's promise to stand "shoulder to shoulder" with the United States in the war on terror, and Premier Stephen Harper's characterless cabinet.

**Right:** Ann Telnaes takes on the powerful gun lobby in the United States.

**Below, left:** Rodolphe Urbs in France's *SudOuest*, on the hysteria over the death of former president Jacques Chirac. A Roman soldier tells a crucified Christ: "Seriously dude, stop thinking you're Chirac."

**Below, right:** South Africa's Brandan Reynolds on state capture by big business.

OUR GUN LAWS WILL CHANGE

OUR GUN LAWS WON'T CHANGE

NRA

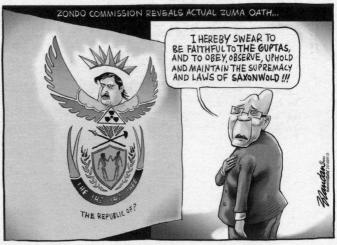

# Media vs. the mob

**The buck stops with me, an Indonesian editor tells religious hardliners acting up over a cartoon. He exemplifies the kind of protection a cartoonist should expect when working for a free press.**

JAKARTA, INDONESIA — On 16 March 2018, hundreds of members of a hardline Muslim organization descended on the offices of Indonesia's leading news magazine, *Tempo*, to complain about a cartoon that made fun of the group's exiled leader.

*Tempo* is a bastion of investigative journalism and liberal commentary in the world's third largest democracy. Its hard-hitting political reporting got it banned for four years in the 1990s, under the authoritarian reign of President Suharto.

When Suharto fell in 1998, Indonesia swiftly rewrote its constitution and media laws. Since then, Indonesian jour-

nalists have not needed to fear political censorship by government leaders.

Instead, the main opponents of press freedom are anti-democratic religious na-

tionalists – the dark side of the people power that flourished after Suharto was overthrown.

One such group is the Islamic Defenders Front

The 26 February 2018 edition of the *Tempo* Magazine carried this cartoon alluding to Rizieq Shihab, leader of the Islamic Defenders Front, FPI. After being charged in a pornography case in 2017, he left for Saudi Arabia. His anxious followers awaited his reappearance. In the cartoon, a cleric apologizes for not being able to return. The girl complains that he had been cruel to her. The cartoon borrows a well-known café scene from a hit romantic comedy.

(Front Pembela Islam, FPI).

FPI is to the manufacture of religious outrage what Nike is to shoes. They've got strong brand recognition and a big chunk of the market, achieved largely through cheap labor and clever marketing. They've been described as a morality racket – they tend to leave you alone once a donation is deposited into the right bank account – but nobody in public life can afford to ignore them. In 2016, FPI played a leading role in the downfall of Jakarta's Chinese Christian governor, whom they accused of blasphemy.

So, when an angry FPI delegation showed up at *Tempo*, chief editor Arif Zulkifli (not to mention the cartoonist) had reason to be nervous.

But, thanks to its deeply cherished democratic values, the magazine has a policy of hearing out groups with grievances about its journalism.

"We believe we must be open, transparent and accountable to the public," Arif says. So, FPI leaders

Arif Zulkifli

Yuyun Nurrachman

were ushered into Tempo's meeting room.

As for the cartoonist, Yuyun Nurrachman, it was his day off when FPI came calling.

He watched it all on TV. "FPI is very intimidating. They had named me on social media, so I was anxious," he recalls.

"They asked to meet me. But the editor told them it was not necessary. He took responsibility."

Arif apologised for the impact of the cartoon on FPI members' feelings – but not for publishing it.

The apology was enough, but they wanted him to repeat it to the crowd gathered outside.

He obliged, braving a parking lot overrun by FPI members, mounting their lorry and taking the mic. Arif spent several minutes defending *Tempo*'s policies, and apologising for the impact of the cartoon. At one point, an FPI supporter lashed out and flung off Arif's spectacles. But, once their performance of outrage was over, the crowd dispersed.

*Tempo* still publishes Yuyun's and other cartoonists' work. And, Arif still has his glasses. "They are very hardy."

**Above, left:** FPI leaders confront editor Arif Zulkifli (extreme right).
**Above, right:** Arif (2nd from left) atop FPI's vehicle, addressing the protesters.

# Not all good news

Cartoonists like Yuyun Nurrachman and Terry Mosher enjoy enviable democratic freedoms.

Government censorship is almost non-existent.

In addition, they can count on job security, professional autonomy, and protection from intolerant public opinion.

But, none of these conditions are guaranteed. They face limitations that — while nowhere as restrictive or dangerous as authoritarian red lines — compel us to question the freedoms of "free" societies ...

# CAPITALIST TIMES

A FINANCIAL REALITY CHECK

## Order restored after worker vandalizes comic franchise

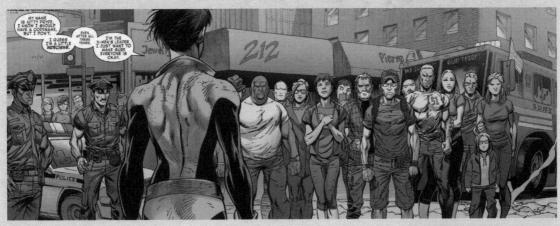

**"Freedom of the press is guaranteed only to those who own one,"** wrote media critic A.J. Liebling in 1960. Artists who challenge that principle quickly learn who's boss.

MARVEL UNIVERSE — When Ardian Syaf was drawing art for Marvel Comics' X-Men Gold series, the Indonesian artist inserted references to his country's biggest recent political controversy. After he shared his handiwork on Facebook, he was slammed for adding messages seen as anti-Christian and anti-Jewish. Within a week, Marvel terminated his contract. The offending artwork would be removed from future printings, the company said.

The artist claimed he merely wanted to ccommemorate a rally that he had taken part in. But what nobody disputed was Marvel's stand that he had no right to use its comic book for his own political self-expression. As one visitor to his Facebook put it: "You dont bite the hand that feed you, unless you are a dog, a very stupid dog."

In a world ruled by capitalist values, the artist's right to express himself through his labor is limited by the publisher's ownership of intellectual property. "I don't think this is about freedom of expression, it's about breaking a contractual understanding in an attempt to sneak something by the bosses," says Charles

**Top:** The artist added a store sign "Jewelry" next to Jewish heroine Kitty Pryde's neck. The "212" in the middle refers to 2 December, the day in 2016 when Jakarta saw a major demonstration against its Chinese Christian governor. 212 became a tag for the Islamist movement against Indonesia's multi-religious democracy. **Above:** "QS 5:51" on the t-shirt refers to the Quranic passage that hardliners claim forbids voting for a non-Muslim leader.

Brownstein, founder of the Comic Book Legal Defense Fund, which has fought many battles against censorship.

"The person or organization who owns the intellectual property has a right to control how that property is used. My personal view is that if you're going to say something, make something new. Syaf could have developed his own science fiction story about mutant heroes and placed any message he wanted in there and either shopped it to other publishers or published it himself. He didn't do that. He inserted unauthorized content into work he was contracted to execute in the context of a work-for-hire agreement."

# Freedom, with strings attached

**Unlike most comic book artists, political cartoonists are hired to express their own opinions. But, even they know the pencil isn't mightier than the purse.**

In South Africa, Brandan Reynolds draws seven cartoons a week for national newspapers, with negligible supervision. He stopped sending sketches to his editors for approval years ago. Interviewed in August 2019, he said that there was not a single occasion that year when his cartoon was rejected.

He acknowledges that the main reason the relationship is so smooth is that his own viewpoints are in sync with his newspapers'. "In fact I can usually predict the editorial line on most issues," he says.

Thus, friction-free relations between cartoonists and publishers are as much about fit as about freedom. In Turkey, *Cumhuriyet* was a champion of press freedom. (This was eventually too much for the government to take. See Chapter 4.) But Ramize Erer's feminist cartoons were too radical for the upmarket daily newspaper.

She was fired after six months. In contrast, when she moved to *Radikal*, she fit right in. "Reactions were still coming in, but the editors protected me. They told me that I could draw whatever I wanted, that I should not self-censor," she says.

At its best, the relationship between cartoonist and editor is one of mutual respect and trust, each appreciating the other's skills. "Good editors save you from your own stupid impulses," says American cartoonist Ted Rall.

Turkish cartoonist Ramize Erer and a sample of her taboo-breaking work.

Some of *Cumhuriyet*'s readers, and then its editors, felt that Erer's cartoons were immoral.

Patrick Chappatte's practice when he was working for the *New York Times* was to let editors vote on a set of sketches. He didn't always go with the most popular idea, but he would kill the one with fewest votes. "It is a sign that the cartoon just doesn't work."

French cartoonist Patrick Lamassoure ("Kak") acknowledges that relations can get too cosy, resulting in self-censorship. He works full-time for *L'Opinion*, which he describes as "rather studious." He has encountered no censorship, but admits this is partly because he does not attempt to draw cartoons that are too shocking or vulgar for *L'Opinion*. "You know your readers, you know your editor, you know the publication for which you work," he says. "Sometimes I draw that idea just to make my chief editors laugh, but I know that they would not run it."

Most editorial cartoonists accept the final authority of editors as protectors of the news outlet's reputation and standards.

> ## "Most of the time I agree with the editors' position."
> Brandan Reynolds

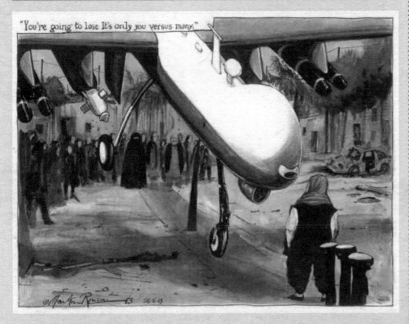

"You're going to lose It's only you versus many."

**Above:** Martin Rowson drew this cartoon in 2013, soon after a soldier in Britain was slashed to death by two Muslim men. The most extraordinary thing about the incident was a female passerby who confronted the assailants and engaged them in conversation. She told them they were outnumbered and would lose. The lengthy exchange was caught on video and caused a sensation in the British media.

Rowson transferred the scene to Afghanistan, showing a woman confronting a drone with the same words used by the Brit: "You're going to lose. It's only you versus many." Appearing just days after the attack, the cartoon was making a comparison that most British newsapers would have deemed offensive. But, Rowson's uncompromising left-wing view of politics suits the *Guardian*'s sensibilities, he says. An editor even helped with this piece. "I had the germ of an idea but I wanted to make sure it was absolutely perfect. I discussed it with the comment editor, what wording we should use, and it was really really helpful."

> ## "When you work for a publication you have to put yourself in a spirit of collaboration. I accept the deal."
> Kak (Patrick Lamassoure)

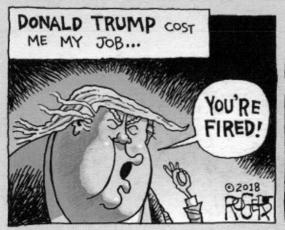

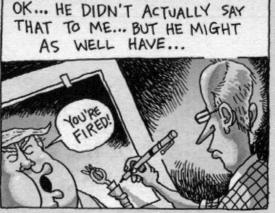

# Freedom, denied: Paper fires cartoonist for being 'obsessed with Trump'

**Sometimes, interventions by editors and publishers amount to an exercise of power that looks a lot like state censorship.**

THE RELATIONSHIP between cartoonists and their media organizations can snap when political tremors divide the society, and the cartoonist and editor take different sides. Or, when an owner decides to take the publication in a new political direction that the cartoonist refuses to follow.

This was how Rob Rogers got fired from his job.

He was terminated by the *Pittsburgh Post-Gazette* in 2018 after a 25-year career with the paper. He had been one of the few remaining cartoonists on the staff of an American daily newspaper. While others lost their jobs because of the news industry's financial crisis, that wasn't what cost

Rogers his. As if to make the point, the *Post-Gazette* hired a replacement cartoonist soon after.

Rogers was fired for being too critical of President Donald Trump. Defending the newspaper's decision, publisher John Robinson Block said Rogers had stopped being funny. "He's obsessed with Trump," Block told *Politico*. "I wanted clever and funny instead of angry and mean."

Rogers responded: "If I drew Trump more often than Block would have liked, it was because I base my cartoons on the most urgent topics at hand. Sadly, Trump provides that fodder every day."

Many in the media were outraged that this could happen in a country that prides itself on its freedom to dissent, and to a member of a profession that practically exists for that very purpose.

Even Pittsburgh Mayor William Peduto, a frequent target of Rogers, issued a statement to voice his disappointment.

"This is precisely the time when the constitutionally protected free press — including critics like Rob Rogers — should be celebrated and supported, and not fired for doing their jobs," said Peduto.

"I've known Rob a long time. That has never stopped

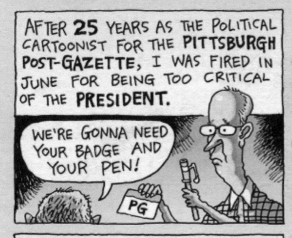

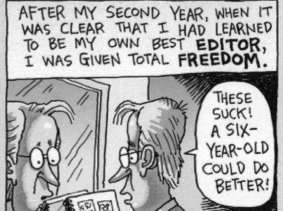

him from publishing cartoons that are critical of me, of my policy positions, or of my actions (or inactions) in office. He's even made fun of my weight. But he is one of the best in the world at his time-honored craft."

### Tip of the iceberg?

The *Post-Gazette*'s decision to shift away from anti-Trump cartoons made waves because it entailed firing its well-known staff cartoonist. The vast majority of newspapers, though, do not have cartoonists to fire. They instead subscribe to syndicates that serve them a regular stream of cartoons from which they can pick and choose.

There is a big difference be-

Rob Rogers (2nd from left) and Daryl Cagle (right) at the Association of American Editorial Cartoonists annual meeting in Sacramento, 2018.

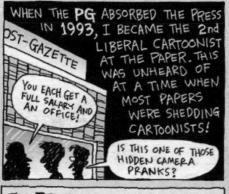

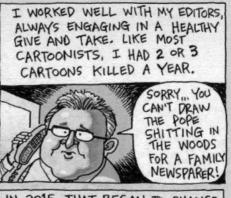

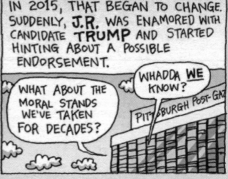

tween syndicated and staff cartoonists, notes the Pulitzer-winning Nick Anderson, whose position at the *Houston Chronicle* was axed in 2017. "It's harder to kill a cartoon from your staff cartoonist ... They fight back. They have a voice that they can raise with you in person," Anderson says. "It's easier to kill a cartoon from a syndicate. You just quietly discard it in favor of a less controversial cartoon. The power to select content is also the power to stifle content."

Daryl Cagle, who founded his own syndicate in 2001, notes that most American newspapers are not the big-name liberal titles. "From a syndicate's point of view, the market is in the more numerous, smaller, conservative, rural and suburban papers."

After Trump's victory in 2016, cartoonists stopped criticizing Hillary Clinton and Barack

Obama and turned their fire on the new president. The cartoonists were only doing what they had always done. "Editorial cartooning is a negative art, and cartoons supporting anything are lousy cartoons," Cagle points out. But, conservative editors interpreted this as cartoonists shifting to the left.

"We were flooded with calls from rural and suburban editors complaining about how all the cartoons they liked had disappeared, and we lost some newspapers. Some went to other syndicates and came back, after seeing that they also weren't getting what they wanted from other syndicates. Many editors insisted that they wanted cartoons 'supporting Trump,'" Cagle says.

To reassure this market, Cagle Cartoons even created a section on its website titled "Trump Friendly Cartoons."

### Is it censorship?

Although the *Post-Gazette*'s move did not result from any state action, its effect was to curb a cartoonist's freedom to criticize the president. Isn't that "censorship"?

Cagle doesn't think so. "Freedom of the Press belongs to the guy who owns the press, even if the guy who owns the press acts like a jerk," he says. "It isn't 'censorship' for a publisher not to print what a publisher doesn't want to print."

Others think it is.

"They may have the right to censor but it is still an act of censorship," argues cartoonist Ted Rall. "If anyone has ever been censored, Rob Rogers was censored, otherwise the word has no meaning."

Unlike in countries with strong state censorship,

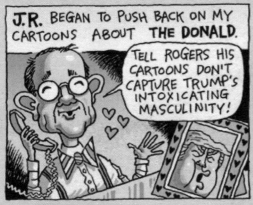

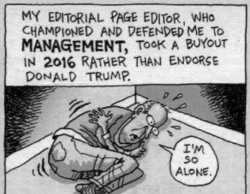

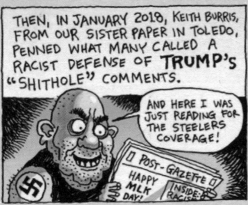

Rogers could still publish his work in other news outlets. But such spaces are increasingly difficult to come by.

There's self-publishing on the internet, of course. But that's unlikely to gain as much attention as a regular space in a news outlet, or earn the cartoonist enough to live on.

"It's like taking milk out of the biggest grocery store chain in the country," Rall continues. "You could still get it if you go to a small local store. Or, just go buy a cow. But you've now made milk considerably more difficult to find, and the practical effect is that overall milk consumption will decline. Similarly, overall consumption of Rob Rogers is going to decline. That's what censorship is."

## Whose freedom?

Whether or not we call it censorship is the flip side of a larger question: what we mean by "media freedom."

This much is clear: media freedom must mean media are free from illegitimate restrictions imposed by government. This is what's explicitly enshrined in the American Bill of Rights.

The First Amendment to the United States Constitution

## TRUMP-FRIENDLY CARTOONS

BETO THE TAKER

#230390      10/02/19
by Gary McCoy

BERNIE BLEEDING HEART

#230376      10/02/19
by Rick McKee

#23030
by Rick

Responding to market signals: Daryl Cagle's syndicate includes a prominent section of pro-Trump cartoons on its website to reassure conservative editors that cartoonists aren't all left-wing.

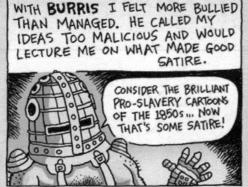

says that government "shall make no law... abridging the freedom of speech, or of the press." Supreme Court judgments in the latter half of the 20th century have turned this into the world's firmest ban on state interference in freedom of expression.

The First Amendment sides decisively with media in the battle between media and the state.

But that's not the only tussle that has implications for artistic and journalistic freedom. When we open up the "media" box, we see power struggles among owners, managers, and workers, not to mention external stakeholders such as advertisers and audiences.

If we say that media freedom belongs to media owners, what we're implying is that the property rights of media owners are more important than the expressive rights of writers and artists.

## A right to receive

Then, there's the public. Although a free press (like the state) likes to equate itself with "the people," the relationship is – complicated.

By the early 20th century, it had become obvious that the press in free societies had become a powerful institution in its own right. It frequently acted in its own commercial interests even when these conflicted with the public interest. The arrival of radio, and later television, intensified these concerns. It was clear that

laissez-faire markets would result in big business quickly appropriating scarce airwaves for themselves, leaving the public interest underserved.

This concern was prominent in American First Amendment discourse in the first half of the 20th century, and especially in the 1940s.

Philosopher Alexander Meiklejohn, notably, argued that the First Amendment was meant to enable collective self-government. That would require advancing people's right to hear the range of ideas they require to form opinions and make decisions together.

This broader view of the First Amendment embraced the whole society's "positive" freedom to read, see, and hear, and not just a small number of media owners' and producers'

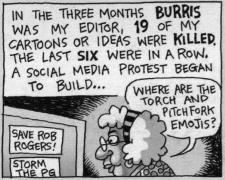

IN THE THREE MONTHS **BURRIS** WAS MY EDITOR, **19** OF MY CARTOONS OR IDEAS WERE **KILLED.** THE LAST **SIX** WERE IN A ROW. A SOCIAL MEDIA PROTEST BEGAN TO BUILD...

SAVE ROB ROGERS!

STORM THE PG

WHERE ARE THE TORCH AND PITCHFORK EMOJIS?

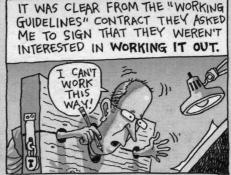

IT WAS CLEAR FROM THE "WORKING GUIDELINES" CONTRACT THEY ASKED ME TO SIGN THAT THEY WEREN'T INTERESTED IN **WORKING IT OUT.**

I CAN'T WORK THIS WAY!

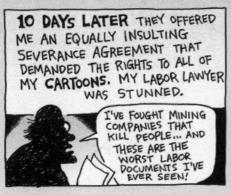

**10 DAYS LATER** THEY OFFERED ME AN EQUALLY INSULTING SEVERANCE AGREEMENT THAT DEMANDED THE RIGHTS TO ALL OF MY **CARTOONS.** MY LABOR LAWYER WAS STUNNED.

I'VE FOUGHT MINING COMPANIES THAT KILL PEOPLE... AND THESE ARE THE WORST LABOR DOCUMENTS I'VE EVER SEEN!

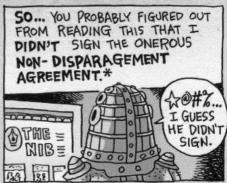

**SO...** YOU PROBABLY FIGURED OUT FROM READING THIS THAT I **DIDN'T** SIGN THE ONEROUS **NON-DISPARAGEMENT AGREEMENT.***

THE NIB

☆@#%... I GUESS HE DIDN'T SIGN.

"negative" rights protecting their property and speech from government intervention. In a similar vein, the 1947 Hutchins Commission observed: "Protection against government is now not enough to guarantee that a man who has something to say shall have a chance to say it. ... The owners and managers of the press determine which persons, which facts, which versions of the facts, and which ideas shall reach the public."

Freedom of the press, it went on, must include "the almost forgotten rights of speakers who have no press." The notion of press freedom as a "positive" right may not be in the letter of the US Bill of Rights, but it is explicitly mentioned in the Universal Declaration of Human Rights, adopted by the United Nations General Assembly in 1948.

Article 19 of the UDHR says that "the right to freedom of opinion and expression" includes the right to "seek, receive and impart" information and ideas. People's right to "receive" is also mentioned in Article 10 of the European Convention on Human Rights, and influences most liberal democracies' approach to media.

Even if enshrined in principle, though, how to implement it is another matter. States have tried to uphold that right mainly by funding public service broadcasters, such as the BBC in the United Kingdom and Deutsche Welle in Germany, which counterbalance commercial media. But it would be unthinkable for the state in a liberal democracy to intervene in private media's hiring and firing decisions, as long as they observe labor laws. In the words of the Hutchins Commission, such state actions would be "a cure worse than the disease."

In the trade-off between media owners' and media workers' speech rights, the "speakers who have no press" generally lose.

\* HEY, LAWYERS... ALL DIALOGUE IS SATIRE!

"With newspapers struggling, believing I would land another staff job is like believing in Santa Claus."

Rob Rogers

Rogers now contributes to *Counterpoint*, a cartoon-only email newsletter co-founded in 2019 by the Pulitzer-winning former *Houston Chronicle* staff cartoonist Nick Anderson – the last editorial cartoonist employed by a newspaper in Texas.

# Obituaries

## The Political Cartoon, Adopted by the Gray Lady, Dies at Her Hands

**The New York Times pulls the plug after a bruising cartoon controversy.**

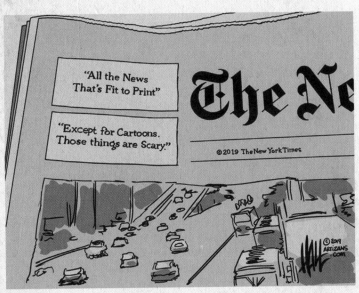

*Ed Hall's cartoon was one of many expressing scorn at the NYT move.*

NEW YORK — Accepted but never truly loved by America's most prestigious newspaper, political cartoons departed the *New York Times* on 1 July 2019. Editors said they would still welcome other forms of visual journalism, such as graphic storytelling. But opinionated cartoons were evidently too high-maintenance for the paper, despite its hard-earned reputation as a bastion of press freedom.

That April, the *Times* had pleaded guilty to accusations that a syndicated cartoon published by its international print edition was anti-Semitic. Within days, editors declared they would no longer run any syndicated cartoons – ready-for-publication works sold by agencies – presumably because these were not subject to stringent quality control.

That left original cartoons drawn by its two contracted cartoonists, Patrick Chappatte and Heng Kim Song. In May, though, the two were told their contracts would be terminated. From July 1, no part of the paper, print or online, would carry political cartoons.

The *Times* had never felt a familial bond to the genre. Political cartoons were the progeny of *International Herald Tribune* (IHT), NYT's Paris-based joint venture with the *Washington Post*. When NYT became the sole owner of IHT and rebranded it with the mothership's name in 2013, it accepted custody of IHT's cartoon tradition. There were signs of budding affection. The cartoons were posted at NYTimes.com, which does not have separate domestic and foreign sites. The *Times* even took the trouble to translate them for its Chinese and Spanish editions.

The events of mid-2019, however, showed how far down political cartoonists were in the *Times'* pecking order, compared with its pantheon of writers. Three days after the controversial cartoon appeared, conservative op-ed columnist Bret Stephens was given space to slam not only the cartoon but also his newspaper's editors for "an astonishing act of ignorance of anti-Semitism."

From that point, Chappatte says, "it was just damage-control, and freaking out."

Chappatte's contract for

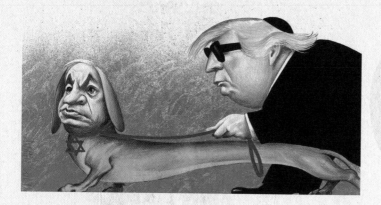

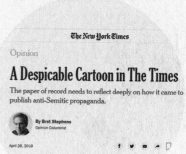

A Despicable Cartoon in The Times

The paper of record needs to reflect deeply on how it came to publish anti-Semitic propaganda.

*Showing the Israeli leader as a dog leading a kippah-wearing Trump, this cartoon was condemned as anti-Semitic when it appeared in the NYT International Edition. Artist António Antunes does not accept this interpretation. "The cartoon was politically topical, criticizing Netanyahu's policy of annexing Palestinian territories with the support of Trump," he says.*

two cartoons a week was part of the collateral damage. "I was fired for a cartoon I didn't draw," the Geneva-based cartoonist laughs.

Then again, it was never really about the offending cartoon, but the political opportunity it created for the newspaper's right-wing enemies. "Through a cartoon, more often than not it is the media that they want to attack," Chappatte says.

The global impact of the *Times* decision bothers him more than the termination of his contract. Editors in less free countries look to the *New York Times* for inspiration, he points out. "And now you are getting rid of all political cartoons because some can be problematic? That's sending a terrible signal no matter what your intentions were."

Dutch cartoonist Joep Bertrams agrees. He responded with a cartoon likening the NYT decision to authoritarian censorship. A dictator may use brute force to break the cartoonist, but editors in free

societies, often profit-driven, can make the cartoonist simply disappear from the page, his cartoon suggests.

"Of course, it isn't as harmful or dangerous as repression by dictators, and the *New York Times* will continue to

publish very relevant opinions as it did before," Bertrams says. "But banning cartoons, just to avoid a little collateral damage after a mis-hit, doesn't fit a newspaper of high standard."

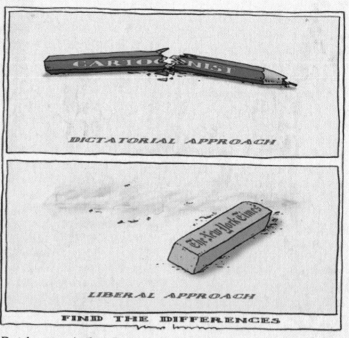

*Dutch cartoonist Joep Bertrams' comment.*

*Jakarta Post's former chief editor Meidyatama Suryodiningrat.*

# A Case in Indonesia Shows How Cartoons Become Proxy Targets

JAKARTA — if you want to attack a newspaper, its cartoons are an easy target. Former *Jakarta Post* chief editor Meidyatama Suryodiningrat found this out the hard way. He now lives with a blasphemy charge hovering over him, due to a cartoon his paper published. It was never really about the cartoon, though.

In 2014, the *Jakarta Post* decided to do something it had never done before. It endorsed a presidential candidate. On Friday 4 July, five days before the polls, it published an editorial declaring its support for the eventual winner, Joko "Jokowi" Widodo.

The *Post*, the country's main English-language paper, had a small circulation of around 40,000 elites in a country with 185 million voters. But, the paper's controversial endorsement of Jokowi was reported widely, provoking a bigger reaction than its editors anticipated.

Meidyatama wondered how the other side would hit back. The editorial had called them "hard-line Islamic groups who would tear the secular nature of the country apart" and "religious thugs who forward an intolerant agenda... highlight-ing polarizing issues for short-term gain."

Ironically, if it was right, the paper could expect to fall victim to that same intolerance.

"I knew something was going to happen," Meidyatama recalls.

That weekend, he took home with him the past 10 issues of the paper. He went through every issue, trying to anticipate how the *Post* would be hit. "We know what they will go after: libel, SARA." SARA is the Indonesian acronym for the sensitive issues of ethnicity, religion and race.

He identified a few items

that he suspected might be targeted. One of them was an anti-ISIS cartoon by the Bangkok-based French cartoonist Stephff, published the day before the paper endorsed Jokowi.

### Damage control

On Monday morning, he retracted the cartoon from the paper's online version. He felt there was something larger at stake than press freedom. The cartoon would be used to hurt Jokowi, with just days to go before the election: "They would say, the paper that endorsed Jokowi is blasphemous."

The paper published an apology for running a cartoon that contained religious sym-

bolism, and explained that its intent was to criticize ISIS, not disrespect any religion. But the outrage machine was already rolling. Muslim groups attacked the paper, with the fundamentalist group Hizb ut Tahrir accusing the *Jakarta Post* of a "campaign of insulting Islam."

The police declared Meidyatama a blasphemy suspect that December. Prosecutors did not pursue the case, though they never closed it either.

The case was widely reported as a hardline religious reaction to a cartoon. But that wasn't the real story, Meidyatama insists. "It was never about the cartoon itself. It was about timing and context."

# Defending the field of journalism

*Pierre Bourdieu.*

PARIS, FRANCE – The ideas of sociologist Pierre Bourdieu offer a way to understand the tension between cartoonists and the press. His "field theory" suggests that the journalism profession, like other fields, constantly needs to establish its distinctiveness. Canons such as neutrality and detachment are part of the project to maintain journalism's boundaries, say media scholars influenced by Bourdieu.

This boundary work protects against the external political and economic forces that threaten journalists' autonomy. But the journalistic field can also be destabilized from within, like when bloggers operate outside of the norms and hierarchies of news organizations.

Unlike bloggers, cartoonists are not fresh arrivals to the field. What's new is the increased risk that people will take extreme offense. To editors besieged by the outrage industry, redrawing professional boundaries to exclude political cartoonists may seem a small price to pay.

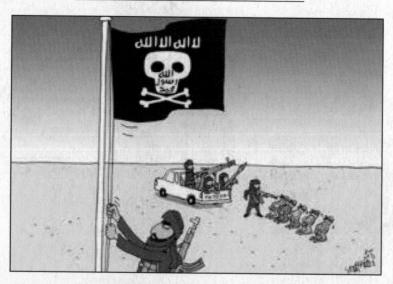

*Stephff's anti-ISIS cartoon happened to be published the day before the* Jakarta Post *endorsed Joko Widodo for president. The ISIS flag in the cartoon, just like the real thing, bears the Arabic phrase "There is no God but Allah," and the seal of the Prophet Mohammed. The cartoonist added the skull and crossbones. At the time, ISIS was not yet taken seriously in the country; the government banned the group only two months later. When the* Jakarta Post *published the cartoon, therefore, it was not difficult for hardline groups to frame it as an attack on Islam.*

# What the press taught Marx about capitalism

**Capital's relentless drive for surplus value has no patience for media workers.**

A 19th CENTURY German intellectual named Karl Marx had a firsthand view of different modes of press censorship. When the newspaper *Rheinische Zeitung* was launched in January 1842, the 24-year-old Marx started writing for it. He became its editor in October that year. Under pressure from the Prussian government, the paper lasted barely 15 month, closing in March 1843.

Like other papers, it operated under an official system of prior censorship — censorship before publication. All copy had to be delivered to the government censor in the evening. He would strike out objectionable parts in red pencil before the paper was printed in the morning.

This was not enough for the government, which decided in January 1843 that the *Rheinische Zeitung* should be banned with effect from April.

At first, the market stood up for the paper. Subscribers and other citizens petitioned against the government's decision. But it was also the market that stabbed Marx in the back. The newspaper's shareholders, wanting to save the paper, asked the editor to tone down its strident political views. Marx submitted his resignation in mid-March 1843, two weeks before the newspaper ceased publication. Thus, media

**Above: A lithograph depicting the censorship of the popular *Rheinische Zeitung*. Editor Karl Marx and his printing press are shackled. An eagle, symbolizing the Prussian throne, feeds on Marx's liver. On the ground, cities of the Rhine are in despair.**

**Above: Extracts from *The Communist Manifesto* by Martin Rowson.**

owners succeeded where even the King of Prussia and his government did not, making Marx give up his post.

His *Rheinische Zeitung* experience must have contributed to his distrust of capitalism and its exploitation of labor.

### A different class of worker?

For a long time, though, artists and other cultural workers were widely assumed to operate outside of Marxist theory. Compared with factory workers making widgets, cultural workers have more autonomy to express their individuality.

They use mental labor, which gives them more cultural privileges and social status than manual workers. Their jobs can be fulfilling, and cool.

But we now know that aesthetic labor is not immune to capital's relentless drive to increase surplus value by lowering the cost of labor.

"Contemporary conditions of cultural production... are undermining relative autonomy," notes Nicole Cohen, who studies media industries from the political economy perspective pioneered by Marx. "Cultural workers are experiencing declining material conditions and intensifying precarity."

Many artists love their work so much that they accept lower pay and more uncertainty for more independence. This does nothing to chip away at capital's power, though.

"The risks and costs of production are downloaded onto workers who, motivated by the relentless search for work and increasing competition, strive to produce their best works, providing capital ample choice from a pool of skilled workers bargaining down the costs of their labour power," Cohen writes.

**Left: After leaving *Rheinische Zeitung*, Marx, together with his comrade Friedrich Engels, freelanced for the popular *New York Tribune* as international correspondents. He knew full well that the *Tribune* did not share his radical views. "Nauseating," Marx called the *Tribune* in a letter to Engels. He was willing to swallow its mainstream politics and occasional censorship in return for the audience and paycheck that their radical alternative outlets couldn't give him — a trade-off familiar to many cartoonists today.**

# How the market failed journalism and its public

**You don't have to be a Marxist to understand why political cartooning is a case of market failure.**

MARKET FUNDAMENTALISTS believe that free market forces of demand and supply should drive the marketplace of ideas. Capitalism will support political cartoonists who deserve support, the theory goes.

Mainstream economics tells us why this isn't necessarily true. There are many important public services — like education, healthcare, and defence — that wouldn't be provided adequately if left completely to the market forces.

Most of the journalism that aims to serve the public interest, including editorial cartooning, falls in the same category of "market failure." Most citizens agree that democracy needs the kind of journalism that clarifies current affairs and holds the powerful to account. But most are unwilling to pay for it.

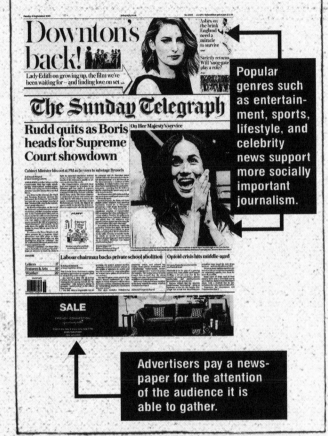

## NEWSPAPERS' TRADITIONAL BUSINESS MODEL

Back when newspapers were highly profitable, those profits didn't all come from their public-interest journalism. The journalism required for democratic life was subsidized by other content, bundled together with news and commentary about public affairs.

Popular genres such as entertainment, sports, lifestyle, and celebrity news support more socially important journalism.

Advertisers pay a newspaper for the attention of the audience it is able to gather.

For a long time, journalism of high social value was protected from these market realities by "subsidies" from two main sources: entertainment and advertising.

This was the business model behind what in hindsight seems like a golden age of the press — when newspapers were highly profitable, and many owners were happy to grant editors a high degree of autonomy to serve perceived public needs, and not just pander to market demand.

# THE GREAT INTERNET DISRUPTION

The internet gave audiences and advertisers choices newspapers never did. Specialized websites and apps challenged newspapers' model of bundling journalism that they believe the public needs together with content that customers want.

But the market's subsidy for journalism depended on technological constraints that limited advertisers' and readers' choices. The internet disrupted this century-old model.

These tectonic shifts exposed the cruel reality: journalism had depended on subsidized and incidental consumption. A minority were news junkies prepared to pay for high-quality journalism, but most news consumers had been exposed to the news while seeking out other kinds of entertainment and information. The internet sparked a choice revolution that allowed them to zero in on the content they most wanted, without having to wade through the journalism that editors believed they needed.

Going online didn't solve the dilemma. Newspapers with a captive audience charged premium rates for print ads. Online, though, advertisers have multiple ways to reach audiences and to measure the effectiveness of their ads. They are willing to pay only a small fraction of what they used to for print ads.

News media also depend on intermediaries like Google and Facebook to reach audiences – and these companies cream off most the ad revenue.

## ENDANGERED SPECIES

WHITE RHINO

ORANGUTAN

EDITORIAL CARTOONISTS

KUPER

This cartoon by Peter Kuper was a response to the New York Times' 2019 decision to abandon the medium, but it also reflects a decade-old angst about job losses at newspapers.

# Newspaper shakeout pushes cartoonists to the edge

## The bottom line: economic insecurity may be no less intimidating than state action.

The news media's financial crisis has hit the cartooning profession hard.

There are fewer news outlets for cartoons, and a much smaller number that are willing to employ full-time cartoonists. In theory, the same digital technologies that have disrupted newspapers' business model allow cartoonists direct access to the public.

In practice, most cartoonists are not able to earn a living on the internet. Online advertisers and readers are notoriously stingy with their cash, so political cartoonists around the world still rely heavily on the custom of news organizations.

In the United States, there were around 1,200 paid-circulation daily newspapers in 2019. But the vast majority are rural and suburban papers with small budgets. If they buy political cartoons at all, they tend to go through syndicates. These focus on national and international subjects to appeal to clients across the country.

"With the loss of staff cartoonists, we've seen a loss of local cartoons," notes Daryl Cagle. "Local cartoons can have a big impact on their communities; local and state politicians don't suffer from the prying eyes of cartoonists and journalists as they did in the past."

The shift from full-time employment to freelance work is a trend across the cultural and creative industries. Glamorized as the "gig economy," flexible contracts only benefit an industry's rock stars, who are able to set their own prices.

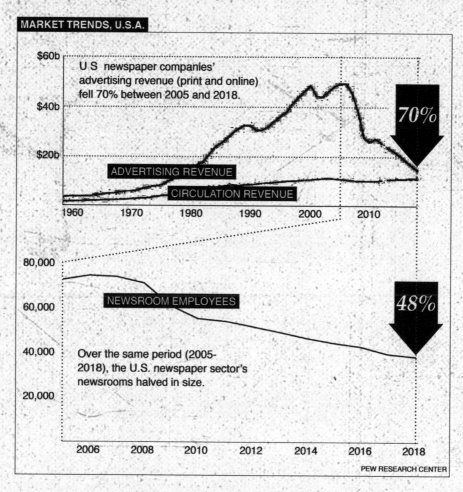

**MARKET TRENDS, U.S.A.**

U S newspaper companies' advertising revenue (print and online) fell 70% between 2005 and 2018.

**70%**

ADVERTISING REVENUE

CIRCULATION REVENUE

NEWSROOM EMPLOYEES

**48%**

Over the same period (2005-2018), the U.S. newspaper sector's newsrooms halved in size.

PEW RESEARCH CENTER

At the start of the 20th century, there were around 2,000 editorial cartoonists working at U.S. newspapers. The number fell to under 40 a century later. Most local and suburban media no longer have cartoonists, so local affairs don't get scrutinized and satirized like they used to.

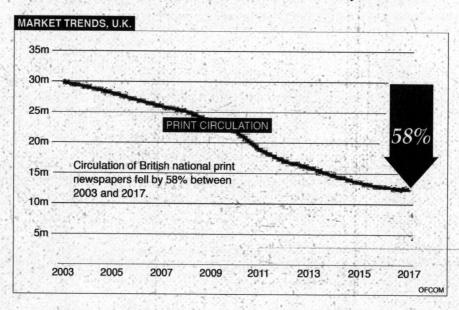

**MARKET TRENDS, U.K.**

PRINT CIRCULATION

**58%**

Circulation of British national print newspapers fell by 58% between 2003 and 2017.

OFCOM

That's not typical of most media work. "For publishers, exploitation is made easier by the casualization of media work, which has increased competition for work, made workers insecure, and pressured wages down," says Nicole Cohen.

Job security contributes to the autonomy of cartoonists and other media workers. With it — like tenured faculty — cartoonists can follow their conscience and their values without worrying about the potential impact on their livelihood. Without it, they are prone to fears that can be as restrictive as state censorship.

This is a blind spot in most Americans' understanding of political fear in their country, says political theorist Corey Robin. Constitutional limits on executive power did not spare the United States from the repression and intimidation of the McCarthy era, Robin notes.

 **France: Fall in newspaper revenues, 2006-2017.**

McCarthy's anticommunist scaremongering worked not only because of mass paranoia, but also by mobilizing economic and civil society organizations to the cause – the same institutions of pluralism that are supposed to keep democracies free, according to liberal theory.

These organizations impose discipline through fear, which arises from the internal hierarchies that exist in every society regardless of political system. At workplaces, the fear of losing steady employment is always in the air, influencing everyday relationships without explicit intimidation.

"In fact, what makes this unspoken fear so influential, especially in a liberal democracy, is that it does not, as a rule, require overt acts of coercion," Robin argues.

"This unspectacular, quotidian fear is the American way of repression," he adds. "Wielding threats of firing, demotion, harassment, and other sanctions, employers and managers attempt to stifle speech and action, to ensure that workers don't talk back or act up."

Thus, increased economic insecurity can have a direct impact on cartoonists' autonomy.

---

# Cartoonist class structure

Scholars use the term "precariat" to capture the combination of precarity and proletarian or working class status, which seems to characterize the lot of many workers in the modern economy, including many in the cultural and creative industries. The term is part of British economist Guy Standing's proposed vocabulary of 21st century class relations.

**The Elite**
The "tiny number of absurdly rich global citizens lording it over the universe." Cartoonists don't belong here, unless they are millionaires who cartoon as a hobby.

**The Salariat**
Those in stable full-time employment in firms, with their pensions, paid days off, and medical benefits. A small proportion of cartoonists fall into this category.

**The Proficians**
Those whose highly marketable skills allow them to earn high incomes as contract workers. They are free to choose clients and projects, so many cartoonists prefer this to joining the salariat (though they envy the latter's health benefits).

**The Precariat**
Those who lack labor security, and experience bouts of unemployment or underemployment. Many political cartoonists are already within, or at risk of sliding into the precariat. To escape, they may give up some control over their work, or earn a living through other means.

# CAREERS

DARIO ADANTI
Co-founder of *Mongolia*

# Be your own Boss!

## Tired of the tyranny of markets? Seeking job satisfaction?

Cartoonists turn to self-publishing, and working for free.

**ALL OVER THE** "free" world, cartoonists are seeking the final freedom — autonomy from media owners that don't appreciate the value of hard-hitting cartoons.

"It's a paradox that free speech developed in capitalist democracies, but if a

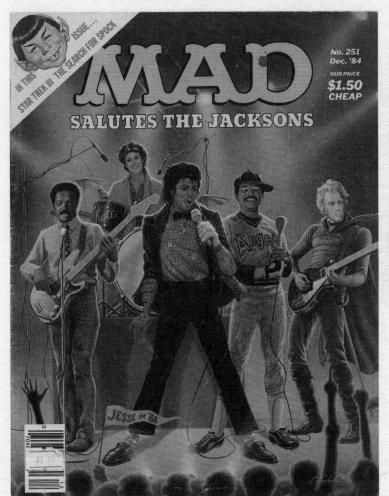

▲

**GRANT FUNDING**
Dutch cartoonist Tjeerd Royaards founded the Cartoon Movement in 2010. The network of more than 400 cartoonists supplements its commercial work with projects sponsored by nonprofits such as United Nations agencies.

neoliberal media company's investment is threatened by free speech, see you later," says Dario Adanti, an Argentinian cartoonist and humorist who moved to Spain in 1995. He co-founded the satirical monthly magazine *Mongolia* in 2012.

*Mongolia* is part of a long tradition of satirical magazines that let political cartoonists go far beyond what mainstream newspapers would allow. They include France's groundbreaking *La Caricature* (1830–1843), the highly profitable *Le Canard*

*Enchaîné* (since 1915), and *Charlie Hebdo* (1970–1981 and since 1992). Britain had *Punch* (1841–1992; 1996–2002), and still has *Private Eye* (since 1961).

The United States produced probably the 20th century's most influential satirical cartoon magazine, *Mad*. Founded in 1952, *Mad* converted to magazine format in 1955 to evade vetting by the McCarthy era Comics Code Authority. At the peak of its popularity in the 1970s, it sold 2.8 million copies.

Perhaps because its irreverence had seeped into the mainstream of American popular culture, it declined over the following decades. In 2019, it announced it would no longer publish new material.

*Mongolia* sells a modest 10,000 copies per issue. News kiosks are the main retail outlet for newspapers and magazines in Spain, but the number of kiosks is falling rapidly. The company makes ends meet by publishing books and performing live comedy.

Thus, even if independent cartoonists and their publications are willing to sacrifice some profits for the sake of autonomy, they eventually have to confront the challenge of financial sustainability.

Donor funding is one response to the journalism profession's financial crisis.

Similarly, cartoonists are experimenting with non-commercial sponsorships and grants.

Their most common strategy, however, is to supplement their income with better-paying jobs, such as in commercial illustration, graphic design, and animation. The political cartoonist can then be guided by conviction, instead of commercial considerations.

Aji Prasetyo in Indonesia has deliberately adopted this strategy. He is part of a movement trying to defend the multicultural soul of his country from the forces of religious intolerance. His cartooning is an extension of his activism; it's not his livelihood.

He relies instead on music, commercial art, and his café business to earn a living.

He can thus take financial risks with his cartooning. "Nobody pays me. I have other ways to make money, so if they try to stop a book, it doesn't hurt me. I've already shared it on social media for free."

Centuries ago, artists tied to church or state patrons found freedom through markets. For cartoonists like Aji Prasetyo, it's also important to find freedom from the market.

# 7. Democratically Rejected
## The X'ed Files

CARTOONISTS WORKING IN DEMOCRACIES MAY FACE NO
SIGNIFICANT *GOVERNMENTAL* RESTRICTIONS ON THEIR WORK.

BUT IF THEY DEPEND ON MEDIA OUTLETS, THEIR LEGAL FREEDOMS
DON'T GUARANTEE THAT THEIR CARTOONS WILL CIRCULATE FREELY.

SEEING THEIR CARTOON IDEAS EDITED, KILLED, OR
GO DOWN A BLACK HOLE COMES WITH THE TERRITORY.

MANY OF THE CARTOONS IN THIS CHAPTER HAVE NEVER BEEN PUBLISHED BEFORE.
OTHERS APPEARED, BUT WERE SUBSEQUENTLY REMOVED BY EDITORS OR PUBLISHERS.

WHETHER THEY ARE VICTIMS OF "CENSORSHIP" IS ARGUABLE.

SOME CASES CERTAINLY FIT THAT DESCRIPTION, AT LEAST IN THE CARTOONIST'S EYES.

THESE ARE INSTANCES WHERE A VIEWPOINT WAS SUPPRESSED FOR NON-JOURNALISTIC REASONS, PERHAPS FOR FEAR OF HOW AN ANTICIPATED CONTROVERSY WOULD HURT THE PUBLISHER'S FINANCIAL BOTTOM LINE.

AT THE OTHER END OF THE SPECTRUM ARE CASES WHERE THE CARTOONIST READILY ADMITS THAT THERE WAS A REASONABLE JUSTIFICATION FOR MODIFYING OR KILLING THE CARTOON.

CARTOONISTS MAY BE DRIVEN PARTLY BY EGO, BUT MANY ACKNOWLEDGE THAT GOOD EDITORS HAVE IMPROVED THEIR WORK.

IN BETWEEN THESE TWO ENDS OF THE SPECTRUM IS A VAST GRAY AREA.

WHETHER THE EDITOR WAS RIGHT TO THWART THE CARTOONIST IS DEBATABLE.

IT IS A QUESTION OF TASTE, CULTURE, TIMING, AND SUBJECTIVE RISK ASSESSMENTS.

WHETHER OR NOT YOU AGREE WITH EACH DECISION, THOUGH, THIS COLLECTION HELPS CLARIFY THE RED LINES THAT RESTRICT POLITICAL CARTOONING IN DEMOCRACIES.

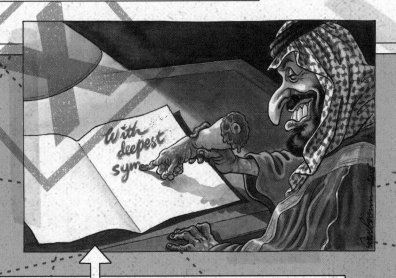

DAVE BROWN, IN HIS CARTOON FOR BRITAIN'S *INDEPENDENT*, SATIRIZED THE SAUDI CONDOLENCE MESSAGE TO THE FAMILY OF MURDERED OF JOURNALIST JAMAL KHASHOGGI. KHASHOGGI WAS MURDERED BY SAUDI AGENTS AND HIS BODY CUT INTO PIECES.

BEFORE PUBLICATION, EDITORS REFERRED THE CARTOON TO THE *INDEPENDENT*'S LAWYERS, WHO WARNED THAT SAUDI CROWN PRINCE MOHAMMED BIN SALMANCOULD SUE FOR DEFAMATION. BROWN TOUCHED UP THE CARTOON, CONCEALING THE SAUDI CHARACTER'S FACE.

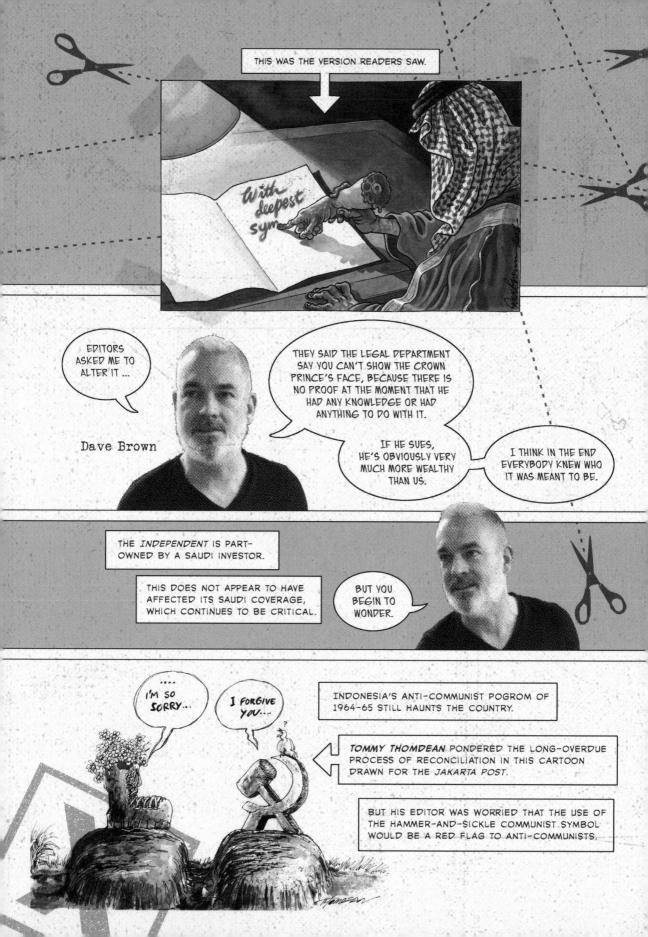

THOMDEAN'S PUBLISHED VERSION REPLACED THE HAMMER AND SICKLE WITH A TOMBSTONE ENGRAVED WITH "1965" TO AVOID ANY PERCEPTION THAT THE CARTOON WAS GLORIFYING COMMUNISM.

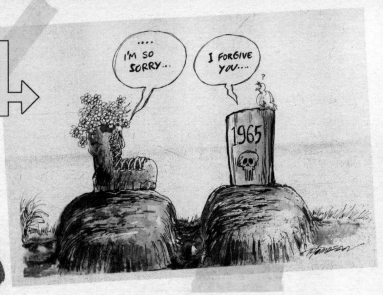

I AGREED TO CHANGE IT BECAUSE THE MAIN IDEA WAS INTACT.

THE GOVERNMENT IS NOT SO RESTRICTIVE COMPARED WITH THE SUHARTO ERA WHEN THERE WAS VERY STRONG FEAR OF THE GOVERNMENT.

NOW WE WORRY MORE ABOUT THE REACTION FROM READERS.

Tommy Thomdean

THE 2016 PANAMA PAPERS' REVELATIONS OF INDIVIDUALS AND COMPANIES WITH SECRET BANK ACCOUNTS IN THE TAX HAVEN OF PANAMA IMPLICATED PROMINENT INDONESIAN BUSINESSMEN.

THOMDEAN'S ORIGINAL CARTOON DRESSING DOWN TWO WELL-KNOWN CORPORATE FIGURES WAS CULTURALLY INAPPROPRIATE, THE EDITORS FELT.

MANY INDONESIANS ARE NOT COMFORTABLE ABOUT SHAMING INDIVIDUALS, THOMDEAN ACKNOWLEDGES.

THOMDEAN FIXED THE PROBLEM BY DRAWING THE SAME TWO BUSINESSMEN IN SUITS INSTEAD OF BEACHWEAR.

HIS PUBLISHED VERSION ALSO PLACED THEM IN A CROWD, TO AVOID THE PERCEPTION THAT THE NEWSPAPER WAS SINGLING THEM OUT WHEN MANY OTHERS WERE ALSO SUSPECTED OF TAX EVASION.

179

THE FAR-RIGHT DUTCH PARTY FVD (FORUM FOR DEMOCRACY) SET UP A YOUTH WING, JFVD, TO APPEAL TO THE YOUNGER GENERATION.

CARTOONIST *JOEP BERTRAMS* RESPONDED WITH THIS CARTOON DEPICTING THE PROMINENT FVD POLITICIAN THEO HIDDEMA GIVING A YOUNGER MAN THE HITLER LOOK.

THE CAPTION "SHAVE AND HAIRCUT" IS A DUTCH EXPRESSION FOR A CON JOB. THIS CARTOON WAS NEVER PUBLISHED, BY MUTUAL CONSENT.

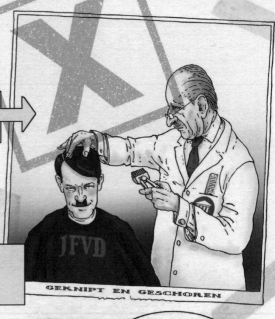

GEKNIPT EN GESCHOREN

THE CARTOONIST HIMSELF WAS OF TWO MINDS ABOUT IT WHEN HE SUBMITTED THE CARTOON. HE WONDERED IF THE HITLER COMPARISON WAS TRIVIALIZING THE HORROR OF THE NAZI PERIOD.

I WASN'T 100% SURE IF THE CARTOON WOULD BE APPROPRIATE; MAYBE A LITTLE TOO MUCH OVER THE TOP.

IN OUR CONVERSATION, THE EDITOR EXPLAINED HE WOULD HAVE PLACED THE CARTOON IF I INSISTED, WHICH I DIDN'T.

HIS EDITOR WAS ALSO UNEASY, BUT LEFT THE FINAL DECISION TO BERTRAMS.

BERTRAMS WITHDREW THE CARTOON.

---

JEREMY CORBYN WAS ELECTED LEADER OF BRITAIN'S LABOUR PARTY IN 2015. THE DATE: 12 SEPTEMBER, OR WHAT AMERICANS WOULD CALL 9/12.

THE IDEALISTIC, LEFT-WING CORBYN REJECTED THE CENTRISM OF LABOUR PREMIERS TONY BLAIR AND GORDON BROWN.

GUARDIAN CARTOONIST *MARTIN ROWSON* THOUGHT OF DRAWING A CARTOON TITLED "9/12." IT WOULD SHOW CORBYN AS MARY POPPINS FLOATING INTO THE DECREPIT TWIN TOWERS OF BLAIR AND BROWN.

I PITCHED THIS TO THE *GUARDIAN*, KNOWING THEY WOULD SAY NO.

AS HE EXPECTED, THE *GUARDIAN* TURNED DOWN THE IDEA. YOU COULDN'T JOKE ABOUT 9/11.

HIS USUAL BACK-UP PLAN WAS TO DONATE REJECTED CARTOONS TO THE COMMUNIST *MORNING STAR* ...

... BUT ITS NEW EDITOR VETOED HIS IDEA, PERHAPS BECAUSE CORBYN'S PEOPLE WOULDN'T LIKE HIM BEING ASSOCIATED WITH TERRORISM.

The Guardian

Morning

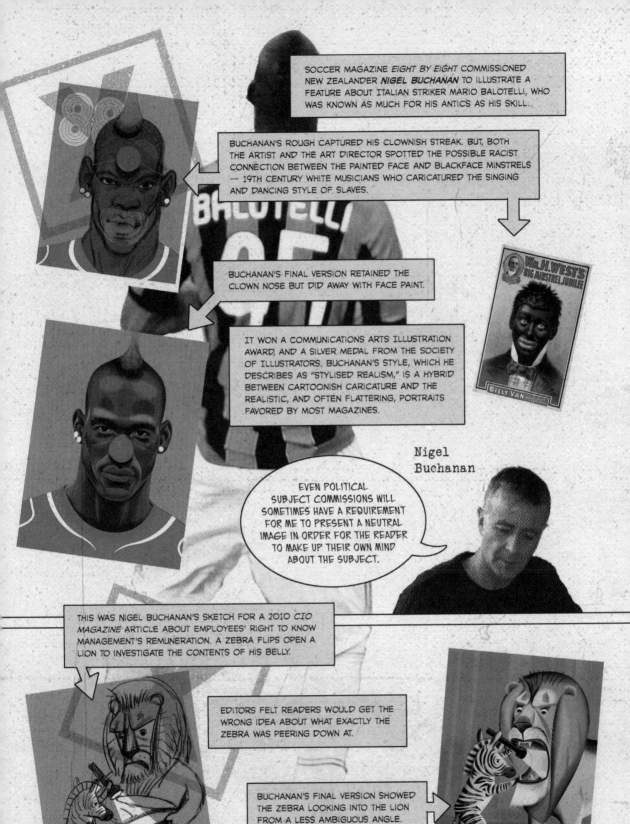

SOCCER MAGAZINE *EIGHT BY EIGHT* COMMISSIONED NEW ZEALANDER *NIGEL BUCHANAN* TO ILLUSTRATE A FEATURE ABOUT ITALIAN STRIKER MARIO BALOTELLI, WHO WAS KNOWN AS MUCH FOR HIS ANTICS AS HIS SKILL.

BUCHANAN'S ROUGH CAPTURED HIS CLOWNISH STREAK. BUT, BOTH THE ARTIST AND THE ART DIRECTOR SPOTTED THE POSSIBLE RACIST CONNECTION BETWEEN THE PAINTED FACE AND BLACKFACE MINSTRELS -- 19TH CENTURY WHITE MUSICIANS WHO CARICATURED THE SINGING AND DANCING STYLE OF SLAVES.

BUCHANAN'S FINAL VERSION RETAINED THE CLOWN NOSE BUT DID AWAY WITH FACE PAINT.

IT WON A COMMUNICATIONS ARTS ILLUSTRATION AWARD, AND A SILVER MEDAL FROM THE SOCIETY OF ILLUSTRATORS. BUCHANAN'S STYLE, WHICH HE DESCRIBES AS "STYLISED REALISM," IS A HYBRID BETWEEN CARTOONISH CARICATURE AND THE REALISTIC, AND OFTEN FLATTERING, PORTRAITS FAVORED BY MOST MAGAZINES.

Nigel Buchanan

EVEN POLITICAL SUBJECT COMMISSIONS WILL SOMETIMES HAVE A REQUIREMENT FOR ME TO PRESENT A NEUTRAL IMAGE IN ORDER FOR THE READER TO MAKE UP THEIR OWN MIND ABOUT THE SUBJECT.

THIS WAS NIGEL BUCHANAN'S SKETCH FOR A 2010 *CIO MAGAZINE* ARTICLE ABOUT EMPLOYEES' RIGHT TO KNOW MANAGEMENT'S REMUNERATION. A ZEBRA FLIPS OPEN A LION TO INVESTIGATE THE CONTENTS OF HIS BELLY.

EDITORS FELT READERS WOULD GET THE WRONG IDEA ABOUT WHAT EXACTLY THE ZEBRA WAS PEERING DOWN AT.

BUCHANAN'S FINAL VERSION SHOWED THE ZEBRA LOOKING INTO THE LION FROM A LESS AMBIGUOUS ANGLE.

AMERICAN CARTOONIST *DARYL CAGLE* FELT THE POWER OF THE MILITARY-INDUSTRIAL COMPLEX WHILE HE WAS CONTRACTED TO DRAW FIVE CARTOONS A WEEK FOR THE *HONOLULU ADVERTISER* IN HAWAII.

IN 2001, A U.S. NAVY SUBMARINE OFF THE COAST OF HAWAII WAS ENTERTAINING VISITORS WITH AN EMERGENCY SURFACING MANEUVER. IT RAMMED A JAPANESE VESSEL, WHICH IMMEDIATELY SUNK, KILLING NINE OF HER CREW.

THE SCANDAL WAS THE BIGGEST STORY IN TOWN, BUT THE *HONOLULU ADVERTISER* KILLED A STRING OF CAGLE'S CARTOONS ON THE TOPIC.

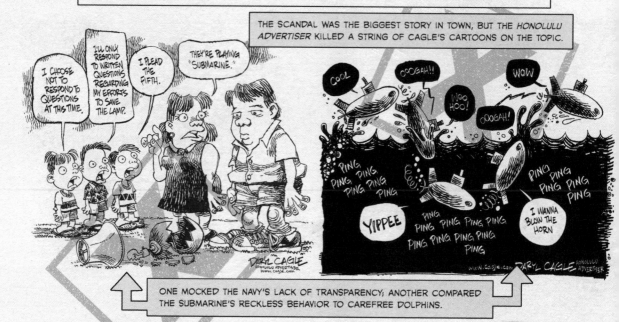

ONE MOCKED THE NAVY'S LACK OF TRANSPARENCY; ANOTHER COMPARED THE SUBMARINE'S RECKLESS BEHAVIOR TO CAREFREE DOLPHINS.

HIS EDITOR EXPLAINED TO HIM THAT HONOLULU WAS A "NAVY TOWN" AND THE PAPER HAD TO BE VERY CAREFUL ABOUT CRITICIZING THE NAVY.

CAGLE'S CARTOONS APPEARED INSTEAD IN MAINLAND U.S. NEWSPAPERS THAT SUBSCRIBED TO HIS NEW SYNDICATE.

I THINK *CENSORSHIP* IS VERY RARE IN AMERICA, AND IF IT HAPPENS, IT ISN'T CLEARLY IN THE FORM OF A DEMAND FROM THE GOVERNMENT.

Daryl Cagle

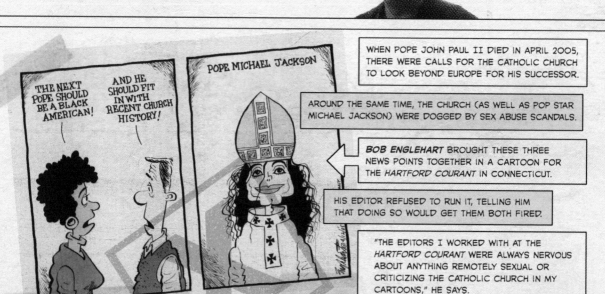

WHEN POPE JOHN PAUL II DIED IN APRIL 2005, THERE WERE CALLS FOR THE CATHOLIC CHURCH TO LOOK BEYOND EUROPE FOR HIS SUCCESSOR.

AROUND THE SAME TIME, THE CHURCH (AS WELL AS POP STAR MICHAEL JACKSON) WERE DOGGED BY SEX ABUSE SCANDALS.

*BOB ENGLEHART* BROUGHT THESE THREE NEWS POINTS TOGETHER IN A CARTOON FOR THE *HARTFORD COURANT* IN CONNECTICUT.

HIS EDITOR REFUSED TO RUN IT, TELLING HIM THAT DOING SO WOULD GET THEM BOTH FIRED.

"THE EDITORS I WORKED WITH AT THE *HARTFORD COURANT* WERE ALWAYS NERVOUS ABOUT ANYTHING REMOTELY SEXUAL OR CRITICIZING THE CATHOLIC CHURCH IN MY CARTOONS," HE SAYS.

WHILE PRESIDENT BILL CLINTON WAS BEING IMPEACHED IN 1998, HE ORDERED MILITARY ATTACKS ON ALLEGED TERRORIST TARGETS IN THE MIDDLE EAST.

BOB ENGLEHART DREW THIS CARTOON FOR THE *HARTFORD COURANT* TO COMMEMORATE CLINTON'S FEAT. THE PUNCHLINE WAS IN THE CAPTION, BUT HIS EDITOR SAW SOMETHING ELSE.

" AMAZING! THIS PRESIDENT FIGHTS WITH HIS PANTS DOWN! "

HE SAID HE WOULDN'T RUN IT BECAUSE THE *CRUISE MISSILE* LOOKED LIKE A *DILDO.*

AT THE TIME, MY REACTION TO THESE THINGS WAS TO HAVE A MAJOR HISSY FIT IN THE HOPES THAT THEY'D THINK TWICE BEFORE THEY KILLED A *CARTOON.*

Bob Englehart

NEVERTHELESS, TO GET AROUND THE UNINTENDED PHALLIC SYMBOLISM, HE AMENDED THE DRAWING.

" AMAZING! THIS PRESIDENT FIGHTS WITH HIS PANTS DOWN! "

HE GAVE THE MISSILE A POINTED NOSE "ALTHOUGH THERE WERE NO CRUISE MISSILES WITH A POINTED NOSE." THE EDITOR WAS SATISFIED AND RAN THE CARTOON WITH THE ANATOMICALLY INCORRECT MISSILE.

IN DECEMBER 2015, PRESIDENTIAL HOPEFUL TED CRUZ APPEARED WITH HIS WIFE AND TWO YOUNG DAUGHTERS IN A TELEVISION COMMERCIAL.

THE "CRUZ FAMILY CHRISTMAS" INFOMERCIAL-STYLE AD FEATURED CHRISTMAS STORIES WITH A POLITICAL TWIST.

ONE OF THE GIRLS WAS MADE TO READ A PARODY OF *HOW THE GRINCH STOLE CHRISTMAS*, MOCKING DEMOCRATIC CONTENDER HILLARY CLINTON FOR LOSING EMAILS.

THIS *WASHINGTON POST* CARTOON BY **ANN TELNAES** CRITICIZED CRUZ'S FLAGRANT EXPLOITATION OF HIS CHILDREN FOR POLITICAL GAIN, USING THE VISUAL METAPHOR OF A 19TH CENTURY ORGAN GRINDER WITH HIS PERFORMING MONKEYS.

BUT A SOCIAL MEDIA STORM ACCUSED TELNAES OF ATTACKING A POLITICIAN'S KIDS -- TRADITIONALLY A NO-GO AREA.

THE *WASHINGTON POST* SIDED WITH THE CRITICS AND DELETED THE CARTOON, REPLACING IT WITH A MESSAGE FROM EDITORIAL PAGE EDITOR FRED HIATT: "IT'S GENERALLY BEEN THE POLICY OF OUR EDITORIAL SECTION TO LEAVE CHILDREN OUT OF IT."

WHAT THE CRUZ CAMPAIGN WAS REALLY TRYING TO DO WAS ATTACK THE *POST*.

WITH SOCIAL MEDIA IT HAPPENS VERY, VERY FAST. I THINK THAT SURPRISED THE *POST* AND THAT'S PROBABLY ONE REASON WHY THEY TOOK IT DOWN.

Ann Telnaes

---

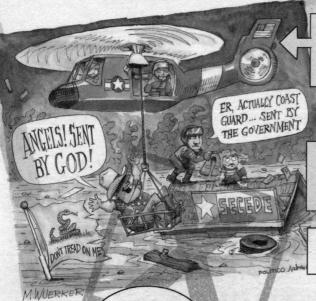

ANGELS! SENT BY GOD!

ER, ACTUALLY COAST GUARD... SENT BY THE GOVERNMENT

DON'T TREAD ON ME

SECEDE

POLITICO Andrew

M. WUERKER

WHEN TEXAS WAS HIT BY HURRICANE HARVEY IN 2017, *POLITICO'S* **MATT WUERKER** DREW A CARTOON COMMENTING ON THE IRONY OF THE STATE'S MANY LIBERTARIANS AND SECESSIONISTS WELCOMING ASSISTANCE FROM THE FEDERAL GOVERNMENT.

CONSERVATIVES POUNCED.

ALT RIGHT ORGAN *BREITBART* SAID, "THE LEFT-LEANING *POLITICO* WEBSITE HAS TAKEN A POTSHOT AT WHITE SOUTHERN CHRISTIANS IN AN INSULTING NEW CARTOON DEPICTING BELIEVERS AS STUPID AND STILL YEARNING FOR THE SECESSION OF THE SOUTH."

A PANICKY *POLITICO* SOCIAL MEDIA EDITOR DELETED THE TWEET CONTAINING THE CARTOON, THOUGH EDITORS LEFT IT ON THE WEBSITE.

IN THE MEDIA WARS, PEOPLE WILL BEAT UP ON THEIR RIVALS.

I'M PRETTY SURE THEY SAW IT AS AN OPPORTUNITY TO ATTACK *POLITICO*.

Matt Wuerker

# THE NEW YORKER

The covers of the *New Yorker* are among the most prized pieces of cartooning real estate around. Newsy and often controversial, the weekly magazine's cover art is given the room to make a cultural statement with no connection to the articles within. Needless to say, the competition for that space is intense.

Canadian artist Anita Kunz has had many of her works used – but also many rejections. "I don't take it personally," she says. She has done illustrations for many other top magazines, including *Time* and *Rolling Stone*. Rejections come with the job, and she readily acknowledges that the reasons could include editors having been offered better art than hers:

"I have a box full of rejected sketches. I have hundreds."

What bothers her more is the loss of autonomy. When she

got into magazine illustration, art directors had full authority over their publication's visuals and passed that autonomy on to artists. While she would have

to match the respective magazine's style, she was often given the freedom to comment on the accompanying article. "I didn't have to say exactly the same thing the article was saying," she says. "I felt I was able to respect readers enough to challenge them with a different viewpoint."

She adds, "That has changed dramatically over the past two decades. I have almost no autonomy anymore. Now, we answer to editors, and editors are not trained to think visually."

She attributes this in part to print magazines becoming much more vulnerable financially. "They don't want to risk losing subscribers."

Kunz was not told why these sketches were rejected, but she is quite sure it wasn't because they were too critical of Donald Trump. The *New Yorker* and its liberal readership were not coy about their hostility toward the 45th President.

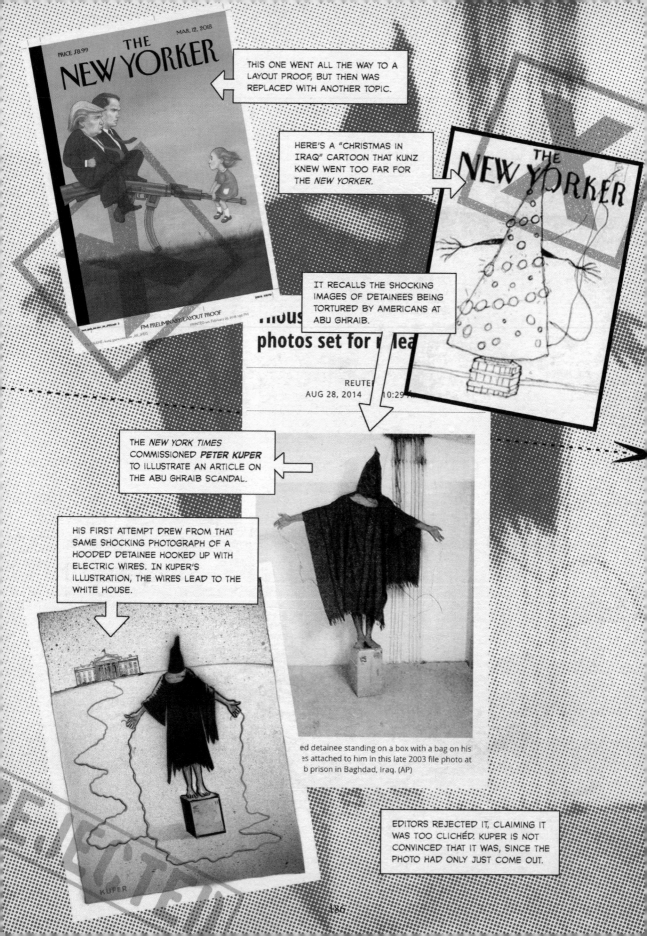

THE NEW YORKER

PRICE $8.99

MAR. 12, 2018

THIS ONE WENT ALL THE WAY TO A LAYOUT PROOF, BUT THEN WAS REPLACED WITH ANOTHER TOPIC.

FM PRELIMINARY/LAYOUT PROOF

PRINTED on February 26, 2018 1:06 PM

HERE'S A "CHRISTMAS IN IRAQ" CARTOON THAT KUNZ KNEW WENT TOO FAR FOR THE *NEW YORKER*.

THE NEW YORKER

IT RECALLS THE SHOCKING IMAGES OF DETAINEES BEING TORTURED BY AMERICANS AT ABU GHRAIB.

...hous...
photos set for r lea...

REUTE...
AUG 28, 2014 10:29...

THE *NEW YORK TIMES* COMMISSIONED *PETER KUPER* TO ILLUSTRATE AN ARTICLE ON THE ABU GHRAIB SCANDAL.

HIS FIRST ATTEMPT DREW FROM THAT SAME SHOCKING PHOTOGRAPH OF A HOODED DETAINEE HOOKED UP WITH ELECTRIC WIRES. IN KUPER'S ILLUSTRATION, THE WIRES LEAD TO THE WHITE HOUSE.

...ed detainee standing on a box with a bag on his
...es attached to him in this late 2003 file photo at
...b prison in Baghdad, Iraq. (AP)

EDITORS REJECTED IT, CLAIMING IT WAS TOO CLICHÉD. KUPER IS NOT CONVINCED THAT IT WAS, SINCE THE PHOTO HAD ONLY JUST COME OUT.

KUPER

THE *NEW YORK TIMES* PUBLISHED KUPER'S SECOND VERSION.

IT CONVEYS THE SENSE OF NATIONAL SHAME THROUGH A MODIFIED AMERICAN COAT OF ARMS: THE EAGLE'S SHIELD IS BLOOD-SPLATTERED, WITH ITS ARROWS SUPPLEMENTED BY ELECTRIC WIRE, AND ITS OLIVE BRANCH SHEDDING LEAVES.

KUPER SAYS HE TAKES REJECTIONS IN STRIDE, PARTLY BECAUSE THE TIME PRESSURE REQUIRES HIM TO JUST GET ON WITH THE JOB.

THE TIME FRAMES ARE SO SHORT, SO IT'S NOT AS IF I HAVE A HUGE AMOUNT OF TIME TO CONTEMPLATE.

IT'S ALL SAME-DAY ILLUSTRATION.

Peter Kuper

STAFF CARTOONISTS FOR DAILY NEWSPAPERS DON'T LOSE SLEEP OVER THE OCCASIONAL REJECTION.

*ROB ROGERS* OF THE *PITTSBURGH POST-GAZETTE*, THOUGH, HAD A STREAK OF KILLED CARTOONS, PORTENDING HIS UNCEREMONIOUS SACKING (SEE HIS STORY IN THE PREVIOUS CHAPTER).

EVERY YEAR, A FEW OF MY CARTOONS GET KILLED.

BUT SUDDENLY, IN A THREE-MONTH PERIOD, 19 CARTOONS OR PROPOSALS WERE REJECTED.

Rob Rogers

IT WAS A STARK DEMONSTRATION OF THE FIRST AMENDMENT'S INABILITY TO PROTECT CARTOONISTS' INDEPENDENCE FROM THE OVERRIDING WILL OF PRIVATE OWNERS.

HERE ARE JUST A FEW OF THE CARTOONS THAT THE EDITORIAL PAGE EDITOR AND PUBLISHER FOUND UNFUNNY ...

TAKE A PARDON

©2018 ANDREWS MCMEEL SYND.

THE WEEK BEFORE THIS ROGERS CARTOON, PRESIDENT DONALD TRUMP PARDONED DINESH D'SOUZA, A CONSERVATIVE AUTHOR CONVICTED OF MAKING ILLEGAL CAMPAIGN CONTRIBUTIONS.

TRUMP WAS UNUSUALLY ENERGETIC IN USING HIS CONSTITUTIONAL POWER TO PARDON CRIMINALS, BYPASSING INSTITUTIONALIZED PROCESSES.

COU
BE T
AMBI

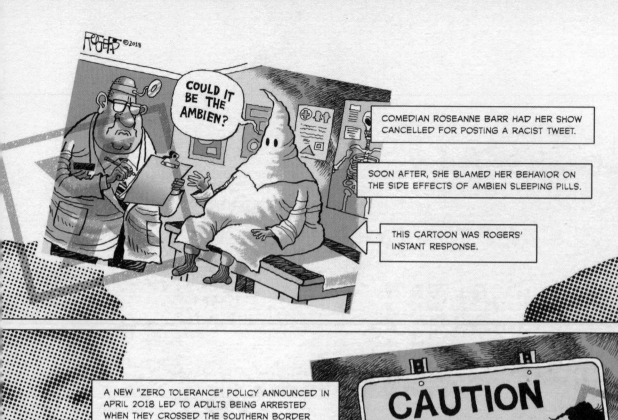

COMEDIAN ROSEANNE BARR HAD HER SHOW CANCELLED FOR POSTING A RACIST TWEET.

SOON AFTER, SHE BLAMED HER BEHAVIOR ON THE SIDE EFFECTS OF AMBIEN SLEEPING PILLS.

THIS CARTOON WAS ROGERS' INSTANT RESPONSE.

A NEW "ZERO TOLERANCE" POLICY ANNOUNCED IN APRIL 2018 LED TO ADULTS BEING ARRESTED WHEN THEY CROSSED THE SOUTHERN BORDER INTO THE UNITED STATES WITHOUT AUTHORIZATION.

THEIR CHILDREN, WHO WERE TOO YOUNG FOR CRIMINAL DETENTION, WERE CRUELLY SEPARATED FROM THEM.

ROGERS' CARTOON WAS TWIST ON A FAMILIAR ROAD SAFETY SIGN WARNING DRIVERS TO LOOK OUT FOR IMMIGRANTS DARTING ACROSS THE HIGHWAY.

MEMORIAL DAY IS A FEDERAL HOLIDAY IN THE U.S. HONORING FALLEN ARMED FORCES PERSONNEL. IN THIS CARTOON, ROGERS MOURNED OTHER VICTIMS OF THE TRUMP PRESIDENCY. LIKE THE CARTOONS ABOVE, IT NEVER APPEARED IN THE *PITTSBURGH POST-GAZETTE*.

IN 2014, THE POSTCARD MARKETING COMPANY BOOMERANG COMMISSIONED DUTCH CARTOONIST *TJEERD ROYAARDS* TO CREATE A POSTCARD ABOUT THE ISLAMIC STATE TERROR ORGANIZATION, WHOSE EXECUTION VIDEOS WERE HORRIFYING THE WORLD.

ROYAARDS FELT THAT, IN THE DUTCH CONTEXT, SIMPLY CONDEMNING ISLAMIC STATE WOULD BE PREACHING TO THE CONVERTED. "EVERYONE HATES ISLAMIC STATE HERE," HE SAYS.

"SO I WANTED TO DO ONE ABOUT RELIGION. RELIGION HAS THIS TRACK RECORD OF NOT BEING VERY NICE TO PEOPLE."

HIS CARTOON READS "GOD IS GOOD" AND SHOWS THE ICONIC YOUTUBE SCENE OF AN IS PRISONER ABOUT TO BE DECAPITATED.

IN THE BACKGROUND ARE TORTURE SCENES FROM THE CATHOLIC INQUISITION.

"THESE ARE ALL ACTUAL DRAWINGS FROM MEDIEVAL TIMES, SO I MADE NOTHING UP," ROYAARDS SAYS.

AFTER IT WENT UP ON BOOMERANG RACKS ALL OVER THE COUNTRY, DUTCH COMMENTATORS CONDEMNED THE POSTCARD.

THE BIGGEST CINEMA CHAIN IN THE NETHERLANDS TOOK THE POSTCARD OFF THE RACKS, AND OTHER VENUES FOLLOWED SUIT.

A LOT OF PEOPLE *GOT* REALLY MAD ABOUT THIS *COMPARISON* OF ISLAMIC TERRORISM TO CHRISTIAN HISTORY.

BUT THIS IS ONE WHERE, FIVE YEARS ON, I FEEL IT'S COMPLETELY DEFENSIBLE AS AN IMAGE.

IT'S A HARSH COMPARISON BUT IT DOESN'T MAKE IT ANY LESS TRUE.

Tjeerd Royaards

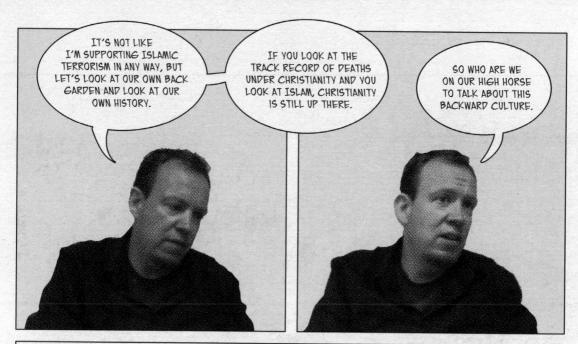

IT'S NOT LIKE I'M SUPPORTING ISLAMIC TERRORISM IN ANY WAY, BUT LET'S LOOK AT OUR OWN BACK GARDEN AND LOOK AT OUR OWN HISTORY.

IF YOU LOOK AT THE TRACK RECORD OF DEATHS UNDER CHRISTIANITY AND YOU LOOK AT ISLAM, CHRISTIANITY IS STILL UP THERE.

SO WHO ARE WE ON OUR HIGH HORSE TO TALK ABOUT THIS BACKWARD CULTURE.

IN THIS CENTURY, NO CARTOON SUBJECT HAS PROVOKED AS MUCH NERVOUSNESS AS ISLAM'S PROPHET MOHAMMED.

WHEN INTERNATIONAL REACTIONS TO THE DANISH CARTOONS TURNED VIOLENT IN EARLY 2006 (SEE CHAPTER 13), *R. J. MATSON* OF THE *ST. LOUIS POST-DISPATCH* DREW THIS CARTOON ...

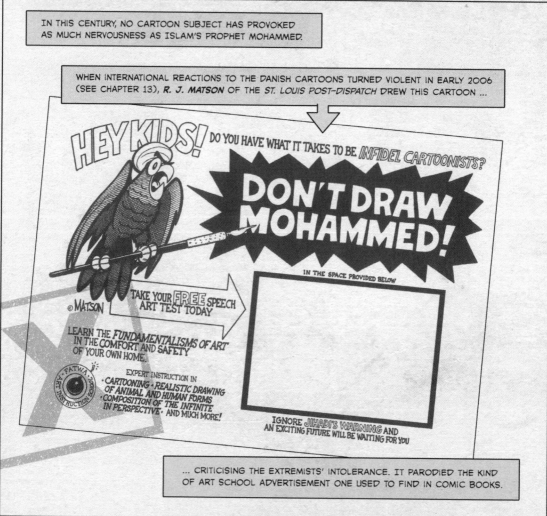

... CRITICISING THE EXTREMISTS' INTOLERANCE. IT PARODIED THE KIND OF ART SCHOOL ADVERTISEMENT ONE USED TO FIND IN COMIC BOOKS.

ALTHOUGH MATSON DIDN'T DRAW THE PROPHET -- HE FELT HE DIDN'T HAVE TO IN ORDER TO MAKE HIS POINT -- HIS PUBLISHER INTERVENED AND STOPPED ITS PUBLICATION.

HE CONTINUED TO ARGUE WITH HIS EDITORS THAT THEIR READERS WOULD EXPECT SOME CARTOON ON THE CONTROVERSY.

A FEW DAYS LATER, HIS NEWSPAPER AGREED TO RUN THIS PRESCIENT CARTOON -- WHICH ANTICIPATED THE EVENTUALITY THAT CARTOONISTS WOULD DIE IN THIS CONFLICT.

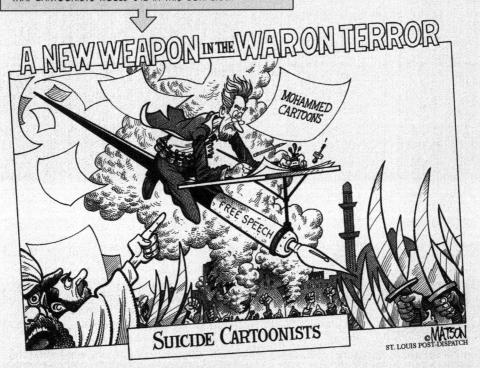

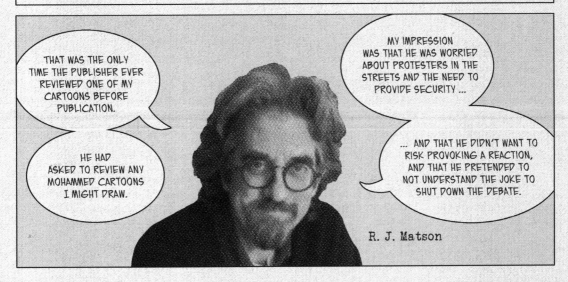

THAT WAS THE ONLY TIME THE PUBLISHER EVER REVIEWED ONE OF MY CARTOONS BEFORE PUBLICATION.

HE HAD ASKED TO REVIEW ANY MOHAMMED CARTOONS I MIGHT DRAW.

MY IMPRESSION WAS THAT HE WAS WORRIED ABOUT PROTESTERS IN THE STREETS AND THE NEED TO PROVIDE SECURITY ...

... AND THAT HE DIDN'T WANT TO RISK PROVOKING A REACTION, AND THAT HE PRETENDED TO NOT UNDERSTAND THE JOKE TO SHUT DOWN THE DEBATE.

R. J. Matson

191

GRAMEDIA, ONE OF INDONESIA'S LARGEST BOOK RETAILERS, TOOK *AJI PRASETYO*'S 2010 CARTOON ANTHOLOGY OFF ITS SHELVES AFTER PROTESTS BY THE HARDLINE ISLAMIC DEFENDERS FRONT (FPI).

THE BOOK'S COVER CARRIED A CARTOON HE FIRST PUBLISHED ONLINE TWO YEAR EARLIER.

IT SHOWS THREE MEN ON A MOTORCYCLE CHALLENGING A POLICEMAN TO CITE THE RELEVANT RELIGIOUS VERSE UNDER WHICH THEY HAD ALLEGEDLY COMMITTED A TRAFFIC VIOLATION.

Aji Prasetyo

FROM THEIR ATTIRE AND ATTITUDE, THEY WERE CLEARLY SUPPOSED TO BE FPI MEMBERS.

FPI KICKED UP A FUSS.

GRAMEDIA DECIDED NOT TO TAKE ANY RISKS. IT RETURNED ITS REMAINING STOCKS TO THE PUBLISHER,

Indah Pratidina

GRAMEDIA ALSO WITHDREW FROM ITS BOOKSTORES THE INDONESIAN TRANSLATION OF *PERSEPOLIS*, MARJANE SATRAPI'S GRAPHIC MEMOIR OF GROWING UP IN IRAN.

FIRST PUBLISHED IN FRANCE IN 2000, THE BOOK WAS BANNED IN IRAN BECAUSE OF ITS CRITICAL FEMINIST PERSPECTIVE ON THE SUPPRESSION OF WOMEN DURING AND AFTER THE IRANIAN REVOLUTION.

SOME CONSERVATIVES IN INDONESIA WERE ALSO UPSET.

"THERE WERE CONCERNS THAT SOME PEOPLE WOULD TAKE THE PICTURES OUT OF CONTEXT AND USE THEM AGAINST THE PUBLISHER," SAYS INDAH PRATIDINA OF THE UNIVERSITY OF INDONESIA, WHO TRANSLATED THE BOOK.

IN THE FIRST TWO DECADES OF THE 21ST CENTURY, RELIGIOUS EXTREMISM WAS THE MAIN EXTERNAL CHALLENGE TO CARTOONISTS LIVING IN OPEN SOCIETIES (SEE CHAPTERS 13-14).

NOW, CHINA IS EMERGING AS A NEW CROSS-BORDER THREAT.

IN JANUARY 2020, NEWS SPREAD ABOUT A NEW CORONAVIRUS EPIDEMIC THAT CHINESE AUTHORITIES HAD INITIALLY TRIED TO COVER UP.

MANY CARTOONISTS AROUND THE WORLD COMMENTED ON THIS NATIONAL CRISIS THAT WAS GOING GLOBAL.

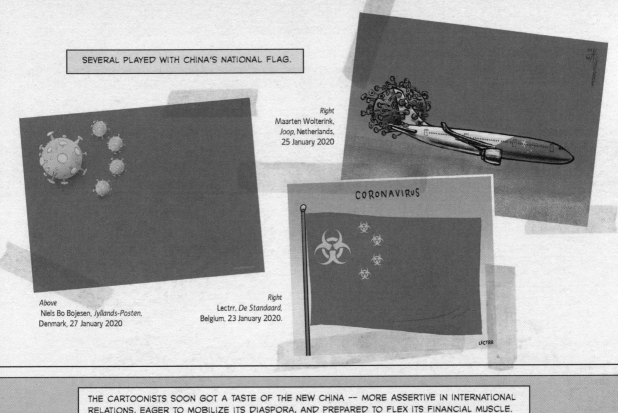

SEVERAL PLAYED WITH CHINA'S NATIONAL FLAG.

*Right*
Maarten Wolterink,
*Joop*, Netherlands,
25 January 2020

CORONAVIRUS

*Above*
Niels Bo Bojesen, *Jyllands-Posten*,
Denmark, 27 January 2020

*Right*
Lectrr, *De Standaard*,
Belgium, 23 January 2020.

LECTRR

THE CARTOONISTS SOON GOT A TASTE OF THE NEW CHINA -- MORE ASSERTIVE IN INTERNATIONAL RELATIONS, EAGER TO MOBILIZE ITS DIASPORA, AND PREPARED TO FLEX ITS FINANCIAL MUSCLE.

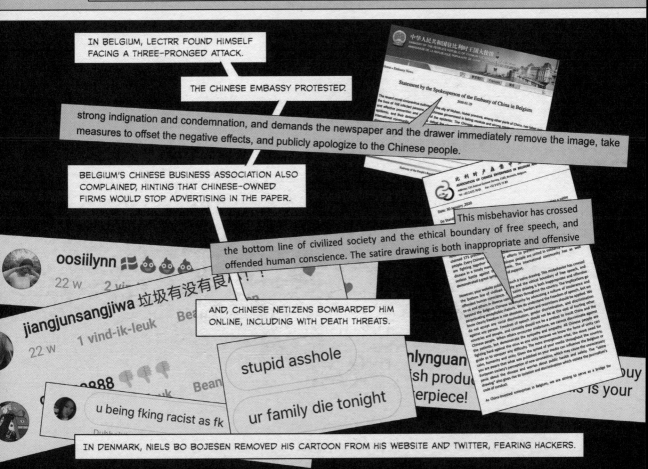

IN BELGIUM, LECTRR FOUND HIMSELF FACING A THREE-PRONGED ATTACK.

THE CHINESE EMBASSY PROTESTED.

strong indignation and condemnation, and demands the newspaper and the drawer immediately remove the image, take measures to offset the negative effects, and publicly apologize to the Chinese people.

BELGIUM'S CHINESE BUSINESS ASSOCIATION ALSO COMPLAINED, HINTING THAT CHINESE-OWNED FIRMS WOULD STOP ADVERTISING IN THE PAPER.

This misbehavior has crossed the bottom line of civilized society and the ethical boundary of free speech, and offended human conscience. The satire drawing is both inappropriate and offensive

oosiilynn

22 w

jiangjunsangjiwa 垃圾有没有良心！！！

22 w    1 vind-ik-leuk

AND, CHINESE NETIZENS BOMBARDED HIM ONLINE, INCLUDING WITH DEATH THREATS.

stupid asshole

u being fking racist as fk    ur family die tonight

IN DENMARK, NIELS BO BOJESEN REMOVED HIS CARTOON FROM HIS WEBSITE AND TWITTER, FEARING HACKERS.

193

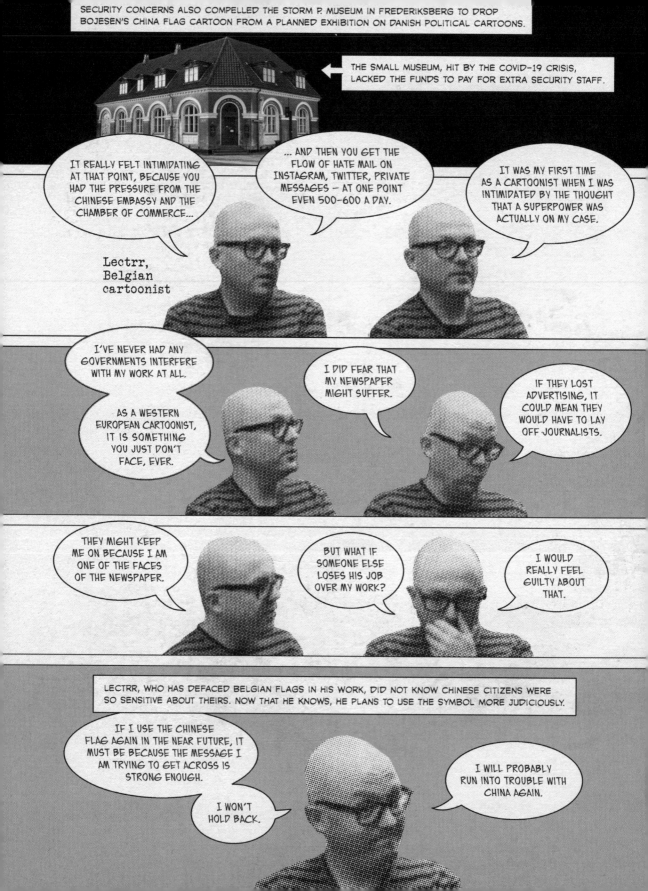

# 8. From Liberation Technology to Platform Censorship

# A NEW WORLD

**Once upon a time, at the dawn of the World Wide Web, it was possible to dream of an internet that transcended power, enabling its users to create a better society.**

WE ARE CREATING A WORLD THAT ALL MAY ENTER WITHOUT PRIVILEGE OR PREJUDICE ACCORDED BY RACE, ECONOMIC POWER, MILITARY FORCE, OR STATION OF BIRTH.

... WHERE ANYONE, ANYWHERE MAY EXPRESS HIS OR HER BELIEFS, NO MATTER HOW SINGULAR, WITHOUT FEAR OF BEING COERCED INTO SILENCE OR CONFORMITY.

YOUR LEGAL CONCEPTS OF PROPERTY, EXPRESSION, IDENTITY, MOVEMENT, AND CONTEXT DO NOT APPLY TO US. THEY ARE ALL BASED ON MATTER, AND THERE IS NO MATTER HERE.

**John Perry Barlow,** lyricist for the Grateful Dead and digital rights activist.

"A Declaration of the Independence of Cyberspace," 1996.

IN CHINA, GERMANY, FRANCE, RUSSIA, SINGAPORE, ITALY AND THE UNITED STATES, YOU ARE TRYING TO WARD OFF THE VIRUS OF LIBERTY BY ERECTING GUARD POSTS AT THE FRONTIERS OF CYBERSPACE.

THESE MAY KEEP OUT THE CONTAGION FOR A SMALL TIME, BUT THEY WILL NOT WORK IN A WORLD THAT WILL SOON BE BLANKETED IN BIT-BEARING MEDIA.

WE WILL SPREAD OURSELVES ACROSS THE PLANET SO THAT NO ONE CAN ARREST OUR THOUGHTS. WE WILL CREATE A CIVILIZATION OF THE MIND IN CYBERSPACE.

MAY IT BE MORE HUMANE AND FAIR THAN THE WORLD YOUR GOVERNMENTS HAVE MADE BEFORE.

TODAY, MOST POLITICAL CARTOONISTS ARE ONLINE, TAKING ADVANTAGE OF THE FREEDOM AND OPPORTUNITY THAT THE INTERNET OFFERS.

SEVERAL OF THE ARTISTS FEATURED IN THIS BOOK DO THEIR POLITICAL CARTOONING ALMOST EXCLUSIVELY ONLINE. MOST OF THE OTHERS MAY APPEAR REGULARLY IN PRINT, BUT HAVE A MUCH LARGER DIGITAL AUDIENCE.

Online, there are individual cartoonists with a larger following than some publications. Most cartoonists work seamlessly across media; and so do censors.

**Zapiro**
@zapiro

Get notified as soon as the latest cartoon is published.

◎ South Africa    ⊘ zapiro.com
▦ Joined April 2008

348 Following   **491.2K** Followers

Followed by Cartooning for Peace, Procartoonists, The Cartoon Mov...

Follow

**Ann Telnaes** ✔
@AnnTelnaes   Follows you

Pushy Nasty Woman Pulitzer prize winning editorial cartoonist for the Washington Post. Trump's ABC fantagraphics.com/trumpsabc/ photo @cheriangeorge

◎ Washington, DC
⊘ washingtonpost.com/people/ann-tel...
▦ Joined April 2012

920 Following   **46.2K** Followers

Followed by CRNI, Terry Anderson, The Surreal McCoy, and 23 others

Following

neyestanimana

♡ ◯ ◁    ⊡

32,781 likes

neyestanimana مردم و ولایت مطلقه

Emad Hajjaj Cartoons ✔
2,977 Tweets

**Emad Hajjaj Cartoons** ✔
@EmadHajjaj

رسام #كاريكاتير اردني معروف بشخصية #أبومحجوب الساخرة يعمل في صحيفة وموقع #العربي_الجديد #cartoons #Abu_Mahjoob

◎ Amman, Jordan    ⊘ hajjajcartoons.com    ▦ Joined January 2012

581 Following   **124.9K** Followers

Followed by Media@Risk, CRNI, and 10 others you follow

Follow

Digital media have revolutionized political cartooning, arguably even more than advances in printing technologies did in the 19th century.

## Technologies of reproduction

Underground "zine" artists — who had been experimenting with borrowed images as part of their "make your own culture" ethic since the 1930s — went wild with photocopiers from the 1980s.

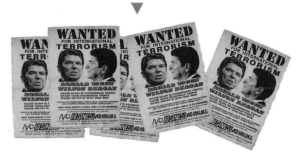

The World Wide Web opened a virtually limitless vista of images and video clips for creative individuals to appropriate.

▲ The face that launched a thousand memes: This Reuters image was gleefully grabbed from online sources such as Google Images.

## Technologies of creation

Digital tools brought photo editing and manipulation out of the darkroom and onto personal computers and phones. Today, standard camera apps on smartphones have built-in technology to add text to an image.

Do try this at home: Smartphones allow users to add text to images. For better results, there are specialized meme-making apps such as Imgur and Mematic. ▶

## Technologies of distribution

Social media enable any user to share content with local and global publics. Endorsement and amplification by big-media gatekeepers still helps — but it is no longer a prerequisite for virality.

# MEMES

## are the most prevalent genre of political cartooning today.

They are images or short video clips that spread rapidly through the internet, undergoing adaptation along the way.

Most memes do not fit our definition of political cartooning as visual commentary about current affairs (cute cats may be popular, but rarely qualify as matters of public interest). But some memes certainly do.

One classic example is the memeification of news photographs of US Secretary of State Hillary Clinton on board a military plane bound for Libya.

Months later, they were transformed into a visual joke. In a single week, the original memes generated more than 30 versions with 83,000 shares on Facebook and news coverage around the world.

So then I sent her a text saying I think left my favorite sunglasses in the desk.

Sorry Condi, haven't seen them.

Clinton's predecessor, Condoleezza Rice, wonders if she left something behind at the State Department.

Any advice?

Drink.

Republican Mitt Romney challenged Barack Obama for the Presidency in 2012. Clinton knew what it felt like to lose to Obama: she lost the Democratic Party nomination to him in 2008.

I DID NOT HAVE

TEXTUAL RELATIONS WITH THAT SERVER

imgflip.com

In her unsuccessful 2016 Presidential campaign, Hillary Clinton was dogged by revelations that she had used a non-secure private server for e-mail correspondence.

POLITICAL CARTOONS HAVE ALWAYS HAD A ROLE IN PROTEST MOVEMENTS.

MEMES, AN EMBODIMENT OF THE INTERNET'S PARTICIPATORY CULTURE, ARE AN ESPECIALLY EFFECTIVE MEANS OF ENGAGING A MOVEMENT'S INSIDERS AND BYSTANDERS.

IN THE *OCCUPY WALL STREET* MOVEMENT, ARTISTS CREATED DO-IT-YOURSELF PROTEST ART FOR BOTH ONLINE AND OFFLINE DISTRIBUTION.

A REAL DOLLAR BILL IS STAMPED WITH THE LABEL "FUTURE PROPERTY OF THE 1%," BECAUSE "UNLESS THINGS CHANGE, IT'S SAFE TO ASSUME THAT OUR MONEY WILL ULTIMATELY END UP IN THE HANDS OF THE ONE PERCENT."

THE "OCCUPY GEORGE" CAMPAIGN CREATED FIVE VERSIONS OF THIS GRAPHIC CONCEPT.

SUPPORTERS WERE INVITED TO SHARE THE IMAGES VIA SOCIAL MEDIA...

OR TO DOWNLOAD TEMPLATES TO PRINT AT HOME ON REAL DOLLAR BILLS.

BUT THE MOST PRODUCTIVE MEME FACTORY IN THE WORLD HAS TO BE CHINA.

EVEN AS THE SPACE FOR TRADITIONAL POLITICAL CARTOONS HAS ALL BUT DISAPPEARED UNDER XI JINPING, INTERNET MEMES ARE PART OF THE DAILY ONLINE EXPERIENCE OF HUNDREDS OF MILLIONS OF CHINESE.

WINNIE THE POOH MEMES (CHAPTER 4) ARE PROBABLY THE BEST KNOWN OVERSEAS.

LESS FAMOUS OUTSIDE OF CHINA ARE THE "TOAD WORSHIP" MEMES DEDICATED TO FORMER PRESIDENT JIANG ZEMIN, WHO RETIRED IN 2003

THE BANNED MOVEMENT FALUN GONG CALLED HIM A TOAD AS AN INSULT, BUT JIANG'S FANS LATER EMBRACED IT AS AN AFFECTIONATE NICKNAME.

JIANG ZEMIN MEMES TOOK OFF AROUND 2014 AS A REACTION TO THE RISE OF XI JINPING.

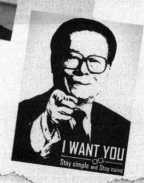

"Xi centralized power and showed his hardline conservative mindset. We couldn't express our criticism through normal channels, so we turned to other indirect ways, including lauding Jiang's personality and characteristics in various memes."

-- Anonymous meme maker.

THEIR POPULARITY IS RELATED TO PEOPLE'S RESENTMENT OF XI JINPING.

XI IS REGARDED AS UNINTERESTING AND CLOSED-MINDED. JIANG IS MORE WESTERNIZED AND EMOTIONAL.

TOAD WORSHIPPERS ARE MAINLY CRITICS WHO WANT THE COMMUNIST PARTY TO REFORM ITSELF.

Fang Kecheng, media scholar

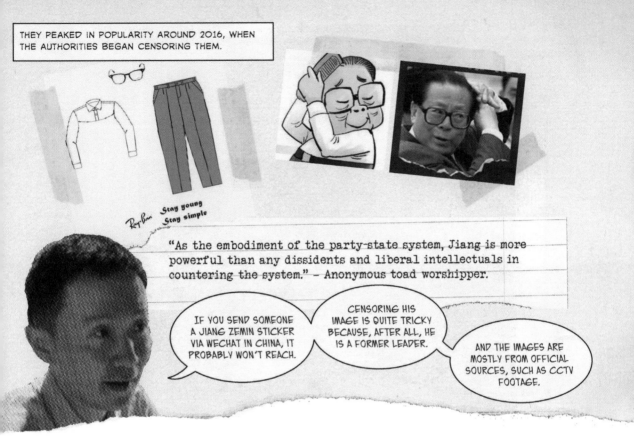

THEY PEAKED IN POPULARITY AROUND 2016, WHEN THE AUTHORITIES BEGAN CENSORING THEM.

*Ray-Ban* Stay young
Stay simple

"As the embodiment of the party-state system, Jiang is more powerful than any dissidents and liberal intellectuals in countering the system." – Anonymous toad worshipper.

IF YOU SEND SOMEONE A JIANG ZEMIN STICKER VIA WECHAT IN CHINA, IT PROBABLY WON'T REACH.

CENSORING HIS IMAGE IS QUITE TRICKY BECAUSE, AFTER ALL, HE IS A FORMER LEADER.

AND THE IMAGES ARE MOSTLY FROM OFFICIAL SOURCES, SUCH AS CCTV FOOTAGE.

# Trying to share Jiang Zemin stickers

June 2020

The Chinese tech giant Tencent – which is as big and as profitable as Facebook – runs China's biggest social network, known internationally as WeChat.

Its international WeChat app lets Jiang Zemin memes through...

*Kecheng's WeChat, registered with a +1 (US) mobile number.*

*Cherian's WeChat, registered with a +852 (Hong Kong) mobile number.*

... but its domestic Weixin app blocks most of them (even if the user is outside China).

*Student's Weixin app, registered
with a +86 (China) mobile number.*

Occasional censorship notwithstanding, internet memes are so ubiquitous that some ask if they have made political cartooning redundant.

Perhaps a thousand user-generated memes do make up for the professional cartoonist whose job is eliminated or whose work is suppressed.

But this view is based on two fallacies.

1. The fallacy that memes are so different from cartoons that meme-makers are immune to the problems cartoonists face.

In fact, there is a big overlap.

Several of the cartoonists in this book — Zunar in Malaysia and Khalid Albaih in Qatar, for example — would qualify as meme-makers.

Cartoonists like Ann Telnaes regularly create animated gif versions of their hand-drawn cartoons. Other artists like Ai Weiwei and Badiucao have also embraced the meme genre.

Provocative, impactful memes are as prone to censorship as non-meme cartoons.

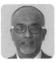

2. The fallacy that memes serve the same role as political cartoons, making the new a functional substitute for the old.

Both can play a democratic role, but those roles are not identical.

Meme culture is more participatory than traditional cartooning. Through digital technology, memes have democratized the ability for millions to create little bits of culture in their spare time.

But democracy also needs individuals who devote their working life to the discipline of monitoring the news and making sense of it through their art.

Through regular, self-conscious practice, they hone three separate skills: their knowledge of current affairs, their commitment to public discourse, and their art.

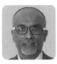

Just as citizens should not have to choose between user-generated comments and a leading public intellectual's weekly opinion column — why shouldn't they have both? — the choice between amateur memes and the professionally produced cartoon is a false one.

# GROWING DISILLUSIONMENT

Direct, instant, borderless. These attributes of the internet may seem like an unmitigated blessing for cartoonists. Not necessarily.

While these features of online communication allow a cartoonist to circumvent censorship, they also result in a loss of control over meaning. When shared through social media, context and intention are lost.

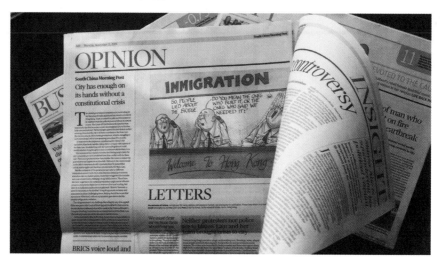

▲ The editorial cartoon on a newspaper's op-ed page is enveloped in a cultural environment dedicated to reasoned debate about current affairs. In contrast, a cartoon carried in a social media stream is decontextualized.

## "It's very difficult to control your narrative"
## — Ann Telnaes

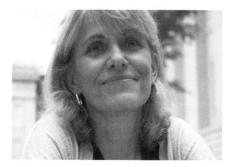

"What's great about the internet is that we can reach the entire world, which wasn't possible before," says Ann Telnaes.

"But, there is that other side: it's very difficult to control your narrative. A lot of people don't actually speak the language of editorial cartoons, and it's tough to educate them very quickly when something happens."

**"Once on the internet, people can do whatever they want with it." – Laurent Deloire**

"Our work is not ours anymore. There is no way we can claim ownership of it," says French illustrator Laurent Deloire.

"Some people share your drawings online and say things they don't understand, make judgements and unfair attributions. I don't want to sound contemptuous, but there is an issue with media literacy. People don't always understand the meaning of things."

# DISINFORMATION

It gets worse.

Cartoonists don't only have to deal with **accidental** misattributions by readers who don't get the joke (see Chapter 11). They also have to contend with **deliberate** manipulation of their work.

This was happening before "fake news" got its name.

In 2005, when Danish Muslim activists wanted to instigate a reaction from Arab governments by circulating a dossier to show how the Prophet was being defamed (Chapter 13), their file contained not only *Jyllands-Posten*'s cartoons, but also a photocopied image that allegedly showed a European caricature of the Prophet as a pig.

▲ A black-and-white photocopy of this photo was passed off as an anti-Muslim cartoon.

In fact, it was a photo of a man taking part in a pig-squealing contest in rural France.

**Disinformation** has become big business since then.

In 2017, South African media exposed a covert campaign by public relations consultants to provoke racial animosities as a way to distract from the Gupta family's hijack of the Zuma government.

Zapiro (Jonathan Shapiro), the country's most famous cartoonist, has been a victim of similar disinformation attempts designed to push South Africans' racial buttons and incite hatred against him.

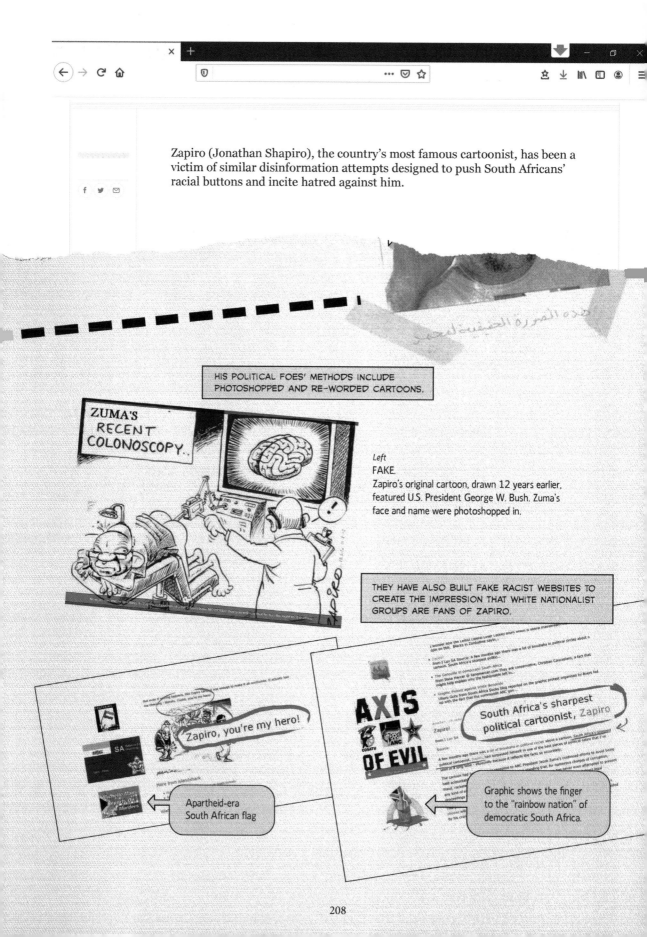

HIS POLITICAL FOES' METHODS INCLUDE PHOTOSHOPPED AND RE-WORDED CARTOONS.

ZUMA'S RECENT COLONOSCOPY...

Left
FAKE.
Zapiro's original cartoon, drawn 12 years earlier, featured U.S. President George W. Bush. Zuma's face and name were photoshopped in.

THEY HAVE ALSO BUILT FAKE RACIST WEBSITES TO CREATE THE IMPRESSION THAT WHITE NATIONALIST GROUPS ARE FANS OF ZAPIRO.

Zapiro, you're my hero!

Apartheid-era South African flag

AXIS OF EVIL

South Africa's sharpest political cartoonist, Zapiro

Graphic shows the finger to the "rainbow nation" of democratic South Africa.

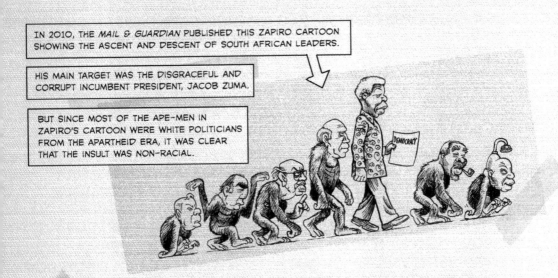

IN 2010, THE *MAIL & GUARDIAN* PUBLISHED THIS ZAPIRO CARTOON SHOWING THE ASCENT AND DESCENT OF SOUTH AFRICAN LEADERS.

HIS MAIN TARGET WAS THE DISGRACEFUL AND CORRUPT INCUMBENT PRESIDENT, JACOB ZUMA.

BUT SINCE MOST OF THE APE-MEN IN ZAPIRO'S CARTOON WERE WHITE POLITICIANS FROM THE APARTHEID ERA, IT WAS CLEAR THAT THE INSULT WAS NON-RACIAL.

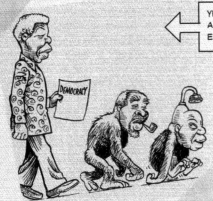

YEARS LATER, THOUGH, THE SPOKESPERSON OF A MINISTER IN ZUMA'S CABINET TWEETED THIS EXTRACT FROM ZAPIRO'S CARTOON.

"PRES MBEKI AND PRES ZUMA MONKEYS ACCORDING TO ZAPIRO. HE SAYS CARTOONISTS LIKE HIM ARE NOT RACIST," THE OFFICIAL'S TWEET SAID.

VICTIMS OF SUCH MANIPULATION CAN TRY TO SET THE RECORD STRAIGHT, BUT RESEARCH ON FACT-CHECKING SHOWS THAT IT CAN'T TOTALLY UNDO THE DAMAGE CAUSED BY DISINFORMATION.

# RECOLONIZATION OF CYBERSPACE

Cyberlibertarians' rousing declarations of independence reflected their aspirations — but did not describe reality.

Yes, the internet lowered the barriers to entry to political participation. But it was naive to think that only progressive, pro-democratic movements would enter these new spaces.

The same opportunities were seized by hate groups, religious extremists, and the supporters of authoritarian politicians. And, governments realized that they didn't have to fear this new terrain. They could go on the offensive.

It became clear that offline power could dominate online space.

Evgeny Morozov's 2011 book *The Net Delusion* was a milestone in the world's awakening to the realpolitik of cyberspace.

"All the government has to do is to 'seed' a pro-government movement at some early stage – inject it with the right ideology and talking points and perhaps some money – and quietly withdraw into the background.

The democratization of access to launching cyber-attacks has resulted in the democratization of censorship; this is poised to have chilling effects on freedom of expression."

- The Net Delusion

Actually, the realists had tried to warn us from the very start of the internet boom.

The cyberutopians, they said, wrongly assumed that the internet had some inherent, natural bias towards the democratic values of freedom and equality.

No, the internet is just man-made code, which creates an architecture that structures how people enter, move about, mingle, and transact in cyberspace.

While it has many freedom-enhancing features, the internet's architecture could always be modified, experts warned as early as 1998.

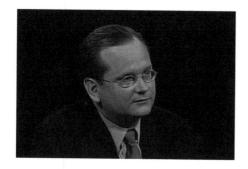

▲ Lawrence Lessig, law professor and co-founder of Creative Commons.

"While we celebrate the 'inherent' freedom of the net ... technicians and politicians are working together to change that architecture ... from an architecture of freedom to an architecture of control.

Cyberspace has the potential to be the most fully, and extensively, regulated space that we have ever known — anywhere, at any time in our history. It has the potential to be the antithesis of a space of freedom."

- Lawrence Lessig, 1998

# RISE OF THE PLATFORMS

The most extreme example of an internet architectured for control is China's walled garden (Chapter 4). The trends Lessig spotted, however, affect even the free world's "open" internet.

Although the technology was supposed to make powerful middlemen redundant, it quickly became a victim of its own success. Cyberspace got too crowded and chaotic for users to plunge in without professional and technical help.

So, the internet generated its own middlemen: Google for search, YouTube for videos, Facebook for social connecting, Twitter for microblogging, and so on.

Facebook helps you connect and share with the people in your life.

Our mission is to organize the world's information and make it universally accessible and useful.

▲ Most people's use of the internet is now mediated by a handful of giant corporations.

They are among the most highly valued firms in stock market history. Their size and market dominance make these intermediaries more influential than any newspaper publisher ever was.

These companies insist they are **not publishers**. They prefer to think of themselves as utilities, like the passive networks that enable water or phone calls to be delivered to the right address.

Strictly speaking, though, they were never really neutral or value-free in how they displayed content. They promote some content and relegate others based on code reflecting their programmers' values and priorities.

Above all, internet platforms prioritize their own **profitability**.

**"By helping people form these connections, we hope to rewire the way people spread and consume information. We have already helped more than 800 million people map out more than 100 billion connections so far, and our goal is to help this rewiring accelerate."**

**– Mark Zuckerberg on Facebook's $16 billion initial public offering in 2012**

Cartoonists have noticed that if they want lots of exposure on Facebook, they have to pay for it. Once their fan pages gather lots of followers, the reach of individual cartoons suddenly drops drastically. Facebook expects businesses to pay to ensure that their stuff appears on their followers' news feeds.

Of course, traditional news publishers were not charities either. They have always looked after their business interests (Chapter 6). But newspapers' business model allowed for win-win outcomes: publishers investing in professional journalism were often able to attract advertisers while serving a public need.

Internet platforms' business models are radically different. So different, and so secretive, that it took more than a decade for analysts to figure it out. Some call it **surveillance capitalism**: exploiting big data to predict behavior and then influence it through micro-targeted nudges.

Jennifer Cobbe,
law and technology researcher

"'Surveillance capitalism,' as it's known, involves gathering as much data as possible about as many people as possible doing as many things as possible from as many sources as possible.

These huge datasets are then algorithmically analysed so as to spot patterns and correlations from which future behaviour can be predicted."

**— Jennifer Cobbe**

# PRESSURE TO CENSOR

Silicon Valley culture is a product of the American First Amendment tradition, which is strongly opposed to government censorship of political viewpoints – including extreme speech. European democracies, which tend to regulate hate speech more strictly, were never great fans of American platforms' laissez faire approach.

Rodolphe Urbs, who cartoons for the French periodicals *SudOest* and *Le Canard Enchaîné* and occasionally gets censored on the internet, says the internet giants apply hypocritical standards.

Rodolphe Urbs, cartoonist

"To put it simply, in Anglo-Saxon minds, breasts are deemed 'dangerous' but a Nazi isn't. If you glorify Nazis, it's gonna take ages before being moderated but if you post breasts, you are de-facto banned. To these companies, racism seems less dangerous than a pair of boobs. That's not the way we see it in France."

**— Rodolphe Urbs**

A spree of terror attacks and hate crimes in 2015 — including the *Charlie Hebdo* murders — prompted European lawmakers to threaten legislation.

In 2016, social media manipulation by Vote Leave in the Brexit Referendum and by the Donald Trump campaign in the US presidential race heightened policy-makers' concerns.

As the harms of an unregulated cyberspace grew more alarming, publics demanded more accountability from the internet giants.

News magazine covers reflecting the mounting anxiety about the internet.

In Britain, for example, Members of Parliament grilled platform companies on their content standards. They found it "shockingly easy to find examples of material that was intended to stir up hatred against ethnic minorities" on Facebook, Twitter, and YouTube.

One of the cartoons cited in British MPs' probe

12.   On Twitter, there were numerous examples of incendiary content found using Twitter hashtags that are used by the far-right, as identified in research by Dr Imran Awan and Dr Irene Zempi.[10] A search for those hashtags identified significant numbers of racist and dehumanising tweets that were plainly intended to stir up hatred, including a cartoon of a white woman being gang raped by Muslims over the 'altar of multiculturalism'; a cartoon stating that 'Muslims rape'; and an example of the racist 'Pakemon' campaign that featured numerous smears against Muslims. In response to our complaints, Twitter removed some of the tweets and suspended most of the accounts we identified; however many of the same vile and provocative images could still be found on the platform six weeks later when this report was drafted. Twitter refused to remove a cartoon that we

Extract from the UK Commons report (highlights added)

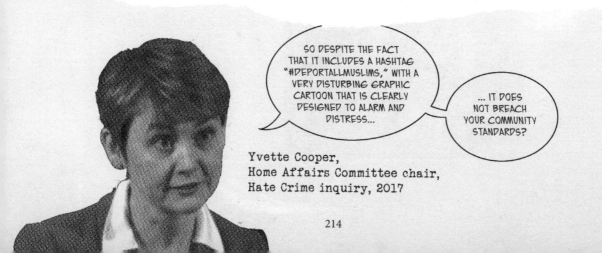

Yvette Cooper,
Home Affairs Committee chair,
Hate Crime inquiry, 2017

214

YES, IT IS OFFENSIVE BUT YOU WILL NEVER GET TO A POINT WHERE THERE IS NOTHING ON THE INTERNET THAT OFFENDS ANYBODY...

... AND NOR SHOULD WE SEEK TO GET TO THAT POINT.

Nick Pickles,
Twitter representative

ARE YOU REALLY SAYING THAT THE CARTOON WE SENT TO YOU IS NOT RACIST, DEGRADING OR A REPEATED SLURS?

THESE DECISIONS ARE VERY HARD.

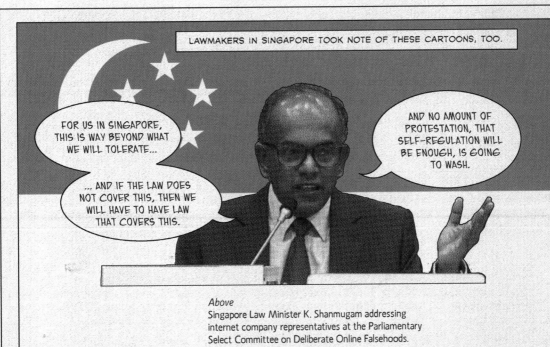

LAWMAKERS IN SINGAPORE TOOK NOTE OF THESE CARTOONS, TOO.

FOR US IN SINGAPORE, THIS IS WAY BEYOND WHAT WE WILL TOLERATE...

... AND IF THE LAW DOES NOT COVER THIS, THEN WE WILL HAVE TO HAVE LAW THAT COVERS THIS.

AND NO AMOUNT OF PROTESTATION, THAT SELF-REGULATION WILL BE ENOUGH, IS GOING TO WASH.

*Above*
Singapore Law Minister K. Shanmugam addressing
internet company representatives at the Parliamentary
Select Committee on Deliberate Online Falsehoods.

215

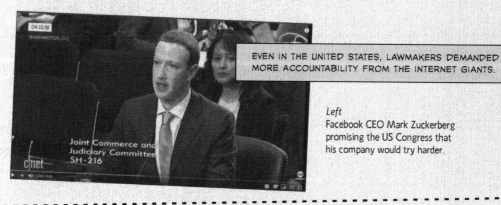

*Left*
Facebook CEO Mark Zuckerberg promising the US Congress that his company would try harder.

GOOGLE EXECUTIVES GRAPPLED WITH THE DILEMMA OF HOW TO BALANCE FREE SPEECH WITH GROWING PRESSURE TO CONTAIN HARMFUL CONTENT.

WE KNOW THIS BECAUSE A SLIDE DECK PREPARED FOR INTERNAL DISCUSSION WAS LEAKED TO THE PRESS.

## Google

\ Insights Lab \

# The Good Censor

How can Google reassure the world that it protects users from harmful content while still supporting free speech?

CULTURAL CONTEXT REPORT - MARCH 2018

Proprietary + Confidential

## Can Google protect free-speech *and* police harmful content?

internet. **Is it possible to have an open and inclusive internet** while simultaneously limiting political oppression and despotism, hate, violence and harassment? **Who should be responsible for censoring 'unwanted' conversation, anyway? Governments? Users? Google?**

216

# How are tech firms mismanaging the issues?

### Inconsistent interventions

Human error by content moderators combined with AI that falls short when faced with complex context mean that digital spaces are rife with user's frustrations about removed posts and suspended accounts, especially when it seems like plenty of bad behaviour is left untouched.

### Lack of transparency

The tech platforms' algorithms are complicated, obscure and constantly changing. In lieu of satisfactory explanations for why bad things are happening, people assume the worse – whether that's that Facebook has a liberal bias or that Youtube doesn't care about weeding out bad content.

### Underplaying the issues

When faced with a scandal, the tech platforms have often underplayed the scope of the problem until facts prove otherwise. They've frustrated users by not giving their complaints and fears the respect and attention they've deserved, creating a picture of ill-informed arrogance.

### Slow corrections

From a users' perspective, the tech platforms are quick to censor and slow to reinstate content that was wrongfully taken down. While the platforms can suspend an account in an instant, users often endure a slow and laborious appeals process, compounding the feeling of unfair censorship.

### Global inconsistency

In a global world, the platforms' status as bastions of free speech is hugely undermined by their willingness to bend to requirements of foreign repressive governments. When platforms compromise their public-facing values in order to maintain a global footprint, it can make them look bad elsewhere.

### Reactionary Tactics

When a problem emerges, the tech platforms seem to take their time and wait to see if it's going to blow over before wading in with a solution or correction. The lag gives users and governments plenty of time to point fingers, gather supporters and get angrier.

With so much bad behavior it's not surprising that users and governments have been ~~fighting~~ ways to

finding

**FIGHT BACK**

Tech firms are performing a balancing act between two **incompatible positions**...

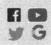

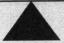

Create unmediated 'marketplaces of ideas'

**100% commit to the American tradition** that prioritises free speech for democracy, not civility

**By creating** spaces where all values, including civility norms, are always open for debate

Create well-ordered spaces for safety and civility

**100% commit to the European tradition** that favors dignity over liberty, and civility over freedom

**By censoring** racial and religious hatred, even when there's no provocation of violence

TO STAVE OFF GOVERNMENT REGULATION, SOCIAL PLATFORMS TRIED TWEAKING THEIR ALGORITHMS AND SHAPING PUBLIC DISCOURSE MORE ACTIVELY THROUGH THEIR TERMS OF SERVICE, COMMUNITY STANDARDS, AND CONTENT MODERATION.

GOOGLE TRAINED ITS SEARCH ENGINE TO PROMOTE AUTHORITATIVE SOURCES OVER PROPAGANDA SITES.

FACEBOOK AND TWITTER TRIED TO IMPROVE THEIR DETECTION OF ACCOUNTS VIOLATING THEIR TERMS OF SERVICE.

THE SHEER VOLUME OF CONTENT COURSING THROUGH PLATFORMS' CIRCULATION SYSTEMS PRECLUDES THE USE OF HUMAN EDITORS EXERCISING CAREFUL, CASE-BY-CASE JUDGMENT.

CRITICS SAY THAT THE INTERNET GIANTS COULD DO IT BETTER, BUT THAT THEY CHOOSE NOT TO, BECAUSE THEY ARE IN THE ATTENTION BUSINESS, WITH NO REAL FINANCIAL INCENTIVE TO IMPROVE THE QUALITY OF CONTENT, AS LONG AS THAT CONTENT IS ATTRACTING EYEBALLS.

THEY DO JUST ENOUGH TO KEEP REGULATORS AND CONCERNED CITIZENS OFF THEIR BACKS.

THEY USE ROBOTS AND ARMIES OF CHEAP LABOR TO FILTER AND MODERATE CONTENT.

CARTOONISTS ARE NOT IMPRESSED.

# Censored by Facebook

## A cartoonist's losing battle with the social media giant.

▲ Mysh is shirtless in this video call because he just got home from cycling in the Tel Aviv heat.

In Israel, artist Michael Rozanov or "Mysh" is a fierce critic of the Benjamin Netanyahu government's racist policies. Mysh was accustomed to receiving hate mail and threats. But, in 2012, he encountered a new kind of reaction – Facebook censorship.

He had created an alternative Israeli Independence Day poster inspired by the American superhero, the Hulk. "I could see the Hulk as a metaphor for the state of Israel: a superbrainy guy, but every time he's triggered, he bursts out as this dumb, crazy monster that reacts in totally disproportionate ways and ruins everything."

הצבר הירוק

שולט. רק לא בעצמו!

כבר 64 שנה!!!

▲ The Green Sabra

הזקפה הלאומית

50 שנה של ריקבון

1967 - 2017

▲ "The National Erection: 50 years of Rot"

Mysh named the superhero "the Green Sabra," after a cactus that Palestinian farmers used to grow for food. The symbol was appropriated by Israelis to represent a nation that is tough on the outside, but soft and sweet on the inside.

"The Green Sabra controls – but not himself," reads the text on Mysh's poster. In his Facebook post, Mysh wrote that after 64 years, the Green Sabra was finding it harder to remember the tender person deep inside. "His temper gets shorter, too, and friends from his past now fear being around him, avoiding his mighty fists. So, he wanders alone in the desert he once dreamed of filling with flowers," the post said.

"Suddenly, what the fuck! All of a sudden, I got this note from Facebook that I am suspended from posting because something I put on Facebook was inappropriate, blah blah. This was the first time, so I was quite shocked. We were still very naive about this platform."

He was suspended for 72 hours. After he appealed, Facebook reinstated the post two weeks later.

Another commemorative poster that got the same treatment was the one he did in 2017.

Titled "The National Erection: 50 years of Rot," it was timed for the 50th anniversary of Israeli occupation of the West Bank and Gaza Strip. It presents the map of Israel as an erect penis, rotting from the inside.

He used to think that these take-downs were purely due to complaints from users who did not want to be challenged by provocative work.

It reminded him of Ray Bradbury's novel, *Fahrenheit 451*. "The reason why they burned books in this dystopian society is not some ideological censorship. He explains that it began with people being offended about some books – smokers were offended by books about the harms of smoking, for example – so the government tried to appease everyone and they ended up blacklisting most of the books that exist."

He gradually realised that there was more to the censorship than random visitors sincerely feeling offended. Reports were surfacing about the Israeli establishment's use of cyber troops and its shady collaboration with Facebook.

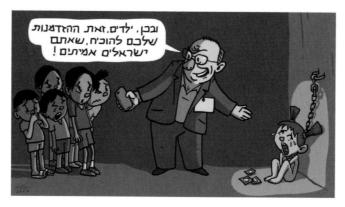

▲ This Mysh cartoon was a comment on reports of Israeli youths gang-raping girls, while innocent children born to migrant workers were being expelled. "I was so enraged by this hypocrisy. The cartoon was very provocative, and it was intended to be," Mysh says. The Israeli politician in the cartoon advises the migrant workers' kids: "Well, children, this is your chance to prove that you are a true Israeli!"

Mysh is now convinced that Israeli politicians and right-wing groups are behind the roadblocks he encounters on Facebook. Another target was the 2019 cartoon above. Usually, the penalty includes being locked out of the platform for 72 hours – no small matter if you are an artist who depends on being seen online.

"What I realized after the last time is that I need to move on," Mysh says. "I'm building a website now. It's important that my work exists online in places that are not Facebook, because I don't trust them."

CARTOONISTS FIGHTING FOR PROGRESSIVE CAUSES AND AGAINST TYRANNY CAN THUS FIND THEIR INNOCUOUS WORK TAKEN DOWN AND THEIR ACCOUNTS BLOCKED, EVEN AS GENUINELY HARMFUL SPEECH CONTINUES TO PROLIFERATE.

*Below*
Extracts from "The Good Censor" report by Google executives.

### Inconsistent interventions

Human error by content moderators combined with AI that falls short when faced with complex context mean that digital spaces are rife with user's frustrations about removed posts and suspended accounts, especially when it seems like plenty of bad behaviour is left untouched.

### Slow corrections

From a users' perspective, the tech platforms are quick to censor and slow to reinstate content that was wrongfully taken down. While the platforms can suspend an account in an instant, users often endure a slow and laborious appeals process, compounding the feeling of unfair censorship.

MAKING MATTERS WORSE, BAD ACTORS HAVE LEARNED TO GAME PLATFORMS' COMPLAINTS MECHANISMS.

GROUPS LIKELY TO BE VICTIMS OF ABUSE AND HATE SPEECH MAY THEMSELVES FIND THEIR *COMMUNICATIONS* CENSORED.

Jennifer Cobbe

NOT ONLY DOES CENSORSHIP REMOVE SOME USEFUL SPEECH...

... MARGINALIZED GROUPS ARE OFTEN THE FIRST TO BE IMPACTED BY PRIVATE CENSORSHIP.

THIS CENSORSHIP DOES NOT DIFFERENTIATE WELL BETWEEN HATEFUL SPEECH AND SPEECH THAT DRAWS ATTENTION TO THE HATRED.

Cindy Cohn, executive director, Electronic Frontier Foundation.

---

THIS POSTER BY AUSTRIA'S SOCIALIST STUDENT UNION (VSSU) CARRIED AN ANTI-RACIST CARTOON BY THE LATE *MANFRED DEIX*.

IT SHOWS AN AUSTRIAN MAN WITH A RIFLE SHOOING OFF THE BIBLICAL THREE WISE MEN, TELLING THEM THAT *"OUR BOAT IS FULL"* AND USING THE GERMAN N-WORD.

ALTHOUGH THE HATE-FILLED DIALOG WAS CLEARLY INTENDED TO CALL OUT RACIST AND ANTI-IMMIGRANT ATTITUDES, THE CARTOON TRIGGERED FACEBOOK'S HATE DETECTORS.

DEIX'S OFFICIAL FACEBOOK PAGE AND OTHER USERS WERE BLOCKED TEMPORARILY WHEN THEY POSTED THE CARTOON.

"OUR REPORTING SYSTEMS ARE DESIGNED TO PROTECT PEOPLE FROM ABUSE, HATE SPEECH AND MOBBING," FACEBOOK SAID.

"IT IS UNFORTUNATE THAT THIS OCCASIONALLY LEADS TO ERRORS. WE KNOW THAT IT CAN BE FRUSTRATING WHEN SUCH AN ERROR OCCURS."

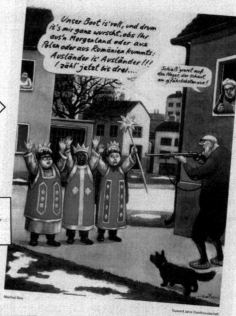

IN *ECUADOR*, A PRIEST ACCUSED OF SEXUAL ABUSE SAID HE WAS JUST TICKLING THE GIRL.

THIS CARTOON BY VILMA VARGAS EXPRESSES DESPAIR AT THE CHURCH'S SEEMINGLY UNENDING SERIES OF SEX SCANDALS. JESUS SAYS: "I'M TIED HAND AND FOOT."

FACEBOOK BLOCKED THE IMAGE, INFORMING HER THAT IT DID NOT COMPLY WITH ITS COMMUNITY STANDARDS. THE CARTOON MET THE SAME FATE ON INSTAGRAM.

"I SUPPOSE THE CATHOLIC GROUPS SEND A NOTICE TO FACEBOOK CLAIMING INCITEMENT TO HATRED," VARGAS SAYS.

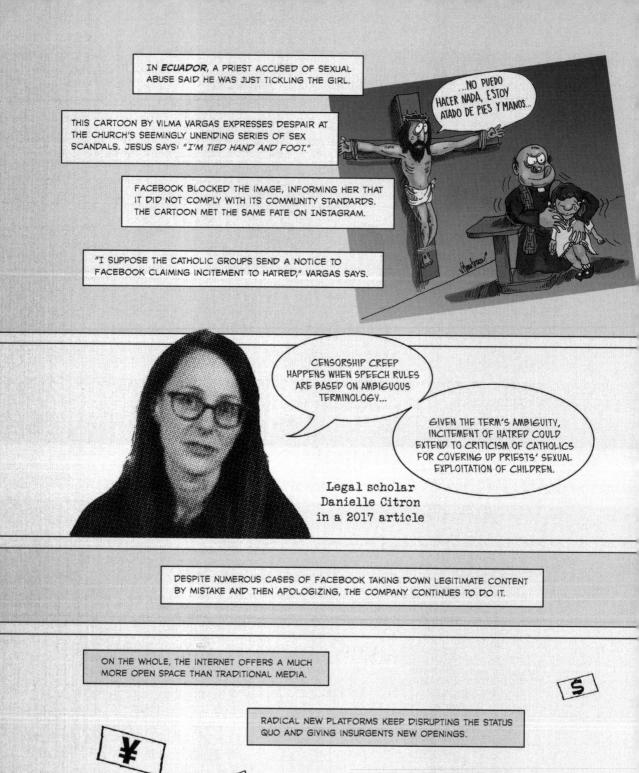

CENSORSHIP CREEP HAPPENS WHEN SPEECH RULES ARE BASED ON AMBIGUOUS TERMINOLOGY...

GIVEN THE TERM'S AMBIGUITY, INCITEMENT OF HATRED COULD EXTEND TO CRITICISM OF CATHOLICS FOR COVERING UP PRIESTS' SEXUAL EXPLOITATION OF CHILDREN.

Legal scholar Danielle Citron in a 2017 article

DESPITE NUMEROUS CASES OF FACEBOOK TAKING DOWN LEGITIMATE CONTENT BY MISTAKE AND THEN APOLOGIZING, THE COMPANY CONTINUES TO DO IT.

ON THE WHOLE, THE INTERNET OFFERS A MUCH MORE OPEN SPACE THAN TRADITIONAL MEDIA.

RADICAL NEW PLATFORMS KEEP DISRUPTING THE STATUS QUO AND GIVING INSURGENTS NEW OPENINGS.

BUT THE INTERNET HASN'T ERASED THE CONTRADICTIONS OF MEDIA FREEDOM CAPITALIST-STYLE. THE ADVANTAGE STILL BELONGS TO THOSE WHO OWN THE MEANS OF PRODUCTION.

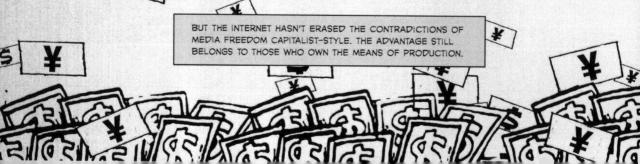

STÉPHANE PERAY (STEPHFF) IS YET ANOTHER CARTOONIST WHO HAS BEEN CENSORED BY FACEBOOK. THE PLATFORM BLOCKED THIS CARTOON ABOUT THE MASSACRE OF ROHINGYA IN MYANMAR.

ORDINARY RACISM IN MYANMAR

BURMESE MILITARY'S PROPAGANDA

**Stephff**
July 14, 2019

If you can , support my work on Patreon : https://www.patreon.com/posts/28369797

PATREON.COM
**Rohingya genocide in Myanmar | Stephff on Patreon**
Official Post from Stephff:

👍 1

A FURIOUS STEPHFF WROTE AN OPEN LETTER TO FACEBOOK CHIEF MARK ZUCKERBERG, PROTESTING THE PLATFORM'S POLICIES.

What are these "Facebook rules" exactly? That we cannot complain about a genocide in the making because some ultranationalist, xenophobic Burmese netizens have complained to Facebook?

*Left*
Rohingya refugees.

What is Facebook's policy, exactly? To stop people who battle against bad things happening in this world, or only to allow people to publish pictures of their lunch?

Why don't you employ real people with brains to judge whether a cartoon is racist or if – on the contrary – it fights against racism. Apparently, your dumb algorithms are far from able to tell the difference.

FURTHERMORE, THE FOCUS ON OBJECTIONABLE CONTENT DISTRACTS FROM A MORE INSIDIOUS PROBLEM: THE TECHNOLOGIES AND BUSINESS MODELS OF SURVEILLANCE CAPITALISM, WHICH GATHER DATA TO MANIPULATE USERS IN SECRETIVE WAYS.

HERE WE ARE ENTERING THE THIRD DECADE OF THE 21ST CENTURY...

... EXPECTING THIS DIGITAL CENTURY TO BE THE MOST DEMOCRATIZED OF ALL — THE DEMOCRATIZATION OF KNOWLEDGE.

INSTEAD WHAT DO WE HAVE?

Shoshana Zuboff, author, The Age of Surveillance Capitalism

WE ENTER THIS DECADE WITH AN EXTREME ASYMMETRY OF KNOWLEDGE, AND A POWER OVER OUR BEHAVIOR THAT THAT KNOWLEDGE PROVIDES ...

... WITH THESE COMPANIES KNOWING EVERYTHING ABOUT US AND US KNOWING SO LITTLE ABOUT THEM.

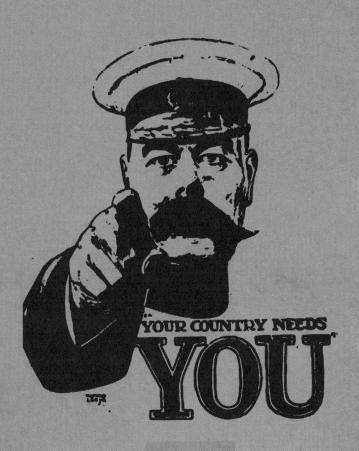

YOUR COUNTRY NEEDS
YOU

## 9. No Man's Land

### Dissent in Wartime

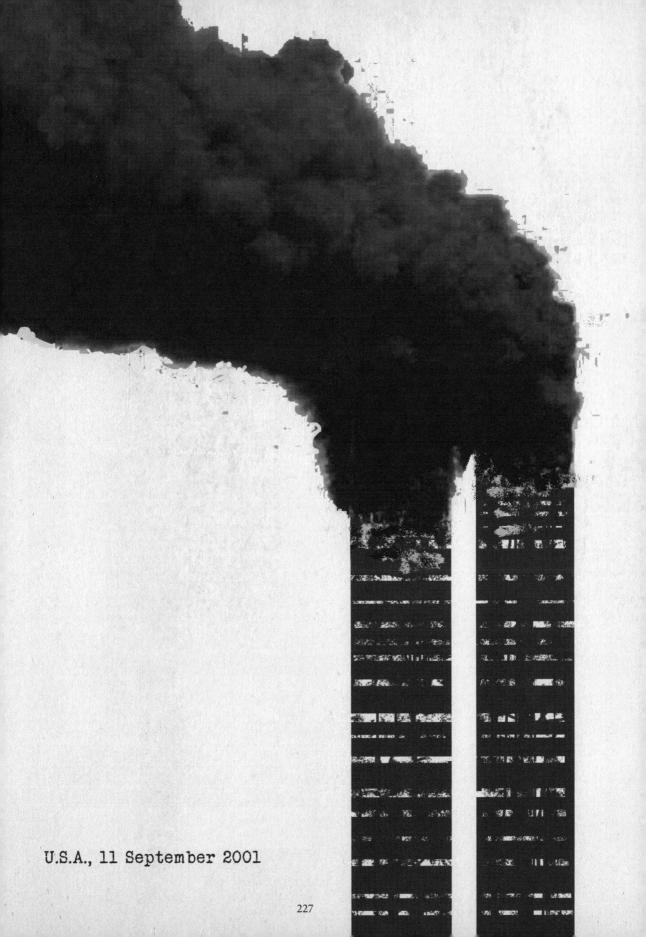

U.S.A., 11 September 2001

AFTER THEIR COUNTRY WAS HIT BY THE TERROR ATTACKS OF 9/11,
AMERICANS TOLD THEMSELVES THAT LIFE WOULD HAVE TO GO BACK
TO NORMAL -- OR ELSE THE TERRORISTS WOULD HAVE WON.

AT THE SAME TIME, MANY BELIEVED IT
COULDN'T BE BUSINESS AS USUAL.

POLITICIANS AND OTHER OPINION LEADERS,
SUCH AS COLUMNISTS AND TALK SHOW HOSTS,
WERE VIRTUALLY UNANIMOUS THAT AMERICANS
HAD TO PUT ASIDE THEIR OLD DIFFERENCES.

WITH THE NATION UNDER ATTACK, THEY FELT, IT
WAS A TIME TO STAND UNITED BENEATH THE FLAG.

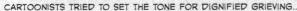

*Below*
Joe Heller
2001

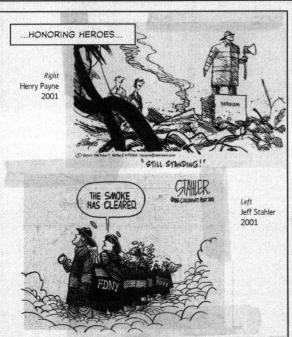

*Above*
Daryl Cagle
2001

...HONORING HEROES...

*Right*
Henry Payne
2001

"STILL STANDING!"

THE SMOKE HAS CLEARED.

STAHLER.

*Left*
Jeff Stahler
2001

...AND STEELING THE NATION'S RESOLVE FOR RETALIATION BY INVOKING THE MEMORY OF PEARL HARBOR.

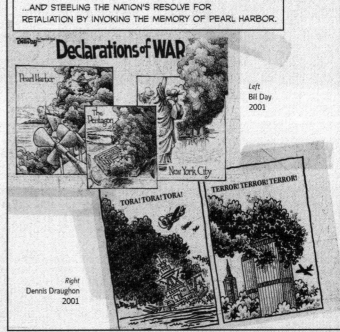

Bill Day

Declarations of WAR

Pearl Harbor

The Pentagon

New York City

TORA! TORA! TORA!

TERROR! TERROR! TERROR!

*Left*
Bill Day
2001

*Right*
Dennis Draughon
2001

THREE YEARS AFTER 9/11, WASHINGTON POST CARTOONIST *ANN TELNAES* REFLECTED ON THIS MOMENT IN AMERICAN HISTORY.

BEING HUMAN, IT WAS NATURAL THAT CARTOONISTS HAD FEELINGS OF WANTING TO BAND TOGETHER WITH THEIR FELLOW CITIZENS IN TIMES OF CRISIS.

BUT AS A WHOLE, AMERICAN EDITORIAL CARTOONISTS WERE SLOW TO BREAK FREE OF FLAG-WAVING IMAGES.

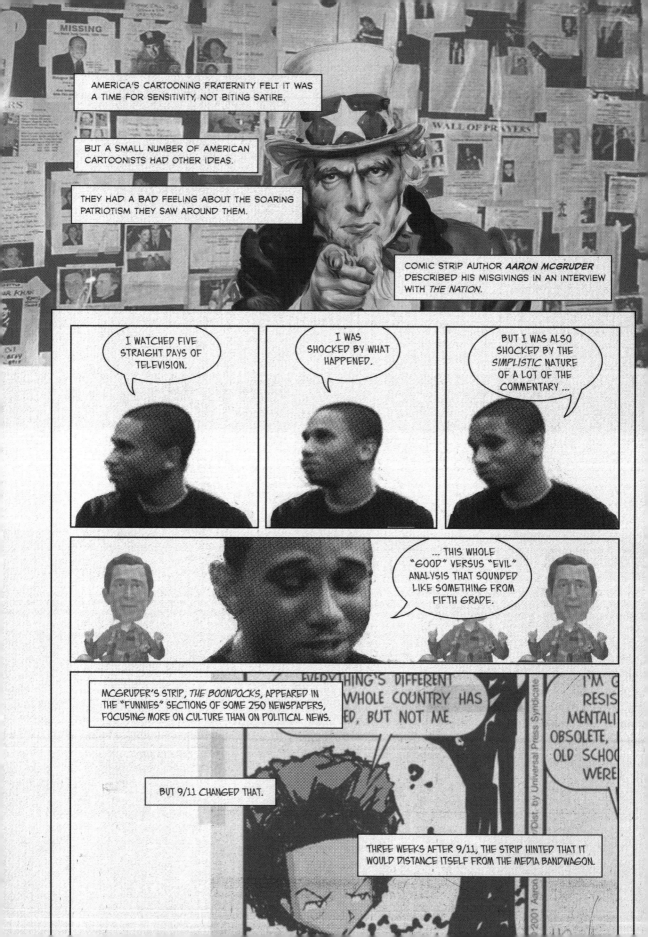

AMERICA'S CARTOONING FRATERNITY FELT IT WAS A TIME FOR SENSITIVITY, NOT BITING SATIRE.

BUT A SMALL NUMBER OF AMERICAN CARTOONISTS HAD OTHER IDEAS.

THEY HAD A BAD FEELING ABOUT THE SOARING PATRIOTISM THEY SAW AROUND THEM.

COMIC STRIP AUTHOR *AARON MCGRUDER* DESCRIBED HIS MISGIVINGS IN AN INTERVIEW WITH *THE NATION*.

I WATCHED FIVE STRAIGHT DAYS OF TELEVISION.

I WAS SHOCKED BY WHAT HAPPENED.

BUT I WAS ALSO SHOCKED BY THE *SIMPLISTIC* NATURE OF A LOT OF THE COMMENTARY ...

... THIS WHOLE "GOOD" VERSUS "EVIL" ANALYSIS THAT SOUNDED LIKE SOMETHING FROM FIFTH GRADE.

MCGRUDER'S STRIP, *THE BOONDOCKS*, APPEARED IN THE "FUNNIES" SECTIONS OF SOME 250 NEWSPAPERS, FOCUSING MORE ON CULTURE THAN ON POLITICAL NEWS.

BUT 9/11 CHANGED THAT.

THREE WEEKS AFTER 9/11, THE STRIP HINTED THAT IT WOULD DISTANCE ITSELF FROM THE MEDIA BANDWAGON.

THE BOONDOCKS FEATURED *HUEY FREEMAN*, AN ADOLESCENT WHO IS KNOWLEDGEABLE -- AND RADICAL -- BEYOND HIS YEARS.

*Above*
**The Boondocks**
Oct. 1, 2001
Aaron McGruder

TRUE TO CHARACTER, FREEMAN SEES THROUGH AMERICAN HYPOCRISY, IN A SERIES OF STRIPS CALLING OUT AMERICA'S LONGTIME ROLE IN SUPPORTING MILITANTS AND ROGUE REGIMES.

*Below*
**The Boondocks**
Oct. 4, 2001, Aaron McGruder

THIS WAS TOO MUCH FOR TWO OF THE NEW YORK AREA'S LARGEST NEWSPAPERS, *THE DAILY NEWS*, WHICH DROPPED *THE BOONDOCKS* FOR SEVERAL WEEKS, AND *NEWSDAY*, WHICH DROPPED IT FOR A WEEK.

A FEW MONTHS AFTER THE U.S. INVASION OF IRAQ IN MARCH 2003, MCGRUDER TOOK AIM AT BUSH'S HAWKISH NATIONAL SECURITY ADVISOR *CONDOLEEZZA RICE*.

*Below and right*
**The Boondocks (Extracts)**
Oct. 14 and 29, 2001
Aaron McGruder

THE *WASHINGTON POST* DROPPED THE SIX-PART SERIES ON RICE, SAYING IT VIOLATED THE PAPER'S STANDARDS FOR "TASTE, FAIRNESS AND INVASION OF PRIVACY."

TED RALL WAS ANOTHER CARTOONIST WHO FELT HE HAD TO CHALLENGE THE FLAG-WAVING EPIDEMIC.

AN EDITOR TOLD ME, IT WAS THE END OF HUMOR.

BUT I RESOLVED IMMEDIATELY — THAT SAME DAY, 9/11 — NOT TO CHANGE A THING ABOUT MY WORK.

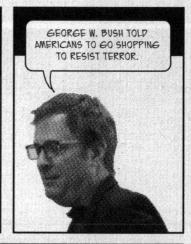

GEORGE W. BUSH TOLD AMERICANS TO GO SHOPPING TO RESIST TERROR.

I RESISTED RIGHT-WING B.S. BY BEING THE SAME EXACT KIND OF CARTOONIST I WAS BEFORE 9/11 ...

... CYNICAL, QUESTIONING, OCCASIONALLY PROFANE, SUSPICIOUS OF OFFICIAL NARRATIVES DEVOID OF EVIDENCE.

IN FEBRUARY 2002, RALL FELT COMPELLED TO TAKE AIM AT *OPPORTUNISTS* WHO MILKED THEIR BEREAVEMENT FOR SELF-PROMOTION, AND WHO COMPLAINED THAT THE AVERAGE $1.6 MILLION COMPENSATION FOR VICTIMS WASN'T ENOUGH.

*Below*
**Terror Widows (Extracts)**
March 5, 2002
Ted Rall

THEY'RE EERILY CALM. THEY SMILE AND CRACK JOKES AND LAUGH OUT LOUD. THEY'RE THE SCOURGE OF THE MEDIA:

TERROR WIDOWS

I KEEP WAITING FOR KEVIN TO COME HOME, BUT I KNOW HE NEVER WILL. FORTUNATELY THE $3.2 MILLION I COLLECTED FROM THE RED CROSS KEEPS ME WARM AT NIGHT.

NEXT UP: TERROR WIDOW MEETS TERROR WIDOWER!

A PRENUP?! I GOT $1.8 MILLION FROM THE AIRLINE SECURITY FIRM!

YEAH, BUT I SUED THE AIRLINE ITSELF — I SCORED $5 MILLION!

SOME CORRECTIVE SATIRE, I FELT, WAS CLEARLY IN ORDER.

RALL WAS ALSO STRUCK BY THE FACT THAT NEW YORK CITY'S
FIREHOUSES WERE BEING *FLOODED* WITH DONATIONS AND GIFTS.

HE WONDERED WHAT THINGS WOULD BE LIKE IN TEN
YEARS' TIME IF THE PUBLIC LARGESSE CONTINUED.

## NEW YORK CITY FIRE DEPARTMENT 2011

HIS CRYSTAL-BALLSY CARTOON WAS INTENTIONALLY RIDICULOUS,
BUT ALSO REFLECTED HIS UNEASE ABOUT A TAXPAYER-FUNDED
ESSENTIAL SERVICE ACCEPTING DONATIONS.

THEY FIGHT FIRES IN SUMPTUOUS FUR RAINCOATS. BEST OF ALL, THEY HAVE THEMSELVES DRIVEN TO FIRES - AVOIDING THE OLD DANGERS OF PASSING THROUGH THE WINDSHIELD IN AN ACCIDENT!

ARE YOU SURE THIS IS THE RIGHT ADDRESS, JEFFREY? I DON'T SEE ANY SMOKE.

SORRY, SIR. LOOKS LIKE THE OLD G.P.S. IS ACTING UP AGAIN.

A FEW PERNICIOUS POLITICIANS SUGGEST THAT SOME FDNY LOOT MIGHT BE DIVERTED TO OTHER NEEDS, BUT THEIR EFFORTS ARE ROUNDLY DEFEATED

SCHOOLS?! IF IT WEREN'T FOR FIREMEN, ALL THE SCHOOLS WOULD BURN DOWN!

*Above & Right*
**FDNY 2011**
**(Extracts)**
Feb 2, 2002
Ted Rall

RALL'S CARTOONS ABOUT WIDOWS AND FIREFIGHTERS
RECEIVED MIXED REVIEWS, TO PUT IT MILDLY.

THE *NEW YORK TIMES*' WEBSITE, AMONG THE MANY OUTLETS THAT SUBSCRIBED TO RALL'S SYNDICATED CARTOONS, HAD UPLOADED "TERROR WIDOWS" AUTOMATICALLY.

⚠

File not found (404 error)

If you think what you're looking for should be here, please contact the site owner.

BOWING TO THE COMPLAINTS, IT DELETED THE CARTOON.

TWO YEARS LATER, NYT AS WELL AS MSNBC.COM CANCELED HIS STRIP ENTIRELY AFTER A CARTOON ABOUT A FOOTBALL STAR, *PAT TILLMAN*, WHO ENLISTED FOR THE WAR IN IRAQ AND WAS LATER KILLED BY "FRIENDLY FIRE" IN AFGHANISTAN.

TILLMAN, WHO EARNED $18,000, FALSELY BELIEVED BUSH'S WARS AGAINST IRAQ AND AFGHANISTAN HAD SOMETHING TO DO WITH 9/11.

WE'RE ATTACKING AFGHANISTAN TO GET AL QAEDA, WHICH IS BASED IN PAKISTAN AND FUNDED BY SAUDI ARABIA, AND IRAQ TO GET AL QAEDA, WHICH HATES SADDAM HUSSEIN.

MAKES SENSE.

ACTUALLY, HE WAS A COG IN A LOW-RENT OCCUPATION ARMY THAT SHOT MORE INNOCENT CIVILIANS THAN TERRORISTS TO PROP UP PUPPET RULERS AND EXPLOIT GAS AND OIL RESOURCES.

MUSEUMS? LET 'EM BURN! GET DOWN TO BASRA AND REPAIR THAT PIPELINE!

SO WHEN TILLMAN GOT KILLED BY THE AFGHAN RESISTANCE, ONE WORD NATURALLY CAME TO MIND:

UH- IDIOT?

SAP?

DAILY NEWS

HERO!

NEWS HERO!

EDITOR

4.29.04.C

DISTRIBUTED BY UNIVERSAL PRESS SYNDICATE

*Above & right*
**Pat Tillman Cartoon
(Extracts)**
April 29, 2004
Ted Rall

We thought the subject matter was inappropriate.

NYT response to "Terror Widows" strip.

𝕿𝖍𝖊
𝕹𝖊𝖜 𝖄𝖔𝖗𝖐
𝕿𝖎𝖒𝖊𝖘

Postscript: The truth about Tillman emerged years later. Although a patriot who signed up to defeat Al Qaeda, he was also a liberal who opposed the invasion of Iraq.

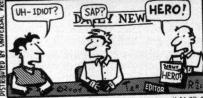

Pat Tillman

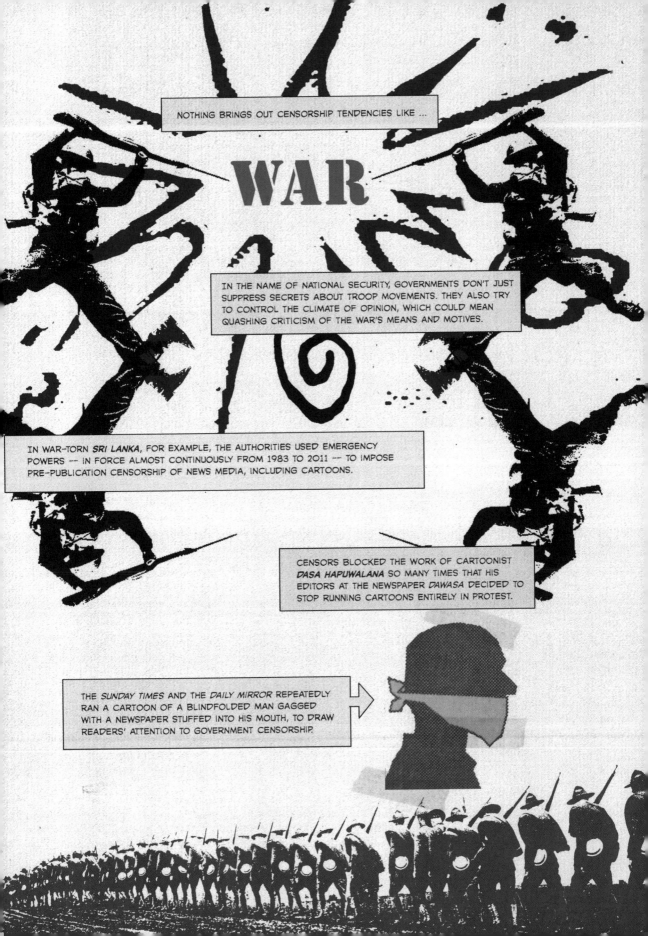

NOTHING BRINGS OUT CENSORSHIP TENDENCIES LIKE ...

# WAR

IN THE NAME OF NATIONAL SECURITY, GOVERNMENTS DON'T JUST SUPPRESS SECRETS ABOUT TROOP MOVEMENTS. THEY ALSO TRY TO CONTROL THE CLIMATE OF OPINION, WHICH COULD MEAN QUASHING CRITICISM OF THE WAR'S MEANS AND MOTIVES.

IN WAR-TORN *SRI LANKA*, FOR EXAMPLE, THE AUTHORITIES USED EMERGENCY POWERS -- IN FORCE ALMOST CONTINUOUSLY FROM 1983 TO 2011 -- TO IMPOSE PRE-PUBLICATION CENSORSHIP OF NEWS MEDIA, INCLUDING CARTOONS.

CENSORS BLOCKED THE WORK OF CARTOONIST *DASA HAPUWALANA* SO MANY TIMES THAT HIS EDITORS AT THE NEWSPAPER *DAWASA* DECIDED TO STOP RUNNING CARTOONS ENTIRELY IN PROTEST.

THE *SUNDAY TIMES* AND THE *DAILY MIRROR* REPEATEDLY RAN A CARTOON OF A BLINDFOLDED MAN GAGGED WITH A NEWSPAPER STUFFED INTO HIS MOUTH, TO DRAW READERS' ATTENTION TO GOVERNMENT CENSORSHIP.

IN INDIAN-ADMINISTERED *KASHMIR*, WHERE GOVERNMENT FORCES BATTLED AN INSURGENCY THEY SAY IS BACKED BY ARCH-ENEMY PAKISTAN, INDEPENDENT MEDIA FACE VARIOUS THREATS -- PHYSICAL VIOLENCE, RAIDS, ARRESTS, WITHHOLDING OF GOVERNMENT ADVERTISING, AND OUTRIGHT BANS.

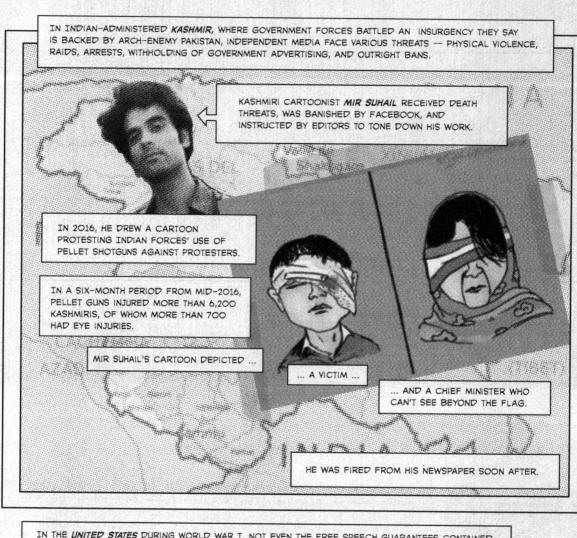

KASHMIRI CARTOONIST *MIR SUHAIL* RECEIVED DEATH THREATS, WAS BANISHED BY FACEBOOK, AND INSTRUCTED BY EDITORS TO TONE DOWN HIS WORK.

IN 2016, HE DREW A CARTOON PROTESTING INDIAN FORCES' USE OF PELLET SHOTGUNS AGAINST PROTESTERS.

IN A SIX-MONTH PERIOD FROM MID-2016, PELLET GUNS INJURED MORE THAN 6,200 KASHMIRIS, OF WHOM MORE THAN 700 HAD EYE INJURIES.

MIR SUHAIL'S CARTOON DEPICTED ...

... A VICTIM ...

... AND A CHIEF MINISTER WHO CAN'T SEE BEYOND THE FLAG.

HE WAS FIRED FROM HIS NEWSPAPER SOON AFTER.

IN THE *UNITED STATES* DURING WORLD WAR I, NOT EVEN THE FREE SPEECH GUARANTEES CONTAINED IN THE CONSTITUTION COULD STOP THE STATE FROM PUNISHING CRITICS OF THE WAR.

CONGRESS PASSED WOODROW WILSON'S *ESPIONAGE ACT* OF 1917, WHICH CONTAINED BROAD RESTRICTIONS ON SPEECH.

CONGRESS SHALL MAKE NO LAW respecting an establishment of religion, or prohibiting the free exercise thereof; or abridging the freedom of speech, or of the press; or the right of the people peaceably to assemble, and to petition the Government for a redress of grievances.

☛ THE FIRST AMENDMENT TO THE U.S. CONSTITUTION
15 DECEMBER 1791

THERE ARE CITIZENS OF THE UNITED STATES WHO HAVE POURED THE POISON OF DISLOYALTY INTO THE VERY ARTERIES OF OUR NATIONAL LIFE ...

... WHO HAVE SOUGHT TO BRING THE AUTHORITY AND GOOD NAME OF OUR GOVERNMENT INTO CONTEMPT.

Woodrow Wilson

AMONG THE FIRST VICTIMS OF THE ESPIONAGE ACT WAS THE RADICAL ANTI-WAR MAGAZINE *THE MASSES*, TOGETHER WITH ITS CARTOONIST *ARTHUR "ART" YOUNG* (1866-1943).

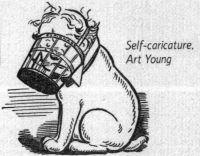

*Self-caricature, Art Young*

FOR THE SAFETY OF THE PUBLIC.

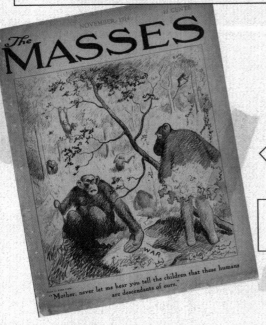

THIS ART YOUNG CARTOON ON THE COVER OF *THE MASSES* SHOWS CHIMPANZEES READING NEWS OF THE OUTBREAK OF WORLD WAR I.

(THE APE SAYS: "MOTHER, NEVER LET ME HEAR YOU TELL THE CHILDREN THAT THESE HUMANS ARE DESCENDANTS OF OURS.")

THE POSTMASTER OF NEW YORK DECLARED THAT THE AUGUST 1917 ISSUE OF *THE MASSES* WAS "UNMAILABLE" UNDER THE NEW ESPIONAGE ACT.

IN ADDITION TO THREE ARTICLES, FOUR CARTOONS WERE DEEMED TO HAVE CROSSED THE LINE.

ART YOUNG'S CARTOON IN THAT ISSUE DEPICTED BIG BUSINESS AS RUNNING THE WAR, AND CONGRESS AS ITS MERE SERVANT.

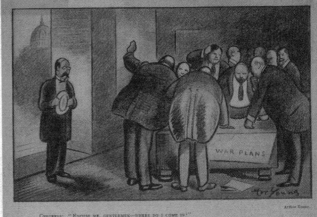

(THE CONGRESSMAN ON THE LEFT SAYS: "EXCUSE ME, GENTLEMEN -- WHERE DO I COME IN?")

(BIG BUSINESS, PORING OVER THE WAR PLANS, REPLIES: "RUN ALONG NOW! WE GOT THROUGH WITH YOU WHEN YOU DECLARED WAR FOR US.")

The final issue of *The Masses*.

WITHOUT ACCESS TO THE POSTAL SYSTEM, *THE MASSES* COULD NOT SURVIVE BEYOND 1917.

THE GOVERNMENT WAS *NOT* CONTENT.

IN 1918, AND AGAIN IN 1919, IT CHARGED THE MAGAZINE'S CONTRIBUTORS, INCLUDING ART YOUNG, UNDER THE ESPIONAGE ACT.

BOTH TIMES, JURY MEMBERS COULDN'T AGREE ON A VERDICT AND THE ACCUSED WERE ACQUITTED.

THE COURT VICTORIES WERE HOLLOW.

*THE MASSES* WAS ALREADY DEAD.

ITS EDITOR HAD LAUNCHED A NEW, MORE CENSOR-FRIENDLY MAGAZINE, *THE LIBERATOR*, THAT SUPPORTED THE WAR EFFORT.

Art Young (second from left) and comrades outside the New York courthouse in 1918.

AFTER WORLD WAR I, THE U.S. SUPREME COURT STRENGTHENED FREE SPEECH PROTECTIONS THROUGH SUCCESSIVE REINTERPRETATIONS OF THE FIRST AMENDMENT.

THE BEST TEST OF TRUTH IS THE POWER OF THE THOUGHT TO GET ITSELF ACCEPTED IN THE *COMPETITION OF THE MARKET.*

WE SHOULD BE ETERNALLY VIGILANT AGAINST ATTEMPTS TO CHECK THE EXPRESSION OF OPINIONS THAT WE LOATHE AND BELIEVE TO BE FRAUGHT WITH DEATH ...

... UNLESS THEY SO IMMINENTLY THREATEN IMMEDIATE INTERFERENCE WITH THE LAWFUL AND PRESSING PURPOSES OF THE LAW THAT AN IMMEDIATE CHECK IS REQUIRED TO SAVE THE COUNTRY.

JUSTICE OLIVER WENDELL HOLMES' DISSENT IN ABRAMS V UNITED STATES, 1919.

THE PRESS WAS TO *SERVE THE GOVERNED,* NOT THE GOVERNORS.

ONLY A FREE AND UNRESTRAINED PRESS *CAN* EFFECTIVELY EXPOSE DECEPTION IN GOVERNMENT.

AND PARAMOUNT AMONG THE RESPONSIBILITIES OF A FREE PRESS IS THE DUTY TO PREVENT ANY PART OF THE GOVERNMENT FROM DECEIVING THE PEOPLE ...

... AND SENDING THEM OFF TO DISTANT LANDS TO DIE OF FOREIGN FEVERS AND FOREIGN SHOT AND SHELL.

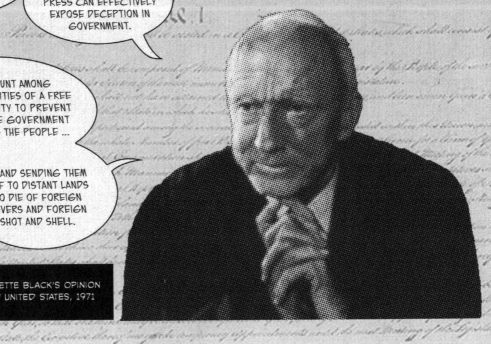

JUSTICE HUGO LAFAYETTE BLACK'S OPINION IN NEW YORK TIMES V UNITED STATES, 1971

THE SUPREME COURT'S INCREASINGLY *ROBUST* INTERPRETATIONS OF THE FIRST AMENDMENT RADICALLY LIMITED THE U.S. GOVERNMENT'S POWER TO CENSOR, EVEN ON NATIONAL SECURITY GROUNDS.

AMERICAN GOVERNMENTS STILL TRY TO WRAP THEIR MILITARY AND SECURITY OPERATIONS IN SECRECY, BUT THEY CAN'T SILENCE CRITICAL VIEWPOINTS THE WAY THEIR PREDECESSORS COULD A CENTURY AGO -- OR LIKE MANY GOVERNMENTS CONTINUE TO DO TODAY.

THE FIRST AMENDMENT, THOUGH, DOESN'T PROTECT CARTOONS FROM CENSORSHIP BY *NON-STATE* ACTORS.

FLAG-WAVING CITIZENS ARE FREE TO DEMAND THAT NEWSPAPERS KILL UNPATRIOTIC CARTOONS, AND EDITORS ARE FREE TO COMPLY.

AARON MCGRUDER EXPECTED THE WORST WHEN THE BOONDOCKS CRITICIZED THE POST–9/11 WAR ON TERROR.

I DECIDED THAT I WAS GOING TO RISK THROWING MY CAREER AWAY.

I ABSOLUTELY THOUGHT THAT WAS THE RISK I WAS TAKING.

IN THE END, THOUGH, THERE WERE A JUST A HANDFUL OF TEMPORARY SUSPENSIONS. NONE OF HIS 250 CLIENTS CANCELED THE STRIP.

IT COULD HAVE BEEN A LOT WORSE.

*'M GOING TO STAY CYNICAL ...
RESIST THIS BAN ON WAR
NTALITY. SURE, ED MAY
ETE, BUT SO W M FRON
CHOOL. I RE THINGS*

*ELIZABETH SILLS*, A SCHOLAR OF HUMOR AND RHETORIC, WONDERS IF MCGRUDER GOT AWAY WITH HIS RADICAL CRITIQUE BECAUSE OF HIS CHOSEN MEDIUM ...

... A SMART-ALECKY KID.

READERS WHO MIGHT OTHERWISE HAVE FELT THREATENED BY HIS OPINIONS COULD BRUSH THEM ASIDE AS ADOLESCENT SILLINESS.

THUS (LIKE CALVIN OF *CALVIN & HOBBES*, ONE OF MCGRUDER'S INFLUENCES), HUEY FREEMAN ENJOYED WIDE LICENCE TO BE POLITICALLY INCORRECT.

TED RALL, ON THE OTHER HAND, HAD NO SUCH COVER.

I LOST TONS OF CLIENTS AND MORE THAN HALF MY INCOME AND MY CAREER NEVER FULLY RECOVERED FROM THE BLOW.

THE WORLD TRADE CENTER STANDS IN HISTORY WITH PEARL HARBOR.

IT WAS AN OCCASION OF PROFOUND GRIEF.

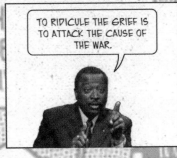

TO RIDICULE THE GRIEF IS TO ATTACK THE CAUSE OF THE WAR.

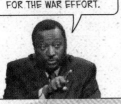

IT IS TO ASSAULT SOMETHING VITAL TO THE MORAL SUPPORT REQUIRED FOR THE WAR EFFORT.

SHOULD SUCH A CARTOONIST BE PUNISHED, ARRESTED?

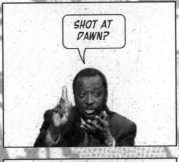

*SHOT AT DAWN?*

SERIOUS DEBATE ABOUT THE WAR AND ITS PURPOSE IS CRUCIAL.

BUT THIS BRUTAL AND INHUMAN COMIC STRIP WAS *NOT* DEBATE –

IT WAS AN ASSAULT ON THE DECENT NATIONAL SENSIBILITIES CRUCIAL TO THE WAR EFFORT.

SUCH ASSAULTS ARE A KIND OF *PORNOGRAPHY IN CIVIC DISCOURSE*.

PORNOGRAPHERS SHOULD BE SHUNNED BY ALL...

AND LIKEWISE MR. TED RALL SHOULD HAVE BEEN *FIRED* IMMEDIATELY BY THOSE WITH PROFESSIONAL AUTHORITY OVER HIM, OR IN CONTRACTUAL RELATIONS WITH HIM.

ASSAULTS ON THE DECENT JUDGMENT OF AMERICAN CITIZENS REGARDING THE JUST AND NOBLE CHARACTER OF A NATIONAL STRUGGLE...

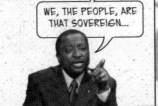

...ARE, LITERALLY, ATTEMPTS TO POISON THE SOVEREIGN.

WE, THE PEOPLE, ARE THAT SOVEREIGN...

...AND WE SHOULD NOT TOLERATE THOSE WHO SEEK TO DEBASE OUR JUDGMENT AND DESTROY OUR UNITY AND RESOLVE.

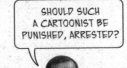
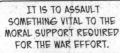

IT WASN'T ABOUT GRIEF, IT WAS ABOUT *ANGER*, IT WAS ABOUT LASHING OUT AT ENEMIES, FOREIGN AND DOMESTIC.

WE BOMBED ENEMIES FOREIGN, AND WE PURGED ENEMIES DOMESTIC.

I STOPPED COUNTING AT A THOUSAND DEATH THREATS.

WHEN I DID BOOK SIGNINGS THEY HAD TO HIRE LOCAL POLICE, PRIVATELY, TO PROVIDE SECURITY.

I HAD AN FBI AGENT ASSIGNED TO ME...

I HAD LOCAL POLICE OUTSIDE OF MY HOUSE MORE TIMES THAN I COULD COUNT.

RELATIVE TO CARTOONISTS IN AUTHORITARIAN REGIMES, OF COURSE, YES, I ENJOY FREEDOM.

BUT NOT COMPARED WITH THE SELF-PROFESSED IDEALS THAT AMERICAN SCHOOLCHILDREN LEARN ABOUT IN NARRATIVES ...

... WHERE REBELS ARE ENSHRINED AND REVERED.

FOR A CARTOONIST, FREEDOM MEANS THE ABILITY TO EARN A LIVING AND BEING PUBLISHED WITHOUT FEAR.

I DON'T HAVE THAT. I CONSTANTLY WORRIED ABOUT BEING KILLED OVER SOMETHING I DREW.

WHEN THE BUSH ADMINISTRATION DECIDED TO INVADE AFGHANISTAN AS PART OF ITS "WAR ON TERROR," THE MILITARY LOGIC WAS TENUOUS.

THE WAR WAS VERY, VERY POPULAR.

YEARS LATER, AMERICANS WANTED OUT ...

BUT IN THE POST-9/11 PERIOD, BUSH GAUGED CORRECTLY THE PUBLIC'S APPETITE FOR ACTION.

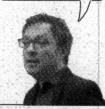

242

IF RALL COULDN'T SEE EYE TO EYE WITH MANY OF HIS FELLOW AMERICANS, MAYBE IT WAS BECAUSE HE'D ACTUALLY BEEN TO AFGHANISTAN.

IN NOVEMBER 2001, HE SPENT THREE WEEKS THERE COVERING THE U.S. INVASION FOR ALTERNATIVE MEDIA.

HE COULD SEE THAT THE U.S. WOULD NEVER WIN, BECAUSE AFGHANS WOULD NEVER ACCEPT THE OCCUPATION.

I'M NOT SAYING 9/11 WASN'T A HORRIBLE THING ...

... I JUST THINK AMERICANS ARE WIMPS.

YOU WOULDN'T SEE PEOPLE IN ANY OTHER COUNTRY BEHAVING THIS WAY.

WE GET ONE TERRORIST ATTACK OF SIGNIFICANCE IN OUR ENTIRE HISTORY AND, LIKE, SUDDENLY IT IS THE END OF THE WORLD.

AMERICANS THINK NOTHING OF KILLING A MILLION IRAQIS AND BLOWING UP AFGHANISTAN TO THE POINT WHERE THERE'S NOTHING LEFT STANDING.

IT'S LIKE, WE BLOW UP OTHER PEOPLE, WE KILL OTHER PEOPLE, BUT THEY ARE NOT SUPPOSED TO KILL US.

WE ARE BULLIES.

243

THE FIRST CASUALTY OF WAR IS TRUTH, THE OLD SAYING GOES.

BUT IT MAY ALSO BE THE FINAL CASUALTY.

LONG AFTER PEACE RETURNS AND THE WARTIME GENERATION PASSES, MEMORIES OF WAR ARE REPRESSED OR RETROFITTED TO SUIT THE IDEOLOGICAL NEEDS OF THE PRESENT DAY.

KEIJI NAKAZAWA'S SEARING MEMORIES OF THE ATOMIC BOMBING AND ITS AFTERMATH, *BAREFOOT GEN*, HAD TO CLEAR MULTIPLE HURDLES BEFORE AND AFTER EMERGING AS A CLASSIC ANTI-WAR COMIC.

FIRST, JAPANESE PEOPLE DIDN'T WANT TO KNOW.

MANY DIRECTED THEIR *WAR SHAME* AT A-BOMB SURVIVORS.

THERE WERE EVEN IRRATIONAL FEARS THAT ONE COULD "CATCH" RADIATION SICKNESS FROM VICTIMS.

*Right*
**Barefoot Gen**
**Vol. 1**, first published 1975
Keiji Nakazawa

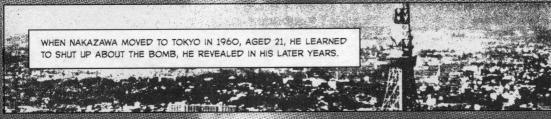

WHEN NAKAZAWA MOVED TO TOKYO IN 1960, AGED 21, HE LEARNED TO SHUT UP ABOUT THE BOMB, HE REVEALED IN HIS LATER YEARS.

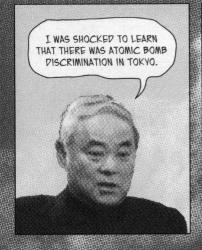

I WAS SHOCKED TO LEARN THAT THERE WAS ATOMIC BOMB DISCRIMINATION IN TOKYO.

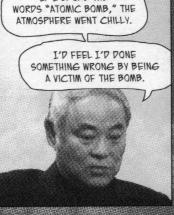

IF I SPOKE THE WORDS "ATOMIC BOMB," THE ATMOSPHERE WENT CHILLY.

I'D FEEL I'D DONE SOMETHING WRONG BY BEING A VICTIM OF THE BOMB.

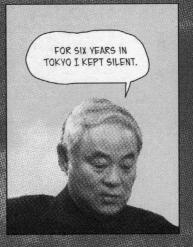

FOR SIX YEARS IN TOKYO I KEPT SILENT.

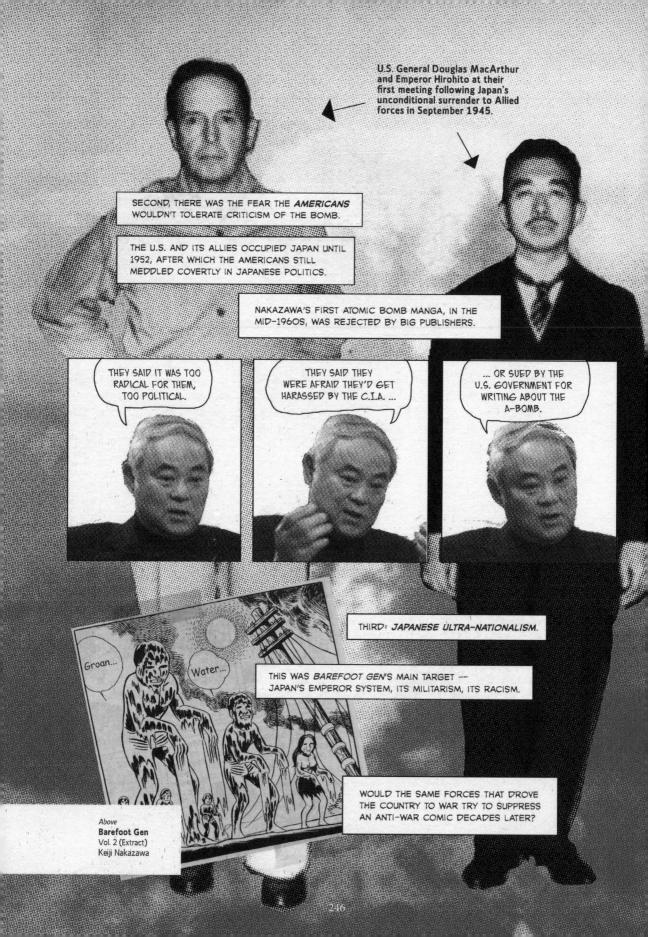

U.S. General Douglas MacArthur and Emperor Hirohito at their first meeting following Japan's unconditional surrender to Allied forces in September 1945.

SECOND, THERE WAS THE FEAR THE *AMERICANS* WOULDN'T TOLERATE CRITICISM OF THE BOMB.

THE U.S. AND ITS ALLIES OCCUPIED JAPAN UNTIL 1952, AFTER WHICH THE AMERICANS STILL MEDDLED COVERTLY IN JAPANESE POLITICS.

NAKAZAWA'S FIRST ATOMIC BOMB MANGA, IN THE MID-1960S, WAS REJECTED BY BIG PUBLISHERS.

THEY SAID IT WAS TOO RADICAL FOR THEM, TOO POLITICAL.

THEY SAID THEY WERE AFRAID THEY'D GET HARASSED BY THE C.I.A. ...

... OR SUED BY THE U.S. GOVERNMENT FOR WRITING ABOUT THE A-BOMB.

THIRD: *JAPANESE ULTRA-NATIONALISM.*

THIS WAS *BAREFOOT GEN*'S MAIN TARGET -- JAPAN'S EMPEROR SYSTEM, ITS MILITARISM, ITS RACISM.

Groan...

Water...

WOULD THE SAME FORCES THAT DROVE THE COUNTRY TO WAR TRY TO SUPPRESS AN ANTI-WAR COMIC DECADES LATER?

*Above*
**Barefoot Gen**
Vol. 2 (Extract)
Keiji Nakazawa

FORTUNATELY, NO. AT LEAST, NOT YET.

WE EXPECTED RIGHT-WING PRESSURE, BUT WE NEVER EXPERIENCED ANY.

WHEN GEN FIRST APPEARED, I WARNED MY WIFE TO BE PREPARED TO GET HATE MAIL OR THREATENING PHONE CALLS.

NOT A THING.

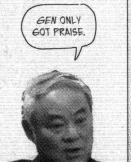

GEN ONLY GOT PRAISE.

DECADES LATER, THOUGH, HE SPOTTED THE SIGNS OF RESURGENT NATIONALISM.

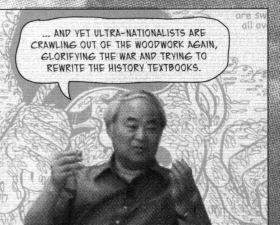

HERE'S A COUNTRY THAT EXPERIENCED COMPLETE DEVASTATION IN THE LAST WAR ...

... AND YET ULTRA-NATIONALISTS ARE CRAWLING OUT OF THE WOODWORK AGAIN, GLORIFYING THE WAR AND TRYING TO REWRITE THE HISTORY TEXTBOOKS.

SURE ENOUGH, IN 2012, JUST BEFORE NAKAZAWA DIED, RIGHT-WING ACTIVISTS IN *MITSUE CITY* DEMANDED THAT THE AUTHORITIES REMOVE *BAREFOOT GEN* FROM THE CITY'S SCHOOLS (IT WAS IN MOST OF THEIR LIBRARIES).

THEY ACCUSED THE COMIC OF GIVING A *FALSE ACCOUNT OF HISTORY* AND UNDERMINING CHILDREN'S LOVE FOR THEIR COUNTRY.

*Below*
**Scene from Barefoot Gen, Vol. 10,**
Keiji Nakazawa

They rammed saké bottles into women, crushing their pelvises and killing them.

MITSUE CITY BOARD OF EDUCATION OFFICIALS READ ALL TEN VOLUMES AND DECIDED THAT NAKAZAWA'S GRAPHIC DEPICTIONS OF JAPANESE SOLDIERS' SEXUAL VIOLENCE AGAINST WOMEN WERE TOO STRONG FOR CHILDREN.

THE BOARD ASKED THE CITY'S ELEMENTARY AND JUNIOR HIGH SCHOOL PRINCIPLES TO MOVE THE BOOKS FROM OPEN SHELVES TO CLOSED SHELVES.

EIGHT MONTHS LATER, THE PRESS GOT WIND OF THIS, SPARKING THE PUBLIC CONTROVERSY THAT THE LATE AUTHOR HAD EXPECTED 40 YEARS EARLIER.

MITSUE CITY'S MOVE HAD SOME *DEFENDERS* ...

... BUT MANY MORE *CRITICS*.

DISCRETION IS REQUIRED IN TEACHING CHILDREN.

VS

朝日新聞

The education board's decision could deprive children of a good opportunity to learn about the tragedy.

There is no need to keep children from accessing this material.

Hakubun Shimomura
Education minister with the LDF government

Asahi Shimbun
Editorial

HAVING SOLD MORE THAN 6.5 MILLION COPIES IN JAPAN ALONE, NAKAZAWA'S *GEN* HAD BECOME A BELOVED CLASSIC IN A MANGA-OBSESSED NATION.

THE MITSUE CITY BOARD OF EDUCATION WITHDREW ITS REQUEST. PUBLISHERS REPORTED THAT THE CONTROVERSY GENERATED RENEWED INTEREST IN THE WORK, BOOSTING SALES.

Starting out in serialised form in the early 1970s, Barefoot Gen was compiled into 10 volumes.

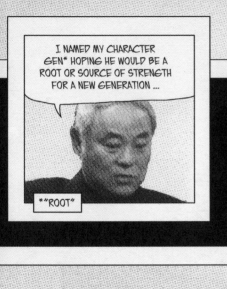

I NAMED MY CHARACTER GEN* HOPING HE WOULD BE A ROOT OR SOURCE OF STRENGTH FOR A NEW GENERATION ...

*"ROOT"

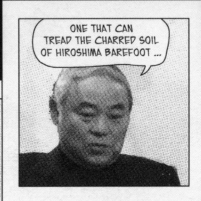

ONE THAT CAN TREAD THE CHARRED SOIL OF HIROSHIMA BAREFOOT ...

AND HAVE THE STRENGTH TO SAY 'NO' TO NUCLEAR WEAPONS.

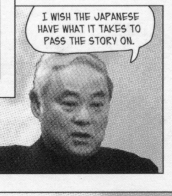

I WISH THE JAPANESE HAVE WHAT IT TAKES TO PASS THE STORY ON.

I WANT TO PASS THE BATON TO THEM.

KEIJI NAKAZAWA DIED AGED 73 ON DEC. 19, 2012, IN HIROSHIMA.

# 10. The Boys' Club
## Gender-based Censorship

_____

_____

_____

# What should female cartoonists talk about?

*Below*
**Neener's Adventures**
March 6, 1994
Nina Paley

MAINTAINING *HIERARCHIES OF POWER* ALWAYS DEPENDS, AT LEAST PARTLY, ON CENSORSHIP -- ON IMPEDING THE CIRCULATION OF INFORMATION AND IDEAS.

AND OF ALL SOCIAL HIERARCHIES -- RACIAL, RELIGIOUS, CLASS, EDUCATIONAL, AND SO ON -- THE MOST ENDURING AND UNIVERSAL DISCRIMINATION HAS BEEN ALONG THE LINES OF *GENDER* ...

... WITH MEN ALMOST ALWAYS PLACED IN THE PRIVILEGED POSITION.

*Left*
Lord Rama and his wife Sita in the film *Sita Sings the Blues*, by Nina Paley.

IF GENDER-BASED HIERARCHIES ARE UBIQUITOUS, WE SHOULD EXPECT TO SEE *GENDER-BASED CENSORSHIP* EVERYWHERE.

CENSORSHIP CAN BE THE HANDMAIDEN OF GENDER-BASED POWER, DISCRIMINATION, AND INEQUALITY.

GENDER-BASED CENSORSHIP EXPRESSES ITSELF IN MANY SHAPES, COLOURS, AND VOICES.

BUT ULTIMATELY, LIKE ALL OTHER FORMS OF CENSORSHIP, IT ALTERS REALITY, DISEMPOWERS, CONTROLS, RENDERS INVISIBLE, AND SILENCES.

Agnes Callamard, human rights defender

Paper for International Women's Day

TRADITIONAL STUDIES OF CENSORSHIP DIDN'T EXPLORE THE GENDER DIMENSION. SILENCES RESULTING FROM SEXUAL DISCRIMINATION WERE OFTEN IGNORED.

WOMENS' ABSENCES FROM THE PUBLIC SPHERE WERE REGARDED AS NORMAL AND NATURAL.

*Right*
**Silencing (Extract)**
**Mimi & Eunice**
Nina Paley

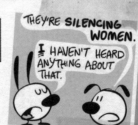

THEY'RE SILENCING WOMEN.

I HAVEN'T HEARD ANYTHING ABOUT THAT.

THAT'S BECAUSE THE WOMEN TRYING TO TELL YOU HAVE BEEN SILENCED.

PERNICIOUS LIES!

GRADUALLY, PEOPLE RECOGNIZED THE NEED TO GIVE "VOICE" TO WOMEN -- A CLAIM THAT REQUIRES AN IMPORTANT CAVEAT ...

THERE'S REALLY NO SUCH THING AS THE *VOICELESS* ...

... THERE ARE ONLY THE *DELIBERATELY SILENCED* OR THE *PREFERABLY UNHEARD.*

Writer Arundhati Roy in a 2004 lecture

253

IN INDIA, ONE OF THE FIRST GOALS FOR WOMEN'S EMPOWERMENT WAS CREATING SAFE PUBLIC SPACES, LIKE SEGREGATED SECTIONS ON BUSES WHERE THEY COULD STAY OUT OF HARM'S WAY -- THAT IS, AWAY FROM MEN.

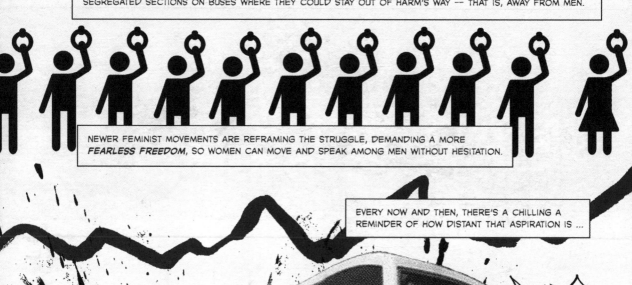

NEWER FEMINIST MOVEMENTS ARE REFRAMING THE STRUGGLE, DEMANDING A MORE *FEARLESS FREEDOM*, SO WOMEN CAN MOVE AND SPEAK AMONG MEN WITHOUT HESITATION.

EVERY NOW AND THEN, THERE'S A CHILLING A REMINDER OF HOW DISTANT THAT ASPIRATION IS ...

ONE NIGHT IN DECEMBER 2012, A DELHI COLLEGE STUDENT ON HER WAY HOME FROM WATCHING *LIFE OF PI* AT A CINEMA WAS GANG-RAPED BY STRANGERS ON A MOVING PRIVATE BUS.

THE SAVAGERY OF THE ATTACK -- THE MEN EVEN PENETRATED HER WITH A METAL ROD -- SPARKED UNPRECEDENTED PUBLIC OUTRAGE.

A SURGING MASS MOVEMENT DUBBED THE VICTIM *"NIRBHAYA"* -- "FEARLESS" -- AND DEMANDED GOVERNMENT ACTION AGAINST SEXUAL VIOLENCE.

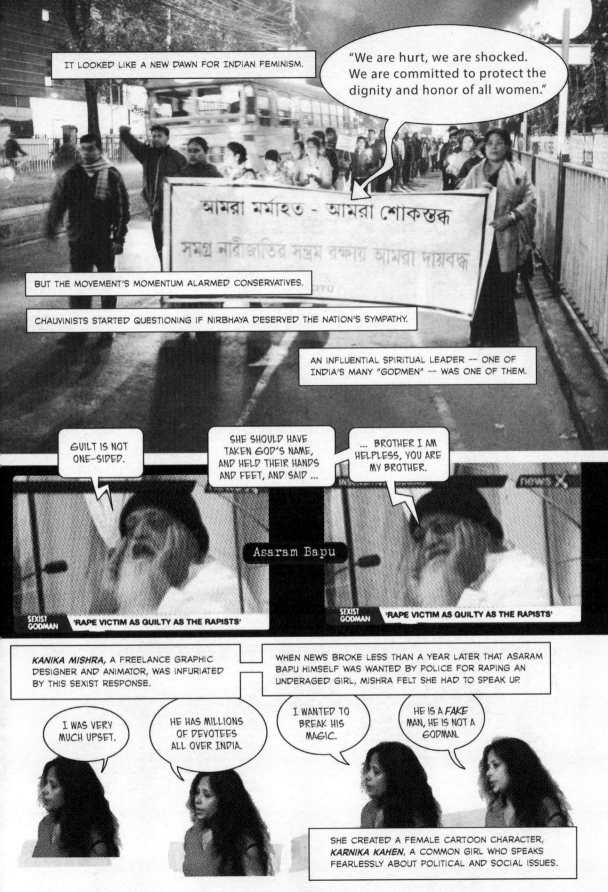

IT LOOKED LIKE A NEW DAWN FOR INDIAN FEMINISM.

"We are hurt, we are shocked. We are committed to protect the dignity and honor of all women."

আমরা মর্মাহত - আমরা শোকস্তব্ধ

সমগ্র নারীজাতির সম্ভ্রম রক্ষায় আমরা দায়বদ্ধ

BUT THE MOVEMENT'S MOMENTUM ALARMED CONSERVATIVES.

CHAUVINISTS STARTED QUESTIONING IF NIRBHAYA DESERVED THE NATION'S SYMPATHY.

AN INFLUENTIAL SPIRITUAL LEADER -- ONE OF INDIA'S MANY "GODMEN" -- WAS ONE OF THEM.

GUILT IS NOT ONE-SIDED.

SHE SHOULD HAVE TAKEN GOD'S NAME, AND HELD THEIR HANDS AND FEET, AND SAID ...

... BROTHER I AM HELPLESS, YOU ARE MY BROTHER.

Asaram Bapu

SEXIST GODMAN    'RAPE VICTIM AS GUILTY AS THE RAPISTS'

SEXIST GODMAN    'RAPE VICTIM AS GUILTY AS THE RAPISTS'

KANIKA MISHRA, A FREELANCE GRAPHIC DESIGNER AND ANIMATOR, WAS INFURIATED BY THIS SEXIST RESPONSE.

WHEN NEWS BROKE LESS THAN A YEAR LATER THAT ASARAM BAPU HIMSELF WAS WANTED BY POLICE FOR RAPING AN UNDERAGED GIRL, MISHRA FELT SHE HAD TO SPEAK UP.

I WAS VERY MUCH UPSET.

HE HAS MILLIONS OF DEVOTEES ALL OVER INDIA.

I WANTED TO BREAK HIS MAGIC.

HE IS A FAKE MAN, HE IS NOT A GODMAN.

SHE CREATED A FEMALE CARTOON CHARACTER, KARNIKA KAHEN, A COMMON GIRL WHO SPEAKS FEARLESSLY ABOUT POLITICAL AND SOCIAL ISSUES.

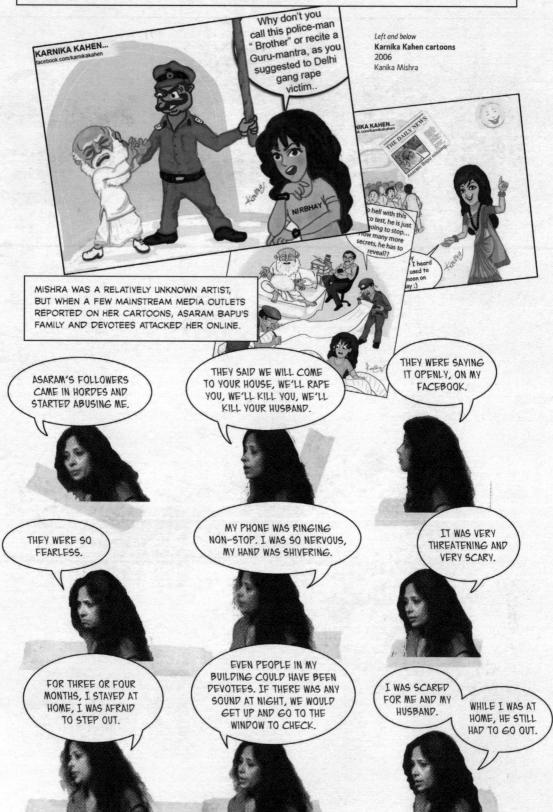

*Left and below*
**Karnika Kahen cartoons**
2006
Kanika Mishra

THEY WEREN'T BEING PARANOID.

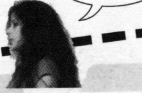

**hindustantimes**

**3 witnesses killed, several attacked and threatened for speaking against Asaram**

Followers of Asaram and his son Narayan Sai accused of threatening people who testified against the self-styled spiritual gurus.

LATER, DURING ASARAM BAPU'S TRIAL, KEY WITNESSES WERE FOUND DEAD.

THE POLICE WERE NOT MUCH HELP.

I WENT TO THE POLICE STATION TO COMPLAIN.

THEY ADVISED ME TO STOP MAKING THESE CARTOONS, UNTIL THEY COULD FIND THESE PEOPLE.

SUCH POLICE INDIFFERENCE ISN'T UNUSUAL IN THE GLOBAL SOUTH.

WHEN MOBS INDULGE IN VIOLENT BOUTS OF OFFENSE-TAKING, THE AUTHORITIES OFTEN CHOOSE EXPEDIENCY OVER JUSTICE -- IT'S EASIER TO *SILENCE LAWFUL SPEECH* THAN TO TRY TO STOP LAWLESS ACTION.

BUT I SAID, HOW CAN I STOP?

IF I STOP MAKING CARTOONS, THE MESSAGE WILL BE THAT I'M AFRAID OF THESE GOONS ...

... THAT THE TRUTH IS VERY WEAK, AND THAT THESE GOONS ARE VERY STRONG.

I CANNOT DO THAT.

IN 2014, MISHRA BECAME THE FIRST WOMAN TO RECEIVE THE COURAGE IN EDITORIAL CARTOONING AWARD FROM CARTOONISTS RIGHTS NETWORK INTERNATIONAL (CRNI).

**CRNI**

DEFENDING POLITICAL CARTOONISTS ON THE FRONT LINES OF FREE SPEECH

*Right*
Mishra with Nik Kowsar and Robert Russell of CRNI in San Francisco.

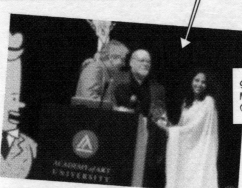

SHE CONTINUES TO BE TROLLED, MAINLY BY FAR-RIGHT FOLLOWERS OF PRIME MINISTER NARENDRA MODI.

THEY THINK IT'S EASY TO SHAME A WOMAN, ASKING HOW MUCH DO YOU CHARGE A NIGHT, AND SO ON.

BUT IF YOU DO NOT FIGHT FOR YOURSELF, WHO WILL FIGHT? MEN AND WOMEN ARE PART OF THIS SOCIETY.

YOU ARE NO LESSER AND YOU ARE NO GREATER.

WHEN STRONG RELIGIOUS CONSERVATIVES COMBINE WITH WEAK CIVIL LIBERTIES, YOU GET THE PERFECT STORM AGAINST OUTSPOKEN WOMEN.

TAKE THE ORDEAL OF IRANIAN ACTIVIST AND ARTIST *ATENA FARGHADANI*.

Atena Farghadani

BETWEEN 2014 AND 2016, SHE SPENT A TOTAL OF ALMOST TWO YEARS IN JAIL FOR HER POLITICAL DISSENT ...

... INCLUDING FOR A CARTOON PROTESTING THE GOVERNMENT'S PLAN TO RESTRICT ACCESS TO CONTRACEPTIVES AND BAN VOLUNTARY STERILIZATION -- A POLICY U-TURN THAT HUMAN RIGHTS DEFENDERS SAID TREATED WOMEN AS "BABY-MAKING MACHINES."

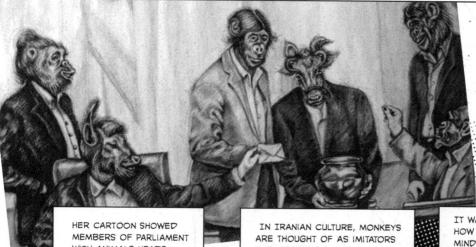

*Left*
**Iranian Parliament**
Atena Farghadani,
2014

HER CARTOON SHOWED MEMBERS OF PARLIAMENT WITH ANIMALS HEADS.

IN IRANIAN CULTURE, MONKEYS ARE THOUGHT OF AS IMITATORS AND COWS AS STUPID.

IT WAS A COMMENT ON HOW LAWMAKERS WERE MINDLESSLY FOLLOWING THE GOVERNMENT'S LEAD.

SHE POSTED IT ON FACEBOOK AND LEFT IT THERE DESPITE WARNINGS FROM FRIENDS.

THERE WAS NO REACTION AT FIRST ...

... BUT THEN SHE HELD AN EXHIBITION OF HER POLITICAL DRAWINGS, ATTENDED BY SEVERAL ACTIVISTS.

LATER, A DOZEN REVOLUTIONARY GUARDS ARRIVED AT HER FAMILY'S HOME AND ARRESTED HER.

SHE RELATED HER EXPERIENCE TO AMNESTY INTERNATIONAL ...

I WAS BLINDFOLDED, HANDCUFFED, AND PUT IN A CAR ALONG WITH LOTS OF MY POSSESSIONS.

WHEN THE GUARDS FOUND ONE OF MY DRAWINGS, THEY STOPPED BRINGING ME PAPER CUPS.

THEY STARTED SWEARING AT ME AND THREATENING ME AS I SAT THERE BLINDFOLDED.

I'D GATHER FLOWER PETALS AND TWIGS IN THE PRISON YARD, AND CRUSH THE PETALS INTO A PASTE TO USE AS PAINT.

IN

JAIL

THE 27-YEAR-OLD ARTIST WAS TAKEN TO EVIN PRISON.

I WAS IMMEDIATELY PUT IN SOLITARY CONFINEMENT.

MY CELL HAD NO WINDOW AND NO TOILET.

THE GUARDS WOULD BRING MILK IN PAPER CUPS, WHICH I WOULD SAVE TO DRAW ON.

IT WAS INFESTED WITH INSECTS.

I WAS INTERROGATED FOR SIX WEEKS, AND SPENT THE FIRST FIFTEEN DAYS IN SOLITARY CONFINEMENT.

Evin Prison, Tehran

THEY WANTED TO KNOW THE MEANING OF MY DRAWINGS, AND ABOUT THE EXHIBITION I HELD.

THE FIRST INTERROGATION DOCUMENT THEY PUT IN FRONT OF ME WAS MY CARTOON.

259

SHE WAS LATER IMPRISONED IN GHARCHAK, A NOTORIOUS FACILITY WHOSE INMATES INCLUDED VIOLENT CRIMINALS.

THERE WERE FIGHTS IN THE JAIL THAT WERE SO BRUTAL THAT SOMETIMES PEOPLE WERE KILLED.

... WHERE TIME DIES.

I CONSIDER GHARCHAK PRISON AS A GRAVEYARD OF TIME ...

THERE WAS A WOMAN IN JAIL WHO PROPOSITIONED ME FOR SEX.

IN JAIL

I SOMETIMES SEE THOSE INMATES IN MY NIGHTMARES.

WHAT BOTHERED ME THE MOST WAS TO SEE INMATES WHO WERE NOT TREATED LIKE HUMAN BEINGS.

WHEN I REJECTED HER SHE THREATENED TO RAPE ME.

Gharchak prison, on the outskirts of Tehran

ONLY AFTER GOING ON A LIFE-THREATENING HUNGER STRIKE WAS SHE EVENTUALLY TRANSFERRED BACK TO EVIN PRISON. BUT MORE INDIGNITIES WERE TO FOLLOW.

WHEN HER MALE LAWYER VISITED HER IN JAIL AND THEY SHOOK HANDS -- PHYSICAL CONTACT BETWEEN UNRELATED MEN AND WOMEN IS FROWNED UPON BY CONSERVATIVE MUSLIMS -- THE AUTHORITIES SUBJECTED HER TO A VIRGINITY AND PREGNANCY TEST.

IN JAIL

THE PROSECUTOR SAID IF I WAS A GOOD GIRL I WOULD NOT SHAKE HANDS WITH A MAN.

THEY WERE SMEARING MY DIGNITY. IT'S A TACTIC THEY USE SOMETIMES AGAINST POLITICAL PRISONERS.

HER CASE ALARMED INTERNATIONAL HUMAN RIGHTS MONITORS...

21.    On 10 January 2015, Atena Farghdani, a peaceful activist and artist, was arrested and beaten in front of her parents and later in front of a court judge. In June 2015, she received a sentence of 12 years and six months of imprisonment. While in prison, she was reportedly subject to torture, sexual harassment and degrading detention conditions. Furthermore, she was reportedly forced to take virginity and pregnancy tests, and held in prolonged solitary confinement for 20 days.[25] In their comments on this report, the

United Nations
Secretary-General

*Left*
United Nations Secretary-General Ban Ki-moon's report on human rights in Iran.

"VIRGINITY TESTING" IS HIGHLY DISCRIMINATORY, COMPROMISES WOMEN'S DIGNITY AND RIGHTS TO PHYSICAL AND MENTAL INTEGRITY ...

... AND HAS BEEN RECOGNISED AS A VIOLATION OF THE PROHIBITION OF TORTURE AND OTHER ILL-TREATMENT.

Magdalena Mughrabi in an Amnesty report.

ARTIST FAITH XLVII SHOWED SOLIDARITY THROUGH THIS MURAL IN BROOKLYN, NEW YORK.

I FELT A LOT OF EMPATHY FOR ATENA.

THE WAY SHE HAD BEEN TREATED IN CUSTODY, THE MASSIVE SENTENCE THAT SHE RECEIVED, WERE ALL SO HORRIFIC TO ME.

Faith XLVII

IRONICALLY, THE TRIBUTE WAS DEFACED, AND THEN REMOVED AFTER LOCALS COMPLAINED THAT A GIANT MURAL OF A MUSLIM WOMAN WAS NOT RESPECTFUL TO THE MEMORY OF 9/11.

(BUT THAT'S ANOTHER STORY.)

FARGHADANI WAS ORIGINALLY SENTENCED TO MORE THAN 12 YEARS IN JAIL FOR A RANGE OF POLITICAL OFFENSES.

BUT UNDER PRESSURE FROM THE THE INTERNATIONAL COMMUNITY AND HUMAN RIGHTS ORGANIZATIONS, A JUDGE REDUCED THE SENTENCE.

SHE WAS RELEASED IN MAY 2016.

IN AN INTERVIEW WITH AMNESTY INTERNATIONAL THE FOLLOWING YEAR, SHE REFLECTED ON HER EXPERIENCE.

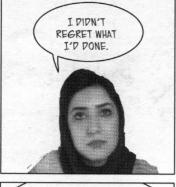

I DIDN'T REGRET WHAT I'D DONE.

BUT I REALLY WANTED MY FAMILY TO ACCEPT WHAT HAD HAPPENED AND UNDERSTAND WHY IT HAD HAPPENED SO THEY'D BE ABLE TO SUPPORT ME.

THAT WAS THE MOST IMPORTANT THING TO ME.

AS I DON'T WANT TO LEAVE IRAN, THEY GET WORRIED AND ARE ALWAYS TELLING ME, THEY DON'T HAVE THE STRENGTH TO SUPPORT ME ANYMORE.

BUT ART IS LIKE A PART OF ME, AND I CAN'T GIVE UP ON POLITICAL OR PROTEST ART.

I FEEL OLD AND I FEEL DEPRESSED, PARTLY DUE TO THE NIGHTMARES I'M SUFFERING FROM.

I AM STUCK IN A GRAVE THAT IS ACTUALLY A TOILET. OR I GET STUCK IN A BATHROOM WITH NO DOOR.

I DIDN'T HAVE THESE DREAMS IN PRISON.

I HAD BETTER SLEEP IN PRISON.

ATENA FARGHADANI'S EXPERIENCE IN IRAN IS AN EXTREME CASE.

IN COUNTRIES THAT ARE LESS VIOLENTLY REPRESSIVE FOR WOMEN, GENDER-BASED CENSORSHIP MANIFESTS ITSELF DIFFERENTLY.

A WOMAN CARTOONIST IN THE WEST WOULDN'T BE JAILED OR TORTURED FOR EXPRESSING FEMINIST VIEWS ...

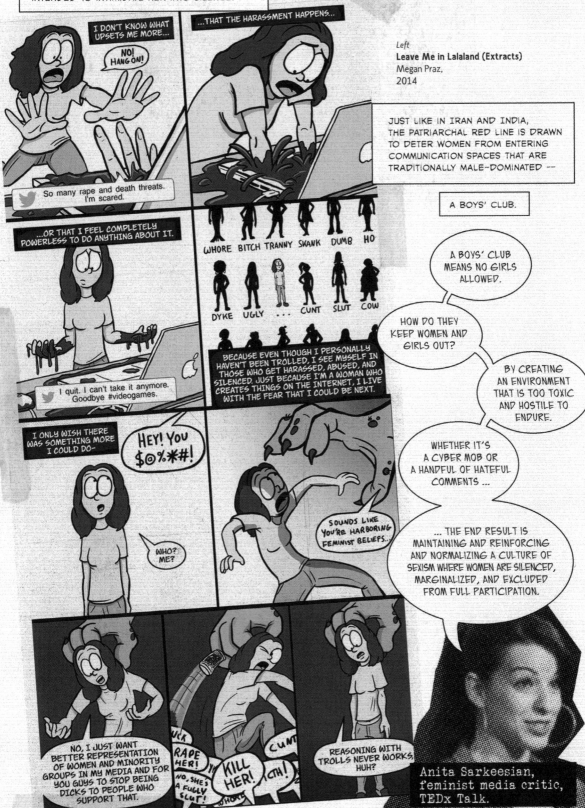

Left
**Leave Me in Lalaland (Extracts)**
Megan Praz,
2014

263

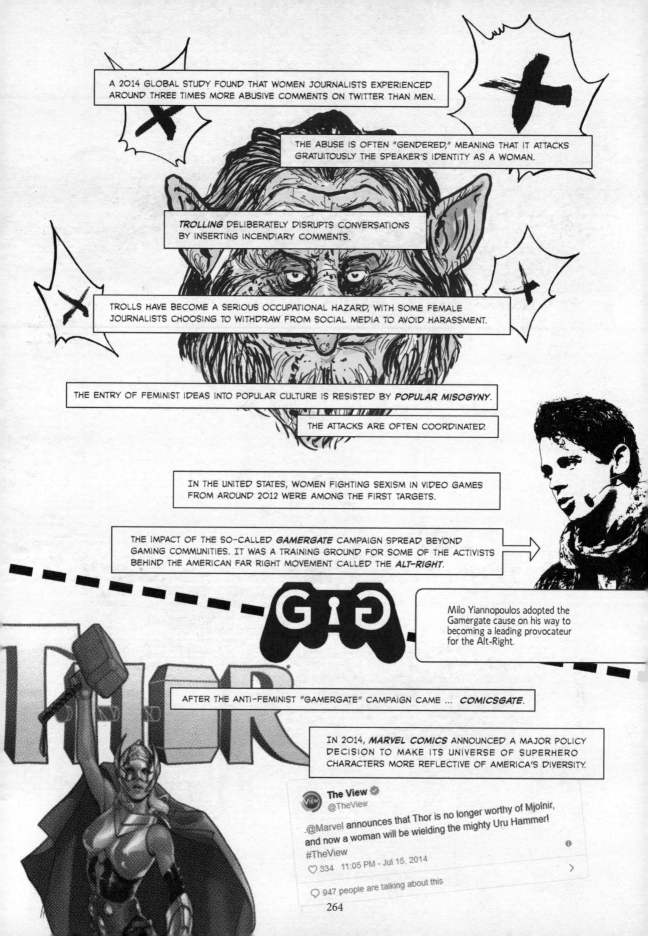

A 2014 GLOBAL STUDY FOUND THAT WOMEN JOURNALISTS EXPERIENCED AROUND THREE TIMES MORE ABUSIVE COMMENTS ON TWITTER THAN MEN.

THE ABUSE IS OFTEN "GENDERED," MEANING THAT IT ATTACKS GRATUITOUSLY THE SPEAKER'S IDENTITY AS A WOMAN.

*TROLLING* DELIBERATELY DISRUPTS CONVERSATIONS BY INSERTING INCENDIARY COMMENTS.

TROLLS HAVE BECOME A SERIOUS OCCUPATIONAL HAZARD, WITH SOME FEMALE JOURNALISTS CHOOSING TO WITHDRAW FROM SOCIAL MEDIA TO AVOID HARASSMENT.

THE ENTRY OF FEMINIST IDEAS INTO POPULAR CULTURE IS RESISTED BY *POPULAR MISOGYNY*.

THE ATTACKS ARE OFTEN COORDINATED.

IN THE UNITED STATES, WOMEN FIGHTING SEXISM IN VIDEO GAMES FROM AROUND 2012 WERE AMONG THE FIRST TARGETS.

THE IMPACT OF THE SO-CALLED *GAMERGATE* CAMPAIGN SPREAD BEYOND GAMING COMMUNITIES. IT WAS A TRAINING GROUND FOR SOME OF THE ACTIVISTS BEHIND THE AMERICAN FAR RIGHT MOVEMENT CALLED THE *ALT-RIGHT*.

Milo Yiannopoulos adopted the Gamergate cause on his way to becoming a leading provocateur for the Alt-Right.

AFTER THE ANTI-FEMINIST "GAMERGATE" CAMPAIGN CAME ... *COMICSGATE*.

IN 2014, *MARVEL COMICS* ANNOUNCED A MAJOR POLICY DECISION TO MAKE ITS UNIVERSE OF SUPERHERO CHARACTERS MORE REFLECTIVE OF AMERICA'S DIVERSITY.

**The View** ✓
@TheView

.@Marvel announces that Thor is no longer worthy of Mjolnir, and now a woman will be wielding the mighty Uru Hammer! #TheView

♡ 334   11:05 PM - Jul 15, 2014

💬 947 people are talking about this

264

BY 2016, IT BECAME OBVIOUS THAT NOT EVERYONE WAS HAPPY WITH SUCH DEVELOPMENTS.

FEMALE COMIC ARTISTS AND WRITERS WHO ADVERTISED THEIR SOLIDARITY WITH THE FEMINIST CAUSE SUDDENLY FOUND THEMSELVES GENDERTROLLED.

**Chelsea Cain @ ECCC D-1** ✓
@ChelseaCain

Follow

Please buy Mockingbird #8 this Wed. Send a message to @marvel that there's room in comics for super hero stories about grown-up women.

12:59 AM - 18 Oct 2016

**131** Retweets **224** Likes

*CHELSEA CAIN*, THE WRITER OF MARVEL'S SERIES *MOCKINGBIRD*, MARKED THE END OF ITS RUN WITH A FEMINIST TWEET, AND WAS IMMEDIATELY TARGETED FOR MISOGYNISTIC ABUSE.

THIS SOCIAL MEDIA POST WAS ALSO TOO MUCH FOR SOME MEN TO TAKE: ARTIST *JOELLE JONES* DREW THE TITLE CHARACTER WEARING A (SELF-MOCKING?) SHIRT THAT READ, "ASK ME ABOUT MY FEMINIST AGENDA."

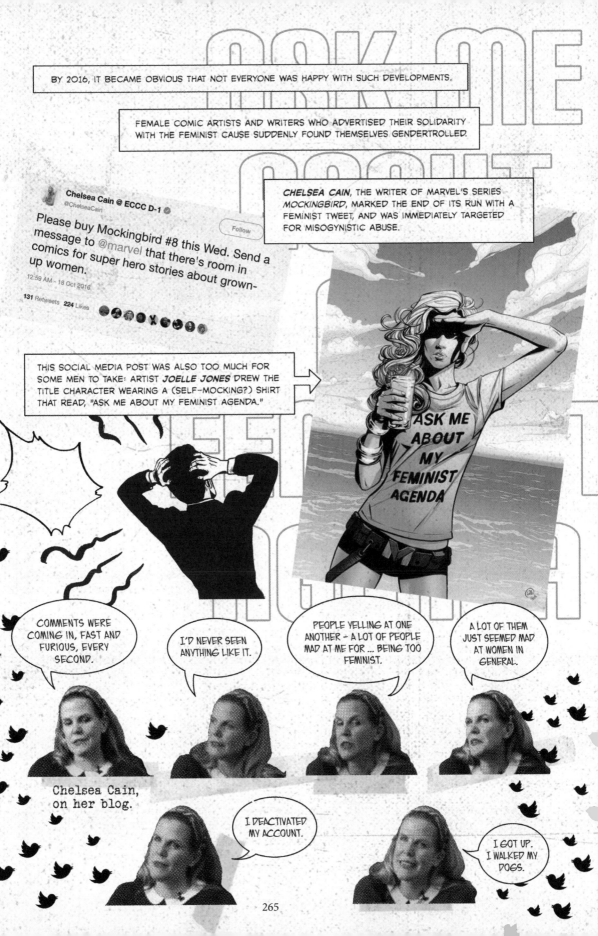

ASK ME ABOUT MY FEMINIST AGENDA

COMMENTS WERE COMING IN, FAST AND FURIOUS, EVERY SECOND.

I'D NEVER SEEN ANYTHING LIKE IT.

PEOPLE YELLING AT ONE ANOTHER – A LOT OF PEOPLE MAD AT ME FOR ... BEING TOO FEMINIST.

A LOT OF THEM JUST SEEMED MAD AT WOMEN IN GENERAL.

Chelsea Cain, on her blog.

I DEACTIVATED MY ACCOUNT.

I GOT UP. I WALKED MY DOGS.

IN 2017, A GROUP OF FEMALE MARVEL EMPLOYEES WENT FOR MILKSHAKES TO CELEBRATE THE LEGACY OF A FORMER STAFFER WHO HAD JUST DIED.

EDITOR *HEATHER ANTOS* TWEETED A PHOTO.

THIS WAS ENOUGH TO TRIGGER ANOTHER ROUND OF ATTACKS.

THE ANTI-FEMINIST CAMPAIGN CAME TO BE KNOWN BY ITS HASHTAG ...

# #COMICSGATE

**Heather Antos @ ECCC** ✓
@HeatherAntos
Follow

It's the Marvel milkshake crew! #FabulousFlo

2:35 AM - 29 Jul 2017

**732** Retweets **5,331** Likes

PEOPLE WHO IDENTIFIED WITH COMICSGATE PROBABLY HAD DIFFERENT MOTIVATIONS ...

... SOME MAY HAVE SINCERELY FELT THAT THE INDUSTRY WAS TAKING TOO MANY CREATIVE LIBERTIES WITH CHERISHED COMIC BOOK CHARACTERS.

"FOR FANS OF THE ORIGINAL INCARNATIONS OF THESE MEDIA TEXTS, THE NEW, DIVERSE CASTS CAN SEEM TO 'RUIN' THE ORIGINAL, WHILE OTHERS CELEBRATE WHAT THEY SEE AS A MOVE TOWARD INCLUSIVITY," SAYS ONE STUDY OF THE "TOXIC TURN" IN COMIC BOOK FANDOM.

**B BREITBART**

# READERS ARE ABANDONING MARVEL COMICS AFTER SOCIAL JUSTICE INVASION. CAN YOU BLAME THEM?

SUCH DISPUTES AMONG FANS ARE NOTHING NEW, THOUGH SOCIAL MEDIA GIVE THEM A VERY PUBLIC PLATFORM.

BUT WHAT *COULD* HAVE BEEN A PRODUCTIVE DEBATE WAS INSTANTLY SUCKED INTO AMERICA'S POLARIZED *"CULTURE WARS."*

*Left*
Marvel's pro-diversity policy is another sign of runaway feminism, charged the Alt-Right website Breitbart.

THE ALT-RIGHT SEIZED THE CHANCE TO COMPLAIN ABOUT THE COMIC BOOK INDUSTRY AS YET ANOTHER DOMAIN BEING OVERRUN BY "SOCIAL JUSTICE WARRIORS" INTENT ON PUSHING TRADITIONAL AMERICAN VALUES TO THE MARGINS.

CHARLIE NASH | 7 Jul 2016

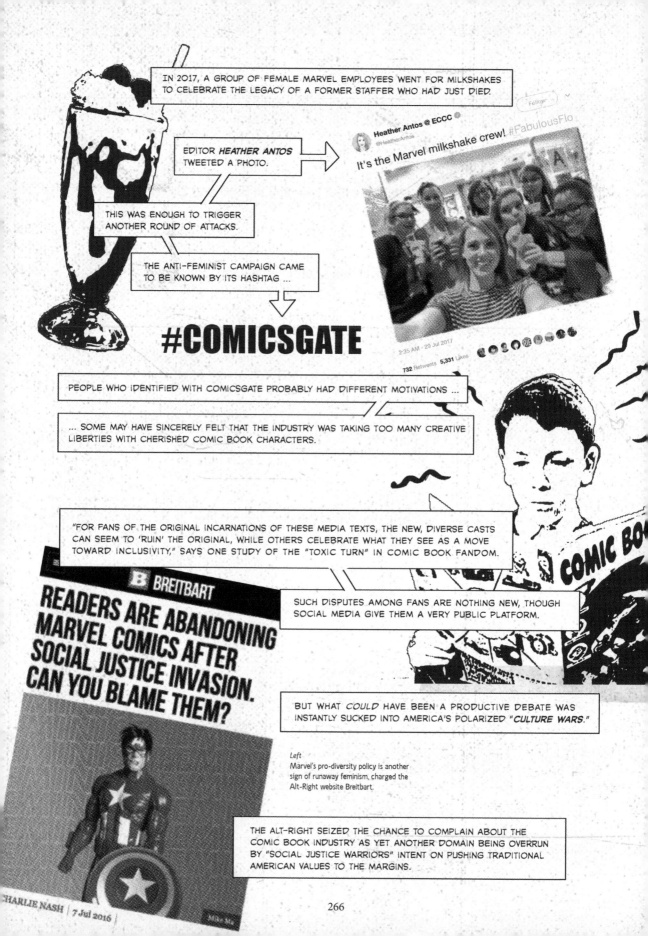

COMICSGATE SUPPORTERS CAME UP WITH A *BLACKLIST* OF COMIC BOOK PROFESSIONALS TO BOYCOTT, CLAIMING THEY WERE RESPONSIBLE FOR DECLINING *QUALITY*.

MOST OF THE PROFESSIONALS SINGLED OUT WERE WOMEN, PEOPLE OF COLOR, OR LEFT-LEANING.

**Comic Management**

Andy Khouri - *Editor,* **DC**
Alanna Smith - *Assistant Editor,* **Marvel**
Heather Antos - *Editor,* **Marvel**
Tom Breevort - *Assistant EiC,* **Marvel**

**Writer Pool**

Aleš Kôt - *Writer,* **Image**
Aubrey Sitterson - *Writer/Podcaster, Freelance*
B. Clay Moore - *Writer/Scammer, Freelance*
Dan Slott - *Writer,* **Marvel**
Gabby Rivera - *Writer, Freelance*
Gail Simone - *Writer, Freelance*
Jennifer de Guzman - *Writer, Freelance*
Kelly Sue DeConnick - *Writer/Adapter,* **Image**
Kurt Busiek - *Writer,* **DC**
Larry Hama - *Writer, Freelance*
Magdalena Vissagio - *Writer, Freelance*
Mark Waid - *Writer,* **Marvel/Archie Comics**
Matthew (Fraction) Frichtman - *Writer,* **Marvel/Image**
Max Bemis - *Writer,* **Marvel**
Nick Spencer - *Writer,* **Marvel**
Sina Grace - *Writer, Marvel/The Atlantic*
Ta-Nehisi Coates - *Writer, Freelance*
Tim Doyle - *Writer, Freelance*
Zachary Davisson - *Writer, Freelance*

**The Pravda Press**

David Brothers - *Reporter, Freelance*
Kieran Sciach - *Reporter,* **Polygon/CBR**
Rich Johnston - *Reporter,* **Bleeding Cool**
Jude Terror - *Reporter,* **Bleeding Cool**
Joseph Glass - *Writer/Reporter, Freelance/Bleeding Cool*
Matthew Santori Griffin - *Reporter,* **Comicosity**
Stephanie Cooke - *Reporter, Freelance*
Colin Spacetwinks - *Reporter,* **Giant Bomb**

**Asinine Artists**

Andrea Shockling - *Artist, Freelance*
Colleen Doran - *Artist, Freelance*
Jamal Igle - *Writer/Artist,* ...
Jim Zub - *Writer/Artist,* ...
Marissa Louise - *Artist,* ...
Ramon Villalobos - *Artis*...
Tess Fowler - *Artist, Fre*...

**Toxic Colorists**

Kelly Fitzpatrick - *Co*...
Tamra Bonvillain - C...
Triona Tree Farrel - ...

**Indie Mafia**

Alex de Campi - W...
Amy Chu - Publis...
Christopher Sebe...
Justin Jordan - W...
Kirk Perez - Unk...
Paul Allor - Wri...
Ryan Ferrier - ...
Ulysses Farine...

*Below*
**Leave Me in Lalaland (Extract)**
Megan Praz

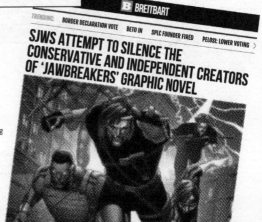

ON THE OTHER HAND, LIBERALS AND THE CULTURAL LEFT HAVE MOBILIZED QUITE EFFECTIVELY AGAINST COMICSGATE, WHICH IT HAS CALLED OUT AS A HATE GROUP, JUST AS THEY'D DONE WITH GAMERGATE.

THE COMICSGATE COUNTER-PROTEST LOBBIED SUCCESSFULLY AGAINST *JAWBREAKERS*, AN INDIE GRAPHIC NOVEL DREAMT UP WITH THE EXPLICIT INTENT TO REVIVE OLD-STYLE MALE SUPERHEROES.

THE *JAWBREAKERS* PROJECT MANAGED TO CROWDFUND MORE THAN *$250,000*, BUT ITS PUBLISHER CANCELED THE DEAL AFTER PROTESTS OVER THE WRITER'S IDENTITY -- *RICHARD C. MEYER* WAS ONE OF COMICSGATE'S LEADING INSTIGATORS.

IRONICALLY, THE LEFT'S VIGOROUS COUNTER-CAMPAIGN ALLOWED COMICSGATE'S SPOKESMEN TO CLAIM THAT *THEY* WERE THE REAL VICTIMS OF INTOLERANCE ...

... WHICH, THEY CLAIMED, PROVED THEIR POINT THAT THE COMICS WORLD WAS INFESTED WITH *SOCIAL JUSTICE WARRIORS* TRYING TO PUSH WHITE MEN TO THE MARGINS OF THEIR COUNTRY.

*Right*
Alt-right website Breitbart cries censorship by left-wing feminists.

Richard C. Meyer

AS A RESULT OF SUCH DEVELOPMENTS, A DEBATE IS RAGING WITHIN WESTERN FEMINISM ABOUT WHETHER MISOGYNIST SPEAKERS AND VIEWPOINTS SHOULD BE ...

... DENIED A PLATFORM

(BY SUPPRESSING A COMIC BOOK LIKE *JAWBREAKERS*, FOR EXAMPLE)

OR

... FOUGHT WITH COUNTER-SPEECH.

(BY CALLING OUT SEXIST COMICS AND MAKING BETTER ONES)

WHERE DOES ONE PERSON'S RIGHT TO FREE SPEECH END AND ANOTHER PERSON'S RIGHT TO GO TO WORK OR SCHOOL WITHOUT HAVING TO DEAL WITH BIGOTRY OR HARASSMENT BEGIN?

THIS IS ABOUT THE LINE-IN-THE-SAND.

YOU CAN'T HAVE A SOCIETY WHERE WOMEN ARE FULLY RESPECTED, BUT WHERE EXPRESSIONS OF RAMPANT SEXISM ARE ALSO CONDONED.

IT IS SIMPLY NOT POSSIBLE.

Julia Serano, author

TODAY'S CENSORIOUS FEMINISM ENCOURAGES WOMEN TO SEE THEMSELVES AS VULNERABLE.

WE NEED A LIBERATION MOVEMENT THAT PROMOTES FREE SPEECH, NOT CENSORSHIP.

Joanna Williams, writer

SURELY BY NOW LIBERALS HAVE REALIZED THE FOLLY IN ASSUMING JUSTICE IS DELIVERED BY "SPEAKING TRUTH TO POWER"?

IF SOMEONE IS SPEAKING ON SOMETHING I THINK IS WRONG AND DANGEROUS AND JUST THIS SIDE OF VIOLENCE, I WOULD NOT KEEP THAT PERSON FROM SPEAKING, I WOULD DEMAND EQUAL TIME.

POLICIES AGAINST INCOHERENTLY DEFINED "HATE SPEECH" GIVE CERTAIN GROUPS ENORMOUS INCENTIVE TO BE OFFENDED, BECAUSE THEY CAN USE THEIR OFFENDED-NESS TO CENSOR.

Gloria Steinem, activist

EVERYONE IS UNDERSTANDABLY TERRIFIED OF FASCISM.

Tash Lennard, journalist

MY ADVICE IS, THE BEST WAY TO RESIST FASCISM IS TO NOT BEHAVE LIKE A FASCIST.

Nina Paley, artist and animator

SADLY THAT'S NOT WHAT'S HAPPENING HERE. THE "LEFT" IN THE US HAS LOST ITS MIND, ALONG WITH THE RIGHT.

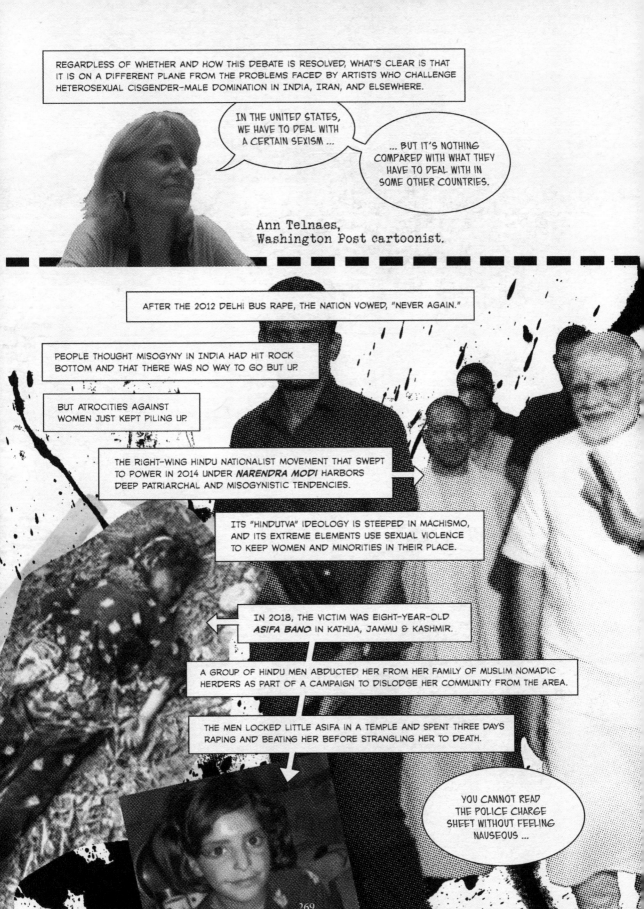

REGARDLESS OF WHETHER AND HOW THIS DEBATE IS RESOLVED, WHAT'S CLEAR IS THAT IT IS ON A DIFFERENT PLANE FROM THE PROBLEMS FACED BY ARTISTS WHO CHALLENGE HETEROSEXUAL CISGENDER-MALE DOMINATION IN INDIA, IRAN, AND ELSEWHERE.

IN THE UNITED STATES, WE HAVE TO DEAL WITH A CERTAIN SEXISM ...

... BUT IT'S NOTHING COMPARED WITH WHAT THEY HAVE TO DEAL WITH IN SOME OTHER COUNTRIES.

Ann Telnaes,
Washington Post cartoonist.

AFTER THE 2012 DELHI BUS RAPE, THE NATION VOWED, "NEVER AGAIN."

PEOPLE THOUGHT MISOGYNY IN INDIA HAD HIT ROCK BOTTOM AND THAT THERE WAS NO WAY TO GO BUT UP.

BUT ATROCITIES AGAINST WOMEN JUST KEPT PILING UP.

THE RIGHT-WING HINDU NATIONALIST MOVEMENT THAT SWEPT TO POWER IN 2014 UNDER *NARENDRA MODI* HARBORS DEEP PATRIARCHAL AND MISOGYNISTIC TENDENCIES.

ITS "HINDUTVA" IDEOLOGY IS STEEPED IN MACHISMO, AND ITS EXTREME ELEMENTS USE SEXUAL VIOLENCE TO KEEP WOMEN AND MINORITIES IN THEIR PLACE.

IN 2018, THE VICTIM WAS EIGHT-YEAR-OLD *ASIFA BANO* IN KATHUA, JAMMU & KASHMIR.

A GROUP OF HINDU MEN ABDUCTED HER FROM HER FAMILY OF MUSLIM NOMADIC HERDERS AS PART OF A CAMPAIGN TO DISLODGE HER COMMUNITY FROM THE AREA.

THE MEN LOCKED LITTLE ASIFA IN A TEMPLE AND SPENT THREE DAYS RAPING AND BEATING HER BEFORE STRANGLING HER TO DEATH.

YOU CANNOT READ THE POLICE CHARGE SHEET WITHOUT FEELING NAUSEOUS ...

269

... THE INDIA WE THOUGHT HAD CHANGED HAS NOT CHANGED AT ALL.

POLITICAL AND SOCIETAL RESPONSES TO THESE CHARGES OF RAPE HAVE REVEALED ENTRENCHED MISOGYNY, RELIGIOUS HATRED AND A SHAMEFUL CLASS BIAS.

Barkha Dutt,
TV journalist,
op-ed in the Washington Post.

IN RESPONSE TO A DEMONSTRATION BY MUSLIMS CALLING FOR JUSTICE, HINDU POLITICIANS ORGANIZED A COUNTER-PROTEST, DEFENDING THE MEN WHO HAD BEEN ARRESTED FOR THE RAPE.

A GROUP OF LAWYERS EVEN TRIED TO OBSTRUCT POLICE FROM FILING CHARGES.

The NEWS NOW

SINGH

Hindu Ekta Manch Holds Protest in Kathua

THE HORRIFIC RAPE AND MURDER OF ASIFA BANO WAS NOT THE ONLY SEXUAL VIOLENCE SCANDAL MAKING NEWS AT THE TIME.

IN UTTAR PRADESH (U.P.) STATE, TWO RULING PARTY POLITICIANS ACCUSED OF SEPARATE RAPES SEEMED TO BE GETTING AWAY WITH IT.

ONE WAS A STATE ASSEMBLYMAN (OR M.L.A.), ANOTHER A FORMER MINISTER.

SHE GOES AND APPEALS...

AND HE GETS HER FATHER ARRESTED AND THAT MAN DIES IN POLICE CUSTODY!

WHY IS THAT M.L.A. STILL SCOT-FREE?

THE U.P. GOVERNMENT HAS GONE AHEAD AND WITHDRAWN THE RAPE CASE AGAINST ANOTHER RAPE ACCUSED, FORMER MINISTER AND BJP LEADER SWAMI CHINMAYANAND.

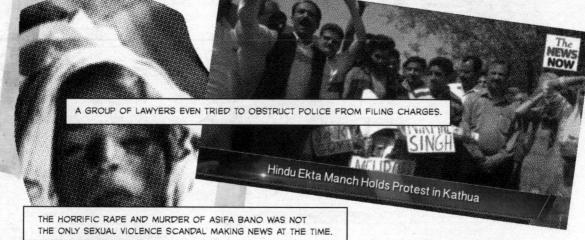

NDTV

REALITY CHECK
BRUTALITY AGAINST RAPE VICTIM'S DAD

NDTV

THE NEWS
BADAUN RAPE SURVIVOR DEMANDS JUSTICE

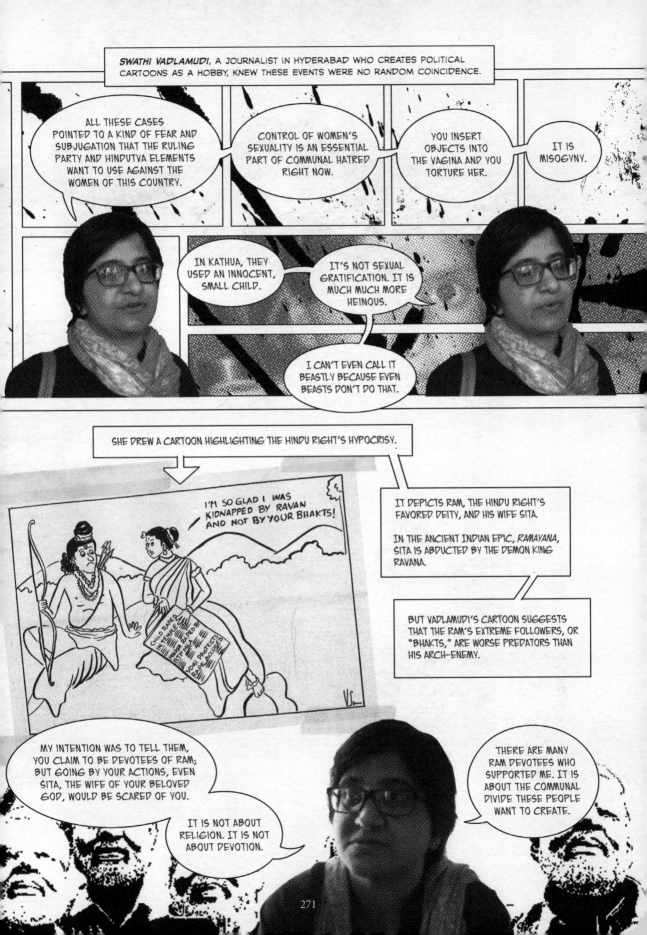

SWATHI VADLAMUDI, A JOURNALIST IN HYDERABAD WHO CREATES POLITICAL CARTOONS AS A HOBBY, KNEW THESE EVENTS WERE NO RANDOM COINCIDENCE.

ALL THESE CASES POINTED TO A KIND OF FEAR AND SUBJUGATION THAT THE RULING PARTY AND HINDUTVA ELEMENTS WANT TO USE AGAINST THE WOMEN OF THIS COUNTRY.

CONTROL OF WOMEN'S SEXUALITY IS AN ESSENTIAL PART OF COMMUNAL HATRED RIGHT NOW.

YOU INSERT OBJECTS INTO THE VAGINA AND YOU TORTURE HER.

IT IS MISOGYNY.

IN KATHUA, THEY USED AN INNOCENT, SMALL CHILD.

IT'S NOT SEXUAL GRATIFICATION. IT IS MUCH MUCH MORE HEINOUS.

I CAN'T EVEN CALL IT BEASTLY BECAUSE EVEN BEASTS DON'T DO THAT.

SHE DREW A CARTOON HIGHLIGHTING THE HINDU RIGHT'S HYPOCRISY.

I'M SO GLAD I WAS KIDNAPPED BY RAVAN AND NOT BY YOUR BHAKTS!

CHILD RAPED IN TEMPLE
MINOR RAPED BY BJP MLA
YOGI PROTECTS RAPE ACCUSED!

IT DEPICTS RAM, THE HINDU RIGHT'S FAVORED DEITY, AND HIS WIFE SITA.

IN THE ANCIENT INDIAN EPIC, RAMAYANA, SITA IS ABDUCTED BY THE DEMON KING RAVANA.

BUT VADLAMUDI'S CARTOON SUGGESTS THAT THE RAM'S EXTREME FOLLOWERS, OR "BHAKTS," ARE WORSE PREDATORS THAN HIS ARCH-ENEMY.

MY INTENTION WAS TO TELL THEM, YOU CLAIM TO BE DEVOTEES OF RAM; BUT GOING BY YOUR ACTIONS, EVEN SITA, THE WIFE OF YOUR BELOVED GOD, WOULD BE SCARED OF YOU.

IT IS NOT ABOUT RELIGION. IT IS NOT ABOUT DEVOTION.

THERE ARE MANY RAM DEVOTEES WHO SUPPORTED ME. IT IS ABOUT THE COMMUNAL DIVIDE THESE PEOPLE WANT TO CREATE.

271

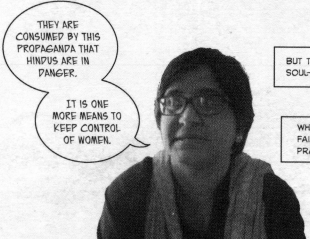

THEY ARE CONSUMED BY THIS PROPAGANDA THAT HINDUS ARE IN DANGER.

IT IS ONE MORE MEANS TO KEEP CONTROL OF WOMEN.

BUT THE CARTOON DID NOT PROMPT ANY SOUL-SEARCHING AMONG ITS INTENDED AUDIENCE.

WHEN INTOLERANT SEGMENTS OF INDIA'S MANY FAITH GROUPS ARE CHALLENGED, THEY DON'T PRAY FOR DIVINE WISDOM OR FORBEARANCE.

THEY REACH FOR *SECTION 295A* OF THE INDIAN PENAL CODE.

[1][**295A. Deliberate and malicious acts, intended to outrage religious feelings of any class by insulting its religion or religious beliefs.-** Whoever, with deliberate and malicious intention of outraging the religious feelings of any class of [2][citizens of India], [3][ by words, either spoken or written, or by sings or by visible representations or otherwise], insults or attempts to insult the religion or the religious beliefs of that class, shall be punished with imprisonment of either description for a term which may extend to [4][three years], or with fine, or with both.]

Office of the
Special Investigation Team,
Hyderabad-City,

Dated : 11.09.2018.

C No 81-2018/SIT/Hyd.

THIS COLONIAL-ERA PIECE OF LEGISLATION WORKS LIKE BLASPHEMY LAW, ALLOWING THE MOST INTOLERANT GROUPS TO DEMAND PUNISHMENT FOR ANYONE WHO (THEY CLAIM) HAS OFFENDED THEM.

U/s.91/100 Cr.P.C

You ar                                                    2018 or complaint of Sri.

SURE ENOUGH, PEOPLE WHO DID NOT LIKE VADLAMUDI'S CARTOON WERE SWIFT AND PERSISTENT IN PUSHING FOR HER TO BE PUNISHED.

Kashimshetty Kar

registered in Cr.No.132/2018 U/s 295(A) IPC at Police Station Saidabad and the file

has                    to CCS and re-registered in Cr.No.81/2018 dated 10-05-2018

and

THE HYDERABAD POLICE EVENTUALLY SUMMONED HER FOR AN INTERVIEW.

In this complaint stated that you are sketching the derogatory cartoon on Hindu gods hurting the sentiments of Hindus and posted on twitter, a separate complaint was given on 14.04.2018 by the complainant against you.

Hence, you are requested to offer your specific remarks, and also appear before me within 1 week from receipt of this notice along with your reply and evidence if any for the purpose of investigation.

(K.S. RAVI)
Sub-Inspector of Police
Spl. Investigation Team,
Hyderabad City.
Ph:9490616684

To,
The Investigating Officer
The Special Investigation Team
Hyderabad City

HYDERABAD
October 26, 2018

Dear Madam/Sir,

Sub: Statement as requested by the addressed authority apropos the case titled Cr.No.81/2018 reg.

I am Swathi Vadlamudi, residing at 600, Dwarakapuri, Hyderabad-60, with the phone number ... ... October 2003. I worked for the Telugu news daily 'Eenadu' ... ... cation since June, 2007. I am a Special Correspondent with the news paper now.

Apropos the complaint and the case referred to in your notice U/S 91/160 Cr.PC issued to me on September 11, 2018, this is to humbly submit myself for complete cooperation with regard to the investigation into the said ...

In m... ... ... ... political cartoons for the past 2.5 years, and posting them only on social media. The cartoon mentioned by you in the notice was drawn by me on April 11, and posted on Facebook and Twitter platforms.

The cartoon was drawn by me in the backdrop of several alleg... ... ... ... ous parts of the country, major among them being the rape and murder of a girl Asifa Bano in Kathua of Jammu region in Ja... ... ... ice in April, 2018, the little girl of eight yea... ... ... ly before being murdered by a few persons ...

Rallies were conducted by one fringe organisation 'Hindu Ekta Manch' in support of the rape-murder accused in this case, and efforts were made by lawyers from Bar Association to block the police from filing charge-sheets, by shouting 'Jai Shriram' slogans, which was wid... ... ... rs. The rallies were attended by ministers of the coalition government, ... ... ... Party (BJP) known for its devotion to Lord Shriram.

Around the same time, another BJP MLA from Unnao of Uttar Pradesh, Kuldeep Sengar, was accused of rape of a minor girl and ...

I was merely exercising my Freedom of Expression as granted by the Indian Constitution, and there was no intention whatsoever on my behalf to hurt anybody's religious sentiments, and there was no indecent depiction of Hindu Gods in the said cartoon. Besides, the cartoon was shared widely among practising Hindus, which is ample evidence that the cartoon had not hurt their sentiments.

I was merely exercising my Freedom of Expression as granted by the Indian Constitution, and there was no intention whatsoever on my behalf to hurt anybody's religious sentiments, and there was no indecent depiction of Hindu Gods in the said cartoon. Besides, the cartoon was shared widely among practising Hindus, which is ample evidence that the cartoon had not hurt their sentiments.

Hence, it is my earnest request to your esteemed self to dismiss the complaint and close the case.

Thanking you,

*Swathi Vadlamudi*
Swathi Vadlamudi

273

ASIDE FROM THE LEGAL THREAT, THERE WAS THE OMNIPRESENT DANGER OF VIGILANTE VIOLENCE.

ONLINE THREATS WARNED THAT SHE WOULD SHARE THE FATE OF *CHARLIE HEBDO*, WHOSE CARTOONISTS WERE MURDERED IN PARIS IN 2015, AND GAURI LANKESH, THE INDIAN JOURNALIST AND ACTIVIST WHO WAS ASSASSINATED THE YEAR BEFORE.

THOSE SORTS OF THREATS MADE ME SCARED, NOT FOR MYSELF BUT FOR MY FAMILY.

I COULD NOT SLEEP IN THE NIGHT, FEARING SOMEBODY MIGHT BARGE IN.

UNLESS YOU EXPERIENCE IT FIRST HAND, YOU WILL NEVER KNOW THE KIND OF STRESS IT CAN PUT YOU UNDER.

PUBLICLY, VADLAMUDI TRIED TO SHOW A BRAVE FACE, AIDED BY SUPPORT SHE RECEIVED FROM WITHIN INDIA AND OVERSEAS.

BUT SHE ACKNOWLEDGES THAT THE ATTACKS HAVE TAKEN A TOLL.

IN SPITE OF ALL THE POSTURING, THAT I WILL KEEP DRAWING, THAT THESE RIGHT-WING ELEMENTS CANNOT DETER ME, I HAVE NOTICED THAT I AM THINKING TWICE BEFORE POSTING.

I'M THINKING, WILL SOMETHING HURT THESE NUTCASES' SENTIMENTS.

IF I KEEP DOING SUCH THINGS, EVEN THE SUPPORT I GOT MIGHT DISAPPEAR. I CANNOT BANK ON SUCH SUPPORT IN FUTURE.

SOON AFTER THE RAM CARTOON CONTROVERSY, VADLAMUDI DREW ONE COMMENTING ON A B.J.P. CHIEF MINISTER'S BIZARRE CLAIM THAT DIANA HAYDEN DIDN'T DESERVE THE MISS WORLD TITLE SHE WON FOR INDIA IN 1999, UNLIKE AISHWARYA RAI, THE 1994 WINNER.

**SILVERSCREEN INDIA**
INDIA'S PREMIER CINEMA MAGAZINE

SUBSCRIBE

FEATURES   PHOTOS   VIDEOS

HINDI

## Diana Hayden Not 'Indian' Enough To Win Miss World Crown: Tripura Chief Minister Biplab Deb

BY SILVERSCREEN ON **APRIL 27, 2018**

TWITTER   FACEBOOK   REDDIT   GOOGLE+   EMAIL

I AM NOT CRITICISING HER BUT DID NOT FIND TRAITS OF INDIAN BEAUTY IN HER.

Biplab Deb

HAYDEN HAPPENS TO HAVE A DARKER COMPLEXION THAN RAI. ACCORDING TO THE MINISTER, RAI RESEMBLES THE HINDU GODDESSES LAKSHMI AND SARASWATI.

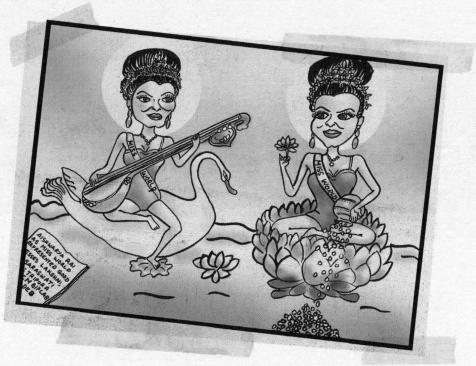

*Above*
**Aishwarya Rai as the goddesses Lakshmi and Saraswati.**
Swathi Vadlamudi,
2018.

I JUST SHARED IT PRIVATELY AMONG FRIENDS IN MY WHATSAPP GROUP ...

... HOPING SOMEBODY ELSE WOULD POST IT PUBLICLY.

I DIDN'T HAVE THE GUTS TO POST IT MYSELF.

# 11. The Trap
# of Accidental
# Associations

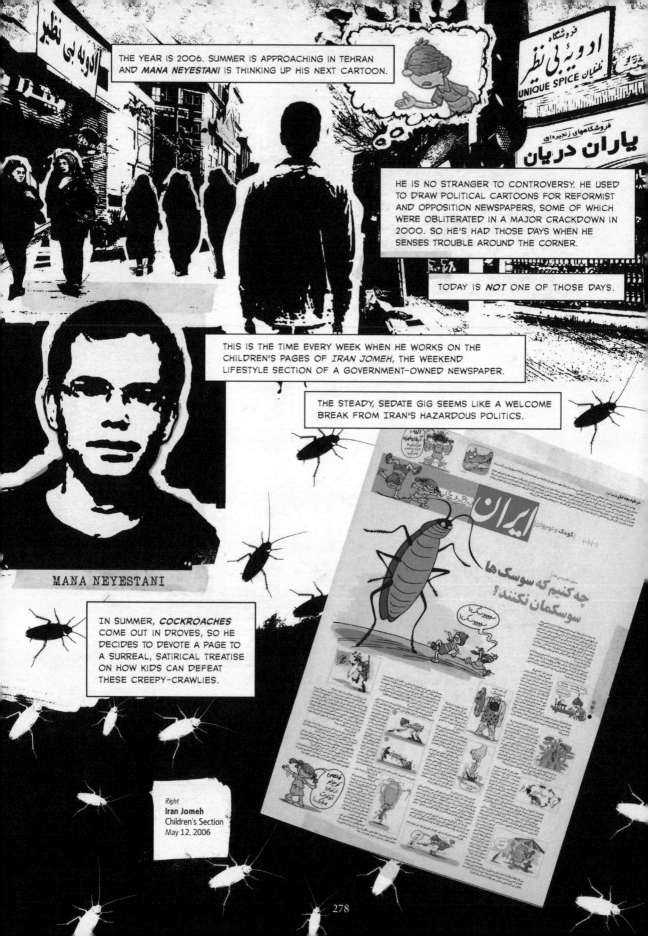

THE YEAR IS 2006. SUMMER IS APPROACHING IN TEHRAN AND *MANA NEYESTANI* IS THINKING UP HIS NEXT CARTOON.

HE IS NO STRANGER TO CONTROVERSY. HE USED TO DRAW POLITICAL CARTOONS FOR REFORMIST AND OPPOSITION NEWSPAPERS, SOME OF WHICH WERE OBLITERATED IN A MAJOR CRACKDOWN IN 2000. SO HE'S HAD THOSE DAYS WHEN HE SENSES TROUBLE AROUND THE CORNER.

TODAY IS *NOT* ONE OF THOSE DAYS.

THIS IS THE TIME EVERY WEEK WHEN HE WORKS ON THE CHILDREN'S PAGES OF *IRAN JOMEH*, THE WEEKEND LIFESTYLE SECTION OF A GOVERNMENT-OWNED NEWSPAPER.

THE STEADY, SEDATE GIG SEEMS LIKE A WELCOME BREAK FROM IRAN'S HAZARDOUS POLITICS.

MANA NEYESTANI

IN SUMMER, *COCKROACHES* COME OUT IN DROVES, SO HE DECIDES TO DEVOTE A PAGE TO A SURREAL, SATIRICAL TREATISE ON HOW KIDS CAN DEFEAT THESE CREEPY-CRAWLIES.

*Right*
**Iran Jomeh**
Children's Section
May 12, 2006

278

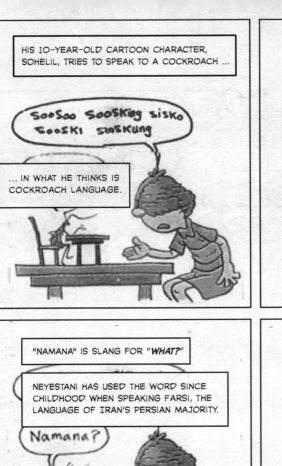

HIS 10-YEAR-OLD CARTOON CHARACTER, SOHELIL, TRIES TO SPEAK TO A COCKROACH ...

SooSoo SooSKing sisko SooSKI staSKung

... IN WHAT HE THINKS IS COCKROACH LANGUAGE.

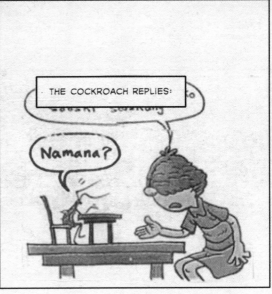

THE COCKROACH REPLIES:

Namana?

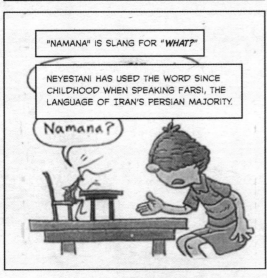

"NAMANA" IS SLANG FOR "*WHAT?*"

NEYESTANI HAS USED THE WORD SINCE CHILDHOOD WHEN SPEAKING FARSI, THE LANGUAGE OF IRAN'S PERSIAN MAJORITY.

Namana?

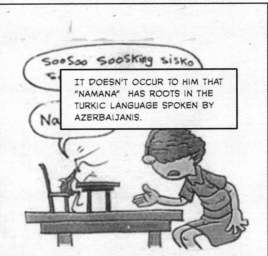

SooSoo SooSKing sisko

IT DOESN'T OCCUR TO HIM THAT "NAMANA" HAS ROOTS IN THE TURKIC LANGUAGE SPOKEN BY AZERBAIJANIS.

Na

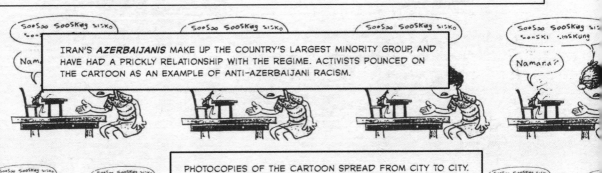

IRAN'S *AZERBAIJANIS* MAKE UP THE COUNTRY'S LARGEST MINORITY GROUP, AND HAVE HAD A PRICKLY RELATIONSHIP WITH THE REGIME. ACTIVISTS POUNCED ON THE CARTOON AS AN EXAMPLE OF ANTI-AZERBAIJANI RACISM.

PHOTOCOPIES OF THE CARTOON SPREAD FROM CITY TO CITY.

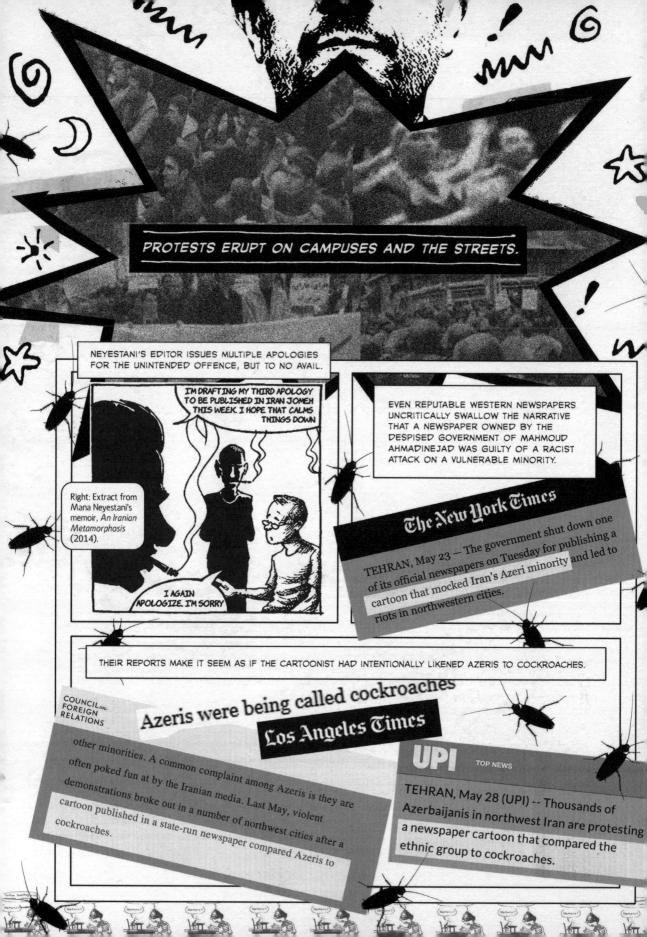

**PROTESTS ERUPT ON CAMPUSES AND THE STREETS.**

NEYESTANI'S EDITOR ISSUES MULTIPLE APOLOGIES FOR THE UNINTENDED OFFENCE, BUT TO NO AVAIL.

I'M DRAFTING MY THIRD APOLOGY TO BE PUBLISHED IN IRAN JOMEH THIS WEEK. I HOPE THAT CALMS THINGS DOWN

Right: Extract from Mana Neyestani's memoir, *An Iranian Metamorphosis* (2014).

I AGAIN APOLOGIZE. I'M SORRY

EVEN REPUTABLE WESTERN NEWSPAPERS UNCRITICALLY SWALLOW THE NARRATIVE THAT A NEWSPAPER OWNED BY THE DESPISED GOVERNMENT OF MAHMOUD AHMADINEJAD WAS GUILTY OF A RACIST ATTACK ON A VULNERABLE MINORITY.

**The New York Times**

TEHRAN, May 23 — The government shut down one of its official newspapers on Tuesday for publishing a cartoon that mocked Iran's Azeri minority and led to riots in northwestern cities.

THEIR REPORTS MAKE IT SEEM AS IF THE CARTOONIST HAD INTENTIONALLY LIKENED AZERIS TO COCKROACHES.

COUNCIL on FOREIGN RELATIONS

**Azeris were being called cockroaches**

**Los Angeles Times**

other minorities. A common complaint among Azeris is they are often poked fun at by the Iranian media. Last May, violent demonstrations broke out in a number of northwest cities after a cartoon published in a state-run newspaper compared Azeris to cockroaches.

**UPI** TOP NEWS

TEHRAN, May 28 (UPI) -- Thousands of Azerbaijanis in northwest Iran are protesting a newspaper cartoon that compared the ethnic group to cockroaches.

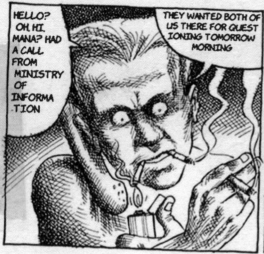

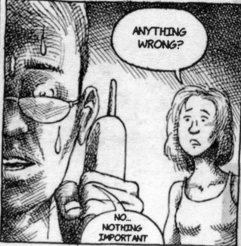

Above
Extracts from
*Iranian Metamorphosis*,
Mana Neyestani.

LIFE WOULD NEVER BE THE SAME AGAIN.

IN RESPONSE TO THE PROTESTS, THE IRANIAN GOVERNMENT IMPRISONED NEYESTANI'S EDITOR-IN-CHIEF, MEHRDAD GHASEMFAR, ALONG WITH THE CARTOONIST.

THEIR NEWSPAPER, *IRAN*, WAS CLOSED DOWN BY THE PRESS REGULATOR. NEYESTANI SPENT AROUND THREE MONTHS IN JAIL.

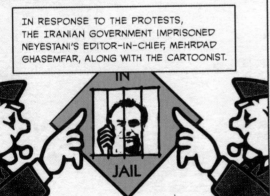

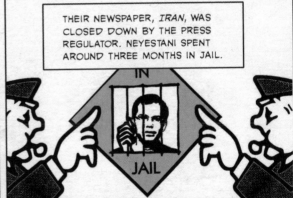

ON A TEN-DAY TEMPORARY RELEASE, HE AND HIS WIFE GOT PERMISSION FOR A VACATION IN DUBAI. FROM THERE, THEY FLED IRAN FOR GOOD.

IN 2011, HE FOUND REFUGE IN FRANCE, WHERE HE NOW LIVES AND WORKS.

EIGHT YEARS AFTER MANA NEYESTANI WAS FORCED TO LEAVE HOME, ANOTHER POLITICAL CARTOONIST ON THE OTHER SIDE OF THE ATLANTIC FLEES HIS COUNTRY, VENEZUELA, IN ODDLY SIMILAR CIRCUMSTANCES.

*ROBERTO WEIL* RETRIEVES HIS PASSPORT AND STASH OF US DOLLARS FROM HIS SAFE.

HE PACKS HIS LAPTOP COMPUTER AND HIS FAVORITE SET OF WATERCOLORS.

HE HEADS TO A PROVINCIAL AIRPORT AND BOARDS A FLIGHT TO CURACAO, AND FROM THERE, TO MIAMI, FLORIDA, WHERE HE NOW LIVES.

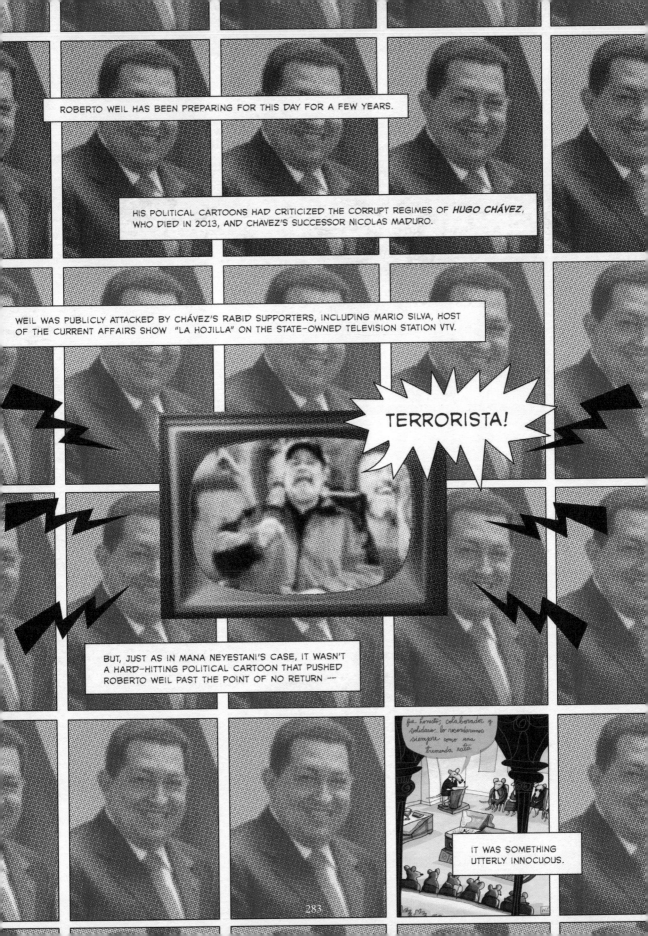

ROBERTO WEIL HAS BEEN PREPARING FOR THIS DAY FOR A FEW YEARS.

HIS POLITICAL CARTOONS HAD CRITICIZED THE CORRUPT REGIMES OF *HUGO CHÁVEZ*, WHO DIED IN 2013, AND CHAVEZ'S SUCCESSOR NICOLAS MADURO.

WEIL WAS PUBLICLY ATTACKED BY CHÁVEZ'S RABID SUPPORTERS, INCLUDING MARIO SILVA, HOST OF THE CURRENT AFFAIRS SHOW "LA HOJILLA" ON THE STATE-OWNED TELEVISION STATION VTV.

TERRORISTA!

BUT, JUST AS IN MANA NEYESTANI'S CASE, IT WASN'T A HARD-HITTING POLITICAL CARTOON THAT PUSHED ROBERTO WEIL PAST THE POINT OF NO RETURN --

IT WAS SOMETHING UTTERLY INNOCUOUS.

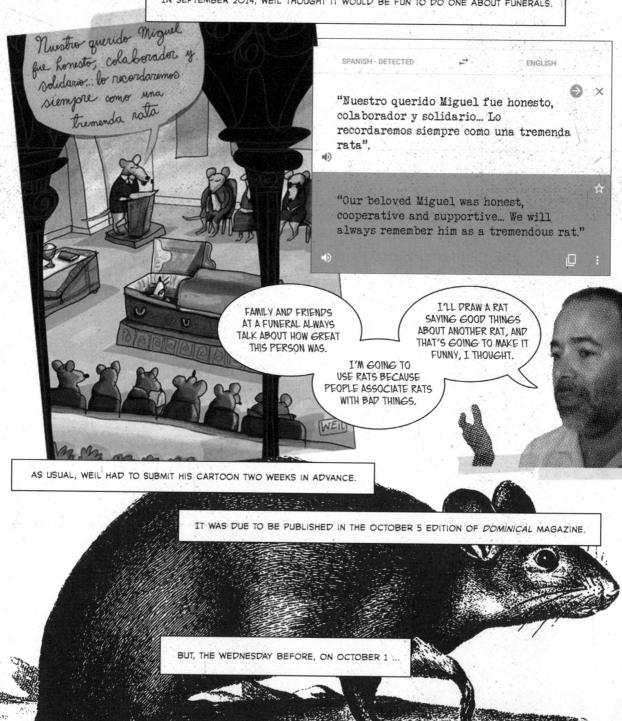

Once A WEEK, WEIL TOOK A BREAK FROM POLITICS. HE HAD A REGULAR SPACE IN THE SUNDAY MAGAZINE OF A GOVERNMENT-OWNED MEDIA COMPANY. HIS SUNDAY CARTOONS MADE LIGHT OBSERVATIONS ABOUT EVERYDAY LIFE, INSPIRED BY PETER ARNO OF THE *NEW YORKER* AND GARY LARSON'S "THE FAR SIDE." HE HAD BEEN DOING THIS FOR SIX YEARS.

IN SEPTEMBER 2014, WEIL THOUGHT IT WOULD BE FUN TO DO ONE ABOUT FUNERALS.

SPANISH - DETECTED    ⇄    ENGLISH

"Nuestro querido Miguel fue honesto, colaborador y solidario... Lo recordaremos siempre como una tremenda rata".

"Our beloved Miguel was honest, cooperative and supportive... We will always remember him as a tremendous rat."

FAMILY AND FRIENDS AT A FUNERAL ALWAYS TALK ABOUT HOW GREAT THIS PERSON WAS.

I'LL DRAW A RAT SAYING GOOD THINGS ABOUT ANOTHER RAT, AND THAT'S GOING TO MAKE IT FUNNY, I THOUGHT.

I'M GOING TO USE RATS BECAUSE PEOPLE ASSOCIATE RATS WITH BAD THINGS.

AS USUAL, WEIL HAD TO SUBMIT HIS CARTOON TWO WEEKS IN ADVANCE.

IT WAS DUE TO BE PUBLISHED IN THE OCTOBER 5 EDITION OF *DOMINICAL* MAGAZINE.

BUT, THE WEDNESDAY BEFORE, ON OCTOBER 1 ...

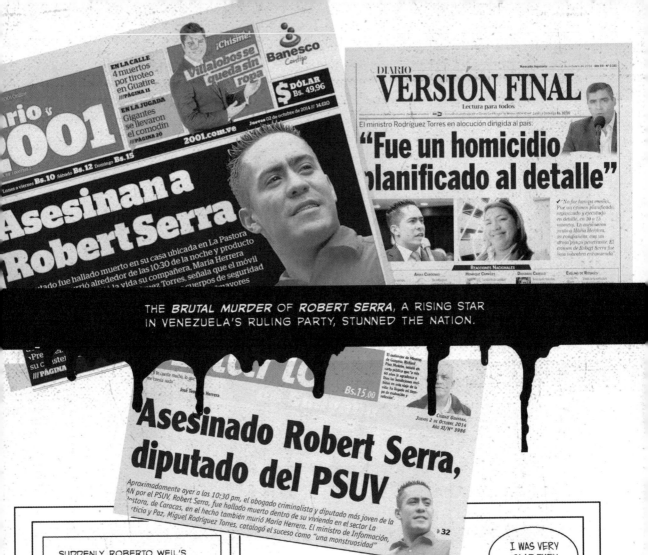

THE *BRUTAL MURDER* OF *ROBERT SERRA*, A RISING STAR
IN VENEZUELA'S RULING PARTY, STUNNED THE NATION.

## Asesinado Robert Serra, diputado del PSUV

Aproximadamente ayer a las 10:30 pm, el abogado criminalista y diputado más joven de la AN por el PSUV, Robert Serra, fue hallado muerto dentro de su vivienda en el sector La Pastora, de Caracas. En el hecho también murió María Herrera. El ministro de Información, ...sticia y Paz, Miguel Rodríguez Torres, catalogó el suceso como "una monstruosidad"

SUDDENLY, ROBERTO WEIL'S CARTOON WAS NOT SO FUNNY -- IT WAS THE WRONG TIME FOR MORBID HUMOR.

BUT, THE MAGAZINE HAD ALREADY BEEN PRINTED.

AS FOR THE CARACAS COPIES, THEY GOT WORKERS TO TEAR OUT THE PAGE WITH THE CARTOON FROM EVERY COPY BEFORE THEY REACHED READERS.

I WAS VERY GLAD THEY DID THAT.

THE SELF-CENSORSHIP DIDN'T WORK.

THE EDITORS MANAGED TO STOP THE DISTRIBUTION OF THE MAGAZINE OUTSIDE OF THE CAPITAL, CARACAS.

SOMEHOW, SOMEBODY, MAYBE WORKING IN THE PRINTING AREA, TOOK A PICTURE OF THE CARTOON AND PUT IT ON SOCIAL MEDIA.

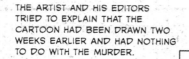

THE ARTIST AND HIS EDITORS TRIED TO EXPLAIN THAT THE CARTOON HAD BEEN DRAWN TWO WEEKS EARLIER AND HAD NOTHING TO DO WITH THE MURDER.

TO NO AVAIL.

THE ALLEGATIONS CAME FLYING FROM SENIOR FIGURES OF PRESIDENT MADURO'S GOVERNMENT.

It's worth investigating what "inspired" the creator to draw this.

roberto weil
@WEIL_caricatura

You are a miserable son of a bitch.

Trash is what you are. FASCIST.

This asshole makes fun of the pain of the Chavista population.

### Tareck El Aissami
Governor of Aragua and former Minister of Interior and Justice.

### Ernesto Villegas
Minister of Popular Power for Communication and Information

---

**Tareck El Aissami** @TareckPSUV
Eres un miserable hijo de puta "@WEIL_caricatura: no me hago eco de comentarios malintencionados sobre una tragedia
7:07 PM - 5 oct 2014
1.045   153

**Ernesto Villegas P.** @VillegasPoljakE
Conviene investigar còmo se coló el ejemplar fotografiado y qué "inspiró" al autor para dibujar esto 15 días atrás
4:08 PM - 5 oct 2014
799   104

**Tareck El Aissami** @TareckPSUV
Basura es lo que eres. FASCISTA. Respeta al pueblo "@WEIL_caricatura: no me hago eco de comentarios malintencionados sobre una tragedia.
7:08 PM - 5 oct 2014
264   25

**Tareck El Aissami** @TareckPSUV
Ahora resulta que este miserable de @WEIL_caricatura se burla del dolor del pueblo chavista y nosotros somos los "groseros".
7:26 PM - 5 oct 2014
358   51

---

TEN DAYS LATER, THE PRESIDENT HIMSELF APPEARED IN A NEWS CONFERENCE TELEVISED ON ALL CHANNELS TO TALK ABOUT ROBERT SERRA'S ASSASSINATION.

MADURO INTRODUCED A VIDEO WARNING THE NATION ABOUT RIGHT-WING TRAITORS IN THEIR MIDST.

ROBERTO WEIL AND HIS PRESCIENT CARTOON FLASH ON THE SCREEN.

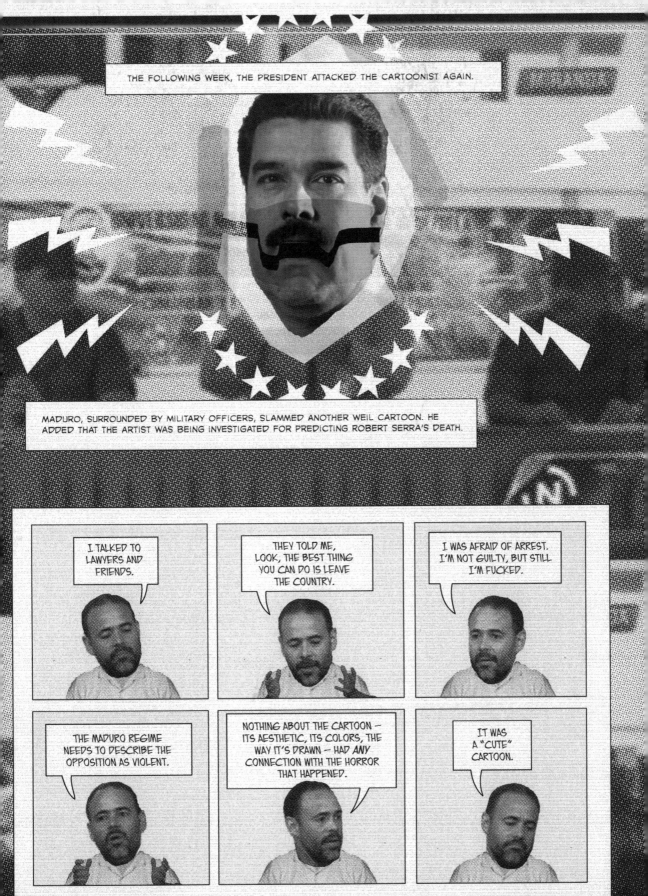

THE FOLLOWING WEEK, THE PRESIDENT ATTACKED THE CARTOONIST AGAIN.

MADURO, SURROUNDED BY MILITARY OFFICERS, SLAMMED ANOTHER WEIL CARTOON. HE ADDED THAT THE ARTIST WAS BEING INVESTIGATED FOR PREDICTING ROBERT SERRA'S DEATH.

I TALKED TO LAWYERS AND FRIENDS.

THEY TOLD ME, LOOK, THE BEST THING YOU CAN DO IS LEAVE THE COUNTRY.

I WAS AFRAID OF ARREST. I'M NOT GUILTY, BUT STILL I'M FUCKED.

THE MADURO REGIME NEEDS TO DESCRIBE THE OPPOSITION AS VIOLENT.

NOTHING ABOUT THE CARTOON — ITS AESTHETIC, ITS COLORS, THE WAY IT'S DRAWN — HAD ANY CONNECTION WITH THE HORROR THAT HAPPENED.

IT WAS A "CUTE" CARTOON.

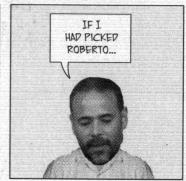

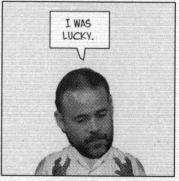

# HIJACKED!

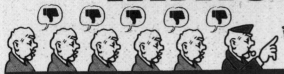

## WHEN READERS GO ROGUE

MANA NEYESTANI AND ROBERTO WEIL WERE VICTIMS OF THE VERY POWER THAT CARTOONISTS WIELD -- THE POWER TO PLANT MEANINGS IN THE VIEWER'S MIND THAT ARE NOT EXPLICITLY WRITTEN OR DRAWN.

THE HUMAN BRAIN IS UNIQUELY CAPABLE OF *METAPHORICAL THINKING.*

IT CAN TAKE TWO SEEMINGLY UNRELATED CONCEPTS AND BLEND THEM *TO CREATE MEANING.*

**Penetrating metaphor**: US Republicans' true attitude to bipartisanship.

By Paul Conrad, 1999.

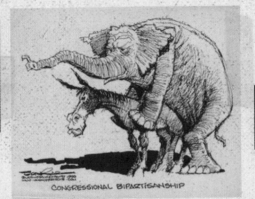

CONGRESSIONAL BIPARTISANSHIP

CARTOONISTS' METAPHORS STIMULATE OUR BRAINS, TURNING US INTO *PARTNERS* IN MEANING-MAKING.

*PAUL CONRAD*'S CARTOON FOR THE *LOS ANGELES TIMES* MADE USE OF THE WELL-KNOWN ANIMAL MASCOTS OF THE REPUBLICAN AND DEMOCRATIC PARTIES. THE REPUBLICANS HAD BEEN PONTIFICATING ABOUT BIPARTISAN COOPERATION EVEN AS THEY MOVED TO IMPEACH PRESIDENT BILL CLINTON. "THE POOR DONKEY DOESN'T KNOW WHAT HIT HIM," CONRAD SAID. HIS EDITORS DECIDED IT WAS TOO RISQUÉ FOR A FAMILY NEWSPAPER AND KILLED IT. .

METAPHORS CAN TAKE *A LIFE OF THEIR OWN.*
ARTISTS CAN'T DICTATE HOW THEIR CARTOONS ARE INTERPRETED.

SOMETIMES, READERS' DRAW MEANINGS NEVER INTENDED BY THE ARTIST. WHEN *ROD EMMERSON* THOUGHT UP AN ELECTION CARTOON SHOWING A THREE-LEGGED DOG (BELOW), HE WAS MERELY VISUALISING THE LOCAL QUIP IN A SAFE LABOR SEAT THAT "A THREE-LEGGED DOG COULD WIN IF ITS NAME WAS LABOR."

EMMERSON DIDN'T KNOW THE LABOR CANDIDATE HAD ONLY ONE LEG. UNDERSTANDABLY, THE POLITICIAN'S FAMILY MEMBERS WERE UPSET AND SHOWED UP AT THE EDITOR'S OFFICE TO COMPLAIN..

THE NEW MEMBER FOR ROCKHAMPTON

LABOR

I LEARNED FROM THIS TO RESEARCH MY CARTOONS.

**Foot in mouth**:: The day when this cartoon appeared, very early in Rod Emmerson's career, he was horrified to learn that the candidate had one leg.

INDIAN CARTOONIST **ASEEM TRIVEDI** GOT CAUGHT IN THIS TRAP WHEN HE DREW A SERIES OF ANTI-CORRUPTION CARTOONS IN 2011. THE CARTOONS WERE ATTACKED BY SOME LEADERS OF THE MARGINALIZED DALIT COMMUNITY—IRONICALLY, AMONG THE GREATEST VICTIMS OF INDIA'S ENDEMIC CORRUPTION.

**Losing control:**
Aseem Trivedi took aim at corrupt politicians, including by comparing parliament to a toilet.

But Dalit activists decided Trivedi was attacking the Constitution ...

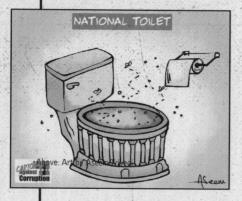

Above: Art by Aseem Trivedi

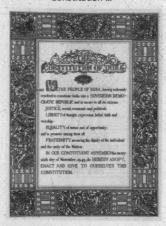

... thus insulting the father of the Constitution, B. R. Ambedkar ...

... and the Dalit community that Ambedkar championed.

Dalit leaders lodged police reports. Trivedi was charged with sedition and other offences. Strong support from civil society helped keep him out of prison.

SEDITION CHARGES STILL HANG OVER THE CARTOONIST. HE IS ONE OF INDIA'S MANY VICTIMS OF OFFENSE-TAKING, A POTENT WEAPON IN IDENTITY POLITICS.

IT'S AN EASY WAY TO GET POWER. JUST TAKE A STAND AGAINST ANYTHING AND START PROTESTING.

MORAL INDIGNATION IS A POWERFUL RESOURCE FOR PROTEST MOVEMENTS. ACTIVISTS CAN WHIP INDIGNATION INTO OUTRAGE, MOBILIZING FOLLOWERS TO ENGAGE IN COLLECTIVE ACTION.

INJUSTICE SYMBOLS ARE PARTICULARLY USEFUL FOR THIS PURPOSE. THESE COULD BE FACTUAL, HISTORIC EVENTS FOREVER ETCHED INTO THE COMMUNITY'S COLLECTIVE MEMORY, LIKE THE SHOA FOR JEWS AND NAKBA FOR PALESTINIANS.

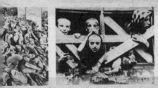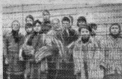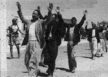

BUT INJUSTICE SYMBOLS ARE IN SUCH GREAT DEMAND THAT MOVEMENT LEADERS DON'T CONFINE THEMSELVES TO FACTS.

AN AMBIGUOUS CARTOON WILL DO FINE.

INSULT CAN BE INTENTIONAL--LIKE CONRAD'S PREDATORY ELEPHANT. BUT OFFENSE IS ASYMMETRIC: IT CAN BE TAKEN EVEN WHEN NONE IS GIVEN. NO MATTER HOW CAREFULLY CARTOONISTS TRY TO NAVIGATE THEIR SOCIETIES' SENSITIVITIES, THEIR SYMBOLS AND METAPHORS CAN BE TAKEN THE WRONG WAY.

IT'S PRACTICALLY IMPOSSIBLE TO PREDICT WHO'S GOING TO TAKE OFFENSE TO WHAT.

JUST ASK ASEEM TRIVEDI, ROBERTO WEIL, AND MANA NEYESTANI.

IN 2012, NEYESTANI RELEASED HIS GRAPHIC MEMOIR, AN IRANIAN METAMORPHOSIS. IT IS ABOUT HIS OWN METAMORPHOSIS, SAYS LITERARY SCHOLAR AMIR KHADEM: HIS PAINFUL REALISATION THAT IT'S IMPOSSIBLE TO EVADE POLITICS THROUGH INNOCUOUS WORDS AND IMAGES--"WHEN THE INTERPRETIVE ARBITRATION IS OUT OF THE CARTOONIST'S OWN HANDS."

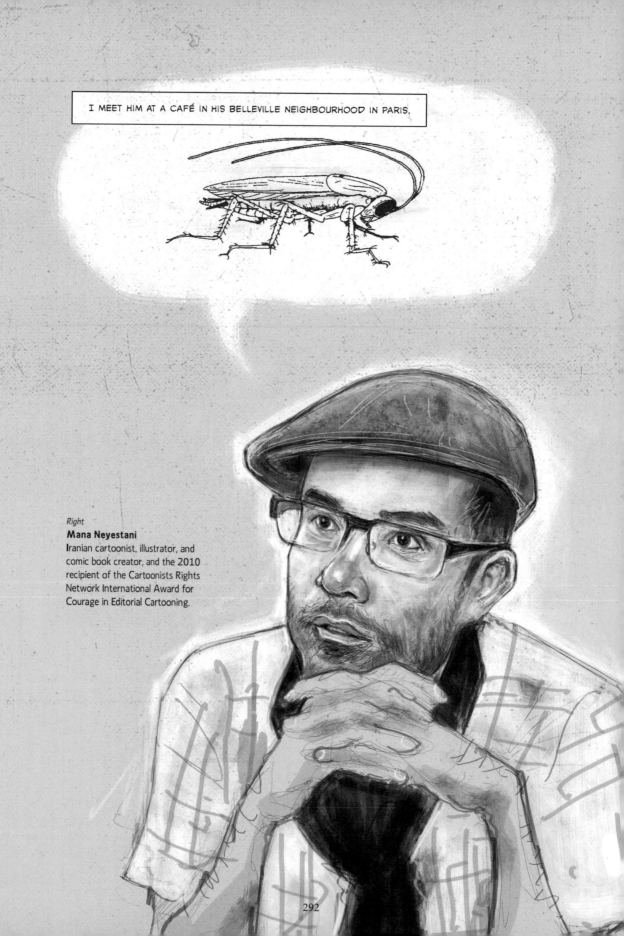

I MEET HIM AT A CAFÉ IN HIS BELLEVILLE NEIGHBOURHOOD IN PARIS.

*Right*
**Mana Neyestani**
Iranian cartoonist, illustrator, and
comic book creator, and the 2010
recipient of the Cartoonists Rights
Network International Award for
Courage in Editorial Cartooning.

292

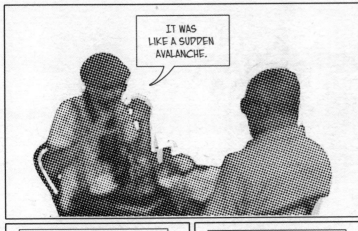

IT WAS LIKE A SUDDEN AVALANCHE.

WE APOLOGISED TWO OR THREE TIMES, OFFICIALLY, IN THE NEWSPAPER.

SOME JOURNALISTS AND CARTOONISTS SIGNED A PETITION TO SUPPORT ME.

THEY SAID I WAS A WELL-KNOWN CARTOONIST WITH A GOOD NAME...

...I'D NEVER BEEN RACIST; IT WAS A MISINTERPRETATION. SO I HAD SOME SUPPORT LIKE THAT, BUT CAUTIOUSLY BECAUSE THEY DIDN'T WANT TO PROVOKE THE AZERIS.

Namana? Namana? Namana

BUT, YOU KNOW, I THINK IT WAS A PRETEXT, AN EXCUSE FOR THE DEMONSTRATORS WHO WANTED TO PROTEST AGAINST THEIR SUPPRESSED RIGHTS.

THEY LOOKED AT ME LIKE THE MONSTER AT THE END OF A LEVEL OF A GAME.

PROBABLY, THEY CANNOT WIN THE GAME AGAINST THE AUTHORITIES. THEY NEED SOMETHING WEAKER TO ATTACK, TO CONQUER.

SO MANY GROUPS TRIED TO TAKE ADVANTAGE OF THE SITUATION.

ONE OF THE PROBLEMS WAS THAT THE OWNER OF THE MAGAZINE WAS THE AHMADINEJAD GOVERNMENT...

...SO EVEN SOME LIBERAL AND DEMOCRATIC ACTIVISTS, THEY TRIED TO USE THE SITUATION TO ATTACK THE GOVERNMENT, WITHOUT CONSIDERING THE REAL STORY.

THE GOVERNMENT NEEDED A SCAPEGOAT, AND THE EASIEST SCAPEGOATS WERE JOURNALISTS AND CARTOONISTS.

LOOKING BACK, IS THERE ANYTHING YOU COULD HAVE DONE TO MAKE THINGS DIFFERENT?

IT'S SO HARD TO SAY.

IT'S LIKE, OK, THIS MORNING YOU TOOK 139 STEPS TO COME HERE.

WHAT IF YOU DIDN'T TAKE THE 14TH STEP? IT WAS JUST A SIMPLE STEP FOR YOU.

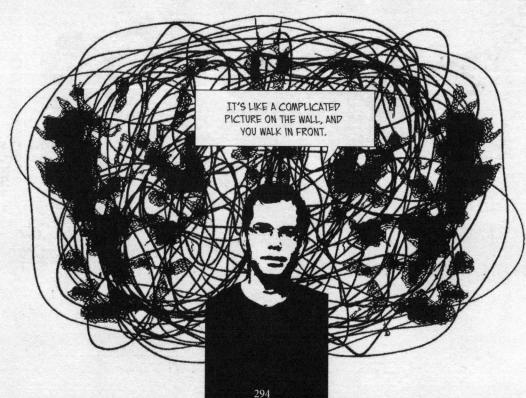

IT'S LIKE A COMPLICATED PICTURE ON THE WALL, AND YOU WALK IN FRONT.

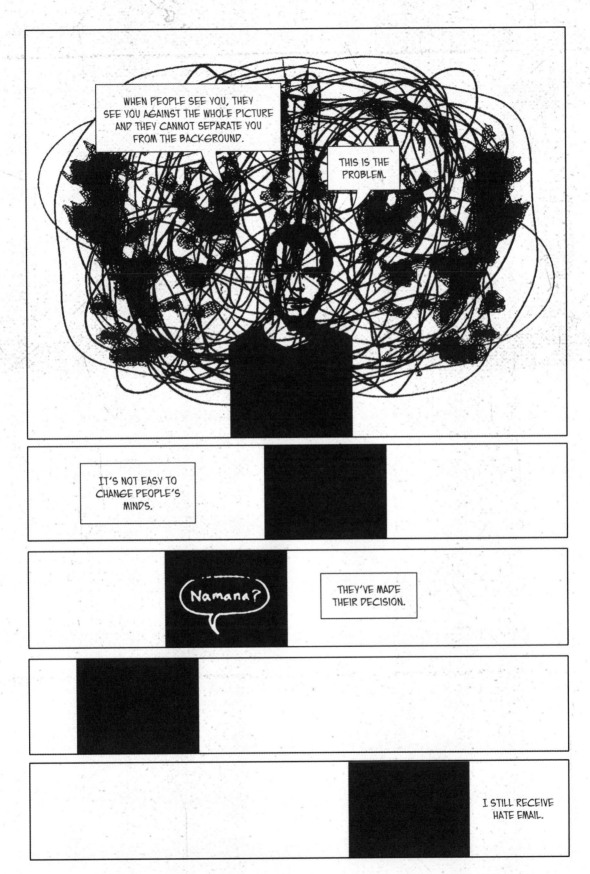

# 12. Hate Speech, Taking Offense, and the "Good Censor"

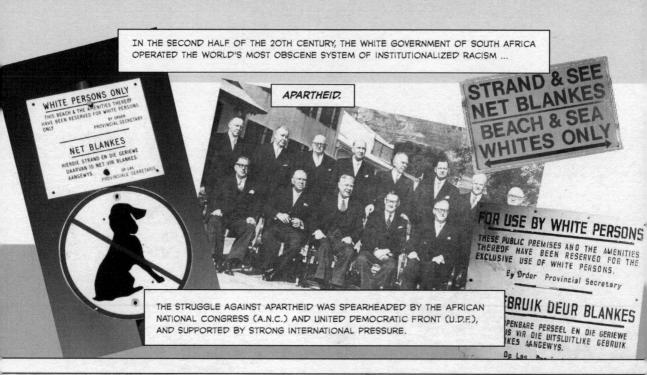

IN THE SECOND HALF OF THE 20TH CENTURY, THE WHITE GOVERNMENT OF SOUTH AFRICA OPERATED THE WORLD'S MOST OBSCENE SYSTEM OF INSTITUTIONALIZED RACISM ...

APARTHEID.

THE STRUGGLE AGAINST APARTHEID WAS SPEARHEADED BY THE AFRICAN NATIONAL CONGRESS (A.N.C.) AND UNITED DEMOCRATIC FRONT (U.D.F.), AND SUPPORTED BY STRONG INTERNATIONAL PRESSURE.

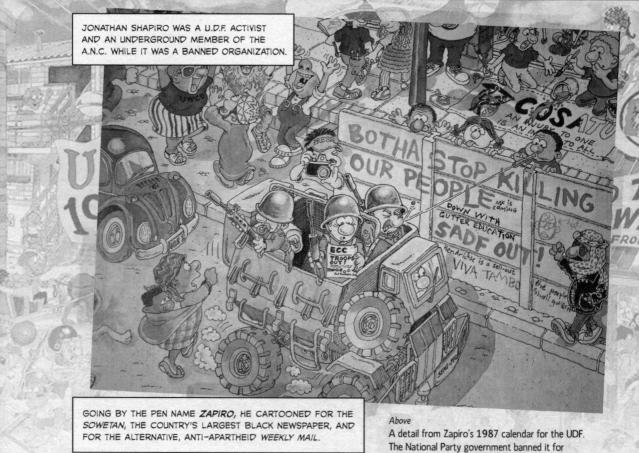

JONATHAN SHAPIRO WAS A U.D.F. ACTIVIST AND AN UNDERGROUND MEMBER OF THE A.N.C. WHILE IT WAS A BANNED ORGANIZATION.

GOING BY THE PEN NAME *ZAPIRO*, HE CARTOONED FOR THE *SOWETAN*, THE COUNTRY'S LARGEST BLACK NEWSPAPER, AND FOR THE ALTERNATIVE, ANTI-APARTHEID *WEEKLY MAIL*.

*Above*
A detail from Zapiro's 1987 calendar for the UDF. The National Party government banned it for "furthering the aims of a banned organisation." It contained slogans in support of ANC leaders.

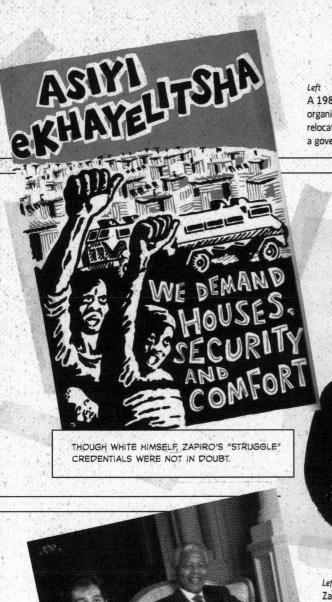

ASIYI eKHAYELITSHA

WE DEMAND HOUSES, SECURITY AND COMFORT

*Left*
A 1983 poster by Zapiro, supporting a women's organization's campaign against the forced relocation of black residents near Cape Town to a government-controlled township.

*Below*
Caricature of President P.W. Botha, Zapiro, 1985.

"We will talk talk to anyone who is prepared to forswear violence."

ZAPIRO 85

THOUGH WHITE HIMSELF, ZAPIRO'S "STRUGGLE" CREDENTIALS WERE NOT IN DOUBT.

*Left*
Zapiro was invited to meet Nelson Mandela at his official residence, three months after Mandela's 1994 inauguration as the first President of the new, democratic South Africa.

IN 2008, THE NELSON MANDELA FOUNDATION EVEN INVITED ZAPIRO TO PRODUCE AN EXHIBITION OF HIS CARTOONS AS PART OF MANDELA'S 90TH BIRTHDAY CELEBRATIONS.

BUT, HIS PROGRESSIVE RESUMÉ DIDN'T PROTECT ZAPIRO FROM ATTACKS BY SOME SEGMENTS OF BLACK SOUTH AFRICAN SOCIETY.

ZAPIRO'S CARTOONS ARE NOW BEING USED BY RACISTS IN OUR COUNTRY TO GLAMORIZE THEIR PREJUDICE.

ANC spokesman Zizi Kodwa, 2016

ZAPIRO IS RACIST MISOGYNIST AND WE'VE TOLERATED HIS PREJUDICIAL CONTENT MASKED AS 'SATIRE' FOR TOO LONG. #ENOUGHISENOUGH.

Dineo Lola Monareng, fashion and lifestyle writer, 2017

ZAPIRO'S STORY ENCAPSULATES THE EXPERIENCE OF MOST LIBERAL DEMOCRACIES.

ONCE UPON A TIME, CARTOONISTS FEARED RULERS ACCUSING THEM OF SEDITION.

NOW, THEY DREAD CITIZENS CRYING RACISM; OR ANTISEMITISM; OR BLASPHEMY.

CROSSING THESE RED LINES COULD TRIGGER DISMISSALS, VIOLENT REPRISAL, REPUTATIONAL RUIN, AND COSTLY ADVERTISER AND CUSTOMER BOYCOTTS OF MEDIA ORGANIZATIONS.

IN THE WORLD'S MOST OPEN DEMOCRACIES, INSULT AGAINST *IDENTITY* HAS GRADUALLY REPLACED INSOLENCE AGAINST AUTHORITY AS THE GREATEST TABOO.

ZAPIRO EXPERIENCED THIS SHIFT HAPPENING IN THE COURSE OF HIS CAREER.

MANDELA'S SUCCESSORS, THABO MBEKI AND JACOB ZUMA, PRESIDED OVER RISING CORRUPTION AND STATE CAPTURE BY BUSINESS INTERESTS.

MBEKI AND ZUMA WERE ALSO RECKLESSLY NEGLIGENT IN THEIR RESPONSE TO THE AIDS CRISIS.

ON TRIAL FOR RAPE, ZUMA FAMOUSLY TESTIFIED THAT, AFTER HE HAD SEX WITH A WOMAN HE KNEW HAD AIDS, HE PROTECTED HIMSELF FROM THE DISEASE BY HAVING A SHOWER.

AIDS MESSAGE

Published in the *Sunday Times*, 6 September 2005

HENCEFORTH, ZAPIRO DREW ZUMA WITH A SHOWER ATTACHED TO HIS SKULL.

SOUTH AFRICA'S LIBERAL 1996 CONSTITUTION MEANT THE ANC GOVERNMENT COULD NOT BAN MEDIA OR DETAIN JOURNALISTS THE WAY THE WHITE NATIONAL PARTY HAD.

# The Constitution
## of the Republic of South Africa, 1996

ZUMA DID LAUNCH DEFAMATION SUITS AGAINST THREE ZAPIRO CARTOONS, BUT EVENTUALLY DROPPED THEM.

THE POLITICIAN'S LAWYERS AND ADVISERS MAY HAVE PERSUADED HIM THAT THE SUITS WOULD IMPRESS NEITHER THE COUNTRY'S INDEPENDENT COURTS NOR PUBLIC OPINION.

WHAT WAS PSYCHOLOGICALLY HARDER FOR ZAPIRO TO DEAL WITH WAS THE BACKLASH FROM THE VERY PUBLIC THAT HE HAD FOUGHT ALONGSIDE IN THE STRUGGLE.

SOME A.N.C. SUPPORTERS BEGAN TO TAKE CRITICISM OF THE GOVERNMENT PERSONALLY, AS AN ASSAULT ON THEIR IDENTITY.

I'D ALWAYS BEEN SEEN AS A SUPPORTER OF THE STRUGGLE, AN ANTI-RACIST CARTOONIST, A PROGRESSIVE.

BUT THEY SUDDENLY SAW PEOPLE LIKE ME AS MORE THAN JUST CRITICS; WE BECAME THE ENEMY.

Zapiro

SOME FELT ZAPIRO CROSSED A LINE IN 2008, WHEN HE DREW WHAT'S BEEN DUBBED THE MOST CONTROVERSIAL CARTOON IN THE HISTORY OF SOUTH AFRICA.

Published in the *Sunday Times*, 7 September 2008

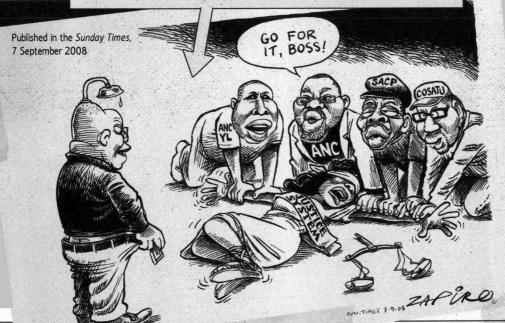

GO FOR IT, BOSS!

ZUMA AND HIS SUPPORTERS HAD BEEN TRYING TO SUPPRESS CORRUPTION CHARGES AGAINST HIM.

WESTERN CULTURE HAS PERSONIFIED JUSTICE AS A WOMAN SINCE ANCIENT GREEK TIMES.

## We're prepared to kill for Zuma: Vavi

🕐 Jun 21, 2008

Cosatu secretary general Zwelinzima Vavi on Saturday echoed the "kill for Zuma" rem. made by ANC Youth League leader Julius Malema, SABC news reported.

"So yes, because Jacob Zuma is one of us, and he is one of our leaders, for him, we are prepared to lay our lives (sic) and to shoot and kill," he said to applause and cheering.

He was speaking at the funeral of the Police and Prisons Ci~
~resident and ANC veteran Pretty Shu~
~nd in defer
~ prepared

SOME ALLIES EVEN SAID THEY WOULD KILL FOR HIM.

~y our own lives (sic) for one another so dearly and so truly, we
one another," he added.

BY SHOWING HER ABOUT TO BE RAPED, ZAPIRO SOUNDED THE ALARM: SOUTH AFRICA'S RULE OF LAW URGENTLY NEEDED PROTECTION FROM ZUMA AND HIS HENCHMEN.

CRITICS, HOWEVER, ARGUED THAT THE RAPE METAPHOR WAS INSENSITIVE, IN A COUNTRY WHERE A SHOCKING NUMBER OF WOMEN HAVE BEEN VICTIMS OF SEXUAL VIOLENCE.

301

ZAPIRO WAS ALSO ACCUSED OF RECYCLING STEREOTYPES ABOUT BLACK RAPISTS.

NATIONAL ASSEMBLY SPEAKER BALEKA MBETE CLAIMED, INEXPLICABLY, THAT THE LADY IN THE CARTOON WAS WHITE, AND THAT ZAPIRO WAS THUS IMPLYING THAT ZUMA WAS A BLACK LEADER WHO RAPES WHITE WOMEN.

DESPICABLE AND RACIST.

ANC Youth League President Julius Malema (one of the men in the cartoon)

ZAPIRO REFUSED TO APOLOGIZE, AND WOULD LATER REUSE THE RAPE METAPHOR.

I STAND BY THAT DRAWING.

THAT'S HOW THEY BEHAVED.

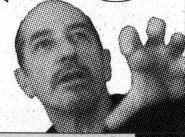

IN 2016, THOUGH, ZAPIRO FELT CHASTENED BY THE REACTION TO ANOTHER OF HIS CARTOONS ...

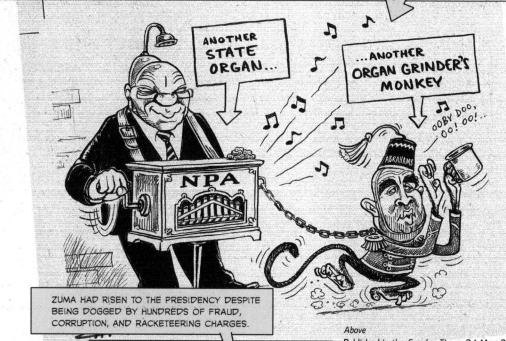

ANOTHER STATE ORGAN...

...ANOTHER ORGAN GRINDER'S MONKEY

OOBY DOO, OO! OO!..

NPA

ABRAHAMS

ZUMA HAD RISEN TO THE PRESIDENCY DESPITE BEING DOGGED BY HUNDREDS OF FRAUD, CORRUPTION, AND RACKETEERING CHARGES.

*Above*
Published in the *Sunday Times*, 24 May 2016

JUST WEEKS BEFORE THE 2009 PRESIDENTIAL ELECTION, THE NATIONAL PROSECUTING AUTHORITY (N.P.A.) CONVENIENTLY DROPPED THE CHARGES.

WHEN A HIGH COURT JUDGE RULED IN 2016 THAT ITS DECISION WAS "IRRATIONAL," N.P.A. BOSS SHAUN ABRAHAMS SAID IT WOULD APPEAL.

ZAPIRO'S CARTOON THE NEXT DAY STATED WHAT WAS CLEAR TO MOST OBSERVERS: THE N.P.A., A SUPPOSEDLY INDEPENDENT STATE ORGAN, WAS DANCING TO ONE POWERFUL POLITICIAN'S TUNE.

INSPIRED BY THE 19TH CENTURY STREET MUSICIANS WHO USED MONKEYS TRAINED TO COLLECT COINS FROM BYSTANDERS, THE "ORGAN-GRINDER'S MONKEY" IS AN OLD METAPHOR FOR SOMEONE WHO ACTS FOR A POWERFUL PERSON BUT HAS NO REAL POWER HIMSELF.

THE METAPHOR HAS BEEN USED BY POLITICAL CARTOONISTS SINCE THE 1870S AT LEAST.

*Left*
Thomas Nast's woodblock print depicts Presidential candidate Horace Greeley as a monkey controlled by Whitelaw Reid and the Liberal Republican movement. It was published in *Harper's Weekly* in 1872.

THE PROBLEM, OF COURSE, WAS THAT THERE IS AN EQUALLY OLD RACIST TRADITION OF DEPICTING NON-WHITES AS MONKEYS.

AND SHAUN ABRAHAMS WAS COLORED.

RACIST TROPES ABOUND IN OUR SOCIETY AND SOMEONE WITH ZAPIRO'S SKILL AND POLITICAL AWARENESS AND IMPRESSIVE BIOGRAPHY MUST HAVE KNOWN HOW THIS CARTOON WOULD (FAIL TO) LAND.

STILL, HE CHOSE TO HAVE IT PUBLISHED.

Commentary by political analyst
Eusebius McKaiser

THE DAY AFTER THE CARTOON APPEARED, ZAPIRO ACKNOWLEDGED THAT IT WAS A MISTAKE, AND THAT HE HAD UNWITTINGLY FED A RACIST TROPE: "I WISH I COULD TURN THE CLOCK BACK AND I SHOULD NEVER HAVE DONE THAT."

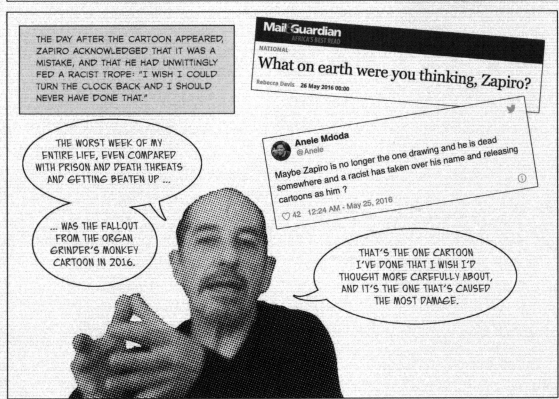

**Mail & Guardian**
AFRICA'S BEST READ

NATIONAL

## What on earth were you thinking, Zapiro?

Rebecca Davis 26 May 2016 00:00

**Anele Mdoda**
@Anele

Maybe Zapiro is no longer the one drawing and he is dead somewhere and a racist has taken over his name and releasing cartoons as him ?

♡ 42   12:24 AM · May 25, 2016

THE WORST WEEK OF MY ENTIRE LIFE, EVEN COMPARED WITH PRISON AND DEATH THREATS AND GETTING BEATEN UP ...

... WAS THE FALLOUT FROM THE ORGAN GRINDER'S MONKEY CARTOON IN 2016.

THAT'S THE ONE CARTOON I'VE DONE THAT I WISH I'D THOUGHT MORE CAREFULLY ABOUT, AND IT'S THE ONE THAT'S CAUSED THE MOST DAMAGE.

IT'S NOT SURPRISING THAT WELL-INTENTIONED CARTOONISTS ARE SOMETIMES ACCUSED OF RACISM.

BOTH PROSOCIAL CARTOONISTS AS WELL AS BIGOTED ONES USE EXAGGERATION, METAPHORS, AND STEREOTYPES TO MAKE THEIR POINTS. THEY DIP INTO THE SAME VISUAL ARMORY.

THE WEAPONS IT CONTAINS CAN BE USED IN GOOD CAUSES AND IN SINISTER ONES.

Art historian E.H. Gombrich

PHYSIOGNOMY, A PSEUDOSCIENCE BASED ON COMPARING HUMANS AND OTHER LIFE FORMS ...

... INSPIRED AMUSING POLITICAL CARICATURES ...

... AS WELL AS DEHUMANIZING RACIST STEREOTYPES.

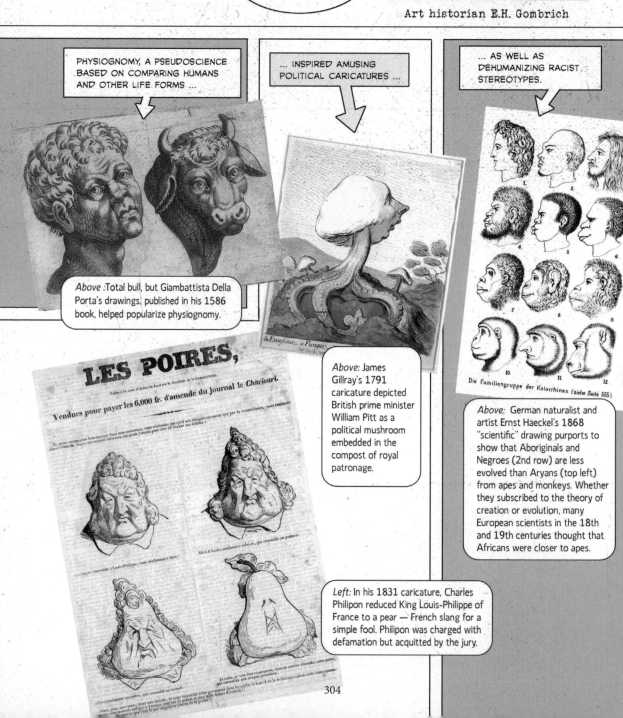

*Above :*Total bull, but Giambattista Della Porta's drawings, published in his 1586 book, helped popularize physiognomy.

*Above:* James Gillray's 1791 caricature depicted British prime minister William Pitt as a political mushroom embedded in the compost of royal patronage.

*Above:* German naturalist and artist Ernst Haeckel's 1868 "scientific" drawing purports to show that Aboriginals and Negroes (2nd row) are less evolved than Aryans (top left) from apes and monkeys. Whether they subscribed to the theory of creation or evolution, many European scientists in the 18th and 19th centuries thought that Africans were closer to apes.

*Left:* In his 1831 caricature, Charles Philipon reduced King Louis-Philippe of France to a pear — French slang for a simple fool. Philipon was charged with defamation but acquitted by the jury.

IN THE 21ST CENTURY, RACISTS CONTINUE TO EQUATE BLACKS TO MONKEYS.

OBAMA in '08

BARACK OBAMA'S BID FOR THE U.S. PRESIDENCY AND HIS TWO TERMS IN THE WHITE HOUSE PROMPTED A SPIKE IN OPENLY RACIST VISUALS, LIKE THIS ANTI-OBAMA CAMPAIGN BUTTON.

GOMBRICH NOTES THAT THE ULTIMATE WEAPON OF CARTOONISTS IS THE "NATURAL METAPHOR" -- METAPHORS THAT ARE SO WIDESPREAD AND ENTRENCHED THAT PEOPLE RESPOND TO THEM WITHOUT MUCH CULTURAL LITERACY.

"RACIAL PROPAGANDA HAS EXPLOITED THIS UNTHINKING FUSION," HE SAYS.

# HALL OF INFAMY

THE GROSS INJUSTICES OF COLONIZATION, IMPERIAL CONQUEST, SLAVERY, APARTHEID, AND GENOCIDE HAVE ALWAYS INVOLVED CONVINCING THE PERPETRATORS THAT THE "OTHER" IS NOT ENTITLED TO BASIC HUMAN DIGNITY.

OVER THE PAST TWO CENTURIES, THESE CAMPAIGNS OF MASS DELUSION HAVE INVARIABLY USED CARTOONS.

Britain and America carry an assortment of barbaric non-Western people to the promised land of of civilization.

"The march of 'civilization' against 'barbarism' is a late-19th-century construct that cast imperialist wars as moral crusades," explains Ellen Sebring, a scholar of visual culture.

The cartoon by Victor Gillam was published in the American satirical magazine, *Judge*, in 1899. It was inspired by Rudyard Kipling's poem, "The White Man's Burden," published two months earlier. Kipling described newly-conquered societies as "sullen peoples, half-devil and half-child."

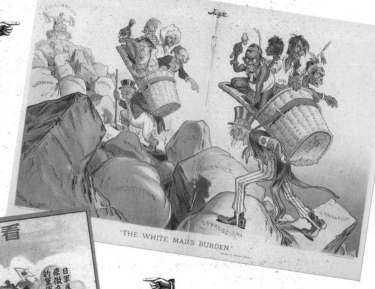

"THE WHITE MAN'S BURDEN."

In this Imperial Japanese propaganda poster, the Japanese Army liberates the Chinese from the cruel injustice of the Communist Party, shown as a dark-skinned man backed by a red devil.

The poster comes from the same period as Japan's worst atrocity against civilians — the Nanjing Massacre, in which 200,000-300,000 residents were murdered in the six weeks following the city's conquest.

305

This 1886 Australian cartoon by Phil May shows the tentacles of Chinese immigrants squeezing white society with their cheap labor, disease, crime, and vice. It was published as a pull-out poster in the magazine *The Bulletin*. Fifteen years later, the country legislated its White Australia immigration policy, which lasted until 1966.

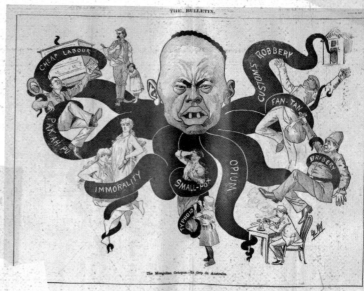

Irish immigrants fleeing famine and poverty from the 1840s faced decades of discrimination in the United States. The Irish were also despised in Great Britain.

Cartoons in English and American magazines commonly gave Irish people dark complexions and ape-like features. This example by Frederick Opper appeared in the American satirical magazine, *Puck*, in 1882.

Comic books reflect their times, racism and all. In 1950, Action Comics released "Superman, Indian Chief!"

The superhero must save Metropolis from an evil mogul who uses his Native American ancestry to claim ownership of all the city's land. Fortunately for white civilization, Superman goes back in time to buy the land from the Indians.

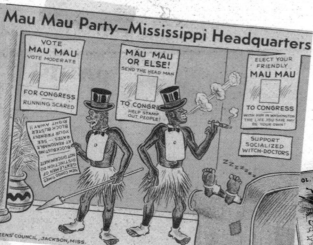

**Mau Mau Party—Mississippi Headquarters**

*Citizen's Council* was a pro-segregationist, white supremacist newspaper published in Mississippi. This 1958 cartoon likens black Mississippians' political mobilization to Kenya's Mau Mau rebellion. It treats black equality as not just threatening but also absurd.

San Francisco's *Illustrated Wasp* was a satirical weekly intent on protecting America's racial order. This 1877 cover shows an undignified African American Uncle Sam and Columbia displacing their iconic white originals.

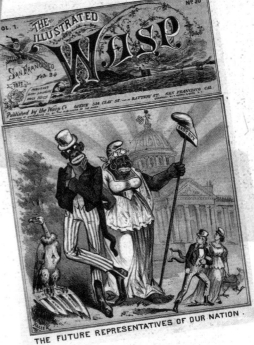

THE FUTURE REPRESENTATIVES OF OUR NATION.

The ground reality of an American empire has always sat uneasily with the nation's self-image as an anti-imperial democratic republic. Cartoonists helped reduce the cognitive dissonance by depicting colonization as a blessing to backward peoples.

This 1898 *Minneapolis Journal* cartoon by Charles L. Bartholomew shows Hawaii, Cuba, and the Philippines as primitive juveniles celebrating (American) Independence Day.

**HURRAH FOR THE FOURTH OF JULY.**

The Nazis' murderous "Final Solution" was their answer to the "Jewish Question," a problem fabricated through decades of anti-Semitic propaganda. In this 1938 cartoon, Nazi artist Josef Plank ("Seppla") shows the world being crushed by a Zionist conspiracy, represented by a Star of David and an octopus.

The beast's head belongs to British Prime Minister Winston Churchill, suggesting that Germany's military foes and the Jewish race are one and the same.

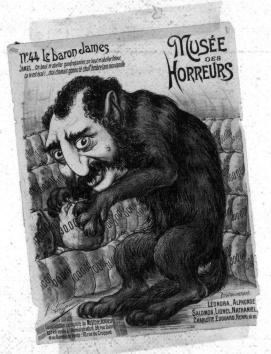

N°44 le baron James

JAMES...On beut m'abelier gandrepantier, on beut m'aboilter foleur,
ça m'est écal !...chai chamais gonnu té chuif brabre tans mon vanille.

MUSÉE DES HORREURS

Prochainement:
LÉONORA, ALPHONSE,
SALOMON, LIONEL, NATHANIEL,
CHARLOTTE, EDOUARD, HENRI, etc, etc.

Anti-Semitic cartoons weren't limited to Germany. This 1900 French poster depicts James de Rothschild, who founded the French branch of the family bank, as a greedy wolf.

Dehumanization is a powerful tool in racist imagery and rhetoric. Jews as vermin was a prevalent trope.

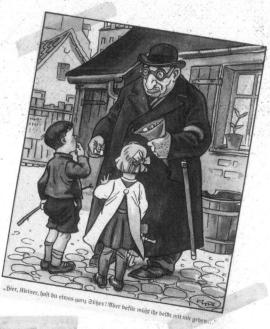

Hans and Else being enticed with sweets by a stranger, in *The Poisonous Mushroom*, a 1938 children's book published in Germany. Hans is too clever for the predator. "You're a Jew!" he cries, running off with his sister. Art by Philipp Rupprecht ("Fips"), who also drew for *Der Sturmer*.

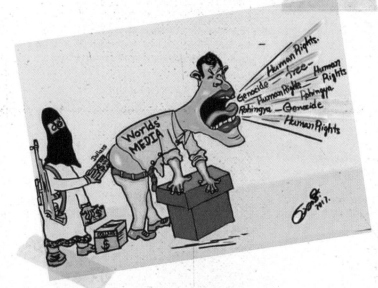

The Myanmar military's campaign against Rohingya could go down in history as the 21st century's first genocide. Anti-Rohingya cartoons circulate freely, many claiming that the world community and foreign media are blindly repeating the Muslim minority's lies.

"The cartoons were produced in such abundance and so quickly that I wondered if there was a concerted propaganda campaign led by the Myanmar military," says human rights defender Matthew Smith. "Given how powerful cartoons can be in shaping people's views, communicating a whole complex set of ideas in a single image, it would make perverse sense for the military to weaponize them, given their genocidal aims."

# HATE SPEECH

MOST OF THE PRECEDING EXAMPLES CAN BE CONSIDERED "HATE SPEECH" -- VILIFYING PEOPLE'S GROUP IDENTITIES (THEIR RACE, RELIGION, NATIONALITY, IMMIGRANT STATUS, SEXUAL ORIENTATION, GENDER, DISABILITY, AND SO ON) IN ORDER TO THREATEN THEIR SECURITY OR DIMINISH THEIR STATUS AS EQUAL MEMBERS OF SOCIETY.

THE NAZI HOLOCAUST HAD A MAJOR IMPACT ON THE INTERNATIONAL COMMUNITY'S STAND ON THE LEGALITY OF HATE SPEECH.

AS THE FULL HORROR OF THE GENOCIDE WAS REVEALED, IT BECAME CLEAR THAT THE NAZI CAMPAIGN TO PERSECUTE AND THEN EXTERMINATE MILLIONS OF JEWS REQUIRED THE IDEOLOGICAL FIREPOWER OF HATE PROPAGANDA, WHICH TURNED A SEEMINGLY CIVILIZED PEOPLE INTO MASS MURDERERS.

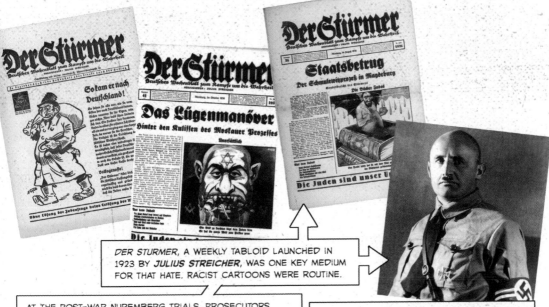

DER STURMER, A WEEKLY TABLOID LAUNCHED IN 1923 BY *JULIUS STREICHER*, WAS ONE KEY MEDIUM FOR THAT HATE. RACIST CARTOONS WERE ROUTINE.

AT THE POST-WAR NUREMBERG TRIALS, PROSECUTORS ACCUSED STREICHER OF "EDUCATING AND POISONING THE PEOPLE WITH HATE, AND OF PRODUCING MURDERERS."

HE RECEIVED THE DEATH SENTENCE FOR CRIMES AGAINST HUMANITY, SPECIFICALLY FOR "INCITEMENT TO MURDER AND EXTERMINATION."

HATE MEDIA ALSO LAID THE GROUND FOR THE 1994 RWANDAN GENOCIDE.

THE FOUNDER AND EDITOR OF THE EXTREMIST HUTU PERIODICAL, *KANGURA*, WAS SENTENCED TO LIFE IMPRISONMENT BY THE UNITED NATIONS CRIMINAL TRIBUNAL FOR RWANDA.

*KANGURA* REGULARLY CARRIED CARTOONS INCITING HATRED AGAINST THE TUTSI MINORITY AND MODERATE HUTU POLITICIANS.

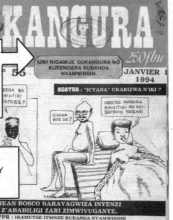

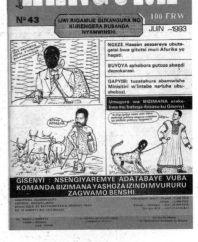

THE FORMULAIC LIBERAL SOLUTION TO BAD SPEECH IS MORE SPEECH.

GOOD SPEECH WILL ULTIMATELY TRIUMPH IN A FREE MARKETPLACE OF IDEAS, THE THEORY GOES.

BUT THIS ASSUMES EVERYONE IS EQUALLY ABLE TO PARTICIPATE IN THAT MARKETPLACE.

HATE SPEECH UNDERMINES ITS VICTIMS' EFFORTS TO DEFEND THEMSELVES IN THE MARKETPLACE, EVEN AS IT INSTIGATES ATTACKS AGAINST THEM.

INTERNATIONAL HUMAN RIGHTS LAW, AND THE DOMESTIC LAWS OF MOST LIBERAL DEMOCRACIES, TREAT THE WORST HATE SPEECH AS FALLING OUTSIDE THE BOUNDARIES OF PERMISSIBLE SPEECH. SPECIFICALLY, THEY PROHIBIT HATE SPEECH THAT AMOUNTS TO A CALL TO ACTION, OR "INCITEMENT."

# "HATE SPEECH" IN INTERNATIONAL HUMAN RIGHTS LAW

## FREE SPEECH? NO EXCUSE

The International Covenant on Civil and Political Rights (ICCPR) protects people from the harms of hate speech (without using that term). Article 19 allows states to restrict freedom of expression to protect the rights of others. Article 20 goes further, requiring states to prohibit incitment to hatred.

**Article 20.2:** "Any advocacy of national, racial or religious hatred that constitutes incitement to discrimination, hostility or violence shall be prohibited by law."

– International Covenant on Civil & Political Rights

# THE LIBERAL HUMAN RIGHTS STANDARD

## ◀ PROTECT

### *OFFENSIVE SPEECH*

EXPRESSION THAT HURTS PEOPLE'S FEELINGS OR INSULTS THEIR BELIEFS, WITHOUT INSTIGATING IMMEDIATE AND OBJECTIVE HARM AGAINST THEM.

LEGAL RESPONSE: *ALLOW*, BECAUSE FREEDOM OF EXPRESSION IS MEANINGLESS IF IT STOPS WHERE ANYONE FEELS PROVOKED. IN DEMOCRATIC DEBATE, THERE IS NO RIGHT TO BE PROTECTED FROM OFFENSE. THE REMEDY IS COUNTER-SPEECH OR OTHER NON-COERCIVE RESPONSES.

## PROHIBIT ▶

### *INCITEMENT*

EXPRESSION THAT DEMEANS PEOPLE'S GROUP IDENTITIES, DIRECTLY CAUSING THEM TO BE HARMED BY DISCRIMINATION OR VIOLENCE.

LEGAL RESPONSE: *RESTRICT\**, BECAUSE PEOPLE HAVE A RIGHT TO BE FREE OF DISCRIMINATION AND VIOLENCE. COUNTER-SPEECH ALONE CAN'T PROTECT THEM IF THE DANGER IS IMMINENT AND THEY AND THEIR ADVOCATES LACK VOICE.

**?**

BUT WHAT ABOUT SPEECH THAT GRADUALLY BUT SYSTEMATICALLY ADDS TO A CULTURE OF DISCRIMINATION AND HATE AGAINST DISADVANTAGED GROUPS?

\* RESTRICTIONS ARE SUBJECT TO THE "3-PART TEST" (CHAPTER 1).

THE LIBERAL CONSENSUS, A PRODUCT OF ENLIGHTENMENT VALUES, HAS BEEN CHALLENGED BY WATCHDOGS OF CULTURAL IDENTITY COMING FROM TWO SEPARATE TRADITIONS ...

... MUSLIM COUNTRIES CAMPAIGNING AGAINST "DEFAMATION OF RELIGION" ...

... AND THE WESTERN CUTURAL LEFT BATTLING AGAINST "MICROAGGRESSIONS."

# DEFAMATION OF RELIGION

MANY MUSLIM POLITICAL AND RELIGIOUS LEADERS OBJECT TO HOW CURRENT INTERNATIONAL STANDARDS ALLOW THE QURAN AND THE PROPHET MOHAMMED TO BE INSULTED WITH IMPUNITY.

WHEN THE DANISH NEWSPAPER *JYLLANDS-POSTEN* PUBLISHED THEIR CARTOONS OF PROPHET IN 2005 (CHAPTER 13), THE DANISH GOVERNMENT'S REFUSAL TO TAKE ACTION -- OR EVEN TO EXPRESS ITS DISAPPROVAL -- CONVINCED MANY NON-WESTERN GOVERNMENTS THAT LIBERAL NORMS WERE UNTENABLE.

AT THE UNITED NATIONS, THE ORGANISATION OF ISLAMIC COOPERATION (OIC) ARGUED THAT SUCH INSULTS, THOUGH NOT REACHING THE THRESHOLD OF DIRECT INCITEMENT, WERE CULTIVATING ISLAMOPHOBIA AND A CULTURE OF INTOLERANCE.

THE LIBERAL APPROACH TREATS RELIGION AS JUST ANOTHER SET OF BELIEFS, LIKE POLITICAL IDEOLOGY, THAT MUST BE OPEN TO DEBATE.

*Left*
Pakistan's U.N. ambassador Munir Akram. Pakistan played a leading role in the campaign against "defamation of religion."

BUT THE ISLAMIC BLOC ARGUED THAT RELIGION IS ALSO AN *IDENTITY*, LIKE RACE, AND THAT ATTACKS ON THE PROPHET AMOUNTED TO RACIST ASSAULTS ON MUSLIMS.

THEY PUSHED FOR "DEFAMATION OF RELIGION" TO BE ADDED TO THE LIST OF LEGITIMATE GROUNDS FOR RESTRICTING FREE SPEECH.

AFTER YEARS OF DEBATE, THE LOBBY BACKED DOWN, ACCEPTING WESTERN GOVERNMENTS' ASSURANCES THAT ISLAMOPHOBIA WOULD BE ADDRESSED THROUGH EDUCATION AND DIALOGUE.

# MICROAGRESSIONS

MEANWHILE, WITHIN WESTERN DEMOCRACIES, SOME SCHOLARS AND ACTIVISTS SAY THAT THE LIBERAL APPROACH MAKES TOO STARK A DISTINCTION BETWEEN SUBJECTIVE OFFENSE AND OBJECTIVE HARM.

HATE MESSAGES CAN HAVE DEBILITATING PSYCHOLOGICAL EFFECTS.

TO AVOID VILIFICATION, THE VICTIM MAY NEED TO RETREAT FROM PUBLIC LIFE, THUS FORGOING THE RIGHT TO PARTICIPATE FULLY IN SOCIETY.

TO BE HATED, DESPISED, AND ALONE IS THE ULTIMATE FEAR OF ALL HUMAN BEINGS.

HOWEVER IRRATIONAL RACIST SPEECH MAY BE, IT HITS RIGHT AT THE EMOTIONAL PLACE WHERE WE FEEL THE MOST PAIN.

Mari Matsuda, American legal scholar and activist

ALL TOO OFTEN, THOSE WHO DEFEND THE EXISTING APPROACH BY SAYING 'THIS IS THE PRICE WE PAY FOR A FREE SOCIETY' ...

... ARE NOT THE ONES THAT PAY VERY MUCH OF THE PRICE.

Frederick Schauer, American law professor

IN THE 1980S, SUCH VIEWS COALESCED AROUND *CRITICAL RACE THEORY*, WHICH SAID THAT THE LIBERAL CONSENSUS ON FREE SPEECH WAS UNFAIR TO THOSE WHO ARE SYSTEMATICALLY EXCLUDED OR INTIMIDATED INTO SILENCE.

IN THE 2000S, STARTING ON AMERICAN CAMPUSES, LIBERAL SOCIETIES GREW MORE SENSITIVE ABOUT *MICROAGGRESSIONS* -- EXPRESSION THAT MAY SEEM HARMLESS TO THE SPEAKER AND MOST LISTENERS, BUT DEMEANS OR INTIMIDATES SOME BECAUSE OF ITS LINKS A COLLECTIVE HISTORY OF VICTIMIZATION.

MICROAGGRESSIONS ARE CONSTANT REMINDERS THAT YOU DON'T BELONG ...

... THAT YOU ARE NOT WORTHY OF THE SAME RESPECT THAT WHITE PEOPLE ARE AFFORDED.

THEY KEEP YOU OFF BALANCE, KEEP YOU DISTRACTED, AND KEEP YOU DEFENSIVE.

... THEY NORMALIZE RACISM.

Ijeoma Oluo, writer

SOME LIBERAL DEMOCRACIES ARE OPEN TO THE IDEA OF RESTRICTING HATE SPEECH THAT HAS MORE INDIRECT AND LONG-TERM EFFECTS.

THUS, IN 2008, DUTCH POLICE ARRESTED A CARTOONIST GOING BY THE PEN-NAME OF *GREGORIUS NEKSCHOT* ON SUSPICION OF INCITING DISCRIMINATION AGAINST MUSLIMS AND DARK-SKINNED IMMIGRANTS.

A DUTCH IMAM HAD LODGED A COMPLAINT THREE YEARS EARLIER.

THE AUTHORITIES RELEASED THE CARTOONIST THE NEXT DAY, BUT GOT HIM TO REMOVE FROM HIS WEBSITE EIGHT INCRIMINATING CARTOONS.

THESE TWO WERE AMONG THE EIGHT....:

de Kerst-Imam wenst U gezegende feestdagen en...

— een voorspoedig 1426

*Above*
A "Christmas imam" greeting card showing an imam sodomizing a goat. Bestiality is a ccenturies-old racist trope that has been used against Jews, Arabs, Africans, and other despised minorities.

ALI ZIT BEST OP ZIJN *POEF*

In de Koran staat helemaal nergens dat je iets terug hoeft te doen voor 30 jaar WAO en Kinderbijslag en Huursubsidie...

*Above*
A cartoon suggesting that Muslim immigrants are a drain on the economy — a standard claim of white nationalists in Europe. "Ali, sitting comfortably on his pouf, says, 'Nowhere does the Quran say you have to do something in return for 30 years of welfare.'"

DUTCH PROSECUTORS, TAKING INTO ACCOUNT THE FACT THAT THE EIGHT CARTOONS HAD BEEN REMOVED, DROPPED THE CASE AFTER TWO YEARS.

WHILE MANY DUTCH CARTOONISTS AND COMMENTATORS AGREED HIS WORK WAS HATEFUL, THE ARREST WAS CONTROVERSIAL.

IT WAS WIDELY SEEN AS AN EXCESSIVE RESPONSE TO A FRINGE ARTIST, AND A TOKEN GESTURE AGAINST THE RISING POWER OF RIGHT-WING POLITICIANS SUCH AS GEERT WILDERS.

Geert Wilders

FOR FAR-RIGHT GROUPS IN EUROPE AND THE UNITED STATES, THE POLICE ACTION WAS A PROPAGANDA WINDFALL, ALLOWING THEM TO CLAIM THAT ISLAMISTS WERE ALREADY WINNING.

## Western Civilization on Trial

# "Legal Jihad"

THE SOCIAL FALLOUT WAS MORE DECISIVE THAN THE POLICE ACTION.

## "What Used to be Known as Christendom"

THE ADVERSE PUBLICITY CAUSED GREGORIUS NEKSCHOT TO LOSE CLIENTS, THE ARTIST SAID.

IN LATE 2011, HE ANNOUNCED HE WOULD GIVE UP HIS POLITICAL CARTOONING AND TAKE DOWN HIS WEBSITE.

THE ARREST OF GREGORIUS NEKSCHOT WAS A RARE EXCEPTION.

OVERALL, THE ISLAMIC BLOC AND THE CULTURAL LEFT HAVE FAILED TO PERSUADE LIBERAL DEMOCRACIES TO NARROW THE LEGAL LIMITS ON OFFENSIVE SPEECH.

ON THE OTHER HAND, MOST MEDIA HAVE LEARNED TO TAKE MORE CARE WITH THEIR WORDS AND IMAGES, EITHER OUT OF GENUINE COMMITMENT TO SOCIAL JUSTICE, OR AS A STRATEGIC RITUAL TO AVOID CRITICISM.

THE PUBLIC'S GENERAL SENSITIVITY GROWS CONSTANTLY, ALONGSIDE SOCIAL MEDIA ALLOWING THEM TO EXPRESS IT WHENEVER THEY WISH.

THIS MEANS THAT THE RISK OF OFFENDING PEOPLE GRADUALLY INCREASES.

WE KEEP CORRECTING WORDS IN OUR VOCABULARY BECAUSE THEY CAN DISCRIMINATE AGAINST A PART OF THE POPULATION.

SO WE DON'T SAY "A BLIND" BUT INSTEAD A "VISUALLY IMPAIRED," THIS KIND OF THING.

THERE ARE GOOD REASONS FOR THIS, TO AVOID HUMILIATING PEOPLE.

BUT THE ACCUMULATION OF ALL THESE LITTLE PRECAUTIONS MEANS YOU ARE ALWAYS QUESTIONING YOUR WORK AS A HUMORIST; IT'S LIKE WALKING ON EGGS.

Patrick Lamassoure (Kak), cartoonist, France

AFTER EACH OF MY DRAWINGS, I ASK MYSELF MORE AND MORE QUESTIONS.

I HAVE TO PREPARE MYSELF TO RESPOND TO QUESTIONS ABOUT MY DRAWINGS.

FOR EXAMPLE, WHY I DEPICTED A WOMAN THIS WAY, OR A BLACK PERSON, OR A CATHOLIC, ET CETERA.

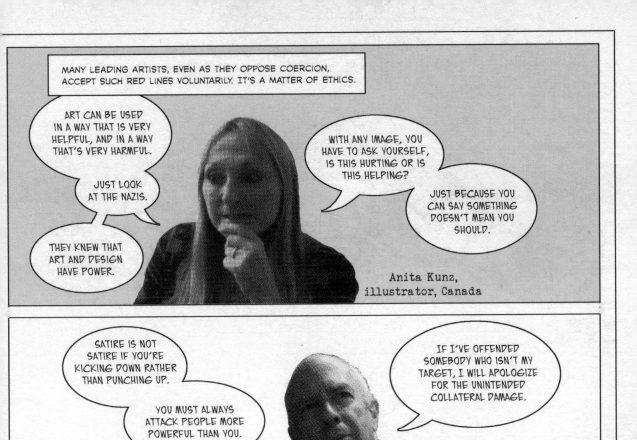

MANY LEADING ARTISTS, EVEN AS THEY OPPOSE COERCION, ACCEPT SUCH RED LINES VOLUNTARILY. IT'S A MATTER OF ETHICS.

ART CAN BE USED IN A WAY THAT IS VERY HELPFUL, AND IN A WAY THAT'S VERY HARMFUL.

JUST LOOK AT THE NAZIS.

THEY KNEW THAT ART AND DESIGN HAVE POWER.

WITH ANY IMAGE, YOU HAVE TO ASK YOURSELF, IS THIS HURTING OR IS THIS HELPING?

JUST BECAUSE YOU CAN SAY SOMETHING DOESN'T MEAN YOU SHOULD.

Anita Kunz, illustrator, Canada

SATIRE IS NOT SATIRE IF YOU'RE KICKING DOWN RATHER THAN PUNCHING UP.

YOU MUST ALWAYS ATTACK PEOPLE MORE POWERFUL THAN YOU.

IF I'VE OFFENDED SOMEBODY WHO ISN'T MY TARGET, I WILL APOLOGIZE FOR THE UNINTENDED COLLATERAL DAMAGE.

Martin Rowson, cartoonist, Britain

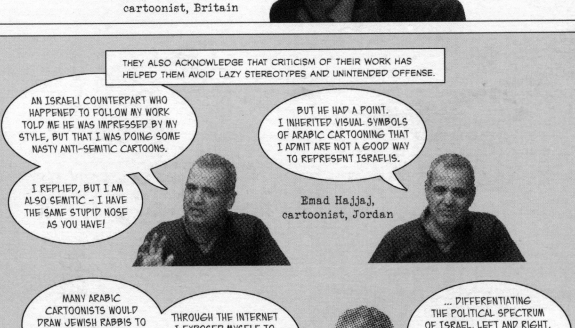

THEY ALSO ACKNOWLEDGE THAT CRITICISM OF THEIR WORK HAS HELPED THEM AVOID LAZY STEREOTYPES AND UNINTENDED OFFENSE.

AN ISRAELI COUNTERPART WHO HAPPENED TO FOLLOW MY WORK TOLD ME HE WAS IMPRESSED BY MY STYLE, BUT THAT I WAS DOING SOME NASTY ANTI-SEMITIC CARTOONS.

I REPLIED, BUT I AM ALSO SEMITIC – I HAVE THE SAME STUPID NOSE AS YOU HAVE!

BUT HE HAD A POINT. I INHERITED VISUAL SYMBOLS OF ARABIC CARTOONING THAT I ADMIT ARE NOT A GOOD WAY TO REPRESENT ISRAELIS.

Emad Hajjaj, cartoonist, Jordan

MANY ARABIC CARTOONISTS WOULD DRAW JEWISH RABBIS TO SYMBOLIZE ISRAEL AND ITS SOLDIERS.

THROUGH THE INTERNET I EXPOSED MYSELF TO INTERNATIONAL CARTOONISTS, AND I BEGAN TO PORTRAY ISRAEL IN A MORE DETAILED WAY ...

... DIFFERENTIATING THE POLITICAL SPECTRUM OF ISRAEL, LEFT AND RIGHT, SECULAR AND CONSERVATIVE, AND NOT JUST REPRESENTING ISRAEL WITH A RABBI.

# WHITE MAN'S P.C. GUIDE

## ANTIRACIST CARTOONISTS OFFER ADVICE TO THE PROFESSION

Joep Bertrams,
Netherlands

Dave Brown,
Britain

Steve Marchant,
Britain

Michael Rozanov
(Mysh), Israel

Tjeerd Royaards,
Netherlands

## STEREOTYPES: HANDLE WITH CARE

"Different races have certain physiognomies and you have to acknowledge that, but not make it a funny feature. Yes, someone from China or Japan may have differently shaped eyes from a white person. But you just draw what you see; you don't draw slits for eyes, or brick teeth and yellow skin."

"It used to be a stock in trade years ago that if a politician went to Africa, there'd be cartoons of cannibals in grass skirts dancing about a big cooking pot. We've moved on a lot since then, thank goodness. The few people who still try to do it rightly get shouted down for being racist."

"Anti-Semitism or any kind of racism is criticizing people for what they are. Legitimate criticism is criticizing them for what they do.

If I want to create a cartoon of a person who happens to be Jewish and want to criticize this person for being a corrupt politician or a pedophile or a sex offender, I won't go for exaggerating the features that have this stereotypical connection to anti-Semitism, because that's not the point.

The current Israeli government is cruel and antidemocratic, not because they are Jewish, but because they are corrupt."

"We work with stereotypes, because we have to draw recognizable things. But we need to draw in ways that don't abuse the stereotypes, unless of course you are drawing about something you want to abuse.

So, when I draw about migrants, for example, I consider the skin tone and stuff like that. This is sensitivity creeping into cartoons in a good way. I don't consider it self-censorship. These are decisions you make out of your own conscience."

## DON'T GENERALIZE

"We need to strive to be as precise as possible in what we want to say. Most anti-Semitic cartoons tend to be sloppy, because racism is sloppy at its core. They don't go for specific follies, they put the blame on an entire group of people. The cartoonists don't understand properly what exactly they want to say, they are not being razor-sharp."

## STAY ON MESSAGE

"I want to achieve something with an image – to make people think about the subject. If they get angry because of the subject, fine. But if too many people get angry because of the image, then I may have done something wrong."

"Even when you are very angry, you need to have compassion as a cartoonist, not for the people you criticize, necessarily, but for your audience. Don't be mean to your audience."

"If your emotion and anger are too great, you won't think clearly. You will be working from your belly, and if you are working from your belly, you get farts. We hope to make people look at subjects more thoughtfully. You don't open people's eyes by slapping them."

DESPITE THE CARE PROFESSIONAL CARTOONISTS SAY THEY TAKE TO AVOID UNNECESSARY OFFENSE, CONTROVERSIES REGULARLY ERUPT OVER ALLEGEDLY RACIST CARTOONS APPEARING IN MAINSTREAM MEDIA.

THE FOLLOWING THREE CASES WERE ADJUDICATED BY NATIONAL PRESS COUNCILS -- PROFESSIONAL BODIES THAT PROMOTE ETHICAL CONDUCT AND LOOK INTO COMPLAINTS FROM THE PUBLIC. IN ALL THREE, THE COUNCILS SIDED WITH THE MEDIA, BUT PROBABLY FAILED TO CONVINCE THE CRITICS.

## CALLED OUT

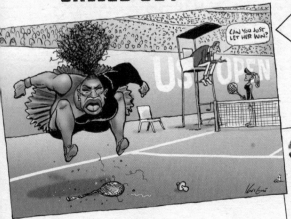

WHEN AUSTRALIAN CARTOONIST *MARK KNIGHT* DREW TENNIS STAR SERENA WILLIAMS LOSING HER TEMPER AT THE 2018 U.S. OPEN, MANY READERS IN THE UNITED STATES AND BRITAIN WERE STUNG BY WHAT THEY SAW AS A GROSSLY RACIST CARTOON.

AUTHOR J.K. ROWLING TOLD HER 14 MILLION TWITTER FOLLOWERS THAT THE CARTOON USED RACIST TROPES. "SAMBO-LIKE," SAID THE U.S. NATIONAL ASSOCIATION OF BLACK JOURNALISTS.

J.K. Rowling
@jk_rowling

Well done on reducing one of the greatest sportswomen alive to racist and sexist tropes and turning a second great sportswoman into a faceless prop. t.co/YOxVMuTXEC

THE ARTWORK IN SOME EDITIONS OF THE POPULAR CHILDREN'S BOOK, *THE STORY OF LITTLE BLACK SAMBO*, WAS A VEHICLE FOR BLACK STEREOTYPES.

KNIGHT CLAIMED IGNORANCE. HE SAID HE WAS ACTUALLY COMPARING SERENA WILLIAMS TO A CHILD THROWING A TANTRUM. HER MOUTH WAS CONTORTED BECAUSE SHE WAS SPITTING OUT HER PACIFIER, OR DUMMY AS AUSTRALIANS CALL IT.

CAN YOU JUST LET HER WIN?

THE PACIFIER IS RIGHT THERE ON THE COURT IN FRONT OF HER.

# Spit the Dummy

Australian Term: To indulge in a sudden display of anger or frustration; to lose one's temper. The phrase is usually used of an adult, and the implication is that the outburst is childish, like a baby spitting out its <u>dummy</u> in a <u>tantrum</u> and refusing to be pacified. (<u>Dummy</u> is <u>a pacifier</u>)

THE AUSTRALIAN PRESS COUNCIL CONSIDERED WHETHER THE CARTOON BREACHED ITS CODE BY FAILING TO "TAKE REASONABLE STEPS" TO "AVOID CAUSING OR CONTRIBUTING MATERIALLY TO SUBSTANTIAL OFFENCE, DISTRESS OR PREJUDICE... UNLESS DOING SO IS SUFFICIENTLY IN THE PUBLIC INTEREST."

**APC** Australian Press Council

THE COUNCIL CONCLUDED THAT THERE WAS NO BREACH.

IT ACCEPTED THAT "SPITTING THE DUMMY" WAS A "NON-RACIST" METAPHOR "FAMILIAR TO MOST AUSTRALIAN READERS." ALTHOUGH "SOME READERS FOUND THE CARTOON OFFENSIVE," THE COUNCIL FELT "THERE WAS A SUFFICIENT PUBLIC INTEREST IN COMMENTING ON BEHAVIOUR AND SPORTSMANSHIP DURING A SIGNIFICANT DISPUTE BETWEEN A TENNIS PLAYER WITH A GLOBALLY HIGH PROFILE AND AN UMPIRE AT THE US OPEN FINAL."

NEVERTHELESS, MANY PEOPLE STILL CITE KNIGHT'S CARTOON AS AN EXAMPLE OF RACISM AND SEXISM IN THE MEDIA.

KNIGHT'S NEWSPAPER THE *HERALD SUN* CHARGED THAT HIS "SELF-APPOINTED CENSORS" WANTED A "POLITICALLY CORRECT LIFE" THAT WOULD BE "VERY DULL INDEED."

# CHEWED OUT

DAVE BROWN IN BRITAIN IS ANOTHER CARTOONIST WHOSE CHOSEN METAPHOR MISFIRED BADLY.

DAYS BEFORE THE 2003 GENERAL ELECTIONS IN ISRAEL, PRIME MINISTER ARIEL SHARON LAUNCHED A MILITARY STRIKE ON GAZA CITY, KILLING PALESTINIAN CIVILIANS.

VOTERS HANDED SHARON'S LIKUD PARTY A RESOUNDING VICTORY.

THE GAZA ASSAULT WAS A MACABRE VERSION OF THE ELECTIONEERING RITUAL OF KISSING BABIES, BROWN FELT. HE PLAYED WITH THIS THEME, AND BORROWED FROM A FRANCISCO GOYA PAINTING BASED ON THE GREEK MYTH OF A GOD WHO WAS SO FEARFUL OF BEING OVERTHROWN BY HIS CHILDREN THAT HE ATE THEM.

(BROWN REGULARLY BASES HIS CARTOONS ON FAMOUS WESTERN PAINTINGS.)

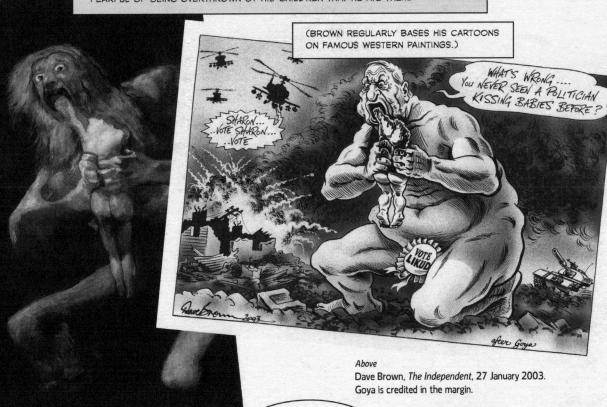

*Above*
Dave Brown, *The Independent*, 27 January 2003.
Goya is credited in the margin.

*Above*
"Saturn Devouring His Son",
Francisco Goya, c.1820.

THE GOYA PAINTING CAME TO MIND, BECAUSE I THOUGHT THIS IS SORT OF WHAT'S GOING ON.

GAZA WAS UNDER ISRAELI CONTROL. SHARON SHOULD BE HAVING A DUTY OF CARE TOWARDS THESE PEOPLE BUT HE'S ATTACKING THEM.

BROWN DELIBERATELY AVOIDED ANY JEWISH SYMBOLISM. HE IDENTIFIED SHARON BY HIS PARTY, LIKUD. HE DREW THE APACHE HELICOPTERS AND TANK WITHOUT THEIR STAR OF DAVID INSIGNIAS.

NEVERTHELESS, THE ISRAELI EMBASSY IN LONDON ACCUSED *THE INDEPENDENT* OF RECYCLING "BLOOD LIBEL," A MEDIEVAL ANTI-SEMITIC MYTH ABOUT JEWS SLAUGHTERING CHRISTIAN CHILDREN TO USE THE BLOOD IN RITUALS. THE NEWSPAPER WAS INUNDATED WITH LETTERS, MOSTLY FROM THE UNITED STATES.

Left
15th century woodcut depicting
Jews murdering an English child.

THE U.K. PRESS COMPLAINTS COMMISSION (P.C.C.) RECEIVED MORE THAN 100 COMPLAINTS, INCLUDING FROM THE ISRAELI EMBASSY. THE P.C.C.'S CODE OF PRACTICE DISALLOWS "PREJUDICIAL OR PEJORATIVE REFERENCE" TO A PERSON'S RACE OR RELIGION.

"[THE COMMISSION] DID NOT CONSIDER THAT THERE WAS ANYTHING PARTICULARLY PREJUDICIAL TO MR SHARON'S RACE OR RELIGION ABOUT SATIRISING HIM IN THIS WAY, ESPECIALLY AS THERE IS NOTHING INHERENTLY ANTI-SEMITIC ABOUT THE GOYA IMAGE ...

... OR ABOUT THE MYTH OF SATURN DEVOURING HIS CHILDREN, WHICH HAS BEEN USED PREVIOUSLY TO SATIRISE OTHER POLITICIANS ACCUSED OF SACRIFICING THEIR OWN 'CHILDREN' FOR POLITICAL PURPOSES."

PRESS COMPLAINTS COMMISSION

ALTHOUGH THE P.C.C. VINDICATED BROWN, HE KNOWS SUCH ACCUSATIONS CAN HAVE A LONG-TERM IMPACT ON A CARTOONIST'S REPUTATION, AND ON EDITORS' FUTURE DECISIONS.

YOU THROW THE ACCUSATION OFTEN ENOUGH, AND THE MUD STICKS.

AND OF COURSE THE WHOLE REASON THESE COMPLAINTS ARE MADE IN THE FIRST PLACE IS TO MAKE PEOPLE SELF-CENSOR.

THE NEXT TIME ISRAEL-PALESTINE CAME UP, I SUGGESTED A CARTOON AND MY EDITOR SUGGESTED GIVING IT A MISS.

IN A WAY, THE ISRAELI EMBASSY HAD WON, THEY MADE US SELF-CENSOR.

# CAST OUT

GERMAN CARTOONIST *DIETER HANITZSCH* WAS SACKED BY THE NEWSPAPER, *SÜDDEUTSCHE ZEITUNG*, FOLLOWING ACCUSATIONS THAT HE HAD DRAWN AN ANTI-SEMITIC CARTOON.

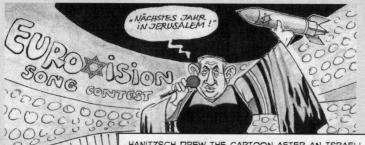

Left
Dieter Hanitzsch,
*Suddeutsche Zeitung*,
15 May 2018

HANITZSCH DREW THE CARTOON AFTER AN ISRAELI WON THE 2018 EUROVISION SONG CONTEST. ISRAEL WAS DUE TO HOST THE COMPETITION THE FOLLOWING YEAR.

"NEXT YEAR IN JERUSALEM!" SAYS PRIME MINISTER BENJAMIN NETANYAHU, DEPICTED AS A SINGER HOLDING ALOFT A BOMB. A STAR OF DAVID -- A SYMBOL OF THE ISRAELI STATE BUT ALSO OF THE JEWISH RELIGION -- IS PLASTERED ON THE "EUROVISION" BANNER AND THE BOMB.

WE GERMANS USED AND ABUSED THIS STAR FOR RACIST CATEGORIZING UNTIL 1945; FROM 1941, JEWS HAD TO SEW IT ON THEIR CLOTHING IN ALL PARTS OF THE NAZI EMPIRE.

IT SCARES ME WHEN I SEE A CARICATURE TWICE USING THE STAR OF DAVID....

THIS PATH LED TO THE HOLOCAUST.

... NEVERTHELESS, HIS VIEW OF STEREOTYPES AND CLICHÉS IS SO FUNDAMENTALLY DIFFERENT FROM THE ONE I HAVE DESCRIBED THAT WE CONSIDER THIS HIGHLY PROBLEMATIC.

FOR A CARTOONIST IN THIS COUNTRY, THE STAR OF DAVID MUST BE SOMETHING OTHER THAN JUST A NATIONAL SYMBOL LIKE THE UNION JACK OR THE STARS AND STRIPES.

I HAVE KNOWN DIETER HANITZSCH LONG ENOUGH TO KNOW THAT HE IS NEITHER A RACIST NOR AN ANTI-SEMITE ...

'Süddeutsche Zeitung' editor-in-chief Kurt Kister, in an opinion column

I THINK IT'S ANTISEMITIC.

BUT, AS AN 84-YEAR-OLD GERMAN ARTIST, HE CAN'T CLAIM NOT TO KNOW NAZI ART.

IF YOU WANT TO SHOW THE FLAG OF ISRAEL WITHOUT A DOUBLE MEANING, IT'S VERY SIMPLE, SHOW THE TWO BLUE BARS AS WELL. BUT HE SIMPLY USES THE STAR OF DAVID.

Isabel Enzenbach, Centre for Research on Antisemitism, Technical University Berlin

FROM A LEGAL PERSPECTIVE, YOU COULD ARGUE IT'S NOT INTENDED, AND THAT IT'S A COINCIDENCE.

IF YOU LOOK AT HOW THE MAIN ARTIST FOR DER STURMER, FIPS, DEPICTED JEWISH FACES, THIS DRAWING OF NETANYAHU IS VERY SIMILAR.

EFFEMINIZATION OF MALE JEWS WAS ANOTHER FEATURE OF ANTI-SEMITIC CARICATURE.

THE GERMAN PRESS COUNCIL WAS INTERNALLY DIVIDED OVER WHETHER THE CARTOON VIOLATED THE PRESS CODE, WHICH PROHIBITS DISCRIMINATION AGAINST A PERSON BECAUSE OF HIS/HER MEMBERSHIP IN AN ETHNIC OR RELIGIOUS GROUP.

BUT THE MAJORITY FINALLY DECIDED THAT THE CARTOON WAS NOT IN VIOLATION.

presserat

"THE FACIAL FEATURES OF THE ISRAELI PRIME MINISTER ARE EXAGGERATED, BUT THIS IS PERMISSIBLE WITHIN THE FRAMEWORK OF FREEDOM OF EXPRESSION," IT SAID. "THE ROLE OF THE STAR OF DAVID AS A RELIGIOUS AND STATE SYMBOL WAS ASSESSED DIFFERENTLY IN THE COMMITTEE."

RACISM IN CARTOONS IS A GRAY AREA, AND INESCAPABLY CONTROVERSIAL.

THE CARTOONS THEMSELVES ARE OPEN TO INTERPRETATION.

IT CAN BE HARD TO ESTABLISH IF THE CARTOONIST IS BIGOTED, CARELESS, OR IGNORANT.

BESIDES, NOT ALL ACCUSERS ARE ACTING IN GOOD FAITH EITHER.

EVEN WITHIN GROUPS WHO ARE GENUINE VICTIMS OF HISTORICAL AND CURRENT INJUSTICE, POLITICIANS, PREACHERS, AND ACTIVISTS MAY CAST A CARTOON IN THE WORST POSSIBLE LIGHT, WHIPPING UP DISPROPORTIONATE INDIGNATION TO SERVE THEIR OWN INDIVIDUAL INTERESTS.

AFTER ALL, THE MANUFACTURE OF OUTRAGE AND THE PERFORMANCE OF VICTIMHOOD ARE PROVEN TACTICS FOR MOBILIZING SUPPORTERS AND SILENCING OPPONENTS.

LEFT-WING AMERICAN JEWISH CARTOONIST ELI VALLEY IS INTIMATELY FAMILIAR WITH SUCH TACTICS.

LIKE MANY AMERICAN JEWS, VALLEY IS CRITICAL OF ISRAEL'S TREATMENT OF PALESTINIANS, AND BELIEVES THAT STRUGGLING FOR JUSTICE AND EQUALITY IS AN ESSENTIAL PART OF JEWISH IDENTITY.

THE JEWISH TRADITION THAT I VALUE IS TOWARDS LIBERATION OF COMMUNITIES; IT'S ANTI-EMPIRE, ANTI-FASCISM; IT'S THE PASSOVER STORY, THE EXODUS FROM TYRANNY.

THEN, THERE IS THE VERY STRONG MODERN JEWISH TRADITION OF APPLYING OUR OWN PARTICULARIST JEWISH PHILOSOPHY TOWARD UNIVERSALIST HUMAN LIBERATION MOVEMENTS.

Eli Valley

VALLEY OPPOSES AMERICA'S JEWISH LEADERS WHO HAVE BETRAYED THIS TRADITION BY CHAMPIONING THE ISRAELI STATE'S MUSCULAR NATIONALISM.

If you're not outraged, you're not paying attention.

Anonymous

Remembering Heather Heyer

HE'S FURIOUS THAT THESE SAME LEADERS EMBRACED DONALD TRUMP JUST BECAUSE HE PANDERS TO ISRAEL -- EVEN THOUGH TRUMP'S POLITICS HAVE EMBOLDENED NEO-NAZIS, RESULTING IN RISING VIOLENCE AGAINST JEWS AND OTHER MINORITIES.

A Nazi flag at the "Unite the Right" rally in Charlottesville, 2017. Donald Trump did not initially criticize the rally or support the counter-demonstration. There were "very fine people, on both sides," he said. Trump consorted with individuals with alleged neo-Nazi links, such as Sebastian Gorka, who served in the White House in 2017.

A MAJOR THEME OF MY COMICS IS HOW JEWISH INSTITUTIONAL LEADERSHIP IS DOMINATED BY CENTER-RIGHT TO EXTREMIST-RIGHT VOICES THAT DON'T REPRESENT AMERICAN JEWRY.

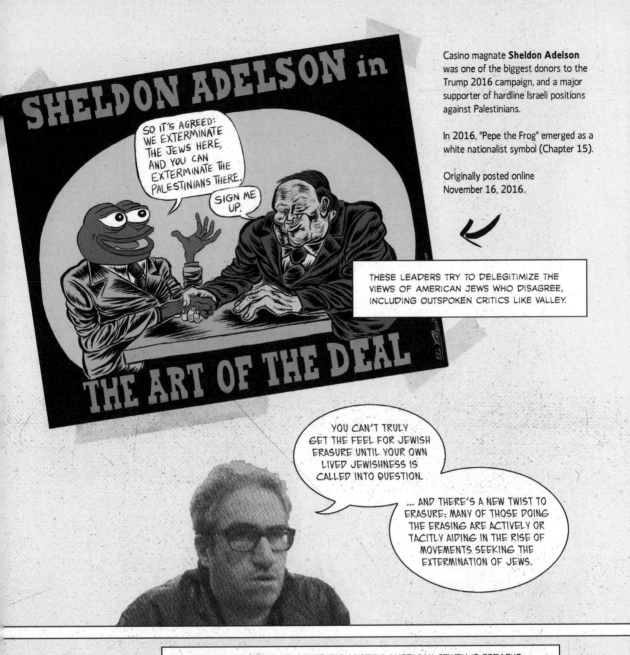

Casino magnate **Sheldon Adelson** was one of the biggest donors to the Trump 2016 campaign, and a major supporter of hardline Israeli positions against Palestinians.

In 2016, "Pepe the Frog" emerged as a white nationalist symbol (Chapter 15).

Originally posted online November 16, 2016.

THESE LEADERS TRY TO DELEGITIMIZE THE VIEWS OF AMERICAN JEWS WHO DISAGREE, INCLUDING OUTSPOKEN CRITICS LIKE VALLEY.

YOU CAN'T TRULY GET THE FEEL FOR JEWISH ERASURE UNTIL YOUR OWN LIVED JEWISHNESS IS CALLED INTO QUESTION.

... AND THERE'S A NEW TWIST TO ERASURE: MANY OF THOSE DOING THE ERASING ARE ACTIVELY OR TACITLY AIDING IN THE RISE OF MOVEMENTS SEEKING THE EXTERMINATION OF JEWS.

ONE MAJOR POINT OF CONTENTION WITHIN AMERICAN JEWRY IS ISRAEL'S SETTLEMENT BUILDING PROGRAM IN OCCUPIED PALESTINIAN TERRITORIES.

IN OCTOBER 2013, A PEW SURVEY FOUND THAT A HIGH PROPORTION OF AMERICAN JEWS DISAPPROVED OF ISRAEL'S WEST BANK SETTLEMENTS.

ABRAHAM FOXMAN, HEAD OF THE ANTI-DEFAMATION LEAGUE (A.D.L.), CLAIMED THAT THESE SURVEY RESPONDENTS WERE JEWS WHO "DON'T CARE." HE ADDED THAT HIS JOB WAS NOT TO FOLLOW BUT TO LEAD.

VALLEY RESPONDED WITH A COMIC SATIRIZING FOXMAN'S MCCARTHY-ESQUE PARANOIA. IT WAS PUBLISHED IN A LEADING PROGRESSIVE JEWISH NEWSPAPER, *THE FORWARD* ...

Abraham Foxman

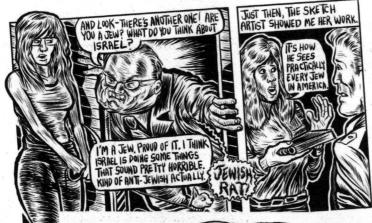

*Left and below*
Excerpts from "It Happened on Halloween,"
*The Forward,*
28 October 2013

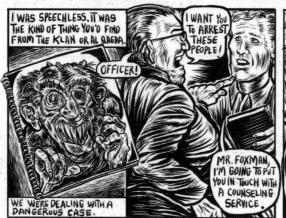

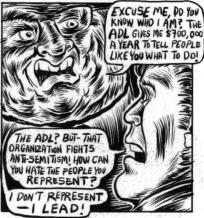

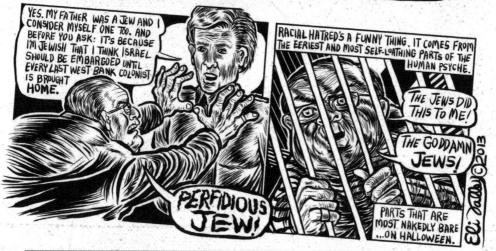

THE A.D.L. WAS AN IMPORTANT NEWSMAKER AND ADVERTISER OF *THE FORWARD.*

IT WAS PROBABLY NO COINCIDENCE THAT THE PAPER SUBSEQUENTLY ENDED ITS FIVE-YEAR RELATIONSHIP WITH THE ARTIST.

VALLEY CREDITS HIS GROTESQUE, EXTREME SATIRICAL STYLE MAINLY TO THE JEWISH CARTOONISTS BEHIND THE *MAD* COMICS OF THE 1950S. AMONG HIS OTHER INSPIRATIONS ARE THE ANTI-FASCIST, ANT-WAR ARTISTS OF WEIMAR GERMANY, OTTO DIX AND GEORGE GROSZ, WHOM THE NAZIS WOULD CONDEMN AS "DEGENERATE."

SO IT'S IRONIC THAT VALLEY IS ACCUSED OF RECYCLING NAZI-STYLE ANTISEMITIC ART.

PEOPLE WHO MAKE THE LEAP TO NAZI-ERA CARTOONS HAVE ZERO COMPREHENSION OF ART HISTORY AND JEWISH ART HISTORY.

THEY JUMP TO NAZI ART HISTORY BECAUSE THEY ARE INTERESTED IN ELIMINATING ANY DEPARTURE FROM ZIONIST ETHOS.

I KNOW WHERE THE TROPES ARE.

I EVEN GO OUT OF MY WAY TO DRAW NETANYAHU WITH A MORE DIMINUTIVE NOSE, FOR INSTANCE.

IT DOES NOT PLACATE THEM.

I DRAW MONSTERS AS MONSTERS ...

... AND NETANYAHU IS A FUCKING MONSTER.

*Right:* Extract from "Code Name: Evangelator" by Eli Valley, *The Forward*, 21 July 2011.

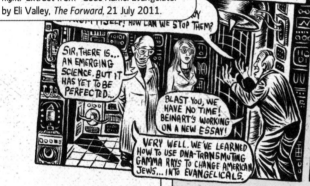

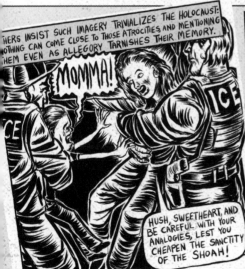

*Left*
Eli Valley on comparing Trump's treatment of refugees to the Holocaust, 2017. Excerpts.

I DO THINK THAT COMPARING ISRAEL TO NAZIS IS FACILE, TOO BROAD A GENERALIZATION, SO I NEVER USED TO DO IT.

BUT NOW THAT NETANYAHU HAS MADE ALLIANCES WITH THE SAME FORCES THAT ARE THE HEIRS TO NAZISM ...

... AND NOW THAT SOME AMERICAN JEWISH COMMUNAL LEADERS ARE CELEBRATING PEOPLE LIKE GORKA, A NAZI ALLY, IT IS NOW FAIR GAME.

325

IN 2019, VALLEY CAME CLOSE TO BEING *"DEPLATFORMED"* -- A STRATEGY, ASSOCIATED WITH THE CULTURAL LEFT, TO DENY PLATFORMS TO RACISTS.

THIS TIME, THOUGH, IT WAS USED AGAINST THE LEFT.

VALLEY HAD BEEN INVITED TO SPEAK AT STANFORD UNIVERSITY BY TWO STUDENT ORGANIZATIONS, ONE PALESTINIAN AND ONE JEWISH. WHEN THE STUDENTS PUBLICIZED THE TALK WITH SAMPLES OF VALLEY'S WORK, STANFORD COLLEGE REPUBLICANS ACCUSED THEM OF PROMOTING "ANTI-SEMITIC CARTOONS BY ISRAEL-HATING PROPAGANDIST."

I HAD BEEN UNDER THE MERCIFULLY MISTAKEN IMPRESSION THAT *DER STÜRMER*, THE NAZI NEWSPAPER EDITED BY JOSEPH GOEBBELS, HAD LONG AGO CEASED PUBLICATION.

... IMAGINE MY SURPRISE WHEN A FLOOD OF IMAGES SEEMINGLY DRAWN FROM *DER STÜRMER'S* ARCHIVES APPEARED ON CAMPUS... AS AN ADVERTISEMENT FOR A TALK BY CARTOONIST ELI VALLEY.

... THIS EVENT IS AN ABOMINATION.

Ari Hoffman, law student, in 'Stanford Daily'

THE RIGHT-WING ACTIVISTS PUT UP THEIR OWN POSTERS, LIKENING ONE OF VALLEY'S CARTOONS TO ANTI-SEMITIC ART FROM *DER STURMER*.

A panel from a Valley comic originally published in *The Forward* in 2009. His Jewish in-joke was so appreciated by Jews themselves that the drawing was printed on tote bags for the 2012 National Jewish Student Journalism Conference.

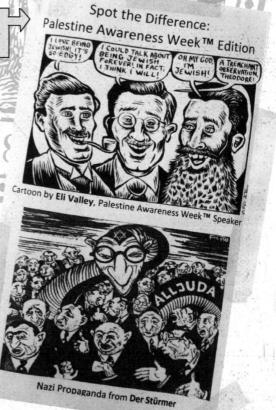

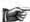

A classic *Der Sturmer* anti-Semitic cartoon.

A TWEET BY *NEW YORK TIMES* OPINION EDITOR BARI WEISS GAVE THE DEBATE NATIONAL PROMINENCE.

**Bari Weiss** ✔
@bariweiss

"Valley's work has nothing to do with peace in the Middle East, and everything to do with the free-form hatred that gloms onto Jews and the Jewish State." Thank you, @arih1987:

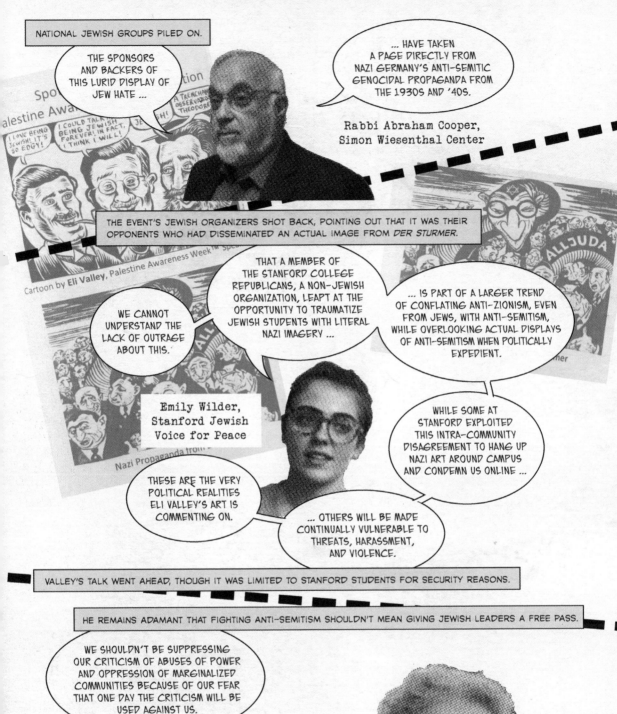

NATIONAL JEWISH GROUPS PILED ON.

THE SPONSORS AND BACKERS OF THIS LURID DISPLAY OF JEW HATE ...

... HAVE TAKEN A PAGE DIRECTLY FROM NAZI GERMANY'S ANTI-SEMITIC GENOCIDAL PROPAGANDA FROM THE 1930S AND '40S.

Rabbi Abraham Cooper, Simon Wiesenthal Center

Cartoon by **Eli Valley**, Palestine Awareness Week™ Spe...

THE EVENT'S JEWISH ORGANIZERS SHOT BACK, POINTING OUT THAT IT WAS THEIR OPPONENTS WHO HAD DISSEMINATED AN ACTUAL IMAGE FROM *DER STURMER*.

THAT A MEMBER OF THE STANFORD COLLEGE REPUBLICANS, A NON-JEWISH ORGANIZATION, LEAPT AT THE OPPORTUNITY TO TRAUMATIZE JEWISH STUDENTS WITH LITERAL NAZI IMAGERY ...

... IS PART OF A LARGER TREND OF CONFLATING ANTI-ZIONISM, EVEN FROM JEWS, WITH ANTI-SEMITISM, WHILE OVERLOOKING ACTUAL DISPLAYS OF ANTI-SEMITISM WHEN POLITICALLY EXPEDIENT.

WE CANNOT UNDERSTAND THE LACK OF OUTRAGE ABOUT THIS.

Emily Wilder, Stanford Jewish Voice for Peace

WHILE SOME AT STANFORD EXPLOITED THIS INTRA-COMMUNITY DISAGREEMENT TO HANG UP NAZI ART AROUND CAMPUS AND CONDEMN US ONLINE ...

Nazi Propaganda from ...

THESE ARE THE VERY POLITICAL REALITIES ELI VALLEY'S ART IS COMMENTING ON.

... OTHERS WILL BE MADE CONTINUALLY VULNERABLE TO THREATS, HARASSMENT, AND VIOLENCE.

VALLEY'S TALK WENT AHEAD, THOUGH IT WAS LIMITED TO STANFORD STUDENTS FOR SECURITY REASONS.

HE REMAINS ADAMANT THAT FIGHTING ANTI-SEMITISM SHOULDN'T MEAN GIVING JEWISH LEADERS A FREE PASS.

WE SHOULDN'T BE SUPPRESSING OUR CRITICISM OF ABUSES OF POWER AND OPPRESSION OF MARGINALIZED COMMUNITIES BECAUSE OF OUR FEAR THAT ONE DAY THE CRITICISM WILL BE USED AGAINST US.

BECAUSE WE'D BE GIVING UP OUR VOICE, WE'D BE GIVING UP OUR MORAL TRADITION, AND WE'D BE LIKE ANTS ON AN ANT FARM JUST SURVIVING REGARDLESS OF THE ETHICAL FOUNDATION OF OUR COMMUNITIES.

327

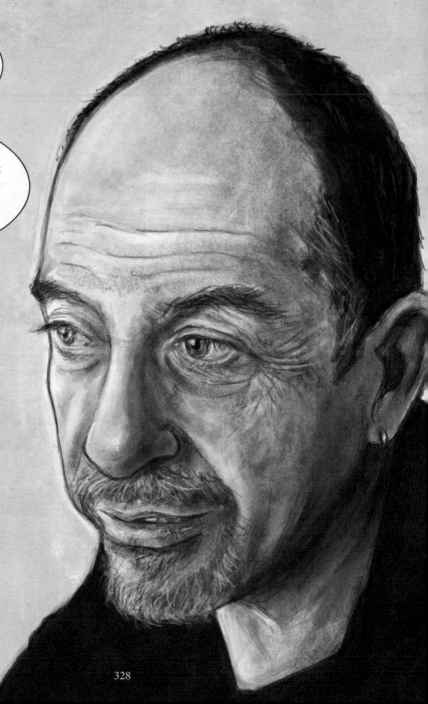

IN SOUTH AFRICA, ZAPIRO IS SIMILARLY COMMITTED TO HIS JOB AS A LOYAL CRITIC.

MY ROLE IS BOTH AS A MORAL MIRROR AND AS A WAY OF POKING FUN AT THE POWERFUL ...

... A WARPING MIRROR WHICH PROVIDES A GROTESQUE AND ALTERED REFLECTION OF EVENTS AND PERSONALITIES IN ORDER TO MAKE SHARP AND FUNNY POINTS.

THE A.N.C. GOVERNMENT AND ITS ALLIES HAVE BEEN KNOWN TO WHIP UP RAGE AGAINST ALLEGEDLY RACIST ART TO DIVERT PUBLIC ATTENTION FROM THE ADMINISTRATION'S FAILINGS.

THIS WAS ZAPIRO'S 2012 COMMENT ON THE CONTROVERSY SURROUNDING ANOTHER ARTIST'S WORK.

SO WE PLAYED THE RACE CARD, WHIPPED UP A FRENZY, THE PAINTING GOT CONVENIENTLY DESTROYED AND WE BULLIED CITY PRESS INTO REMOVING IT FROM THEIR SITE!

...I HAVE A COUNTRY TO RUIN!

GOOD! NOW CAN WE MOVE ON? IF YOU'LL EXCUSE ME...

BRETT MURRAY'S PAINTING "THE SPEAR" (2010) DEPICTED JACOB ZUMA IN A LENINESQUE POSE, BUT WITH HIS GENITALS DANGLING OUT OF HIS UNZIPPED PANTS.

ONE TELL-TALE SIGN OF MANUFACTURED RAGE IS WHEN DISINFORMATION IS INVOLVED, SUCH AS WHEN THE PROVOCATIVE CARTOON ATTRIBUTED TO THE ARTIST IS COMPLETELY FABRICATED (SEE CHAPTER 8).

BUT ZAPIRO ADMITS THAT NOT ALL THE CRITICISM OF HIS WORK CAN BE ATTRIBUTED TO OPPORTUNISTIC MANIPULATION OF RACIAL SENSITIVITIES FOR SELFISH POLITICAL MOTIVES.

HE CONTINUES TO REFLECT ON THE FALLOUT FROM HIS ORGAN-GRINDER'S MONKEY CARTOON.

HE FAULTS HIMSELF FOR NOT SEEING IT COMING. HE WAS AWARE OF THE MONKEY TROPE, OF COURSE.

**Penny Sparrow**
These monkeys that are allowed to be released on New years Eve And new years day on to public beaches towns etc obviously have no education what so ever so to allow them loose is inviting huge dirt and troubles and discomfort to others. I'm sorry to say I was amongst the revellers and all I saw were black on black skins what a shame. I do know some wonderful thoughtful black people. This lot of monkeys just don't want to even try. But think they can voice opinions about statute and get their way dear oh dear . from now I. Shall address the blacks of south Africa as monkeys as I see the cute little wild monkeys do the same pick drop and litter. 😊

Sat at 1:30 PM · Like · 👍 15

AND, LESS THAN SIX MONTHS EARLIER, THERE HAD BEEN NATIONAL OUTRAGE OVER AN ELDERLY WHITE CITIZEN'S FACEBOOK POST LIKENING BLACK BEACHGOERS TO MONKEYS.

SHE WAS AN OUT AND OUT RACIST; SHE WAS PROSECUTED FOR IT. I DON'T KNOW HOW I MISSED THAT.

HOW I COULD I HAVE THOUGHT THAT MY OWN ANTI-RACIST TRACK RECORD COULD SOMEHOW KEEP ME FROM BEING PUT THROUGH THE GRINDER BY SOME PEOPLE?

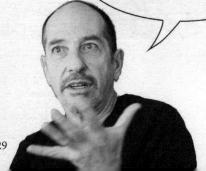

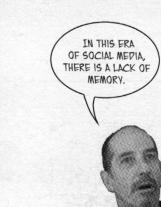

IN THIS ERA OF SOCIAL MEDIA, THERE IS A LACK OF MEMORY.

SOCIAL MEDIA IS A PLACE FOR ATTITUDES.

CONTENT, CONTEXT AND HISTORY AND MEMORY ...

... ALL OF THOSE THINGS ARE UNDERVALUED.

WHAT DOES GET TRACTION IS *SHAMING* IN VARIOUS FORMS.

THOSE THINGS ARE SO SHALLOW, THEY CAN'T TAKE INTO ACCOUNT PEOPLE'S TRACK RECORDS, WHAT THEY REALLY STAND FOR, THE CAUSES THEY'VE CHAMPIONED OVER THE YEARS.

I WAS ALWAYS PRETTY GOOD AT JUDGING THE MOOD OF THE TIMES.

I HAD KIND OF FIGURED IT OUT PRETTY WELL, BUT THIS TIME I MISJUDGED BADLY.

BITTER EXPERIENCE HAS TAUGHT ZAPIRO TO "SECOND-GUESS."

IS THE BLOWBACK THAT'S GOING TO INEVITABLY COME GOING TO BE SO HUGE AND SO DISTRACTING THAT IT TAKES AWAY FROM THE MAIN POLITICAL POINT THAT I'M TRYING TO MAKE WITH THE CARTOON?

IF SO, LET'S FIND ANOTHER WAY TO SAY THE SAME THING STRONGLY, NOT DILUTE THE MESSAGE, BUT BY USING A DIFFERENT METAPHOR.

THIS BUSINESS OF SECOND-GUESSING MYSELF IS CERTAINLY A BIG SHIFT FOR ME, AND I DO ASK MYSELF, IS IT SELF-CENSORSHIP OR IS IT EMOTIONAL INTELLIGENCE?

IT'S A DILEMMA THAT CONFRONTS ALL CARTOONISTS IN DIVIDED SOCIETIES: HOW TO TELL THE DIFFERENCE BETWEEN SURRENDERING TO THE MOB ...

... AND ADAPTING ONE'S WORK IN SOLIDARITY WITH THE OPPRESSED.

# 13. Undrawable

## The Aura of the Sacred

_____

_____

_____

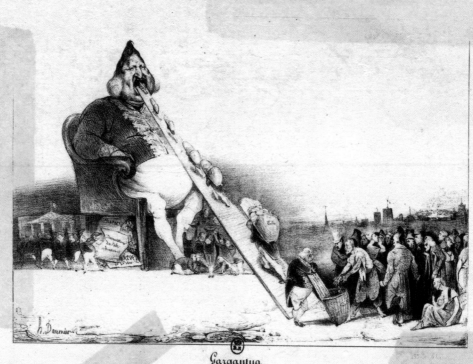

*Gargantua.*

*Above*
Daumier's "Gargantua" shows ministers
carrying tributes from France's poor into
the king's gaping mouth. It was probably
intended for the popular weekly satirical
journal *La Caricature* but turned down by
the publisher for fear of government reprisal.
Instead, prints were sold at a caricature shop.

Honoré
Daumier

... AND NEW PRINTING TECHNOLOGIES MULTIPLIED THEIR TAUNTS FOR ALL TO SEE.

IN FRANCE, *HONORÉ DAUMIER* (1808–79) REVELLED IN THE NEW ENVIRONMENT. IN 1831,
HE CREATED THE ABOVE CARICATURE OF KING LOUIS PHILIPPE AS THE RAVENOUS GIANT
GARGANTUA, A WELL-KNOWN CHARACTER FROM A 16TH CENTURY NOVEL BY FRANÇOIS RABELAIS.

"GARGANTUA" EARNED DAUMIER A SIX-MONTH SENTENCE FOR THE TREASON OF OFFENDING THE KING'S PERSON -- A CRIME KNOWN AS *LESE MAJESTÉ*.

*Left*
Sainte-Pelagie prison, Paris, where Daumier was incarcerated.

AS LIBERALISM AND DEMOCRACY GAINED GROUND, SATIRICAL CARICATURES OF THE POWERFUL WERE NOT JUST TOLERATED BUT ALSO TREATED AS NORMAL, EVEN EXPECTED AND CELEBRATED.

*Left*
Thomas Nast
*Harper's Weekly*, 1871.

Nast's cartoon depicts the corrupt New York politician William Magear Tweed with a money bag for a head. Nast's series on "Boss" Tweed is among the most celebrated cases of political cartoons helping to bring down the powerful.

THE "BRAINS"

*Right*
Morten Morland
The *Times*, 2016.

Morland, who is Norwegian but has lived in London since 2000, dips into Britain's tradition of scatological humor in this cartoon quoting Boris Johnson's actual words following the Conservative politician's decision to campaign for Brexit. "As with most things Boris decides, you get the impression he found the answers up his own arse — where all of his personal ambitions are stored," Morland said.

THIS DID NOT HAPPEN EVERYWHERE, THOUGH. SOME CULTURES CONTINUED TO PROTECT THEIR MOST VENERATED INDIVIDUALS FROM CARTOONISTS' JABS, FORBIDDING ARTISTIC DEPICTIONS OF ANY KIND.

(THE MOST WELL-KNOWN OF THESE TABOOS ARE INJUNCTIONS AGAINST DRAWING ISLAM'S PROPHET MOHAMMAD -- BUT MORE ABOUT THAT LATER.)

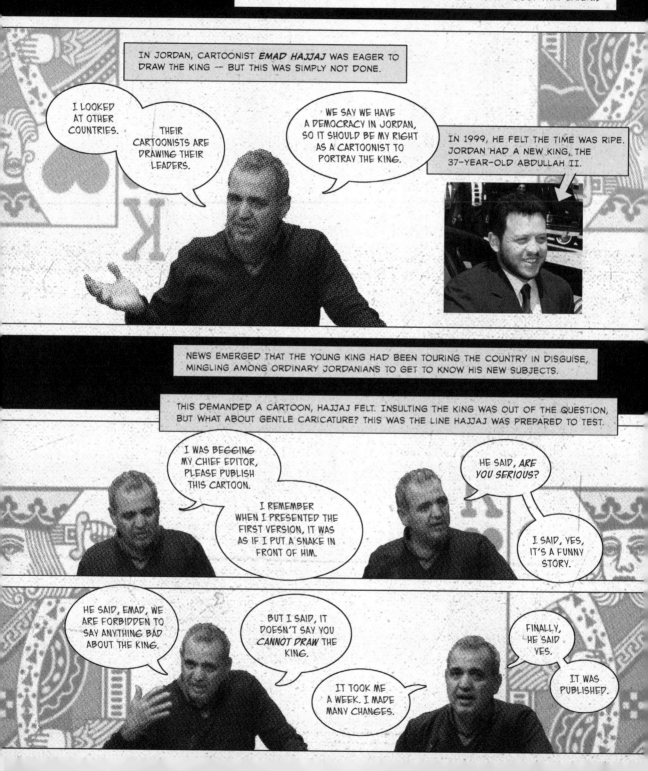

IN JORDAN, CARTOONIST *EMAD HAJJAJ* WAS EAGER TO DRAW THE KING -- BUT THIS WAS SIMPLY NOT DONE.

I LOOKED AT OTHER COUNTRIES.

THEIR CARTOONISTS ARE DRAWING THEIR LEADERS.

WE SAY WE HAVE A DEMOCRACY IN JORDAN, SO IT SHOULD BE MY RIGHT AS A CARTOONIST TO PORTRAY THE KING.

IN 1999, HE FELT THE TIME WAS RIPE. JORDAN HAD A NEW KING, THE 37-YEAR-OLD ABDULLAH II.

NEWS EMERGED THAT THE YOUNG KING HAD BEEN TOURING THE COUNTRY IN DISGUISE, MINGLING AMONG ORDINARY JORDANIANS TO GET TO KNOW HIS NEW SUBJECTS.

THIS DEMANDED A CARTOON, HAJJAJ FELT. INSULTING THE KING WAS OUT OF THE QUESTION, BUT WHAT ABOUT GENTLE CARICATURE? THIS WAS THE LINE HAJJAJ WAS PREPARED TO TEST.

I WAS BEGGING MY CHIEF EDITOR, PLEASE PUBLISH THIS CARTOON.

I REMEMBER WHEN I PRESENTED THE FIRST VERSION, IT WAS AS IF I PUT A SNAKE IN FRONT OF HIM.

HE SAID, *ARE YOU SERIOUS?*

I SAID, YES, IT'S A FUNNY STORY.

HE SAID, EMAD, WE ARE FORBIDDEN TO SAY ANYTHING BAD ABOUT THE KING.

BUT I SAID, IT DOESN'T SAY YOU *CANNOT DRAW* THE KING.

IT TOOK ME A WEEK. I MADE MANY CHANGES.

FINALLY, HE SAID YES.

IT WAS PUBLISHED.

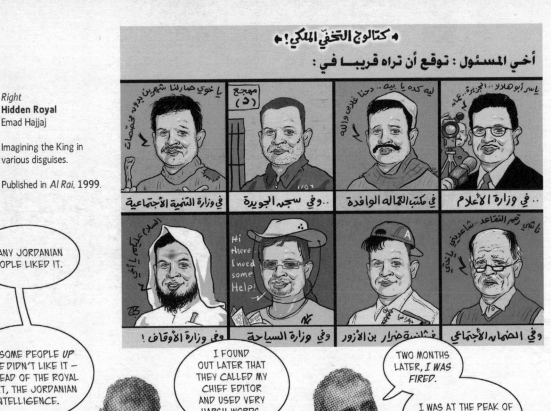

*Right*
**Hidden Royal**
Emad Hajjaj

Imagining the King in various disguises.

Published in *Al Rai*, 1999.

MANY JORDANIAN PEOPLE LIKED IT.

BUT SOME PEOPLE *UP THERE* DIDN'T LIKE IT — THE HEAD OF THE ROYAL COURT, THE JORDANIAN INTELLIGENCE.

I FOUND OUT LATER THAT THEY CALLED MY CHIEF EDITOR AND USED VERY HARSH WORDS.

TWO MONTHS LATER, *I WAS* FIRED.

I WAS AT THE PEAK OF MY CAREER. SUDDENLY, UNEMPLOYED.

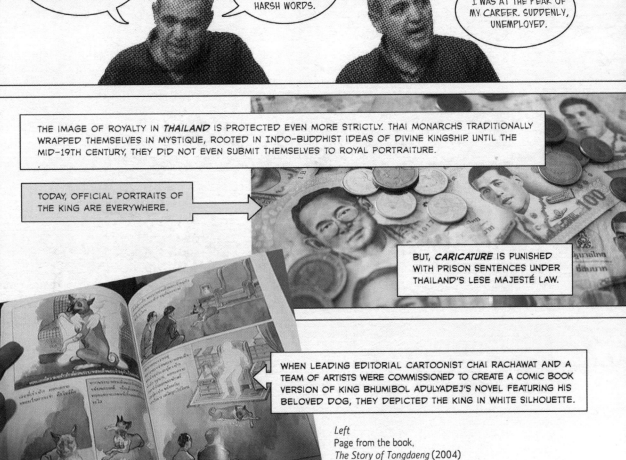

THE IMAGE OF ROYALTY IN *THAILAND* IS PROTECTED EVEN MORE STRICTLY. THAI MONARCHS TRADITIONALLY WRAPPED THEMSELVES IN MYSTIQUE, ROOTED IN INDO-BUDDHIST IDEAS OF DIVINE KINGSHIP. UNTIL THE MID-19TH CENTURY, THEY DID NOT EVEN SUBMIT THEMSELVES TO ROYAL PORTRAITURE.

TODAY, OFFICIAL PORTRAITS OF THE KING ARE EVERYWHERE.

BUT, *CARICATURE* IS PUNISHED WITH PRISON SENTENCES UNDER THAILAND'S LESE MAJESTÉ LAW.

WHEN LEADING EDITORIAL CARTOONIST CHAI RACHAWAT AND A TEAM OF ARTISTS WERE COMMISSIONED TO CREATE A COMIC BOOK VERSION OF KING BHUMIBOL ADULYADEJ'S NOVEL FEATURING HIS BELOVED DOG, THEY DEPICTED THE KING IN WHITE SILHOUETTE.

*Left*
Page from the book,
*The Story of Tongdaeng* (2004)

THE *NATION*'S CARTOONIST STÉPHANE PERAY (STEPHFF) WAITED UNTIL KING BHUMIBOL DIED BEFORE DARING TO DRAW HIM -- ASCENDING TO HEAVEN ON THE GARUDA, THE MYTHICAL CREATURE THAT THAIS ASSOCIATE WITH THE DIVINE POWER OF THEIR KINGS.

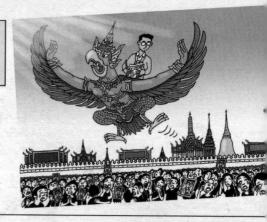

"I MANAGED TO DRAW THE KING WITHOUT OFFENDING ANYBODY," STEPHFF SAID.

"IT WAS A PERILOUS EXERCISE BUT IN THE END EVERYBODY, INCLUDING MY EDITOR, SAW A VERY RESPECTFUL CARTOON."

THE WORLD'S RELIGIONS HAVE CONFLICTING ATTITUDES TOWARDS ARTISTIC REPRESENTATION.

RELIGIOUS FAITH HAS INSPIRED SOME OF THE WORLD'S GREATEST FIGURATIVE ART....

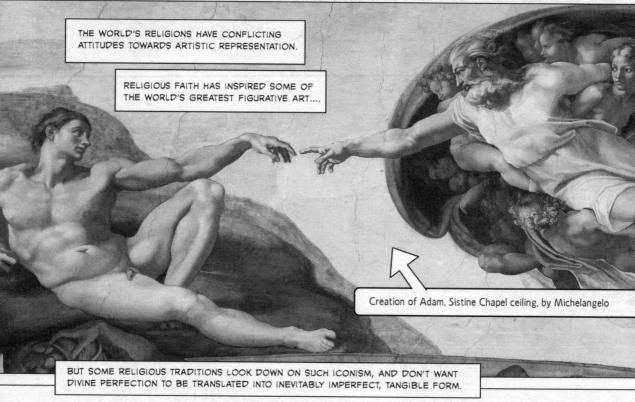

Creation of Adam, Sistine Chapel ceiling, by Michelangelo

BUT SOME RELIGIOUS TRADITIONS LOOK DOWN ON SUCH ICONISM, AND DON'T WANT DIVINE PERFECTION TO BE TRANSLATED INTO INEVITABLY IMPERFECT, TANGIBLE FORM.

PROHIBITIONS AGAINST DEPICTING GOD HAVE EMERGED TO VARYING DEGREES WITHIN THE MONOTHEISTIC FAITHS OF JUDAISM, CHRISTIANITY, AND ISLAM. IN RELIGIOUS STUDIES AND ART HISTORY, SUCH THINKING IS KNOWN AS *"ANICONISM"* -- THE BELIEF THAT THE DIVINE IS BEYOND REPRESENTATION, AND MUST NOT BE TURNED INTO AN ICON.

EXTREME ANICONISM WAS USUALLY A REACTION TO COMPETING BELIEF SYSTEMS. RELIGIOUS LEADERS (LIKE EARLY CALVINIST CHRISTIANS IN THE PROTESTANT REFORMATION) WANTED TO INOCULATE FOLLOWERS AGAINST MORE SEDUCTIVE VISUAL CULTURES THAT SURROUNDED THEM (LIKE THE CATHOLIC CHURCH).

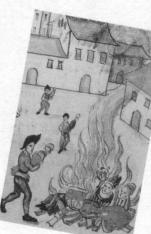

*Right*
Reformists burning Catholic icons in 16th century Zurich. Anonymous.

TODAY, THE MOST FIERCELY GUARDED MORTAL IN THE UNDRAWABLE PANTHEON IS ISLAM'S PROPHET MOHAMMAD. THE TABOO BECAME SPECTACULARLY FAMOUS DURING THE DANISH CARTOON CONTROVERSY OF 2005-06.

CLAIMING TO TAKE A STAND AGAINST MUSLIMS' INTOLERANCE TOWARD CRITICISM OF THEIR RELIGION, THE DANISH NEWSPAPER *JYLLANDS-POSTEN* INVITED ILLUSTRATORS TO DRAW CARTOONS PORTRAYING MOHAMMED AS THEY SAW HIM.

IT PUBLISHED 12 CARTOONS UNDER THE HEADLINE *"THE FACE OF MUHAMMAD."*

Muhammeds ansigt

THE PAPER ARGUED THAT SOME MUSLIMS' INSISTENCE ON "SPECIAL CONSIDERATION OF THEIR OWN RELIGIOUS FEELINGS" WAS "INCOMPATIBLE WITH SECULAR DEMOCRACY AND FREEDOM OF EXPRESSION, WHERE ONE HAS TO BE READY TO PUT UP WITH SCORN, MOCKERY AND RIDICULE."

*KURT WESTERGAARD*'S CARTOON WAS PROBABLY THE MOST PROVOCATIVE.

IT SHOWED A BEARDED MAN WITH GLARING EYES.

INSTEAD OF A TURBAN, HE WEARS A BOMB WITH A SPARKLING FUSE.

THIS WAS A CHANCE TO RESPOND TO THE PROVOCATION BY TERRORISTS WHO USE RELIGION AS THEIR SPIRITUAL AMMUNITION.

AS A FINISHING TOUCH, THE BOMB IS ADORNED WITH THE MUSLIM PROFESSION OF FAITH OR SHAHADA, IN ARABIC CALLIGRAPHY.

*JYLLANDS-POSTEN*'S STUNT WAS MEANT TO SHOWCASE DANES' COMMITMENT TO FREEDOM AND DEMOCRACY. BUT IT ONLY MANAGED TO PROVE THAT THE FORCES THEY WISHED TO REPEL WERE STRONGER THAN ANYONE HAD IMAGINED.

Kurt Westergaard

AFTER THE CARTOONS' PUBLICATION IN SEPTEMBER 2005, THE PROTESTS WERE PEACEFUL AT FIRST. THEY TOOK A TURN FOR THE WORSE IN EARLY 2006, AS POLITICIANS AND PREACHERS EGGED ON THE MASSES.

*Background image Protests in Lebanon*

WE CAN ALSO ANNOUNCE REWARD FOR KILLING THE MAN WHO HAS CAUSED THIS SACRILEGE.

WE ARE NOT JACKASSES TO BE RIDDEN, BUT LIONS THAT ROAR.

Qatari preacher Yusuf Al-Qaradawi

Pakistani mullah Yousef Qureshi

KURT WESTERGAARD WAS THE TARGET OF ASSASSINATION ATTEMPTS, INCLUDING ONE FOUR YEARS LATER BY AN AX-WIELDING INTRUDER WHO BROKE INTO HIS HOME WHILE HE WAS BABYSITTING HIS FIVE-YEAR-OLD GRANDDAUGHTER. WESTERGAARD ESCAPED HARM BY LOCKING HIMSELF IN A BATHROOM HE HAD CONVERTED INTO A REINFORCED PANIC ROOM.

THE FALLOUT FROM *JYLLANDS-POSTEN*'S MOHAMMED CARTOONS AMOUNTED TO THE WORLD'S BIGGEST EVER RUCKUS CONCERNING ART OF ANY KIND. LEGAL, ETHICAL, AND POLITICAL DEBATES RAGED IN THE MEDIA, UNIVERSITIES, PARLIAMENTS, AND THE UNITED NATIONS.

MUSLIMS TRIED TO EXPLAIN WHY MOST FOUND THE CARTOON STUNT SO HURTFUL: IT WAS RACIST BULLYING OF A WEAKER COMMUNITY. THE LOUDEST VOICE, THOUGH, BELONGED TO THE VIOLENT ABSOLUTISTS WHO SCREAMED "BLASPHEMY" AND WERE PREPARED TO KILL FOR IT.

THE RESULT IS *SELF-CENSORSHIP* BY MANY CARTOONISTS, EDITORS, AND PUBLISHERS. THEY INTERNALIZE THE BAN ON DEPICTING THE PROPHET, FEARING VIOLENT REPRISALS FOR NON-COMPLIANCE.

WHEN YALE UNIVERSITY PRESS PUBLISHED A 240-PAGE ACADEMIC BOOK ABOUT THE DANISH CASE, IT DECIDED NOT TO INCLUDE THE 12 CARTOONS AT THE CENTER OF THE CONTROVERSY, OR EVEN EXAMPLES OF ISLAMIC ART WITH REVERENTIAL DEPICTIONS OF THE PROPHET.

# Yale
## UNIVERSITY
## PRESS

... YALE UNIVERSITY CONSULTED A NUMBER OF SENIOR ACADEMICS, DIPLOMATS, AND NATIONAL SECURITY EXPERTS.

THE OVERWHELMING JUDGMENT OF THE EXPERTS WITH THE MOST INSIGHT ABOUT THE THREATS OF VIOLENCE ...

## The Cartoons that Shook the World

### Jytte Klausen

"Deeply researched and sensitively written, this tells a story that has to be told."—Shereen Williams Pulitzer, Member of the House of Lords

*Left*
The 2009 book by Danish-born professor Jytte Klausen, who is quoted in Chapter 14.

... WAS THAT THERE EXISTED AN APPRECIABLE CHANCE OF VIOLENCE OCCURRING IF EITHER THE CARTOONS OR OTHER DEPICTIONS OF THE PROPHET MUHAMMAD WERE PRINTED ...

THIS IMPORTANT CASE OF SELF-CENSORSHIP BY AN ACADEMIC PRESS WAS DISCUSSED WITH THE BOOK'S AUTHOR IN AN INTERVIEW WITH *INDEX ON CENSORSHIP*. IRONICALLY, THE MAGAZINE'S BOARD OF TRUSTEES MADE THE SAME DECISION AS HER PUBLISHER. IT WOULD NOT RUN THE CARTOONS.

INDEX ON CENSORSHIP
Volume 38 Number 4 2009

2009
YEAR IN REVIEW

AI WEIWEI
DEFIES CHINESE INTIMIDATION TACTICS

DMITRY MURATOV
STANDS UP FOR PRESS FREEDOM IN RUSSIA

JOEL SIMON
CHARTS A ROADMAP FOR STOPPING THE KILLERS

MELISSA GOODMAN
EXPLAINS WHY OBAMA BROKE HIS PROMISE

# X index
## the voice of free expression

TO SUMMARISE OUR COMMON VIEW: RE-PUBLICATION OF THE CARTOONS WOULD PUT AT RISK THE SECURITY OF OUR STAFF AND OTHERS WHICH, ON BALANCE, COULD NOT BE JUSTIFIED ON "FREEDOM OF EXPRESSION" GROUNDS ALONE.

IN HIS BOOK, *THE ART OF CONTROVERSY*, AMERICAN EDITOR VICTOR NAVASKY VIGOROUSLY DEFENDS THE DEMOCRATIC VALUE OF CARICATURE.

WHEN DISCUSSING THE DANISH CARTOON CONTROVERSY, NAVASKY'S BOOK REPRODUCES A CLEVER CARTOON DONE AT THE TIME BY JEAN PLANTUREUX (PLANTU) IN FRANCE.

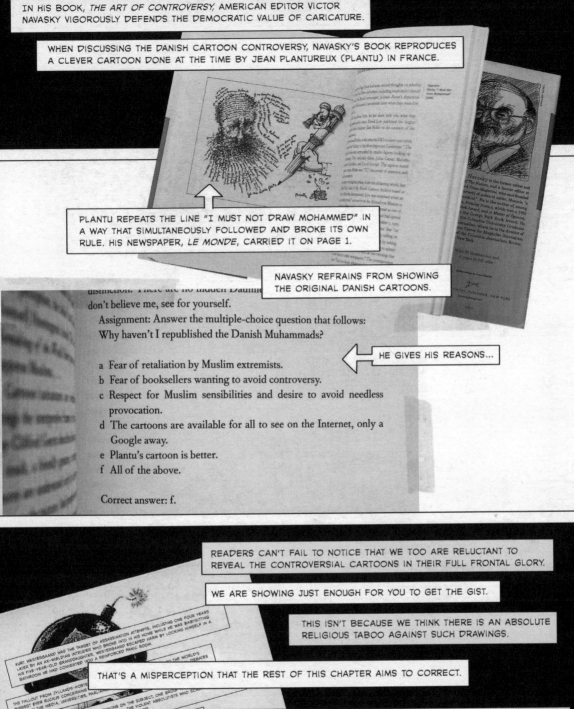

PLANTU REPEATS THE LINE "I MUST NOT DRAW MOHAMMED" IN A WAY THAT SIMULTANEOUSLY FOLLOWED AND BROKE ITS OWN RULE. HIS NEWSPAPER, *LE MONDE*, CARRIED IT ON PAGE 1.

NAVASKY REFRAINS FROM SHOWING THE ORIGINAL DANISH CARTOONS.

distinction. There are no hidden Daumie don't believe me, see for yourself.

Assignment: Answer the multiple-choice question that follows:
Why haven't I republished the Danish Muhammads?

HE GIVES HIS REASONS...

a Fear of retaliation by Muslim extremists.
b Fear of booksellers wanting to avoid controversy.
c Respect for Muslim sensibilities and desire to avoid needless provocation.
d The cartoons are available for all to see on the Internet, only a Google away.
e Plantu's cartoon is better.
f All of the above.

Correct answer: f.

READERS CAN'T FAIL TO NOTICE THAT WE TOO ARE RELUCTANT TO REVEAL THE CONTROVERSIAL CARTOONS IN THEIR FULL FRONTAL GLORY.

WE ARE SHOWING JUST ENOUGH FOR YOU TO GET THE GIST.

THIS ISN'T BECAUSE WE THINK THERE IS AN ABSOLUTE RELIGIOUS TABOO AGAINST SUCH DRAWINGS.

THAT'S A MISPERCEPTION THAT THE REST OF THIS CHAPTER AIMS TO CORRECT.

NOR IS IT BECAUSE WE FEAR THAT THE AVERAGE MUSLIM CAN'T UNDERSTAND THE DIFFERENCE BETWEEN DISCUSSING AND ENDORSING AN INSULT.

BUT THIS IS NOT ABOUT WHAT REASON RECOMMENDS OR THE MAJORITY OF MUSLIMS BELIEVE. IT IS ABOUT THE ACTIONS OF UNCOMPROMISING, UNREPRESENTATIVE, AND UNPREDICTABLE INDIVIDUALS.

THE DANISH CARTOONS AFFAIR AND THE *CHARLIE HEBDO* KILLINGS HAVE CAST A LONG SHADOW AND NOBODY KNOWS FOR SURE WHEN THAT SHADOW CAN BE PUT BEHIND US.

THE PROPHET'S UNDRAWABILITY BECAME WIDELY ACCEPTED AS A PRACTICAL NECESSITY. WHAT IS LESS CLEAR IS WHETHER THE TABOO IS ALSO "GOOD CENSORSHIP" -- A RULE THAT SHOULD BE VOLUNTARILY FOLLOWED, NOT OUT OF FEAR, BUT OUT OF RESPECT FOR A RELIGIOUS COMMUNITY.

MOST **MUSLIM CARTOONISTS** WOULD PROBABLY TELL YOU THAT THIS IS WHY THEY AVOID DRAWING THE PROPHET, AND WHY OTHERS SHOULD, TOO.

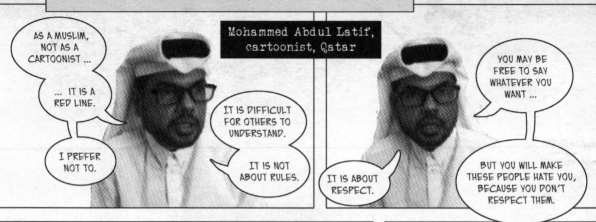

Mohammed Abdul Latif, cartoonist, Qatar

AS A MUSLIM, NOT AS A CARTOONIST ...

... IT IS A RED LINE.

IT IS DIFFICULT FOR OTHERS TO UNDERSTAND.

I PREFER NOT TO.

IT IS NOT ABOUT RULES.

IT IS ABOUT RESPECT.

YOU MAY BE FREE TO SAY WHATEVER YOU WANT ...

BUT YOU WILL MAKE THESE PEOPLE HATE YOU, BECAUSE YOU DON'T RESPECT THEM.

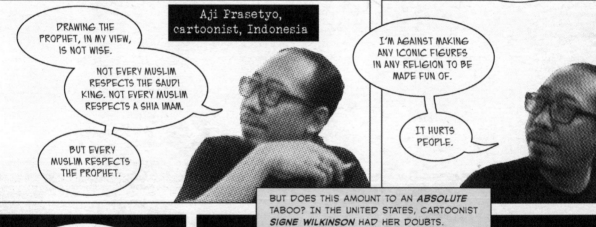

Aji Prasetyo, cartoonist, Indonesia

DRAWING THE PROPHET, IN MY VIEW, IS NOT WISE.

NOT EVERY MUSLIM RESPECTS THE SAUDI KING. NOT EVERY MUSLIM RESPECTS A SHIA IMAM.

BUT EVERY MUSLIM RESPECTS THE PROPHET.

I'M AGAINST MAKING ANY ICONIC FIGURES IN ANY RELIGION TO BE MADE FUN OF.

IT HURTS PEOPLE.

BUT DOES THIS AMOUNT TO AN **ABSOLUTE** TABOO? IN THE UNITED STATES, CARTOONIST **SIGNE WILKINSON** HAD HER DOUBTS.

WHEN YOU GET TO THE BOTTOM OF A LOT PEOPLE'S HOLY SYMBOLS, THEY ONLY OBJECT IF THE CARTOONIST USES IT NEGATIVELY AGAINST THE GROUP ...

... NOT IF IT'S USED POSITIVELY.

WHEN THE DANISH CONTROVERSY CAME OUT, I IMMEDIATELY WANTED TO DRAW MOHAMMAD.

MY EDITOR, WHO HAD BACKED ME UP ON SO MANY CONTROVERSIES, SAID THIS ISN'T OUR CONTROVERSY, LET'S NOT GET INTO IT.

I WENT HOME AND STEWED FOR A WHILE, AND THEN THOUGHT I WOULD TEST MY THEORY THAT PEOPLE ARE ONLY UPSET IF YOU SHOW THEM NEGATIVELY.

Signe Wilkinson

SO I DID HIS CARTOON, WITH MOHAMMAD THIRD FROM THE RIGHT...

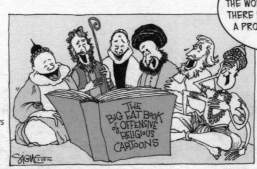

*Right*
**Religious**
Feb 8, 2006
By Signe Wilkinson
*Philadelphia Daily News*

THE BIG FAT BOOK of OFFENSIVE RELIGIOUS CARTOONS

IT HAS GONE AROUND THE WORLD VIRALLY, AND THERE HAS NEVER BEEN A PROTEST ABOUT IT.

AND I'M STILL ALIVE.

NOBODY LIKES TO BE CARICATURED NEGATIVELY.

EVERYONE'S OK IF THE STEREOTYPE IS A POSITIVE STEREOTYPE.

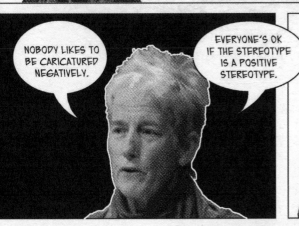

PALESTINIAN CARTOONIST MOHAMMAD SABA'ANEH TAKES A SIMILAR VIEW. AFTER THE *CHARLIE HEBDO* AFFAIR, HE TRIED TO GET FELLOW MUSLIM CARTOONISTS TO RESPOND.

IF WE WANT TO DEFEND THE PROPHET MOHAMMAD WE SHOULD DEFEND IN THE SAME WAY, NOT BY VIOLENCE.

HIS NEWSPAPER PUBLISHED THE CARTOON.

Prophet Muhammad سيدنا محمد

www.sabaaneh.com

*Right*
**Prophet**
Feb 1, 2015
By Mohammad Sabaaneh.
Published in *al-Hayat al-Jadida*

BUT A PALESTINIAN POLITICIAN HE'D CRITICIZED COMPLAINED.

AS A RESULT, HE AND HIS EDITOR WERE SUSPENDED FOR A WEEK.

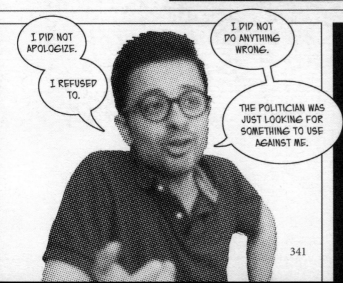

I DID NOT APOLOGIZE.

I REFUSED TO.

I DID NOT DO ANYTHING WRONG.

THE POLITICIAN WAS JUST LOOKING FOR SOMETHING TO USE AGAINST ME.

THERE WERE SEVERAL OTHER MUSLIM EDITORS WHO CLEARLY REJECTED THE NOTION OF AN ABSOLUTE PROHIBITION. THEY BELIEVED THAT CONTEXT AND INTENTION MATTER.

IN INDONESIA –– HOME TO THE WORLD'S LARGEST POPULATION OF MUSLIMS –– THE *RAKYAT MERDEKA* NEWS SITE PUBLISHED A COUPLE OF THE 12 CARTOONS TO ACCOMPANY NEWS STORIES SOON AFTER THEY APPEARED IN DENMARK, AND THEN AGAIN WHEN GLOBAL CONTROVERSY EXPLODED.

341

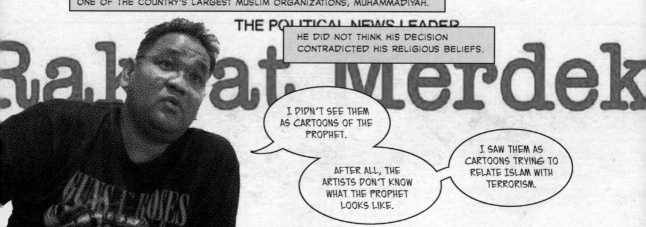

HE DID NOT THINK HIS DECISION CONTRADICTED HIS RELIGIOUS BELIEFS.

I DIDN'T SEE THEM AS CARTOONS OF THE PROPHET.

AFTER ALL, THE ARTISTS DON'T KNOW WHAT THE PROPHET LOOKS LIKE.

I SAW THEM AS CARTOONS TRYING TO RELATE ISLAM WITH TERRORISM.

IT DID NOT MATTER TO SANTOSA THAT *JYLLANDS-POSTEN* HAD TITLED THE PAGE, "THE FACES OF MOHAMMED."

EVEN THOUGH THAT WAS THEIR INTENTION, WE KNOW ANY TEXT DOESN'T BELONG TO THE ARTIST.

IT BELONGS TO THE PUBLIC. IT IS UP TO US TO DECIDE THE MEANING.

I KNEW THE CONTROVERSY WOULD EVENTUALLY REACH INDONESIA.

MUSLIMS ADORE THE PROPHET.

EVEN IF YOU ARE EDUCATED AND YOU KNOW THE CARTOONS ARE A PROVOCATION, YOU CAN'T HELP GETTING ANGRY.

I WANTED TO PREPARE OUR READERS FOR IT.

WE INTERVIEWED MANY SOURCES TO REPORT THE CASE IN CONTEXT.

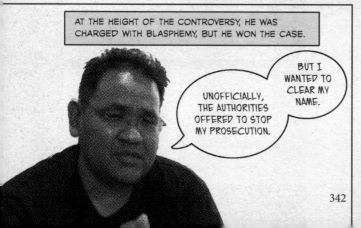

AT THE HEIGHT OF THE CONTROVERSY, HE WAS CHARGED WITH BLASPHEMY, BUT HE WON THE CASE.

BUT I WANTED TO CLEAR MY NAME.

UNOFFICIALLY, THE AUTHORITIES OFFERED TO STOP MY PROSECUTION.

I VISITED MANY MUSLIM SCHOLARS AND ORGANIZATIONS, TO CONSULT THEM AND EXPLAIN TO THEM MY MOTIVES.

THEY SUPPORTED ME.

342

THE OPINION OF THESE MUSLIM EDITORS AND CARTOONISTS -- THAT THE INJUNCTION IS SUBJECT TO THE IMAGE'S MEANING, INTENTION, AND CONTEXT -- IS BACKED BY TEXTUAL AND HISTORICAL EVIDENCE.

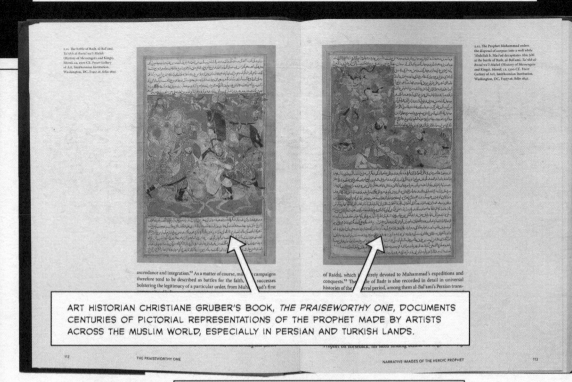

ART HISTORIAN CHRISTIANE GRUBER'S BOOK, *THE PRAISEWORTHY ONE*, DOCUMENTS CENTURIES OF PICTORIAL REPRESENTATIONS OF THE PROPHET MADE BY ARTISTS ACROSS THE MUSLIM WORLD, ESPECIALLY IN PERSIAN AND TURKISH LANDS.

SUDANESE CARTOONIST *KHALID ALBAIH* USED TO WORK FOR THE QATAR MUSEUMS AUTHORITY AND HAS SEEN ORIGINALS WITH HIS OWN EYES.

IN EVERY MUSEUM OF ISLAMIC ART, THERE IS PROBABLY A MANUSCRIPT WHERE THE PROPHET IS DEPICTED.

IT'S THE CONTEXT.

HISTORICALLY, THAT'S NOT THE ISSUE.

THERE'S EVEN A *FATWA* THAT MAKES THE SAME POINT.

IN 1997, MUSLIM GROUPS IN THE US LOBBIED FOR THE MODIFICATION OF A MARBLE FRIEZE IN THE U.S. SUPREME COURT BUILDING.

THE 1932 FRIEZE HONORS HISTORY'S 18 GREATEST LAWGIVERS. A BEARDED INDIVIDUAL, HOLDING AN OPEN QURAN, REPRESENTS THE PROPHET.

THE COURT TURNED DOWN THE COMPLAINANTS' REQUEST. MORE INTERESTINGLY, THEIR CLAIM WAS ALSO REJECTED BY A RESPECTED ISLAMIC JURIST BASED AT THE TIME IN SAUDI ARABIA. IN HIS EXHAUSTIVE OPINION ON THE MATTER, TAHA JABER AL-ALWANI JUDGED THE SCULPTURAL REPRESENTATION OF MOHAMMAD NOT JUST PERMISSIBLE BUT ALSO PRAISEWORTHY.

### *FATWA* CONCERNING THE UNITED STATES SUPREME COURTROOM FRIEZE

*Taha Jaber al-Alwani* [†]

*In the name of God, the most Gracious, the most Merciful*

ISLAMIC JURISTS HAVE DIFFERED WIDELY ON THE TOPIC OF IMAGE-MAKING.

SOME HAVE TAKEN THE POSITION THAT EVERY IMAGE... IS PROHIBITED IF THE SUBJECT OF THE IMAGE HAS A SOUL.

... STILL OTHER JURISTS HAVE TAKEN THE POSITION THAT IMAGERY IS PERMITTED.

WHEN WE READ THE HOLY QUR'AN — THE ONLY CONSTITUTIVE SOURCE OF LEGISLATION IN ISLAM ...

... WE WILL NOT FIND WITHIN IT A SINGLE TEXT THAT DIRECTLY ADDRESSES THE QUESTION OF WHETHER MAKING OR POSSESSING "PICTURES" AND "IMAGES" IS PROHIBITED.

Taha Jaber al-Alwani's fatwa.

HE NOTED THAT IN THE RECORDS KNOWN AS *HADITHS*, HOWEVER, THE PROPHET DID WARN AGAINST MAKING AND SPREADING IMAGES.

ISLAMIC JURISTS DIFFER ON HOW THIS PROHIBITION SHOULD BE TREATED: AS A TOTAL BAN FOR ALL TIMES AND PLACES, OR AS ONE TO BE INTERPRETED CONTEXTUALLY.

HE CRITICIZED THE SCULPTOR FOR FAILING TO CONSULT REFERENCES THAT WOULD HAVE HELPED HIM TO RENDER MORE ACCURATELY THE "DELICATE FEATURES OF THE PROPHET." HE ALSO NOTED THAT, FOR MUSLIMS, THE PROPHET IS "NOT SIMPLY ONE LAWGIVER AMONG MANY."

BUT, HE STRESSED, MUSLIMS SHOULD BE ENCOURAGED THAT THE SUPREME COURT HAD SURMOUNTED COMMON PREJUDICES. DESPITE NOT SHARING MUSLIMS' BELIEFS, IT HAD DECIDED THAT THE PROPHET MERITED RESPECT.

WHAT I HAVE SEEN IN THE SUPREME COURTROOM DESERVES NOTHING BUT APPRECIATION AND GRATITUDE FROM AMERICAN MUSLIMS.

THIS IS A POSITIVE GESTURE TOWARD ISLAM MADE BY THE ARCHITECT AND OTHER ARCHITECTURAL DECISION-MAKERS OF THE HIGHEST COURT IN AMERICA.

CHRISTIANE GRUBER, IN HER BOOK *THE PRAISEWORTHY ONE*, SAYS ATTITUDES HARDENED AFTER THE 9/11 ATTACK ON THE UNITED STATES, THE INVASIONS OF AFGHANISTAN AND IRAQ, AND THE DANISH CARTOON CONTROVERSY.

IT IS AT THIS VERY MOMENT THAT WE SUDDENLY SEE THE MORE PRECISE STATEMENT THAT "ISLAM CONSIDERS IMAGES OF PROPHETS DISRESPECTFUL AND CARICATURES OF THEM BLASPHEMOUS."

THE NOTION OF A LONG-STANDING AND IMMUTABLE ISLAMIC "BAN" ON IMAGES OF THE PROPHET IS NOTHING IF NOT A CONTEMPORARY INNOVATION.

THIS MORE RECENT NARRATIVE ABOUT ISLAMIC ANICONISM... EMERGES FROM, AND RESPONDS TO, THE IDEOLOGICAL CONTESTS UNFOLDING ON TODAY'S INTERNATIONAL STAGE.

IF INDEED THE BAN IS TIED TO POLITICAL COMPETITION, THE QUESTION IS WHO'S BENEFITING FROM IT?

ON THE MUSLIM SIDE, THE ABSOLUTISTS ARE JOINED BY OPPORTUNISTS WHO SEE A CHANCE TO PROJECT THEMSELVES AS DEFENDERS OF THE FAITH.

IT IS EASIER FOR POLITICIANS TO DECLARE JIHAD AGAINST CARTOONS THAN TO SOLVE PROBLEMS LIKE UNEMPLOYMENT AND POVERTY.

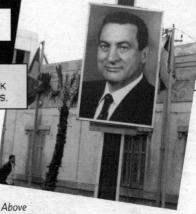

THE DANISH CARTOONS BECAME A GLOBAL CONTROVERSY MAINLY DUE TO THE INSTIGATION OF THE GOVERNMENT OF EGYPT, WHERE PRESIDENT HOSNI MUBARAK NEEDED TO OUTFLANK THE MUSLIM BROTHERHOOD AHEAD OF LOCAL ELECTIONS.

THE MYTH OF A TOTAL BAN ALSO SUITS THE ISLAMISTS' OPPONENTS IN THE WESTERN *ISLAMOPHOBIA INDUSTRY*. IT CONFORMS WITH THEIR SPIN -- THAT MUSLIMS ARE STUCK IN A FEUDAL MINDSET, AND BEYOND REASON.

IT ALSO GIVES *LIBERALS* A NEAT EXPLANATION FOR MUSLIM OUTRAGE, ABSOLVING THEM FROM ETHICAL SELF-REFLECTION.

*Above*
**Mubarak Poster**

KHALID ALBAIH, WHO HAS LIVED IN DENMARK SINCE 2017, HAS EXPERIENCED THIS TENDENCY WHEN THE TOPIC OF CONVERSATION TURNS TO THE *JYLLANDS-POSTEN* CARTOONS.

THEY SAY MUSLIMS DON'T LIKE THE PROPHET TO BE DRAWN.

THEY THINK THIS WAS A MISTAKE BECAUSE THEY SHOULDN'T HAVE STIRRED THE POT.

YES, IT WAS A MISTAKE, BUT NOT BECAUSE YOU STIRRED THE POT. IT WAS A MISTAKE BECAUSE YOU DID IT THE WRONG WAY.

IT WAS A MISTAKE BECAUSE IT CAME FROM A VERY *CONDESCENDING* PLACE.

THAT'S WHY I AM UPSET ABOUT IT. IT'S NOT BECAUSE YOU DREW THE PROPHET.

THE MYTH OF ABSOLUTE UNDRAWABILITY ALSO BLINDS THE WEST TO HOW THE *JYLLANDS-POSTEN* PROVOCATION WAS VIEWED BY MANY MUSLIMS IN COUNTRIES THAT LACK POLITICAL AND ECONOMIC STABILITY.

YOU ARE THE SAME PEOPLE WHO *CONQUERED* THEM, WHO TOOK THEIR OIL, WHO PUT A PRESIDENT ON TOP OF THEM.

NOW YOU ARE TAKING AWAY THE ONLY THING THEY HAVE — THEIR PRIDE.

THE ONLY HERO THEY HAVE IS THE PROPHET MOHAMMAD.

INSTEAD OF SEEING THAT, YOU HAVE THIS IDEA THAT MUSLIMS ARE BARBARIANS WHO WENT OUT TO BURN STUFF BECAUSE OF CARTOONS.

LOOKING DEEPER AT "UNDRAWABILITY" SHOWS US THAT IT IS NOT SO BLACK-AND-WHITE. THE RIGHT QUESTION IS WHY, IN *SOME* PLACES AND AT *SOME* TIMES, DO *SOME* PEOPLE TURN WHAT HAS ALWAYS BEEN A GRAY ZONE INTO A HARD RED LINE?

THE SAME IS TRUE OF *LESE MAJESTE*.

SCHOLARS OF THE THAI MONARCHY EVEN HAVE A SCORNFUL TERM FOR THE COMMON TENDENCY AMONG OBSERVERS TO STEREOTYPE. THEY CALL IT THE *"STANDARD TOTAL VIEW."*

THEY POINT OUT THAT KING RAMA VI (1910-25) TOOK A PERSONAL INTEREST IN POLITICAL CARTOONING AND DREW SATIRICAL CARTOONS ATTACKING CORRUPT OFFICIALS.

HE EVEN DESIGNATED A THAI TERM, *PAAP LOR* (PARODIC IMAGE), TO MEAN CARTOON.

THAI SCHOLARS LINK THE RISE IN THE NUMBER OF LESE-MAJESTE CASES SINCE 1976 TO THE *MILITARY*, RATHER THAN TIMELESS CULTURE OR TRADITION. THE GENERALS SAW LESE-MAJESTE AS A USEFUL WAY TO STIFLE LIBERAL CRITICS.

REVIVING THE SACREDNESS OF THE MONARCHY WAS PART OF A BROADER THRUST TO PROMOTE "RULE BY VIRTUOUS MEN WITH NO NEED FOR THE MESSY AND CORRUPT FEATURES OF DEMOCRACY."

*Right*
Thai Military Personnel

FOUR YEARS AFTER HIS NEWSPAPER SACKED HIM, HE WAS SUMMONED TO MEET THE KING OF JORDAN.

HE TOLD ME HOW MUCH HE LOVED MY CARTOONS.

I REMINDED HIM ABOUT THE ONE THAT GOT ME FIRED.

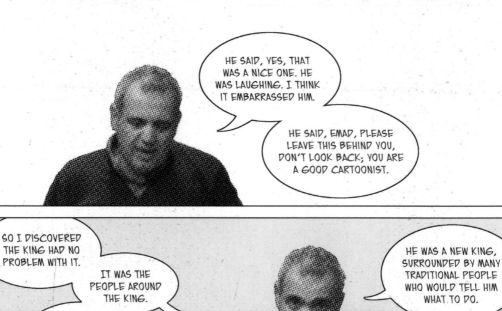

HE SAID, YES, THAT WAS A NICE ONE. HE WAS LAUGHING. I THINK IT EMBARRASSED HIM.

HE SAID, EMAD, PLEASE LEAVE THIS BEHIND YOU, DON'T LOOK BACK; YOU ARE A GOOD CARTOONIST.

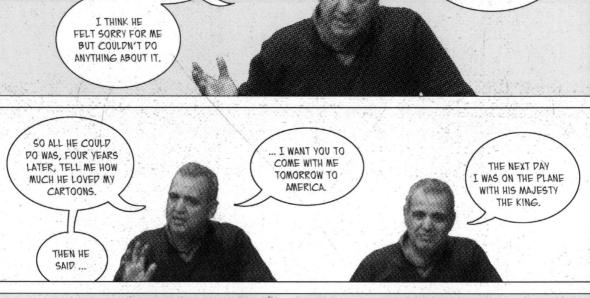

SO I DISCOVERED THE KING HAD NO PROBLEM WITH IT.

IT WAS THE PEOPLE AROUND THE KING.

I THINK HE FELT SORRY FOR ME BUT COULDN'T DO ANYTHING ABOUT IT.

HE WAS A NEW KING, SURROUNDED BY MANY TRADITIONAL PEOPLE WHO WOULD TELL HIM WHAT TO DO.

SO ALL HE COULD DO WAS, FOUR YEARS LATER, TELL ME HOW MUCH HE LOVED MY CARTOONS.

THEN HE SAID ...

... I WANT YOU TO COME WITH ME TOMORROW TO AMERICA.

THE NEXT DAY I WAS ON THE PLANE WITH HIS MAJESTY THE KING.

KING ABDULLAH WAS VISITING THE UNITED STATES WITH A DELEGATION OF JORDANIAN BUSINESSPEOPLE, CULTURAL FIGURES -- AND ONE POLITICAL CARTOONIST.

*Right*
Emad Hajjaj (left) and King Abdullah II (right) meeting with animation company executives in San Francisco.

THEY MET APPLE CHIEF STEVE JOBS. THEY EXCHANGED GIFTS: JOBS GAVE THE KING AN APPLE IPOD MUSIC PLAYER. THE KING GAVE JOBS A CD OF HAJJAJ'S CARTOON BOOK.

HE INTRODUCED ME AS JORDAN'S LEADING CARTOONIST.

ON THE FLIGHT BACK, A POLICEMAN CAME TO MY SEAT HOLDING A BIG MOBILE PHONE.

IT WAS A GUY FROM THE MANAGEMENT OF *AL RAI* NEWSPAPER.

HE SAID WE ARE SORRY FOR WHAT HAPPENED AND YOU ARE WELCOME BACK ANY TIME.

HAJJAJ TURNED DOWN THE OFFER, BUT WAS COMPENSATED FOR WRONGFUL TERMINATION AND LOST INCOME.

I NEVER FELT REGRET, BECAUSE WHAT I DID WAS RIGHT.

BUT THE PROOF ONLY CAME FOUR YEARS LATER.

AS HE HAD SUSPECTED, THE KING WASN'T UNDRAWABLE AFTER ALL.

# JE SUIS CHARLIE

## 14. A Symbolic Battle

WE ARE BACK WHERE WE STARTED THIS BOOK, AT RUE NICOLAS-APPERT, PARIS.

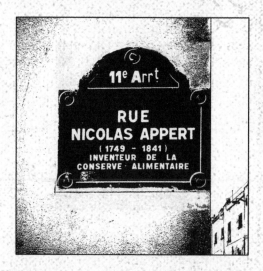

ON 7 JANUARY 2015, TWO FRENCH-BORN BROTHERS OF ALGERIAN DESCENT STORMED INTO THE OFFICES OF *CHARLIE HEBDO*, ARMED WITH RIFLES.

BY THE END OF THE MORNING, ELEVEN PEOPLE LAY DEAD IN THE BUILDING, INCLUDING FIVE CARTOONISTS.

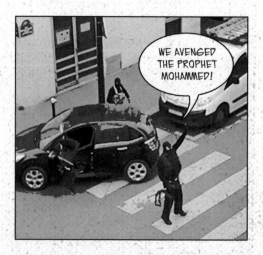

BUT WHERE DOES THIS STORY BEGIN?

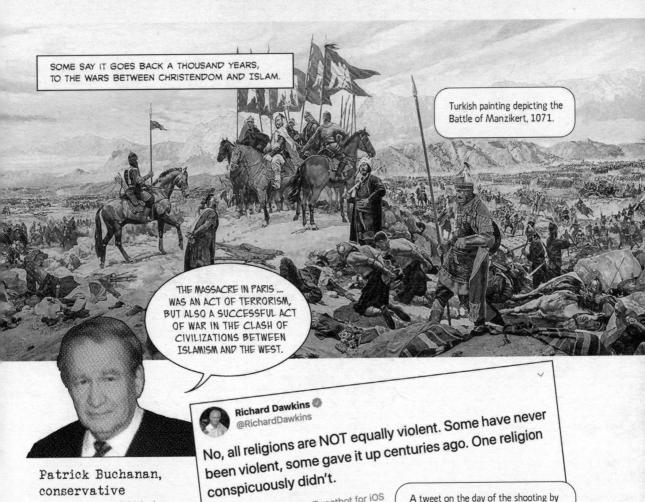

SOME SAY IT GOES BACK A THOUSAND YEARS, TO THE WARS BETWEEN CHRISTENDOM AND ISLAM.

Turkish painting depicting the Battle of Manzikert, 1071.

THE MASSACRE IN PARIS ... WAS AN ACT OF TERRORISM, BUT ALSO A SUCCESSFUL ACT OF WAR IN THE CLASH OF CIVILIZATIONS BETWEEN ISLAMISM AND THE WEST.

Patrick Buchanan, conservative American politician

**Richard Dawkins** ✔
@RichardDawkins

No, all religions are NOT equally violent. Some have never been violent, some gave it up centuries ago. One religion conspicuously didn't.

11:08 PM · Jan 7, 2015 · Tweetbot for iOS

A tweet on the day of the shooting by Richard Dawkins, evolutionary biologist.

OR PERHAPS IT GOES BACK JUST 250 YEARS, WHEN THE FRENCH ENLIGHTENMENT SPARKED CENTURIES OF PROGRESS THROUGH REASON, BUT ALSO GENERATED DEEP *RESSENTIMENT*.

EXHORTING THE PURSUIT OF LUXURY TOGETHER WITH THE FREEDOM OF SPEECH ...

... VOLTAIRE AND OTHERS ARTICULATED AND EMBODIED A MODE OF LIFE IN WHICH INDIVIDUAL FREEDOM WAS ACHIEVED THROUGH INCREASED WEALTH AND INTELLECTUAL SOPHISTICATION.

... THE NEWLY EMERGENT INTELLECTUAL AND TECHNOCRATIC CLASS DID LITTLE MORE THAN PROVIDE LITERARY AND MORAL COVER FOR THE POWERFUL AND THE UNJUST.

Reading Voltaire in a Parisian salon.

Pankaj Mishra, writing in 'Age of Anger'

353

OR WE COULD START WITH THE FRENCH REVOLUTION, WHICH KILLED THE IDEA OF A STATE WITH DIVINE RIGHTS...

... AND SPAWNED THE SECULAR PRINCIPLE OF *LAICITÉ*.

A FUNDAMENTAL VALUE AND ESSENTIAL PRINCIPLE OF THE REPUBLIC, SECULARISM IS A FRENCH INVENTION.

Clergy being squeezed down to size in a 1790 caricature.

**Liberté • Égalité • Fraternité**
Government of France

LIBERTY AT HOME, SUBJUGATION ABROAD: LIKE THE REST OF THE WEST, FRANCE'S DEMOCRATIC AND INDUSTRIAL REVOLUTIONS WERE SYNCED WITH SLAVERY AND COLONIAL RULE. PERHAPS THE STORY OF CHARLIE HEBDO BEGINS WITH THAT PERSISTENT MORAL BLINDNESS.

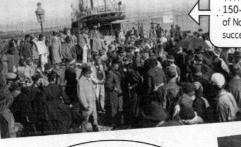

A French steamer arrives at Algiers in 1899, during France's 150-year occupation of Algeria. In the 20th century, millions of North Africans traveled the other way. France has had uneven success in integrating immigrants from its former colonies.

Paintings from the 1840s and 1850s show an enslaved African being taken to a French ship; and a captured runaway slave being whipped in the French West Indies.

FOR SOME HISTORIANS, THE HISTORY OF FRENCH REPUBLICANISM CAN'T BE SEPARATED OUT FROM THE FRENCH HISTORY OF SLAVERY AND COLONIALISM.

IN EXPLAINING THE ORIGINS OF THE *CHARLIE HEBDO* AFFAIR, IT'S USEFUL TO REMEMBER THAT FRANCE HAS A COLONIAL PAST AND PRACTICED SLAVERY ...

Sandrine Sanos, historian of modern Europe

... WHICH REMAINS, TO THIS DAY, UNACKNOWLEDGED AND SILENCED IN THE POPULAR IMAGINATION.

PERHAPS IT IS A STORY OF CLASS...

... BEGINNING IN 1992 WITH THE MAASTRICHT TREATY AND THE CREATION OF THE EUROZONE: SUPPORTED MAINLY BY THE PRIVILEGED CLASSES, AND LESS BY WORKERS -- JUST LIKE THE MASSIVE "JE SUIS CHARLIE" DEMONSTRATIONS IN THE DAYS AFTER THE MASSACRE.

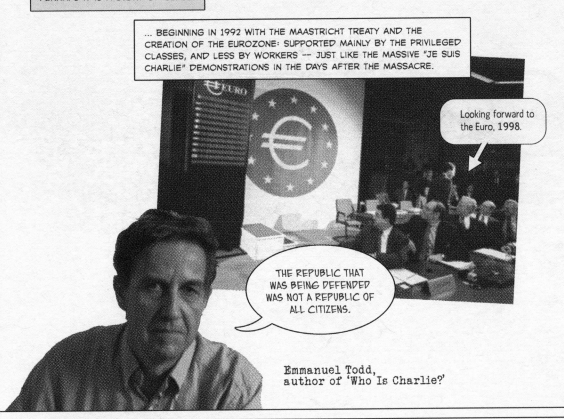

Looking forward to the Euro, 1998.

THE REPUBLIC THAT WAS BEING DEFENDED WAS NOT A REPUBLIC OF ALL CITIZENS.

Emmanuel Todd, author of 'Who Is Charlie?'

THE NARRATIVE COULD BEGIN WITH THE WEST'S 20TH CENTURY ATTEMPTS TO ASSERT CONTROL OVER THE MIDDLE EAST, AND ITS 21ST CENTURY MILITARY OPERATIONS IN AFGHANISTAN, IRAQ, AND SYRIA.

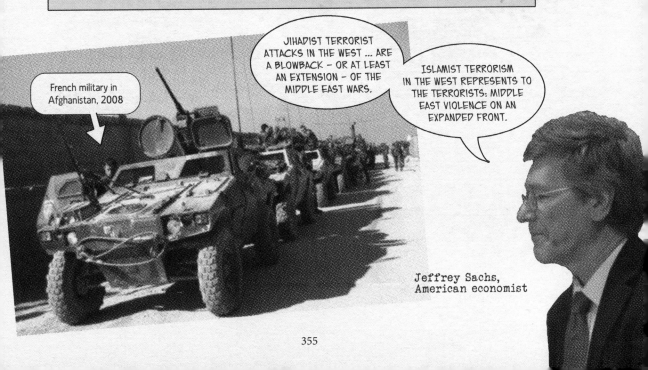

JIHADIST TERRORIST ATTACKS IN THE WEST ... ARE A BLOWBACK – OR AT LEAST AN EXTENSION – OF THE MIDDLE EAST WARS.

ISLAMIST TERRORISM IN THE WEST REPRESENTS TO THE TERRORISTS: MIDDLE EAST VIOLENCE ON AN EXPANDED FRONT.

French military in Afghanistan, 2008

Jeffrey Sachs, American economist

355

TO PUT IT MILDLY ... THERE ARE DIFFERENT VIEWS ABOUT WHAT THE *CHARLIE HEBDO* KILLINGS REPRESENT.

IT'S A CASE OF THE *"RASHOMON* EFFECT" -- WITNESSES EMERGE WITH CONTRADICTORY ACCOUNTS.

THERE IS NO "NEUTRAL" WAY TO TELL SUCH A STORY.

THE COMPETITION TO DEFINE THE DOMINANT HISTORICAL NARRATIVE BY WHICH SUCH SEEMINGLY DISCRETE EVENTS CAN BE EXPLAINED IS THE STUFF OF CONTEMPORARY GLOBAL MEDIATED POLITICS ...

... THE EVENT *CHAIN* IS ITSELF THE OBJECT OF RIVAL ARTICULATIONS, PART OF A STRUGGLE FOR HEGEMONIC DOMINANCE THAT IS NEVER FULLY *ACCOMPLISHED.*

*Background*
**Rashomon**, Akira Kurosawa (1950), was a thriller showing multiple conflicting perspectives.

Annabelle Sreberny, media scholar, on the 'Charlie Hebdo' murders

BUT IN KEEPING WITH THE SPIRIT OF THIS BOOK, WE'LL PRIVILEGE THE PERSPECTIVE OF THE CARTOONISTS AT THE CENTER OF THE CONTROVERSY.

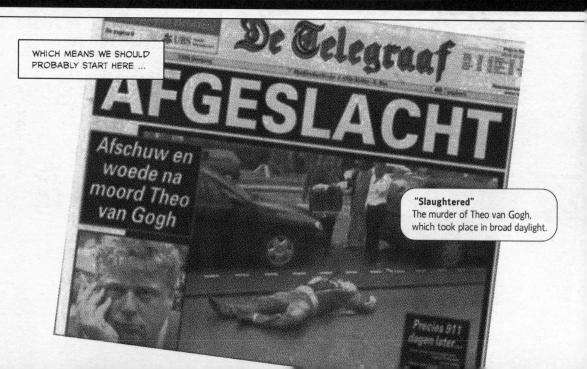

WHICH MEANS WE SHOULD PROBABLY START HERE ...

**De Telegraaf**

# AFGESLACHT

Afschuw en woede na moord Theo van Gogh

"Slaughtered"
The murder of Theo van Gogh, which took place in broad daylight.

## 2004

DUTCH SATIRIST *THEO VAN GOGH* WAS MURDERED ON AN AMSTERDAM STREET BY A DUTCH-MOROCCAN MAN, AS PUNISHMENT FOR MAKING A FILM CRITICAL OF MUSLIMS' TREATMENT OF WOMEN.

FOR MANY EUROPEANS, THE KILLING SHOWED THE FAILURE OF MULTICULTURALISM: INSTEAD OF INTEGRATING, MUSLIM FUNDAMENTALISTS EXPECTED EUROPE TO BOW TO THEIR INTOLERANCE.

## 2005

THE EDITORS OF *JYLLANDS-POSTEN*, UPSET THAT ISLAMISTS WERE GAINING GROUND, DECIDED TO TAKE A STAND AGAINST AN APPARENT TREND OF SELF-CENSORSHIP IN DANISH MEDIA AND THE ARTS.

ON 30 SEPTEMBER 2005, THE PAPER PUBLISHED 12 CARTOONS UNDER THE HEADLINE "THE FACE OF MUHAMMAD" (ALSO SEE CHAPTER 13).

## 2006

THE CONTROVERSY BOILED OVER IN EARLY 2006. SAUDI ARABIA AND OTHER GOVERNMENTS ISSUED OFFICIAL STATEMENTS CONDEMNING THE CARTOONS.

A CAMPAIGN CALLED ON MUSLIMS TO BOYCOTT PRODUCTS FROM DENMARK.

NORWAY WAS HIT TOO, AFTER A NORWEGIAN PAPER PRINTED THE CARTOONS.

A VICIOUS CYCLE SET IN.

MUSLIM GROUPS' ESCALATING DISPLAYS OF OUTRAGE PROMPTED MORE LIBERALS TO ASSERT THEIR RIGHT TO OFFEND, WHICH PROVOKED MORE PROTEST.

IN FRANCE, THE CONTROVERSY HAD STRONG RESONANCE, BECAUSE OF THE DECADES-OLD DEBATE ABOUT THE SLOW INTEGRATION OF ITS MUSLIM MINORITY, THE LARGEST IN EUROPE.

VIEWING THE CARTOON AFFAIR THROUGH THE LENS OF LAÏCITÉ -- THE COUNTRY'S SECULAR PHILOSOPHY -- THE PRESS FELT OBLIGED TO DEFEND THE REPUBLIC'S CORE VALUES.

FRANCE SOIR PUBLISHED ALL DOZEN DANISH CARTOONS ON 1 FEBRUARY, ADDING ITS OWN VERSION ON THE COVER.

"YES, WE HAVE THE RIGHT TO CARICATURE GOD," THE HEADLINE DECLARED. IN ITS COVER CARTOON, A WHITE DEITY TELLS AN ANGRY-LOOKING BROWN FIGURE, "DON'T MOAN, MOHAMMED, WE'VE ALL BEEN CARICATURED HERE."

(Although all three Abrahamic religions have Semitic roots and Jesus was a Middle-Easterner, European art tends to depict Christianity as a white religion and Islam as Arab.)

THE FRANCO-EGYPTIAN OWNER OF FRANCE SOIR IMMEDIATELY APOLOGIZED TO MUSLIMS AND FIRED THE MANAGING EDITOR.

THIS ATTACK ON THE EDITORIAL INDEPENDENCE OF A FRENCH NEWSPAPER SHOCKED THE STAFF OF CHARLIE HEBDO, A WEEKLY SATIRICAL MAGAZINE THAT ROUTINELY PILLORIED THE FAMOUS AND MOCKED RELIGIONS AND IDEOLOGIES.

# CHARLIE HEBDO

AT THE PEAK OF THE TROUBLES, WHILE VIOLENT DEMONSTRATIONS WERE OCCURRING IN SEVERAL MUSLIM COUNTRIES AND DANISH EMBASSIES AND CONSULATES WERE BEING ATTACKED, CHARLIE HEBDO DECIDED TO REPRINT THE DANISH CARTOONS.

IF CHARLIE HEBDO – AN INDEPENDENT SATIRICAL NEWSPAPER ABOUT RELIGION IN FRANCE, THE MOST SECULARIST COUNTRY ON EARTH – SAYS THERE IS A POLEMIC ABOUT DRAWINGS, THERE ARE CARTOONISTS UNDER DEATH THREATS ...

... BUT WE WON'T SHOW YOU THE DRAWINGS SO AS NOT TO OFFEND RELIGIOUS FEELINGS – THIS WOULD BE THE END OF THE FREEDOM OF EXPRESSION.

THERE WOULD BE NO OTHER NEWSPAPER WHO WOULD DARE TO DO IT IF CHARLIE HEBDO IS NOT DOING IT.

SO YOU HAVE A CERTAIN RESPONSIBILITY.

Caroline Fourest, Charlie Hebdo writer and intellectual

AT THEIR EDITORIAL MEETING THAT WEEK, STAFF DISCUSSED WHAT TO PUT ON THE COVER.

THEIR DISCUSSION WAS FILMED BY A DOCUMENTARY CREW WHO WERE ORIGINALLY WORKING ON A PROFILE OF THE CARTOONIST, CABU.

THE IMAGES AND DIALOGUE HERE ARE FROM THE DVD, *IT'S TOUGH BEING LOVED BY JERKS.*

Caroline Fourest, who wrote the cover story

Philippe Val, editor and director

« C'EST DUR D'ÊTRE AIMÉ PAR DES CONS »

Tignous (Bernard Verlhac), cartoonist (killed in 2015)

Luz (Rénald Luzier), cartoonist

MOHAMMED COULD DELIVER A MESSAGE, COOL ...

I DON'T WANT SOME GRIMACING GUY WITH A BEARD.

Georges Wolinski, cartoonist (killed in 2015)

"IT'S TOUGH BEING LOVED BY JERKS?"

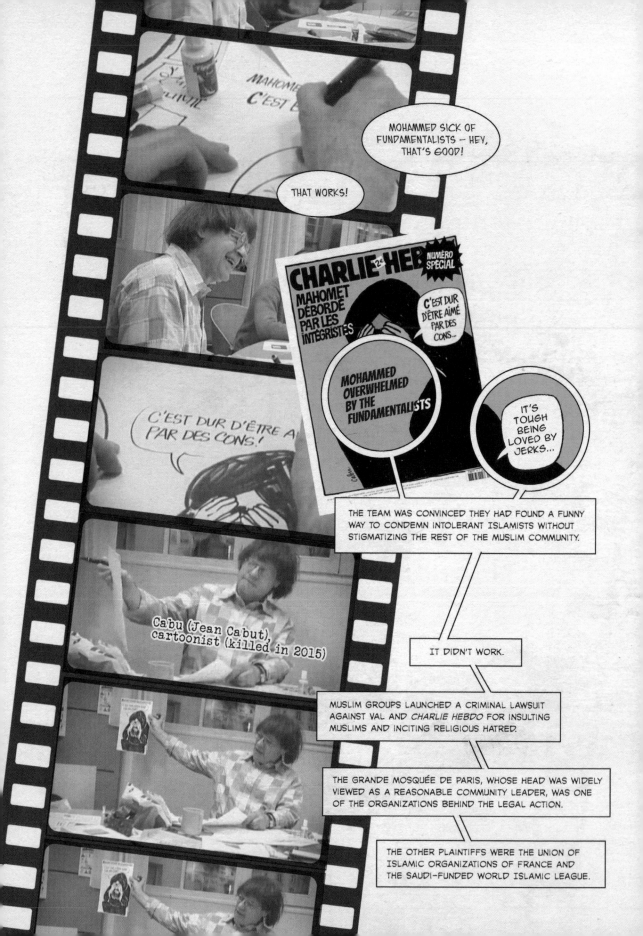

MOHAMMED SICK OF FUNDAMENTALISTS — HEY, THAT'S GOOD!

THAT WORKS!

CHARLIE HEBDO
2€
NUMÉRO SPÉCIAL

MAHOMET DÉBORDÉ PAR LES INTÉGRISTES

C'EST DUR D'ÊTRE AIMÉ PAR DES CONS...

MOHAMMED OVERWHELMED BY THE FUNDAMENTALISTS

IT'S TOUGH BEING LOVED BY JERKS...

C'EST DUR D'ÊTRE A... PAR DES CONS!

Cabu (Jean Cabut) cartoonist (killed in 2015)

THE TEAM WAS CONVINCED THEY HAD FOUND A FUNNY WAY TO CONDEMN INTOLERANT ISLAMISTS WITHOUT STIGMATIZING THE REST OF THE MUSLIM COMMUNITY.

IT DIDN'T WORK.

MUSLIM GROUPS LAUNCHED A CRIMINAL LAWSUIT AGAINST VAL AND *CHARLIE HEBDO* FOR INSULTING MUSLIMS AND INCITING RELIGIOUS HATRED.

THE GRANDE MOSQUÉE DE PARIS, WHOSE HEAD WAS WIDELY VIEWED AS A REASONABLE COMMUNITY LEADER, WAS ONE OF THE ORGANIZATIONS BEHIND THE LEGAL ACTION.

THE OTHER PLAINTIFFS WERE THE UNION OF ISLAMIC ORGANIZATIONS OF FRANCE AND THE SAUDI-FUNDED WORLD ISLAMIC LEAGUE.

AS NEWS OF THE LEGAL THREAT SPREAD, SECULARISTS RALLIED AROUND *CHARLIE HEBDO*. ON 1 MARCH, THE MAGAZINE PUBLISHED A MANIFESTO IN DEFENSE OF SECULAR FREEDOMS.

## MANIFESTO: Together facing the new totalitarianism

After having overcome fascism, Nazism, and Stalinism, the world now faces a new totalitarian global threat: Islamism.

We, writers, journalists, intellectuals, call for resistance to religious totalitarianism and for the promotion of freedom, equal opportunity and secular values for all.

The recent events, which occurred after the publication of drawings of Muhammed in European newspapers, have revealed the necessity of the struggle for these universal values. This struggle will not be won by arms, but in the ideological field. It is not a clash of civilisations nor an antagonism of West and East that we are witnessing, but a global struggle that confronts democrats and theocrats.

IT WAS SIGNED BY A DOZEN WRITERS, INCLUDING CULTURAL FIGURES ALREADY CONDEMNED TO DEATH BY MUSLIM CLERICS.

WRITER OF THE FILM *SUBMISSION* (2004), FOR WHICH DIRECTOR THEO VAN GOGH WAS KILLED. A LETTER CONTAINING A DEATH THREAT AGAINST HER WAS FOUND STUCK ON VAN GOGH'S CORPSE WITH A KNIFE.

Ayaan Hirsi Ali

AUTHOR OF *THE SATANIC VERSES* (1988), THE FIRST CASE OF THE GLOBALIZATION OF VIOLENT OFFENSE-TAKING BY MUSLIM FUNDAMENTALISTS. INCITED BY IRAN'S AYATOLLAH KHOMEINI, A $2.5 MILLION BOUNTY WAS PLACED ON HIS HEAD.

Salman Rushdie

# 2007

*CHARLIE HEBDO*, A RELATIVELY OBSCURE WEEKLY MAGAZINE WITH A NICHE FOLLOWING, THUS TOOK ON ICONIC STATUS IN A GLOBAL DEBATE.

THE HIGHLY PUBLICIZED TRIAL TOOK PLACE OVER TWO DAYS IN FEBRUARY 2007.

CONSERVATIVE PRESIDENTIAL FRONTRUNNER NICOLAS SARKOZY AND SOCIALIST PARTY LEADER FRANCOIS HOLLANDE WERE AMONG THE POLITICIANS WHO SPOKE UP IN DEFENSE OF THE MAGAZINE.

I PREFER AN EXCESS OF CARICATURES TO AN ABSENCE OF CARICATURES.

IT'S NOT ABOUT QUESTIONING THIS OR THAT RELIGION, BUT A DEVIATION OF RELIGION.

François Hollande, head of the French Socialist Party.

Nicolas Sarkozy, interior minister and presidential candidate, in a letter of support read out in court by Charlie Hebdo's lawyer.

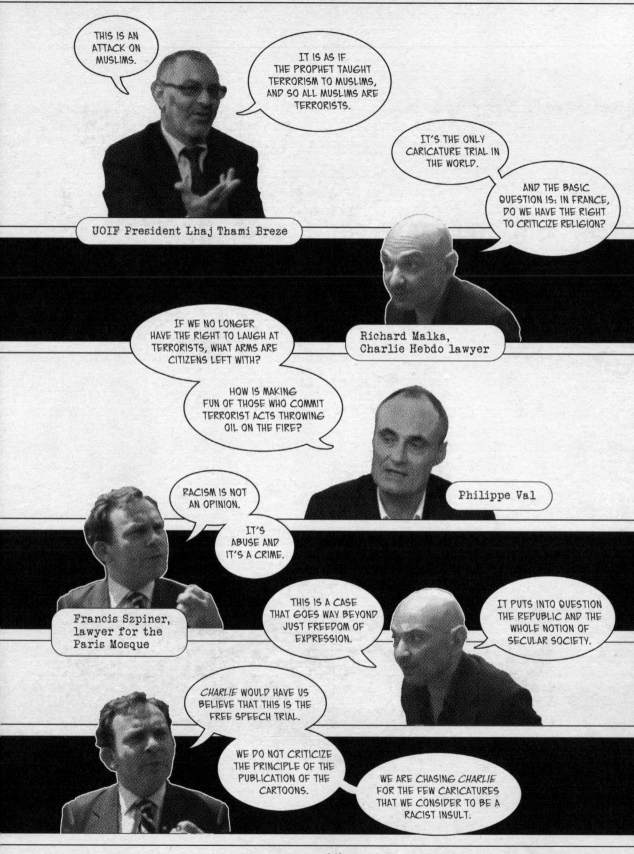

THIS IS AN ATTACK ON MUSLIMS.

IT IS AS IF THE PROPHET TAUGHT TERRORISM TO MUSLIMS, AND SO ALL MUSLIMS ARE TERRORISTS.

UOIF President Lhaj Thami Breze

IT'S THE ONLY CARICATURE TRIAL IN THE WORLD.

AND THE BASIC QUESTION IS: IN FRANCE, DO WE HAVE THE RIGHT TO CRITICIZE RELIGION?

IF WE NO LONGER HAVE THE RIGHT TO LAUGH AT TERRORISTS, WHAT ARMS ARE CITIZENS LEFT WITH?

Richard Malka, Charlie Hebdo lawyer

HOW IS MAKING FUN OF THOSE WHO COMMIT TERRORIST ACTS THROWING OIL ON THE FIRE?

Philippe Val

RACISM IS NOT AN OPINION.

IT'S ABUSE AND IT'S A CRIME.

Francis Szpiner, lawyer for the Paris Mosque

THIS IS A CASE THAT GOES WAY BEYOND JUST FREEDOM OF EXPRESSION.

IT PUTS INTO QUESTION THE REPUBLIC AND THE WHOLE NOTION OF SECULAR SOCIETY.

CHARLIE WOULD HAVE US BELIEVE THAT THIS IS THE FREE SPEECH TRIAL.

WE DO NOT CRITICIZE THE PRINCIPLE OF THE PUBLICATION OF THE CARTOONS.

WE ARE CHASING CHARLIE FOR THE FEW CARICATURES THAT WE CONSIDER TO BE A RACIST INSULT.

ON 22 MARCH 2OO7, THE COURT ACQUITTED VAL AND *CHARLIE HEBDO*.

THE JUDGE ACKNOWLEDGED THAT FRENCH LAW PROTECTS AGAINST RELIGIOUS DEFAMATION, EVEN THOUGH IT DOES NOT RECOGNIZE BLASPHEMY.

BUT HE DID NOT BELIEVE THE CARTOONS CROSSED THE LINE.

"THE ACCEPTABLE LIMITS OF FREEDOM OF EXPRESSION HAVE NOT BEEN OVERSTEPPED, WITH THE CONTENTIOUS PICTURES PARTICIPATING IN A PUBLIC DEBATE OF GENERAL INTEREST."

THREE CARTOONS HAD BEEN CITED IN THE LAWSUIT: THE CABU CARTOON ON THE COVER OF *CHARLIE HEBDO*, AND TWO OF THE *JYLLANDS-POSTEN* CARTOONS REPRINTED INSIDE ...

THE JUDGE AGREED WITH *CHARLIE HEBDO* THAT ITS COVER WAS NOT DIRECTED AT MUSLIMS IN GENERAL BUT AT FUNDAMENTALISTS.

ONE OF THE DANISH CARTOONS SHOWED TERRORISTS REACHING HEAVEN, AND BEING TOLD BY THE PROPHET, "STOP, STOP, WE HAVE RUN OUT OF VIRGINS" -- A REFERENCE TO THE MYTH THAT ISLAM PROMISES MARTYRS 72 VIRGINS IN PARADISE.

THE JUDGE FELT THIS WASN'T A GENERALIZED ATTACK ON THE MUSLIM COMMUNITY EITHER.

AS FOR THE MOST CONTROVERSIAL OF THE DANISH CARTOONS, THE JUDGE AGREED WITH THE PLAINTIFFS THAT THIS WAS DEFAMATORY AGAINST MUSLIMS -- BUT ONLY IF VIEWED IN ISOLATION.

*CHARLIE HEBDO* HAD PUBLISHED IT WITH AN ARTICLE ON THE TOPIC AS PART OF AN ATTEMPT TO DEBATE A PUBLIC ISSUE, AND NOT TO ATTACK MUSLIMS, THE JUDGE SAID.

363

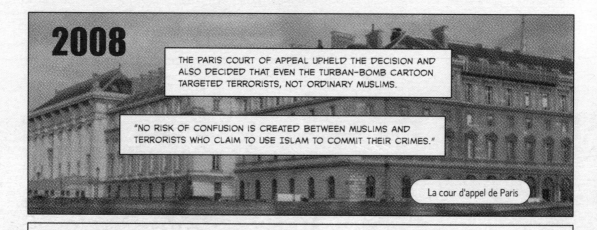

**2008**

THE PARIS COURT OF APPEAL UPHELD THE DECISION AND ALSO DECIDED THAT EVEN THE TURBAN-BOMB CARTOON TARGETED TERRORISTS, NOT ORDINARY MUSLIMS.

"NO RISK OF CONFUSION IS CREATED BETWEEN MUSLIMS AND TERRORISTS WHO CLAIM TO USE ISLAM TO COMMIT THEIR CRIMES."

La cour d'appel de Paris

**2011**

*CHARLIE HEBDO* PUBLISHED A "CHARIA HEBDO" SPECIAL ISSUE MOCKING SHARIA OR ISLAMIC LAW.

THE SAME WEEK, ITS OFFICE WAS DESTROYED BY AN ARSON ATTACK.

STAFF MOVED TO THE OFFICES OF *LIBERATION*, WHERE THEY PRODUCED A FOUR-PAGE WRAPAROUND FOR THE NEWSPAPER.

THE SPECIAL EDITION CARRIED NEW CARTOONS OF MOHAMMED.

LES CATHOS INTÉGRISTES CONTRE LE THÉÂTRE
CHARLIE HEBDO
CHARIA HEBDO
MAHOMET RÉDACTEUR EN CHEF
100 COUPS DE FOUET, SI VOUS N'ÊTES PAS MORTS DE RIRE!
LUZ

Luz's cartoon reads "100 lashes if you don't die laughing"

Luz talking to reporters outside the destroyed office. Luz, editor Charb and managing editor Riss were placed under police protection.

IF THE ARSON ATTACK PRESAGED WORSE TO COME, SO DID THE REACTION FROM FRANCE'S WHITE, CULTURAL ELITE: ANTI-MUSLIM RHETORIC BECAME NORMALIZED, EVEN AS HATE CRIMES AGAINST MUSLIMS AND OTHER MINORITIES MOUNTED.

IN RESPONSE, A GROUP OF INTELLECTUALS AND ANTI-DISCRIMINATION ACTIVISTS ISSUED A STATEMENT IN DEFENSE OF FREEDOM OF EXPRESSION -- AND AGAINST *CHARLIE HEBDO*.

THE FREEDOM TO CRITICIZE ISLAM IS ANYTHING BUT THREATENED.

... NOT ONLY CRITICISM BUT ALSO *CARICATURE* AND *INSULT* HAVE PROSPERED IN PEACE AND BONHOMIE FOR AT LEAST A DECADE.

ON THE OTHER HAND, THERE IS A FREEDOM OF EXPRESSION WHICH IS INDEED THREATENED ...

... WOMEN FED UP WITH THE STARES, INSULTS, AND DISCRIMINATION THEY SUFFER DAILY BECAUSE THEY WEAR A HEADSCARF ...

... UNDOCUMENTED MIGRANTS WHO WOULD LIKE TO HAVE A SAY AND INFORM THE PUBLIC ABOUT THE REALITY OF THEIR LIVING CONDITIONS.

Sociologist and feminist Christine Delphy, one of the authors of the statement.

# 2012

AN AMERICAN-MADE ANTI-MUSLIM VIDEO, *INNOCENCE OF MUSLIMS*, SHIFTED THE CULTURE WAR OVER BLASPHEMY TO A NEW BATTLEGROUND: YOUTUBE.

*CHARLIE HEBDO* RODE ON THE NEWS, PUBLISHING CARTOONS OF MOHAMMED WIDELY SEEN AS EXCESSIVELY VULGAR.

In a movie-themed section, a Luz cartoon shows a naked Mohammed echoing a famous Brigitte Bardot line from a 1963 film: "What about my ass? You like my ass?"

This cartoon by Coco, "Mohammed: A Star Is Born," shows Mohammed in a porn film with a star covering his anus.

THE FRENCH GOVERNMENT PREEMPTIVELY CLOSED EMBASSIES AND OTHER POTENTIAL TARGETS IN SOME 20 COUNTRIES.

IS IT REALLY SENSIBLE OR INTELLIGENT TO POUR OIL ON THE FIRE?

Laurent Fabius, French foreign minister

LE FILM QUI EM LE MONDE MUSULMAN

ET MES FESSES? TU LES AIMES ? MES FESSES

MAHOMET: E ÉTOILE EST NÉE!

---

# 2013

IN FEBRUARY 2013, *INSPIRE*, THE GLOSSY MAGAZINE OF AL QAEDA IN THE ARABIAN PENINSULA, FEATURED A "WANTED" LIST ...

... THAT INCLUDED STEPHANE CHARBONNIER, EDITOR OF *CHARLIE HEDBO*.

WANTED
DEAD OR ALIVE FOR CRIMES AGAINST ISLAM

CARSTEN LUSTE · TERRY JONES · KURT WESTERGAA
GIRT WILDERS · LARS VILKS · STÉPHANE CHARBONNIE
FLEMMING ROSE · MORRIS SWADIQ · SALMAN RUSHDIE
AYAAN HIRSI ALI

YES WE CAN
A BULLET A DAY KEEPS THE INFIDEL AWAY
Defend Prophet Muhammad peace be upon him

IN JULY 2013, *CHARLIE HEBDO*'S COVER MADE LIGHT OF GENERAL ABDEL-FATTAH AL-SISI'S MILITARY COUP IN EGYPT.

THE COVER WAS WIDELY CONDEMNED AS BOTH BLASPHEMOUS AND TASTELESS.

*Right*
The cover mocked the deposed President Mohamed Morsi's Muslim Brotherhood supporters who were killed resisting the coup: "Killings in Egypt: The Quran is shit. It doesn't stop bullets."

CHARLIE HEBDO

LE CORAN C'EST DE LA MERDE
CA N'ARRÊTE PAS LES BALLES
CORAN

## 2014

THE LEAGUE OF JUDICIAL DEFENCE OF MUSLIMS SUED *CHARLIE HEBDO* OVER THE JULY 2013 COVER..

THE SUIT WAS FILED IN THE REGION OF ALSACE–MOSELLE, WHERE THE PENAL CODE STILL CRIMINALIZED BLASPHEMY (THE LAW WAS LAST APPLIED IN 1918).

THE MUSLIM GROUP ALSO SUED IN PARIS, FOR INCITEMENT TO RELIGIOUS HATRED.

THE SUITS WERE UNSUCCESSFUL.

## 2015    Wednesday 7 January

*CHARLIE HEBDO* STAFF WERE HOLDING AN EDITORIAL MEETING AT THE MAGAZINE'S HEADQUARTERS.

CARTOONIST COCO (CORINNE REY) LEFT THE MEETING EARLY TO COLLECT HER CHILD FROM THE NURSERY.

DOWNSTAIRS, SHE WAS STOPPED BY TWO MEN DRESSED IN BLACK, WEARING BALACLAVAS AND CARRYING KALASHNIKOVS.

THEY CALLED HER BY NAME.

THEY TELL ME THAT THEY ARE FROM AL QAEDA YEMEN.

THEIR WEAPONS ARE PRESSED AGAINST ME.

THEY TELL ME, 'WE WANT CHARB.'

I FEEL THE KALASHNIKOV ON MY BACK, I THINK OF MY DAUGHTER.

Coco

THEY FORCED COCO TO KEY IN THE CODE TO UNLOCK THE OFFICE DOOR.

A MAINTENANCE WORKER WAS THE FIRST PERSON SHOT DEAD.

THE GUNMEN MOVED ON TO THE MEETING ROOM ...

THE DOOR OPENS AND THESE GUYS APPEAR.

I LAY DOWN IMMEDIATELY.

I DIDN'T WAIT FOR THEM TO START SHOOTING, I JUST HEARD THE SHOOTING.

Riss (Laurent Sourisseau), cartoonist

Interviews from the documentary, 'Je Suis Charlie' (2015).

I HEARD REALLY JERKY SHOTS, AS IF FROM PERSON TO PERSON.

MONSTROUS ...

AT ONE POINT THEY CAME BACK, I THINK TO VERIFY THAT CHARB WAS INDEED ONE OF THE VICTIMS.

I BELIEVE THEY SHOT HIM AGAIN WHILE HE WAS ALREADY ON THE GROUND.

IT LASTED MAYBE A MINUTE BETWEEN THE FIRST SHOT AND THE MOMENT WHEN WE REALIZED THAT THEY WERE NO LONGER THERE.

CHARLIE HEBDO'S FINANCE DIRECTOR ERIC PORTHEAULT WAS ANOTHER SURVIVOR.

THERE WERE DEAD BODIES COVERED IN BLOOD.

I FELT LIKE I WAS ON A BATTLEFIELD.

I WILL NOT GO INTO THE DETAILS OF WHAT I SAW BECAUSE I DO NOT WANT TO INFLICT IT ON THE FAMILIES.

Eric Portheault

ELEVEN PEOPLEE SUFFERED FATAL GUNSHOT WOUNDS IN THE BUILDING.

OUT ON THE STREET, THE GUNMEN SHOT DEAD A LOCAL POLICEMAN ON PATROL.

FROM EVIDENCE IN THEIR ABANDONED GETAWAY CAR, POLICE IDENTIFIED THE ATTACKERS AS SAID KOUACHI AND HIS YOUNGER BROTHER, CHERIF.

POLICE KILLED THEM IN A GUN BATTLE TWO DAYS LATER.

THE YOUNG MEN HAD BEEN RADICALISED BY A PREACHER WHO SET UP A PIPELINE FOR YOUNG FRENCH MUSLIMS TO JOIN ABU MUSAB AL-ZARQAWI'S AL QAEDA NETWORK IN IRAQ.

367

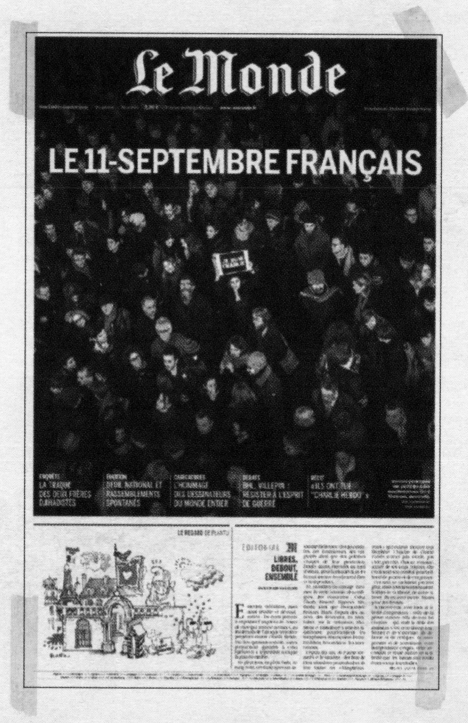

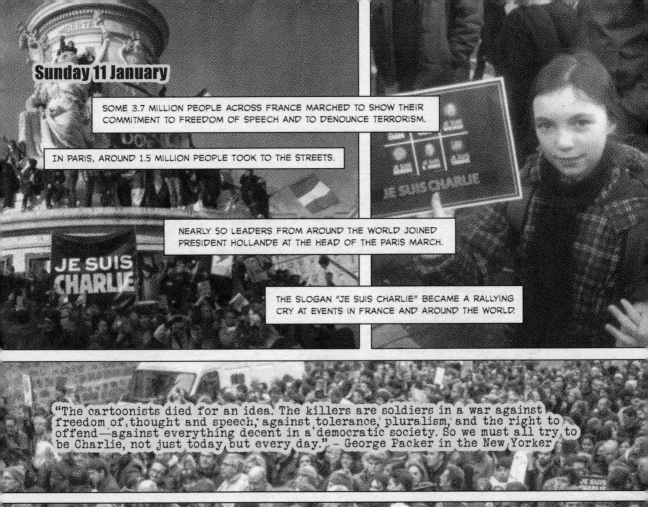

## Sunday 11 January

SOME 3.7 MILLION PEOPLE ACROSS FRANCE MARCHED TO SHOW THEIR COMMITMENT TO FREEDOM OF SPEECH AND TO DENOUNCE TERRORISM.

IN PARIS, AROUND 1.5 MILLION PEOPLE TOOK TO THE STREETS.

NEARLY 50 LEADERS FROM AROUND THE WORLD JOINED PRESIDENT HOLLANDE AT THE HEAD OF THE PARIS MARCH.

THE SLOGAN "JE SUIS CHARLIE" BECAME A RALLYING CRY AT EVENTS IN FRANCE AND AROUND THE WORLD.

"The cartoonists died for an idea. The killers are soldiers in a war against freedom of thought and speech, against tolerance, pluralism, and the right to offend—against everything decent in a democratic society. So we must all try to be Charlie, not just today, but every day." – George Packer in the New Yorker

ANYONE WHO BELIEVES IN THE SANCTITY OF HUMAN LIFE WOULD HAVE BEEN HORRIFIED BY THE SUMMARY EXECUTION METED OUT ON 7 JANUARY 2015.

ANY MISGIVINGS ABOUT *CHARLIE HEBDO*'S TABOO-BREAKING SATIRICAL STYLE HAVE TO BE SEPARATED FROM THE ABOMINATION THAT WAS THE KOUACHI BROTHERS' CHOSEN RESPONSE.

BUT THE CONVERSE IS ALSO TRUE.

CONDEMNING THE ASSASSINATION, ABSOLUTELY AND WITHOUT RESERVATION, DOESN'T REQUIRE US TO SUSPEND CRITICAL JUDGMENT ABOUT THE MAGAZINE.

ONE PERSISTENT QUESTION: WHO OR WHAT WERE THE TARGETS OF *CHARLIE HEBDO*'S SATIRE?

WE DON'T MEAN ALL MUSLIMS ...

... JUST FUNDAMENTALISTS.

Philippe Val at a press conference before the 2007 trial

THE PEOPLE WHO THINK FANATICISM IS NOT AN ACTUAL DANGER, THOSE PEOPLE ARE LIVING IN A DREAM.

FANATICISM IS A TOTALITARIAN THREAT.

Caroline Fourest

THEY ARE WINNING ON BOTH SIDES.

IN THE COUNTRIES THEY COME FROM, THEY SAY, WE ARE THE MAJORITY, THIS IS THE OFFICIAL RELIGION, YOU SHOULD FOLLOW, AND THEY WIN BY FORCE AND CULTURAL DOMINATION.

AND WHEN THEY ARE IN EUROPE THEY SAY WE ARE A MINORITY, YOU SHOULD NOT CRITICIZE US, YOU SHOULD NOT OFFEND US, BECAUSE OFFENDING US IS OFFENDING HUMAN RIGHTS.

BUT CRITICS SAY THE COLLATERAL DAMAGE WAS MUCH WIDER, HURTING A VULNERABLE AND MARGINALIZED COMMUNITY.

... WHEREAS SATIRE HAS LONG BEEN A WAY TO MOCK AND CHALLENGE THE POWERFUL ...

... IN THE CASE OF THE FRENCH MAGAZINE, IT ONLY ADDED INSULT TO INJURY, TARGETING AN ALREADY STIGMATIZED AND DISCRIMINATED GROUP.

Didier Fassin, anthropologist and sociologist

THE MAGAZINE'S DEFENDERS MAINTAINED THAT IT REPRESENTED PROGRESSIVE, ANTI-RACIST VALUES. IT CONSISTENTLY OPPOSED FRANCE'S FAR RIGHT.

THE CRITICS AREN'T PERSUADED.

THEY SAY THAT EVEN AS *CHARLIE HEBDO* FIGHTS THE RIGHT WING RACISM OF THE NATIONAL FRONT, IT CULTIVATES A LIBERAL FORM OF ISLAMOPHOBIA, PLACING OBSERVANT MUSLIMS AND THE WEST ON DIFFERENT SIDES OF A FALSE BINARY.

THOUGH THE MAGAZINE IS FAMOUS FOR CARTOONS OF THE PROPHET MOHAMMED, ITS OEUVRE ALSO INCLUDES DEMEANING CARICATURES OF ARABS AND MUSLIMS.

CHARLIE HEBDO'S PORTRAYAL OF "ISLAMIC FUNDAMENTALISTS" MINED A PREDICTABLE REGISTER OF CLICHÉS ...

... OFTEN REPRESENTING THESE "MUSLIM MEN" AS SEXUALLY REPRESSED AND ENVIOUS OF WESTERN EMANCIPATION.

Sandrine Sanos, historian

CHARB'S DRAWINGS WOULD PORTRAY THESE MEN AS DESIRING TO BE SODOMIZED...

... EMBODYING A DEFICIENT, PATRIARCHAL, AND PERVERSE MASCULINITY THAT WAS ALWAYS POTENTIALLY VIOLENT BECAUSE UNMOORED FROM THE BENEFITS OF CIVILIZATION.

ET LE CUL DE MAHOMET, ON A LE DROIT?

"Mohammed's ass, is it allowed?" by Charb, published in the 11 November 2011 issue

PROBABLY THE MOST SCATHING CRITIQUE CAME FROM A FORMER *CHARLIE HEBDO* JOURNALIST.

OLIVIER CYRAN WAS FURIOUS WITH THE EDITORIAL DIRECTION TAKEN BY VAL AND THEN CHARB, WHO HAD JUST WRITTEN A PIECE IN *LE MONDE* DEFENDING *CHARLIE HEBDO*.

CYRAN'S RESPONSE CHALLENGED CHARB'S CLAIMS THAT THE MAGAZINE WAS NOT RACIST. HE WARNED THAT IT WAS PROVOKING A REACTION, WITH NO NOBLE JUSTIFICATION. HIS ARTICLE WAS PUBLISHED JUST 13 MONTHS BEFORE THE MASSACRE.

Olivier Cyran

"After 9/11, Charlie Hebdo was among the first in the so-called leftist press to ride the horse of Islamic peril. ... Little by little, the loose denunciation of the 'bearded,' of veiled women, and their imaginary accomplices became a central axis of your journalistic and satirical production.

The obsessional shelling of Muslims that your weekly has been doing for a good ten years has quite concrete effects. It has powerfully helped to spread in 'left' opinion the idea that Islam is a major 'problem' of French society. Belittling Muslims is no longer a privilege of the Far Right.

You claim the anticlerical tradition, while pretending to ignore how it differs fundamentally from Islamophobia. The first was built during a hard, long and fierce struggle against the Catholic clergy's formidable power... The second attacks the members of a minority faith devoid of any kind of influence on the spheres of power."

- Olivier Cyran,
former 'Charlie Hebdo' journalist

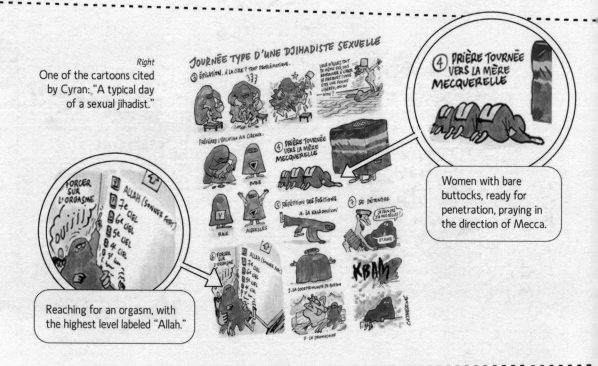

*Right*
One of the cartoons cited by Cyran: "A typical day of a sexual jihadist."

Women with bare buttocks, ready for penetration, praying in the direction of Mecca.

Reaching for an orgasm, with the highest level labeled "Allah."

THE HARM THAT THEY HAVE CAUSED IS IN MAKING IT OK TO STIGMATIZE BLACK, ARAB, MUSLIM MINORITIES WHILE STILL CLAIMING THAT THEY ARE PROGRESSIVE AND ON THE LEFT.

THEY SAY, I CANNOT BE RACIST BECAUSE I LOVE COUSCOUS AND I GO TO MARRAKESH.

THE FAR RIGHT IS NOT A PROBLEM WHEN IT IS SECLUDED AND CLEARLY IDENTIFIED AS A PROBLEM.

BUT WHEN YOU TAKE THEIR IDEAS AND YOU RECODE THEM, THAT'S WHEN YOU INOCULATE THE MAINSTREAM AND THEY BECOME MOST DANGEROUS.

Marwan Muhammad, French anti-discrimination activist

SO INSTEAD OF SAYING, YOU DIRTY ARABS DON'T BELONG HERE ...

... THEY SAY, WE NEED TO REAFFIRM LAÏCITÉ, AS A SHIELD TO PROTECT US FROM POLITICAL ISLAM.

AND EVERYBODY UNDERSTANDS YOU ARE TALKING ABOUT THESE DIRTY ARABS AND THAT YOU WANT THEM TO BE INVISIBLE OR TO GO AWAY.

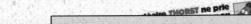

ONE SHOCKING COVER WAS ABOUT THE MILITANT ISLAMIST GROUP BOKO HARAM'S KIDNAPPING OF 276 NIGERIAN SCHOOLGIRLS IN APRIL 2014.

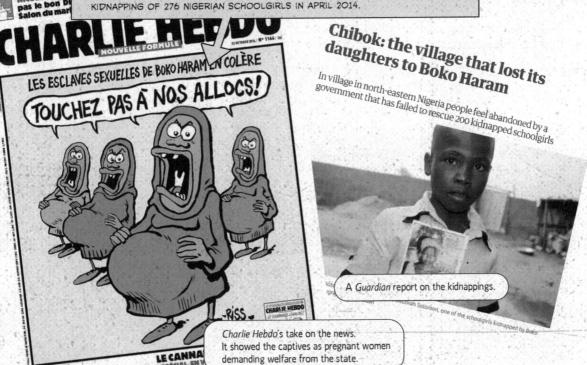

### Chibok: the village that lost its daughters to Boko Haram

In village in north-eastern Nigeria people feel abandoned by a government that has failed to rescue 200 kidnapped schoolgirls

A *Guardian* report on the kidnappings.

*Charlie Hebdo*'s take on the news. It showed the captives as pregnant women demanding welfare from the state.

373

THE CARTOON DREW ON FRENCH RIGHT-WING IDEAS ABOUT THE BLACK WOMAN, THE MUSLIM, AFRICAN IMMIGRANTS, AND PEOPLE ON GOVERNMENT ASSISTANCE.

THE CHIBOK GIRLS, LIKE THEIR CARTOON DISTORTIONS, WERE TO BE CONSIDERED NEITHER REAL GIRLS NOR *OUR* GIRLS.

THE VIOLENCE THAT THEIR PREGNANCIES OFFERED TESTIMONY TO DISAPPEARED.

Abosede George, historian

THE CARTOON HAS BEEN PLAUSIBLY DEFENDED AS *"SECOND-DEGREE"* HUMOR ...

... THAT IT IS ACTUALLY *PARODYING* THE FRENCH RIGHT WING'S TENDENCY TO ACCUSE IMMIGRANTS AND REFUGEES OF BEING GREEDY FOR WELFARE PAYOUTS.

*CHARLIE HEBDO'S* LEFT-LEANING READERS WOULD SUPPOSEDLY GET THE JOKE.

BUT DOES A CARTOONIST NEED TO RECYCLE RACIST TROPES WHEN FIGHTING RACISTS?

Another cartoon that shocked many referred to the iconic news photos of a three-year-old Syrian refugee who was found dead on a Turkish beach in 2015.

*Charlie Hebdo*'s take: "If little Aylan grew up, what would he become? A butt groper in Germany."

This was supposedly another instance of second-degree humor, satirizing racist generalizations about immigrants and refugees as perverts.

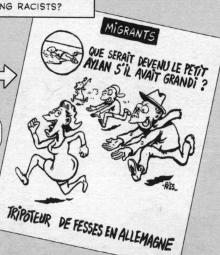

MIGRANTS

QUE SERAIT DEVENU LE PETIT AYLAN S'IL AVAIT GRANDI ?

TRIPOTEUR DE FESSES EN ALLEMAGNE

*CHARLIE HEBDO'S* ANTIRACIST POLITICS HAS ALWAYS BEEN AN AMBIGUOUS EXERCISE.

*CHARLIE HEBDO* HAS HAD A HABIT OF DENOUNCING RACISM THROUGH THE REPRODUCTION OF RACIAL STEREOTYPES IT CLAIMED TO SUBVERT.

Sandrine Sanos

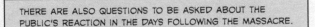

THERE ARE ALSO QUESTIONS TO BE ASKED ABOUT THE PUBLIC'S REACTION IN THE DAYS FOLLOWING THE MASSACRE.

French newspaper covers.
"La France debout" (France stands) is well known in France as a nationalist slogan.

ALTHOUGH "JE SUIS CHARLIE" WAS BILLED AS A CAMPAIGN FOR FREEDOM OF SPEECH AND NON-VIOLENCE AS FUNDAMENTAL HUMAN VALUES ...

... THERE WERE ALSO TRACES OF *TRIBALISM* BENEATH THE VENEER OF *UNIVERSALISM*.

NOAM CHOMSKY AND OTHER CRITICS DETECTED A CERTAIN HYPOCRISY.

IT FELT AS IF DOMINANT CULTURAL INTERESTS IN FRANCE AND THE WEST WERE USING THE OPPORTUNITY TO ASSERT THEMSELVES.

THERE WAS ONE WORD THAT WAS NOT MUCH HEARD DURING THE CRISIS OF JANUARY 2015: THE WORD *"EQUALITY."*

*CHARLIE* WAS CONTENT JUST TO AFFIRM HIS LIBERTY.

... THE LOWER-CLASS MILIEU WERE REDUCED TO SILENCE, AS WERE THE DESCENDANTS OF IMMIGRANTS IN THE SUBURBS.

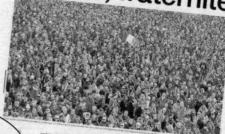

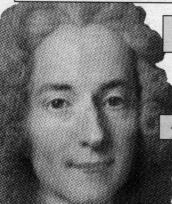

IN THIS POLARIZED ATMOSPHERE, THERE WAS AN ODD SHIFT IN SOME LIBERALS' UNDERSTANDING OF OFFENSIVE EXPRESSION.

IN LIBERAL THOUGHT, HURTING PEOPLE'S RELIGIOUS FEELINGS IS NOT THE *PURPOSE* OF FREEDOM OF EXPRESSION...

... IT'S JUST AN UNFORTUNATE SIDE-EFFECT.

MOST LIBERAL PHILOSOPHERS URGE CIVILITY IN PUBLIC DISCOURSE -- CITIZENS SHOULD VOLUNTARILY EXERCISE SOCIAL RESPONSIBILITY IN HOW THEY USE THEIR SPEECH, EVEN IF THE STATE DOESN'T COMPEL THEM TO.

IN ADDITION, LIBERALISM'S APPROACH TO SPEECH DRAWS A DISTINCTION BETWEEN *APPROVAL* AND *LEGALITY*.

IN A LIBERAL ORDER, THE GOOD CITIZEN MAY DISAPPROVE OF WHAT YOU SAY, YET "DEFEND TO THE DEATH YOUR RIGHT TO SAY IT."

AS LIBERALS, WE PROMISE "FREEDOM FOR THE THOUGHT WE HATE."

 Voltaire's biographer Evelyn Beatrice Hall summarized his view on tolerance: "I disapprove of what you say, but I will defend to the death your right to say it."

BUT LIBERAL DEMOCRACY DOESN'T REQUIRE US TO STOP HATING WHAT WE DISAPPROVE OF -- ONLY TO GIVE IT SPACE.

FROM 2005, THE PROPHET MOHAMMED CARTOON CONTROVERSIES TESTED LIBERALISM'S COMMONSENSE WISDOM.

SOME EUROPEANS STARTED VIEWING BLASPHEMY AS MORE THAN A RIGHT.

IT BECAME AN OBLIGATION. THE WILLINGNESS TO INSULT RELIGIONS WAS SEEN AS CENTRAL TO WESTERN CULTURE, AND THUS A PROXY TEST OF OTHERS' INTEGRATION INTO A SECULAR HUMANIST ORDER.

IN FRANCE, CITIZENS WERE PRESSURED TO SHOW SOLIDARITY TOWARD A MAGAZINE, NOT JUST RESPECT ITS RIGHT TO PUBLISH.

WE MUST LOCATE THOSE WHO ARE NOT *CHARLIE* ...

... THEY ARE THOSE WE HAVE TO SPOT, TREAT, AND INTEGRATE OR REINTEGRATE IN THE NATIONAL COMMUNITY.

Nathalie Saint-Cricq, chief political editor of public TV channel France 2

THE MAGAZINE WAS CERTAINLY A BENEFICIARY AND LIVING PROOF OF FRANCE'S LIBERAL ORDER.

BUT SUDDENLY IT WAS ALSO HELD UP AS THE EMBODIMENT OF FRENCH VALUES.

IT WAS NOT ENOUGH THAT MUSLIMS CONDEMNED THE VIOLENCE.

THEY HAD TO IDENTIFY WITH THE SATIRICAL MAGAZINE, NOTWITHSTANDING THE FACT THAT IT HAD INSISTENTLY DENIGRATED THEM.

Didier Fassin

THE FREE WORLD'S MEDIA, SIMILARLY, WERE CALLED UPON TO SHOW SOLIDARITY WITH *JYLLANDS-POSTEN* AND THEN *CHARLIE HEBDO*, NOT JUST BY CONDEMNING THE VIOLENT REACTIONS, BUT ALSO BY REPUBLISHING THE CARTOONS.

MANY MAINSTREAM NEWS OUTLETS, INCLUDING MOST IN BRITAIN AND THE UNITED STATES, DECIDED NOT TO; *CHARLIE*'S SUPPORTERS REGARDED THEM AS COWARDLY TRAITORS TO THE CAUSE.

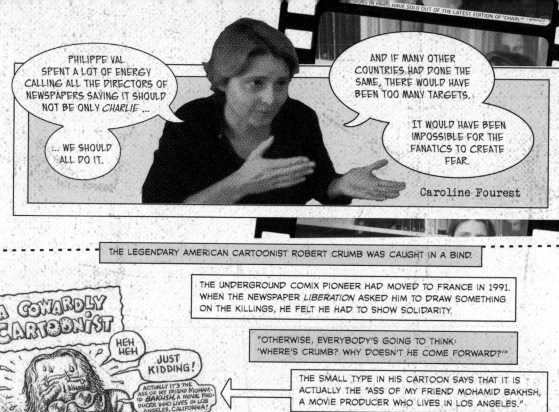

PHILIPPE VAL SPENT A LOT OF ENERGY CALLING ALL THE DIRECTORS OF NEWSPAPERS SAYING IT SHOULD NOT BE ONLY *CHARLIE* ...

... WE SHOULD ALL DO IT.

AND IF MANY OTHER COUNTRIES HAD DONE THE SAME, THERE WOULD HAVE BEEN TOO MANY TARGETS.

IT WOULD HAVE BEEN IMPOSSIBLE FOR THE FANATICS TO CREATE FEAR.

Caroline Fourest

THE LEGENDARY AMERICAN CARTOONIST ROBERT CRUMB WAS CAUGHT IN A BIND.

THE UNDERGROUND COMIX PIONEER HAD MOVED TO FRANCE IN 1991. WHEN THE NEWSPAPER *LIBERATION* ASKED HIM TO DRAW SOMETHING ON THE KILLINGS, HE FELT HE HAD TO SHOW SOLIDARITY.

"OTHERWISE, EVERYBODY'S GOING TO THINK: 'WHERE'S CRUMB? WHY DOESN'T HE COME FORWARD?'"

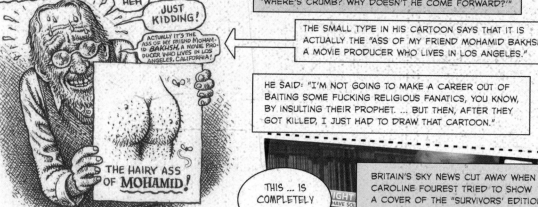

A COWARDLY CARTOONIST

HEH HEH

JUST KIDDING!

ACTUALLY IT'S THE ASS OF MY FRIEND MOHAMID BAKHSH, A MOVIE PRODUCER WHO LIVES IN LOS ANGELES, CALIFORNIA!

THE HAIRY ASS OF MOHAMID!

R. CRUMB— SHOWIN' SOLIDARITY WITH MY MARTYRED COMRADS—JAN. 8, '15

THE SMALL TYPE IN HIS CARTOON SAYS THAT IT IS ACTUALLY THE "ASS OF MY FRIEND MOHAMID BAKHSH, A MOVIE PRODUCER WHO LIVES IN LOS ANGELES."

HE SAID: "I'M NOT GOING TO MAKE A CAREER OUT OF BAITING SOME FUCKING RELIGIOUS FANATICS, YOU KNOW, BY INSULTING THEIR PROPHET. ... BUT THEN, AFTER THEY GOT KILLED, I JUST HAD TO DRAW THAT CARTOON."

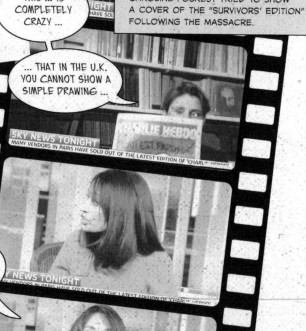

THIS ... IS COMPLETELY CRAZY ...

BRITAIN'S SKY NEWS CUT AWAY WHEN CAROLINE FOUREST TRIED TO SHOW A COVER OF THE "SURVIVORS' EDITION" FOLLOWING THE MASSACRE.

... THAT IN THE U.K. YOU CANNOT SHOW A SIMPLE DRAWING ...

SKY NEWS TONIGHT
MANY VENDORS IN PARIS HAVE SOLD OUT OF THE LATEST EDITION OF 'CHARLIE HEBDO'

AT SKY NEWS WE'VE CHOSEN NOT TO SHOW THAT COVER SO WE'D APPRECIATE, CAROLINE, NOT SHOWING THAT.

I DO APOLOGIZE FOR [SIC] ANY OF OUR VIEWERS WHO MIGHT HAVE BEEN OFFENDED...

# Sky News Freaks Out When Journalist Shows *Charlie Hebdo* Cover on Air

Jay Hathaway
01/15/15 09:45AM Filed to: CHARLIE HEBDO

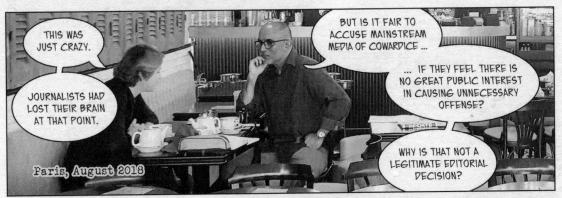

THIS WAS JUST CRAZY.

JOURNALISTS HAD LOST THEIR BRAIN AT THAT POINT.

BUT IS IT FAIR TO ACCUSE MAINSTREAM MEDIA OF COWARDICE ...

... IF THEY FEEL THERE IS NO GREAT PUBLIC INTEREST IN CAUSING UNNECESSARY OFFENSE?

WHY IS THAT NOT A LEGITIMATE EDITORIAL DECISION?

Paris, August 2018

WHEN IT'S A WORLDWIDE POLEMIC, AND THERE ARE PEOPLE UNDER DEATH THREATS ...

... AND WHEN IT IS ABOUT FREEDOM OF THE PRESS AND YOU ARE A NEWSPAPER, AND YOU DO A REPORT WITHOUT SHOWING THE DRAWINGS ...

... YOU ARE DOING AUTO-CENSORSHIP, FOR SURE.

IF EVEN 10 NEWSPAPERS HAD SAID, WE ALL THINK WE SHOULD NOT BE AFRAID OF DRAWINGS ...

... AND WE SHOULD BE FREE TO SHOW THEM WITHOUT FEARING FOR OUR LIVES ...

... AND THIS IS WHY WE ARE SHOWING THEM NO MATTER WHAT WE THINK OF THEM ...

IF THEY DID THAT ...

... MY COLLEAGUES WOULD BE STILL ALIVE.

MANY EDITORS AND PUBLISHERS HAVE READILY ADMITTED THAT FEAR WAS A RESTRAINING FACTOR.

BUT IT WASN'T THE ONLY JUSTIFICATION FOR NOT REPUBLISHING THE CARTOONS.

MANY ARGUED THAT IT WOULD BE GRATUITOUS TO DO SO GIVEN THAT THE CARTOONS WERE READILY ACCESSIBLE TO THOSE WHO WANTED TO SEE THEM.

IT'S ALSO DOUBTFUL THAT THE MEDIA WOULD BE DOING DEMOCRACY A FAVOR BY INDULGING IN CONSPICUOUS CONSUMPTION OF THEIR RIGHT TO OFFEND.

DELIBERATELY HURTFUL SPEECH USUALLY POLARIZES SOCIETY AND MAKES DEMOCRATIC DELIBERATION LESS LIKELY.

AT BOTH ENDS OF THE IDEOLOGICAL DIVIDE, ATTITUDES ABOUT DEPICTIONS OF THE PROPHET HARDENED.

AMONG SOME MUSLIMS, OUT WENT THE REASONED AND CONTEXTUAL APPROACH THAT HAD EXISTED IN MUSLIM SOCIETIES FOR CENTURIES (SEE CHAPTER 13).

IN CAME AN ABSOLUTE TABOO.

OUT WENT JUDGMENT, IN CAME UNDIFFERENTIATED OUTRAGE.

THEY DREW A RED LINE FOR NO OTHER REASON THAN TO POSITION THEIR ENEMY ON THE WRONG SIDE OF IT.

ON THE OTHER HAND, SOME LIBERALS IN THE WEST FELT THEY HAD TO CLOSE RANKS IN THIS GLOBAL CIVILIZATIONAL WAR.

THEY SHELVED THEIR RESPECT FOR HETERODOX OPINIONS, THEIR HEALTHY SELF-DOUBT, AND THE TRADITION OF SELF-RESTRAINING CIVILITY.

THEY BECAME MORE DOGMATIC IN THEIR SECULARISM, AND ABSOLUTIST IN THEIR BELIEF IN FREE SPEECH.

FOR THEM, IT WAS ABOUT PURPOSEFULLY CROSSING RED LINES, NOT TO ADVANCE ANY SUBSTANTIAL ARGUMENT BUT ONLY BECAUSE YOUR ENEMY HAD DRAWN IT.

THIS SHIFT RESULTED IN THE *CHARLIE HEBDO* AFFAIR'S BIGGEST IRONY. THE TRAUMA DIDN'T JUST REIGNITE FRANCE'S LOVE AFFAIR WITH THE IDEA OF FREE SPEECH. IT ALSO PRODUCED A MORE RESTRICTIVE PRACTICE OF THIS VIRTUE -- THERE WAS LESS "FREEDOM FOR THE THOUGHT WE HATE."

THE PREVIOUS YEAR, FRANCE HAD ENACTED A NEW LAW CRACKING DOWN ON APOLOGISTS FOR TERRORISM, MEANT TO TARGET JIHADIST RECRUITERS.

AFTER THE KILLINGS, AUTHORITIES CITING THIS LAW HARASSED THOSE -- INCLUDING CHILDREN AND YOUTHS -- WHO REFUSED TO SHOW SUFFICIENT SOLIDARITY WITH *CHARLIE HEBDO.*

A JUVENILE COURT IN NANTES SENTENCED TO PROBATION A HIGH SCHOOL KID FOR DEFENDING TERRORISM.

HIS CRIME?

SHARING THIS CARTOON ON FACEBOOK.

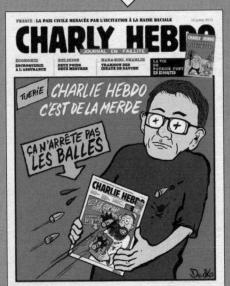

THE TEXT READS, "CHARLIE HEBDO IS SHIT. IT DOES NOT STOP BULLETS."

THE BOY LIVED AT HOME WITH HIS PARENTS AND SHOWED NO INCLINATION TO JIHADISM, PROSECUTORS ACKNOWLEDGED.

HE SHARED THE CARTOON, WHICH HAD APPEARED SOON AFTER THE MASSACRE, BECAUSE HE THOUGHT IT WAS FUNNY.

THE CARTOON WAS A PARODY OF THAT ACTUAL 2013 *CHARLIE HEBDO* COVER MOCKING VICTIMS OF SISI'S COUP IN EGYPT.

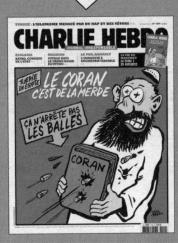

UP TO THE POINT WHEN THIS COVER WAS PUBLISHED, AT LEAST AS MANY PEOPLE WERE KILLED IN THE COUP AS AT *CHARLIE HEBDO.*

(IN THE TWO MONTHS FOLLOWING THE COUP, POLICE AND ARMY FORCES KILLED OVER 1,150 DEMONSTRATORS, ACCORDING TO HUMAN RIGHTS WATCH.)

IF, AS *LE MONDE* SAID, 7 JANUARY 2015 WAS FRANCE'S 9-11, IT'S NOT SURPRISING THAT MAINSTREAM FRENCH OPINION REACTED MUCH LIKE AMERICANS DID AFTER THE ORIGINAL 9-11: WITH HEIGHTENED PATRIOTISM, PARANOIA, AND POLICING OF SPEECH.

BUT FRANCE'S SURGE IN SENSITIVITY WAS MORE IRONIC, GIVEN THAT JE SUIS CHARLIE WAS SUPPOSED TO BE ABOUT FREEDOM OF EXPRESSION.

"SELL!" THIS WAS THE MAGAZINE'S COVER THE WEEK OF 9/11, WHEN TWO HIJACKED JETS CRASHED INTO THE WORLD TRADE CENTER IN NEW YORK'S FINANCIAL DISTRICT.

THE COVER EXEMPLIFIED *CHARLIE HEBDO*'S CARTOONISTS' OWN ATTITUDE TOWARD THE TABOO OF DEATH.

N° 483 / 19 SEPTEMBRE 2001   161

spécial ça va chier!

CHARLIE HEBDO

VENDEZ!

IT WAS NEVER TOO SOON TO LAUGH, EVEN AT THE VICTIMS OF A HORRIFIC TERROR ATTACK.

NO WONDER SOME COMMENTATORS QUESTIONED THE IMPOSITION OF NATIONAL MOURNING AND THE POLICING OF NAYSAYERS.

"WE MAY ASK OURSELVES WHAT WOULD BE A MORE APPROPRIATE WAY OF HONORING THE CARTOONISTS THAN MOCKING THEIR DEATHS. THIS WOULD CELEBRATE THEIR PROJECT AND FOLLOW DIRECTLY IN THEIR FOOTSTEPS," NOTED SOCIAL ANTHROPOLOGIST AXEL RUDI.

BUT TO SOME IN FRANCE, *CHARLIE HEBDO*, THE SLAYER OF TABOOS, HAD BECOME ITS OWN TABOO.

THE IRONY WAS NOT LOST ON LUZ, WHO HAD ESCAPED THE ATTACK ONLY BECAUSE HE REACHED THE OFFICE LATER THAN USUAL THAT DAY.

THE MEDIA MADE A MOUNTAIN OUT OF OUR CARTOONS, WHEN ON A WORLDWIDE SCALE, WE ARE MERELY A DAMN TEENAGE FANZINE.

SINCE 2007, WE ARE BEING MADE TO CARRY A SYMBOLIC RESPONSIBILITY THAT DOESN'T FIGURE IN *CHARLIE*'S CARTOONS.

SYMBOLIC WEIGHT IS EXACTLY WHAT *CHARLIE* HAS ALWAYS WORKED AGAINST: DESTROYING SYMBOLS, BREAKING DOWN TABOOS, BURSTING BUBBLES OF FANTASY.

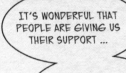
IT'S WONDERFUL THAT PEOPLE ARE GIVING US THEIR SUPPORT ...

... BUT THE REPUBLIC MUSTN'T TURN INTO A HYSTERICAL MOURNER.

I DIDN'T GO TO THE SPONTANEOUS RALLY ON JANUARY 7TH.

PEOPLE SANG THE NATIONAL ANTHEM ...

WE'RE TALKING ABOUT CHARB, TIGNOUS, CABU, HONORÉ, WOLINSKI ...

Rénald Luzier, "Luz"

THEY WOULD'VE SCORNED THIS KIND OF ATTITUDE.

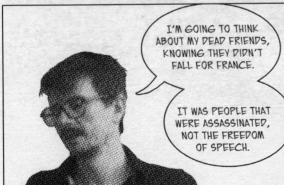
I'M GOING TO THINK ABOUT MY DEAD FRIENDS, KNOWING THEY DIDN'T FALL FOR FRANCE.

IT WAS PEOPLE THAT WERE ASSASSINATED, NOT THE FREEDOM OF SPEECH.

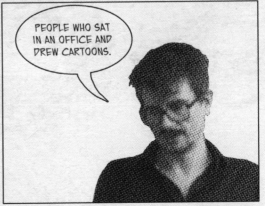
PEOPLE WHO SAT IN AN OFFICE AND DREW CARTOONS.

# Concluding Lines, in Words and Cartoons

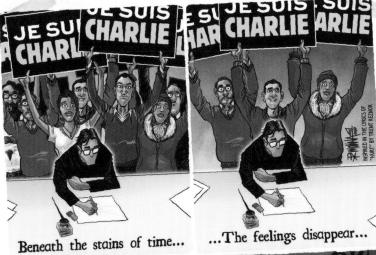

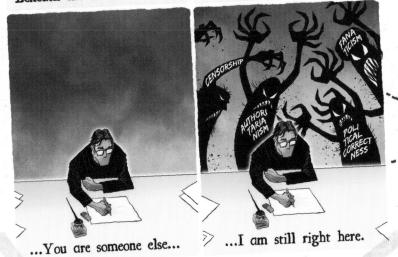

Beneath the stains of time...

...The feelings disappear...

...You are someone else...

...I am still right here.

Left: Pedro Molina, Nicaragua, 2020.

Drawn for the fifth anniversary of the *Charlie Hebdo* killings, Molina's cartoon comments on the fleeting nature of public support for cartoonists under threat.

Molina is no stranger to danger (see Chapter 3). He uses his cartoons to draw global attention to human rights abuses in his own country, and to other cartoonists at risk around the world.

CARTOON CENSORSHIP EXPOSES GAPS AND FAILURES IN THE LIBERAL PROJECT.

# An asymmetric battle

The outpouring of sympathy for the victims of the *Charlie Hebdo* massacre in January 2015 was unprecedented. Never had an attack on cartoonists' freedom — or freedom of expression of any kind — mobilized such mass, transborder demonstrations of solidarity.

People were probably reacting to the sheer one-sidedness of the encounter at Rue Nicolas-Appert that fateful morning. Pen and paper versus blazing guns. It was an extreme illustration of the imbalance of power that political cartoonists have always had to deal with. But although "Je Suis Charlie" was an uplifting event for those who took part, its long-term impact was negligible. As Nicaraguan cartoonist Pedro Molina observes above, the cartoonist is left to deal with the same old despots and dogmas.

Below: Jean Gouders, Netherlands, 2011

A tribute to Syrian cartoonist Ali Ferzat (see Chapter 1), this cartoon is subtitled "the dictator's nightmare." It belongs to a genre that depicts the cartoonist as possessing larger-than-life powers – a trope gently mocked by Tom Tomorrow, bottom, right.

C artoons have an almost magical quality. Their power to provoke can take even veteran cartoonists by surprise. In most of the cases studied in this book, the cartoonist did not predict the reaction.

Their opponents' powers are more prosaic — but usually more efficient. Their language is the rejection letter, the lawsuit, the bolted prison door, the rifle to the head.

Below: Adjim Danngar (Achou), Chad/France, 2015

Tribute to Ali Ferzat

Scorpius Cartoonus Satiricus

commonly known as "the dictator's nightmare"

Below: Dan Perkins (Tom Tomorrow), USA, 2015

Extract from a response to the *Charlie Hebdo* killings.

Right: Mary Zins, United States, 2018.

This illustration echoes what countless resistance fighters have declared: you can imprison a body, but not the mind. But at another level this cartoon represents an exercise in futility, since symbolic keys can't open literal locks.

The cartoon won an honorable mention in an "Art of Resistance" international competition organized by Cartoon Movement. Zins died in 2019.

BONUS FUN FACT: ALL THOSE CARTOONS YOU'VE SEEN WITH THE GIANT PENS AND PENCILS ARE NOT VISUAL METAPHORS FOR THE POWER OF SATIRE--BUT RATHER, LITERAL REPRESENTATIONS OF STANDARD CARTOONING TOOLS!

# Autocracy's many faces

Political cartoons were thrust into the public sphere by the twin revolutions of the printing press and democracy. Communication technologies kept advancing, at accelerating speed. But political progress has been uneven. Cartoon censorship exposes the gaps and failures of democracy's liberal project. On paper, freedom of expression is recognized by most states as a fundamental human right. The reality on the ground can be rather different, as most of the cases in this book attest to.

Authoritarian leaders render free speech meaningless when they

prohibit cartoons that criticize or demean them. Or when cartoonists face extreme punishments, like physical violence, long jail terms, and massive lawsuits (Chapters 1–4). Increasingly, they ride on market forces and popular sentiment (Chapters 4–5) to discipline dissent.

Left: Akram Raslan, Syria, c.2012

Like other despots, Syrian president Bashar al-Assad's voice is amplified by brute force – a power that cartoonists try to neutralize through wit. Works like this by Akram Raslan got him picked up from his newspaper office by government agents in October 2012. He died in a prison hospital in 2013, presumably after being tortured.

Below: Elihu Duayer, Brazil, 2018.

Human rights, enshrined in international treaties and national constitutions, are a joke to the police and military in many parts of the world.

Right: Maarten Wolterink,
Netherlands, 2018

Wolterink's cartoon
suggests that Equatorial
Guinea's despotic ruler
Teodoro Obiang – the
world's longest-serving
president – envies the
appeal of cartoonist
Ramón Nse Esono Ebalé,
who was imprisoned for
nearly six months on
trumped-up counterfeiting
charges. The cartoon's title
is a reference to Ebalé's
satirical graphic novel, *La
pesadilla de Obi* (Obi's
Nightmare), which is
censored in the country.

Below: Steven Degryse
(Lectrr), Belgium, 2020

Lectrr's follow-up to his
run-in with the Chinese
government (Chapter 7)
shows a surgical mask as
part of China's "coronavirus
policy" and a taped mouth
as part of its "coronavirus
cartoon policy."

G overnments' emergency
responses to the
COVID-19 pandemic
and the resulting
economic crisis have worsened
the problems highlighted in this
book. "During the collective effort
required to meet a great crisis it
is all too easy to decry humor as
inappropriate, even criminal,"
notes Terry Anderson, executive
director of Cartoonists Rights
Network International. "But satire
is synonymous with scrutiny and
right now the use of extraordinary
power demands it."

Unlike whistleblowers and
investigative reporters, cartoonists
do not deal in exposés. Instead,
they tend to express truths that
many already sense — just more
trenchantly. What the despot finds
dangerous are not the revelations
in a cartoon's content, but its
potentially infectious contempt.

Perhaps he also envies the
ease with which skilled cartoonists
establish a bond with the public;
he fears that if he permits such
unrestrained intercourse, his
own powers will be demeaned or,
worse, laughable.

# Money talks, money silences

artoonists' freedom is threatened by not only liberalism's external enemies but also its inner contradictions. One's right to speak doesn't automatically come with the means to make one heard. Economic power — and thus media power — is still concentrated in the hands of a few.

Authoritarian states exploit this contradiction, shifting from direct state censorship to economic carrots and sticks, and using proxies in the commercial sector (Chapters 4–5).

Even without the state's help, markets exert powerful pressures (Chapter 6). "A commercial system, especially one that is overly reliant on advertising revenue, will systematically privilege some views and values over others," says Victor Pickard, author of *America's Battle for Media Democracy*. "This leads to predictable patterns over time. The market ultimately does the ideological work that oppressive states try to do through more overt means. A market-driven system often will predictably not support — and thereby censor out — controversial, dissident, and minority views and voices."

Journalism's financial crisis has made news organizations even less hospitable to cartoonists. Owners and editors have grown more conscious of the financial bottom line, making them more sensitive to complaints from readers, advertisers, and investors.

Below: Stephane Peray (Stephff), France/Thailand, 2005

Thailand-born French cartoonist Stephff has seen the outlets for his pro-human-rights cartoons shrink as private newspapers in Thailand come under political pressure. Facebook has also censored his work (Chapter 8).

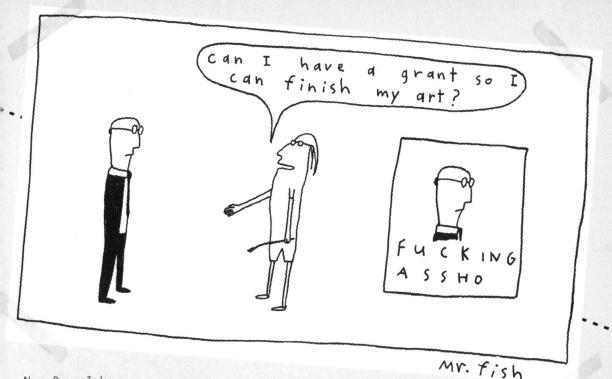

Can I have a grant so I can finish my art?

FUCKING ASSHO

mr. fish

Above: Dwayne Taylor Booth (Mr. Fish), United States, 1991

"The drawing," says Fish, "is a metaphor for how we all must remain subservient to power, even while recognizing the injustice of the system, because to ridicule it would jeopardize our access to the life-sustaining capital that is meted out by the profit-making institutions that undermine our personal integrity as freethinking individuals, if only because cogs on a wheel need to be mindless, regimented and made wholly predicable, otherwise the economic cycle has no forward momentum and the fat cats don't get fatter."

Editors and publishers have grown weary and wary of potentially controversial cartoons. Thus, the borders of the journalistic field are being realigned. The profession is consolidating around its comfort zone of the objective and unobjectionable. The strongly opinionated cartoon that challenges readers is as welcome as a landmine.

As news media close their doors, cartoonists turn to smaller alternative outlets. They are also more likely to work with the art world and book publishers. Self-publishing on the internet is the easiest way to put your work out there — though not necessarily to put food on the table.

Left: Agim Sulaj, Albania/Italy, 2015

"Censorship"

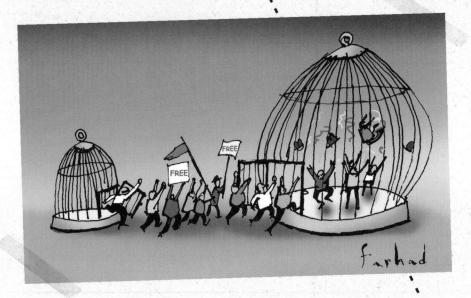

Farhad Foroutanian, Iran/ Netherlands, 2011

Foroutanian's original version of this cartoon was about the Iranian Revolution, which replaced one form of tyranny with another. He drew this version in response to events three decades later. "When the 'Arab Spring' started, I felt the same thing was happening to those people."

# Shape-shifting censorship

T he Iranian Revolution, the fall of the Soviet Union, and the Arab Spring showed that removing a tyrant isn't the same as establishing democratic government. You could just be swapping one form of repression for another.

Furthermore, people don't always use their new freedoms in support of others' rights.

In the world's most established democracies, after revolutionary movements wrested power from monarchs, it took decades or even centuries for liberty to spread horizontally to women and other groups on the margins. That project remains incomplete in liberal societies, and far behind in others.

In the ongoing struggle for equality, we find cartoons on both sides of the battle. Cartoonists continue to produce work that deliberately or unwittingly promote exclusion, intolerance, and hate. At the other end of the spectrum are cartoonists who are committed to the struggle against racism and other forms of discrimination, but are attacked for causing offense.

Above: Khalid Albaih, Sudan/Qatar, 2019

"Some people rather live in their own jail," the cartoonist said in a post about this "D.I.Y. jail."

Above: Anne Derenne, France/Spain, 2019

Sometimes, people's freedoms are not compatible. Expanding freedoms have produced clashing rights that are manageable only if everyone acknowledges everyone else also has rights.

Right: Kuang Biao, China, 2016

Traditional values can be enlisted by the modern state to keep them submissive. Kuang Biao (Chapter 4) shows the Chinese character for filial piety bound up. He was reacting to a report on national television in which citizens interviewed agreed that loyalty to the state is a form of filial piety.

"It seems like huge numbers of people have within their heads two completely incompatible opinions," says British cartoonist Martin Rowson. "First, their greatest human right is to say whatever they like irrespective of the consequences. Second, their other greatest human right is that they themselves must never be upset."

Setting aside the cartoonist's hyperbole, his underlying point is hard to refute: although the principle of reciprocity is central to the idea of democracy, the concept of freedom for *us* has always been easier to internalize than freedom for *them*.

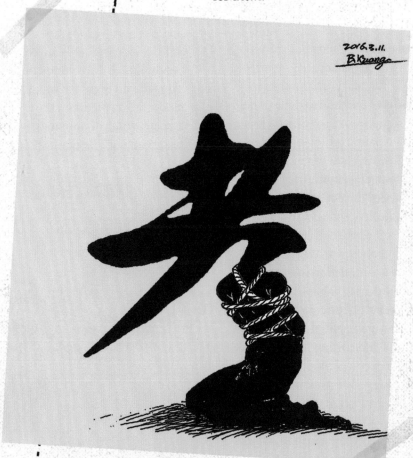

# Platform power

Facebook boss Mark Zuckerberg's topsy-turvy relationship with President Donald Trump — first cozying up to him, then banning him — was the latest iteration of media tycoons influencing politics. Think of Rupert Murdoch in Britain, and Mukesh Ambani in India.

Owners' political leanings aside, there are also structural biases encoded in internet platforms (Chapter 8). The commercial orientation of these firms has resulted in an internet architecture that favors mineable data over meaningful information. Facing public pressure, they have engaged in clumsy attempts at "good" censorship, which regularly ensnares feminist and anti-racist cartoons — often as a result of malicious complaints. Though still regarded as an empowering medium, the internet is increasingly dominated by traditional offline power holders.

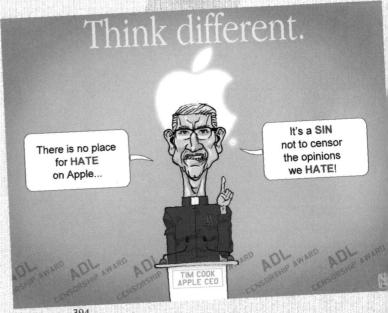

# Culture wars

Cartoonists everywhere report a proliferation of groups demanding that their collective identities be accorded due dignity. The most extreme cases involve vigilante violence meted out against perceived insults against Islam or its Prophet (Chapters 13–14).

The "cultural left" in the West, like religious conservatives, does not believe liberals who say the answer to bad speech is more speech. Bad speech that kicks people when they are down — nations robbed of dignity by dictators and drones, despised immigrants, people of color, or women — rarely leads to a conversation where they are helped to their feet.

Above: "Red Lines" by Doaa el-Adl, Egypt, 2020

In societies with low levels of political violence and strong rule of law, identity groups usually express their displeasure peacefully.

Nevertheless, when the movement is influential enough or militant enough, its complaints about a cartoon can have material effects (Chapters 8, 9, 11). You can get fired or lose clients. Publishers and galleries avoid you. You have to retreat from social media and lie low for a while. You may even need bodyguards to protect yourself and your family.

All this can feel a lot like life in an authoritarian regime, even though you're living in a liberal democracy with constitutional free speech protections.

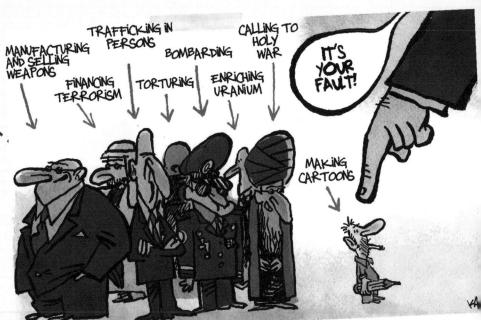

MANUFACTURING AND SELLING WEAPONS

TRAFFICKING IN PERSONS

FINANCING TERRORISM

BOMBARDING

TORTURING

CALLING TO HOLY WAR

ENRICHING URANIUM

IT'S YOUR FAULT!

MAKING CARTOONS

Left: Jaume Capdevila (Kap), Spain, 2015.

"What should be offensive is not, and cannot be, the drawing, but the reality portrayed," argues Kap. "Cartoonists usually portray the reality, or what is in the news, even if it is through the corrosive prism of satire."

# The blame game

Even drawings that are straightforwardly denotative — with a one-to-one correspondence between the cartoonist's chosen signifiers and what they intend to signify — are prone to misinterpretation. Sometimes, a cockroach is just a cockroach, as Iranian cartoonist Mana Neyestani would tell you (Chapter 11). But others are free to make it something else.

While cartooning as a mode of communication could be said to be a universal language, each cartoon uses symbolic signs whose intended connotations are based on conventions that are culturally specific. The clever visual metaphor falls flat when it confronts readers who don't share the same stock of cultural references the cartoonist takes for granted.

Thus, Ann Telnaes in the United States (Chapter 7) and Zapiro in South Africa (Chapter 12) found out the hard way that the nineteenth-century "organ grinder's monkey" metaphor was not universally known, even within their own societies.

Cartoonists count not only on the visceral appeal of their art, but also on a cultural and political literacy that globalization cultivates only patchily.

Above: Godfrey Mwampembwa (Gado), Tanzania/Kenya, 2016.

Regardless of the political system they work in, cartoonists report feeling increasingly constrained by identity politics.

# Who's up, who's down?

To separate democracy-enhancing satire from gratuitous sadism, many political cartoonists apply this rule of thumb: punch up, not down. Attack the powerful, but don't demean the weak.

But many controversies boil down to disputes over whether the groups being lampooned are "up" or "down." Whether they are dangerous or defenseless is the eyes of the beholder.

Are cartoons about Muslims and terrorism (Chapters 13–14) punching up at a global movement of extremists who spout Quranic verses? Or kicking down at marginalized Muslim minorities in the West?

Should cartoonists treat Israel (Chapter 12) as a militarized state that oppresses Palestinians with impunity? Or the besieged homeland of a Jewish community subjected to bigotry around the world?

Is Serena Williams a privileged member of Forbes' list of 100 most powerful celebrities, and as such fair game for satire (Chapter 12)? Or must she be protected as a rare icon of a gender and race still struggling for equality?

Is China (Chapter 8) an emerging global bully, or a people scarred by their Century of Humiliation by whites who still treat Asians with racist condescension?

Cartoonists can try to escape these binaries and find a middle way. When they fail, as they often do, their work provokes extreme reactions — either that it is gratuitously offensive, or that it's obviously not.

Michael Rozanov (Mysh), Israel, 2012.

Mysh drew this cartoon, "The Problem of Self Esteem," after a thousand Israelis protested against African refugees and asylum seekers in Tel Aviv. The tattoos on the thug's back are popular racist slogans such as "A good Arab is a dead Arab" and "Russians to Russia." Cartoonists who try to "punch up" at Israel's bullies are accused of anti-Semitism by those who can only see a vulnerable, historically oppressed community.

397

# Fluid victimhood

Above: Ward Sutton as "Kelly," United States, 2018.

Sutton's political cartoons in the *Onion* by his alter ego "Stan Kelly" parody the perspectives of a fictional semi-talented conservative cartoonist. In the cartoon above, Kelly complains that the American comic book industry's turn toward greater inclusivity has marginalized its core white male fan base. While Kelly is a fake, his opinion mirrors the real-world grievances fueling the "Comicsgate" controversy (Chapter 10).

Victimhood is an elastic concept. Even the most powerful man in the country can persuade himself and his followers that he deserves special protection — usually by claiming that an attack on him is an attack on the genuinely downtrodden communities he represents. Nicolas Maduro in Venezuela (Chapter 11) and Jacob Zuma in South Africa (Chapter 12) are just two examples.

Although nobody wants to be an actual victim, the cloak of victimhood is a useful political resource. Fundamentalist clerics as well as populists politicians know this, claiming to be beset by the dominant establishment or enemies foreign and domestic.

Spokespersons for progressive, anti-racist groups are also capable of strategic offense-taking. Activists often condemn a cartoon not as harmful in and of itself, but as an injustice symbol — as evidence of larger social ills.

Many cartoonists are skeptical of such outrage. While some may be in denial about the hurt and harms their cartoons cause, other artists featured in this book are probably right to feel that they are convenient, defenseless targets (yes, victims) in much wider culture wars.

# Baiting censors

**C**ritique from the cultural left has helped the cartooning profession evolve. Many cartoonists have internalized social justices causes into their work.

But the cultural left's victimhood rhetoric has also been appropriated by majoritarian nationalist groups who claim that they are the ones being silenced.

Nowadays, hate propaganda campaigns are often booby-trapped against liberal outrage and "good censorship." For example, American white supremacists adopted Pepe the Frog as a deliberately ridiculous anti-Semitic meme to bait liberals. It was a "prank with a big attention payoff."

THE NEW EUROPEANS

Above: Anonymous, c. 2016.

This cartoon, circulated by Europe's far right, incorporates a pre-emptive response to censorship. It depicts Barack Obama and Angela Merkel silencing the victim with a gag labeled "racism."

This is in line with the right-wing claim that political correctness is silencing concerns about violent immigrants and refugees. To the cartoon's intended audience, censorship would only prove its point.

Right: Anonymous, 2016.

Pepe as a genocidal Nazi officer.

Right: Matt Wuerker, United States, 2015.

Pamela Geller, a leading Islamophobia merchant, organized a Prophet cartoon contest in 2015 to bait Muslims.

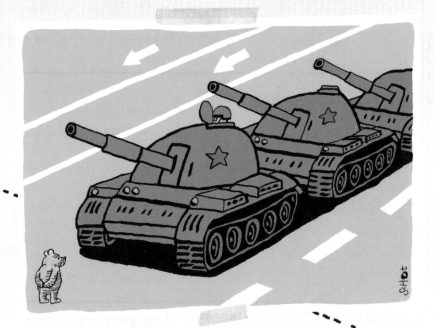

Left: Bas van der Schot, Netherlands, 2018

Based on the iconic "tank man" photo from the 1989 Tiananmen protest, Schot's cartoon ridicules the Chinese government's ban on Winnie the Pooh, following the cartoon character's adoption in in memes poking fun at President Xi Jinping. The ban is just one extreme example of how cartoon censorship episodes are often battles over symbols that have no inherent meaning.

# Symbolic battles

Cartoonists relish the disproportionate impact of their deceptively simple tools. But even they get incredulous when raging conflicts erupt around cartoons.

Most of these events only make sense as symbolic battles. Beyond the specific message it communicates, a cartoon becomes intolerable because of what it represents. To the despot, it symbolizes some wider political threat such as a popular uprising. To community guardians, it epitomizes deeper social injustice such as systemic racism.

At another level, the battles themselves are symbolic. Cartoon controversies are occasions for political actors to hog the limelight, draw attention to their values, assert claims on the state and other elites, and put opponents on the defensive.

It shouldn't surprise us that censorship battles have this symbolic function. The same has always been true of many social taboos, religious edicts, and secular laws.

The red lines of cartoon censorship are not like red lights, whose role is purely instrumental. Traffic rules regulate traffic. They have no special significance beyond that.

The red lines of cartoon censorship are more like alcohol bans during the Prohibition years in the United States or in Pakistan today.

Such restrictions have an expressive function. They are statements of a society's values — or, more to the point, the values of those with the power to speak for society, or at least have a seat at the table where those values are negotiated.

The same is true of bans on cow slaughter and beef consumption in Indian states; the lese majeste law in Thailand; and Switzerland's minaret ban.

The locations of such red lines say something about who really counts, who's in, and who's out. Red line debates thus become proxy battles in the competition for political status. When we witness an eruption of moral outrage over a cartoon, this is often due to changes in the actors' political calculations. They may feel a need to mobilize supporters, or spot an opportunity to corner opponents.

It's not just cartoons that can serve such political purposes. Combatants fight over flags, statues, clothing, food, novels. But cartoons are among the most attractive bones of contention, for the same reasons that they are such an effective genre of political commentary. They are fluid in their meanings, and appear in mass media — which are themselves favorite targets in culture wars.

Sure, a political cartoon is difficult to argue against. How to disprove a visual comment? But, by the same token, it is hard to argue against non-cartoonists' reading of a cartoon. How to dismiss readers' pain and outrage? Trying to do so just rubs salt into the wound.

Al Qaeda understands the utility of picking a fight with cartoons. When its glossy magazine *Inspire* published a list of cultural and ideological enemies in 2013 (Chapter 14), more than half of the infidels — six out of eleven — were "wanted" in connection with cartoons.

David Fitzsimmons, United States, 2015

The Confederate flag, used by the Southern states during the American Civil War, is extremely divisive, embraced as a symbol of Southern pride, but also adopted by white supremacists, just like the Nazi swastika. Here, Fitzsimmons uses a cartoon to privilege one intepretation over another. But he has no monopoly over that ability. Cartoonists' works are prone to be twisted and turned by viewers.

THE CONFEDERACY OF RACIAL SUPERIORITY

# The median, not the message?

The image contains a speech bubble: "TELL ME AGAIN HOW WORLD WAR III STARTED OVER A BUNCH OF CARTOONS?"

his book about cartoon censorship is reaching an awkward, counter-intuitive conclusion: that cartoonists' encounters with red lines are often not about their cartoons' content, but about the line itself.

This may seem an odd claim. Yet that's the way it looks to many cartoonists. Pondering the 2006 Prophet Mohammed cartoon controversy, *Maus* author Art Spiegelman wrote, "The tragedy of the Danish 'cartoon war' … is that it really wasn't about cartoons at all." The same applies to several of the disputes chronicled in this book.

The symbolic nature of these battles helps explain the intractability of the Prophet Mohammed cartoon dispute, even among people committed to the peaceful resolution of differences.

To some Europeans, deliberate offense became a kind of citizenship test: you must be willing to produce and celebrate (not just tolerate) cartoons that cross Muslims' red line. If not, you either don't belong in Western society, or you are a coward.

Your self-restraint may actually come from a place of principle because you can express yourself without crossing that line, and because you empathize with a weaker community. No matter. You must cross that line.

To some Muslims, meanwhile, defending the red line regardless of context became a show of piety and solidarity, divorced from reason, history, and theology.

Signe Wilkinson, United States, 2006.

The Pulitzer Prize-winning editorial cartoonist drew this sarcastic piece when the Danish cartoon controversy exploded.

"Cartoons are commentary, they can't kill someone, blow people up, or force people to believe anything," she says.

**T**he line matters more than the cartoon. Perhaps the *New York Times*, criticized for abandoning editorial cartoons entirely (Chapter 6), understands the rules of this new game. The *Times* promises "all the news that's fit to print." It seeks to tell the American public "all" they need to hear; but editors increasingly attacked for carrying what even some insiders believe is not "fit" for the paper's illustrious platform, as former opinion editor Bari Weiss put it.

When elite media are involved, cartoon controversies may be less about what the art was trying to say, than about where the publisher stands in relation to a red line. The *Times* is not alone in treating political cartoons as a liability, even if others haven't cut them off entirely.

Highly polarized political contention negates content and context, resulting in extreme reactions like murder, and amazing leaps of logic that have cartoonists shaking their heads in disbelief. Like when Venezuelan politicians condemned a cartoonist for allegedly mocking a murder — even though the murder hadn't happened yet (Chapter 11).

Reality outpaces satire.

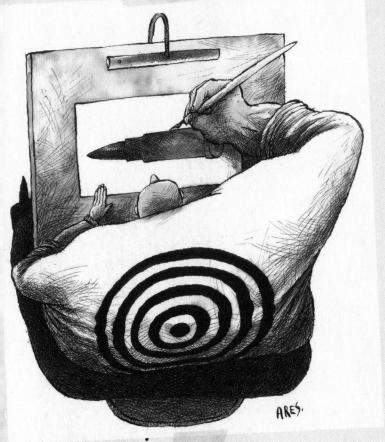

Aristides Hernandez (Ares),
Cuba, 2015

This post-*Charlie* cartoon by Ares, one the world's most critically acclaimed cartoonists, reminds us that cartoonists attract responses that go beyond verbal criticism. They have been literally targeted for fatal attack. But the reasons cartoonists are targeted are complex. The strongest reactions are rarely about what the cartoonist actually drew.

ARTICLES AND BOOKS ABOUT CARTOON CENSORSHIP USUALLY END ON A HOPEFUL NOTE.

# The hopeful note

**C**artooning is an extremely resilient genre of art and journalism. It won't die. Cartoonists will, however, need to struggle — as they always have — for the space to participate in democratic conversations. These struggles will continue to reveal the potential and limits of freedom of expression for all of us.

Despite the many threats and restrictions they face, most cartoonists feel obliged to offer reason for optimism. But witty comebacks aside, they have no answer for the tangible retribution they may face, against their bodies, bank accounts, and loved ones.

"I am a realist," says Mana Neyestani (Chapter 11), who drew the final cartoon in this gallery. But like most of the best political cartoonists, his unsentimental view of the harsh realities of power is coupled with the conviction that life could be better. "I always say 'hope' should be the last thing that we give up. It is important to keep our realism and at the same time to encourage each other, to have hope for the upcoming generations."

Mana Neyestani, Iran/France, 2016.

On the death of cartoonist Akram Raslan
in a Syrian jail.

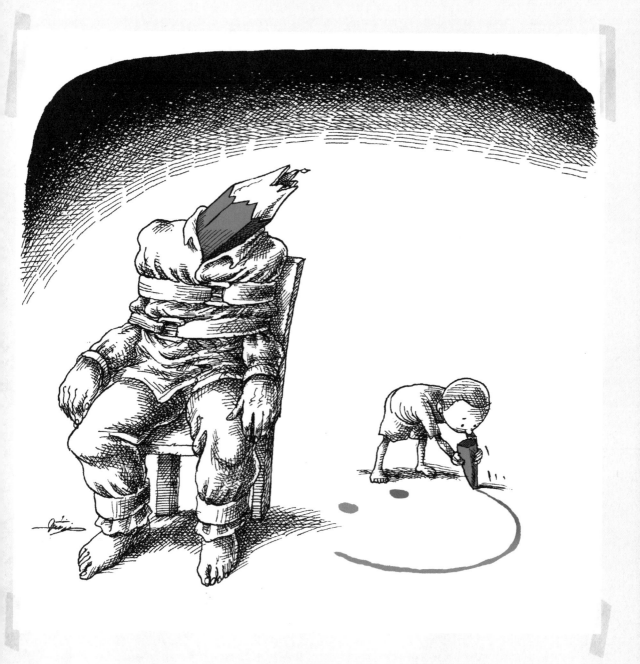

# end

# Acknowledgments

THE ARTISTS whose experiences and viewpoints are featured in this book were generous with their time and their artwork. Many were also open with their doubts and fears, mostly out of solidarity with fellow artists and writers who continue to work in challenging circumstances. To capture not just the facts and figures of censorship but also the inner debates and societal conflicts that accompanied many of the events related in this book, the project became larger and took longer than planned. It still does not do full justice to the rich perspectives our sources shared with us. We are deeply grateful for their indulgence.

Presenting academic research in graphic form does not fit most people's stereotypes of what scholarship should look like. Fortunately — as with anything worth doing — you don't need most people to believe in your plan, just the right number of peers and partners who can help you realize it. Sandra Braman (editor of the Information Policy series of which this book is an atypical part) and Gita Manaktala (editorial director at the MIT Press) were enthusiastic and unflinching backers from the instant the topic surfaced in idle conversation over breakfast in San Diego in May 2017.

The project was funded by Hong Kong Baptist University's Research Committee and School of Communication. Research in the United States was cofunded by the Center for Media at Risk at the University of Pennsylvania's Annenberg School for Communication. Cherian's sabbatical at the Center in 2018 was at the invitation of Barbie Zelizer, whose moral and material support for the project is deeply appreciated. Center coordinator Emily Plowman helped organize the Red Lines: Cartooning at Risk international symposium that helped accelerate the research. Interaction with graduate students in Cherian's classes on Censorship at the Annenberg School and Baptist University helped refine some of the thinking that went into the book.

Almost all of the artists in this book were not personally known to the authors at the start of the project. We relied heavily on a couple of super-connectors — John Lent and Robert Russell. Cartoonists Dwayne Taylor Booth, Terry Anderson, Emad Hajjaj, and Daryl Cagle also helped expand our network.

Our main research assistant Raphael Blet was always reliable and enterprising. We are also grateful to several other assistants and translators: Eureka Wang Shiqi, Scarlett Zhou Huiwen, Moldir Seilkhanova, Florin Serban, Rita Lau Hoi Yan, Sarah Kefi, Daniel Metz, Gladys Angelica, Abby Qin Youran, and Kyle Huang Qihua.

In addition to the anonymous reviewers arranged by our publisher, several other readers gave us valuable feedback on various drafts, lending us their expertise on specialized topics and geographical areas: Abdullahi Tasiu Abubakar, Romain Badouard, Kecheng Fang, Didier Fassin, Kai Hafez, John Lent, Vincent Mosco, Victor Pickard, Shakuntala Rao, Margaret Roberts, Sandrine Sanos, Majken Jul Sørensen, Annabelle Sreberny, Nadine Strossen, Anita Varma, Roopa Vasudevan, Gayathry Venkiteswaran, Meredith Weiss, Caitlin Williams, and Yuan Zeng.

On the home front, we were able to count on our loved ones for being there, regardless of whether we were fully present. Cherian is thankful for Zuraidah, who tolerated the many absences from home that this project required — and then, in the coronavirus-stricken world, endured his presence. Sonny did much less traveling for the project, and is very grateful for all loved ones who put up with his many idiosyncrasies, which he knows are only very occasionally amusing.

# Artists Featured

Interviewed

# Notes

| ✏️ | 👁 | ❝❞ | **keyword** |
|---|---|---|---|
| Cartoon/Art | Photo/Image | Quote | Concept/Topic |

Name, "Short title." → Full reference in **Bibliography**

Cover

✏️  Design by Sonny Liew

Series Editor's Introduction

👁  Sandra Braman: photo by Colin Sparks.

## Chapter 1: Introduction: The Power and Precarity of the Pencil

1-3   👁 Rue Nicolas Appert: photos by Sonny Liew; Cherian George; Céréales Killer.

9   ❝❞ Terry Anderson, interview by author, July 2019.

👁 Terry Anderson: photos by Cherian George.

10-11   ❝❞ John Lent, interview by author, October 2018.

👁 John Lent's home: photos by Cherian George.

👁 John Lent: photos by Kyle Cassidy, University of Pennsylvania.

11   **(Jeffrey) Yoonus:** Wasantha Siriwardena, "Yoonus Undeterred by a Brush with Death," *Sunday Observer*, July 10, 2016, archives. sundayobserver.lk.

12   **Naji al-Ali:** Jonathan Guyer, "Revisiting the Great Palestinian Cartoonist Naji Al-Ali 30 Years after His Assassination," *The World*, August 31, 2017, pri.org.

✏️ Handala by Naji al-Ali.

✏️ Naji al-Ali by Mohammed Sabaaneh, 2015.

**Prageeth Eknaligoda:** Kanya D'Almeida, "In Sri Lanka Cartoonists Aren't Killed – They're Disappeared," *Inter Press Service*, January 13, 2015, ipsnews.net; Bharatha Mallawarachi, "Abducted Sri Lanka journalist's wife: Military derails case," *Associated Press*, December 31, 2019, apnews.com.

👁 Family of Prageeth Eknaligoda: photo by Amnesty International.

13   **Akram Raslan:** "Well-Known Syrian Cartoonist Died in Detention after Being Tortured," *RSF*, January 20, 2016, rsf.org.

✏️ Akram Raslan by Mohammed Sabaaneh, 2015.

✏️ UN and Bashar al Assad cartoons by Akram Raslan, courtesy of Fadi Abou Hassan and Cartoon Movement.

14   **Ali Ferzat:** Malu Halasa, "Ali Farzat's Creative Dissent in Syria," *Index on Censorship*, May 11, 2017, indexoncensorship.org.

✏️ Self-portrait by Ali Ferzat, c.2012.

👁 Ali Ferzat: photo courtesy of the artist.

👁 Atena Farghadani: Atena Farghadani's Facebook.

✏️ Karnika Kahen by Kanika Mishra, 2013.

15   ✏️ "I'm suing" by Zapiro, 2006.

✏️ Online censorship cartoon by Kuang Biao.

✏️ Excerpt from "I was fired for criticizing Trump" by Rob Rogers, originally published in *The Nib*, July 3, 2018, thenib.com.

16   **satirical impulse:** Freedman, "The Offensive Art"; Mr Fish, "Warning!"

**Iran:** Farjami, "Iranian Political Satirists."

**Turkey:** Brummett, "Censorship in Late Ottoman Istanbul."

**Japan:** Duus, "Presidential Address."

**liberal tradition:** Garton Ash, *Free Speech*.

❝❞ Denis Diderot, quoted in Tim Blanning, *The Romantic Revolution*, London: Penguin Random House, 2012.

👁 Diderot statue, Paris: photo by Cherian George.

17   👁 Sweden Press Freedom Act: photo by Donna Sokol, US Library of Congress.

**human rights:** Iriye et al., *Human Rights*; Ishay, *Human Rights*.

❝❞ Sen, "Democracy as Public Reason," 324.

👁 Amartya Sen: photo by Fronteiras do Pensamento.

18   ❝❞ Article 19, in UN General Assembly, *International Covenant on Civil and Political Rights*, December 16, 1966, United Nations Treaty Series, refworld.org.

👁 Treaty map: adapted from "Ratification of 18 International Human Rights Treaties," *OHCHR Dashboard*, 2019, indicators. ohchr.org.

19   **three-part test:** UN Human Rights Committee, *General Comment No. 34*, September 12, 2011, Office of the United Nations High Commissioner for Human Rights, ohcr.org.

**key challenges:** "Report of the Special Rapporteur on the Promotion and Protection of the Rights to Freedom of Opinion and Expression," UN Office of the High Commissioner for Human Rights, March 25, 2010, ap.ohchr.org.

20   👁 Basiji: still from video, "Basijis going towards protestors," Unity4Iran video, Feb 14, 2011, youtube.com.

👁 Swathi Vadlamudi: photo by Cherian George.

**Zapiro lawsuits:** Deji Olukotun, "South African President Drops Defamation Suits Against Zapiro and Media Outlets," PEN America, June 14, 2013, pen.org.

👁 Jacob Zuma: photo by Eric Miller, World Economic Forum.

21   **ICCPR enforcement:** Goldsmith, *Limits of International Law*.

**calibrating censorship:** George, "Journalism and Authoritarian Resilience"; Simon, *The New Censorship*.

22    **neglect of censorship studies:** Bunn, "Reimagining repression"; Jansen, *Censorship.*

    **self-censorship preferred:** Bunn, "Reimagining repression."

23    **simple model:** Birkner, "Censorship."

    **self-censorship:** Lee, "Self-Censorship."

24    **ideology:** Schimpfossl and Yablokov, "Coercion or Conformism?"

    **proxy censorship:** Kreimer, "Censorship by Proxy"; Kuper, "Censorship by Proxy."

25    **market censorship:** Pickard, "The violence of the market"; Podesta, "Soft Censorship"; Germano and Meier, "Self-Censorship"; Corduneanu-Huci and Hamilton, "Selective Control."

27    ✎ Idriss Deby caricature by Adjim Danngar (Achou).

28    ✎ Catholic Church cartoon by Vilma Vargas.

    ✎ Bashar al-Assad cartoons by Ali Ferzat.

    **psychological release:** Bruner, "Carnivalesque Protest."

29    **lasting impact:** Kutz-Flamenbaum, "Humor."

    ❝❞ Sorensen, "Humor," 183.

    👁 Majken Jul Sørensen: photo from Karlstad University.

    ❝❞ Mao Zedong, quoted in Wang Fanxi and Gregor Benton, *Mao Zedong Thought* (Leiden: Brill, 2020), 109.

    👁 Mao Zedong: unknown photographer, 1949.

    ✎ Propaganda painting of Red Guards holding the "Little Red Book" (The Thoughts of Chairman Mao), 1967.

30    ❝❞ Jesus Christ, quoted in Matthew 7:15, New Testament Bible.

    👁 Jesus Christ by Nicholas Morosoff, Liberal Catholic Church of St Francis of Assisi, c.1935.

    ❝❞ Karl Marx and Friedrich Engels, *Communist Manifesto,* Chapter IV.

    👁 Karl Marx: International Institute of Social History.

    ❝❞ Napoleon Bonaparte, quoting Nicola Machiavelli. See: Peter Hicks, "Napoleon as a Politician," in *The Napoleonic Empire and the New European Political Culture,* edited by Michael Broers, Peter Hicks, and Agustin Guimera, (Basingstoke, UK: Palgrave Macmillan, 2012).

    👁 "Napoleon in 1806" by Jean-Baptiste-Édouard Detaille.

    ❝❞ Winston Churchill, "Their finest hours" speech to the UK House of Commons, June 18, 1940.

    👁 Winston Churchill in 1943: Franklin D. Roosevelt Presidential Library and Museum.

    ❝❞ Martin Luther King, Jr., "I have a dream" speech, August 28, 1963.

    👁 Martin Luther King, Jr.: photo by Yoichi Okamoto, Lyndon Baines Johnson Library and Museum.

    **imagery:** Gombrich, "The Cartoonist's Armoury"; See also Abraham, "Cartoons," 117-65.

    ❝❞ Gombrich, "The Cartoonist's Armoury," 119.

    👁 Themis and King Aigeus: Antikensammlung Berlin collection, photo by Bibi Saint-Pol.

    ✎ "Lady Justice" by Zapiro, 2011.

31    ❝❞ Gombrich, "The Cartoonist's Armoury," 130

    👁 Erst Gombrich: photo by Bert Verhoeff, Dutch National Archives.

    ❝❞ Harari, *Sapiens,* 30-35; See also Anderson, *Imagined Communities.*

    👁 Yuval Noah Harari: stills from video, "21 Lessons for the 21st Century," Talks at Google, October 11, 2018, youtube.com.

32    ❝❞ Adjim Danngar, interview by authors, August 2018.

    👁 Adjim Danngar: photo by Cherian George.

    ❝❞ Vilma Vargas, presentation at "Red Lines: Cartooning at Risk" conference, Annenberg School for Communication, University of Pennsylvania, December 7, 2018.

    👁 Vilma Vargas: photo by Cherian George.

33    ❝❞ Ali Ferzat, quoted in Jurgen Balzan, "The Cartoonist Who Broke the Barriers of Fear," *Malta Today,* November 22, 2016, maltatoday.com.mt; Caro Hills, "Slideshow: Syrian Cartoonist Not Silenced by Attack," *The World,* December 16, 2011, pri.org; Soumaya El Azem, "Interview with Syrian Cartoonist Ali Ferzat," *Magill,* March 18, 2012, magill.ie.

    👁 Ali Ferzat: photo courtesy of the artist.

## Chapter 2: When Censorship Backfires

36    ✎ Art by Sonny Liew, in the style of the Malaysian humor magazine, *Gila-Gila.* Based on a photo taken at the Association of American Editorial Cartoonists Annual Convention, Sacramento, California, September 21, 2018.

37-54    👁 Najib Razak and Rosmah images: digitally manipulated from official Malaysian government portrait, 2008, and other sources.

38    👁 Patrick Chappatte and Zunar: photo by Cherian George.

    ❝❞ Patrick Chappatte, welcome remarks at Association of American Editorial Cartoonists Annual Convention, Sacramento, California, September 21, 2018.

    **2018 Malaysian election:** Lemière, "The Downfall of Malaysia's Ruling Party"; Wong, "Malaysia's Dominant Coalition."

    **financial scandal:** Randeep Ramesh, "1MDB: The inside Story of the World's Biggest Financial Scandal," *Guardian,* July 28, 2016, theguardian.com.

39    👁 Newspaper headline: Richard C. Paddock, "Malaysia's Leader, Dogged by a Billion-Dollar Scandal, Proves Untouchable."

    *New York Times,* July 30, 2016, nytimes.com.

    👁 Najib Razak: photo by Firdaus Latif.

    👁 Protest rally: photo from *The Rocket,* October 28, 2012, therocket.com.my.

40    ❝❞ Ambiga Sreenevasan, text interview by author, February 2019.

    👁 Ambiga Sreenevasan: still from video, "BFM Uncensored," May 22, 2018, youtube.com.

    **weapons of the weak:** Scott, *Weapons of the Weak.*

40    ✎ "Just Thief League" by Zunar, November 2017.

41-53    ❝❞ Zunar, interview by author, May 2018.

    ✎ "Steal Everything" by Zunar, February 2018.

42    👁 Election rally: still from video, "Celebrations as Malaysia's Mahathir wins shock election victory," *AFP TV,* May 9, 2018, youtube.com.

    👁 Najib Razak: photo by Kremlin.ru.

43    **Streisand Effect:** "What Is the Streisand Effect?," *Economist,* April 16, 2013, economist.com.

43    California coast: photo by Kenneth & Gabrielle Adelman, California Coastal Records Project, californiacoastline.org.

Barbara Streisand: photo by Lifescript.

Sorensen, "Humour," 183.

Mohandas K. Gandhi: photo from gandhiserve.org.

Mohandas K. Gandhi, quoted in Brian Martin, "How nonviolence works," *Borderlands* e-journal 4, no. 3 (2005).

43    **political jiujitsu:** Sharp, *The Politics of Nonviolent Action*.

44    **backfire:** Martin, *Backfire Manual*.

Martin, *Backfire Manual*, 70.

**repulsed by censorship:** Curry and Martin, "Making Censorship Backfire."

**carnival-like:** Bruner, "Carnivalesque Protest," 136.

45    **government/protester tactics:** Martin, *Backfire Manual*.

46    Zunar portrait by Sonny Liew.

47    "The story of cartoonist Zunar" by Zunar, November 2017.

"Dear Police": photo by *Malaysiakini*.

News headline: Sally Hayden, "A Malaysian Cartoonist Told Us Why He's Risking 43 Years in Prison for Tweeting," *Vice News*, November 6, 2015, vice.com.

48    News headline: Ian Burrell, "Malaysian Cartoonist Faces 43 Years in Prison for 'Sedition'," *Independent*, October 26, 2015, independent.co.uk.

**Donald Duck:** Susan Loone, "Zunar Heeds IGP's Suggestion,

Draws 'Donald Dedak'," *Malaysiakini*, December 5, 2016, malaysiakini.com.

"Cartoon resist" by Zunar, April 2015.

Zunar, quoted in "Zunar: Thank You IGP for Disney Idea," *Free Malaysia Today*, December 5, 2016, freemalaysiatoday.com.

50    Patrick Chappate, remarks in "Davos 2017 – The Art of Dissent," World Economic Forum, January 19, 2017, youtube.com.

Davos panel: still from video, "Davos 2017," ibid.

Ambiga Sreenevasan, text interview by author, February 2019.

**Sedition Act:** Maren Williams, "Zunar Launches Legal Challenge to Malaysia's Sedition Act," *Comic Book Legal Defense Fund*, November 6, 2015. cbldf.org.

52    **media logic:** Altheide and Snow, *Media Logic*.

News page: "Malaysia Police Seize Copies of Cartoonist Zunar's 'Ros in KangKong Land'." *Straits Times*, January 23, 2016.

News page: "Malaysian Cartoonist Charged with Sedition," *BBC News*, April 3, 2015, bbc.com.

53    **Malaysia democratic movement:** Chong, "Democratic Breakthrough"; Khoo, "Bersih."

**soft authoritarian:** Freedom House's *Freedom in the World 2018* report rated Malaysia under the Najib regime as "partly free" (freedomhouse.org. Polity IV data classified Malaysia as an "open anocracy," in between autocracy and democracy (ourworldindata.org/democracy).

## Chapter 3: We Know Where You Live: Intimate Invasions

55    Fidel Castro: photo by Marcelo Montecino.

56    Revolutionary banner in Cuba: photo by Krokodyl.

**Black Spring:** "Cuba's Long Black Spring," Committee to Protect Journalists, March 18, 2008, cpj.org.

**jailer of journalists:** "Journalists in Prison in 2005," Committee to Protect Journalists, December 13, 2005, cpj.org.

Cuban cartoonists: photo courtesy of Gustavo Rodriguez.

56-83  Gustavo Rodriguez (Garrincha): photos by Cherian George.

Gustavo Rodriguez, interview by author, November 2018.

59    **calculus of repression:** de Meritt, "State Repression."

60    taken by surprise: "Safety Manual," Cartoonists Rights Network International, April 2014, cartoonistsrights.org.

Robert Russell, interview by author, October 2018.

Robert Russell: photo by Cherian George.

62    Chambo, Ecuador photos: Google Street View.

Break-in: photos courtesy of Vilma Vargas.

63-82  Vilma Vargas: photos by Cherian George.

Vilma Vargas, interview by author, December 2018.

63    Rafael Correa photos: Ecuadorian embassy, Paris; Agencia de Noticias ANDES.

**institutional violence:** "2015: Journalism under the Gun and Club in the Americas," Reporters Without Borders, February 14, 2018, rsf.org; "OAS Annual Report on Human Rights," Organization of American States, August 1, 2009, oas.org.

Luis Carrera: photo from "Presidente Correa Detiene a Joven Por Darle 'Yuca'," *Ecuador Noticias*, September 3, 2019, ecuadornoticias.com.

**Correa accosts boy:** "Ecuador's President Stops Motorcade to Bully Finger-Flipping Teen," *Juicio Crudo*, May 8, 2015, juiciocrudo.com; Manuel Rueda, "Ecuador's President Stops Motorcade to Bully Finger-Flipping Teen," *Splinter*, May 7, 2015, splinternews.com.

64    Rafael Correa and boy cartoon by Vilma Vargas, 2015.

Text messages: Vilma Vargas's phone.

**Picasso:** The artist said, "We all know that Art is not truth. Art is a lie that makes us realize truth, at least the truth that is given us to understand." From an interview with an American arts magazine, 1923.

Fernando Alvarado: from his Twitter feed, @mashisurfer.

65    **Correa's ideology:** Eguren, "Socialism," 105-27.

Metamorphosis cartoon by Vilma Vargas.

66    Vilma Vargas portrait by Sonny Liew.

67    Nicaragua protest: photo by Julio Vannini.

**human rights:** "Human Rights Violations and Abuses in The Context of Protests in Nicaragua," United Nations Office of the High Commissioner for Human Rights, 2018, ohchr.org.

67-68  Cartoons by Pedro Molina.

69-70  Pedro Molina, interview by author, September 2020.

Pedro Molina: photo by Cherian George.

71    West Bank barrier: photo by W. Hagens.

71-74  Cartoons by Mohammed Sabaaneh.

72    Book: Mohammed Sabaaneh, *White and Black: Political Cartoons from Palestine*, Washington DC: Just World Books, 2017.

72-75  Mohammed Sabaaneh, interview by author, July 2019.

Mohammed Sabaaneh: photos by Cherian George.

72    **detention:** "Israel Extends Detention of Palestinian Cartoonist," Committee to Protect Journalists, February 21, 2013, cpj.org

    ❛❜ "Israeli Authorities Urged to Release Palestinian Cartoonist: Reporters without Borders," Reporters Without Borders, January 20, 2016, rsf.org

74    👁 Airport security: photo by Mohammed Sabaaneh.

75    ❛❜ Benjamin Netanyahu: "Full Text of Prime Minister Netanyahu's UN Speech," *Jerusalem Post*, September 29, 2014, jpost.com.

    👁 Benjamin Netanyahu photo: United Nations, un.org.

76    ❛❜ Amy Braunschweiger, "Witness: How Israel Muzzles Free Expression for Palestinians," Human Rights Watch, December 19, 2019, hrw.org.

77    👁 Mesbah Yazdi: Photo by Mohammad Reza Dehdari.

    **crocodile cartoon:** Kowsar, "Being Funny."

    ✏ Cartoons by Nikahang Kowsar.

78    👁 Qum: still from video, "Shrine of Fatima Almasomh," *SJ Travel*.

    👁 Qum seminary students: photo by Amir Hesaminejad.

    👁 Arrest: photo by Behrouz Mehri, AFP.

79-82  👁 Nikahang Kowsar: photos by Cherian George

    ❛❜ Nikahang Kowsar, interview by author, May 2019.

79    👁 Basij militia beating a protester: photo from payvand.com.

    **Chain Murders:** Sarah Fowler, 2018, "Iran's Chain Murders: A Wave of Killings That Shook a Nation," *BBC News*, December 2, 2018, bbc.com.

    👁 Chain Murders victims: photo of Fereydoun Farrokhzad by M. Sadr, *Ettelaat*; others anonymous.

83    ❛❜ Zunar, interview with author, May 2018.

    👁 Zunar: photos by Cherian George.

84    ✏ Cartoons by Alfredo Pong.

84-85  👁 Alfredo Pong: photos by Cherian George

    ❛❜ Alfredo Pong, interview by author, September 2018.

85    **U.M.A.P.:** Unidades Militares de Ayuda a la Producción were agricultural labor camps.

    👁 Family photos courtesy of Alfredo Pong.

86    ❛❜ Coetzee, *Giving Offense*, 36, 38, 118.

    👁 J.M Coetzee: photo by Mariusz Kubik.

## Chapter 4: Post-Orwellian Censorship

88    👁 Torture scene: still from film, *1984*, directed by Michael Radford (1984).

    ❛❜ Dialog from *1984*, ibid.

89    👁 Josef Stalin photo, 1942: US Library of Congress.

    👁 Adolf Hitler, unknown date/source.

    👁 Book cover: George Orwell's *1984*, 1st edition (London: Harcourt Brace and Company, 1949)

    👁 Recep Tayyip Erdogan photo: Government of Chile.

    👁 Xi Jinping: photo by Antilong.

    👁 Vladimir Putin photo: Press Service of the President of the Russian Federation.

    👁 German army Luger pistol: photo by Luis Miguel Bugallo Sanchez.

    **cloaked coercion:** Anderson, "The Antinomies." Also see: George, "Authoritarian Rule"; Simon, *New Censorship*; Guriev and Treisman, "Informational Autocrats."

    ❛❜ Puddington, *Breaking Down Democracy*, 1.

89,95  👁 Arch Puddington: photo by Cherian George.

90    **power needs legitimacy:** Arendt, *On Violence*.

    ❛❜ totalitarian domination: Arendt, *On Violence*, 52, 53.

    **mature one-part state:** Haraszti, *Velvet Prison*.

    ❛❜ neutrality is treason: Haraszti, *Velvet Prison*, 96.

    ❛❜ guidelines: Haraszti, *Velvet Prison*, 74.

91    👁 Scene from Cultural Revolution photo: *China Pictorial*.

    ✏ Gang of Four cartoon depicting "Anti-Party Block" falsifying Chairman Mao's directives, courtesy of the Chinese University of Hong Kong Library.

    👁 *Satire and Humour*, January 5, 1982.

91-92  **cartooning in China:** Lent and Xu, *Comic Art in China*.

92    ✏ "Self Mockery" by Liao Bingxiong, 1979, courtesy of Liao Linger.

    👁 Liao Bingxiong, 1979: photo courtesy of Liao Linger.

    👁 Deng Xiaoping: US National Archives and Records Administration photo.

    👁 Xi Jinping: still from Chinese Communist Party 13th Five Year Plan promotional video, youtube.com.

92-93  **Mao and Xi:** Xiangwei Wang, "'Di Jihong', 'Gao Jihei': Signs China's Flattery of Xi Has Gone Too Far," *South China Morning Post*, March 16, 2019, scmp.com; Zhao, "Xi Jinping."

93    ✏ "Garden of plenty" by Liu Dahong, 2014.

    👁 Liu Dahong: photo by Cherian George.

93   👁🗨 Liu Dahong, online interview by Eureka Wang for authors, translated from Chinese. Liu's reference to the hand holding the whip is a twist on a Mao poem from 1959.

👁 Revolutionary China poster: eastisred.com.

👁 Happy Beijing shoppers, 2008: photo by Lou Linwei.

**fear, friction, flooding:** Roberts, *Censored*.

94   👁 Tea-pouring: still from video, "Spouts of Fury: When Tea and Kung Fu Collide," Great Big Story, February 7, 2017, youtube.com.

👁 Wang Liming: photo by Cherian George.

👁🗨 Wang Liming, interview by author, October 2018.

94-95   ✎ Cartoons by Rebel Pepper.

**invitation to tea:** Yuwen Wu, "Tea? Reining in Dissent the Chinese Way," *BBC News*, January 17, 2013, bbc.com.

95   👁 News headline: "Laying bare 'Rebel Pepper': the Japan-worshipping traitor," Qiangguo forum, *People.CN*, August 18, 2014.

👁🗨 Puddington, *Breaking Down Democracy*, 17.

96   **friction:** King et al., "Censorship in China."

**Jingjing and Chacha:** Qiang, "Liberation Technology."

**Winnie the Pooh:** Anthony Tao, "'Find the Thing You Love and Stick with It': Xi Jinping and the Perfect Meme," *SupChina*, February 26, 2018, supchina.com.

96-99   👁 Margaret Roberts: stills from video, MIT Institute for Data, Systems, and Society Seminar, November 29, 2018, youtube.com.

96-97   👁🗨 Margaret Roberts, quoted in "Do Not Censor This Blog: Margaret Roberts on Information Control in China," The Center for Effective Global Action, *Medium*, July 12, 2018, medium.com.

97   **taboo topics:** Tai, "Media Censorship."

**grass mud horse:** "Brush and Ink Paintings of Grass Mud Horses," *China Digital Times*, August 16, 2009, chinadigitaltimes.net.

98-99   👁 Assorted publicity materials of the Chinese government and Communist Party.

👁 Tim Wu: stills from video, "Attention Hacking," Gottlieb Duttweiler Institute, March 26, 2019, youtube.com.

👁🗨 Wu, "First Amendment."

**social media comments:** King et al., "Censorship in China."

👁🗨 Roberts, *Censored*, 10.

100   ✎ Kuang Biao portrait by Sonny Liew.

**Guangdong model:** "The Guangdong Model," *The Economist*, November 26, 2011, economist.com.

101   **Nanfang Media Group:** Repnikova and Fang, "Behind the Fall"; Bandurski, "Why Southern Weekly?"

101-106   ✎ Cartoons by Kuang Biao.

102   👁🗨 Kuang Biao's comment on Chang Ping quoted in Bandurski, "Chang Ping Under Pressure."

**Chang Ping:** Yaxue Cao, "The Fate of Press Freedom in China's Era of 'Reform and Opening up': An Interview With Chang Ping," *China Change*, December 15, 2016, chinachange.org.

103   **Ren Zhiqiang:** Chris Buckley, "Chinese Tycoon Criticizes Leader, and Wins Surprising Support," *New York Times*, March 18, 2016, nytimes.com.

**balance of power:** Wang and Sparks, "Chinese Newspaper Groups"; Tong, "Critical Journalism im China."

104-106   👁 Kuang Biao: photos by Cherian George.

👁🗨 Kuang Biao, interview by author (through translator), February 2019.

107   👁 Istanbul photo: Pixabay.

👁 Recep Tayyip Erdoğan photo: US State Department.

**Turkish media system:** Akser, "Censorship in Turkey"; Coskuntuncel, "Privatization of Governance"; Yesil, "Press Censorship in Turkey."

👁 Coup: still from video, "Military attempts coup in Turkey," July 15, 2016, youtube.com.

**journalists in prison:** Data from Committee to Protect Journalists, cpj.org.

108   👁 Musa Kart sent to jail: photo by @Musakart, Twitter

👁🗨 Erol Onderoglu, phone interview by author, May 2019.

👁 Erol Onderoglu: still from video, "La liberté de la presse en Turquie: interview avec Erol Önderoğlu," Amnesty Switzerland, June 21, 2016, youtube.com.

👁🗨 "Musa Kart's Opening Statement at Trial," Cartoonists Rights' Network International, January 31, 2020, cartoonistsrights.org.

108-109   👁 Musa Kart: stills from video, "Musa Kart: Meet the Turkish cartoonist jailed over making a holiday booking," *Euronews*, April 27, 2019, youtube.com.

109   👁🗨 "Musa Kart, lauréat Prix International du dessin de presse Cartooning for Peace 2018" video, Cartooning for Peace, 2018, dailymotion.com.

👁🗨 news page: "Turkey votes in historic referendum on presidential powers," *Euronews*, April 16, 2017, euronews.com.

✎ Hologram cartoon by Musa Kart, *Cumhuriyet*, February 1, 2014.

**corruption scandal:** Barkey, "Icarus and Erdogan's Corruption Scandal."

**hologram:** "PM Erdoğan Uses Hologram to Address İzmir Party Members for First Time in Turkey," *Hürriyet Daily News*, January 27, 2014, hurriyetdailynews.com.

👁 Turkey's post-coup crackdown: still from video, "Turkey clamps down after attempted coup," *Time*, July 17, 2016, time.com.

**media capture:** Finkel, *Captured News Media*.

👁🗨 Nelson, "Foreword."

👁 Mark Nelson: still from video, "Statement from Mark Nelson," Symposium of the Forum Media and Development, Konrad Adenauer Stiftung, 2017, youtube.com.

**diversified conglomerates:** Kaya and Svante, "Politics Media and Power in Turkey."

110-111   👁🗨 Faruk Bildirici, video interview by author (through translator), April 2019.

👁 Faruk Bildirici: photo by Cherian George off video call.

111   **Dogan Group:** Akser, "News Media Consolidation" ; "Turkish Media Group Bought by Pro-Government Conglomerate," *New York Times*, March 21, 2018, nytimes.com.

111-112   👁🗨 Salih Memecan, video call interview by author, June 2020.

👁 Salih Memecan: stills from video, TEDxIhlasCollegeED, April 9, 2013.

112   **Turkish satire:** Aviv, "Cartoons in Turkey"; Brummett, "Ottoman Istanbul Censorship"; Sabine Küper-Büsch, "Satire in Turkey: the Enclave of the Indomitable," *Ahval*, August 23, 2018, ahvalnews.com.

👁 Periodicals: *Diojen* (1870–1873); *Karagoz* (1908–1955); *Diken* (1918-1920); *Karikatur* (1930s-40s); *Girgir* (1972–1993).

👁 Shadow play puppets, Istanbul Toy Museum: photo by Kıvanç.

113   **Musa Kart lawsuit:** "The Haranguing of a Cartoonist Reveals Turkey's Illiberal Backslide," *The Economist*, June 11, 2018, economist.com.

✍ Cat cartoon by Musa Kart, *Cumhuriyet,* May 9, 2004.

**Penguen response:** Liselotte Mas, "In Turkey, Cartoonists Are Calling out the Government despite Harsh Censorship Laws," *France 24*, August 28, 2017, france24.com.

👁 *Penguen* cover: February 24, 2005.

👁 *Leman* cover: February 23, 2006.

👁 Mock jail: photo courtesy of Tuncay Akgun.

113-115 👂🗣 Tunkay Akgun, interview by author (through translator), April 2019.

👁 Tunkay Akgun: photo by Cherian George.

114 👁 *Leman* covers: January 6, 2015; February 23, 2011.

👁 Pro-Erdogan demonstration: photo by Mstyslav Chernov.

**troll armies:** Bradshaw and Howard, "The Global Information Disorder"; Ergin and Yoruk, "Digital Populism."

115 👁 *Leman* cover: July 20, 2016.

**intolerant populism:** Roth, "Populism"; Kubicek, "Faulty Assumptions."

👁 Two Minutes of Hate: still from film, *1984*, directed by Michael Radford (1984).

116 👂🗣 George Orwell, "Chapter 1, Ignorance Is Strength," *1984* (London: Secker & Warburg, 1949).

## Chapter 5: Gilded Cages: Censorship by Seduction

118-123 👁 Cherian George: photos by Cherian George, Sonny Liew.

118 👁 Singapore downtown: photo by Cherian George.

👂🗣 independent media: "Singapore's Hypocrisy on Paris and Free Speech," *Asia Sentinel*, January 18, 2015, asiasentinel.com.

119 👁 Father and child: photo by Cherian George.

**air-conditioned nation:** George, *Air-Conditioned Nation*.

👁 Times House photo: StreetDirectory.com.

119- 👁 Prudencio Miel: photos by Cherian George.

120 **leaders off-limits:** Tju, "Political Cartoons in Singapore."

👁 *Sunday Times* covers: September 6, 1998; July 18, 1999.

121 👁 National Library bookshelf: photo by Prudencio Miel.

122 👁 Singapore street art: photo by Marialoukou.

123 👁 Miel family photo courtesy of Prudencio Miel.

👁 Human Development Index graphic generated by Human Development Reports data visualizer, hdr.undp.org/en/data.

**Human Development Index:** See United Nations Development Programme, Human Development Reports, hdr.undp.org.

👁 Development status vs press freedom status table based on United Nations Human Development Report 2018, hdr.undp.org, and Freedom House Freedom of the Press 2018, freedomhouse.org.

124 👁 Lee Kuan Yew photo: US Department of Defense.

**Singapore press system:** George, *Freedom from the Press.*

125 **Singapore Herald:** ibid.

👁 *Singapore Herald*, May 28, 1971: Photo by Cherian George.

👁 Morgan Chua: photo courtesy of Morgan Chua's family.

126 **Morgan Chua:** Philip Bowring, "Obituary: Cartoonist Morgan Chua," *Correspondent Online*, June 29, 2018, www.fcchk.org.

👁 *Far Eastern Economic Review*, cover of July 10-16, 1981.

👁 News report: Ng Huiwen "Veteran political cartoonist Morgan Chua dies at 68," *Straits Times*, March 23, 2018, straitstimes.com.

127 👁 News reports: "The Red agent who played Cinderella on TV," *New Nation*, May 27, 1976, 13; "The faces of subversion," *Straits Times*, May 28, 1976, 18; "'Confession' denial by detained Nanyang executives," *Straits Times*, June 8, 1971, 1.

👁 Morgan Chua: Still from video, "Morgan Chua speaks about Tiananmen: 25th Anniversary Edition," Epigram Books, June 3, 2014. youtube.com.

128 👁 Morgan Chua and Prudencio Miel: photo by Prudencio Miel.

129 ✍ Excerpt from *The Art of Charlie Chan Hock Chye* by Sonny Liew (Epigram Books, 2015).

130 **National Arts Council grant:** Sulaiman Daud, "Sonny Liew Reveals Why NAC Revoked Grant for The Art of Charlie Chan Hock Chye," *Mothership*, September 29, 2017, mothership.sg.

131 **Streisand Effect:** See page 43.

**Eisner Awards:** Simon Cameron-Moore, "Alternate History of Singapore Scoops Comic Books Awards in U.S." *Reuters*, July 22, 2017, reuters.com.

132 **gray list:** George, "Directing Artistic and Intellectual Energies."

133 ✍ Caricatures by Sonny Liew.

134 **creative industries:** Tan, "Renaissance Singapore?"

👁 *Time* magazine cover, July 19, 1999; *Crazy Rich Asians* movie poster, Warner Bros; "Singapore: Passion Made Possible," visitsingapore.com; "Lucasfilm boost for S'pore with state-of-the-art facility," *Today Online*, January 14, 2014; "Virus Vanguard" COVID-19 public service cartoon, 2020, gov.sg; Singapore Biennale poster 2006.

135 👂🗣 Lim Cheng Tju, interview by author, November 2019.

👁 Lim Cheng Tju: photo by Cherian George.

135   👁 Cuban mural: photo by Gustavo Rodriguez.

**Cuban cartoon event:** Amaury Ricardo, "Cuba Hosts International Biennial of Graphic Humor March 31-April 3," *Havana Times*, March 26, 2019, havanatimes.org.

💬 Gustavo Rodriguez: interview by author, November 2018.

136   👁 Iranian House of Cartoon: website screen grab. irancartoon.com.

137-138  💬 Kianoush Ramezani, interview by author, August 2018.

👁 Kianoush Ramezani, photos by Cherian George and Sonny Liew.

**Iranian House of Cartoon:** Aida Ghajar, "Iran's Cartoon Goons: Behind the Scenes of the Holocaust Cartoons Exhibition," *IranWire*, January 28, 2017, iranwire.com.

138   👁 Massoud Shojai Tabatabai: Photo from irancartoon.com.

139   💬 Haraszti, *Velvet Prison*, 74-79.

👁 Miklos Haraszti: still from video, "Miklos Haraszti," Budapest Beacon. vimeo.com.

139-142  💬 Khalid Albaih, interview by author, January 2019. See also Isma'il Kushkush, "Cartoonist's Pen Leaves Mark Across Arab World," *New York Times*, June 7, 2013, nytimes.com.

👁 Khalid Albaih: photo by Cherian George.

140   ✎ "The rest will follow" by Khalid Albaih, 2011.

💬 Patrick Lamassoure: phone interview by Raphael Blet for authors, October 2019, translated from French.

👁 Patrick Lamassoure: still from video, "KAK, le dessinateur de l'Opinion se confie à Europe," *L'Opinion*, Jan 27, 2017. lopinion.fr.

## Chapter 6: Market Censorship: Freedom for Those who Own a Press

146   👁 Terry Mosher: photo by Cherian George.

👁 Ring: photo courtesy of Terry Mosher.

💬 Terry Mosher, interview by author, September 2018.

💬 Ann Telnaes, interview by author, October 2018.

147   ✎ "Shoulder to shoulder" by Terry Mosher, 2001.

✎ "Cabinetry" by Terry Mosher, 2007.

✎ "Gun laws" by Ann Telnaes, 2019.

✎ "Chirac" by Rodolphe Urbs, 2019.

✎ "Zuma's oath" by Brandan Reynolds, 2018.

148-149  👁 Mob: still from video, "Ratusan Massa Geruduk Kantor Tempo, FPI Tuntut Permintaan Maaf," *Tribun-video.com*, March 16, 2018, youtube.com.

**Tempo:** Steele, *Story of Tempo*.

✎ Yuyun Nurrachman, *Tempo*, February 26, 2018.

💬 Arif Zulkifli, interview by author, April 22, 2019.

💬 Yuyun Nurrachman, interview by author, April 22, 2019.

**Rizieq Shihab:** John Emont, "Hard-Line Moralist in Indonesia Faces Pornography Charges," *New York Times*, May 30, 2017, nytimes.com.

**Islamic Defenders Front:** Wilson, *Post-New Order Indonesia*; Facal, "Islamic Defenders."

**Jakarta elections:** Badrun, "Religiosity"; Aspinall and Mietzner, "Troubling Elections."

👁 Arif Zulkifli: photo by Cherian George.

👁 Yuyun Nurrachman: photo by Cherian George.

👁 Meeting: still from video, "FPI Aksi Damai Di Gedung Tempo," *Tempodotco*, March 16, 2018, youtube.com.

👁 Speaking to crowd: still from video, "Sempat Tegang, FPI dan Tempo Klarifikasi Kartun Rizieq Shihab," *Viva News*, March 16, 2018, youtube.com.

151-152  💬 those who own one: A.J. Liebling, "The Wayward Press: Do You Belong in Journalism," *The New Yorker*, May 14, 1960.

✎ Panels from X-Men Gold #1, Marvel Comics, 2017.

**X-Men Gold case:** "Marvel Fires Artist Ardian Syaf over Religious References in X-Men Comic Book," *BBC*, April 12, 2017, bbc.co.uk; Kaila Hale-Stern, "Marvel Cancels X-Men Gold Artist's Contract Over Hidden Political and Religious References," *The Mary Sue*, April 11, 2017, themarysue.com; "Ardian Syaf Mulls Future after Being Fired by Marvel," *Jakarta Post*, April 18, 2017, thejakartapost.com; "Art of Ardian Syaf" Facebook.

**212 symbolism:** "Understanding the 212 Movement in Indonesia," *Malay Mail*, April 18, 2018, malaymail.com.

💬 Charles Brownstein, e-mail interview by author, November 2019.

152   💬 Ramize Erer, interview by author, April 2019.

✎ Cartoon by Ramize Erer, *Radikal*, 1995.

👁 Ramize Erer: photo by Cherian George.

152-157  💬 Ted Rall, interview by author, October 2018.

153   💬 Brandan Reynolds, interview by author, August 2019.

💬 Patrick Chappatte, e-mail and phone interview by author, October 2019.

💬 Patrick Lamassoure, phone interview by Raphael Blet for the authors, October 2019, translated from French.

💬 Martin Rowson, interview by author, July 2019.

✎ "You versus many" by Martin Rowson, 2013.

154-160  ✎ "I was fired for criticizing Trump" by Rob Rogers, originally published in *The Nib*, July 3, 2018, thenib.com.

154   💬 John Robinson Block and Rogers, quoted in Daniel Lippman, "'He's Just Become Too Angry': Pittsburgh Post-Gazette Publisher Defends Firing Cartoonist," *Politico*, June 17, 2018, politico.com.

154-155  💬 William Peduto, quoted in "Statement by Mayor William Peduto on Cartoonist Rob Rogers," 2018, City of Pittsburgh, June 14, 2018, pittsburghpa.gov.

155   👁 Cartoonists in Sacramento: photo by Cherian George.

156   💬 power to select: Nick Anderson, "Rob Rogers' Firing Is a Frightening Omen," *CNN*. June 24, 2018, cnn.com.

156-169  💬 Daryl Cagle, e-mail interview by author, September 2019.

157   👁 Trump-friendly cartoons: screen capture, caglecartoons.com.

158   **right to receive:** Pickard, *America's Battle*; Meiklejohn, "The First Amendment."

159   💬 Hutchins Commission, *A Free and Responsible Press*.

💬 UDHR: UN General Assembly, Universal Declaration of Human Rights, December 10, 1948, 217 A (III), un.org.

💬 European Convention: Council of Europe, European Convention for the Protection of Human Rights and Fundamental Freedoms, as amended by Protocols Nos. 11 and 14, November 4, 1950, refworld.org.

160   💬 Rob Rogers: Presentation at "Red Lines: Cartooning at Risk"

symposium, Annenberg School for Communication, University of Pennsylvania, Dec 7, 2018.

👁 Rob Rogers: photo by Kyle Cassidy, University of Pennsylvania.

161-162 **NYT cartoons:** Steve Lohr, "New York Times's Global Edition Is Ending Daily Political Cartoons," *New York Times*, June 11, 2019, nytimes.com; Joseph A. Wulfsohn, "NY Times Will End Its Political Cartoons after 'Anti-Semitic' Depiction of Netanyahu, Cartoonist Says," *Fox News*, June 11, 2019, foxnews.com.

👄 Bret Stephens, "A Despicable Cartoon in The Times," *New York Times*. April 28, 2019, nytimes.com.

👁 Bret Stephens opinion column, ibid.

✎ Trump-Netanyahu cartoon by António Moreira Antunes, April 2019.

👄 Joep Bertrams, e-mail interview by author, October 2019.

✎ "Liberal approach" by Joep Bertrams, 2019.

163-164 👄 Meidyatama Suryodiningrat, interview by author, April 2019.

👁 Meidyatama Suryodiningrat: photo by Cherian George.

**endorsing Jokowi:** "Editorial: Endorsing Jokowi," *Jakarta Post*, July 4, 2014, thejakartapost.com; Indra Akuntono, "Harian 'Jakarta Post' Nyatakan Dukung Jokowi Halaman All," *Kompas*, July 4, 2014, nasional.kompas.com.

**blasphemy accusations:** Julkifli Marbun, "Muhammadiah's Youth: Jakarta Post's ISIL Cartoon Inappropriate," *Republika Online*, July 8, 2014, republika.co.id; "Hizbut Tahrir Meets 'The Post'," *Jakarta Post*, July 12, 2014, thejakartapost.com; "Statement: Indonesia Insult by Jakarta Post Magazine (Translated)," Hizb-Ut-Tahrir, July 9, 2014, hizb-ut-tahrir.info.

✎ Anti-ISIS cartoon by Stephane Peray (Stephff), 2014.

👁 Pierre Bourdieu, still from video, "La sociologie de Pierre Bourdieu," *Lumni*, Apr 28, 1998. enseignants.lumni.fr.

164 **field theory:** Bourdieu, *Cultural Production*.

165 **Rheinische Zeitung:** Sanders, "Prussian Censorship"; Mehring, *Karl Marx*.

👁 Marx and Prussian censors by Lorenz Clasen, Deutsches Historisches Museum, Berlin.

166 ✎ Extracts from Martin Rowson, *The Communist Manifesto*. London: SelfMadeHero, 2018.

**cultural workers:** Mosco, "Marx is Back."

👄 Cohen, "Cultural Work," 142.

👄 nauseating: Marx et al., *Dispatches for the New York Tribune*.

167 **market failure:** Pickard, "The Violence of the Market."

👁 newspaper: *Sunday Telegraph*, Sept 8, 2019.

169 ✎ "Endangered species" by Peter Kuper, 2019.

**USA daily newspapers:** Amy Watson, "Number of Daily Newspapers in the U.S. 2018," *Statista*, March 3, 2020, statista.com.

👄 Daryl Cagle, e-mail interview by author, September 2019.

170 **market trends USA:** "Trends and Facts on Newspapers: State of the News Media," *Pew Research Center's Journalism Project*, July 9, 2019, journalism.org.

**market trends UK:** "News Consumption in the UK," Ofcom, January 31, 2020, ofcom.org.uk.

**editorial cartoonists:** "The Golden Age for Editorial Cartoonists at the Nation's Newspapers Is Over," n.d, The Herb Block Foundation, herbblockfoundation.org

171 👄 Cohen, "Cultural Work," 147.

👄 Robin, *Fear: The History of a Political Idea*, 19-21.

**precariat:** Standing, "Defining the Precariat."

172-173 👁 Dario Adanti: photo by Cherian George

👄 Dario Adanti, interview by author.

👁 *Mad* magazine cover, December 1984.

👁 Tjeerd Royaards: photo by Cherian George

**Mad magazine:** Marc Tracy, "Mad Magazine, Irreverent Baby Boomer Humor Bible, Is All but Dead," *New York Times*, July 5, 2019, nytimes.com.

**Mongolia:** James Breiner, "Spain's Satirical Revista Mongolia Offers Humor but Still Struggles with Business Model," International Journalists' Network, May 25, 2015, ijnet.org.

174 ✎ Excerpt from "Richie Bush" by Peter Kuper, 2004.

👁 *World War 3 Illustrated* cover No. 6, 1986.

👁 Peter Kuper: photo from peterkuper.com.

👄 Peter Kuper, video interview by author, October 2019.

👄 Aji Prasetyo, interview by author, June 2019.

## Chapter 7: Democratically Rejected: The X'ed Files

177-178 ✎ Khashoggi murder cartoons by Dave Brown, published in *Independent*, October 23, 2018.

👁 Dave Brown: photo by Cherian George.

👄 Dave Brown, interview by author, July 2019.

**Saudi owners:** Graham Ruddick and Mark Sweney, "Saudi Investor Buys Significant Stake in the Independent," *Guardian*, July 28, 2017, theguardian.com; Andrew Woodcock, "Sale of Stake in Independent to Saudi Investor Has 'No Influence' on Editorial Coverage, Watchdog Rules," *Independent*, September 16, 2019, independent.co.uk.

178 **Indonesia anti-communist:** Leong, "Filling in the Gaps."

✎ 1965 reconciliation cartoon by Tommy Thomdean, *Jakarta Post*, April 14, 2016.

178-179 👄 Tommy Thomdean, interview by author, April 2019.

👁 Tommy Thomdean: photo by Cherian George.

179 ✎ "I don't have any money" by Tommy Thomdean, *Jakarta Post*, May 1, 2016.

**Panama Papers:** "803 Indonesians Named in Panama Papers," *Tempo*, April 6, 2016, tempo.co.

180 👁 Adolf Hitler: unknown photographer.

**FVD party:** Barr, "The New Dutch Far Right."

✎ JFVD cartoon by Joep Bertrams, 2019.

👁 Joep Bertrams: photo by Cherian George.

👄 Joep Bertrams, interview by author, July 2019.

👁 Martin Rowson: photo by Cherian George.

👄 Martin Rowson, interview by author, July 2019.

181 👁 Nigel Buchanan photo courtesy of the artist.

👄 Nigel Buchanan, e-mail interview by author, October 2019.

✎ Mario Balotelli portrait by Nigel Buchanan published in *Eight By Eight*, 2015.

181    Minstrel poster, 1900, Library of Congress.

Lion and zebra illustration by Nigel Buchanan published in *CIO*, 2010.

182    **submarine accident:** "Office of Safety Recommendations and Communications," National Transportation Safety Board (NTSB), October 19, 2005, ntsb.gov; Daryl Cagle, "Was I Sunk by Submarines?" July 21, 2019, darylcagle.com.

Cartoons by Daryl Cagle, 2001.

Daryl Cagle: photo by Cherian George

Daryl Cagle e-mail interview by author, November 2019.

182    Pope Michael cartoon by Bob Englehard, 2005.

183    Clinton pants down cartoon by Bob Englehart, published in *Hartford Courant*, 1998.

Bob Englehart, e-mail interview by author, October 2019.

Bob Englehart photo: twitter.com/bobenglehart .

Ted Cruz: photo by Frank Fey, US Senate.

Cruz family, still from video, "Cruz Christmas Classics," cruz.org, December 18, 2015, youtube.com.

184    Ted Cruz cartoon by Ann Telnaes, December 2015.

Fred Hiatt, quoted in Michael Cavna, and David Betancourt, "The Post Just Pulled a Ted Cruz Cartoon, Would You Have Published It?" *Washington Post*, December 23, 2015.

Ann Telnaes interview by author, October 2018. See also: Ann Telnaes, "How Social Media Has Changed the Landscape for Editorial Cartooning," *Columbia Journalism Review*, June 29, 2016, cjr.org.

Ann Telnaes: photo by Cherian George.

"Angels sent by God" by Matt Wuerker, *Politico*, August 30, 2017.

potshot: Thomas D. Williams, "Politico's Matt Wuerker Mocks Texas Hurricane Victims in Political Cartoon," *Breitbart*, August 30, 2017, breitbart.com.

Matt Wuerker interview by author, May 2019.

Matt Wuerker: photo by Cherian George.

185    Anita Kunz, video interview by author, October 2019.

Anita Kunz: photo off video call by Cherian George.

185-186    Art by Anita Kunz.

186    "Thousands of Abu Ghraib Photos Set for Release ," *New York Daily News*, January 9, 2019, nydailynews.com.

Abu Ghraib illustration by Peter Kuper, 2014.

187    Coat of Arms illustration by Peter Kuper, *New York Times*, 2014.

Peter Kuper, video interview by author, October 2019.

Peter Kuper photo courtesy of the artist.

Rob Rogers photo by Kyle Cassidy, University of Pennsylvania.

Rob Rogers, "I Was Fired for Making Fun of Trump," *New York Times*, June 15, 2018, nytimes.com.

188    Cartoons by Rob Rogers, 2018.

189    "God is Goed" postcard by Tjeerd Royaards, 2014.

Boomerang rack photo courtesy of Tjeerd Royaards.

189-190    Tjeerd Royaards: photo by Cherian George.

Tjeerd Royaards, interview by author, July 2019.

190    "Don't draw Mohammed" by R.J. Matson, 2006.

191    "A New Weapon" by R.J. Matson, *St Louis Post-Dispatch*, 2006.

R.J. Matson, e-mail interview by author, May 2020.

R.J. Matson photo, courtesy of the artist.

192    book: Aji Prasetyo, *Hidup Itu Indah* (Jakarta: Cendana Art Media, 2010).

Aji Prasetyo: photo by Cherian George.

Aji Prasetyo interview by author, June 2019.

Indah Pratidina, e-mail interview by author, May 2020.

Indah Pratidina photo courtesy of the interviewee.

193    Coronavirus cartoon by Niels Bo Bojesen, originally published online on January 24, 2020.

Coronavirus cartoon by Martin Wolterink, published in *Joop*, January 25, 2020.

Coronavirus cartoon by Steven Degryse (Lectrr), published in *De Standaard*, January 23, 2020.

**China assertive:** Zhu, "China's Wolf-Warrior Diplomacy"

Statement by the Spokesperson of the Embassy of China in Belgium, January 29, 2020, be.chineseembassy.org.

Letter from the Association of Chinese Enterprises in Belgium and Luxembourg to *De Standaard*, January 30, 2020.

Screen captures of social media comments, courtesy of Steven Degryse.

194    Storm P. Museum: photo by Janus Kannuberg.

**museum security:** e-mail interview with Astrid la Cour, Director, The Frederiksberg Museums, July 2020.

Niels Bo Bojesen, e-mail interview by author, July 2020.

Steven Degryse video interview by author, June 2020.

Steven Degryse stills from video, "Standaard Koekhandel - Lectrr," Lukas Lelie, February 3, 2020, youtube.com

## Chapter 8: Liberation Technology and the Rise of the Platforms

196    John Perry Barlow, "A Declaration of the Independence of Cyberspace," Electronic Frontier Foundation, February 8,1996, eff.org.

John Perry Barlow: photo by J.D. Lasica.

197    Cartoonists' social media: Zapiro on Twitter @zapiro; Ann Telnaes on Twitter @anntelnaes; Mana Neyestani on Instagram, neyestanimana; Emad Hajjaj on Twitter @emadhajjaj.

198    **zines:** Duncombe, *Notes from Underground*.

"Ronald Reagan wanted for international terrorism" poster, 1980s, artist unknown.

Google Images search results: composite image.

198-200    Hillary texting, by Kevin Lamarque, Reuters. See Kevin Lamarque, "Texts from Hillary," Reuters, September 24, 2014, widerimage.reuters.com.

199    **memes as political cartoons:** Scully, "Editorial Cartoons"; Chen et al., "Towards a Discipline of Political Cartoon Studies"; Milner, *The World Made Meme*.

200    **Hillary texting meme:** Stacy Lambe and Adam Smith, *Texts from Hillary* blog, June 7, 2016.  textsfromhillaryclinton.tumblr.com

200   Hillary memes from *Texts from Hillary* blog, ibid.

👁 Bill Clinton still from video, "President Bill Clinton's response to the Lewinsky allegations, Jan. 26, 1998," Miller Center of Public Affairs, University of Virginia, youtube.com

201   👁 Occupy Wall Street: photo by Cherian George.

**memes and movements:** Mina, *Memes to Movements*; Milner, "Pop Polyvocality."

✎ Dollar art by Occupy George, occupygeorge.com.

👁 Printing dollar art: Occupy George, occupygeorge.com.

202   ✎ Winnie the Pooh meme: anonymous.

✎ Toad Worship memes, anonymous, courtesy of Fang Kecheng, toadworship.tumblr.com.

👄 Anonymous meme maker, quoted in Fang, "Turning a communist party leader into an internet meme."

202-203 👄 Fang Kecheng, interview by author, June 2020.

👁 Fang Kecheng: photo by Cherian George.

203   👄 Anonymous toad worshipper, quoted in Fang, "Turning a communist party leader into an internet meme."

203-204 👁 WeChat, Weixin experiment photos, June 2020.

205   **cartoons redundant:** Grygiel, "Political Cartoonists Are out of Touch."

206   👁 *South China Morning Post* op-ed pages with cartoon by Harry Harrison: photo by Cherian George.

👄 Ann Telnaes, interview by author, October 2018.

👁 Ann Telnaes: photo by Cherian George.

207   👄 Laurent Deloire, phone interview by Raphael Blet for the authors, November 2019, translated from French.

👁 Laurent Deloire: photo courtesy of the artist.

**disinformation:** Wardle, "Fake News."

**Danish cartoons dossier:** Asser, Martin. "What the Muhammad Cartoons Portray." *BBC News*, January 2, 2010. bbc.co.uk.

👁 Pig-squealing contest: photo, credited to Bob Edme, appeared in a news story, Associated Press, "Duo Hogs Top Prize in Pig-Squealing Contest," *NBC News*, August 15, 2005, nbcnews.com.

208-209 👁 Doctored and faked cartoons and websites, courtesy of Jonathan Shapiro.

**attacks on Zapiro:** Antoni, Marie Louise. "Zapiro Triggers the Mob." *Politicsweb*, February 22, 2020. politicsweb.co.za; Stone, Jasmine. "Here's The Fake Zapiro, Zuma Colonoscopy Cartoon." *2oceansvibe News*, June 10, 2014. 2oceansvibe.com.

209   ✎ "Democracy" by Zapiro, *Mail and Guardian*, August 19, 2010.

210   👄 Morozov, *The Net Delusion*.

👁 Book cover: Morozov, *The Net Delusion*.

👄 Lessig, "The Laws of Cyberspace." Also see Lessig, *Code.*

👁 Lawrence Lessig still from video, "Lawrence Lessig discusses copyright law, AOL Time Warner, and the issue of open access," Charlie Rose, January 4, 2002. charlierose.com.

211   **platformization:** Nieborg et al., "Platformization"; Graham et al., *Society and the Internet.*

**Facebook IPO:** Julianne Pepitone, "Facebook's IPO Price: $38 per Share," *CNN Money*, May 17, 2012, money.cnn.com.

👁 Mark Zuckerberg: photo by Simon Steinberger.

212   **surveillance capitalism:** Zuboff, *Surveillance Capitalism*; Zuboff, "Remotely Controlled."

👄 Cobbe, "Fake News."

212   👁 Jennifer Cobbe stills from video, "Who Runs the Internet:

Internet Consolidation and Control," *Chatham House*, December 10, 2019. chathamhouse.org.

**Silicon Valley vs. Europe:** Balkin, "Free Speech"; Citron, "Extremist Speech"; "The Yahoo! Case."

👄 Rodolphe Urbs, phone interview by Raphael Blet for the authors, November 2019, translated from French.

👁 Rodolphe Urbs, still from video, "Plein phare avec Rodolphe Urbs," France 3 Nouvelle-Aquitaine, March 3, 2018, youtube.com.

213   👁 Magazine covers: *The Atlantic*, November 2016; *The Economist*, September 10–16, 2016; *L'Obs*, January 10–16, 2019; *Time*, August 29, 2016.

✎ "Don't be racist Nigel" cartoon, artist unknown, c. 2017.

👄 *Hate Crime: Abuse, Hate and Extremism Online*, Home Affairs Committee, UK House of Commons, April 27, 2017, publications. parliament.uk.

213-214 👄 Yvette Cooper and Nick Pickles quoted in *Hate Crime*, ibid.

👁 Yvette Cooper, stills from BBC Newsnight, August 14, 2015, youtube.com.

👁 Nick Pickles, stills from "Home Affairs Committee on Countering Extremism" video, Vox-Pol, May 27, 2016, youtube.com.

214   👄 K. Shanmugam, quoted in *Report of the Select Committee on Deliberate Online Falsehoods*, Part C: Minutes of Evidence, presented to Parliament of Singapore, September 19, 2018, C446-C447. parliament.gov.sg.

👁 K. Shanmugam, still from video, "Social media giants cannot say they will take down a racist cartoon," Government of Singapore, Mar 22, 2018, youtube.com.

215   **Zuckerberg testimony:** "Mark Zuckerberg Testimony: Senators Question Facebook's Commitment to Privacy," *New York Times*, April 10, 2018, nytimes.com.

👁 Zuckerberg testimony, still from video, CNET.com: Zuckerberg's Senate hearing highlights in 10 minutes, 2018, youtube.com.

216-220 👁 Google: The Good Censor, 2018. Google Insights Lab.

218   **attention business:** Wu, *Attention Merchants.*

218-220 👄 Michael Rozanov, video interview by author, October 2019.

218   👁 Michael Rozanov, video still by Cherian George.

219   ✎ "The Green Sabra" by Mysh, 2012.

✎ "The National Erection" by Mysh, 2017.

**Israel and Facebook:** Oded Yaron, "How Fake News Is Threatening the Upcoming Elections in Israel," *Haaretz*, September 16, 2018, haaretz.com.

220   ✎ "True Israeli" by Mysh, 2019.

221   👄 Cobbe, "Algorithmic Censorship."

👄 Cohn, "Bad Facts Make Bad Law."

👁 Cohn, stills from video, "Speaking Freely with Cindy Cohn."

✎ Three Wise Men cartoon by Manfred Deix, 2005. Published as a poster in 2017 by Verband Sozialistischer StudentInnen Österreichs.

**Manfred Deix case:** Janko Roettgers, "Facebook Filters Strike Again: Social Network Blocks, Then Reinstates Anti-Racist Cartoon," *Variety*, January 10, 2017, variety.com.

222   ✎ Tickling priest cartoon by Vilma Vargas, 2019.

👄 Vilma Vargas, e-mail interview by author, October 2019.

👄 Danielle K. Citron. "Extremist Speech."

👁 Danielle K. Citron still from video, "Danielle K. Citron," McArthur Foundation 2018, youtube.com.

223   ✎ Racism in Myanmar cartoon by Stéphane Peray (Stephff), 2019.

🖅 🗩 "An Open Letter to Mr Mark Zuckerberg from *Nation* Cartoonist Stephff," *The Nation* Thailand, August 31, 2018, nationthailand.com.

224 🖅 🗩 "Shoshana Zuboff on 'Surveillance Capitalism' and How Tech

companies are always watching us," Channel 4 News, September 23, 2019, youtube.com.

👁 Shoshana Zuboff, still from Channel 4 News video, ibid.

## Chapter 9: No Man's Land: Dissent in Wartime

229 · ✎ "Liberty Laments 9/11" by Joe Heller.

✎ Uncle Sam weeping, by Daryl Cagle.

✎ "Still standing" by Henry Payne, *Detroit News*. Distributed by Andrews McMeel Syndication.

✎ "The smoke has cleared" by Jeff Stahler.

✎ "Declarations of War" by Bill Day.

✎ "Terror! Terror! Terror!" by Dennis Draughon, *Scranton Times*.

🖅 🗩 Telnaes, "The Red, White and Blue Palette."

👁 Ann Telnaes still from video, C-Span Washington Journal, Apr. 19, 2001, c-span.org.

👁 *USS Arizona* burning after the attack on Pearl Harbor: US Navy photo, December 7, 1941.

230 👁 Uncle Sam image from "I want you for U.S. Army" World War I recruitment poster.

230-240 🖅 🗩 Aaron McGruder quoted in John Nichols, "Huey Freeman: American Hero," *The Nation*, January 28, 2002.

👁 Aaron McGruder stills from Charlie Rose interview, Jul. 15, 1999, youtube.com.

👁 "The Boondocks" by Aaron McGruder, 2001, 2002. Distributed by Andrews McMeel Syndication.

**media reactions:** Michael Getler, "Putting 'The Boondocks' in the Dock," *The Washington Post*, October 19, 2003.

👁 Condoleezza Rice: photo by Tina Hager, White House.

232-243 🖅 🗩 Ted Rall, interview by author, November 2018; Ted Rall, *America Gone Wild: Cartoons*, (Kansas City, MO: Andrews McMeel, 2006).

👁 Ted Rall photos by Kyle Cassidy, University of Pennsylvania.

232 ✎ "Terror Widows" by Ted Rall, 2002.

233 ✎ "FDNY 2011" by Ted Rall, 2001.

234 **media reactions:** Jim Romenesko, "Rall's Cartoons Don't Fit Tone of Our Website, Says NYT.com," *Poynter*, March 4, 200, poynter.org; David Astor, "Rall's 'Tillman' Cartoon Pulled by MSNBC.com," *Editor & Publisher*, May 3, 2004, editorandpublisher.com; "NYTimes.com Pulls 9/11 Widows Cartoon," *Editor & Publisher*, March 6, 2002, editorandpublisher. com.

✎ Pat Tillman cartoon by Ted Rall, 2004.

👁 Pat Tillman photo: US Department of Defense.

**Pat Tillman postscript:** "War Propaganda," *SourceWatch*, n.d., sourcewatch.org; Ryan Devereaux, "The NFL, the Military, and the Hijacking of Pat Tillman's Story," *The Intercept*, September 28, 2017, theintercept.com.

235 **Sri Lanka:** De Silva, *Limits of Expression*; De Silva, "Political Cartoonists."

✎ Sri Lanka censorship icon from the cover of De Silva, Limits of Expression, based on *The Sunday Times* cartoon.

👁 Troops marching (27th Division, New York National Guard) photo: US War Department, National Archives and Records Administration.

236 **Kashmir pellet guns:** Mirza Waheed, "India's Crackdown

in Kashmir: Is This the World's First Mass Blinding?" *Guardian*, November 8, 2016, theguardian.com.

🖅 🗩 Mir Suhail, interview by author, January 2019.

**Espionage Act:** Forte, "Righting a Wrong."

🖅 🗩 Woodrow Wilson, State of the Union Address, December 7, 1915. Let.rug.nl.

👁 Woodrow Wilson photo: US War Department, National Archives and Records Administration.

237 **The Masses:** Cohen, "Cartooning Capitalism"; Baran, "A Brief History."

👁 *The Masses* cover, Nov. 1914.

✎ "For the safety of the public" by Art Young, Art Young Cartoon Gallery, cartooningcapitalism.com.

✎ "War plans" by Art Young, *The Masses*, Aug. 1917.

👁 *The Masses* final cover, Nov.–Dec. 1917.

238 👁 *The Masses* journalists outside New York Courthouse, May 1918: photographer unknown.

🖅 🗩 Oliver Wendell Holmes, *Abrams v. United States*, 250 U.S. 616 (1919). loc.gov.

👁 Oliver Wendell Holmes: National Photo Company collection, Library of Congress.

239 🖅 🗩 Hugo Lafayette Black, in *New York Times Co. v. United States*, 403 U.S. 713 (1970). loc.gov.

👁 Hugo Lafayette Black: portrait by John Black, US Supreme Court.

**First Amendment, national security:** Stone, "National Security."

**adolescent silliness:** Sills, "Inappropriate Political Content."

241 🖅 🗩 Alan Keyes, "Shunning the intolerable," WND.com, November 3, 2002.

👁 Alan Keyes stills from video, "Debate for US Senator from Illinois," City Club of Chicago, October 26, 2004, youtube.com.

243 👁 Ted Rall in Afghanistan: photo courtesy of the artist.

244 👁 Atomic bomb cloud: U.S. Army photo, National Archives and Records Administration.

245 👁 *Hadashi No Gen*, Vol. 1, published by Shueisha Chuokoron-Shinsha, 1975.

👁 Tokyo cityscape, 1960: oldtokyo.com

🖅 🗩 Keiji Nakazawa, quoted in Alan Gleason, "Keiji Nakazawa Interview," *The Comics Journal* no. 256 (2003), tcj.com; Keiji Nakazawa, "A Note from the Author," Essay, In *Barefoot Gen*, 2:147–48, (San Francisco, CA: Last Gasp of San Francisco, 2018).

👁 Keiji Nakazawa stills from video, "Der Manga Barfuss durch Hiroshima," Mediacontainer, May 13, 2011, youtube.com.

246 **censorship in Occupied Japan:** Tim Weiner, "C.I.A. Spent Millions to Support Japanese Right in 50's and 60's," *New York Times*, October 9, 1994, nytimes.com.

👁 MacArthur and Hirohito photo: U.S. Army, Tokyo, September 27, 1945.

✎ Scene from Keiji Nakazawa, *Barefoot Gen* Vol. 2.

247-248 **Barefoot Gen dispute:** Mizuno, "Barefoot."

👁 Keiji Nakazawa: still from video, "Barefoot Gen's Hiroshima Trailer," February 24, 2013, youtube.com.

👂💬 Hakubon Shimomura, quoted in: Dong-hwan Ko, "'Barefoot Gen' Bifurcates Japanese Stance on WWII," *Korea Times*, August 28, 2013, koreatimes.co.kr.

👂💬 *Asahi Shimbun* editorial, quoted in: Linda Sieg, "Classic

Japan Anti-War Comic Stirs History Controversy," *Reuters*, August 23, 2013, reuters.com.

✏ Scene from Keiji Nakazawa, *Hidashi No Gen* Vol. 10 (Tokyo, Japan: Chobunsha, 2003).

👂💬 Keiji Nakazawa, quoted in: Robyn Chapman, "Barefoot Gen Vol. 1 Study Guide," *Reading with Pictures*, April 2008, readingwithpictures.org.

## Chapter 10: The Boys' Club: Gender-based Censorship

252 ✏ Nina Paley, "Neener's Adventures," March 6, 1994.

**gender hierarchies:** Harari, Sapiens, 150.

253 ✏ Rama and Sita, still from film, *Sita Sings the Blues* by Nina Paley (2008). sitasingstheblues.com.

👂💬 Callamard, "Gender-based censorship," 2.

👁 Agnes Callamard: stills from video, "Maintaining journalism standards," *Newsant Media*, September 19, 2011, vimeo.com.

✏ "Silencing" by Nina Palley, mimiandeunice.com.

👂💬 Arundhati Roy, "The 2004 Sydney Peace Prize Lecture" (lecture, University of Sydney, November 4, 2004), sydney.edu.au.

👁 Arundhati Roy: photo by Jean Baptiste Paris.

254 **safe public spaces:** Varma, "(Un)Modifying India."

**fearless freedom:** Ibid.

**Nirbhaya case:** Sonali Pimpuktar, "Nirbhaya Gang Rape Case: Complete Timeline of Events in 2012 Delhi Gang-Rape Case and How the Case Unfolded," *Free Press Journal*, July 9, 2018, freepressjournal.in.

👁 Rape bus: photo from *The Telegraph*, September 13, 2018.

**Nirbhaya movement:** Dasgupta, "On a Different Footing"; Bakshi, "The 'Nirbhaya' Movement".

255 👁 Nirbhaya march: photo by Biswarup Ganguly.

👂💬 Asaram Bapu, quoted in "Delhi gang-rape incident: Asaram blames Nirbhaya, sparks furore," *Times of India*, January 8, 2013, timesofindia.indiatimes.com.

👁 Asaram Bapu stills from video, "Rape victim as guilty as rapists: Asaram Bapu," NewsX, January 7, 2013, youtube.com.

255-258 👁 Kanika Mishra still from video, "Life and challenges of women on social media," TEDxYouth@OIS, March 14, 2016, youtube.com.

👂💬 Kanika Mishra, interview by author, February 2019.

256 ✏ Karnika Kahen cartoons by Kanika Mishra, 2014.

257 👁 News page: "3 witnesses killed, several attacked and threatened for speaking against Asaram," *Hindustan Times*, April. 25, 2018, hindustantimes.com.

**silencing lawful speech:** Viswanath, "Economies of Offense"; George, *Hate Spin*.

👁 CRNI award photo: Kanika Mishra Facebook.

258 👁 Atena Farghadani photo from Free Atena Facebook.

**birth control policy:** Saeed Kamali Dehghan, "Iran Aims to Ban Vasectomies and Cut Access to Contraceptives to Boost Births," *Guardian*, March 11, 2015, theguardian.com.

**Atena case:** Michael Cavna, "Iranian artist Farghadani, who drew parliament as animals, sentenced to 12-plus years," *Washington Post*, June 1, 2015, washingtonpost.com.

✏ Iran Parliament cartoon by Atena Farghadani, 2014.

259-262 👂💬 Atena Farghadani, interview by Amnesty International UK, "Podcast: Atena Farghadani, imprisoned for her art in Iran," January 10, 2019, amnesty.org.uk.

👁 Evin Prison: photo by Ehsan Iran.

260 👁 Gharchak Prison: satellite view image from Google Maps.

👂💬 Human Rights Council, "Situation of human rights in the Islamic Republic of Iran – Report of the Secretary-General," A/HRC/31/26, May 17, 2016, undocs.org.

261 👂💬 Magdalena Mughrabi, quoted in "Iran: Overdue Release of Artist Must Be Followed by Freedom for Other Prisoners of Conscience," *Amnesty International*, May 4, 2016, refworld.org.

👁 Magdalena Mughrabi still from video, "The War In Syria: interview by Magda Mughrabi," *TRT World*, August 19, 2016. trtworld.com.

👂💬 Faith XLVII, e-mail interview by author, March 2019.

👁 Faith XLVII photo: faith47.com

👁 Brooklyn mural photo courtesy of Faith XLVII.

**Brooklyn mural controversy:** Colin Moynihan, "In Brooklyn, a Protest Mural Draws Its Own Protest," *New York Times*, September 25, 2015. nytimes.com.

262 👁 Atena Farghadani, stills from video, December 30, 2014, youtube.com.

263 ✏ "Leave me in LaLaLand" by Megan Praz, 2014, excerpt, leavemeinlalaland.com.

👂💬 Anita Sarkeesian, TEDxWomen talk, December 4, 2012, youtube.com.

👁 Anita Sarkeesian still from video, ibid.

264 **Twitter abuse:** Barton and Storm, *Violence and Harassment against Women*.

**gendered trolling:** Mantilla, *Gendertrolling*; Sobieraj, "Bitch, Slut, Skank, Cunt."

**occupational hazard:** Henrichsen and Betz, "Building Digital Safety for Journalism."

**popular misogyny:** Banet-Weiser, *Empowered*.

**coordinated attacks:** Marwick and Caplan. "Drinking Male Tears."

**Gamergate and Alt-Right:** Matt Lees, "What Gamergate Should Have Taught Us about the 'Alt-Right,'" *Guardian*, December 1, 2016, theguardian.com; Bezio, "Ctrl-Alt-Del: GamerGate"; Zaid Jilani, "Gamergate's Fickle Hero: The Dark Opportunism of Breitbart's Milo Yiannopoulos," *Salon*, October 30, 2014, salon.com.

**Marvel announcement:** Kwame Opam, "Marvel's New Thor Will Be a Woman," *The Verge*, July 15, 2014, theverge.com.

👁 *The View* @theview, Twitter, July 15, 2014.

✏ Female Thor, Marvel comics.

265 👁 Chelsea Cain @chelseacain, Twitter, October 18, 2016.

265 ✎ *Mockingbird* Issue 8 cover by Joelle Jones, Marvel Comics.

❝ Chelsea Cain, "140 characters, plus a few thousand more, on the Twitter hubbub," ChelseaCain.com, October 27, 2016. Also see: Ananya Bhattacharya, "A New 'Gamergate' Is Brewing in the World of Comic Books," *Quartz*, October 29, 2016, qz.com.

👁 Chelsea Cain stills from video, "Writers on the Fly: Chelsea Cain," Iowa City UNESCO City of Literature, June 2, 2017, youtube.com.

266 **milkshake tweet:** Heather Antos @heatherantos, July 29, 2017.

**milkshake controversy:** Matthew Rozsa, "Via Milkshake Selfie, Anti-Feminists Expose Themselves as the Real 'Fake Geeks,'" *Salon*, August 2, 2017, salon.com.

❝ toxic turn: Proctor and Kies, "Editors' Introduction."

👁 Web page: Charlie Nash, "Readers Are Abandoning Marvel Comics After Social Justice Invasion. Can You Blame Them?" *Breitbart*, July 7, 2016, breitbart.com.

267 **blacklist:** John F. Trent, "Fans Create List of Comic Book Professionals to Boycott," *Bounding into Comics*, February 9, 2018, boundingintocomics.com.

✎ "Leave me in LaLaLand" by Megan Praz, 2014, excerpt, leavemeinlalaland.com.

**left-wing mobilization:** Eric Francisco, "What Is Comicsgate? The Newest Geek Controversy, Explained," *Inverse*, February 9, 2018, inverse.com; Eric Francisco, "Comicsgate: The Industry Finally Speaks Out," *Inverse*, August 27, 2018, inverse.com; Gavia Baker-Whitelaw, "Indie Comic 'Jawbreakers' Canceled Due to Comicsgate Links," *The Daily Dot*, February 28, 2020, dailydot. com; Matt Battaglia, "The 'Jawbreaker' Comics Outrage Cycle Is A Ginned Up Controversy," *The Federalist*, May 18, 2018. thefederalist.com.

👁 Web page: Lucas Nolan, "SJWs Attempt to Silence the Conservative and Independent Creators of 'Jawbreakers' Graphic Novel," *Breitbart*, May 14, 2018, breitbart.com.

👁 Richard C. Meyer still from video, "Diversity in Comics Makes Bigots Mad," *The Jim Jefferies Show*, July 24, 2018, youtube.com.

268 ❝ Julia Serano, "How to Write a 'Political Correctness Run Amok' Article," *Medium*, August 19, 2018, medium.com.

👁 Julia Serano: photo by Pax Ahimsa Gethen.

❝ Natasha Lennard, "Don't Give Fascism an Inch," *In These Times*, August 23, 2017, inthesetimes.com.

👁 Natasha Leonard: photo from Tash Leonard Facebook.

❝ Joanna Williams, "Censorious Feminism Ultimately Backfires," *Index on Censorship*, October 18, 2017, indexoncensorship.org.

👁 Joanna Williams: photo by University of Kent.

❝ Gloria Steinem, quoted in: Nick Clark, "Feminist Icon Gloria Steinem Says No-Platforming 'Is Wrong.'" *Independent*, February 27, 2016, theindependent. co.uk.

👁 Gloria Steinem: photo by Gage Skidmore.

❝ Nina Paley, e-mail interview by author, March 2019.

👁 Nina Paley: photo from Nina Paley Facebook.

269 ❝ Ann Telnaes, interview by author, September 2019.

👁 Ann Telnaes: photo by Cherian George.

**sexual violence in India:** Sujan Bandyopadhyay, "A Closer Look at Statistics on Sexual Violence in India," *The Wire*, May 8, 2018, thewire.in; Ramesh Menon, "India's Losing Battle against Sexual Violence," *The Week*, November 27, 2017, theweek.in.

👁 Narendra Modi: photo by Prime Minister's Office photo.

270 ❝ Barkha Dutt, "Hindu 'Nationalists' Defend Accused Rapists and Shame India," *Washington Post*, April 12, 2018, washingtonpost.com.

👁 Barkha Dutt: photo by NDTV.

**Asifa Bano case:** Rayan Naqash, "After Hindu Group Rally to Support Man Accused of Muslim Child's Rape and Murder, Jammu Rift Widens," *Scroll*, June 11, 2019, scroll.in; "Kathua Rape and Murder Case: Full Text of Chargesheet Filed by Jammu and Kashmir Police," *Firstpost*, April 15, 2018, firstpost.com.

👁 Protest still from video, "Hindu Ekta Manch Holds Protest in Kathua," *The News Now*, March 22, 2018, youtube.com.

👁 TV news reports: "Unnao Horror: Exposing The Cover-Up," NDTV, April 10, 2018, youtube.com; "Amid Move To Drop Case Against Ex-Minister, Rape Survivor Appeals To President," NDTV, April 13, 2018, youtube.com.

271-275  👁️ 💬 Swathi Vadlamudi, interview by author, February 2019.

👁️ Swathi Vadlamudi photos by Cherian George.

271  ✏️ Ram cartoon by Swathi Vadlamudi, 2018.

272  👁️ 💬 Indian Penal Code Section 295A, indiankanoon.org.

**taking offense:** Doniger, "India: Censorship"; George, "Regulating 'Hate Spin'."; Viswanath, "Economies of Offense."

👁️ Police summons, courtesy of Swathi Vadlamudi.

273  👁️ Statement to police, courtesy of Swathi Vadlamudi.

## Chapter 11: The Trap of Accidental Associations

278-279  ✏️ Cockroach cartoon feature by Mana Neyestani, *Iran Jomeh*, May 12, 2006.

280  **Azerbaijani protests:** Nayereh Tohidi, "Iran: Regionalism, Ethnicity and Democracy," *Open Democracy*, June 28, 2006, opendemocracy.net.

280-281  ✏️ Excerpts from Mana Neyestani, *An Iranian Metamorphosis*, (Minneapolis, MN, USA, Uncivilized Books 2014).

280  👁️ News reports: Barbara Garson, "Make Jokes, Not War," *Los Angeles Times*, November 26, 2006, latimes.com; Nazilla Fathi, "Iran Shuts Down Newspaper Over Cartoon," *New York Times*, May 24, 2006, nytimes.com; Beehner Beehner, "Iran's Ethnic Groups," Council on Foreign Relations, November 29, 2006, cfr.org.

282  ✏️ Portrait of Roberto Weil by Sonny Liew.

283  👁️ Hugo Chavez: photo by Roberto Stuckert Filho.

👁️ Mario Silva: still from "La Hojilla," Venezolana de Televisión.

284  ✏️ "Miguel" by Roberto Weil, 2014.

284-288  👁️ 💬 Roberto Weil, interview by author, October 2018.

285  👁️ Newspaper covers: *Diario* 2001, October 2, 2014; *El Diario*, October 2, 2014; *Diario Version Final*, October 3, 2014.

286  👁️ Tareck El Aissami: photo by EneasMx

👁️ Ernesto Villegas: Ernesto Villegas publicity photo.

👁️ 💬 Tareck El Aissami and Ernesto Villegas tweets: Twitter, October 5, 2014.

👁️ Maduro news conference stills from VTV video, October 15,

2014, youtube.com.

287  👁️ Maduro news conference stills from Lapatilla Patillavideo, October 24, 2014.

289  **metaphorical thinking:** Navasky, *Art of Controversy.*

👁️ 💬 Paul Conrad, quoted in Wallis, *Killed Cartoons.*

✏️ "New member for Rockhampton" by Rod Emmerson, c.1996.

👁️ 💬 Rod Emmerson, e-mail interview by author, November 2018.

290  ✏️ "National toilet" by Aseem Trivedi, 2011.

**Aseem Trivedi case:** "Sedition Charges to Stay, but Cartoonist Aseem Trivedi Freed," *Indian Express*, September 12, 2012, indianexpress.com.

**Dalit activism:** Harish S. Wankhede "The Post-political Dalit Movement in Maharashtra," *Economic and Political Weekly* 54, no. 36 (September 7, 2019).

👁️ 💬 Aseem Trivedi, interview by author, February 2018.

291  **moral indignation:** Tarrow, *Power in Movement.*

**injustice symbols:** Olesen, *Global Injustice Symbols*; Gamson, "Injustice Frames."

**asymmetric offense:** George, *Hate Spin*; Daly, "On Insults."

👁️ 💬 Khadem, "Framed Memories."

292  ✏️ Mana Neyestani portrait by Sonny Liew.

293-295  👁️ 💬 Mana Neyestani, interview by authors, August 2018.

👁️ Mana Neyestani: photos by Cherian George and Sonny Liew.

## Chapter 12: Hate Speech, Taking Offense, and the "Good Censor"

298  👁️ Apartheid-era signs: photos by Ulrich Stelzner; SmartRebeccaJoy; Dewet.

👁️ Cabinet 1958: National Archives of South Africa.

✏️ 1987 U.D.F. calendar by Zapiro, 1986 (detail).

✏️ U.D.F. poster by Zapiro, 1983.

299  ✏️ P.W. Botha caricature by Zapiro, 1985.

👁️ Zapiro and Mandela, 1994: photo by Karina Turok.

**Mandela exhibition:** "Zapiro Leaves His Mark," Nelson Mandela Foundation, November 18, 2008, nelsonmandela.org.

👁️ 💬 Zizi Kodwa, quoted in "Is Zapiro a Racist or Victim of Double-Speak?" *South African Jewish Report*, June 1, 2016, sajr.co.za.

👁️ 💬 Dino Lola Monareng, quoted in "Zapiro Needs to Take a Hard Look in the Mirror," *The Daily Vox*, May 8, 2017, thedailyvox.co.za.

300  **opposing Mbeki and Zuma:** Amato, "Weapons of Mass Provocation."

✏️ "AIDS message" by Zapiro, September 2005.

**Zuma shower:** "SA's Zuma 'showered to avoid HIV'," *BBC News*, April 5, 2006, news.bbc.co.uk.

**Zuma lawsuits:** Deji Olukotun, "South African President Drops Defamation Suits Against Zapiro and Media," *PEN America*, June 14, 2013, pen.org.

301  👁️ Jonathan Shapiro: photo by Cherian George

👁️ 💬 Jonathan Shapiro, interview by author, August 2019.

✏️ Rape of Justice cartoon by Zapiro, September 2008.

👁️ News item: "We're prepared to kill for Zuma: Vavi," *IOL*, June 21, 2008, iol.co.za.

302  👁️ 💬 "Zapiro cartoon 'despicable and racist' – Julius Malema," *PoliticsWeb*, September 10, 2008, politicsweb.co.za.

👁️ Julius Malema still from video, eNCA. "Julius Malema: Don't compare me with Jacob Zuma," December 4, 2019, youtube.com

274  👁️ 💬 Biplap Deb, quoted in Priyanka Deb Barman, "Diana Hayden Not an Indian Beauty, Aishwarya Rai Is, Says Tripura CM Biplab Deb," *Hindustan Times*, April 26, 2018, hindustantimes.com.

👁️ Web page: "Diana Hayden Not 'Indian' Enough To Win Miss World Crown: Tripura Chief Minister Biplab Deb," *Silverscreen India*, April 27, 2018, silverscreen.in.

275  ✏️ Aishwarya Rai by Swathi Vadlamudi, 2018.

302 **Rape cartoon controversy:** Koelble and Robins, "Zapiro"; Mason and Opperman, "South African Cartooning."

✎ Organ grinder's monkey, by Zapiro, 2016.

**Charges against Zuma:** TMG Digital. "NPA to Appeal High Court Ruling on Zuma Charges." *TimesLIVE*, May 23, 2016. timeslive.co.za; "South Africa Prosecutor to Challenge Jacob Zuma Corruption Ruling." *BBC News*, May 23, 2016. bbc.com.

303 ✎ 1872 Presidential Election by Thomas Nast, *Harper's*, June 8, 1872.

❛❜ Eusebius McKaiser, "Artistic Criticism Isn't Censorship," IOL, November 12, 2016. iol.co.za.

👁 Eusebius McKaiser photo, Radio 702.

👁 News headline: Rebecca Davis, "What on Earth Were You Thinking, Zapiro?" *Mail & Guardian*, May 25, 2016. mg.co.za.

👁 Anele Mdoda @anele, Twitter, May 25, 2016.

❛❜ Zapiro's apology: Nomahlubi Jordaan. "Zapiro: Monkey and Organ Grinder Cartoon Was 'a Mistake'," *Rand Daily Mail*, May 26, 2016. businesslive.co.za; Tara Penny, "Zapiro Apologises for Cartoon after Backlash," *Eyewitness News*, November 19, 2016. ewn.co.za.

304 ❛❜ Gombrich, "The Cartoonist's Armoury."

✎ Physiognomic drawings by Giambatista della Porta, *De Hum. Physiognomonia*, 1586, italianways.com.

✎ "An excrescence" by James Gilray, 1791, UK Parliament.

✎ "The Pears" by Charles Philipon, 1831.

**The Pears:** McQuiston, "The Royal Image."

✎ "The family group of the catarrhines" by Ernst Haeckel, *Natural History of Creation*, 1868.

305 👁 Barack Obama: photo by Pete Souza.

👁 "Obama in '08" button: "The Coon Caricature: Blacks as Monkeys," *History on the Net*, n.d. historyonthenet.com.

❛❜ natural metaphor: Gombrich, "The Cartoonist's Armoury."

✎ "March of civilization" by Victor Gillam, *Judge*, April 1, 1899. Ohio State University Billy Ireland Cartoon Library & Museum.

❛❜ Sebring, "Civilization and Barbarism."

✎ Japanese Occupation poster, artist unknown, 1938, IISH Collection.

306 ✎ "The Mongolian Octopus" by Phil May, *The Bulletin*, 1886.

**White Australia policy:** Guy Hansen, "Australia for the White Man," National Library of Australia, May 10, 2019. nla.gov.au.

✎ "The king of a shantee" by Frederick Opper, *Puck*, 1882, thesocietypages.org.

**Irish as apes:** Wade, "Irish Apes."

✎ "Superman Indian Chef!" *Action Comics*, 1950. See: "The Most Racist Moments in Comics," *Ranker Comics*, July 28, 2020, ranker.com.

307 ✎ "Mau Mau Party," artist unknown, *Citizens Council*, 1958, citizenscouncils.com.

✎ "The Future Representatives of Our Nation," artist unknown, *Illustrated Wasp*, 1877, California Historical Society, foundsf.org.

✎ "Hurrah for the Fourth of July" by Charles L. Bartholomew, *Minneapolis Journal*, 1898, apjjf.org.

**American Empire:** Brewer, "Selling Empire."

✎ Churchill octopus by Joseph Plank, 1938. Library of Congress.

308 ✎ "Museum of Horrors: Le Baron James" by V. Lenepveu, 1900. U.S. Holocaust Memorial Museum.

✎ "The Poisonous Mushroom" by Ernst Hiemer, 1938. U.S. Holocaust Memorial Museum.

✎ Anti-Rohingya cartoon, artist unknown.

❛❜ Matthew Smith, e-mail interview by author, August 2020. Also see: AFP, "Myanmar Cartoonists Lead Media-Jeering as Rohingya Flee," *Coconuts*, September 24, 2017, coconuts.co.

309 **hate speech:** Waldron, *The Harm in Hate Speech*.

👁 *Der Sturmer* covers: U.S. Holocaust Memorial Museum, courtesy of Helen Fagin.

👁 Julius Streicher photo: Wikimedia Commons.

**Nuremberg trial:** "The First Trial at Nuremberg." Facing History and Ourselves. facinghistory.org; "Individual Responsibility of Defendants: Julilus Streicher." Nuremberg Tribunal Charges. phdn.org.

👁 *Kangura* covers: Wikimedia Commons.

**Rwanda media trials:** Thompson, *The Media and the Rwanda Genocide*.

310 ❛❜ Article 20.2, in UN General Assembly, *International Covenant on Civil and Political Rights*, December 16, 1966, United Nations Treaty Series, refworld.org.

**offense vs. incitement:** George, *Hate Spin*.

311 **defamation of religions:** Langer, *Religious Offence and Human Rights*; Appiah, "What's Wrong with Defamation of Religion?".

**anti-Muslim racism:** Cheng, "Islamophobia, Muslimophobia or Racism?"; Erdenir, "Islamophobia qua Racial Discrimination."

👁 Representative of Pakistan addresses the General Assembly, 2007: photo by Macro Castro, United Nations photo.

312 ❛❜ Matsuda, "Public Response to Racist Speech," 24–25.

👁 Mari Matsuda: photo by University of Hawai'i at Manoa.

❛❜ Schauer, "Uncoupling Free Speech," 265.

👁 Frederick Schauer: photo by Maina Kiai, University of Virginia.

**critical race theory:** See Lederer and Delgado R., *The Price We Pay*.

**microaggressions:** Freeman and Schroer, *Microaggressions and Philosophy*; Williams, "Microaggressions."

❛❜ Ijeoma Oluo, *So You Want to Talk About Race* (New York: Seal Press, 2018).

👁 Ijeoma Oluo photo: ijeomaoluo.com.

313 **Gregorius Nekschot:** "The Case of Gregorius Nekschot 2008," Censorship! Pers Museum, n.d.; "Discrimination Case Dropped against Cartoonist," *Dutch News*, September 21, 2010, dutchnews.nl; "The Nekschot 8," *MediaWatchWatch*, May 24, 2008, mediawatchwatch.org.uk.

✎ Christmas Imam, Poef cartoons by Gregorius Nekschot, c.2005.

👁 Geert Wilders: photo by Rijksoverheid/Phil Nijhuis.

314 👁 Muslims-winning headlines: Daniel Pipes, "Western Civilization on Trial," *Catholic Exchange*, February 9, 2010, catholicexchange.com; "Legal Jihad," Henry Jackson Society, November 11, 2008; Baron Bodissey, "What Used to Be Known as Christendom," *Gates of Vienna*, July 12, 2008, gatesofvienna.net.

❛❜ Patrick Lamassoure (Kak), phone interview by Raphael Blet for the authors, October 2019, translated from French.

👁 Patrick Lamassoure (Kak): still from video, "KAK, le dessinateur de l'Opinion se confie à Europe 1" *L'Opinion*, Jan. 27, 2017. lopinion.fr.

315 ❛❜ Anita Kunz, video interview by author, October 2017.

👁 Anita Kunz: photos off video call by Cherian George.

❛❜ Martin Rowson, interview by author, July 2019.

👁 Martin Rowson: photo by Cherian George.

👂💬 Emad Hajjaj, interview by author, December 2018.

👁 Emad Hajjaj: photo by Kyle Cassidy, University of Pennsylvania.

316-317 👂💬 Joep Bertrams, interview by author, July 2019.

👁 Joep Bertrams: photo by Cherian George.

👂💬 Dave Brown, interview by author, July 2019.

👁 Dave Brown: photo by Cherian George.

👂💬 Steve Marchant, interview by author, July 2019.

👁 Steve Marchant: photo by Cherian George.

👂💬 Michael Rozanov, video interview by author, October 2019.

👁 Michael Rozanov: photo supplied by the artist.

👂💬 Tjeerd Royaards, interview by author, July 2019.

👁 Tjeerd Royaards: photo by Cherian George.

✎ "Serena Williams" by Mark Knight, *Herald Sun*, September 11, 2018.

**Serena Williams cartoon case:** Helen Davidson, "'Repugnant, Racist': News Corp Cartoon on Serena Williams Condemned," *Guardian*, September 11, 2018, theguardian.com; Kate Legge, "Cartoonist Mark Knight: 'They Wished I Was Dead,'" *The Australian*, January 18, 2019, theaustralian.com.au.

318   ✎ Black Mumbo by John R. Neill in Helen Bannerman, *The Story of Little Black Sambo* (Chicago: Reilly & Lee, 1908).

👂💬 spit the dummy: urbandictionary.com.

👂💬 Australian Press Council ruling: "Adjudication 1758: Complainant/Herald Sun," Australian Press Council, February 25, 2019, presscouncil.org.au.

321   ✎ "Kissing babies" by Dave Brown, *Independent*, January 27, 2003.

✎ "Saturn devouring his son" by Francisco Goya, c.1820.

👂💬 Dave Brown, interview by author, July 2019.

👁 Dave Brown: photo by Cherian George

**blood libel:** Benjamin Ivry, "Why the Blood Libel Won't Die," *The Forward*, September 7, 2015, forward.com.

✎ Blood libel woodcut by Michel Wolgemut, Wilhelm Pleydenwurff; text: Hartmann Schedel, 1493.

320   **PCC:** The Press Complaints Commission was succeeded by the Independent Press Standards Organisation. Editors Code of Practice: editorscode.org.uk.

👂💬 PCC ruling, quoted in "Press Watchdog Says 'Independent' Cartoon of Israeli PM Was Not Anti-Semitic," *Independent*, May 21, 2003.

✎ Eurovision by Dieter Hanitzch, *Süddeutsche Zeitung*, May 15, 2018.

321   👂💬 Kurt Kister, "Stereotype und Klischees," *Süddeutsche Zeitung*, May 18, 2018, sueddeutsche.de.

👁 Kurt Kister: still from video, "Das Beste zweier Welten," *SZ.de*, January 15, 2015. sueddeutsche.de.

👂💬 Isabel Enzenbach, interview by author, September 2018.

👁 Isabel Enzenbach: photo by Cherian George.

**German Press Code:** *German Press Code: Guidelines for journalistic work as recommended by the German Press Council, Deutscher Presserat (German Press Council)*, version of March 22, 2017, presserat.de.

👂💬 German Press Council ruling: "Netanjahu-Karikatur in der Süddeutschen Zeitung von der Meinungsfreiheit gedeckt," *Presserat*, June 17, 2018, presserat.de.

322   **manufacture of outrage:** Olesen, "The Muhammad Cartoons Conflict"; George, *Hate Spin*.

👂💬 Eli Valley, interview by author, October 2019.

👁 Eli Valley: photos by Cherian George, Azad Essa.

**American Jewish opinion:** "Comparisons Between Jews in Israel and the U.S.," *Pew Research Center's Religion & Public Life Project* blog, March 8, 2016, pewforum.org; Josh Marshall, "Jews and Islamophobia," *Talking Points Memo*, May 6, 2019, talkingpointsmemo.

👁 Unite the Right rally: photo by Anthony Crider.

👁 "If you're not outraged" screen shot: Facebook page of Heather Heyer, killed in the Unite the Right rally.

👂💬 Jewish erasure: Eli Valley, "A Springtime of Erasure," *Jewish Currents*, November 25, 2019, jewishcurrents.org.

323   ✎ Sheldon Adelson by Eli Valley, 2016.

**Sheldon Adelson:** Ghanem, "The Deal of the Century."

**Pew survey:** "A Portrait of Jewish Americans," Pew Research Center, October 1, 2013, pewresearch.org.

👂💬 Abraham Foxman, quoted in "Jewish-American Leaders Dismiss Pew Findings on Negative Attitudes toward Israel," *Haaretz*, October 3, 2013, haaretz.com.

👁 Abraham Foxman: photo by Justin Hoch, Hudson Union Society.

324   ✎ "It Happened on Halloween" by Eli Valley, *The Forward*, October 28, 2013.

**sacked by the Forward:** Eli Valley, *Diaspora Boy: Comics on Crisis in America and Israel* (New York: OR Books, 2017).

325   ✎ "Code Name: Evangelator" by Eli Valley, *The Forward*, July 21, 2011.

✎ Holocaust by Eli Valley, "Never Again? Five Jewish cartoonists on the use of holocaust imagery in Trump's America," *The Nib*, March 14, 2017, thenib.com.

**Gorka:** Sebastian Gorka, a Donald Trump aide. See forward.com

326   **deplatforming:** McDowall, "Hate Speech on Campus."

👂💬 Ari Hoffman, "Op-Ed: A Disgrace in the Valley - Co-Sponsoring Anti-Semitism at Stanford," *Stanford Daily*, May 7, 2019. stanforddaily.com.

👁 Ari Hoffman still from video, "Ari Hoffman HarvardX Whitman," Jan. 15, 2014. youtube.com

326  👁 "Spot the difference" poster, anonymous, 2019.

👁 Bari Weiss @bariweiss, Twitter, May 2019.

327  💬 Abraham Cooper, quoted in "SJP, Jewish Voice for Peace Chapters at Stanford Promote Anti-Semitic Cartoons," *JNS*, May 8, 2019, www.jns.org.

👁 Abraham Cooper: photo by Cherian George.

💬 Emily Wilder and Esther Tsvayg, "Stanford Jewish Voice for Peace's Statement on Eli Valley Art Exhibition," *Stanford Daily*, May 8, 2019. stanforddaily.com.

👁 Emily Wilder still from Jewish Voices for Peace video, April 26, 2018, youtube.com.

328  💬 Jonathan Shapiro, quoted in Koelble and Robins, "Zapiro."

✎ Jonathan Shapiro portrait by Sonny Liew.

329  **ANC tactics:** Mason and Opperman, "South African Cartooning."

✎ "Race card" cartoon by Zapiro, *Sunday Times*, May 29, 2012.

✎ "The Spear" by Brett Murray, 2012.

**The Spear:** Okeowo, Alexis. "The Spear Affair." *The New Yorker*, June 8, 2012. newyorker.com; Corrigall, Mary. "Brett Murray Breaks His Silence on That 'Spear' Painting." TimesLIVE, February 26, 2017. timeslive.co.za.

👁 Penny Sparrow Facebook, January 2016.

**Penny Sparrow:** Sisonke Msimang, "South Africa has no patience for Penny Sparrow's apartheid nostalgia," *Guardian*, January 7, 2016, theguardian.com.

330  💬 Additional Zapiro quotes from Koelble and Robins, "Zapiro."

## Chapter 13: The Aura of the Sacred

332  **Honoré Daumier:** Childs, "Big Trouble."

✎ "Gargantua" by Honoré Daumier, 1831.

👁 Honoré Daumier portrait by Félix Nadar, c.1856-8.

333  👁 Sainte-Pelagie prison, the Blanqui Archive, n.d.

✎ Boss Tweed caricature by Thomas Nast, *Harper's Weekly*, October 21, 1871.

✎ Boris Johnson caricature by Morton Morland, *The Times*, October 17, 2016.

💬 Morten Morland, quoted in: Emily Hill, "The Colourful World of Politics," *Gentleman's Journal*, November 3, 2017.

334-349  💬 Emad Hajjaj, interview by author, December 2018.

👁 Emad Hajjaj photo by Kyle Cassidy, University of Pennsylvania.

334  👁 King Abdullah II: photo by Robert D. Ward.

335  ✎ Hidden Royal by Emad Hajjaj, *Al Rai*, 1999.

👁 Bhumibol Adulyadej, *The Story of Tongdaeng* (Amarin Printing and Publishing, 2004).

336  ✎ Flight of the Garuda to Heaven, Stéphane Peray (Stephff), *The Nation*, c.2016.

💬 Stéphane Peray, e-mail interview by author, April 2020.

👁 Creation of Adam by Michelangelo: photo by Joörg Bittner Unna.

**aniconism:** Gaifman, "Aniconism" 335-52; Jensen, "Aniconic Propaganda."

✎ Destruction of icons in Zurich, 1524, artist unknown.

337  **Danish cartoons case:** Klausen, *Cartoons That Shook the World*.

👁 "The face of Muhammad," *Jyllands-Posten*, Sept. 30, 2005.

💬 put up with scorn: FlemmingRose, "Muhammeds ansigt," *Jyllands-Posten* (September 20, 2005), jyllands-posten.dk.

👁 Westergaard at work: stills from documentary film, *Muhammedkrisen* (*Bloody Cartoons*), directed by Karsten Kjaer, 2007, archive.org.

💬 Yusuf Al Qaradawi, quoted in "Sheikh Al-Qaradhawi Responds to Cartoons of Prophet Muhammad," *Memri*, February 9, 2006, memri.org.

💬 Yousef Qureshi, quoted in Reuters, "Imam Offers Reward to Kill Cartoonists," *Al Jazeera*, February 18, 2006, aljazeera.com.

338  **ax attack:** Marie Louise Sjølie, "The Danish Cartoonist Who Survived an Axe Attack," *Guardian*, January 4, 2010, theguardian.com.

💬 Yale decision, quoted in John Donatich, "Why Yale UP Did Not Publish the Danish Cartoons," *Free Speech Debate*, April 18, 2014, freespeechdebate.com. See also: Klausen, "A Comedy of Errors."

👁 Book cover: Klausen, *Cartoons That Shook the World*.

💬 Index on Censorship statement: Jonathan Dimbleby, "Default," ***Index on Censorship***, December 18, 2009, indexoncensorship.org.

339  👁 Navasky, *The Art of Controversy*.

💬 Navasky, *The Art of Controversy*.

340  💬 Mohammed Abdul Latif, interview by author, January 2019.

👁 Mohammed Abdul Latif: photo by Cherian George.

💬 Aji Prasetyo, interview by author, April 2019.

👁 Aji Prasetyo photo: by Cherian George.

340-341  💬 Signe Wilkinson, remarks at Red Lines: Cartooning at Risk Symposium, Annenberg School for Communication, University of Pennsylvania, December 7, 2018.

👁 Signe Wilkinson: photo by Kyle Cassidy, University of Pennsylvania.

341 ✎ Big Fat Book by Signe Wilkinson, *Philadelphia Daily News*, February 8, 2006.

❝ ❞ Mohammad Sabaaneh, interview by author, July 2019.

👁 Mohammad Sabaaneh: photo by Cherian George.

✎ Prophet by Mohammed Sabaaneh, *al-Hayat al-Jadida*, February 1, 2015.

342 ❝ ❞ Teguh Santosa, interview by author, June 2019.

👁 Teguh Santosa: photo by Cherian George.

343 👁 Pages from Gruber, *Praiseworthy One*.

343-346 ❝ ❞ Khalid Albaih, interview by author, January 2019.

👁 Khalid Albaih: photos by Cherian George.

343-344 👁 Supreme Court frieze: photo by Office of the Curator, Supreme Court of the United States.

**Supreme Court frieze:** Laurie Asseo, "Supreme Court Won't Change Mohammed Sculpture," *Associated Press*, March 12, 1997, apnews.com.

344 ❝ ❞ Al-Alwani, "Fatwa Concerning the United States Supreme Courtroom Frieze."

👁 Taha Jabir Al-Alwani, still from video, "5 Pieces of Advice for Muslims," March 18, 2016, youtube.com.

345 ❝ ❞ Gruber, "Ban"; Gruber, *Praiseworthy One*, 361.

👁 Christiane Gruber: still from video, "La lune dans la culture musulmane au coeur d'une exposition," ICI Toronto, March 7, 2019, youtube.com

**Mubarak's role:** Rolfe, "Clashing Taboos."

👁 Mubarak poster: photo by Papillus, 2006.

**Islamophobia industry:** Lean, *The Islamophobia Industry*.

346 **standard total view:** Connors, "When the Walls Come Crumbling Down."

**King Rama VI:** Warat, "The Uphill Climb."

👁 Coronation portrait of King Vajiravudh, 1911.

❝ ❞ Streckfuss, "Lese Majeste."

👁 Thai military: photo from Official Site of The Prime Minister of Thailand Abhisit Vejjajiva, 2010.

347 ✎ Emad Hajjaj portrait by Sonny Liew.

348 👁 Emad Hajjaj in San Francisco: photo courtesy of the artist.

349 👁 Apple iPod, Apple Computer.

👁 Emad Hajjaj's first book, Al Mahjoob, 1999.

350 ✎ King Abdullah II connect-the-dots by Sonny Liew.

## Chapter 14: Je Suis Charlie: A Symbolic Battle

352 👁 Gunmen: still from video by anonymous witness.

353 ✎ Battle of Manzikert by O. Mustafin, Istanbul Military Museum.

👁 Patrick Buchanan: photo by BBSRock.

❝ ❞ Patrick Buchanan, "Europe's Illusions Collapse in Paris," *American Conservative*, January 9, 2015, theamericanconservative.com.

👁 Richard Dawkins @RichardDawkins, Twitter, January 7, 2015.

✎ Reading Voltaire: "In the Salon of Madame Geoffrin in 1755" by Anicet Charles Gabriel Lemonnier, 1812.

❝ ❞ Pankaj Mishra, "How Rousseau Predicted Trump," *New Yorker*, July 25, 2016, newyorker.com.

👁 Pankaj Mishra: still from video, "On Contact: Age of Anger with Pankaj Mishra," *RT America*, November 6, 2017, youtube.com.

354 ✎ "Patience Monsignor Your Turn Will Come," unknown artist, 1790, Bibliothèque Nationale de France.

❝ ❞ secularism: "Secularism and religious freedom," Government of France, 2014-2016. gouvernement.fr.

❝ ❞ Sandrine Sanos, e-mail interview by author, June 2020.

👁 Sandrine Sanos: still from video, "H-France Webinar," May 13, 2019, youtube.com.

👁 L'Eugène Péreire arriving in Algiers, c.1899: photographer unknown, US Library of Congress.

✎ "Enslaved Africans Sold to French" by Henry Hand, 1858, UK National Archives, slaveryimages.com.

✎ "Whipping of a Fugitive Slave, French West Indies" by Marcel Verdier, 1849, slaveryimages.com.

355 👁 Euro launch: photo by Danny Gys, European Commission.

❝ ❞ Todd, *Who Is Charlie?*, 64

👁 Emmanuel Todd: photo by Oestani.

❝ ❞ Jeffrey D. Sachs, "The War with Radical Islam," *Project Syndicate*, January 15, 2015, projectsyndicate.org.

👁 Jeffrey Sachs: photo by Fourandsixty.

👁 French soldiers and vehicles in Afghanistan, 2008: photo by Michael E. Wagoner, International Security Assistance Force Headquarters Public Affairs Office.

356 ❝ ❞ Sreberny, "The 2015 Charlie Hebdo Killings," 3489, 3498.

**Rashomon effect:** Also applies to the Danish cartoon controversy, according to Klausen, *Cartoons That Shook the World*.

👁 Annabelle Sreberny: still from video, "Holberg Symposium 2012," February 26, 2014, youtube.com.

👁 Rashomon movie poster, 1962: Daiei Film.

👁 *De Telegraaf* front page: November 3, 2004.

356-357 **Theo van Gogh killing:** Roland Rovers, "The Silencing of Theo van Gogh," *Salon*, November 25, 2004, salon.com; Buruma, *Murder in Amsterdam*.

357 **Jyllands-Posten:** Klausen, *Cartoons That Shook the World*.

👁 Boycott Danish products: Pemuda PAS website, February 9, 2006, pemudawilayah.blogspot.com.

358 **French media response:** Berkowitz and Lyombe, "Blasphemy as a Sacred Rite/Right."

👁 *France Soir* front page: February 1, 2006.

**France Soir case:** "Caricatured: Le Monde and the Mohammed Cartoons," Columbia University, n.d., ccnmtl.columbia.edu.

358-379 ❝ ❞ Caroline Fourest, interview by author, August 2018.

👁 Caroline Fourest: photo by Sonny Liew.

359-360 👁 *Charlie Hebdo* team: stills from documentary, *C'est dur d'être aimé par des cons*, Daniel Leconte, 2008.

❝ ❞ *Charlie Hebdo* team dialog: from documentary, ibid.

360-364 **2006 legal case:** Kahn, "Tragedy, Farce or Legal Mobilization?"

361 ❝ ❞ Manifesto: "Full Text: Writers' Statement on Cartoons," *BBC*, March 1, 2006, news.bbc.co.uk.

👁 Ayaan Hirsi Ali: photo by Gage Skidmore.

361 &#128065; Salman Rushdie: photo by David Shankbone.

&#10076;&#10077; Nicolas Sarkozy, quoted in Tom Heneghan, "Sarkozy Letter Surprises French Cartoons Hearing," Reuters, February 7, 2007, reuters.com.

&#128065; Nicolas Sarkozy: photo by Ricardo Stuckert, Agencia Brasil.

&#10076;&#10077; Francois Hollande, quoted in Lara Marlowe, "Trial Starts of Editor Who Published Cartoons," Irish Times, February 8, 2007, irishtimes.com.

&#128065; Francois Hollande: photo by Guillaume Paumier.

362 &#10076;&#10077; Lhaj Thami Breze, quoted in Heneghan, "Sarkozy Letter Surprises" (see earlier note).

&#128065; Lhaj Thami Breze: still from video, "Rencontre privée," Iqraa – Français, June 24, 2015, youtube.com.

&#10076;&#10077; Richard Malka, quoted in Alexandra Bogaert, "Les Caricatures De Mahomet Conduisent 'Charlie Hebdo' Au Tribunal," Libération, September 22, 2006, liberation.fr.

&#128065; Richard Malka: stills from video, "Lire la politique," Radio RCJ, February 27, 2018, youtube.com.

&#10076;&#10077; Philippe Val, quoted in "Sarkozy defends Muhammad cartoons," BBC, February 7, 2007. bbc.co.uk.

&#128065; Philippe Val: still from video, "Philippe Val 'on a inventé le mot islamophobie,'" C à vous, April 10, 2015.

&#10076;&#10077; Francis Szpiner, quoted in "French Court to Rule on Whether Cartoons Insulted Muslims," Religion News, February 6, 2007.

&#128065; Francis Szpiner: still from video, 'Election législative à Louhans," Ina Politique, June 4, 2022, youtube.com.

363 &#128065; Paris court: photo by Zairon.

&#10076;&#10077; Court verdict, quoted in Thierry Leveque, "French Court Clears Weekly in Mohammad Cartoon Row," Reuters, March 22, 2007, reuters.com.

&#10076;&#10077; Appeals Court verdict, quoted in "Procès," Charlie Hebdo, charliehebdo.fr/pages/proces.

364 &#128065; Ile de la Cité: photo by Guilhem Vellut.

fire bomb: Brian Love, "French paper reprints Mohammad cartoon after fire-bomb," Reuters, November 4, 2011, reuters.com.

&#128065; "Charia Hebdo" issue: Charlie Hebdo, November 2, 2011.

&#128065; Luz: photo by Coyao.

&#10076;&#10077; statement: "Pour la défense de la liberté d'expression, contre le soutien à Charlie Hebdo!" November 5, 2011. indigenes-republique.fr.

&#128065; Christine Delphy: still from video, "Le genre précède le sexe," The Rain, September 23, 2018, youtube.com.

365 Innocence of Muslims: Tom Herrenberg, "Denouncing Divinity: Blasphemy, Human Rights, and the Struggle of Political Leaders to Defend Freedom of Speech in the Case of Innocence of Muslims," SSRN, June 8, 2015, ssrn.com.

&#9999; Charlie Hebdo cover: September 19, 2012.

&#10076;&#10077; Laurent Fabius, quoted in Scott Sayare and Nicola Clark, "French Magazine Runs Cartoons That Mock Muhammad," New York Times, September 19, 2012, nytimes.com.

&#128065; Laurent Fabius photo: Greece Foreign Ministry.

Al Qaeda wanted list: Dashiel Bennett, "Look Who's on Al Qaeda's Most-Wanted List," The Atlantic, October 30, 2013, theatlantic.com.

&#128065; Coran issue: Charlie Hebdo, July 10, 2013.

366 2014 lawsuit: Gianluca Mezzofiore, "France Satirical Mag Charlie Hebdo Sued by Islamists for 'Blasphemy,'" International Business Times, Feb 19, 2014, ibtimes.co.uk.

366-367 2015 attack: "Charlie Hebdo Attack: The Three Days That Shook France," France 24, January 6, 2016, france24.com.

&#10076;&#10077; Corinne Rey (Coco), Laurent Sourisseau (Riss), and Eric Fourtheault interviews: Emmanuel Lecomte and Daniel Lecomte, dir., Je Suis Charlie (France: TIFF, 2015).

&#128065; Corinne Rey (Coco), Laurent Sourisseau (Riss), and Eric Fourtheault stills from video, Je Suis Charlie, ibid.

367 Kouachi brothers: "Charlie Hebdo Attackers' Path to Radicalization," New York Times, January 17, 2015, nytimes.com; Angelique Chrisafis, "Charlie Hebdo Attackers: Born, Raised and Radicalised in Paris," Guardian, January 12, 2015, theguardian.com.

368 &#128065; Le Monde front page, January 9, 2015.

369 &#128065; Je Suis Charlie rally photos by Olivier Ortelpa; Mogador; Yann Caradec.

&#10076;&#10077; George Packer, "The blame for the Charlie Hebdo murders," New Yorker, January 7, 2015, newyorker.com.

370 &#10076;&#10077; Philippe Val, in documentary, Daniel Lecomte, dir., C'est dur d'être aimé par des cons (France: Doc en Stock, 2008).

&#128065; Philippe Val press conference, still from documentary, C'est dur, ibid.

&#10076;&#10077; Fassin, "In the Name of the Republic."

&#128065; Didier Fassin still from video, University of California Television, May 9, 2016, youtube.com.

371 liberal Islamophobia: Mondon and Winter, "Charlie Hebdo"; Glenn Greenwald, "204 PEN Writers (Thus Far) Have Objected to the Charlie Hebdo Award – Not Just 6," The Intercept, April 30, 2015, theintercept.com.

&#10076;&#10077; Sanos, "The Sex and Race of Satire."

&#9999; "Is it allowed?" by Charb, Charlie Hebdo, November 11, 2011.

371-372 &#10076;&#10077; Olivier Cyran, "Charlie Hebdo, Pas Raciste? Si Vous Le Dites…," Article 11, December 5, 2013, article11.info.

&#128065; Olivier Cyran still from video, "Tout le monde déteste le Travail," Tlm dIT, Feb. 26, 2018, youtube.com.

&#9999; sex jihad: Charlie Hebdo, Sept. 25, 2013.

373 &#10076;&#10077; Marwan Muhammad, interview by authors, August 2018.

&#128065; Marwan Muhammad photos by Cherian George and Sonny Liew.

&#128065; Boko Haram cover: Charlie Hebdo, October 22, 2014.

&#128065; News article: Chika Oduha, "Chibok: the village that lost its daughters to Boko Haram," Guardian, May 15, 2014, theguardian.com.

374 &#10076;&#10077; George, "Saving Nigerian Girls."

&#128065; Abosede George still from video, "Is Wakanda Real?" Inside Edition, March 1, 2018, youtube.com.

second degree humor: Fisher, "What Everyone Gets Wrong."

Aylan: "Charlie Hebdo blasted for migrant cartoon – again," France 24, January 15, 2016, france24.com.

&#10076;&#10077; Sanos, "The Sex and Race of Satire."

375 La France debout: Louis Hausalter, "La France 'Debout', La Presse Est Unanime," Europe 1, January 12, 2015, europe1.fr.

&#128065; front pages, January 12, 2015: Le Figaro, Sud-Ouest, Liberation, La-Croix.

&#128065; Je Suis Charlie rally: photo by Eric Walter.

hypocrisy: Chomsky, "Paris Attacks Show Hypocrisy."

376 &#128065; Ouest France front page, January 12, 2015.

&#10076;&#10077; Todd, Who Is Charlie?

&#10076;&#10077; defend to the death: Attributed to Voltaire's biographer, Evelyn Beatrice Hall, 1906.

thought we hate: Oliver Wendell Holmes, dissenting opinion in *United States v. Schwimmer*, 279 U.S. 644 (1929).

👁 Voltaire painting by Nicolas de Largillière, c.1724/5.

377 **blasphemy test:** Larsen, "Towards the Blasphemous Self"; Keane, "Cartoons, Comics and Human Rights."

👄💬 Nathalie Saint-Cricq, quoted in Fassin, "In the name of the Republic."

👁 Nathalie Saint-Cricq, still from video, France 2, January 12, 2015.

**embodiment of France:** Toor, "Art as/and Politics."

378 **UK, US press:** Jenkins and Tandoc Jr., "Journalism under Attack."; Eko and Hellmueller, "To Republish or Not to Republish"; Savan, "Why It's OK."

✎ "A cowardly cartoonist" by Robert Crumb, 2015.

👄💬 Robert Crumb, quoted in Celia Farber, "Legendary Cartoonist Robert Crumb on the Massacre in Paris," *Observer*, January 13, 2015, observer.com.

👁 Caroline Fourest on British TV, stills from Sky News Tonight, January 14, 2015.

379 👁 News headline: Jay Hathaway, "Sky News Freaks Out When Journalist Shows Charlie Hebdo Cover on Air," *Gawker*, January 15, 2015, gawker.com.

380 **policing solidarity:** Rudi, "Thoughtcrimes."

381 **does not stop bullets:** Ali Abinumah, "France Begins Jailing People for Ironic Comments," *Electronic Intifada*, January 19, 2015, electronicintifada.net; Christophe Turgis, "Charlie Hebdo: à Nantes, un adolescent de 16 ans poursuivi pour 'apologie du terrorisme' sur Facebook," *France Info*, January 17, 2015, francetvinfo.fr.

**Sisi coup:** "All According to Plan," *Human Rights Watch*, February 18, 2020, hrw.org.

382 👁 *Charlie Hebdo* cover: September 19, 2001.

👄💬 Rudi, "Charlie Hebdo," 28.

383-384 👄💬 Luz, quoted in Anne Laffeter, "All Eyes Are on Us, We've Become a Symbol," *Les Inrockuptibles*, January 10, 2015, lesinrock.com.

👁 Luz stills from video, "Exclusive Interview by 'Charlie Hebdo' Cartoonist Luz," VICE News. January 31, 2015, youtube.com.

## Chapter 15: Concluding Lines, in Words and Cartoons

386 "I am still right here" by Pedro Molina, 2002.

387 ✎ "Scorpius Cartoonus Satiricus" by Jean Gouders, 2011.

✎ "Key" by Mary Zins, Cartoon Movement, 2018.

✎ "Danger" by Adjim Danngar (Achou), 2015.

✎ "Bonus Fun Fact", excerpt from This Modern World by Tom Tomorrow, 2015.

388 ✎ Bashar al-Assad by Akram Raslan, c.2012, courtesy of Fadi Abou Hassan (FadiToOn) and Cartoon Movement.

✎ "Human Rights" by Elihu Duayer, 2018.

389 ✎ "Chinese coronavirus policy" by Steven Degryse (Lectrr), 2020.

✎ "Obi's Nightmare" by Maarten Wolterink, 2018.

**COVID-19 impact:** "Coronavirus pandemic heralds renewed threat to cartoonists," Statement from Cartoon Movement, Cartooning for Peace, and Cartoonists Rights Network International, June 15, 2020.

👄💬 Terry Anderson, quoted in "Press cartoonists in Europe must be protected," Statement from Media Freedom Rapid Response, June 11, 2020, ecpmf.eu.

390 👄💬 Victor Pickard, e-mail interview by author, July 2020. See also: Pickard, *America's Battle for Media Democracy*.

✎ "Three Monkeys" by Stéphane Peray (Stephff), 2005.

391 ✎ "Can I have a grant" by Dwayne Taylor Booth (Mr Fish), 1998.

✎ "Censorship" by Agim Sulaj, 2015 (www.agimsulaj.com).

392 ✎ "Free" by Farhad Foroutanian, 2011.

✎ "DIY Jail" by Khalid Albaih, 2019.

393 ✎ "Freedom" by Anne Derenne, 2019.

✎ "Filial piety" by Kuang Biao, 2016.

👄💬 Martin Rowson, interview by author, July 2019.

394 ✎ "Facebook" by Satish Acharya, 2018.

✎ "Think Different" by Jose Neves (Nemo), 2018.

👄💬 Jose Neves, interview with author, April 2020.

395 ✎ "Red Lines" by Doaa el-Adl, 2010.

396 ✎ "It's your fault" by Jaume Capdevila (Kap), Spain, 2015.

✎ "Cartoonist's Life" by Godfrey Mwampembwa (Gado), 2016.

397 ✎ "The Problem of Self Esteem" by Michael Rozanov (Mysh), 2012.

398 ✎ "Neglected Audiences" by "Stan Kelly" (Ward Sutton), 2018.

399 ✎ "The new Europeans," anonymous, c.2016.

✎ Pepe the Frog Nazi meme, anonymous, c.2016.

✎ Pam Geller cartoon by Matt Wuerker, 2015.

👄💬 prank: Daniels, "The Algorithmic Rise of the 'Alt-Right,'" 64.

400 ✎ "Tanks" by Bas van der Schot, 2018.

**symbolic censorship:** Gamson and Stuart, "Media Discourse"; Gusfeld "On Legislating Morals"; Gusfeld, Symbolic Crusade; Zurcher et al., "Anti-Pornography Campaign."

401 ✎ "Confederacy of Racial Superiority" by David Fitzsimmons, 2015.

402 ✎ "World War III" by Signe Wilkinson, 2006.

👄💬 Signe Wilkinson, e-mail interview by author, April 2020.

👄💬 Spiegelman, "Drawing Blood."

403 ✎ "Target" by Aristides Hernandez (Ares), 2015 (www.areshumour.com).

👄💬 Bari Weiss @bariweiss, Twitter, June 5, 2020.

404 👄💬 Mana Neyestani, e-mail interview with author, April 2020.

✎ "Akram Raslan" by Mana Neyestani, 2016.

# Bibliography

Abraham, Linus. "Effectiveness of Cartoons as a Uniquely Visual Medium for Orienting Social Issues." *Journalism & Communication Monographs* 11, no. 2 (2009): 117-65.

Akser, Murat. "News Media Consolidation and Censorship in Turkey: From Liberal Ideals to Corporatist Realities." *Mediterranean Quarterly* 29, no. 3 (2018): 78-97.

Al-Alwani, Taha Jaber. "'Fatwa Concerning the United States Supreme Courtroom Frieze." *Journal of Law and Religion* 15, no. 1/2 (2000): 1-28.

Altheide, David L., and Robert P. Snow. *Media Logic.* Beverly Hills, Calif.: Sage Publications, 1979.

Anderson, Benedict. *Imagined Communities: Reflections on the Origin and Spread of Nationalism.* London: Verso, 1983.

Anderson, Perry. "The Antinomies of Antonio Gramsci." *New Left Review* (1977): 5-80.

Appiah, Kwame Anthony. "What's Wrong with Defamation of Religion?" In *The Content and Context of Hate Speech: Rethinking Regulation and Responses,* edited by Michael Herz and Péter Molnár, 164-182. New York: Cambridge University Press, 2012.

Arendt, Hannah. *On Violence.* Orlando, FL: Harcourt Brace Jovanovich, 1972.

Aspinall, Edward, and Marcus Mietzner. "Southeast Asia's Troubling Elections: Nondemocratic Pluralism in Indonesia." *Journal of Democracy* 30, no. 4 (2019): 104-18.

Aviv, Efrat E. "Cartoons in Turkey - From Abdülhamid to Erdoğan." *Middle Eastern Studies* 49, no. 2 (2013): 221-236.

Badru, Ubedilah. "Social Movement Based on Religiosity as a New Model of Social Movements in Jakarta (The 212 Social Movement in Jakarta 2016)." *International Journal of Multicultural and Multireligious Understanding* 6, no. 4 (2019): 235.

Bakshi, Garima. "The 'Nirbhaya' Movement: An Indian Feminist Revolution." *Gnovis Journal* (2017). www.gnovisjournal.org

Balkin, Jack M. "Free Speech in the Algorithmic Society: Big Data, Private Governance, and New School Speech Regulation." *U.C. Davis Law Review* 51 (2018): 1149-1210.

Bandurski, David. "Chang Ping Under Pressure." *China Media Project,* August 25, 2010. chinamediaproject.org.

Bandurski, David. "Why Southern Weekly?" *China Media Project,* September 9, 2017. chinamediaproject.org.

Banet-Weiser, Sarah. *Empowered: Popular Feminism and Popular Misogyny.* Duke University Press, 2018.

Baran, Madeleine. "A Brief History of The Masses." *The Brooklyn Rail,* February 25, 2008. brooklynrail.org.

Barr, Nicolaas P. "The New Dutch Far Right." *Jewish Currents,* July 2, 2020. jewishcurrents.org

Barkey, Henri J. "Icarus and Erdogan's Corruption Scandal." *Foreign Policy,* December 27, 2013. Foreignpolicy.com.

Barton, Alana, and Hannah Storm. *Violence and Harassment against Women in the News Media: A Global Picture.* Washington, D.C. and London: International Women's Media Foundation and International News Safety Institute, 2014.

Berkowitz, Dan, and Lyombe Eko. "Blasphemy as a Sacred Rite/Right: 'The Mohammed Cartoons Affair' and Maintenance of Journalistic Ideology." *Journalism Studies* 8, no. 5 (2007): 779-97.

Bezio, Kristin M.S. "Ctrl-Alt-Del: GamerGate as a Precursor to the Rise of the Alt-Right." *Leadership* 14, no. 5 (2018): 556-66.

Birkner, Thomas. "Censorship." *The International Encyclopedia of Journalism Studies,* 2019, 1-5.

Bourdieu, Pierre. *The Field of Cultural Production: Essays on Art and Literature.* Cambridge: Columbia University Press, 1993.

Bradshaw, Samantha, and Philip N. Howard. "The Global Disinformation Order: 2019 Global Inventory of Organised Social Media Manipulation." *The Computational Propaganda Project,* December 3, 2019.

Brewer, Susan A. "Selling Empire: American Propaganda and War in the Philippines." *Asia-Pacific Journal* 11, no. 40 (2013).

Brummett, Palmira. "Censorship in Late Ottoman Istanbul: The Ordinary, The Extraordinary, The Visual." *Journal of the Ottoman and Turkish Studies Association* 5, no. 2 (2018): 75-98.

Bruner, M. Lane. "Carnivalesque Protest and the Humorless State." *Text and Performance Quarterly* 25, no. 2 (2005): 136-55.

Bunn, Matthew. "Reimagining Repression: New Censorship Theory and After." *History and Theory* 54, no. 1 (2015): 25-44.

Buruma, Ian. *Murder in Amsterdam: Liberal Europe, Islam, and the Limits of Tolerance.* New York: Penguin Books, 2007.

Callamard, Agnes. "Gender-Based Censorship and the News Media." *Article 19,* March 8, 2006, article19.org.

Chen, Khin Wee, Robert Phiddian, and Ronald Stewart. "Towards a Discipline of Political Cartoon Studies: Mapping the Field." In *Satire and Politics: The Interplay of Heritage and Practice,* edited by Jessica Milner Davis, 125-62. London: Palgrave Macmillan, 2017.

Cheng, Jennifer E. 2015. "Islamophobia, Muslimophobia or Racism? Parliamentary Discourses on Islam and Muslims in Debates on the Minaret Ban in Switzerland." *Discourse & Society* 26 (5): 562- 586

Childs, Elizabeth C. "Big Trouble: Daumier, Gargantua, and the Censorship of Political Caricature." *Art Journal* 51, no. 1 (1992): 26–37.

Chomsky, Noam, "Paris Attacks Show Hypocrisy of West's Outrage." *CNN*, January 20, 2015, cnn.com.

Chong, Chan Tsu. "Democratic Breakthrough in Malaysia – Political Opportunities and the Role of Bersih." *Journal of Current Southeast Asian Affairs* 37, no. 3 (2018): 109–37.

Citron, Danielle K. "Extremist Speech, Compelled Conformity, and Censorship Creep." *Notre Dame Law Review* 93, no. 3 (2018): 1035–71.

Cobbe, Jennifer. "Algorithmic Censorship by Social Platforms: Power and Resistance." *SSRN* Scholarly Paper. Rochester, NY: Social Science Research Network, August 14, 2019.

Cobbe, Jennifer. "Why a Focus on 'Fake News' and Facebook Misses the Internet's Real Problems – and Solutions." *Open Democracy*, February 19, 2019. Opendemocracy.net.

Coetzee, J. M. *Giving Offense: Essays on Censorship.* (University of Chicago Press, 1997).

Cohen, Michael. "'Cartooning Capitalism': Radical Cartooning and the Making of American Popular Radicalism in the Early Twentieth Century." *International Review of Social History* 52, no. S15 (2007): 35–58.

Cohen, Nicole S. "Cultural Work as a Site of Struggle: Freelancers and Exploitation." *TripleC: Communication, Capitalism & Critique* 10, no. 2 (2012): 141–55.

Cohn, Cindy. "Bad Facts Make Bad Law: How Platform Censorship Has Failed So Far and How to Ensure That the Response to Neo-Nazis Doesn't Make It Worse." *Georgetown Law Technology Review* 2 (2018): 432–47.

Commission on Freedom of the Press. *A Free and Responsible Press. A General Report on Mass Communication: Newspapers, Radio, Motion Pictures, Magazines, and Books.* 1947. Chicago: University of Chicago Press.

Connors, Michael K. "When the Walls Come Crumbling Down: The Monarchy and Thai-Style Democracy." *Journal of Contemporary Asia* 41, no. 4 (2011): 657–73.

Corduneanu-Huci, Cristina, and Alexander Hamilton. "Selective Control: The Political Economy of Censorship." *Policy Research Working Papers* no. 8556. 2018. World Bank.

Coskuntuncel, Aras. "Privatization of Governance, Delegated Censorship, and Hegemony in the Digital Era." *Journalism Studies* 19, no. 5 (April 4, 2018): 690–708.

Daly, Helen L. "On Insults." *Journal of the American Philosophical Association* 4, no. 4 (2018): 510–24.

Daniels, Jessie. "The Algorithmic Rise of the 'Alt-Right.'" *Contexts*, April 3, 2018, 60–65.

Dasgupta, Shamita Das. "On a Different Footing: Has 'Nirbhaya' Turned India Around?" In *Human Rights in Postcolonial India*, edited by Om Prakash Dwivedi and V. G. Julie Rajan, 225–246. Abingdon, Oxford: Routledge, 2016.

de Meritt, Jacqueline H.R. "The Strategic Use of State Repression and Political Violence." In *Oxford Research Encyclopedia of Politics*. 2016. Oxfordre .com.

De Silva, Annemari. "Limits of Expression: Creative Artists and Censorship in Sri Lanka." *International Centre for Ethnic Studies*, March 2018. Ices.lk.

De Silva, Annemari. "Political Cartoonists and Censorship in Sri Lanka." *International Journal of Comic Art* 20, no. 1 (2018): 297–330.

Doniger, Wendy. "India: Censorship by the Batra Brigade." *New York Review of Books*, May 8, 2014.

Duncombe, Stephen. *Notes from Underground: Zines and the Politics of Alternative Culture.* London: Verso, 1997.

Duus, Peter. "Presidential Address: Weapons of the Weak, Weapons of the Strong – The Development of the Japanese Political Cartoon." *Journal of Asian Studies* 60, no. 4 (2001): 965–97.

Eguren, Fernando. "Socialism in the Twenty-First Century and Neo-Liberalism: Diverse Ideological Options Do Not Always Generate Different Effects." *International Development Policy / Revue Internationale de Politique de Développement* 9, no. 9 (2017): 105–27.

Eko, Lyombe, and Lea Hellmueller. "To Republish or Not to Republish: The 'Je Suis Charlie' Mohammed Cartoon and Journalistic Paradigms in a Global Context." *International Communication Gazette* 80, no. 3 (2017): 207–29.

Erdenir, Burak. 2010. "Islamophobia qua Racial Discrimination." In *Muslims in 21st Century Europe: Structural and Cultural Perspectives*, edited by Anna Triandafyllidou, 27– 44. London: Routledge.

Ergin, Bulut, and Erdem Yoruk. "Digital Populism: Trolls and Political Polarization of Twitter in Turkey." *International Journal of Communication*, 11 (2017): 4093–4117.

Facal, Gabriel. "Islamic Defenders Front Militia (Front Pembela Islam) and Its Impact on Growing Religious Intolerance in Indonesia." *TRaNS: Trans-Regional and -National Studies of Southeast Asia* 8, no. 1 (2019), 7-20.

Fang, Kecheng. "Turning a Communist Party Leader into an Internet Meme: The Political and Apolitical Aspects of China's Toad Worship Culture." *Information, Communication & Society* 23, no. 1 (2020): 38-58.

Farjami, Mahmud. *Iranian Political Satirists: Experience and Motivation in the Contemporary Era.* Amsterdam, Netherlands: John Benjamins Publishing Company, 2017.

Fassin, Didier. "In the Name of the Republic: Untimely Meditations on the Aftermath of the *Charlie Hebdo* Attack." *Anthropology Today* 31, no. 2 (2015): 3-7.

Finkel, Andrew. *Captured News Media: The Case of Turkey*. Washington, D.C.: Center for International Media Assistance, National Endowment for Democracy, 2015.

Fish, Mr. *WARNING! Graphic Content: Political Cartoons, Comix and the Uncensored Artistic Mind*. USC Annenberg Press, 2014.

Fisher, Max. "What Everyone Gets Wrong about *Charlie Hebdo* and Racism." *Vox*, January 12, 2015.

Forte, David F. "Righting a Wrong: Woodrow Wilson, Warren G. Harding, and the Espionage Act Prosecutions." *Case Western Reserve Law Review* 68, no. 4 (2018): 1097.

Freedman, Leonard. *The Offensive Art: Political Satire and Its Censorship around the World from Beerbohm to Borat*. Westport, Connecticut: Praeger, 2008.

Freeman, Lauren, and Jeanine Weekes Schroer, eds. *Microaggressions and Philosophy*. New York: Routledge, 2020.

Gaifman, Milette. *"Aniconism: Definitions, Examples and Comparative Perspectives."* *Religion* 47, no. 3 (2017): 335-52.

Gamson, William A. "Injustice Frames." In *The Wiley-Blackwell Encyclopedia of Social and Political Movements*, edited by David A. Snow, Donatella Della Porta, Bert Klandermans, and Doug McAdam, 607-608. Oxford: Blackwell, 2013.

Gamson, William A., and David Stuart. "Media Discourse as a Symbolic Contest: The Bomb in Political Cartoons." *Sociological Forum* 7, no. 1 (1992): 55-86.

George, Abosede. "Saving Nigerian Girls: A Critical Reflection on Girl-Saving Campaigns in the Colonial and Neoliberal Eras." *Meridians* 17, no. 2 (2018): 309-24.

George, Cherian. *Air-Conditioned Nation Revisited: Essays on Singapore Politics*. Singapore: Ethos Books, 2020.

George, Cherian. "Directing Artistic and Intellectual Energies in Singapore: 'Passion Made Possible'?" *AcademiaSG*, April 21, 2020. academia.sg.

George, Cherian. *Hate Spin: The Manufacture of Religious Offense and Its Threat to Democracy*. Cambridge, MA: MIT Press, 2016.

George, Cherian. "Regulating 'Hate Spin': The Limits of Law in Managing Religious *Incitement and Offense*." *International Journal of Communication* 10 (2016): 2955-72.

George, Cherian. "Consolidating Authoritarian Rule: Calibrated Coercion in Singapore." *The Pacific Review* 20, no. 2 (2007): 127-45.

George, Cherian. "Journalism and Authoritarian Resilience." In *The Handbook of Journalism Studies*, edited by Karin Wahl-Jorgensen and Thomas Hanitzsch, 2nd ed., 538-53. New York: Routledge, 2020.

Germano, Fabrizio, and Martin Meier. "Concentration and Self-censorship in Commercial Media." *Journal of Public Economics* 97 (2013): 117-130.

Ghanem, As'ad. "The Deal of the Century in Context – Trump's Plan Is Part of a Long-Standing Settler-Colonial Enterprise in Palestine." *The Arab World Geographer* 23, no. 1 (2020): 45-59.

Goldsmith, Jack L., and Eric Posner. *The Limits of International Law*. Oxford: Oxford University Press, 2007.

Gombrich, Ernst H. "The Cartoonist's Armoury." In *Meditations on a Hobby Horse and Other Essays on the Theory of Art*, 4th ed., 127-42. Oxford: Phaidon Press, 1985.

Graham, Mark, and William H. Dutton. *Society and the Internet: How Networks of Information and Communication Are Changing Our Lives*. Oxford: Oxford University Press, 2019.

Gruber, Christiane. "How the 'Ban' on Images of Muhammad Came to Be." *Newsweek*, March 14, 2016. Newsweek.com.

Gruber, Christiane Jacqueline. *The Praiseworthy One: the Prophet Muhammad in Islamic Texts and Images*. Bloomington: Indiana University Press, 2019.

Grygiel, Jennifer. "Political Cartoonists Are out of Touch – It's Time to Make Way for Memes." *The Conversation*, May 17, 2018.

Guriev, Sergei M., and Daniel Treisman. "Informational Autocrats." *SSRN Electronic Journal*, 2018.

Gusfield, Joseph R. "On Legislating Morals: The Symbolic Process of Designating Deviance." *California Law Review* 56, no. 1 (1968): 54-73.

Gusfield, Joseph R. *Symbolic Crusade: Status Politics and the American Temperance Movement*. Urbana: University of Illinois Press, 1963.

Harari, Yuval Noah. *Sapiens: A Brief History of Humankind*. New York: Harper, 2015.

Haraszti, Miklós. *The Velvet Prison: Artists Under State Socialism*. Tauris, 1988.

Henrichsen, Jennifer R., and Michelle Betz. *Building Digital Safety for Journalism: A Survey of Selected Issues*. Paris: UNESCO, 2015.

Iriye, Akira, Petra Goedde, and William I. Hitchcock. *The Human Rights Revolution: an International History*. Oxford: Oxford University Press, 2012.

Ishay, Micheline. *The History of Human Rights*. University of California Press, 2008.

Jansen, Sue Curry. *Censorship: The Knot That Binds Power and Knowledge*. Reprint edition. New York: Oxford University Press, 1991.

Jansen, Sue Curry and Brian Martin. "Making censorship backfire." *Counterpoise* 7, no. 3 (July 2003): 5-15.

Jenkins, Joy, and Edson C Tandoc Jr. "Journalism under Attack: The *Charlie Hebdo* Covers and Reconsiderations of Journalistic Norms." *Journalism* 20, no. 9 (2019): 1165-1182.

Jensen, Hans J. L. "Aniconic Propaganda in the Hebrew Bible, or: The Possible Birth of Religious Seriousness." *Religion* 47, no. 3 (July 3, 2017): 399-407.

Kahn, Robert. "Tragedy, Farce or Legal Mobilization? The Danish Cartoons in Court in France and Canada." *SSRN* Scholarly Paper. Rochester, NY: Social Science Research Network, 2010.

Karuchit, Warat. "The Uphill Climb to Reach a Plateau: Historical Analysis of the Development of Thai Cartooning." In *Southeast Asian Cartoon Art: History, Trends and Problems*, edited by John A. Lent, 75–104. Jefferson, NC: McFarland, 2014.

Kaya, M. K., and Svante E. Cornell. "Politics, Media and Power in Turkey." *Turkey Analyst* 1, no. 8 (2008). turkeyanalyst.org.

Keane, David. "Cartoons, Comics and Human Rights after the Charlie-Hebdo Massacre." *Religion and Human Rights* 10 (2015): 229–43.

Khadem, Amir. "Framed Memories: The Politics of Recollection in Mana Neyestani's An Iranian Metamorphosis." *Iranian Studies* 51, no. 3 (2018): 479–97.

Khoo, Gaik Cheng. "Bersih and Civic Empowerment in Malaysia." In *Regime Resilience in Malaysia and Singapore*, edited by Greg Lopez and Bridget Welsh, 75–84. Rowman & Littlefield, 2018.

King, Gary, Jennifer Pan, and Margaret E. Roberts. "How Censorship in China Allows Government Criticism but Silences Collective Expression." *American Political Science Review* 107, no. 2 (2013): 326–343.

Klausen, Jytte. *The Cartoons That Shook the World*. New Haven: Yale University Press, 2009.

Klausen, Jytte. "A Comedy of Errors." *Free Speech Debate*, August 13, 2012. freespeechdebate.com.

Koelble, Thomas A., and Steven L. Robins. "Zapiro: The Work of a Political Cartoonist in South Africa: Caricature, Complexity, and Comedy in a Climate of Contestation." *PS: Political Science and Politics* 40, no. 2 (2007): 315–18.

Kowsar, Nikahang (2012) "Being Funny Is Not that Funny: Contemporary Editorial Cartooning in Iran." *Social Research* 79(1): 117–144.

Kreimer, Seth F. "Censorship by Proxy: The First Amendment, Internet Intermediaries, and the Problem of the Weakest Link." *University of Pennsylvania Law Review* 155, no. 1 (2006): 11–101.

Kubicek, Paul. "Faulty Assumptions about Democratization in Turkey." *Middle East Critique* 29, no. 3 (2020): 245-257.

Kuper, Leo. "Censorship by Proxy." *Index on Censorship* 4, no. 3 (1975): 48–50.

Kutz-Flamenbaum, Rachel V. "Humor and Social Movements." *Sociology Compass* 8, no. 3 (2014): 294–304.

Langer, Lorenz. *Religious Offence and Human Rights: The Implications of Defamation of Religions*. Cambridge: Cambridge University Press, 2014.

Larsen, Signe Engelbreth. "Towards the Blasphemous Self: Constructing Societal Identity in Danish Debates on the Blasphemy Provision in the Twentieth and Twenty-First Centuries." *Journal of Ethnic and Migration Studies* 40, no. 2 (2014): 194–211.

Lee, Francis L. F. "Self-Censorship." *The International Encyclopedia of Journalism Studies*, 2019, 1–5.

Lean, Nathan. *The Islamophobia Industry: How the Right Manufactures Fear of Muslims*. Chicago: University of Chicago Press, 2012.

Lederer, Laura, and Richard Delgado, eds. *The Price We Pay: The Case against Racist Speech, Hate Propaganda and Pornography*. New York: Hill and Wang, 1995.

Lemière, Sophie. "The Downfall of Malaysia's Ruling Party." *Journal of Democracy* 29, no. 4 (2018): 114-128. Doi:10.

Lent, John A., and Xu Ying. *Comics Art in China*. Jackson, Mississippi: University Press of Mississippi, 2017.

Leong, Kar-Yen. "Filling in the Gaps: Remembering the 1965 Killings in Indonesia." *Kritika Kultura*, no. 33/34 (2019): 729-760.

Lessig, Lawrence. *Code: And Other Laws of Cyberspace, Version 2.0*. 2nd Revised ed. edition. New York: Basic Books, 2006.

Lessig, Lawrence. "The Laws of Cyberspace." Paper presented at Taiwan Net '98, Taipei, Taiwan, March 1998.

Mantilla, Karla. *Gendertrolling: How Misogyny Went Viral*. Santa Barbara, CA: Praeger, 2015.

Martin, Brian. *Backfire Manual: Tactics Against Injustice*. Sparsnäs: Irene Publishing, 2012.

Marwick, Alice E., and Robyn Caplan. "Drinking Male Tears: Language, the Manosphere, and Networked Harassment." *Feminist Media Studies* 18, no. 4 (2018): 543–559.

Marx, Karl, and James Ledbetter. *Dispatches for the New York Tribune: Selected Journalism of Karl Marx*. London: Penguin Books, 2007.

Marx, Karl, Franz Mehring, and Eduard Fuchs. *Karl Marx; the Story of His Life*. London: Allen & Unwin, 1936.

Mason, Andy, and Su Opperman. "South African Cartooning in the Post-Apartheid Era." In *Taking African Cartoons Seriously: Politics, Satire, and Culture*, edited by Peter Limb and Tejumola Olaniyan, 33–70. East Lansing: Michigan State University Press, 2018.

Matsuda, Mari J. "Public Response to Racist Speech: Considering the Victim's Story." In *Words That Wound: Critical Race Theory, Assaultive Speech, And The First Amendment*, edited by Mari J. Matsuda, Charles R. Lawrence III, Richard Delgado, and Kimberle Williams Crenshaw, 17-52. New York: Routledge, 1993.

McDowall, Matt. "Hate Speech on Campus: Reframing the Discourse." *Journal of Intellectual Freedom & Privacy* 4, no. 1 (June 3, 2019): 14–17.

McGrogan, Manus. "*Charlie Hebdo*: The Poverty of Satire." *Jacobin*, January 7, 2017, jacobinmag.com.

McQuiston, Liz. "The Royal Image Goes Pear-Shaped: Liz McQuiston." *Lapham's Quarterly*, October 29, 2019, laphamsquarterly.org.

Meiklejohn, Alexander. "The First Amendment Is an Absolute." *Supreme Court Review*, 1961, 245–66.

Milner, Ryan M. "Pop Polyvocality: Internet Memes, Public Participation, and the Occupy Wall Street Movement." *International Journal of Communication* 7 (2013): 2357–90.

Milner, Ryan M. *The World Made Meme: Public Conversations and Participatory Media*. Cambridge, MA: MIT Press, 2016.

Mina, An Xiao. *Memes to Movements: How the World's Most Viral Media Is Changing Social Protest and Power*. Boston: Beacon Press, 2019.

Mizuno, Norihito. "The Dispute over Barefoot Gen (Hadashi No Gen) and Its Implications in Japan." *International Journal of Social Science and Humanity* 5, no. 11 (2015): 955–61.

Mondon, Aurélien, and Aaron Winter. "*Charlie Hebdo*, Republican Secularism and Islamophobia." In *After* Charlie Hebdo: *Terror, Racism and Free Speech*, edited by Gavan Titley, Des Freedman, Gholam Khiabany, and Aurélien Mondon, 31–45. London: Zed Books, 2017.

Mosco, Vincent. "Marx Is Back, But Which One? On Knowledge Labour and Media Practice." *TripleC: Cognition, Communication, Co-Operation* 10, no. 2 (2012): 570–76.

Navasky, Victor S. *The Art of Controversy: Political Cartoons and Their Enduring Power*. New York: Alfred A. Knopf, 2013.

Nieborg, David B, and Thomas Poell. "The Platformization of Cultural Production: Theorizing the Contingent Cultural Commodity." *New Media & Society* 20, no. 11 (2018): 4275–92.

Olesen, Thomas. *Global Injustice Symbols and Social Movements*. New York: Palgrave Macmillan, 2015.

Olesen, Thomas. "The Muhammad Cartoons Conflict and Transnational Activism." *Ethnicities* 9, no. 3 (2009): 409–426.

Pickard, Victor. *America's Battle for Media Democracy: The Triumph of Corporate Libertarianism and the Future of Media Reform*. New York: Cambridge University Press, 2014.

Pickard, Victor. "The Violence of the Market." *Journalism* 20, no. 1 (2019): 154–58.

Podesta, Don. *Soft Censorship: How Governments Around the Globe Use Money to Manipulate the Media*. Washington, D.C.: Center for International Media Assistance, National Endowment for Democracy, 2009.

Proctor, William, and Bridget Kies. "Editors' Introduction: On Toxic Fan Practices and the New Culture Wars." *Participation: Journal of Audience & Reception Studies* 15, no. 1 (2018).

Puddington, Arch. *Breaking Down Democracy: Goals, Strategies, and Methods of Modern Authoritarians*. Washington, D.C.: Freedom House, 2017.

Reimann, Mathias. "Introduction: The Yahoo! Case and Conflict of Laws in the Cyberage." *Michigan Journal of International Law* 24 (2003 2002): 663–72.

Repnikova, Maria, and Kecheng Fang. "Behind the Fall of China's Greatest Newspaper." *Foreign Policy*, January 29, 2015. Foreignpolicy.com.

Roberts, Margaret E. *Censored: Distraction and Diversion Inside China's Great Firewall*. Princeton: Princeton University Press, 2018.

Robin, Corey. *Fear: The History of a Political Idea*. Oxford: Oxford University Press, 2006.

Rolfe, Mark. "Clashing Taboos: Danish Cartoons, the Life of Brian and Public Diplomacy." *The Hague Journal of Diplomacy* 4, no. 3 (2009): 261–81.

Roth, Kenneth. "The Dangerous Rise of Populism: Global Attacks on Human Rights." *Human Rights Watch*, 2017.

Rudi, Axel. "*Charlie Hebdo*: The West and the Sacred." In *The Event of* Charlie Hebdo: *Imaginaries of Freedom and Control*, edited by Alessandro Zagato, 25–35. New York: Berghahn Books, 2015.

Rudi, Axel. "The Thoughtcrimes of an Eight-Year-Old." In *The Event of* Charlie Hebdo: *Imaginaries of Freedom and Control*, edited by Maria Dyveke Styve, 36–42. New York: Berghahn Books, 2015.

Sanders, Huub. "Prussian Censorship and Karl Marx's Brief Career as an Editor for the Rheinische Zeitung." *International Institute of Social History* (April 3, 2019), iisg.nl.

Sanos, Sandrine. "The Sex and Race of Satire: *Charlie Hebdo* and the Politics of Representation in Contemporary France." *Jewish History* 32, no. 1 (2018): 33–63.

Savan, Leslie. "Why It's OK for *The New York Times* to Not Be *Charlie*." *The Nation* (January 15, 2015), thenation.com.

Schauer, Frederick. "Uncoupling Free Speech." In *The Price We Pay: The Case against Racist Speech, Hate Propaganda, and Pornography*, edited by Laura Lederer and Richard Delgado, 259–65. New York: Farrar, Straus and Giroux, 1995.

Schiffrin, Anya, ed. *In the Service of Power: Media Capture and the Threat to Democracy*. Washington, D.C.: National Endowment for Democracy (2017).

Schimpfössl, Elisabeth, Ilya Yablokov, Olga Zeveleva, Taras Fedirko, and Peter Bajomi-Lazar. "Self-Censorship Narrated: Journalism in Central and Eastern Europe." *European Journal of Communication* 35, no. 1 (2020): 3–11.

Scott, James C. *Weapons of the Weak: Everyday Forms of Peasant Resistance*. New Haven: Yale University Press, 1985.

Scully, Richard. "Editorial Cartoons." In *The International Encyclopedia of Journalism Studies*, edited by Tim P. Vos and Folker Hanusch. Hoboken, NJ: John Wiley & Sons, 2019.

Sebring, Ellen. "Civilization and Barbarism: Cartoon Commentary and 'The White Man's Burden' (1898–1902)." *Asia-Pacific Journal* 13, no. 27 (2015): No. 1.

Sen, Amartya. "Democracy as Public Reason." In *The Idea of Justice*, 321–37. London: Penguin Books, 2009.

Sharp, Gene. *The Politics of Nonviolent Action: a Study Prepared under the Auspices of Harvard University's Center for International Affairs*. Boston: P. Sargent Publisher, 1973.

Sills, Elizabeth. "Inappropriate Political Content: Serialized Comic Strips at the Intersection of Visual Rhetoric and the Rhetoric of Humor." In *Black Comics: Politics of Race and Representation*, edited by Sheena C. Howard and Ronald L. Jackson II, 207–21. London: Bloombsbury, 2002.

Simon, Joel. *The New Censorship: inside the Global Battle for Media Freedom*. New York: Columbia University Press, 2015.

Sobieraj, Sarah. "Bitch, Slut, Skank, Cunt: Patterned Resistance to Women's Visibility in Digital Publics." *Information, Communication & Society* 21, no. 11 (2018): 1700–1714.

Sorensen, Majken Jul. "Humor as a Serious Strategy of Nonviolent Resistance to Oppression." *Peace & Change* 33, no. 2 (2008): 167–90.

Spiegelman, Art. "Drawing Blood: Outrageous Cartoons and the Art of Outrage," *Harper's Magazine*, June 2006.

Sreberny, Annabelle. "The 2015 Charlie Hebdo Killings, Media Event Chains, and Global Political Responses." *International Journal of Communication* 10 (2016): 3485–3502.

Standing, Guy. "Defining the Precariat: A Class in the Making." *Eurozine*, April 19, 2013, eurozine.com.

Standing, Guy. "The Precariat and Class Struggle." *RCCS Annual Review*, October 1, 2015.

Steele, Janet E. *Wars Within: The Story of Tempo, an Independent Magazine in Soeharto's Indonesia*. Sheffield, UK: Equinox Pub., 2005.

Stone, Geoffrey R. "Free Speech and National Security." *Indiana Law Journal* 84, no. 3 (2009).

Streckfuss, David. "Lese-Majeste, Asian Style: Crisis of Monarchy in Pre-War Japan and Present-Day Thailand." In *Routledge Handbook of Asian Law*, edited by Christoph Antons, 378-97. Oxford and New York: Routledge, 2017.

Tai, Qiuqing. "China's Media Censorship: A Dynamic and Diversified Regime." *Journal of East Asian Studies* 14, no. 2 (2014): 185–209.

Tarrow, Sidney. *Power in Movement: Social Movements and Contentious Politics*. 2nd ed. Cambridge: Cambridge University Press, 1998.

Telnaes, Ann. "The Red, White and Blue Palette." *Nieman Reports* (December 15, 2004).

Thompson, Allan, ed. *The Media and the Rwanda Genocide*. Ottawa: International Development Research Centre, 2007.

Todd, Emmanuel. *Who Is Charlie?: Xenophobia and the New Middle Class*. Cambridge: Polity, 2015.

Tong, Jingrong. "The Taming of Critical Journalism in China." *Journalism Studies* 20, no. 1 (2019): 79–96.

Toor, Saadia. "Art as/and Politics: Why the Attack on *Charlie Hebdo* Was Not About a 'Fear of Art'." *Social Research* 83, no. 1 (2016): 21–31.

Tsesis, Alexander. *Destructive Messages: How Hate Speech Paves the Way For Harmful Social Movements*. New York: New York University Press, 2002.

Varma, Rashmi. "(Un)Modifying India: Nationalism, Sexual Violence and the Politics of Hindutva." *Feminist Dissent*, no. 2 (2017): 57–82.

Viswanath, Rupa. "Economies of Offense: Hatred, Speech, and Violence in India." *Journal of the American Academy of Religion* 84, no. 2 (2016): 352–63.

Wade, Lisa. "Irish Apes: Tactics of De-Humanization." *The Society Pages*, January 28, 2011.

Waldron, Jeremy. *The Harm in Hate Speech*. Cambridge, MA: Harvard University Press, 2012.

Wallis, David, ed. *Killed Cartoons: Casualties from the War on Free Expression*. New York: W. W. Norton & Company, 2007.

Wang, Haiyan, and Colin Sparks. "Chinese Newspaper Groups in the Digital Era: The Resurgence of the Party Press." *Journal of Communication* 69, no. 1 (2019): 94–119.

Wardle, Claire. "Fake News. It's Complicated." *First Draft News*, February 16, 2017. Firstdraftnews.org.

Williams, Monnica T. "Microaggressions: Clarification, Evidence, and Impact." *Perspectives on Psychological Science* 15, no. 1 (2020): 3–26.

Wilson, Ian Douglas. *The Politics of Protection Rackets in Post-New Order Indonesia: Coercive Capital, Authority and Street Politics*. Abingdon: Routledge, 2017.

Wong, Chin-Huat. "The Rise, Resilience and Demise of Malaysia's Dominant Coalition." *The Round Table* 107, no. 6 (2018): 755-769.

Wu, Tim. *The Attention Merchants: The Epic Scramble to Get Inside Our Heads*. New York: Knopf, 2016.

Wu, Tim. "Is the First Amendment Obsolete?" *Knight First Amendment Institute at Columbia University*, September 1, 2017. Knightcolumbia. org.

Xiao, Qiang. "Liberation Technology: The Battle for the Chinese Internet." *Journal of Democracy* 22, no. 2 (2011): 47–61.

Yesil, Bilge. "Press Censorship in Turkey: Networks of State Power, Commercial Pressures, and Self-Censorship." *Communication, Culture & Critique* 7, no. 2 (2014): 154–73.

Zhao, Suisheng. "Xi Jinping's Maoist Revival." *Journal of Democracy* 27, no. 3 (2016): 83-97.

Zhu, Zhiqun. "Interpreting China's 'Wolf-Warrior Diplomacy.'" *The Diplomat*. May 16, 2020. thediplomat.com.

Zuboff, Shoshana. *The Age of Surveillance Capitalism: The Fight for a Human Future at the New Frontier of Power*. New York: PublicAffairs, 2019.

Zuboff, Shoshana. "You Are Now Remotely Controlled." *New York Times*, January 24, 2020, nytimes.com.

Zurcher, Jr., Louis A., R. George Kirkpatrick, Robert G. Cushing, and Charles K. Bowman. "The Anti-Pornography Campaign: A Symbolic Crusade." *Social Problems* 19, no. 2 (1971): 217-38.

# Index

Rushdie, Salman, 361
Russell, Robert, 60
Russia, 196, 397
Rwanda, 309

## S

Sabaaneh, Mohammad, 12, 71-76
Sabah (newspaper), 112
Sachs, Jeffrey, 355
Saint-Crick, Nathalie, 377
Sanos, Sandrine, 354, 371, 374
Santosa, Teguh, 342
Sarkeesian, Anita, 263
Sarkozy, Nicolas, 361
Saudi Arabia, 107, 148, 344, 354
Schauer, Frederick, 312
Sebring, Ellen, 305
Sen, Amartya, 17
Seppla. See Plank, Josef
Serano, Julia, 268
Serra, Robert, 285
Shanmugam, K., 215
Shapiro, Jonathan (Zapiro), 15, 20, 30, 197, 207-9, 298-303, 328-30, 396
Shapour, Bakhtiar, 79
Sharon, Ariel, 318
Shimonura, Hakubun, 248
Silicon Valley, 212
Sills, Elizabeth, 240
Simon Wiesenthal Center, 327
Singapore, 118-35, 139, 196, 215
Singapore Herald, 125-26
Singapore Press Holdings. See Straits Times, The
Sky News, 378-79
Sourisseau, Laurent (Riss), 366
South Africa, 20, 146, 152, 207-9, 298-303, 328-30, 396, 398
South America, 141, 147, 207
Soviet Union, 392
Spain, 161, 173
Sparrow, Penny, 329
Spiegelman, Art, 7, 402
Sreberny, Annabelle, 356
Sreenevasan, Ambiga, 40, 50
Sri Lanka, 11, 235
Stalin, Joseph, 44, 89
Stahler, Jeff. 229

Standing, Guy, 171
Stanford Jewish Voice for Peace, 327
Stanford University, 326
Steinem, Gloria, 268
Stephff. See Peray, Stéphane
Straits Times, The, 119-20, 124
Streicher, Julius, 309
Streisand, Barbara, 43, 131
Süddeutsche Zeitung, 320
Sudan, 139
SudOuest (newspaper), 147, 212, 375
Suhail, Mir, 236
Suharto, 148
Sulaj, Agim, 391
Sunday Times, The (South Africa), 301-02
Sunday Times, The (UK), 235, 333
Superman, 306
Sutton, Ward, 398
Sweden, 17
Switzerland, 50, 162, 401
Syaf, Ardian, 151
Syria, 13-14, 355, 374, 388, 405
Szpiner, Francis, 362
Sørensen, Majken Jul, 29, 43

## T

Tabatabi, Shojai, 138
Taylor, Dwayne, 391
Telnaes, Ann, 36, 146, 184, 197, 205-6, 230, 269, 395-96
Tempo, 148-49
Tencent. See Weixin
Thailand, 335-36, 346, 390, 401
Thomdean, Tobby, 179
Thomson Reuters, 198
Tiananmen, 97
Tibet, 97
Tignous. See Verlhac, Bernard
TikTok. See Douyin
Tillman, Pat, 234
Time (magazine), 213
Tobocman, Seth, 174
Todd, Emmanuel, 355
Tom Tomorrow. See Perkins, Dan
Trivedi, Aseem, 290-91
Trump, Donald, 15, 154-60, 185-87, 213, 323, 394

Turkey, 16, 107-115, 118, 152, 374
Twitter, 49, 97, 211, 214-15, 264-66, 317, 326

## U

United Kingdom, 159, 170, 173, 214, 305, 317-30, 333, 394
United Nations, 18-19, 75, 123, 159, 260, 306, 310-11
United States, 11, 77, 95, 135, 139, 141, 147, 154-60, 169-74, 182-88, 200-1, 213, 216, 227-49, 264, 305-7, 317, 322-23, 345, 348-49, 381-82, 394, 396, 399, 401, 403
Urbs, Rodolphe, 147, 212

## V

Vadlamudi, Swathi, 20, 271-75
Val, Philippe, 359, 362-63, 370, 378
Valley, Eli, 321-27
Van Der Schot, Bas, 400
Van Gogh, Theo, 357
Vargas, Vilma, 28, 32, 62-67, 222
Venezuela, 67, 282-89, 398, 403
Verlhac, Bernard, 3, 359, 383
Villegas, Ernesto, 286
Voice of America, 95
Voltaire, 353, 376

## W

Wall Street Journal, 126
Wang, Liming (Rebel Pepper), 94
Washington Post, 146, 161, 184,
WeChat. See Weixin
Weibo, 96-97, 101, 103
Weil, Roberto, 282-89, 291
Weiss, Bari, 326, 403
Weixin, 87, 103, 203-4
Wendell, Oliver, 239
Westergaard, Kurt, 336-38
Widodo, Joko, 164
Wielder, Emily, 327
Wilders, Geert, 313
Wilkinson, Signe, 340-41, 402
Williams, Joanna, 268

Williams, Serena, 317-18, 397
Wilson, Woodrow, 236
Wolinski, Georges, 3, 359
Wolterink, Maarten, 389
Wu, Tim, 98
Wuerker, Matt, 36, 184, 400, 398

## X

Xi, Jinping, 89, 92-93, 106
Xinjiang, 97

## Y

Yale University, 338
Yazdi, Mesbah, 77
Yemen, 366
Yiannopoulos, Milo, 264
Young, Art, 237
Yousafzai, Malala, 140
YouTube, 211, 214, 217

## Z

Zapiro. See Shapiro, Jonathan
Zempi, Irene, 214
Zins, Mary, 386
Zuboff, Shoshana, 224
Zuckerberg, Mark, 211, 216, 223, 394
Zulkifli, Arif, 149
Zuma, Jacob, 20, 147, 207-9, 300-2, 329, 398
Zunar. See Haque, Zulkiflee Anwar

**Information Policy Series**

Edited by Sandra Braman